After Raphael

After Raphael is the first comprehensive overview of sixteenth-century Italian paint-
ing to be published in over thirty years. Reevaluating the paintings of Raphael,
Michelangelo, Pontormo, Rosso, Bronzino, Salviati, and their followers in the light
of recent research, Marcia Hall offers a new interpretation for the stylistic shifts that
occurred after 1520. By taking into account the social, cultural, political, theological,
and patronage issues that affected taste and stylistic developments, she demonstrates
how the revival of interest in antique Roman relief sculpture affected Mannerist
painters. She also examines the repercussions of the Protestant Reformation, which
changed forever the Church's view of the function of images. Beginning already in
Michelangelo's Pauline Chapel, a new style and decorum of sacred painting evolved
and took shape slowly in the second half of the century. In the realm of public and
private decoration, a new syntax and vocabulary of ornament that developed in this
period provided a legacy that would be used for the next three centuries. This study
also examines the work of the Carracci and Caravaggio, whose personal manners
developed out of this profound shift in style, and from whose work the Baroque
emerged.

Marcia B. Hall is Professor of Art History at Temple University in Philadelphia.
A National Endowment of the Humanities University Professor and fellow of Villa
I Tatti, she is the author of *Color and Meaning: Practice and Theory in Renaissance Paint-
ing* and editor of *Raphael's "School of Athens."*

After Raphael

Painting in Central Italy in the Sixteenth Century

MARCIA B. HALL

CAMBRIDGE
UNIVERSITY PRESS

PUBLISHED BY THE PRESS SYNDICATE OF THE UNIVERSITY OF CAMBRIDGE
The Pitt Building, Trumpington Street, Cambridge CB2 1RP, United Kingdom

CAMBRIDGE UNIVERSITY PRESS
The Edinburgh Building, Cambridge CB2 2RU, UK http://www.cup.cam.ac.uk
40 West 20th Street, New York, NY 10011–4211, USA http://www.cup.org
10 Stamford Road, Oakleigh, Melbourne 3166, Australia

First published 1999

Printed in the United States of America

Typeset in Bembo in QuarkXPress [GH]

Library of Congress Cataloguing-in-Publication Data

Hall, Marcia B.
 After Raphael : painting in central Italy in the sixteenth century /
Marcia Hall.
 p. cm.
 Includes bibliographical references and index.
 ISBN 0-521-48245-3 (hardback)
 1. Painting, Italian – Italy, Central. 2. Painting – 16th century –
Italy, Central. I. Title.
 ND615.H39 1998
 759.5'6' 09031 – dc21 98-15175
 CIP

A catalogue record for this book is available from
the British Library.

Publication of this book has been aided by a grant from the
Millard Meiss Publication Fund of the College Art Association. MM

ISBN 0-521-48245-3 hardback

Dedicated to the memory of Sydney Joseph Freedberg (1914–1997)

Contents

List of Illustrations

A Note on Style Labels

The issue of style labels is a thorny one, and anyone who grasps hold of it these days is certain to come away bloodied. Many in our field have abandoned them altogether, claiming they do more harm than good. The easy confidence with which our predecessors applied them is lost and gone, victim of the worthy effort to talk about art in the terms those who were making it would have used and understood. Yet the need to categorize is universal because categories are helpful. The first to admit it would have been those writers on rhetoric who were so much studied and admired in the Renaissance, for they were the inventors of categories galore. Categories and labels assist us in talking about what we see. To be sure, we mold history according to our needs and vision and values, and taste changes accordingly. What was highly valued in the past century may no longer have the power to touch us today, but it may speak again to the next generation or the next century. If we learn nothing else from the study of art history, we must surely learn this: *labels reflect our particular vision*. They may, indeed, prove an embarrassment when their inadequacy is recognized by a subsequent generation. Such a case is "anticlassical," in my view. But even though this term has been discarded today, it nevertheless tells us something valuable about the history of art history and about the 1920s when it was invented.

I believe we need to approach our material with greater humility and acknowledge that there is no such thing as "timeless" in the writing of history. Another generation will see this art differently, will discard our insights and our categories as we have discarded many of those of the past. Immortality for the historian spans about a generation at best, and our ambition should be to analyze, with as much freshness and honesty as we are capable of, what this art means to us today. Art transcends our categories and constantly reveals itself anew. This characterizes, perhaps even defines, great art.

My position on style labels, then, is this: we create them for our convenience because they correspond to configurations that we perceive. We impose them on the flow of events in accordance with what seems significant to us. There are, consequently, artists who do not fit our categories – Michelangelo is one of these – and even periods that cannot be satisfactorily labeled because no single style seems dominant among several competing strains. Such a period in my judgment is the 1520s and 1530s, following the death of Raphael, previously called Early Mannerism.

It should not be surprising to us that the premature disappearance from the scene of such an authoritative artistic force as Raphael at the height of his powers should have created a profound disturbance. In the years that followed his death, some artists continued to explore the Classic style: Andrea del Sarto, Franciabigio, and others of their generation in Florence, Jacopo Sansovino in sculpture, to name only a sample. In Rome the members of Raphael's *bottega* each pursued particular aspects of the master's style, in accordance with the kind of specialization that seems to have been practiced in his workshop. It is not unlike the situation after the death of another commanding artistic presence, Giotto in 1337, when the synthesis of the master's vision was dismantled at the hands of pupils who each chose to develop different facets of it. The removal of Michelangelo from the Roman scene with his transfer to Florence in 1516 contributed to a loss of direction, to the fragmentation of style that followed. This "fragmentation" should not be construed as a loss of quality, though it did mean a loss of focus. I take it to be a necessary process in the ebb and flow of styles. The time from 1521 to 1538 is a period of transition, full of exciting experimentation. Depending upon your taste, you may find it more stimulating than the moments of stylistic maturity that flank it: Classic on the one side, Maniera on the other.

The solution I offer in this book differs, I regret to say,

from all those previously proposed, but it attempts to simplify the problem of style periods and to reduce the labels used to a minimum: classical (meaning ancient Roman), Classic; transitional, relieflike; Maniera; Counter-Maniera; Counter-Reformation, late Maniera. It should be understood that these style periods do not correspond to time periods in a one-to-one fashion. Not every artist working in central Italy in 1515 can be forced into the category of Classic; as I will discuss in the first chapter, there is a whole competing strain that centers on antiquarianism, and there may well be others yet to be identified and separated out. By the same token, the period at midcentury is very complex, with older painters like Salviati and Vasari continuing to practice in the Maniera style while other, younger artists, sensitized to newly emerging Counter-Reformation views, seek to create a new Counter-Maniera. The end of the century offers even more rival options.

The history of the debate over Mannerism in our century has been reviewed recently by Elizabeth Cropper.[1] She pointed out that the trend in the literature since the 1970s to avoid discussion of Early Mannerism has continued in the recent monographs on Rosso and Pontormo. Nevertheless, a consensus seems to have developed that the term is not satisfactory to describe the style of the 1520s and 1530s.[2] I would suggest that the insistence in the earlier literature upon Florence as the source of innovation, at the expense of Rome, has never adequately been reconsidered and has continued to skew our vision of the period.

"Mannerism," or "Early Mannerism," emphasizes discontinuity with the Classic style at a time when many artists were experimenting but intending to imitate the great Classic masters. As Cecil Gould wrote in rejecting the label, what these painters had most in common was that they were the "post-peak" generation.[3] I therefore prefer not to use "Mannerism," or to use it sparingly for the period of the 1520s and 1530s, and to refer to these works as transitional.

Craig Smyth's insight that the conventions of the Maniera were derived from antique sculpture[4] has been the key to my interpretation of the 1520s and 1530s, where I see a significant difference between what is going on in Rome and in Florence, and between sacred art, where there were strong conventions that tended to keep it more conservative, and the new monumental secular cycles that were beginning to be commissioned in Rome, for which the model chosen was antique. I

have coined the term "relieflike style" to describe what Michelangelo first, in the *Battle of Cascina,* and then Raphael, in his design for the *Battle of the Milvian Bridge,* bequeathed to the painters as a new model and an alternative to the Renaissance compositional mode of central-point perspective.

There are a handful of Florentine paintings, familiar to us all since Walter Friedlaender's essay in which he invented the term "anticlassical"[5] and reproduced over and over again, that have come to constitute the canon of Early Mannerism: Pontormo's *Visitation* in Santissima Annunziata, his *Sacra Conversazione* in San Michele Visdomini (Fig. 40), his frescoes at the Certosa (Fig. 39), his lunette at Poggio a Caiano, the *Entombment* in Santa Felicita; Rosso's *Assunta* in Santissima Annunziata, his *Marriage of the Virgin* in San Lorenzo (Fig. 42), his *Deposition* in Volterra, his *Moses and the Daughters of Jethro* (Fig. 43). It is interesting that Herman Voss (1920), writing before Friedlaender's essay was published, included among the eight illustrations he devoted to these painters only two of these works. On the other hand, Frederick Hartt, in the most influential book in the field, *A History of Italian Renaissance Art,* selected all his illustrations of the works of Pontormo and Rosso from the Friedlaender canon, adding only Pontormo's *Joseph in Egypt* (Fig. 35). A less biased selection, which I have tried to present, reveals painters who are constantly trying out new solutions based on their own and their predecessors' works.

In Rome, the importance of Polidoro da Caravaggio's now-vanished facade decorations *all'antica* has continued to be neglected. Together with Raphael, Michelangelo, and the antiquities on view, they were what the young artists copied to perfect themselves in the new style. Florence had no Polidoro, nor a constant flow of newly discovered antiquities to stimulate its artists and patrons. Consequently there was a much more inward-turning, hothouse atmosphere. Bronzino, beginning in the late 1520s, distanced himself from the agitated emotion and quivering sensibility of his master Pontormo's experiments. His cooler and more disciplined style of the decade 1527–37 provides an interim that makes it still more difficult to trace a continuity between the so-called Early Mannerism and the Maniera that emerged in Rome in the late 1530s.[6] It is more useful to study this period with these regional differences in mind than with the concept of Mannerism at the forefront.

Recent historical scholarship has moved toward a

more positive evaluation of the Counter-Reformation. As Paul Grendler has pointed out, anticlerical bias among intellectuals of the nineteenth and twentieth centuries has obscured the links between Quattrocento humanism and the Counter-Reformation.[7] The challenge for the present generation of historians of Cinquecento art is to reevaluate the second half of the century, particularly its sacred art, from a perspective free of anticlericalism. This task is already well under way, especially among Italian and English scholars.

Federico Zeri in 1957 *(Pittura e controriforma)* had discerned a break in the stylistic development in Rome at about midcentury and identified it as a response to the emerging Counter-Reformation. He isolated painters who concerned themselves with making sacred art that would meet the criteria of the Decrees of the Council of Trent and of the treatise writers like Gilio, Borromeo, Paleotti, and Raffaello Borghini.

The response of artists and patrons in Rome to the religious upheavals, beginning even as early as the 1530s, is more nuanced than was at first thought. Maria Calì (1980) made a sharp distinction between the rigid and dogmatic spirit of the Counter-Reformation and the exploratory and open Catholic Reform movement that preceded it, especially in the 1530s. She undertook to set apart the pedestrian Counter-Reformation painters (Zeri's "painters of the Counter-Reformation") from those she saw as preserving their expressive liberty while conforming their styles as necessary to the new demands for devout painting. I, too, distinguish between the Catholic Reform movement of the thirties and early forties – the *spirituali* to whom Michelangelo with Vittoria Colonna and others belonged – and the Tridentine reform. After the Reform movement had been derailed in the early 1540s, there developed a range of artistic responses to the emerging conditions, from Girolamo Siciolante's suppression of the aesthetic, to Taddeo Zuccaro's tempered Maniera, to Girolamo Muziano's revival of Sebastiano del Piombo's devout nobility.

Against the advice of one revered colleague I have retained the term Counter-Reformation, not in order to insist upon its character as a reaction to Protestantism, but because it is the only widely used term that can characterize the sacred art of the whole period with all its diversity.

Sydney Freedberg (1971) refined and extended Zeri's brilliant insights and invented the term "Counter-Maniera" to describe this art. Intentionally parallel to Counter-Reformation, the term described the painting from which Maniera "abuses" and "errors,"[8] had been purged, but in which it had not yet been discovered that the path of the future lay in the direct appeal to the worshiper's emotions. In Freedberg's careful definition of his term, Counter-Maniera excluded the most egregious artificialities of the Maniera in the interest of a more devout sacred art, but retained much from that style. It was not so much an anti-Maniera as a chastened Maniera. It was applied to the painters of the third generation of Maniera in Florence in my *Renovation and Counter-Reformation* (1979). Here I have applied the term "Counter-Maniera" only to sacred art. Unlike Freedberg I have included Michelangelo's frescoes of the Pauline Chapel, otherwise stylistically orphaned, under the Counter-Maniera rubric.

This last brings up the perennial issue of what labels to use for Michelangelo. His style was constantly evolving, and although it was little influenced by other artists, it was deeply influenced by his own spiritual pilgrimage. Because he was ever the pioneer and never the follower, his style does not fully fit stylistic categories, even at any given moment. He was a major contributor to the formation and evolution of the Classic style of the High Renaissance. His adoption of an anormative figure canon, his cultivation of artificial poses, and his delight in ornaments were much imitated by his contemporaries in the 1520s, particularly in Florence but also in Rome. Returning to residence in Rome in the mid-1530s to paint the *Last Judgment,* Michelangelo viewed it through the lens of his personal religious reawakening, spurred by involvement with the Catholic Reform. His majestic and sober style discarded ornament and eventually rejected grace and physical beauty. This moment coincided almost exactly with the formulation of the Maniera by Perino, Jacopino, Salviati, and Vasari, and they and other younger artists drew upon the intricate poses of the nudes of the *Judgment* as a source and inspiration, taking from it what was quite contrary to Michelangelo's intent. I will argue that in his immediately subsequent Pauline Chapel he abandoned the humanist principal of the *imago dei,* painting creatures totally dependent upon God's Grace to achieve physical grace. Each phase generated imitators, but as he progressed in age and profundity, the imitators' approximations of his style became more and more remote. Although the example of spiritual devotion he provided in the Pauline Chapel caused some other artists to moderate the excesses of their Maniera, almost no one followed him down the path lead-

ing to the abnegation of physical beauty. Thus he was a source for Maniera but never a practitioner of it. He was the pioneer of Counter-Maniera, yet his work remained its most extreme statement and even moved beyond it, to a rejection of Maniera.

From the 1540s onward the situation becomes even more complex because, among alternative styles existing side-by-side, no one dominated. At the same time that the Counter-Maniera was invented for sacred art, older artists like Salviati continued to paint secular commissions in the Maniera style, while some younger ones evolved a more conservative manner that, like the Counter-Maniera, excised some of the artificiality of the Maniera and moved away from the relieflike style. Taddeo Zuccaro's compromise bridged the Maniera and the Counter-Maniera in a way that satisfied both the patrons devoted to opulence and the reformers. It can properly be called late Maniera. For the remainder of the century, in Rome, Florence, and other parts of central Italy, a moderated Maniera flourished and continued to be used in palaces and for other kinds of secular painting.

Toward the end of the century some new solutions were found that set the stage for the Baroque style. Once again, labels fail in a situation of transition. Sixtus V (1585–90) embarked upon a program of decoration that demonstrated a new decorum for paintings according to their site and function. The demands of spokesmen for the Counter-Reformation, like Gilio, for distinctions between private and public, secular and sacred art, were finally met with a definitive codification that would largely put to rest the unease many patrons and artists had felt about the role of classical antiquity in Christian imagery and the suitability of "pagan" motifs in that setting. The urgency with which these decorations were executed took its toll, however. The team of thirty painters working at the same time resulted in works that epitomized the *maniera ammanierata* deplored by the Seicento critics.[9] These are paintings that interest us not for their aesthetic quality but for the iconodule idea they were intended to demonstrate. Maniera as a style had been exhausted and new stylistic solutions were needed.

The discovery of the affective answered the call for an art that would lead worshipers to devotion, rather than distracting them with inappropriate worldly thoughts. Federico Barocci, drawing upon the emotional appeal of Correggio's paintings, led the way toward an acceptable sensuousness, replacing the sensuality of certain Maniera images, which the Decrees of the Council of Trent had explicitly condemned as lascivious.

Caravaggio, bringing to Rome an artistic sensibility developed in northern Italy and an intrinsically rebellious nature, introduced novelties of chiaroscuro and of figure type that created a rival realism to the revitalized Classicism of the Carracci and of the native Roman school. Thus the situation at the end of the century was rife with new potential. None of these new styles chose to revive the relieflike style that had thrived particularly in the second quarter of the century, although that other invention of Roman antiquarianism, the wall treated as surface, fared much better and would have a very long life.

◆

I OFFER HERE a rethinking of what has been called Mannerist painting and of what followed and coincided with it. I have been able, I believe, to reconcile some of the competing interpretations by addressing questions previously neglected and then raised in the past generation, and on the basis of this new research to pursue issues left unresolved when, around 1970, the Mannerism debate was abandoned. What followed in the second part of the Cinquecento makes better sense when some of these issues have been clarified.

My view of the historian's task is that it is less a matter of tying up all the ends than it is a matter of identifying strands and tracing them as far as present knowledge permits. The strands are there to be followed up by future historians, but the fabric does not come apart when we trace a thread farther or identify a pattern in the weave that has not been seen before; rather, another element of its richness is appreciated. It is not the historian's task to cut and shape that fabric into a garment of her making, because the pattern of the garment itself becomes confused with the pattern of the fabric and distracts attention from it. And, as beautiful as the garment may be, it will become outmoded and dated, and it will have to be taken apart or discarded by a future generation.

Acknowledgments

This book was researched, written, and edited in Rome, all at the library of the American Academy in Rome. Little did they know, nor did I, when I timidly requested a desk in September 1994, that I would occupy it for three years. I am grateful to the National Endowment for the Humanities for granting me a Fellowship for University Professors in 1995–96 that, together with a Study Leave from Temple University, enabled me to do the writing. The opportunity to be in Rome was afforded by a teaching assignment on Temple's Rome campus, where my teaching dovetailed nicely with what I was researching. The students there in my High Renaissance class in the fall of 1996 and the spring of 1997 used the manuscript as their text. Their responses and questions helped me clarify and hone it. Graduate students at Temple, Philadelphia, in the fall of 1997, pursued issues raised by the text, in some cases very fruitfully. Ian Verstegen pioneered further thrusts in the study of Barocci's color, and Nicole Leighton's research on Mantegna as a precursor of the relieflike style impelled me to make additions to the text at the copy-editing stage.

There are many friends and colleagues to whom I am indebted either for reading part or all of the draft or for other kinds of help and advice. First among them is Craig Smyth, whose perspicacity and generosity are a model without peer. Others include Paul Barolsky, Janis Bell, Phyllis Bober, Pia Candidas, Maria Ann Conelli, Tracy Cooper, Jan Gadyne, Nicholas Horsfall, John Paoletti, Loren Partridge, Dana Prescott, Maureen Pelta, Ingrid Rowland, Salvatore Settis, Paul Tegmeyer, Franca Trinchieri Camiz, Jack Wasserman, and Mark Weil. I thank colleagues at Temple, Rome, Maria Ponce de Leon and Jan Gadyne, for help with translation. Diane Sarachman acted as my underpaid research assistant in the early stages with her characteristic energy and perfectionism.

Locating and acquiring the photographs took nearly a year. Were it not for grants from the Samuel H. Kress Foundation, the Millard Meiss Publication Fund of the College Art Association, and Temple University, it would have been impossible to illustrate the book as it is. I had help in the arduous task of obtaining photographs from many friends: Sarah Boyd, Denise Bratton, Lucy Clink, Susan Langworthy, Tom Mueller, Sylvia Ferino Pagden, John Shearman, Gyde Shepherd, Fiorella Superbia, Simonetta Serra, Bette Talvacchia, and Mary Vaccaro.

My now long-standing relationship with my editor at Cambridge University Press, Beatrice Rehl, has sustained me throughout this project. I am grateful for her unique combination of intellect, efficiency, and practical good sense. Her assistant, Stephen Grimm, has helped unfailingly with good will and skill. Nicole Leighton volunteered to do the index, drawing upon her knowledge of the field and her familiarity with this text.

I wish to thank Christine Huemer and the staff of the American Academy in Rome for their courtesy and hospitality. Temple University in Rome was my communication center during this project, and the staff there bore the brunt of the endless printing, faxing, and phoning that was necessary. I wish to thank them, especially Dean Kim Strommen and Teri Moretti, for their always gracious help.

I have a special debt to Hellmut Wohl, who stimulated my interest in the antiquarians like Jacopo Ripanda in several lectures given in the early 1990s. I read his forthcoming book, *The Aesthetics of Italian Renaissance Art,* in draft and profited from it.

I thought of Sydney Freedberg as I wrote nearly every page. I have shamelessly repeated his language when I could find no satisfactory substitute. Although his books have proved difficult for those who were not his students and who cannot hear his voice intoning the words in their heads, they remain at the pinnacle of insightful and sensitive response to Renaissance style. It has been my hope that this work, so dependent from his, will help to keep his contribution alive.

Finally, I thank Gerald Hoepfner, my husband, who would be embarrassed if I revealed here the nature and extent of his contribution, so it will remain our secret.

Philadelphia M.B.H.
March 1998

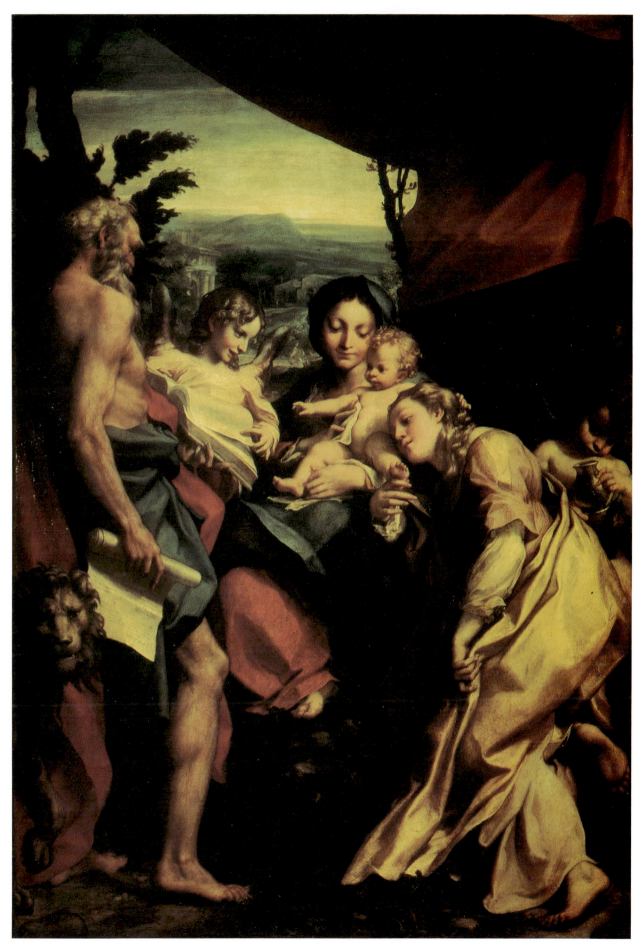

Plate I. Correggio, *Madonna of Saint Jerome.* c. 1526–7. Galleria Nazionale, Parma.

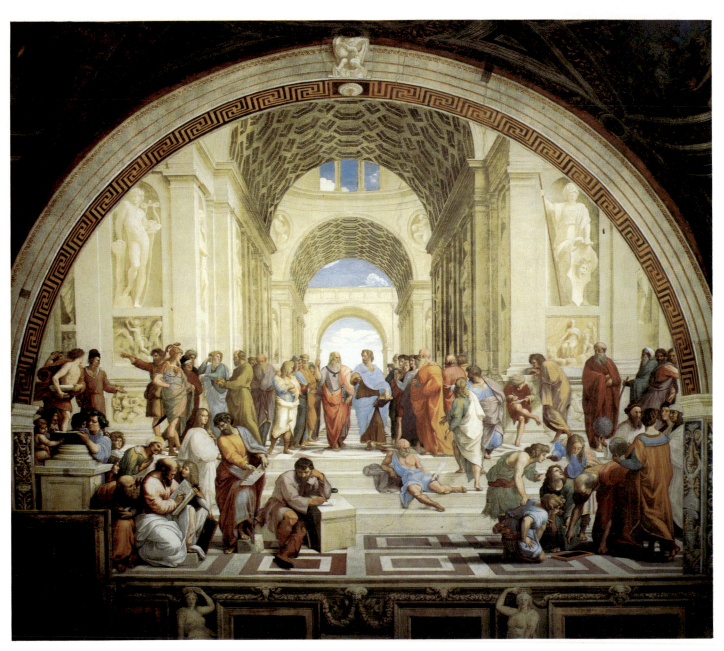

Plate II. Raphael, *School of Athens*. Fresco, 1509. Stanza della Segnatura, Vatican Palace.

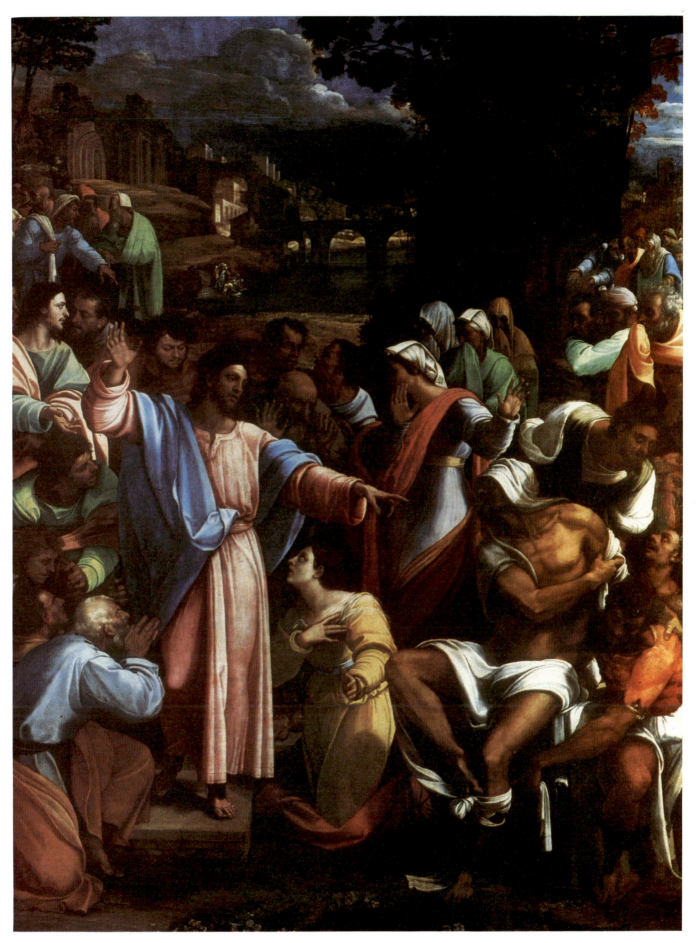

Plate III. Sebastiano del Piombo, *Raising of Lazarus.* 1518. National Gallery, London.

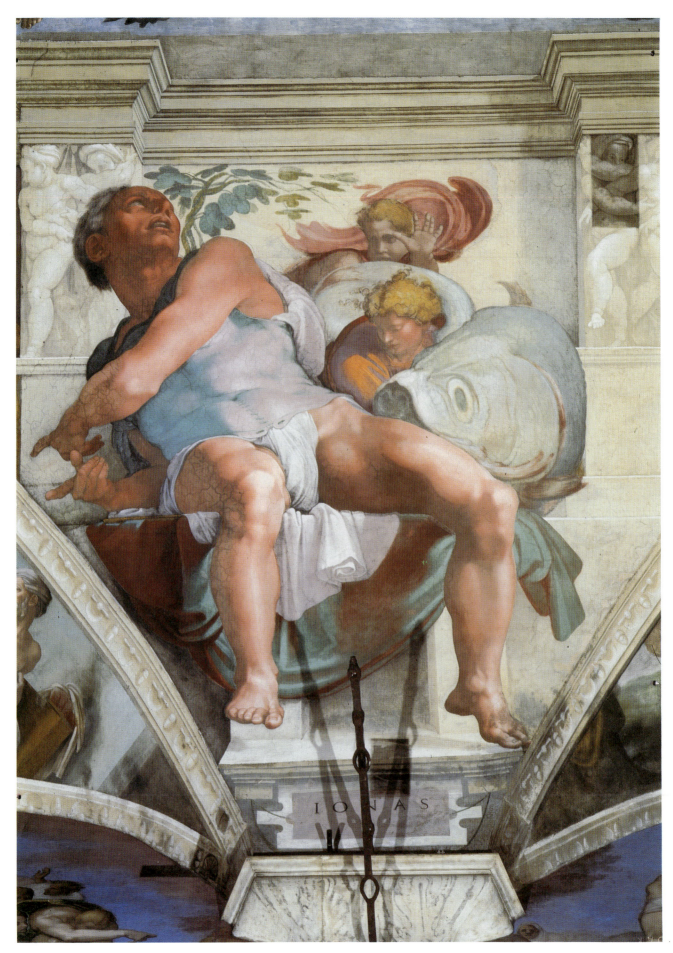

Plate IV. Michelangelo, *Jonah*. Fresco, 1512. Sistine Chapel, detail of ceiling, Vatican Palace.

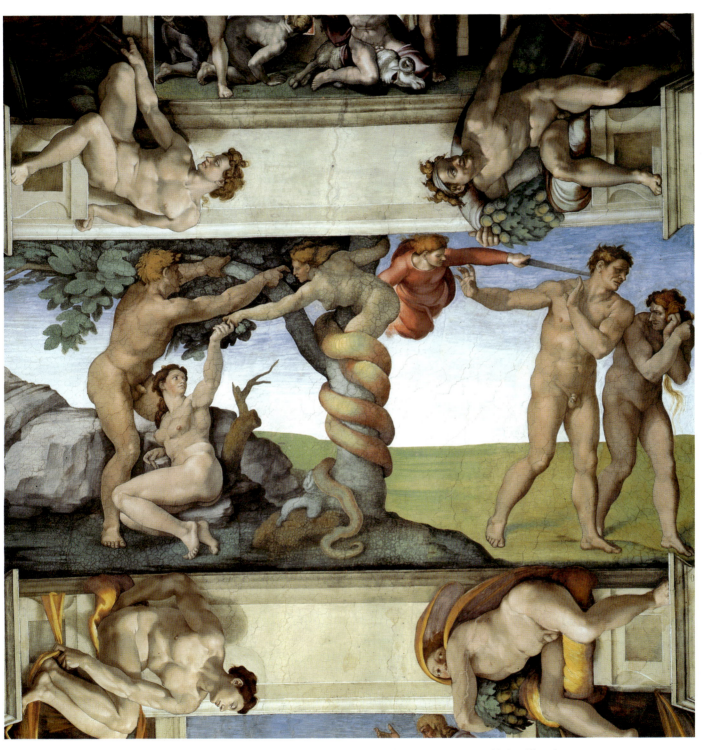

Plate V. Michelangelo, *Temptation and Expulsion of Adam and Eve*. Fresco, c. 1510. Sistine Chapel, detail of ceiling, Vatican Palace.

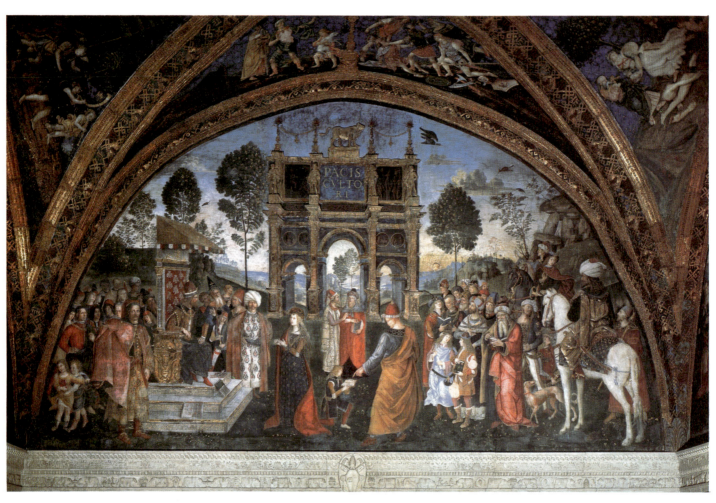

Plate VI. Pinturicchio, *Disputation of Saint Catherine of Alexandria*. Fresco, 1492–5. Borgia Apartment, Vatican Palace.

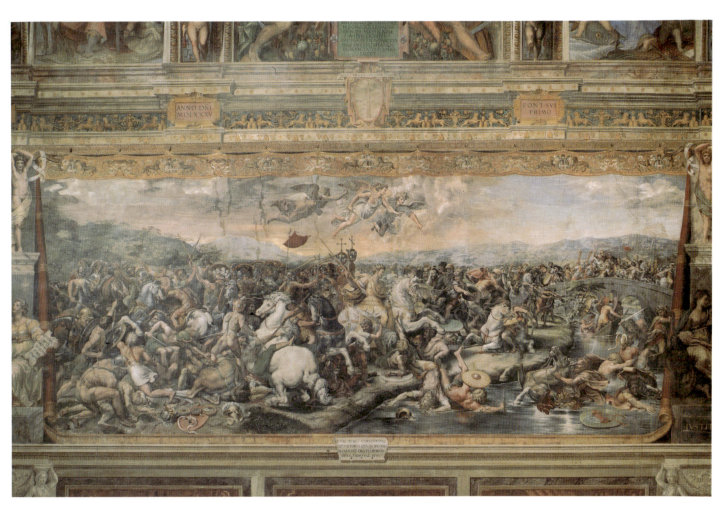

Plate VII. Raphael and workshop, *Battle of the Milvian Bridge.* Fresco, 1519–24. Sala di Costantino, Vatican Palace.

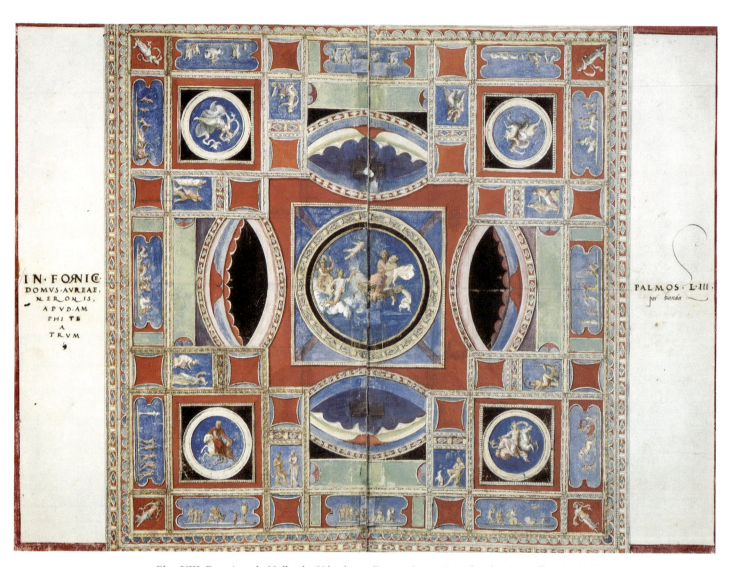

Plate VIII. Francisco de Hollanda, *Volta dorata,* Domus Aurea. *Desenhos das Antigualhas sketchbook.* c. 1539. Escorial, Madrid.

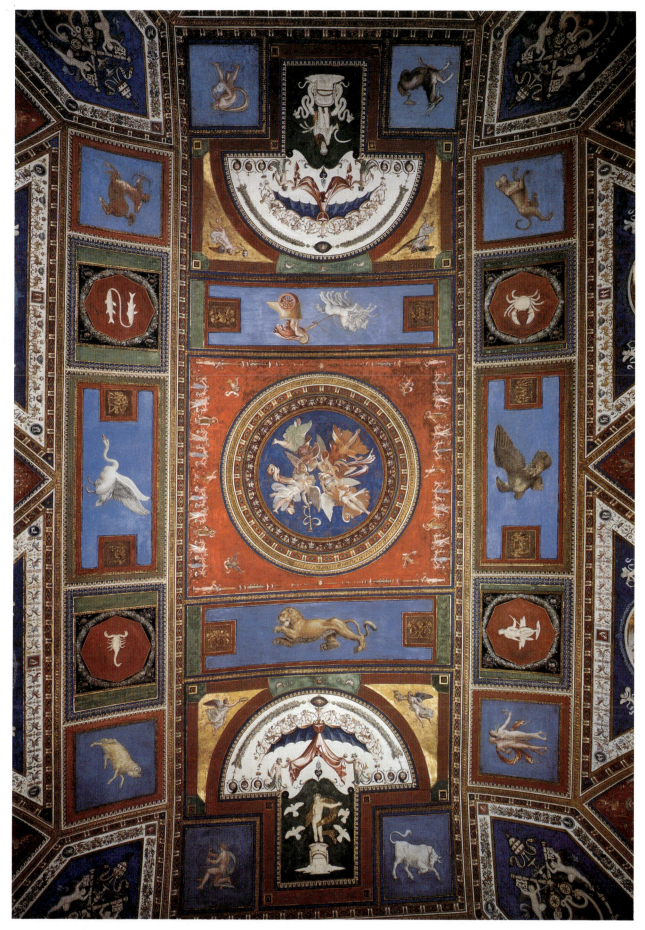

Plate IX. Perino del Vaga and Giovanni da Udine, vault. Fresco and stucco, 1521. Sala dei Pontefici, Vatican Palace.

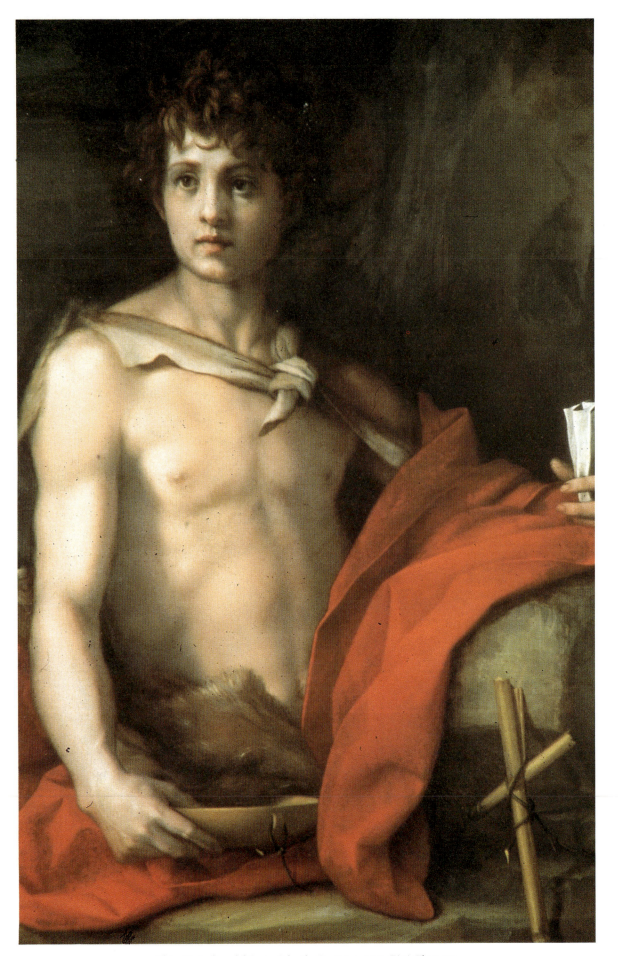

Plate X. Andrea del Sarto, *John the Baptist*. c. 1523. Pitti, Florence.

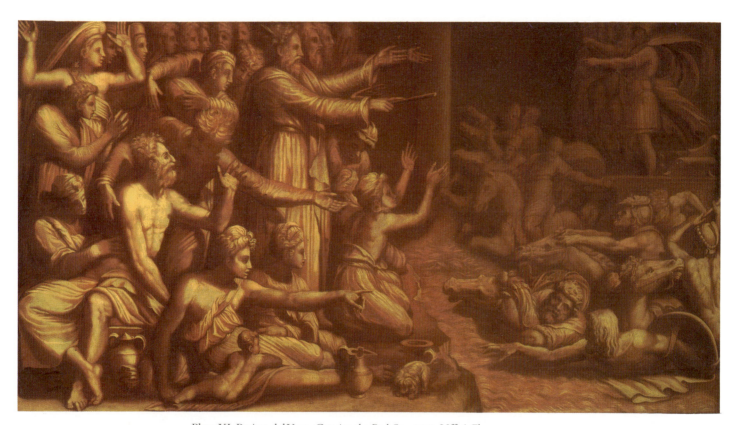

Plate XI. Perino del Vaga, *Crossing the Red Sea.* 1523. Uffizi, Florence.

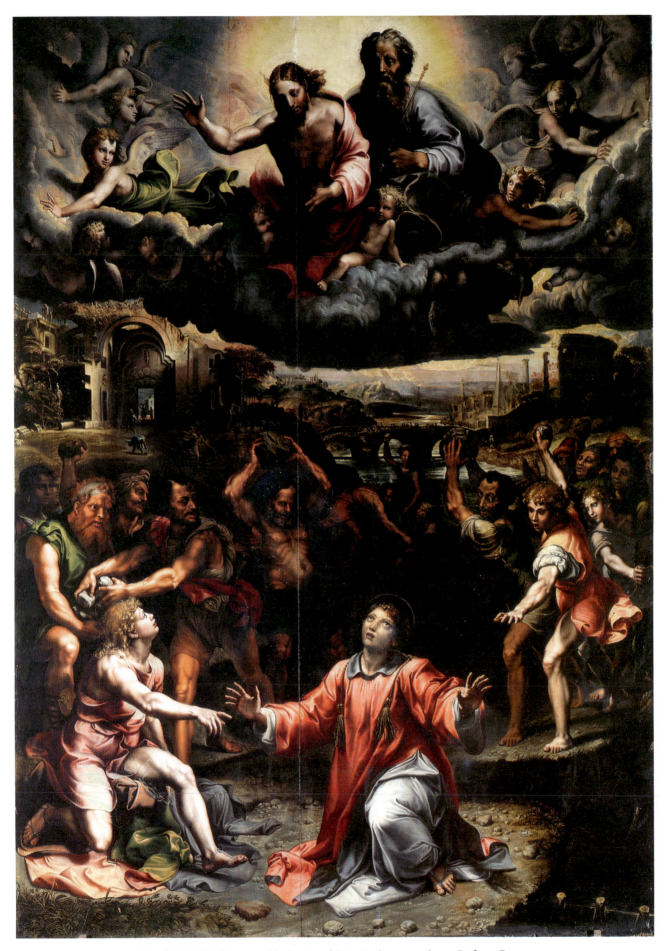

Plate XII. Guilio Romano, *The Stoning of Saint Stephen*. 1520. Santo Stefano, Genoa.

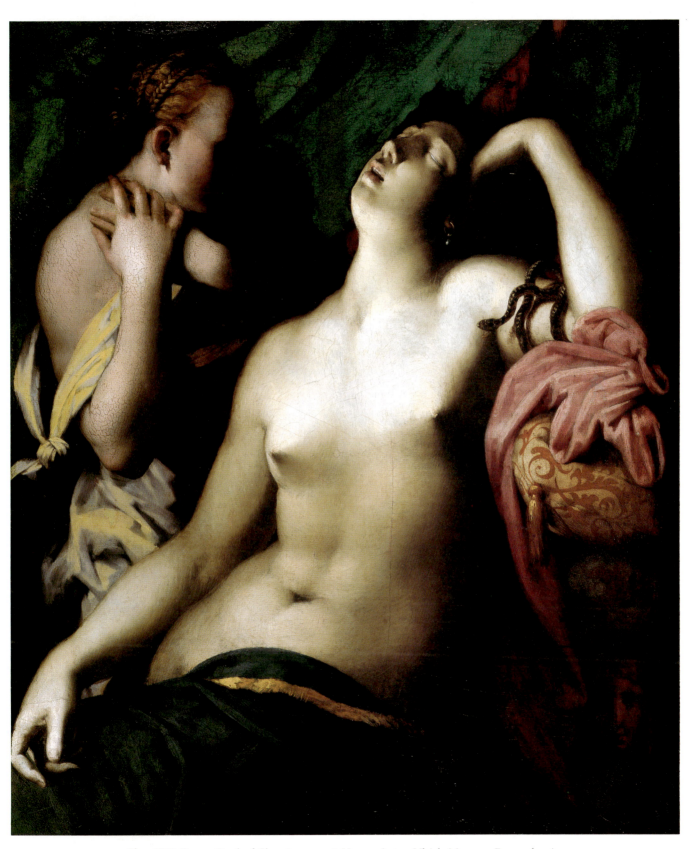

Plate XIII. Rosso, *Death of Cleopatra*. 1525–6. Herzog Anton Ulrich-Museum, Braunschweig.

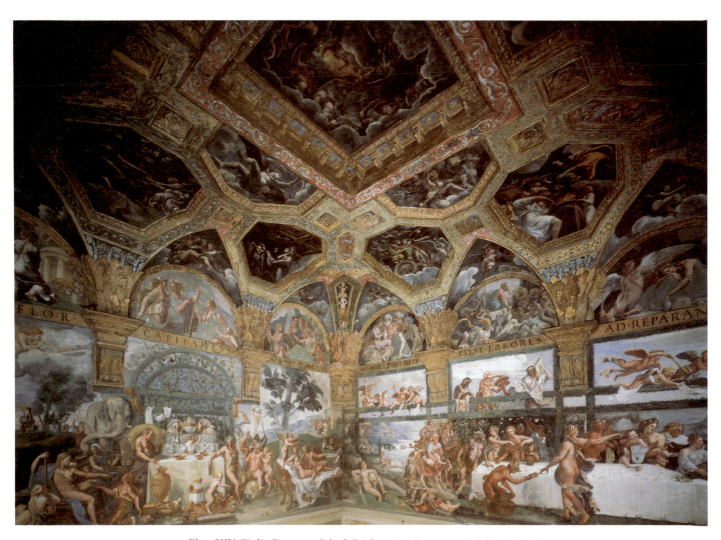

Plate XIV. Giulio Romano, Sala di Psiche, view. Fresco, 1528. Palazzo Te, Mantua.

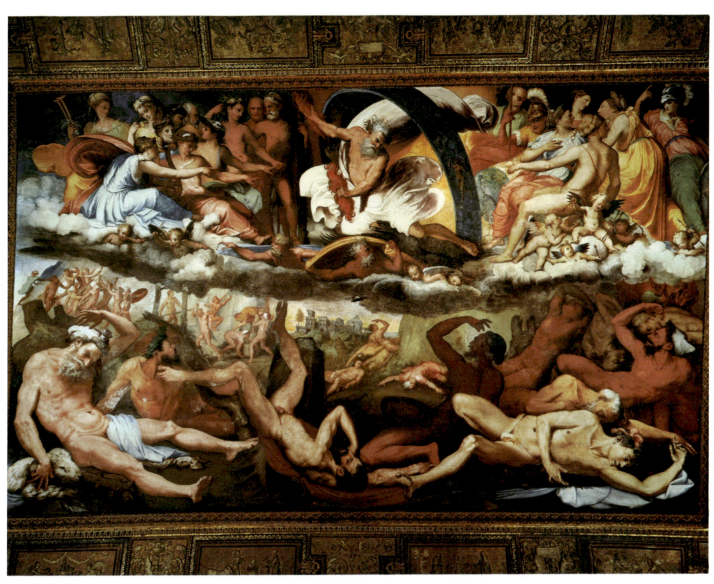

Plate XV. Perino del Vaga, *Jupiter destroying the Giants.* Fresco, c. 1530. Vault, Salone dei Giganti, Palazzo Doria, Genoa.

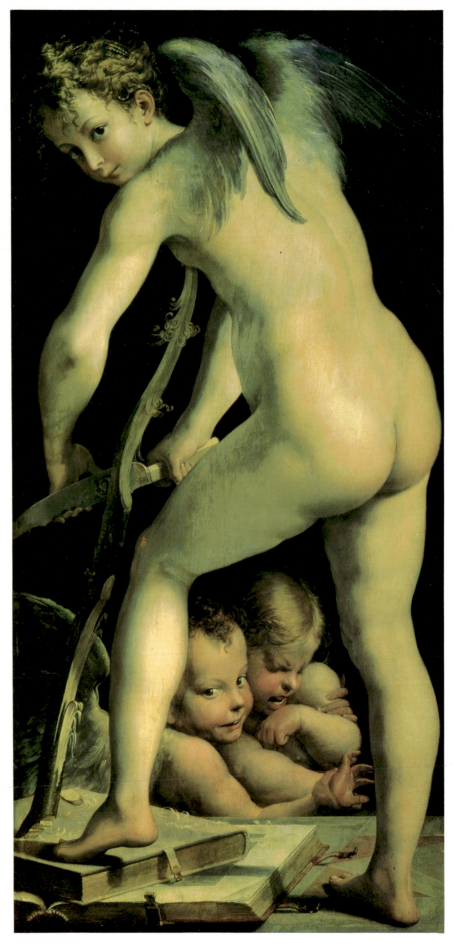

Plate XVI. Parmigianino, *Cupid cutting his Bow.* 1531–2. Kunsthistorisches Museum, Vienna.

Introduction

THE "REBIRTH" TO WHICH THE TERM RENAISSANCE REFERS IS, in one sense, the rebirth of culture after its long sleep in the Middle Ages; in another sense, it is the rebirth of antique culture. To understand the excitement that discovery of the classical world of antiquity generated in the Renaissance, we need to make an imaginary journey into the remains of Nero's palace in the company of some painters in the 1480s. Emperor Nero's Domus Aurea, built after the great fire had destroyed most of the center of Rome, was so lavish, as its nickname the Golden House implies, that it was an embarrassment to later emperors. Early in the second century Trajan filled it with rubble and built his baths on top as a gift to the people of Rome. When, centuries later, the rubble had settled, holes opened up that invited investigation. As the intrepid Renaissance spelunkers lowered themselves into the dark caverns, their lamps picked up the brilliant colors of the vaults, preserved since the first century because they had been sealed. It was possible to walk or crawl on top of the rubble, even to excavate passages into adjacent chambers and reveal new wonders (Pl. VIII). The Renaissance visitor thought he was in the Baths of Titus, but he called the antique decorations he saw and sketched in these caves, or grottoes, "grotteschi."[1] There were certainly other remains of antique Roman painting and stucco available in the Renaissance, but nothing in such a state of preservation. What these *grotteschi* provided was a whole vocabulary and syntax of ornament.

To understand the impact of antique sculpture on those painters who could descend into the grottoes, we need to stand at the edge of the hole being dug in a vineyard on a different part of the same Esquiline hill some years later, on 14 January 1506, alongside Giuliano da Sangallo and Michelangelo. As the marble limbs and bodies of a man and two boys struggling to free themselves from entwining serpents emerge from the dirt, Sangallo recognizes it as the famous *Laocoon* (Fig. 1), praised so highly by Pliny the Elder.[2] Pope Julius II (1503–13) immediately appropriated it and had it transferred to the Vatican palace, where it was displayed in his sculpture court, along with the other treasures of antique sculpture like the *Apollo Belvedere* (Fig. 2), discovered a few years earlier. For inspiration in how to represent the human body, the Cinquecento painters could study these life-sized antique

states and others, nude or lightly draped, which displayed an understanding of anatomy that had long since been lost and only partially recovered.

We should not underestimate, as we have perhaps done in the past, the importance of the influence of sculpture, relief and in the round, on the style of painting developed in Rome in the sixteenth century. The rediscovered antique sculpture inspired the pioneer painters and they, in turn, were imitated by their followers. The importance of Michelangelo (1475–1564), the sculptor turned painter, has long been acknowledged; we will see that Raphael, too, emulated sculpture. At the end of his short life (1483–1520) he invented his version of what is here called the *relieflike style*, based on late antique relief, which would be influential on his followers beginning in the 1520s and continuing throughout the century. This sculptural style was exported to other parts of Italy, including Florence, and abroad. The Roman style was spread not only by artists who traveled but by the increasingly influential medium of prints. The print of the *Laocoon* by Marco Dente illustrated here was the first of many that traveled all over Italy and Europe and made the sculpture known. Prints after the designs of Raphael and the other artists in Rome would disseminate their styles in a similar way.

Today we are puzzled by the obsession of the Cinquecento with the *paragone* (literally "comparison"), the debate over the superiority of painting or sculpture.[3] We frankly have difficulty generating interest in the argument and wonder why it could excite such polemics. The distant Venetians, where the attention of the painters was engaged in issues of light and atmosphere – such a prominent feature of the watery environment of the lagoon – found this fixation of the central Italians almost as curious as we do. But when viewed from a situation in which the models for painters were sculpture, it makes more sense. When Michelangelo said in the context of the *paragone,* "Painting is that much better the closer it resembles sculpture," he spoke the gospel for many central Italian painters.

Already in the Trecento, books of the ancient Greeks and Romans were being resurrected and transcribed, and this undertaking gained momentum in the Quattrocento. Such writings provided a basis for understanding how different the ancient world had been and in what ways. By the dawn of the Cinquecento some of these texts had become available through the new invention of printing. An enthusiasm for recreating antiquity infused the visual arts.

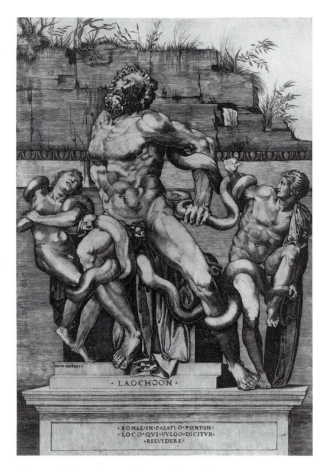

Figure 1. Marco Dente, *Laocoon.* Engraving, 1520–5.

Whereas Florence had been the center of textual study in the Quattrocento, it was Rome that was the locus of the new exploration of the material culture of antiquity. When popes, who understood the potential of art for projecting the image of a dynamic and powerful papacy, began to pour their resources into patronizing painters, sculptors, and architects, the center shifted to Rome. Pope Julius II brought Michelangelo and Raphael and Bramante to Rome to work for him. Thus we recognize that the artists and patrons of the Cinquecento were mining two sources in their quest to emulate and surpass antiquity: written sources and physical remains.

Art historical scholarship has long dealt with the influence of surviving fragments of architecture, sculpture, and painting, but more recently the importance to the artists of the texts, particularly those on rhetoric, has come to be acknowledged. The literature on rhetoric was important because the instructions to the would-be orator in effective *style* could be adapted by artists as guidelines to their artistic style.[4] Despite the difference between words and paint, the literature of rhetoric opened up a new world of possibility for the painters, as we will see.

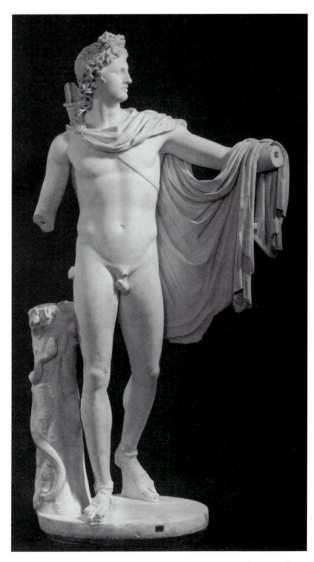

Figure 2. *Apollo Belvedere*. Marble. Roman copy of original Greek bronze by Leochares, discovered in Rome in the late fifteenth century. Belvedere Statue Court, Vatican.

The way we regard Cinquecento painting of central Italy has evolved and developed in the course of the past centuries, and it continues to be revised today. We will present here a less monolithic view and will recognize more diversity and competing strains than has been usual in the past, a perception made possible perhaps by the pluralism and complexity of our own times. In any survey of the historiography of the period, the contemporary view of Giorgio Vasari, an artist writing in the mid-Cinquecento, must inevitably be one's starting point.

VASARI'S VIEW OF HIS TIMES

Giorgio Vasari (1511–74) regarded the art of his own century as the culmination of a development that had begun two centuries earlier. It was he who first recognized the Renaissance in art – some would say he invented it[5] – and who traced the history of the artists from Cimabue (born around 1240) up to the publication of the second edition of his book in 1568. This history consisted of the biographies of the artists, anecdotes he had gathered about their lives, and descriptions of their art. Vasari recognized regional differences and he believed that each new century improved upon the last, but he did not have a concept of period style. Style *(maniera)* for Vasari meant personal style. In the intervening centuries we have labeled the style of the period 1500–21 "High Renaissance Classic," and what succeeded it, lasting until the final decade of the Cinquecento, we have called with less unanimity, "Late Renaissance" or "Mannerism," or "Maniera." Vasari did not perceive any such break in continuity around 1521, although in his view leaps forward had taken place with each new century since the Trecento.

In his preface to the third part of the *Lives of the Most Excellent Italian Architects, Painters and Sculptors from Cimabue to Our Times,*[6] Vasari distinguished the art of the Cinquecento from that of the Quattrocento. Although he felt that artists had improved upon their Trecento predecessors, he nevertheless found the style of the Quattrocento artists hard, dry, and crude. "Their draperies lacked beauty, their fancies variety, their coloring charm *[vaghezza],* their buildings diversity and their landscapes distance and variety."[7] Further, he criticized a lack of finish in their art and a lack of proper proportions.[8] His praise of his own period, the *terza età*, the third period – the Cinquecento – falls into three categories: facility or easy naturalness, freedom within order, and appropriateness. He believed there was too much effort apparent in the works of the Quattrocento, so that they appeared labored and lacked the vivacity of the Cinquecento artists, whose figures seem to breathe, "the faces laughing, the eyes speaking, the very pulses seeming to beat."[9] Vasari pointed out here that an essential quality in the great art of the *terza età* is a freshness, an apparent ease in execution that produced grace. He said of Michelangelo that "difficulties appear easy in his style."[10] This is the quality of behavior identified by Baldassare Castiglione in *Il Cortegiano (The Courtier)* as essential to the perfect gentleman, for which he coined the term "sprezzatura." Writing in the years when Raphael was painting, Castiglione was his friend, and the quality he described he also applied to works of art. Sometimes translated *nonchalance,* it indicates an ease that puts others at ease. In a

work of art it is an apparent lack of concern for effect, so that the viewer forgets the form and goes directly to the content. This is indeed the opposite of a belabored piece that then seems contrived, where the artistry calls attention to itself. Vasari mentions, among other Quattrocento painters with this fault, Andrea del Castagno, Pesellino, Andrea Mantegna, Ercole de' Roberti, Domenico Ghirlandaio, Filippino Lippi, and Luca Signorelli.[11] The source of his insight would appear to be Cicero (probably via Castiglione), who made a similar observation about good rhetoric: a speech must not appear to be well constructed, but rather should have a naturalness that conceals the art. The reason is that if the listeners discern that the speech is contrived, they will distrust the orator and think about how the speaker is trying to persuade them; their attention will be diverted from the content to the form.[12]

The style that Vasari praised attains this unstrained facility through a freedom from the rules, or to put it more precisely, a freedom within order. Too-strict adherence to the rules produced the dryness he criticized; a "resolute boldness" combined with "lightness of touch" *(leggiadria di fare)* is what he called for.[13] Rather than strict adherence to the rules, the artist needs judgment, which allows departure from the rules without disrupting the order. This judgment, attained through experience, will guide the artist to find the appropriate invention, "neither too simple nor too involved, but simply natural."[14]

Appropriateness is what Horace meant by "decorum."[15] Vasari applied it broadly, recognizing that the Quattrocento artist tended to have only one style and to paint everything with the same degree of seriousness. For Vasari and later critics like Heinrich Wölfflin, this was sometimes too serious and sometimes not serious enough. Recognizing that the treatment should accord with the function, Vasari felt a mythological scene for a villa should be as playful and witty as Ovid, but the papal audience rooms should present a grave and high-minded appearance.

Vasari's criticism drew upon those ancient Roman sources, like Cicero and Quintilian, on which art criticism since Leon Battista Alberti had depended, and upon Horace.[16] He repeatedly compared the masters of the *terza età* to the ancients, saying that they had surpassed them. He understood, however, that the comparison was not to be made solely, or even primarily, with surviving objects, for twice in this preface he compared the artists directly to the ancient writers. Speaking of Polidoro da Caravaggio and Maturino's history paintings of the deeds of the Romans, he said that one must wonder that they were produced, "*not by speech, which is easy,* but with the brush."[17] Of Raphael he said that "his works, *which are like writings,* show sites and buildings, and ways and habits of native and foreign peoples."[18]

Roman antiquity, both literary and visual, provided at once the inspiration and the touchstone of creativity. One measured oneself against the ancients, one emulated them, one strove to equal, and then surpass, them. Vasari acknowledged that the artists of the *terza età* had benefited from being able to see the antique statues mentioned by Pliny and others that had been dug out of the earth, like the *Laocoon,* the *Torso Belvedere,* the *Apollo Belvedere,* the *Cleopatra* (now called *Ariadne*), all housed then and now in the Vatican. He said the artists learned something of their grace and vitality from these models. It is clear that what Vasari praised is not what we call "antiquarianism," that is, the taste for antique culture or the imitation of archaeological detail; rather, the style he admired is the style in which antiquity has been assimilated – though he does not use the word[19] – and transformed into something new. The new style these artists invented embodied some of the values of Roman antiquity, but it did not rely on copying antique monuments as did the antiquarians. The intention was to make something that looked "anciently modern and modernly ancient" in the words of the contemporary Pietro Aretino.[20] Antiquarianism, a Renaissance interest reaching back to the Trecento and Quattrocento, in the early Cinquecento is more a trend, or a taste, than it is a unified style. "High Renaissance Classic" is a style, and a new one. To describe this new style, Vasari needed new words.

His words were not new inventions, like Castiglione's *sprezzatura* (which Vasari does not use), but they were words he used very sparingly in discussing the art of the first *età* (the Trecento) and second *età* (the Quattrocento). They refer to elusive qualities that cannot be precisely defined, and to the attraction one feels to these images – loveliness, charm, delight, elegance – rather than to their rational properties. A summary examination of these words will suggest what characterized this art in the view of Vasari.

Venustà means having the qualities of Venus, thus *lovely,* in the original sense. Certainly sensuality is a quality one finds much more in Cinquecento images than in those of the Quattrocento. The sexual appeal of bodies,

so carefully concealed in medieval times but apparent in the antique nude statues, as well as in the retelling of the myths in such authors as Ovid and Apuleius, found expression again in the Classic style of the High Renaissance. But the meaning is also more general: an appeal to all the senses. *Leggiadria* has at its root *leggero* (light, weightless); thus it refers to that easy grace, that seemingly unpremeditated quality derived from easy movement and harmonious proportions.[21] *Vaghezza* contains the sense of vagueness, indeterminacy. In the same way that a photograph not in sharp focus can create a more pleasing image, the Cinquecento painters learned from Leonardo's sfumato to blur their contours, to hide in delicate shadow what would be abrupt transitions, and to do away with the harsh linear contours of the Quattrocento. Forms were permitted to flow together for more harmonious compositions and to allow configurations of groups of figures or objects to be read together, rather than singly and additively. There is the further sense in *vaghezza* of longing and yearning. In the same way that the beloved is vaguely seen in memory, imprecision softens and makes it appealing. *Vaghezza* is frequently used to describe color. *Grazia,* or grace, is the richest of these words. It was by no means reserved for the Cinquecento, but it began to take on new significance then. It is a translation into artistic terms of divine Grace and shares the sense of a quality that is given as a gift and cannot be acquired through study. Grace was understood to be unteachable. It was not identical with beauty, which was a fixed norm the artist could copy by following the rules.[22] *Dolcezza* is sweetness or softness. Although it was not an uncommon word, Vasari found it useful to describe the *terza età* where he contrasted it with rigidity or stiffness.[23]

Many of these words, while not being gender-exclusive, seem to refer to particularly feminine qualities. Two words are more particularly masculine. *Gagliardezza* refers to difficult and forceful movements of the body that display athletic skill or strength. It is as appropriate to use this word to describe the physical movements of men as it is to use *leggiadria* to describe those of women.[24] *Terribilità* is the quality that inspires dread, or at least awe. This is the term almost set aside for Michelangelo's art to describe its majesty. Vasari implied that Raphael's art was replete with *grazia* but deficient in *terribilità*.[25] It is the quality that gives grandeur to the images of "the divine" Michelangelo, making them, and him, godlike. Thus, one of the qualities of the new Cinquecento style was that it

appealed to the senses, as well as to the intellect. In this it resembled rhetoric according to Cicero and Quintilian, who emphasized that good style enabled the speaker to persuade an audience, not just by the force of reason but by evoking emotion.

THE CONCEPTS OF CLASSICISM AND MANNERISM

Vasari made clear how he viewed his own age. It was left to later generations to give it a name and to discern other qualities. The concept of *ideal art* has been applied to the Classic style of the High Renaissance since the seventeenth century and, as we shall see, was already implicit in Vasari. It derives from Plato's forms, or Ideas, which in Platonic and Neoplatonic thinking represent the perfect form, of which everything we know in this world is a copy. Because nature, which the Renaissance artist was exhorted to imitate, was imperfect, the artist's task then became to select the most beautiful elements from many sources and combine them. This synthesis would surpass nature and would approach the beauty of the Ideas.

The story of the ancient painter Zeuxis is told repeatedly in the Renaissance; the best known source was probably Cicero. Zeuxis, when confronted with the task of painting an image of the most beautiful woman in the world – in Cicero's version it was Helen of Troy; in others, it was Venus – requested that the five most beautiful maidens of his city, Croton, be brought to him, and from these he chose their most beautiful features and combined them. That this idea was operative in the High Renaissance we know from Baldassare Castiglione, who attributed it to his friend Raphael, saying that when he came to paint a beautiful woman, he looked at many, then proceeded to paint on the basis of "una certa idea" that he had in his mind.[26] Vasari did not tell these stories in the *Lives,* but he painted the Zeuxis theme in his own house in Arezzo.[27] The words "ideal" and "idealized" do not appear in art theory until later, but the concept clearly was there in the early Cinquecento.[28]

It was Giovanni Pietro Bellori (1613–96), writing in 1672, who systematized the application of the Idea to art. He quoted Cicero and Raphael on the same page, remarking that nature is inferior to art. He rejected art that was too naturalistic and not idealized, such as Caravaggio's (Pl. XXXII; Figs. 181–2), as well as that which had lost touch with nature, as the artists of the later

Cinquecento had done, in his view. Thus Bellori revised Vasari's conception of unreversed forward progress and introduced the notion of a decline. He called this "deterioration" of art *Maniera,* and his appraisal was not fundamentally revised until the twentieth century. Bellori recognized in what he regarded as Classicism – at the center of which for him was Raphael – a balance between the imitation of nature, on the one hand, and the re-vision that artists impose on nature according to their artistic idea. The artists lost this balance when they followed their fantasy too much; we would say when they relied excessively on creative imagination, became too subjective, and lost their touch with the objective world. Bellori did not make clear at what point he believed the decline began. For him, art was rescued by Annibale Carracci in the last decade of the Cinquecento.

In the eighteenth century the concept of Classicism, both ancient and Renaissance, enjoyed a revival when Pompeii and Herculaneum, the Roman towns buried in A.D. 79 under the ashes of Mount Vesuvius, were rediscovered and began to be excavated. At the same time Greek antiquity came to the attention of intellectuals through the impassioned writings of the German scholar Johann Winckelmann (1717–68). He is credited with enlarging the term "style" from that of personal manner to period style. He saw art as an aspect of the evolution of human thought; thus High Renaissance Classicism became an expression of the culture of the early Cinquecento. The characteristics of that period were explored by Jacob Burckhardt in his influential book, *The Civilization of the Renaissance in Italy* (1860).[29]

Heinrich Wölfflin (1864–1945), successor to Burckhardt at Basel and writing at the end of the nineteenth century, took his mentor's interpretation of the Renaissance and applied it to art, vastly refining the analysis of High Renaissance style.[30] Comparing it, as had Vasari, to the art of the Quattrocento, he recognized a new seriousness and dignity in the style after 1500, its intention to grip viewers rather than to amuse them. Artists gave much more attention to the psychology of events and dramatized them, rather than simply narrating them. The emotion expressed by figures was restrained, slow and solemn, aristocratic and heroic, and their gestures conveyed the same air. This was a more exalted conception of humanity, from which had been purged the gaiety and delight in genre of the preceding era. A new suavity of pose and of movement in the figures replaced the Quattrocento angularity and abruptness.

The ideal of beauty shifted from the slim, agile, youthful figure to the fuller, more mature and more rounded type that derived from study of the antique models. Wölfflin saw this development as only superficially affected by regional differences: the new seriousness inaugurated in Florence was carried forward in Rome in the Cinquecento with the help of antique models, but the style of Rome was not essentially different from that of Florence. He did not carry his analysis past 1530, when he believed the decline of Mannerism began.

Wölfflin conceived brilliant comparisons, an example of which reveals the distinctions he made apparent between the late Quattrocento in Florence and the mature Classic style in Rome. In a detail from Ghirlandaio's *Birth of the Baptist* (Fig. 3), a servant carrying fruit and wine to refresh the mother who has just given birth rushes in with drapery and veil flying behind her. She has her counterpart in Raphael's woman bringing water to quench the fire in the Borgo (Fig. 4), painted a quarter century later. Ghirlandaio's slender girl has been replaced by Raphael's fuller, stronger, more purposeful woman, whose curves are not interrupted by an angular elbow but rise in a graceful arc to steady the urn on her head. Rather than the servant's springy, dancing step, Raphael's concentrated figure moves with firmness and force. A powerfully conceived pattern of light and shade sculpts her body, washing out the multiple small folds of drapery that distract the eye and break up the form in Ghirlandaio's image. What Wölfflin did not note is that Raphael, by rotating the figure and conjuring a strong wind blowing from behind her, makes her billowing robe precede her, rather than trail her, and reinforce her swift forward movement.

In the last generation, Sydney Freedberg gave us the most complete, detailed, and balanced interpretation of "Classicism" yet to appear, focused like Wölfflin's exclusively on style.[31] As he saw it, for the High Renaissance, classical antiquity was not a sourcebook of poses but a model for embodying spiritual content in physical form. Liberated from nineteenth-century anticlericalism, he was the first to interpret the style of the High Renaissance within the context of its Christian culture. Idealization, he recognized, gave these artists the solution to the problem that the Early Renaissance had explored but never satisfactorily resolved: the means to express the spiritual dimension in terms of the physical, material world.

As Freedberg explained, the Classic style was not a set of predetermined rules to which the artists con-

formed, but principles that the artists worked out, at
first individually, then in artistic dialogue with one
another. Sometimes the relationship between them was
dependency, sometimes rivalry, but their awareness of
one another helped to motivate the development of the
style. These principles – involving equilibrium, har-
mony, gravity, and restraint – held in balance grace, dra-
matic energy, freedom, variety, and force. Interpreting
the Classic style thus, Freedberg could speak of exceed-
ing, or violating, the principles, terms he used to
describe Mannerism.

It was academic Classicism that evolved rules by
which the Classic style could be copied. This develop-
ment took place principally in the French Academy
beginning in the seventeenth century. By studying
Raphael, who in their view perfectly embodied the
style, the French academicians deduced their rules,

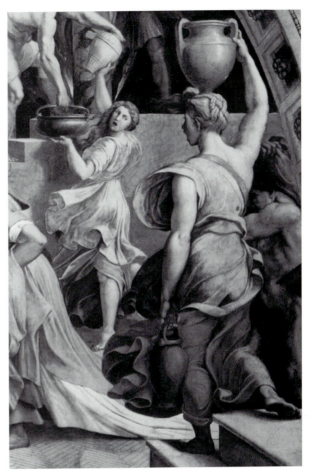

Figure 4. Raphael, Woman carrying Water, detail, *Fire in the
Borgo*. Fresco, 1515. Stanza dell'Incendio, Vatican Palace.

which then hardened into dogma for the instruction of
painting and spread to art academies everywhere. Copy-
ing after the Old Masters and from plaster casts of
antique statues was considered the proper training for an
artist. This had been done enthusiastically in the Cin-
quecento in such places as Baccio Bandinelli's academy,
to be sure, but what the High Renaissance inventors of
the Classic style had done with such initiative and sense
of discovery was now imposed in the curriculum of
every would-be artist. The Classical works that resulted
from such training are distinguished from those of the
High Renaissance by being called Neo-Classical.

THE VIEW OF THE LATE
TWENTIETH CENTURY

Today we can discern more than one strand in the
High Renaissance period. The appeal of antiquarianism,
an alternative to the Classic style, to some of the most

Figure 3. Ghirlandaio, Woman carrying Fruit, detail, *Birth of
the Baptist*. Fresco, c. 1485–90. Santa Maria Novella, Florence.

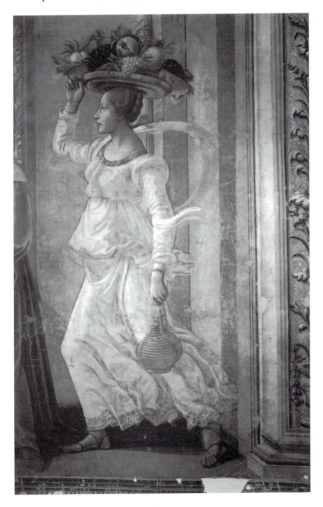

prominent patrons in Rome will be discussed in Chapter 1. What we have learned in the past generation, from the example of Aby Warburg and his school, is that style is much more a function of patronage than we used to recognize. We are beginning to see that artists could adjust their style from one commission to another so that stylistic development is not necessarily linear. In the past, stylistic changes were understood to be driven largely by artistic dynamics – competition, one painter responding to the innovation of another – and by external events, like wars, changes in religious attitudes, and economic prosperity or depression. Increasingly, scholarship is enlarging the circle to include politics and the patron. In the Cinquecento, Rome imitated antiquity because it fed the need to rediscover its own history and identity. Perhaps for the first time since antiquity, styles were consciously chosen to convey certain kinds of messages. Florence, Mantua, Genoa, and the French court became interested in the style *all'antica* (in the manner of the antique) when their rulers needed to project an image lent authority by antique precedent. Not only did the style *all'antica* serve princely politics in the secular sphere, but the Church came to recognize the usefulness of certain styles to motivate devotion and to deplore the contrary effect produced by many of the sacred images being provided around midcentury. Maniera was put to rest for sacred art in the Counter-Reformation when the Church declared that this style did not serve its purposes. We have recognized that artistic style in seventeeth-century France came to be loaded with political baggage,[32] but the acknowledgment that the same thing can be true in the Cinquecento is relatively recent.

A further discovery is that the stylistic means to achieve this kind of diversity depended upon the concept of modes, which the artist of the early Cinquecento could have deduced from the literature of rhetoric. Antique writings on rhetoric taught that different modes could exist side by side to serve different functions. This idea, so fundamental to our pluralistic culture, had not been explored except intermittently until the Cinquecento. In the past, the artist learned the techniques of painting from the master in the workshop. But as Rome began to attract painters from various localities and various traditions, a new range of options emerged. And as the remains of classical antiquity were explored, artists could study alternatives to the Renaissance traditions. The painters of the Classic style first explored two new kinds of modal thinking: modes of composition and modes of coloring.

Modes of composition, offering alternatives to the time-honored central-point perspective system, were demonstrated by Raphael in the last years of his life, inspired by his examination of the painting and sculpture of antiquity. He could work in three modes of wall decoration at the same time, selecting the one most appropriate to the circumstances: one, the traditional central-point perspective system; a second, the wall treated as a surface and covered with Domus Aurea–type ornaments; a third, based on sculptural relief. With the multiple models Raphael provided, the painter could select the one most appropriate to the occasion. The same kind of choice was provided by the modes of color.

Multiple modes of coloring, deriving from Leonardo da Vinci, perhaps influenced by Venice, or developed by Raphael and Michelangelo in their Roman commissions, were first explored in the teens and then elaborated in subsequent decades.

Leonardo developed the sfumato mode, which means smoky. In the interest of harmony and of directing the viewer's focus, he willingly sacrificed bright color in favor of soft shadow. By composing in terms of chiaroscuro, directing the light to the areas of greatest importance to the narrative, he could then obscure others in shadow and blur contours. Sensuous softness, as if his forms were seen through a haze of smoke, was one of his means of revealing ideal beauty. Correggio (Pl. I) developed the sfumato mode, introducing more color than Leonardo had, but making full use of softening shadows, as did Andrea del Sarto. Later in the century Federico Barocci (1535–1612) would return to sfumato and Leonardo, via Correggio.

Raphael invented the *unione* mode in response to Leonardo in order to emulate the harmony of sfumato without giving up the varied color that central Italians delighted in. As the name implies, the unity of colors was its principle, achieved either by reducing all tones to approximately equal intensity and limiting the range of value, or by carefully calculating the juxtaposition of tones.[33] What results is demonstrated in his *School of Athens* (Pl. II), where Raphael has orchestrated a gentle coloristic harmony to blend forms with one another and a movement that flows through the composition.

For more forceful and dramatic purposes Raphael used the chiaroscuro mode, which he also invented, or

perhaps adapted from the Venetian Giorgione. Giorgione's pupil, Sebastiano del Piombo (Pl. III), and Raphael's pupil, Giulio Romano (Pl. XII), preferred chiaroscuro for its theatrical effects, and Raphael himself came to use it most frequently in his later works. High contrasts of value, with abrupt shifts from very light to very dark, combined with intense, saturated hues, produced the drama.

Cangiantismo was developed by Michelangelo out of the coloring system of the Trecento and early Quattrocento (as described by Cennino Cennini), allowing him to exploit especially the virtues of fresco colors. The root of the term refers to changing, so it describes modeling in which volume is achieved by shifting from one hue to another. It is sometimes claimed that *cangiantismo* intends to represent shot silk, but it is unlikely that this kind of naturalism is intended, at least in the Cinquecento. On the contrary, it is frankly, even proudly, artificial and ornamental, and, in Michelangelo's hands (Pls. IV, V), it added another facet of freedom and variety to the Classic style.[34]

It can create a false impression to catalogue the color modes, just as it falsifies the spontaneous process by which the Classic style was invented to describe it in terms of rules. The High Renaissance painters employed the modes freely, working out as they did so the particular usefulness of each. The modes were available to be applied according to the circumstances, in the same way as Raphael's modes of wall decoration.

Our understanding of how the High Renaissance artists approached antiquity has changed. Wölfflin denied that the new Classic style could be attributed to the imitation of the antique, a statement we find curious today. His reason was that in his view the artists of the Classic style "had essentially the same approach to antiquity as the men of the Quattrocento."[35] We now have a different view. Study of the physical remains of antiquity available in the Renaissance has shown us that the artists could not have recaptured the spirit of antiquity as they did on the basis of these remnants alone.[36] Not even the genius of a Michelangelo, a Bramante, a Raphael was sufficient for that on the basis of the meager fragments available to them. A more abstract process was at work: a change in what the artists wanted from antiquity occurred around 1500. They no longer studied antique remains as if they were another copybook; they studied the whole culture to assimilate it, so that they could recreate it. In addition to looking, measuring, and copy-

ing, they read and discussed the instructions of Cicero and Quintilian on rhetoric in order to deduce certain principles of creativity. By extrapolating from the rules for making an eloquent speech, they understood that art could be varied according to its function, in the same way that the ancient writers divided oratory into three kinds according to whether the audience was gathered for the funeral of a great man, or was meeting in the Senate to debate whether to send reinforcements to the Rhine army, or was assembled to try a man for stealing a piece of land from his neighbor. The artists recognized that it was no more appropriate to paint Christ's Crucifixion in the colors of a parade, or to include idly chatting bystanders at the Last Supper, than to discuss the great man's lovely mistress in his eulogy.

We do not know exactly what the artists took from the writers on rhetoric; except in the single case of Castiglione/Raphael's "una certa idea," the evidence is only circumstantial. They seem to have learned the difference between reporting the bare facts and appealing to the audience and winning its assent. They seem to have learned the importance of involving the viewers' senses as well as their rational capacity, as Vasari's new vocabulary bears witness. Although no one would deny that Quattrocento art could be engaging, it did not have the sensuous allure of the graceful creations of Raphael or the towering power of Michelangelo's. They seem to have learned the value of economy of means: just as the rhetorician disdained redundancy but sought the phrase that would arrest the listener's attention, so the artists simplified and streamlined, looking for the eloquent gesture, the large form that told more than a dozen distracting details, the single figure that summed up the response of the crowd. The artists invented visual equivalents of figures of speech and manner of delivery so that they too could modulate their presentation as the orator did.

THE 1520S AND 1530S

Recognizing this kind of diversity does not destroy the identity of the Classic style, but it imposes a less linear interpretation of its development. Importantly, modal thinking helps to explain why the period following the deaths of Pope Leo and Raphael lacked the unity of the Classic style. In the 1520s both patronal and artistic leadership failed to provide the kind of definitive models of the previous decade. A new generation of painters were experimenting, striving to shape their personal

styles. The absence of a patron like Julius II or Leo X meant that the kind of norm supplied by Michelangelo's Sistine Chapel or Raphael's Stanza was not being provided for these young painters to study and to measure themselves against.[37] What we find is much more individualism and diversity than had characterized the decade when the Classic style had dominated. In fact, in the two decades that followed, it is difficult to trace a single thread or to find a unifying principle. This is the period that has been called Early Mannerism, but its differences from the preceding decade may have been exaggerated in the past because we had not noted the appearance of what we might now call multiple modes, that is, diverse personal styles developing side by side.

We have noted that Vasari recognized no break in the continuity of style in the Cinquecento, and there is no doubt that the artists who followed Raphael in the 1520s and who continued to learn from Michelangelo intended to emulate these two masters and pursue what they had pioneered. Along with this undeniable continuity, however, new and different values crept in and replaced some of those of the Classic style. We have said that economy of means characterized the Classic style, but beginning in the 1520s, and even before, copiousness begins to be valued. If "streamlined" could describe the difference between Quattrocento painting and that of the early Cinquecento, then "redundancy" might be said to replace it in some works of the second quarter century. Richness and ornament were valued in the later works of Raphael, as for instance his *Saint Michael* (Fig. 25), and Michelangelo provided exemplars of virtuoso display. In the early years of the century in Florence, he had made the cartoon for the *Battle of Cascina* (Fig. 10), which was cited by critics later in the century as the model of the display of the "excellence of art."

In the Doni *Holy Family* (Fig. 5), of about the same time, the Madonna assumes a serpentine pose that is more impressive for the artifice of its invention than for its plausibility. In the last parts he executed on the Sistine vault, Michelangelo explored various ornamental devices. His *Jonah* was greatly admired because it showed off extreme foreshortening (*scorcia*) in the backward-bending pose of the prophet, which is all the more admirable because it is painted on a part of the wall that is actually curving forward.[38] The *Libyan Sibyl* provided the model for a kind of difficult, twisted pose that pleased because of its artificial elegance. Next to her, his *Brazen Serpent*, in the corner spandrel, gave painters a model for a kind of composition in which the picture surface was filled with forms pressed against the plane. Painters admired these kinds of *difficoltà,* or challenges to the skill of the artist, and took them as license not only to attempt the same but even to surpass the masters' examples. The "excellence of art" or the "force of art" are terms we read in Cinquecento sources to describe what artists came to believe to be a principal purpose of their inventions and also what patrons came to expect.

Many of these qualities were on display in the art of classical antiquity the artists imitated. As Craig Smyth has demonstrated, late antique relief sculpture in particular became the sourcebook for the artificial poses and the "conventions of the figure" (as he first termed them) that entered the repertory of the painters in the 1520s and became the norm around 1540. For the artists of this generation, the models were Raphael, Michelangelo, and antique relief, and their ambition became to combine them aesthetically. How better to surpass one of these models than to combine and surpass all three?

With studies of the Roman cultural ambiance now available,[39] it is possible to appreciate how very different Florence and Rome were in the Cinquecento. Our understanding of what the Renaissance artists knew of antiquity and what it lent to them has increased.[40] With the help of this kind of research, we can now see that antiquarianism was a major influence on art in Rome, particularly on secular art, for which there was not the kind of tradition that existed for sacred art. For altarpieces the painters had an infinity of examples for each subject, but demand for secular art increased rapidly during this period, and there was little precedent on which to draw – except in antique remains. Thus, before the disruption of the Sack of Rome in 1527, religious art tended to remain conservative, whereas secular art broke new ground as it attempted to emulate antique sculpture.

Raphael's explorations of alternative modes for wall decoration proved fertile ground for the next generation, and after his death, members of his former *bottega* (workshop) used all three modes. The relieflike style pioneered in Rome by Raphael in his design for the *Battle of the Milvian Bridge* in the Sala di Costantino (Pl. VII) was the source of the conventions that were eventually codified into the Maniera. We could say that antiquarianism gave birth to the relieflike style, which was one option in the period of transition of the 1520s and 1530s. The relieflike style, in turn, gave birth to the Maniera around 1540. In the period before the Sack of

Figure 5. Michelangelo, Doni *Holy Family*. c. 1507. Uffizi, Florence.

palace in Genoa. In France at the same time, François I was enjoying similar metaphors of rule in the decorations of his palace at Fontainebleau, provided by imported Italian artists under the leadership of Rosso Fiorentino (see Chapter 3).

If we use the term Maniera to apply to these conventions and this style, we can be reasonably sure of what we are talking about, and we can recognize it when we see it. This is not so true of the more personal works of the 1520s, when several styles existed side by side, and it is for this reason that we characterize that period here as "transitional" in style. For a style to merit a label it should have a degree of communality lacking in the experimental art of the 1520s. This terminology acknowledges the link between a certain current of style in the 1520s and 1530s and the Maniera, but it also makes clear that this style was only one of several options available. The term Early Mannerism, discarded here, indicated that continuity but insisted upon it too exclusively.

◆

Rome, the relieflike style was elaborated importantly by the elusive Polidoro da Caravaggio. Although most of his works have vanished, making assessment difficult, it is impossible to exaggerate the importance of his contribution to the formulation of the Maniera.

During the 1520s in Rome the conventions of the relieflike style were utilized by most painters in at least some of their secular commissions, and particularly by the engravers (see Chapter 2). By the late 1530s those conventions had gelled into a mature style, and we see this Maniera demonstrated in Rome by Jacopino del Conte in his fresco of the *Preaching of the Baptist* (Pl. XVIII) (see Chapter 4). Almost immediately the style was transferred to Florence, and the Maniera became the preferred style of Duke Cosimo and the artists who served him (see Chapter 6). Also in the late 1520s and 1530s at Mantua, Giulio Romano employed the relieflike style in some of his works in the service of Gonzaga, where that patron, like Cosimo, appreciated the potency of the aura of classical antiquity in the images of his court. The same selective application of the relieflike style was used by Perino del Vaga at Andrea Doria's

AFTER ABOUT MIDCENTURY, while the Maniera continued to be employed for secular commissions, artists attempted to answer the demands of the Counter-Reformation for a more suitable sacred art. Various painters compromised the Maniera in various degrees and ways, creating a Counter-Maniera style. The propriety of using antique models – now deemed by some strict Reformers to be pagan – was questioned.

By 1585 a new positive spirit took hold of the Church under the leadership of Pope Sixtus V. In response to the Protestants' wholesale rejection of images, a campaign was undertaken proclaiming the Church's advocacy of images and demonstrating how decoration should be differentiated according to function and location. But the Maniera style was exhausted, and Rome welcomed the new directions introduced from other regions of Italy by Federico Barocci, Caravaggio, and the Carracci.

CHAPTER ONE

The High Renaissance

Rome had always been a city of transients, living off the pilgrims who swarmed to visit the holy sites, to view the relics, or to obtain indulgences for their sins, especially in Jubilee years. In the year 1300 a contemporary estimated that in the city of about 35,000 inhabitants, two million pilgrims had shouldered one another.[1] The Roman merchants and innkeepers gouged these tourists and lived off of them. Street booths, like those one finds today lining the route between Saint Peter's and the Vatican Museums, clustered around the great basilicas of the apostles, Saint Peter's and Saint Paul's, selling badges – the medieval equivalent of T-shirts and postcards.

Whereas other cities like Florence and Siena had prospered in the Trecento, before and after the crises of the Black Death and economic depression of midcentury, Rome endured more than a century of severe decline. When the papacy transferred to Avignon in the first decade of the Trecento, it deprived the city of a goodly portion of its population and exposed it to attack. Left defenseless, much of the city had been burnt and plundered. This situation worsened later during the Great Schism, when three popes, elected by competing factions, vied for the throne. Rome did not begin to recover until Martin V (1417–31) entered it in 1420 to reestablish the papal center, and then renewal was hampered by limited funds.

Rome in the Quattrocento trailed far behind other urban centers. Whereas most of the streets of Florence were paved in the thirteenth century, and all by 1339, statutes were only being enacted to this end in Rome in 1452. To be sure, no city faced impediments like those in Rome, where buildings were simply constructed on top of, or in the midst of, the ancient ruins. Obstructions were everywhere. It had been common practice, until it was explicitly forbidden in 1452, to erect private structures on public land, particularly among ruins. Dilapidated buildings were not removed; rather, appendages were tacked onto solid ancient walls, regardless of whether or not they might impede the flow of traffic. The city was so sparsely populated that traffic had not been a matter of great concern. Whereas the population of imperial Rome had reached a million, estimates of the number of inhabitants in 1420 run between 17,000 and 25,000. With the return of the papal court and the resulting prosperity, it increased by midcentury to about 35,000.[2]

Romans had little understanding and less regard for the remnants of the past that surrounded them. They saw the monuments principally as sources of building material; they burned the marble to make mortar. Sad to say, despite the damage done by invaders, most of the destruction of Rome was perpetrated by the Romans themselves. The appreciation of classical culture that humanists elsewhere were stimulating came late to Rome. When Brunelleschi and Donatello came from Florence in the first decade of the Quattrocento to measure and examine the antique ruins, they were spurred by developments that had not yet begun to stir in Rome, where the struggle to survive still occupied most of the attention of the inhabitants. Most of them huddled together on the banks of the Tiber, which was the only source of water. The more salubrious hills had been abandoned when the ancient aqueducts were cut by the invaders. One of the undertakings of the Quattrocento popes, beginning with Nicholas V, was to repair the one ancient aqueduct that still functioned, the Aqua Vergine, and to build a fountain, the forerunner of the Trevi, to free people from carrying water from the river. Throughout the following century, the opening up of new districts of the city followed the supplying of water by successive popes. Much of the city within the walls had been turned into pasture and vineyards that only slowly gave way to new construction as the population increased. (By 1526, on the eve of the Sack, Rome's population had reached about 55,000.)[3]

The papal Curia, which was responsible for drafting Bulls and other official documents, was an employment appropriate and attractive to humanist scholars. In 1432–4, Leon Battista Alberti, Flavio Biondo, and Poggio Bracciolini – "some of the greatest names in contemporary humanism"[4] – were all employed at the Roman Curia. As Roberto Weiss has pointed out, the ancient authors had never ceased to be read, but what was new was using them as sources of history. A humanist like Poggio used literary sources to help him identify ancient remains. Little by little, inscriptions and coins were added as sources for dating and identification. Biondo, who was the father of archaeology, intended to make a reconstruction of the ancient city, and to this end he used every source available to him, not neglecting medieval Christian ones. The Roman Academy, an informal confederation of humanists under the leadership of Pomponio Leto, who shared their mutual enthusiasm for ancient Roman culture, served to raise the consciousness of the Romans, to rediscover

the wonders of ancient sources, and to reawaken civic pride. The seemingly rather silly enterprise of reestablishing the ancient celebration of Rome's birthday, the Palilia, which had been moribund for more than a millennium, takes on significance when we see it in this light. At first only a private gathering of the academicians, by the time of Pope Leo X (1513–21) it was a civic holiday in which papacy and city joined forces to celebrate the rebirth of Rome as the *caput mundi* (head of the world).[5]

At the same time that appreciation for the ancient Roman city was growing and the modern city was being renovated, the popes were rebuilding the Vatican, which had fallen into a sad state of disrepair. We owe to Nicholas V (1447–55) Fra Angelico's gem of a chapel and to Sixtus IV (1471–84) the library and chapel that bears his name. The Sistine Chapel was built in the 1470s and the walls painted in the early 1480s by the finest artists available, imported from Florence and Umbria, including Perugino, Botticelli, Ghirlandaio, and Signorelli. The Villa Belvedere was built under Innocent VIII in the 1480s, and Mantegna came down from Mantua to fresco it, alongside the Umbrian Pinturicchio, who, as we shall see, was the painter chosen by Alexander VI (1492–1503) to fresco his newly built Borgia Apartment in the 1490s. When, at the beginning of the new century, Julius II (1503–13) undertook the projects for which he is famous, including rebuilding Saint Peter's, he was only continuing on an enlarged scale what his predecessors had begun. By that time the prestige of the papacy and the availability of patronage had begun to attract artists from elsewhere in Italy who came to view the splendors of the ancient past and of the present.

Rome's dependency upon the papacy and upon a constant flow of pilgrims in the Middle Ages meant that it had not developed a strong burgher culture like the cities of Tuscany and Umbria, nor was there available the patronage that sustained the artistic communities in Siena and Florence. No native school of artists comparable to those in Florence or Siena had taken shape. Thus it was that the artists needed for building and decorating the new structures were imported for the task from other parts of Italy, and they then returned home. As word spread, artists and others began a new kind of pilgrimage to Rome, but now not so much to visit the pious sites of medieval devotion as to study the newly identified wonders of classical antiquity and the splendors of the modern city. This is not to say that Christian

Rome was neglected, only that what could be appreciated was enlarged. If Early Renaissance humanism had put aside medieval otherworldliness to appreciate this world as God's good creation, the humanists of the High Renaissance would enlarge it to encompass the ancient world as well.

By 1500 the world of the Romans was beginning to come together, both in terms of past history and present reality and in terms of sacred and secular. They had put behind them apocalyptic visions of imminent judgment and destruction, even those elicited in the 1490s by the approach of the half millennium, like the predictions of Savonarola in Florence. The pope, having consolidated his power, was not only the representative of Christ on earth and the guardian of spiritual life, but also the head of state who ruled a considerable portion of the Italian peninsula known as the Papal States. This temporal power was based on a tradition that according to the papacy reached back to antiquity: the Donation of Constantine, the gift to the pope by the first Christian emperor following his conversion to the faith. This temporal power meant that when the pope acted as mediator between political adversaries he was not the disinterested arbiter, the role we see him playing today, but a vitally interested party. Much of the concern of Cinquecento popes was with trying to maintain a balance of power between the two great political entities, France and the Holy Roman Empire, which were vying to control the Italian peninsula. The invasion of the French in 1494, which brought such havoc to Florence, and the Sack of Rome in 1527 by imperial troops, were terrifying evidence of what could happen when papal diplomacy failed.

ROMAN ANTIQUARIANISM

The passion to recreate the ancient world engrossed Rome in the opening years of the Cinquecento, but it inspired Pope Julius II to one kind of patronage, and his contemporaries to others. Whereas Julius came to prefer the Classic style of Raphael (1483–1520) or Michelangelo (1475–1564), who assimilated in their styles their emulation of the antique, other patrons chose the more direct imitation of the antique (all'antica) practiced by the antiquarians.

Antiquarianism was not new in the beginning of the Cinquecento. Since the Trecento, humanists had been interested in reviving ancient Roman letters, and some

artists and patrons throughout central Italy had been imitating ancient art. Andrea Mantegna, in particular, had been painting all'antica for decades. Mantegna's antiquarianism was valued at the Gonzaga court in Mantua, but his commission in the Villa Belvedere proves that the taste for this kind of painting had already spread to Rome itself in the 1480s. But compared to the Classic style of the High Renaissance, antiquarianism in early Cinquecento Roman art has received little attention from scholars. We have been provided with a new understanding of the Roman cultural scene recently by cross-disciplinary studies.[6] The near-obsession with classical antiquity in Rome becomes apparent when the whole picture is studied, and the art that imitated antique subject matter takes on a new interest when viewed in this context. If we reserve the term "Classic" as a stylistic designation, "antiquarian" can be understood to encompass the multiple explorations of antique culture, literary and material, that occupied the Renaissance humanists, patrons, and artists. Some of the art in the period of the High Renaissance is antiquarian without being Classic in style, like Jacopo Ripanda's, and it is this art that has been little studied. It was not until the papacy of Leo X, himself a true antiquarian, that antiquarianism began to enter the mainstream. In the later commissions of Raphael and his workshop, antiquarianism was folded into the Classic style, and this new style came to dominate the art of succeeding decades, first in Rome and then elsewhere. Understanding of antiquarianism is forcing us to reassess the style we have called, with considerable discomfort, Mannerism. For this reason it has become important to study the early stages of art all'antica that have in the past been neglected and marginalized.

In this chapter we shall not attempt to rewrite the history of the Classic style of the High Renaissance. Our concern will be with tracing the threads of antiquarianism in Michelangelo and Raphael, and also in lesser-known painters, and the absorption of antiquarianism into the Classic style. These are the roots of what will be the wellspring of inspiration for artists in the 1520s in Rome.

Awareness that the uniqueness of Rome lay in her magnificent past and in the physical and literary remnants of that past that still survived gained momentum in the latter Quattrocento. Already in 1471 Pope Sixtus IV made a gift to the city of Rome of some bronze statues that had survived since antiquity and belonged

to the Lateran, including the *Spinario* and the *She-Wolf,* which according to the myth had suckled the founders of Rome, Romulus and Remus. Pollaiuolo, possibly, was commissioned to add the infants and complete the image that would become the emblem of Rome.[7] Such a marriage of the antique and the contemporary was exactly how the Roman Renaissance conceived itself. These statues were installed on the Capitoline, the civic center and the ancient site of the Temple of Jupiter Capitolinus, god of the gods, in the Palazzo dei Conservatori. While the patrons of Florence were suffering Savonarola's fiery attacks from the pulpit for turning away from scripture to pagan books and images,[8] in Rome Michelangelo was sculpting a tipsy *Bacchus* (Florence, Bargello, 1497) – lifesize, in the round, and nude – and the Borgia pope, Alexander VI, was decorating his apartment with pagan subjects as exotic as the Egyptian myth of Isis and Osiris (Vatican, Borgia Apartment, Sala dei Santi, vault).

BERNARDINO PINTURICCHIO AND JACOPO RIPANDA

It is a telling contradiction that Ripanda (1490–1530), the painter chosen by the city of Rome for its most prestigious commission, the fresco decoration of the Palazzo dei Conservatori, was not granted a biography in Giorgio Vasari's *Lives.* In part because of Vasari's indifference, Ripanda's oeuvre has only recently been reconstructed, and his paintings have suffered from the neglect of the intervening centuries.[9] Vasari's bias against antiquarianism is evident in his exclusion of such artists as Amico Aspertini (1474/5–1533) and Pirro Ligorio (c. 1510–83) from his biographies, and particularly in his treatment of Pinturicchio (c. 1454–1513), who was actually the leading painter in Rome at the end of the Quattrocento, and decorator of the Borgia Apartment in the Vatican Palace. Vasari's high-handed dismissal of an artist selected by the pope runs contrary to his usual appreciation for the taste of powerful patrons. In this case he clearly regarded Alexander VI's choice to have been mistaken. He opened his biography of Pinturicchio with these remarks, "Just as some are aided by fortune without being greatly talented, others who are gifted are pursued by bad luck. Thus we know that she takes under her wing those who depend utterly upon her and who, if they had to go on their own merit, would go unnoticed. Such a one was Pinturicchio. Prolific though he

was and aided by others, he possessed a far higher reputation than his works merited."[10]

What appealed to Borgia was Pinturicchio's preeminence as the imitator and fabricator of the ornament *all'antica.* Pinturicchio was one of the first painters to explore and make use of what could be seen in the Domus Aurea, where the colors, gilding, and stuccoes of Nero's palace had been preserved as nowhere else. Pinturicchio first used this kind of ornament in the early 1480s in his Bufalini Chapel in Santa Maria in Aracoeli. Humanist patrons immediately sought him out to decorate their palaces and chapels.[11] In the Borgia Apartment he employed not only the new fantastic ornaments but also the gilding, the stuccoes, and the brilliant colors that he had seen on his repeated visits to the grottoes. Although Leon Battista Alberti, writing in 1435, had condemned the use of gold and brilliant color and had steered patrons and painters toward a more austere naturalism,[12] the discovery of the Domus Aurea authorized a reversion to bedizening display such as had not been seen in large-scale commissions since the disappearance of the International Gothic style much earlier in the century.

What Vasari objected to was the loss of narrative focus and the sacrifice of plausibility, the flight into fantasy, that Pinturicchio and his patron Borgia indulged in. On the principal wall of the Room of the Saints (1492–5) the *Disputation of Saint Catherine of Alexandria* is represented (Pl. VI). The saint is shown before the Emperor Maxentius, debating with the fifty pagan philosophers. Like a trained rhetorician, she enumerates her points on her fingers while the emperor and his court, who are garbed in contemporary Turkish costume, look on in awe. Behind her rises a Roman triumphal arch, modeled on the Arch of Constantine, topped by the Borgia bull and the inscription *Pacis Cultori,* Cultivator of Peace. Every Renaissance pope since Eugenius IV had promised to rid Europe of the Islamic threat. Attempt followed aborted attempt to raise a Crusade. In this tradition, Borgia here proposes to defeat Islam, but peacefully, not by force of arms, as Saint Catherine had defeated the pagans with her persuasive rhetoric. Strengthening the association with the present Turkish threat, Pinturicchio may have portrayed the brother of the Sultan, Prince Djem, who was being held hostage in the Vatican, as the turbaned horseman at the far right.[13] On the other side of the arch that represents Borgia's papacy, the verdant landscape is sprinkled

with a fairy-tale dusting of gold. This arch displaces the scene from its historical location in Alexandria, where the event actually took place, to Rome; by the anachronistic addition of the Borgia bull atop it, the scene is transferred from the era of Constantine to the present.

To make explicit the symbolic significance of the arch, Pinturicchio has rendered it in raised stucco, a pictorial device that had disappeared with the invention of scientific perspective. This artifice is what most vexed Vasari. He espoused what is sometimes called the scientific tradition in painting, running from Giotto to Masaccio, through Piero della Francesca to Leonardo and the other masters of the *terza età*, Raphael and Michelangelo. Vasari complained that the raised stucco arch behind the foreground figures calls attention to itself and comes forward, destroying the effect of the perspective. This is, of course, exactly what the painter intended: he was as interested in symbolic meaning as in literal depiction and wanted the arch and its meaning to dominate. The examples of stucco relief in the Domus Aurea must have been his inspiration. Pinturicchio lavished brilliant brocaded garments on his actors, to the further delight of the pope and the dismay of Vasari, who advocated the use of the durable *buon fresco* and would have recognized that such rich surfaces and fine details would require more time to execute than fresco provides and would have to have been executed in perishable *secco*.[14]

The message that the pope desired to have Pinturicchio convey with this scene evidently escaped Vasari, whose interest lay more in tracing the progress of art than in expounding papal propaganda. It was a vision of the Golden Age of Alexander VI, to be glimpsed on the far side of the arch, which would be inaugurated as soon as the threat of the Turkish invasion of Italy was averted by the pope's persuasive diplomacy. The gold-sprinkled world Pinturicchio devised could not be mistaken for a mere depiction of the Alexandria of Saint Catherine. By copying from the Domus Aurea lavish materials and using stucco in a way that had not been seen before, he invented novel means to convey the allegory. Coupled with his command of the ornaments *all'antica* – the *grotteschi*, which were the vogue – this sumptuous style made Pinturicchio the most popular painter on the Roman scene at the turn of the century. Many other powerful patrons appreciated him as well, leading him to garner the most important commissions of the day. In 1501 Cardinal Piccolomini, nephew of

Pope Pius II, brought Pinturicchio to Siena to decorate the library in the cathedral. In the contract the artist was called upon to paint the vault with these "fanciful things *[fantasie]*, colors and compartments which today are called grottesche,"[15] the first use of the term to have come down to us.

While Pinturicchio was still at work in Siena his former assistant, Jacopo Ripanda, was awarded the commission, mentioned earlier, to fresco the halls of the Palazzo dei Conservatori with scenes of Roman history.[16] In the only room in which his paintings have survived, stories of the Punic Wars are depicted, datable 1507–8 (Fig. 6). Here antiquarianism takes another form than grotesque ornament or lavish display inspired by the Domus Aurea. Drawing from antique literary sources, in particular Livy, the painter was required to recreate the world of ancient Rome. Ripanda had to translate into visual form Livy's narratives, and there was no precedent, no iconographical tradition, to depend upon. The sequence begins with the victory of the Romans over the Carthaginians at sea, followed on the next wall by the capture of Sicily. Next we see Hannibal in Italy with his elephants, and the sequence concludes with the Treaty of Peace between the Romans and the Carthaginians. In the *Victory of Rome over Sicily* (Fig. 7), Ripanda, the consummate antiquarian, combined the narrative of the Romans landing and marching through Sicily with an allegorical chariot rolling triumphantly through the countryside. Sitting on top is a personification of *Roma* in armor holding a little winged Victory, smiling benignly down on chained *Sicilia*, who sits, crossing her arms and looking disgruntled, with a crown of gilded grain, indicating why the Romans were so pleased with their conquest: Sicily became the breadbasket of Rome, her harvest the mainstay of the Roman granaries. The laurel-wreathed hero of the war, Lutatius Catullus, marches toward the city gate in front of the chariot. Behind in the lower right some Roman soldiers swarm over a defeated ship to lay claim to the key to the city, handed over with chagrin by one of the conquered enemy.

The look of authenticity, the painter decided, would derive from his careful transcription of the artifacts of antiquity – the armor, the ships, the costumes – especially as there was no hope of recreating authentic settings. Ripanda must have copied whatever he could find with the same devotion and energy as Pinturicchio and others had copied from the Domus Aurea, but he

Figure 6. Ripanda, Sala delle Guerre Puniche. 1507–8. Palazzo dei Conservatori, Rome.

needed to consult other sources, for there was nothing of warfare to be seen in Nero's palace. The chariot is the typical Quattrocento type, but Ripanda antiquized it by showing it drawn by four horses, the quadriga, copied from the relief on the Arch of Titus.[17] Many of the other details no doubt derive from the drawings Ripanda had just completed of Trajan's Column.

The project to copy the reliefs of Trajan's Column indicates the dedication of the Roman antiquarians to obtain firsthand models of antiquity that they could use. A scaffold was built, in the form of a movable tower we must presume, that allowed Ripanda to approach the reliefs closely enough to permit precise copying. We can assess how highly these images were valued by the fact that no fewer than six copies of the manuscript have survived from the sixteenth century.[18] Everywhere – in paintings from the Sala di Costantino (Fig. 27), to Giulio Romano's drawings made in Mantua for the King of France's tapestries (Fig. 69), to

Salviati's frescoes for Duke Cosimo (Fig. 150), and on through the century and across Europe – the minutely rendered details of ancient military artifacts that painters so much loved derive from Ripanda's drawings of Trajan's Column and other sources that were studied and copied with equal rigor.

In style, Ripanda's histories resemble Quattrocento narratives like those of Ghirlandaio or Pinturicchio. They have the loose planar organization and casual composition with frequent asides that Wölfflin characterized as chatty. The procession moves laterally at a leisurely pace; the viewer is invited to enjoy all the minutiae. Nothing is subordinated, except by scale, and the skirmishes that are taking place in the distant landscape are rendered with almost as much precision as are the foreground figures. There is none of the focus and drama of Leonardo's *Battle of Anghiari* recently undertaken in the Florentine Sala di Consiglio and then abandoned for technical reasons.[19] It is important to

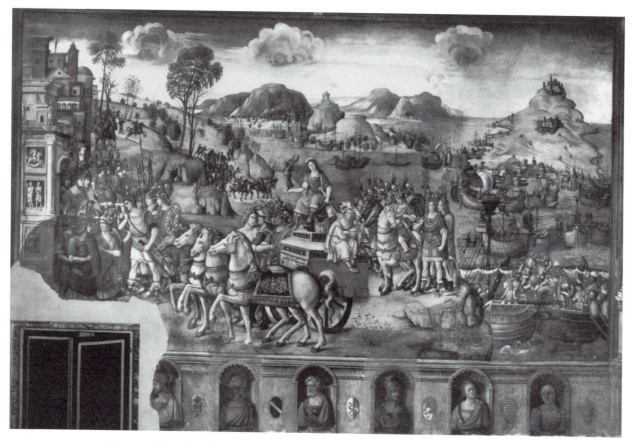

Figure 7. Ripanda, Sala delle Guerre Puniche, *Victory of Rome over Sicily*. Fresco, 1507–8. Palazzo dei Conservatori, Rome.

remember that at this date, before the arrival of Raphael in 1508 and before Michelangelo had begun the Sistine Chapel vault, there was no painting in the Classic style in Rome. Like Perugino (c. 1450–1523, who was also in Rome, at work on the vault of the Stanza dell'Incendio in the Vatican Stanze), Pinturicchio and Ripanda were the most noteworthy painters of the day, and they were all painting in the style of the late Quattrocento.[20] Ripanda frescoed four other rooms in this suite in the Palazzo dei Conservatori with subjects from Roman history, but they were almost all over-painted at the end of the Cinquecento.

At the same time that the patronage of Pope Julius II was being directed to Michelangelo, Raphael, and Bramante, some close associates of the pope were extending their patronage to Ripanda. Immediately preceding the Room of the Punic Wars in 1507, he had frescoed a room in the Santoro Palace (now the Doria-Pamphili Palace) with scenes from the lives of Julius Caesar and Trajan. Although they are lost, we know that they were in monochrome, that is to say, they were imitating mar-

ble relief.[21] It seems a reasonable assumption that they reflected the drawings he had recently made of Trajan's Column. Santoro had just been raised to the cardinalate by Julius II, so the choice of Julius Caesar was surely intended to pay homage to his patron. At about this time Pope Julius had a medal struck commemorating himself as Julius Caesar II. To some later scholars this appeared so arrogantly presumptuous that they believed the medal to be a forgery made by Julius's enemies as an effort to discredit him.[22] But it is only after the Council of Trent that this degree and kind of hubris in a pope came to viewed as inappropriate. The medal is genuine and is only one of many references to Pope Julius as Caesar to have been made following his triumphal return from his conquest of Bologna.[23] Incidentally, Cardinal Santoro's homage to Julius could be said to have been too successful: the pope was so delighted that he required the cardinal to cede the palace to him so that he could make a gift of it to his relative, the Duke of Urbino.

Interest among patrons in Rome in this kind of anti-

quarian decoration rivaled interest in the Classic style, and Ripanda was the leading painter of subjects concerning ancient history. In 1511, when Cardinal Riario della Rovere was awarded the lucrative see of Ostia, the port of Rome where the taxes were collected, he had a new wing added to the Bishop's Palace, including a large audience hall. Riario was a leader in the antiquarian circle. Together with Julius he had the finest collection of antiquities in Rome, displayed in the courtyard of the palace he built, now known as the Palazzo della Cancelleria. It was he who had been tricked into buying Michelangelo's *Sleeping Cupid* for a high price, but when he discovered that it was modern he had no interest in it and demanded his money back. It is no surprise that he would choose to have his reception room decorated in imitation of the antique. These frescoes were lost until 1979, when they were discovered beneath layers of whitewash, some scenes even painted over with later murals. Vasari had apparently never seen them, for his laconic reference, added in the second edition in his life of Baldassare Peruzzi (1481–1536), incorrectly located them in an adjacent building,[24] with the result that no one had ever thought to look for them in the Bishop's Palace. The attribution of the narratives to Ripanda is convincing, especially because they represent scenes from the War of Trajan against the Dacians in a monochrome fictive relief that resembles what the Santoro cycle must have looked like (Fig. 8).[25]

An important clue to the dating of the frescoes is provided by the arms of Julius II alternating with those of the patron, Riario. Because Julius died in February 1513, the frescoes must have been executed as soon as construction of the room was completed, probably in 1512. Although they are today sadly reduced, they are in

Figure 8. Ripanda, *Hand to Hand Combat* and *Conquest of a Mountain Fortress*. Riario Apartment. 1512. Episcopal Palace, Ostia.

sufficiently good condition to convey that it would have been an impressive ensemble. Ripanda relied on his knowledge of Trajan's Column for the fifteen scenes originally circling the room, but he was not narrowly

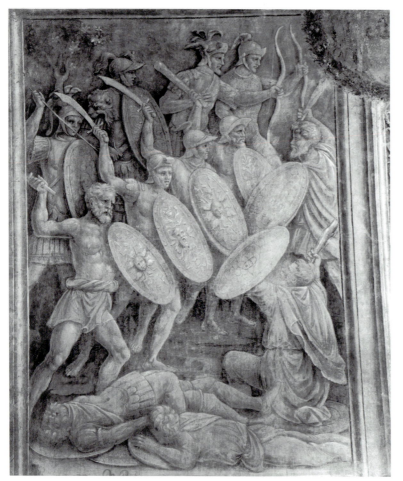

Figure 9. Ripanda, *Hand to Hand Combat*. Fresco, 1512. Riario Apartment, Episcopal Palace, Ostia.

for the action. His figures are still slender in the manner of the Quattrocento and a bit stiff, but he creates pleasing rhythms, as with the repetition of Roman soldiers and shields along a receding diagonal in *Hand to Hand Combat* (Fig. 9). The superior discipline and courage of the Romans is conveyed in the *Conquest of a Mountain Fortress*. The enemy's advantage of position avails them little, for the splendidly equipped Romans deflect with their shields the rocks hurled at them from above, and one valiant warrior mounts a ladder in the teeth of the enemy to decapitate their leader. Exactly contemporary with Raphael's Stanze and the completion of Michelangelo's Sistine vault, these scenes celebrate secular Roman history in a style that is appropriate to that subject matter. Although Pope Julius was concerned with the history of the Church and of Christianity in his pictorial cycles for the Vatican, some of the wealthiest and most distinguished patrons in Rome and in the inner circle of Julius's court preferred Ripanda's antiquarianism.[27]

Ripanda's style had matured quickly, perhaps with the stimulus of Raphael's and Michelangelo's frescoes in the Vatican. What he offered here, however, was a genuine alternative to their Classic style, recreating as it does the look of sculptural relief. Although Michelangelo was no stranger to the idea of imitating sculpture in paint, Ripanda's monochrome compositions go further toward creating a model for the relieflike style than anything Michelangelo or Raphael had invented by this date.

FLORENCE: CRADLE OF THE CLASSIC STYLE

Meanwhile, Florence was recovering from a decade of upheaval. In the 1490s, after two centuries of leadership in the arts, the city-state experienced political and economic difficulties so profound and shaking that its artistic patronage and production all but dried up for a decade.[28] Many of the artists left, seeking commissions elsewhere. When the tide turned in the summer of 1503 with the death of Cesare Borgia, who had been holding

dependent upon the reliefs. In certain instances he combines figures from several reliefs, and in no case is there an exact correspondence between his scene and the Column. He relied as much on the text of Cassius Dio, which described Trajan's Wars, as on the reliefs.[26] As in the histories in the Palazzo dei Conservatori, Ripanda makes his images convincing by the accuracy with which he renders the small detail.

Ripanda's success lies in his very plausible simulation of stone relief in paint. Despite the sacrifice of color, the ensemble is impressive due to the discipline enforced by using sculptural relief as the model. The problem of the treatment of space and landscape, which had been unsatisfactorily resolved in the frescoes of the Punic Wars five years earlier, is avoided here. On the model of the relief, Ripanda has ordered his figures parallel to the plane and has filled the frame from top to bottom with active figures, allowing only as much depth of space as is needed

the city under siege, the pent-up demand of patrons created a surge of commissions. It was a new generation of artists who took center stage in the new half millennium, led by Leonardo and Michelangelo, who had both returned home from abroad, to be joined in 1504 by the younger Raphael. In the brief period in which they were all three working in Florence, they so transformed style and taste that in 1506, when Perugino, who had been Raphael's teacher and had been called the best painter in Italy as recently as 1500,[29] displayed a new work, it was immediately regarded as old-fashioned and out of date. Perugino was bewildered. He could not understand why the same figures he had used before that had garnered praise were scorned when reused now.[30]

Certainly the tradition of Quattrocento Florentine art was the foundation on which the new Classic style of the High Renaissance could be built, but particular factors in Florence's recent history favored innovation, too. Savonarola, the Dominican friar who became effectively the head of state in 1494, had criticized the worldliness of the patrons and the sacred art they commissioned, and he had put his finger on the dilemma the late Quattrocento artists faced and could not resolve: they had become so adept at portraying the natural world that their works all but excluded suggestion of the supernatural world. The idealized images of the new Classic style provided the means to depict the supernatural in terms of the natural.

Michelangelo's nude *David*, begun in the doldrums of 1501 and displayed early in 1504, demonstrated how the biblical hero could be shown as a fully human likeness at the same time that he embodied divine empowerment. Colossal in scale (he is over thirteen feet tall) and perfectly proportioned, David symbolized the combination of strength, determination, and divine Grace that Florence itself needed to defeat its enemies.[31]

When Leonardo had first returned to Florence from Milan and exhibited his cartoon of the *Madonna and Child with Saint Anne* in 1501, we are told by an eyewitness that his fellow painters were dazzled.[32] Leonardo's intense interest in the natural world and his scientific observations had led him to certain discoveries about light and color and how we see them. The way he applied them could produce seemingly magical effects in paint. His portrayal of *Mona Lisa* (Paris, Louvre, begun in 1503) profited from his fascination with the way the pupil of the eye behaves under differing light conditions.

Leonardo placed his sitter in the shade under a covered balcony with a landscape behind. In such a situation we should be able to see very little detail of the figure and chiefly her silhouette, because the pupil closes down in response to the sunlight behind her. (We are familiar with the same phenomenon with the eye of the camera.) Instead Leonardo deceives his viewers, showing them what they would never actually be able to see: the delicately nuanced tones of the figure, visible only in low light when the pupil expands, at the same time that they see the brightly lit landscape beyond.[33] No wonder the painters, if they had seen something similar in his cartoon, had been awed. The extraordinary beauty of Leonardo's figures exceeds anything we can actually experience in this imperfect world. The artists understood empirically that Leonardo had painted the impossible and made it look like a portrait of nature itself. Here were means to depict the divine in terms of human experience, without tearing the veil of their hard-won naturalism.

Not only private patrons but the city government was ready with work for artists. The Sala di Consiglio of the Palazzo Vecchio, which was Florence's city hall, needed to be decorated, and for this Leonardo and Michelangelo were each commissioned to depict a battle important in the city's history. Leonardo's was the *Battle of Anghiari,* a cavalry encounter, which would give him the opportunity to demonstrate his skill at painting horses. Michelangelo's assigned subject was equally appropriate to his special talent, for it called for the treatment of nude men. The battle of Cascina had begun when the Pisans launched a surprise attack, catching the Florentines, who were taking their siesta, resting and bathing in the river. Michelangelo represented the soldiers in all sorts of active poses scrambling up the bank and into their battle gear (Fig. 10).

The murals were to decorate the long wall on either side of the central podium in the enormous Sala di Consiglio, each painting more than fifty feet long.[34] There was no lack of vision on the part of the city fathers, such as we see so often when it comes to commissioning public art today. Had it been completed, this would have been one of the great showpieces of the Renaissance. In the event, technical difficulties with his experimental materials led Leonardo to abandon his mural. Michelangelo responded to the command of Pope Julius II in 1505 that he come to Rome to work on the papal tomb, leaving behind only his precious

Figure 10. Aristotile da Sangallo, after Michelangelo, *Battle of Cascina*. 1504–5. Grisaille painting, 1542. Holkham Hall. Collection of the Earl of Leicester and the Trustees of the Holkham Estate.

cartoon and his fresco unexecuted. Florence had to yield to Rome for the first of many times in the century.

What is known of the *Battles* is only through fragments, drawings, and copies, but they were recognized as being of such importance that they were studiously copied by the artists in Florence. All we have of Leonardo's design, other than a few still-unresolved compositional sketches, are copies of the central episode, the Battle of the Standard, but we can see that in the climactic clash of the opposing forces he has encapsulated all the energy, drama, and tension of the battle.[35]

Michelangelo's cartoon was used as a school, traced over and then torn apart and dispersed, some parts to Mantua, some to Turin. We have a small grisaille copy made in 1542 by Aristotile da Sangallo, and Marcantonio Raimondi's engraving of 1510, which spread the design all across Italy and even beyond. Michelangelo provided a different kind of model, one more sculptural and less atmospheric than Leonardo's. He posed his figures parallel to the picture plane, but twisting in every possible posture in their exertions to ready themselves to fight. Each figure is like an individual sculpture, yet they are combined as if in a sculptural relief. As always

in a relief, the frontal plane is strongly articulated, providing a unifying discipline. The copies probably exaggerated the effect of sculpted figures and of relief;[36] nonetheless, this relieflike style would prove powerfully influential in the decades to come. It was during these years that Michelangelo, responding to the soft sfumato conception of Leonardo's Saint Anne group and "correcting" it, created his Doni *Holy Family* (Fig. 5) in as hard-edged and sculptural a style as can be imagined. Recent scholarship has recognized the source of several of the poses of the background nudes in the Doni *Holy Family* as antique sculptures known to Michelangelo, including the *Laocoon*.[37]

One painter who certainly studied the *Battles* was the young Raphael when he arrived in Florence in 1504. At that moment Leonardo had already been at work on his cartoon for about a year and Michelangelo had just begun his. Years later, when Raphael would design his own battle scene, the *Battle of the Milvian Bridge* in the Vatican (Pl. VII), he would recall and depend upon both Leonardo's and Michelangelo's *Battles* as his models.

In the next four years, before he too was called to Rome, Raphael would assimilate the means to idealize beauty, pioneered by Leonardo and Michelangelo, and

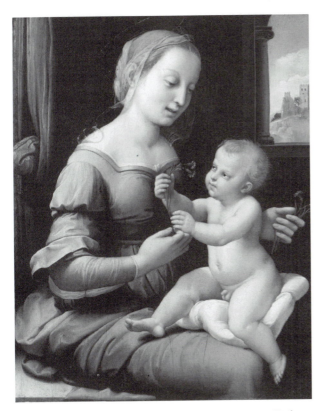

Figure 11. Raphael, *Madonna of the Carnations*. 1507–8. Duke of Northumberland Collection, on loan to the National Gallery, London.

contribute his own components to the style. In his characteristically orderly fashion, he would hone and perfect his personal manner in a long series of Madonna and Child pictures.[38] Seeking to compress energy within a pleasingly regularized geometric unity, he experimented and varied the formula. Yet in the course of these formal explorations he never lost his hold on the delicate and gentle feeling that belongs to the subject.

The *Madonna of the Carnations* (Fig. 11), hardly more than a foot high, displays the formal and emotional qualities of Raphael's Florentine Madonnas.[39] In contrast to the grander and more somber conception of his Roman works, such as the *Alba Madonna* (Washington, National Gallery of Art, c. 1509), the feeling here is of domestic intimacy: a young mother playing with her child on her lap. The flowers, suggesting divine protection,[40] allude simply to the divine nature of this Child and are not, like the symbolism of the Child reaching for the cross in the *Alba Madonna,* full of the foreboding of death. Like Leonardo's *Benois Madonna* (Saint Petersburg, Hermitage, late 1470s), which it closely follows, Raphael's little picture depends upon the distilled purity of its

composition and the mild idealization of figures, drapery, and setting to convey a sense of transcendence.

It took the experience of Rome and of antique ways of thinking and seeing for this Florentine Classic style to be expanded and aggrandized. Under the patronage of popes whose visions of grandeur matched those of the Roman emperors, Raphael and Michelangelo enlarged and deepened their styles. By 1508, Leonardo, Raphael, and Michelangelo had all left Florence, carrying away with them the fruits of their explorations, their rivalries, and their mutual respect. Leonardo returned to Milan. Leadership of the Florentine school was left to Fra Bartolommeo (1472–1517) and, after his death, to Andrea del Sarto (1486–1530).

VILLA FARNESINA

The richest man in Rome, and one of the most powerful, came from Siena, the banker-merchant Agostino Chigi. As the owner of the papal monopoly on alum mines, Chigi's enterprise enriched the papal treasury and enabled him to provide loans as needed to the pope and members of the papal court. Educated as a banker, and not as a humanist, Chigi was not a leisured gentleman, which made it all the more obligatory for him to spend lavishly and conspicuously. His villa on the bank of the Tiber would become the site of many a memorable entertainment enjoyed by the popes and cardinals until Chigi's death in 1520. His patronage of artists has left us with monuments of the first rank, both secular and sacred, and the indispensability of his wealth to the papacy gave him access to the finest artistic talents available. Although Chigi did not amass a collection of antique statues like Riario, his commissions reflect at all levels his interest in imitating the antique.

For his mortuary chapel in Santa Maria del Popolo where Raphael was in charge, begun around 1512–13, the conceit was to create a miniature Pantheon, with an entrance porch, a dome with oculus, and on the walls, colored marble revetment and statues in niches. In the Renaissance the Pantheon was thought to have been an Augustan construction, as the Hadrianic inscription implies, so it was deemed an especially appropriate model for Agostino Chigi because of his name.[41] On the side walls rose-marble pyramids, recalling the funeral pyres of the Roman emperors, serve to memorialize Agostino and his brother. In the marble frieze adjacent to each pyramid on the altar side is an eagle,

like the live one that was tethered to the top of the emperors' pyre; when the flames consumed the string holding it, the eagle would be freed and would fly away, signifying the ascent of the emperor's soul.[42] God the Father, illusionistically presented in Raphael's oculus, has his arms outstretched to receive the souls of the Virgin, whose *Assumption* was originally intended for the altar, and of Chigi. Though what impresses us, in a more democratic age, may be Chigi's unwarranted identification of himself with the Roman emperors, the Renaissance viewer was apparently more awed than offended by the opulence and the reevocation of the world of antiquity that Chigi's patronage created.

The very idea of a suburban villa was of course based on antique prototypes. In the Middle Ages it had not been safe to reside in the countryside outside the protection of the city walls. Positioned just outside Trastevere, Chigi's Villa Suburbana, as it was then called, was not very far outside the city to be sure, and it was, in fact, delightfully accessible from the Vatican as well. As his architect, Chigi employed a fellow Sienese, Baldassare Peruzzi, who had come to Rome early in the century and begun to make a name for himself. Peruzzi began work in 1508 designing the U-shaped structure whose wings embraced an open loggia. This served invitingly as the entrance, more inviting than today, for the rear has become the entrance, and the loggia on the opposite side, with its frescoes of Cupid and Psyche by Raphael, has been enclosed with glass (Fig. 19). The spirit of the villa was playful, intended for brief visits of respite and pleasure – this even though Chigi, like his counterpart, the business magnate of today, could never be far from his equivalent of the fax machine and used the room in the wing to the right of the loggia as an office. The exterior was covered with decoration. Still surviving is the stucco frieze of garlands and putti beneath the cornice of the roof, but vanished are the frescoes, which were painted on the designs of Peruzzi, recalled for us only in a drawing (Fig. 12). Faun-herms flanked the windows, and mythological scenes or scenes from Roman history filled the rectangles above them. This rich ornament would have given the plain exterior a divertingly animated effect. The practice of painting the exterior of palaces and villas was beginning to become the fashion in Rome at this time. Across the front of the loggia was a podium, now buried but visible in the drawing, which was intended to provide a stage for theatrical performances – again in imitation of

the antique – and for which the loggia and the frescoes would provide the backdrop.[43]

On the river side there ran another loggia, now likewise glazed to protect the frescoes, including Raphael's *Galatea,* which gives it its name. Peruzzi painted the famous vault with the planetary bodies and constellations positioned as they were at the moment of Chigi's birth (Fig. 13). It is remarkable that the program and its execution were so precisely worked out – "like a fine clock" as one commentator has noted – that twentieth-century scholars were able to reconstruct the date and time of Chigi's birth working backward from the painted horoscope, data that have now been confirmed within hours by a document.[44]

The allure of astrology had persisted from antiquity through the Middle Ages and, as Jean Seznec has pointed out, was one of the principal means by which the pagan deities survived.[45] Astrology corresponded to Renaissance interests on two counts: it was based on scientific observation, and it invested the planets with the power of pagan divinities to determine human destiny. The flagrant egotism of Chigi's display recalls the Roman emperors and specifically the astrological decorations of the octagonal dining room at Nero's Domus Aurea, described by Suetonius. An earlier age would have viewed it as vulgar, but Chigi's boundless wealth excused it to his Cinquecento contemporaries and transformed it instead into a fashion to be followed.[46] For Chigi and his guests, who dined beneath it, it doubtless provided entertainment and a stimulus to conversation.

Peruzzi's vault, painted in 1511, was designed to be viewed from what was then the loggia's principal entrance, the arches opening to the garden. Within compartments deriving from the Domus Aurea vaults, he showed on the center of the vault two constellations, on the left, *Perseus decapitating Medusa,* and on the right, the *Chariot.* In hexagons in the spandrels are the signs of the zodiac. In the severies between them over the lunettes are more constellations relevant to the horoscope. Peruzzi demonstrates an antiquarian knowledge comparable to Ripanda's. The accuracy of his costumes and attributes must have delighted his patron. Like Ripanda's, his style is still essentially pre-Classic, in marked contrast to Raphael's in his *Galatea* (Fig. 15) on the wall below. Raphael's broader, more fluent forms make Peruzzi's look stilted and prim. Perseus and Medusa appear to pose self-consciously as if in a theatrical performance, or perhaps more accurately, for a

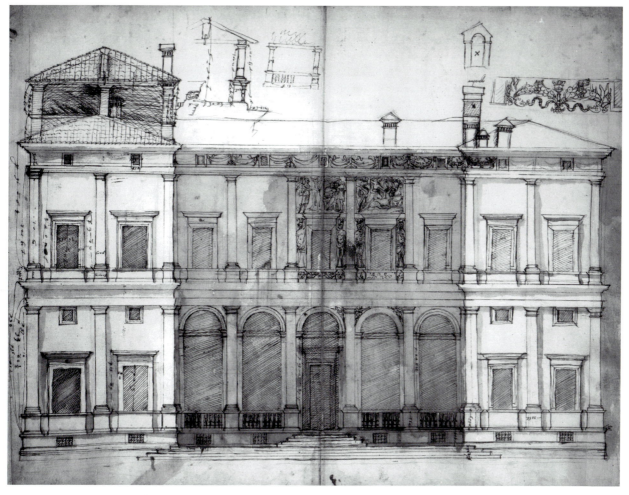

Figure 12. After Peruzzi, drawing of the exterior of the Villa Farnesina, c. 1505–8. Metropolitan Museum of Art, New York. Gift of James and Anne Bigelow Scholz in Memory of Flying Officer Walter Bigelow Rosen, 1949.

sculptural relief. But Peruzzi's images here can be tinged with humor: those stiff, marmoreal men who surround the terrible Medusa are the would-be heroes whom she has turned to stone.[47]

Chigi traveled to Venice on business in 1511. When he returned he brought with him the painter, later known as Sebastiano del Piombo (c. 1485–1547), who had been with Giorgione until his death the previous year. Sebastiano set to work on the lunettes, which represent mythological stories that refer to the air. He had never before worked with the materials of Roman fresco and the difficulties he experienced detract from the effectiveness of these scenes, but by the time he came to the *Polyphemus* (Fig. 14) on the wall below, he was master of his materials.[48] Polyphemus was a cyclops, a one-eyed giant, who fell in love, incongruously, with the nymph Galatea. The story is told in

Ovid's *Metamorphoses* (13, 738ff.) of how the cyclops had hurled a rock at Galatea's lover and killed him and she, of course, fled. Sebastiano's giant, discreetly depicted with his head turned to conceal the disfiguring eye in his forehead, sits in an ungainly pose staring out at the sea, holding the panpipes with which he has uncouthly wooed the nymph. In the adjacent fresco we see the fleeing Galatea.

Raphael has conceived her on a chariot drawn by dolphins, surrounded by mythological creatures of the sea. She looks back over her shoulder sadly and wistfully, not at Polyphemus, but in the direction of her lost lover. For his Galatea, Raphael has quoted the pose of Leonardo's *Leda,* which he had copied while in Florence (Fig. 16)[49] using the serpentine twist to convey at once her forward movement and backward glance. The triad of cupids above her and the one below her feet

25

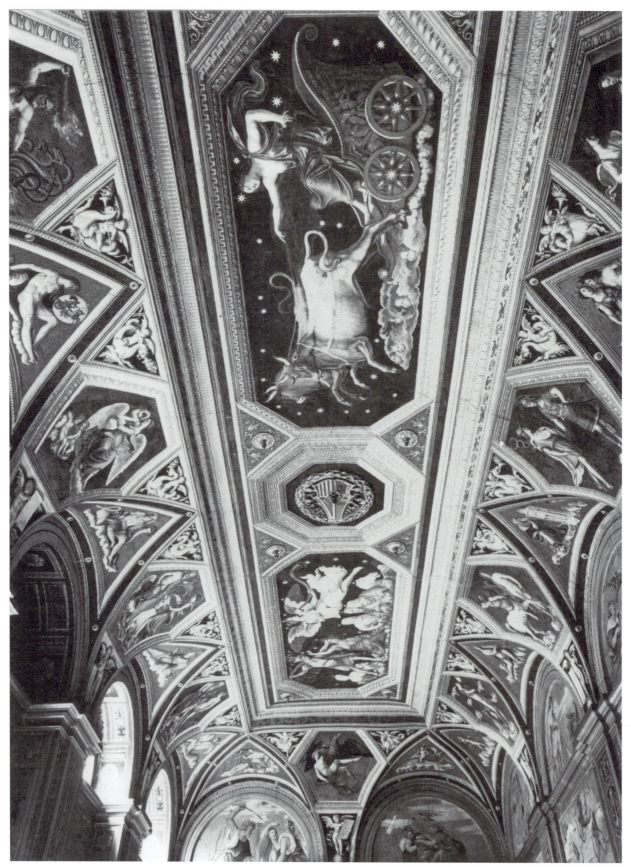

Figure 13. Peruzzi, vault of Sala Galatea. Fresco, 1511. Villa Farnesina, Rome.

Figure 14. Sebastiano del Piombo, *Polyphemus*. Fresco, 1512. Sala Galatea, Villa Farnesina, Rome.

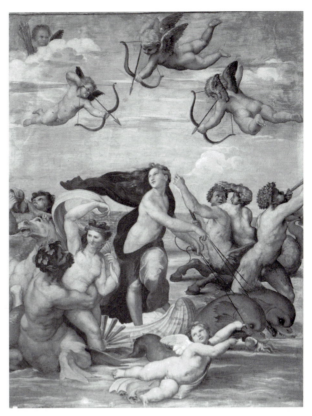

Figure 15. Raphael, *Galatea*. Fresco, 1512. Sala Galatea, Villa Farnesina, Rome.

make it clear that the theme here is love, but a small detail suggests a more precise meaning. The cupid in the foreground, who mimics Galatea's pose, points out the dolphin, a symbol of love, who eats an octopus, symbol of lust, according to an ancient writer.[50] The two frescoes, taken together, then, represent the triumph of love over lust, and they do so in a lighthearted spirit very like that of Ovid and his telling of the classical myth that is imitated here (*Metamorphoses*, Bk. 13). There was also a description by Philostratus of an ancient painting of *Polyphemus and Galatea*,[51] so in yet another sense these are imitations.

Imitation had been the subject of a heated debate in the early years of the Cinquecento. On one side were those like Gian Francesco Pico, who advocated combining sources. They justified their position by referring to the story from antiquity of Zeuxis, who wanted the town beauties assembled so he could select the best features of each to make his portrait of Venus.[52] This "theory of scattered beauty" was opposed by a few, like Cardinal Bembo, who advocated imitating from a single source.[53] We recall that Castiglione attributed the scattered beauty approach to Raphael with the famous remark that in order to paint a beautiful woman he looked at many and

then followed "una certa idea" of beauty that had formed in his mind. Whichever side they agreed with, what everyone in Renaissance Rome agreed upon was that imitation was appropriate and desirable.

John Shearman has codified Renaissance imitation for us, distinguishing three kinds. As he points out, the way imitation was used varied with the audience for whom the piece was intended. Sometimes an artist would imitate another work to help solve a problem, but hoped the source would not be recognized. In other instances an artist quoted from other works, both visual and literary; like any quotation, it carried the flattering message to cultured viewers that they were expected to recognize the reference – on less sophisticated spectators such allusions would, after all, be lost. This category Shearman calls *emulation*. Reference to specific sources that enhanced the meaning of the work were likewise intended to be recognized; these transparent quotations Shearman calls *bearers of signification*.[54] It is not always immediately apparent what kind of quotation one is studying. As helpful as Leonardo's *Leda* may have been to Raphael in solving the compositional problem, we can assume that he expected, and even hoped, his patron would recognize it and appreciate

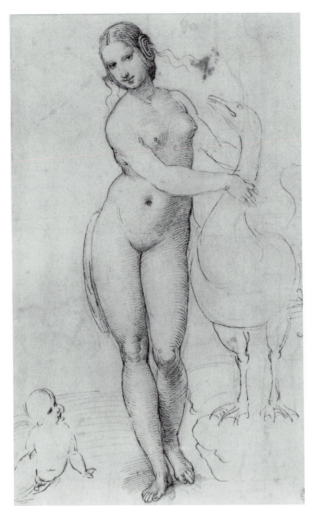

Figure 16. Raphael, after Leonardo da Vinci, study for *Leda and the Swan*. c. 1507. © Her Majesty Queen Elizabeth II.

how apt his quotation of that sensuous figure of Leonardo's invention was to his own rendering of the nymph who embodies love. This quotation then probably contains elements of both emulation and the bearer of signification. The instances of imitation in Chigi's villa, the Farnesina,[55] are multiple, and many are literary allusions, but there are not as many layers of allusion as we will find in the art of the following decades, when artists vied to outdo one another in complexity.

During his Roman years Peruzzi was engaged in numerous projects of ephemeral decoration – festivities, theater sets – many of which required him to make painted architecture. No doubt he painted more architecture than he ever got a chance to build. In his Life of Peruzzi, Vasari emphasized his command of perspective.[56] Vasari also mentions that he painted a large number of facades, one of which is described as showing figures high up *di sotto in su*, that is, illusionistically.[57]

When assigned the decoration of the principal *salone* at the Farnesina, Peruzzi brought that experience to the task. In its visual wit the conceit of the Salone delle Prospettive is in keeping with the jocular spirit of the Farnesina decorations (Fig. 17). Peruzzi has transformed with paint this upstairs room into another (fictive) loggia. The walls have been painted away; the cornice appears to be supported by Doric columns of purplish marble opening onto the loggia, the boundary of which is marked by a balustrade. Beyond, we see views, on the city sides, of Rome, on the country side, of the landscape. The perspective is projected from a point opposite the fireplace, where if we stand with our backs to the windows, the illusion is startlingly convincing.[58] One can imagine Chigi bringing his guests here when the weather would not permit dining in the garden loggia. Warmed by the fire, they could enjoy the *illusion* of the light and air and breeze and the view over the surroundings. The whole room is sheathed in a feigned revetment of colored marbles, emulating the decoration of imperial Roman villas. Above the doors are real niches where those Roman emperors once presided in the form of statue busts. The pagan gods and goddesses above them are painted as if illusionistically present. Over the fireplace is the *Forge of Vulcan,* where an arrowhead for the waiting Cupid is being hammered out, bringing us back to the theme of love that pervades the villa.

In the frieze above, now believed to have been executed by Peruzzi's associates around 1516–18, mythological stories abound, centered around themes of love. Like the adjacent and contemporary bedroom, the subjects suggest that these rooms were being prepared for the marriage of Chigi to his mistress. The sources are various ancient authors, including Ovid, Claudianus, and Philostratus. Herms of fictive marble separate the scenes and occasionally comment upon them with gesture and facial expression. *Deucalion and Pyrrha,* who are charged like the biblical Noah and his wife with repopulating the world after the Flood, do so by throwing rocks over their shoulders (the middle scene on the wall illustrated). The awkward creatures depicted emerging from stone, one in midair, give an amusing genealogy for the human race. It is tempting to see this as a witty comment on, and counterpoint to, Michelangelo's lofty and noble inventions in the *Creation* narratives on the Sistine vault of a few years previous, adapted here to the context of Chigi's marriage – a union that had already produced four children. Features that will appear over and over again in the palace and villa decorations of the

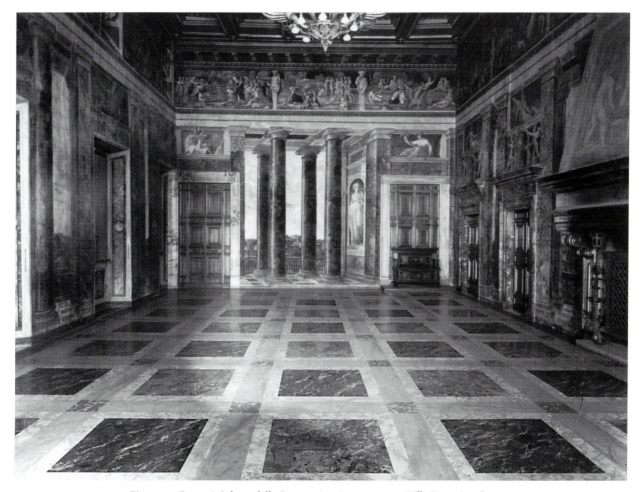

Figure 17. Peruzzi, Salone delle Prospettive. Fresco, c. 1517. Villa Farnesina, Rome.

next decades are introduced here: the witty illusionism, the fictive materials, the pretended confusion between sculptural, painted, and feigned actual presence. These are motifs Raphael will develop in schemes for his late decorations in the Vatican. They will have a long, and constantly renewed, career.

In the adjacent bedroom another Sienese painter, Sodoma (1477–1549), was commissioned in c. 1516–17 to fresco scenes from the life of Alexander the Great.[59] The subject on the principal wall, the *Marriage of Alexander and Roxane* (Fig. 18), certainly refers to Chigi's impending wedding. Once again the tissue of allusion is thick and multilayered, and it is both literary and visual. A painting of this subject by a Greek artist is described by Lucian, and there was a drawing of it by Raphael, now lost but preserved in copies. There is a flattering analogy implied between the patron and Alexander, the conqueror of the world. Chigi never spurned the eulogies of humanist writers who – either hoping to gain his patronage or already enjoying it – compared him

with various ancient heroes, often, punning on his name, with references to Augustus. Sodoma has made the space of the picture continuous with the room, separating it only by an illusionistic balustrade that opens at the center, permitting entry. Seated on the nuptial bed is the modest Roxane, eyes demurely lowered, being offered a crown by the admiring Alexander, who has put aside his helmet for the moment. Putti playfully undress the bride, do cartwheels, hide in the bed hangings, and riot around the room. The painted bed is a sumptuous object, rivaling or mimicking the real bed that stood opposite it and is reflected in the convex mirror hung inside – with *its* curtains discreetly closed.

Sodoma has moved out of the realm of the Quattrocento styles of Ripanda, Pinturicchio, and Peruzzi. He has learned a svelte elegance from Raphael that moves his figures toward his own kind of easy grace. Nevertheless, Sodoma remains devoted to accurate detail in costume, landscape, and artifacts, and it prevents his paintings from soaring to the eloquent heights of

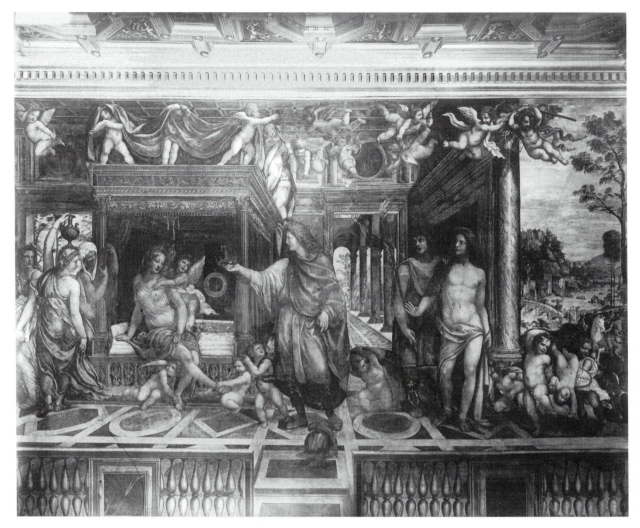

Figure 18. Sodoma, *Marriage of Alexander and Roxane.* Fresco, 1517. Bedroom, Villa Farnesina, Rome.

Raphael's. There is an element of antiquarianism in him too, and it must have appealed to Chigi. Here, then, we can see an intermediate stage, in which antiquarianism is assimilating something of the Classic style. At the same time, as we shall shortly see, the opposite process was also at work, for Raphael was folding antiquarianism into his Classic style.

Raphael returned with his *équipe* to fresco the vault of the entrance loggia (Fig. 19). Scenes of the troubled, but ultimately successful, love affair of the mortal Psyche and the god Cupid were based largely but loosely on Apuleius's satiric telling in the *Golden Ass.*[60] The vault has been turned into a pergola of leaves, flowers, fruits, and vegetables through which one gets glimpses of the sky. In the pendentives are episodes of the story of Psyche's trials, contrived by her unwilling and fractious future mother-in-law, the great goddess Venus. Humor

infiltrates nearly every image, ranging from gently satiric images of the frustrated Venus, through the disconcertingly unmajestic kiss Jupiter plants on Cupid, to the bawdy joke of phallic gourd and overripe fig at which Mercury gleefully points (on the end wall). When Jupiter has the Goddess of Love before him, he loses all his suave dignity, stares at her with schoolboy longing, and clumsily clobbers his emblematic eagle with his great outstretched leg. Here we have an opportunity to observe Raphael adjusting his mode to the audience and use. Instead of the grave mood and monumental figures of the tapestries designed to hang in the Sistine Chapel (Fig. 23), we find a frivolity appropriate to Chigi's shrine to love. At the center of the vault fictive awnings give protection from the glare of the sun, and we see the happy culmination of the story in the *Council of the Gods,* at which Psyche is received among the

Immortals, and the *Wedding Banquet of Cupid and Psyche*. Carrying forward the theme of love are the putti in each of the spandrels who bear away to heaven the emblems of the gods that they have won as the spoils of war. Even the gods themselves must yield to love.[61]

In the southeast corner of Chigi's property there was another loggia, designed for summer dining beside the river. Beneath it there was a grotto – the first of many we will encounter – reached by an exterior staircase that received water piped from the Tiber into a basin filled with fish where one could bathe and look up through a hole in the vault to the sky above. Antique sources inspired the iconography throughout, including the iconography of the garden. The Tiber recalled the river Styx, and the grotto beneath the dining loggia on the river bank could be interpreted as the entrance to Hades. It was here in the riverside loggia that on one occasion, when Pope Leo and other members of the papal court were present, Chigi had his servants remove the silver dishes between courses and toss them into the river. The awed guests were not informed that nets had been deployed to catch them.[62]

Chigi's interests were antiquarian, and he saw his villa as a place of diversion. In his choice of artists he favored his compatriots from Siena, where the Classic style never put down roots. Yet on two occasions he procured the services of Raphael, for whom the Classic style was more than overt imitation of the antique. The question arises, was style a matter of indifference to Chigi so long as his taste for antiquarian allusion was satisfied and the spirit of wit and humor was maintained? Or was it most important of all to rival the popes themselves by stealing their favorite painters away whenever possible?

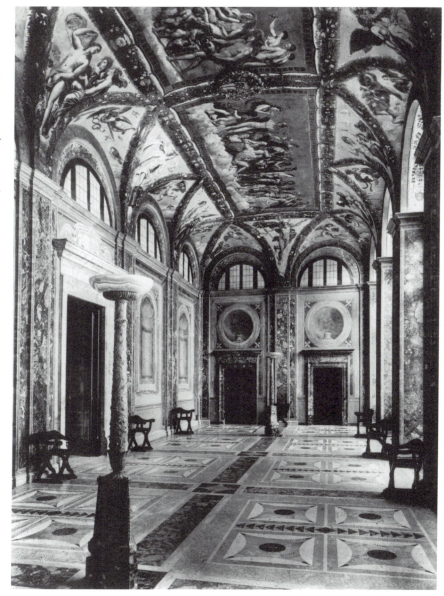

Figure 19. Raphael and workshop, Loggia di Psiche. Fresco, finished 1519. Villa Farnesina, Rome.

THE PATRONAGE OF JULIUS II

The two popes of the High Renaissance shared a passionate interest in Roman antiquity and the view that its emulation would enhance the profile of the Church, but they had distinctly different tastes. To reduce it to a formula we could say that Julius's taste ran to the Classic style, whereas Leo was an antiquarian. Julius, with his choice of name recalling Julius Caesar, signaled from the start of his papacy in 1503 his intentions to renew ancient Rome. He was not the successor of Alexander VI, the Borgia pope who had favored Pinturicchio with his patronage. Upon his death the conclave elected Cardinal

Piccolomini, who had commissioned Pinturicchio to paint his library in the Siena Cathedral. When Piccolomini died within a month of his election, however, Cardinal Giuliano della Rovere (Julius II) ascended the papal throne and for the next ten years contributed with his patronage to the definitive redirecting of sixteenth-century art.

One can speculate about how different the course of Renaissance art might have been had Piccolomini lived and Julius never reigned. Julius had been collecting Roman antiquities during his cardinalate and had already acquired the famous *Apollo Belvedere* (Fig. 2). When the *Laocoon* (Fig. 1) was discovered and identified early in 1506, Julius made haste to acquire it and install it with his other treasures in the Belvedere Statue Court, which he ordered Bramante to build alongside the Villa Belvedere at the far end of the Vatican garden. It is interesting that Julius was sufficiently concerned to give the public access to this collection of antiquities that he had Bramante build the famous spiral staircase that opened at the corner of the Vatican wall, so visitors could enter the Statue Court without passing through other parts of the Vatican complex.[63] The owner of the vineyard where the *Laocoon* was discovered was awarded a memorial plaque after his death in Santa Maria in Aracoeli recording his role.[64] Before Julius's death in 1513 the *Laocoon* and the *Apollo* were joined by other statues, some of which strike us today as unworthy of the exalted treatment they were accorded.[65] We are reminded again that at the time quality was not the only criterion for celebrity and also that the ability to distinguish style by period was still very underdeveloped.

Although Julius II is remembered as the patron of Raphael, Michelangelo, and Bramante, these were not the only artists he called to his service. On the contrary, he was not at all selective. He would bring a well-known artist to the papal court, perhaps give him a small commission on a trial basis as it were, and then if he did not entirely please, rather than dismiss him Julius would leave the artist to languish until he finally gave up and went elsewhere. Perugino, Sodoma, Signorelli, and Bramantino had all been working for the pope when Raphael arrived. The choice of the giants whom Julius favored and who in turn made his name famous as an inspired patron of the High Renaissance was more a matter of trial and error than of careful planning.

Julius's intentions with his architectural commissions were clearly formulated earlier than in his painting commissions. Soon after his election, the pope had Bramante (1444–1514) begin work on an enormous project to remake the Vatican. The Cortile del Belvedere (Fig. 20), joining the Villa Belvedere (constructed in the 1480s) with the Vatican Palace a thousand yards away, was designed in imitation of the great villas of the Roman emperors, like Hadrian's at Tivoli just outside Rome. Following the model of Hadrian's Villa and what could be learned of other villas of imperial times from their remains and from literary sources, Bramante ordered the sloping land of the Vatican hill into a terraced garden between embracing *loggie* running the length. Beneath the windows of the palace he constructed a court, suitable for tournaments, bullfights, theatrical performances, and other festivities reminiscent of the entertainments of the ancient emperors. The pope and his courtiers could view the spectacles from the Raphael Stanze above. Beyond the court and above were planned peaceful gardens, formally planted and animated with fountains.[66] Little remains today, and one must have recourse to engraved views to imagine how it once looked. Its disruption began soon after the engraving of 1579. The sweeping vista was divided by the construction of two cross arms, the library wing built by Sixtus V in 1586 and the Braccia Nuova, added in the eighteenth century to house some of the collection of antiquities; Bramante's court is now a parking lot. Although not completed until long after Bramante's death in 1514, and transformed already in the Counter-Reformation – when its pagan worldliness had become an embarrassment – for more than half a century Julius's grand construction proclaimed the papacy as the Christian reincarnation of the Roman Empire.

Bramante was set to work designing the new Saint Peter's as a domed central-plan church on the model of a classical antique type. The architect proposed to reorient the basilica on a north-south axis, so that the obelisk on the south side, believed to contain the ashes of Julius Caesar, could stand at the middle of the new piazza, but it appears there were limits to how far Julius would go in emulation of Caesar. He emphatically rejected the idea because it would mean moving the tomb of Saint Peter under the altar. Bramante believed that the obelisk could never be moved, but in fact later in the century Sixtus V had it done, so that now it stands at the center of the square, just as Bramante imagined it.[67]

When Julius called Michelangelo to Rome in 1505 it was to create his tomb. Like everything Julius underwrote, the tomb was based on classical prototypes. An enormous freestanding monument, it was designed to

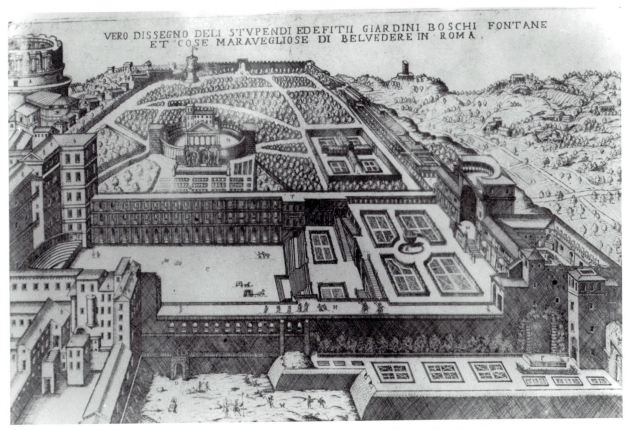

Figure 20. After Bramante. Engraving, 1579. Cortile del Belvedere, Vatican.

rival the emperors' catafalques and to resemble the three-tiered mausolea of ancient rulers, like that of Halicarnassus as described by Pliny the Elder.[68] Michelangelo was to execute over forty statues for it and was energetically occupied with the task for two years before Julius suddenly diverted him to the Sistine ceiling. Only after it became apparent that the major crack that had opened in the ceiling of the Sistine Chapel would require that it be repainted did it occur to the pope that he might replace its now old-fashioned decoration, commissioned by his uncle Sixtus IV just a quarter-century before, with something more à la mode.[69]

A blue field with gold stars, which had been created in the Quattrocento campaign to cover the ceiling, had been a standard decoration for vaults for centuries: one can see it in Giotto's Arena Chapel in Padua dating from the first decade of the fourteenth century. Only with the explorations of the Domus Aurea had it become fashionable to decorate the vaults. Michelangelo's original commission for the Sistine was to paint the twelve Apostles seated in the spandrels where the Seers now are, and then to design compartments, like those of the *Volta dorata* in the Domus Aurea (Pl. VIII),[70] and fill them with what he described as the usual orna-

ments, that is to say, grotesques. The reconstruction is based upon a drawing of Michelangelo for a portion (Fig. 21),[71] and resembles in general format the ceiling that Pinturicchio had recently completed in the Piccolomini Library in Siena. Knowing what we know now of Michelangelo based on his subsequent achievements, it may seem astonishing to us that he was engaged in a project with such a high proportion of ornament and such a low degree of serious content. Speaking in retrospect in a letter, Michelangelo took the credit for diverting the program to a more elevated level. He claimed that he warned the pope about the first project, saying that it would be "a poor thing," and when Pope Julius asked why, he responded, "Because the Apostles were poor." Only then, according to Michelangelo's retelling, did the project take shape to paint the Old Testament narratives and Prophets, the Sibyls of classical antiquity, and, in the lunettes at the top of the side walls and in the severies, the Ancestors of Christ. In the course of the four years that he spent on it, between 1508 and 1512, Michelangelo forged his version of the Classic style. This was virtually simultaneous with Raphael's independent accomplishment along the same lines in the Stanza della Segnatura a few yards

away across a courtyard. What interests us in our context is that Julius's Sistine project began as an essentially antiquarian undertaking that did not differ substantially from what his papal predecessors would have commissioned and been satisfied with. However it came about that the Sistine commission was changed and enlarged, it was the result of the creative interaction of an ambitious patron and an enormously gifted artist.

It is not our task here to analyze the Sistine ceiling or to describe the process by which it evolved, which has been done definitively elsewhere.[72] Rather, we want to single out some of the elements that could be regarded as antiquarian. For all his success as a painter and a colorist, Michelangelo conceived his ceiling as if it were a series of sculptures placed within an architectural framework. The Seers (Pl. IV) in their niches are like seated statues, as has been pointed out many times, related to the seated *Moses* for Julius's tomb on which he had been working. The Genesis narratives, especially the early *Noah* scenes, resemble reliefs (Pl. V). After attempting in the *Deluge* a deep, perspectival space with numerous figures and recognizing (presumably) that it was not legible from the floor of the Chapel, the artist moved to the model of sculptural relief. The figures almost fill the field, occluding the background, and are arranged as lateral sequences parallel to the picture surface. To be sure, as the painter gained experience, moving toward the altar, the figures became less sculptural, but many of the subsidiary components, like the bronze shields held up by the nudes, explicitly simulate relief. The model of sculpturelike painting was there on the Sistine vault and available to anyone seeking precedent for the imitation of sculpture with paint. As we shall see, there were those who had reason to turn to the authority of the "divine" Michelangelo in the next few years.

Everything Julius undertook had the stamp of imperial Rome on it, and the humanists of his court were there to point out the similarities and to celebrate the new Caesar. When the "Warrior Pope," as he was called, returned from his conquest of Bologna in 1507, his entrance into Rome was timed to coincide with Palm Sunday, thereby automatically invoking the analogy between Christ's triumphal entry into Jerusalem and himself as Christ's vicar. The entry itself was designed to resemble an ancient Roman triumph. A *carro* led by four white horses, like that painted by Ripanda in the same year, awaited him as he passed by the Ponte Sant'Angelo. On it was a globe, the symbol of universal dominion,

from which grew an oak tree with gilded acorns, the emblem of Julius's family, the Della Rovere.[73]

Julius surrounded himself with humanists. In the half-century since Pope Nicholas V a new kind of preaching shaped by humanism had developed in the papal chapel. Sermons based in their form on the principles of classical rhetoric offered an alternative to the medieval Scholastic type of sermon based on rational argument. Rather than seeking to prove an interpretation of doctrine, this genre of papal sermons sought to arouse a deeper appreciation for a position to which the listener would already give assent. Derived from the demonstrative genre of rhetoric, this style is called "display" oratory because the artful construction of the oration was almost an end in itself.[74]

These were sermons focused on praise and blame, or "epideictic." The first object of their praise was, naturally enough, God himself. The humanist's optimistic view of humankind pervades this oratory, and celebration of God's good creation, including man himself, was a frequent theme. Julius's favorite preacher was Egidio da Viterbo (Giles of Viterbo), who was notoriously long-winded. The usually impatient pope would sit through sermons running to two or more hours. On several occa-

Figure 21. Michelangelo, Studies for the Sistine Ceiling. 1507–8. © British Museum, London.

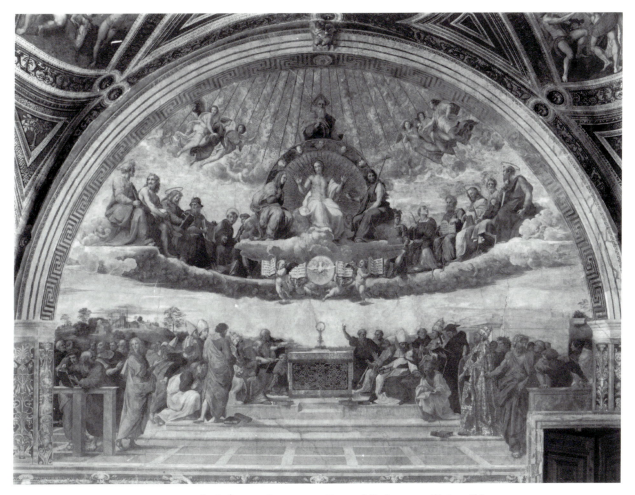

Figure 22. Raphael, *Disputa*. Fresco, 1510. Stanza della Segnatura, Vatican Palace.

sions Egidio preached on topics that led him to describe the present era as the dawn of a Golden Age, a theme derived from "pagan" sources and applied with the confidence in the continuity of the antique with the Christian eras that marks the humanist view of history. The image derives from Virgil's Fourth Eclogue. There the author interpreted the prophecy of the Cumaean Sibyl that the Iron Age would cease and a new Age of Gold would ensue as a prediction of the *Pax romana* of Augustus. The advance of culture and the arts characterized the Golden Age that Julius was predicted to inaugurate.[75] We find the concept applied to Julius's and to Leo's reigns in both sacred and secular contexts. Cardinal Bembo had hailed Julius on the occasion of his election, for example, as the inaugurator of a new Golden Age. Although the sermons of the papal court borrow their form from antique rhetoric and the occasional image from an antique source, their content is orthodox Christianity in a generally positive vein peppered with pleas for reform.

There is probably no more perfect expression of the humanism of Julius's court than the Stanza della Segnatura, the pope's private library, which he had Raphael paint beginning in 1508. On the vault and the four walls above the bookcases were represented the four disciplines in which his books were divided: law, philosophy, theology, the arts. In the tradition of the ancient library the scenes represent the Famous Men, that is, the great poets, philosophers, and theologians whose books were gathered there. With a generosity of spirit that marked the humanists, the pagan philosophers and poets are given almost equal status with the Christian theologians. I say almost: recent authors have discovered again what Wölfflin recognized, that the room subtly focuses on the altar of the *Disputa* (Fig. 22), around which the theologians are gathered.[76]

The *School of Athens* (Pl. II), representing Philosophy, can serve to exemplify the Classic style of Raphael for us. He has presented the principal Greek philosophers

in a monumental architectural structure that recalls the ancient world; specifically it looks like a reconstruction of the Roman Baths, the ruins of which Raphael and his contemporaries could explore all over Rome.[77] The figures are composed in groups, conversing with one another, giving instruction, studying, or listening attentively. What distinguishes Raphael's conception from earlier presentations of Famous Men is that this gathering has been turned into an event, taking place at a particular moment. Instead of the traditional tier of figures presented perhaps in niches or merely lined up, Raphael has breathed life into them by showing them interacting with character-revealing gestures and poses. Socrates is in dialogue with his disciples as if they were his equals. Diogenes, the cynic, is depicted as a loner, lying in isolation on the steps. Euclid, surrounded by students, demonstrates one of his theorems with compass and slate.[78]

The philosophers are individualized, but Raphael was equally concerned to express the unity of the world of knowledge, the common quest in which these thinkers were all engaged. Thus the figures are bound together by careful manipulation of line and color and light, and by the resulting movement that runs through the composition. Raphael designed his figures with a minimum of distracting detail, suppressing the brocades, frills, and curlicues that Pinturicchio and Ripanda and even Peruzzi employed to create verisimilitude. In his color, he restricted the range of value, hues, and saturation in order to maintain the unity. For example, each figure is normally garbed in two colors, and the range of value in the modeling is severely limited. Thus the connections between figures, made with gesture or line, are reinforced by the smooth transitions created by juxtaposing matched values.[79] Unlike the usual Quattrocento method of studying light individually for each figure, Raphael projected dramatic patches of light and shade across the scene, highlighting some portions, allowing others to fall into shadow. For this purpose he needed to make a cartoon, or full-scale preparatory drawing, of all the figures. The cartoon (preserved in Milan in the Biblioteca Ambrosiana) allowed him and the assistants who would help execute the fresco to see the pattern of chiaroscuro across the whole composition.[80]

If Raphael forswore the lifelikeness of multiple precise detail, he gave a compensatory naturalism with his convincing sense of physical presence. His energetic figures exist and move in three dimensions. Compared to the complex, planar compositions of Ripanda or Pinturicchio, Raphael attained a new level of clarity and unity. Unlike his predecessors, he dared to diminish the size of his principal actors, putting Plato and Aristotle as far back in the space as any of his figures; but, by focusing the perspective on them and framing them with the arches of the building, their preeminence is ensured. His choice of the lunette-shaped field, rather than the rectangle used by his predecessors, was crucial to the unity his composition achieves. The arches echo the top of the frame and, as they recede in depth and diminish in size, they tighten the frame around the central protagonists.[81] Raphael's subordination, or elimination, of the nonessential allows us to levitate out of the mundane to a higher sphere of ideality. Here we can contemplate a distilled essence, but without losing touch with reality. For Pinturicchio to depict his vision of a future Golden Age he had to resort to the symbolism of sprinkling the ground with gold (Pl. VI), but Raphael did not wish to transgress against naturalism. His figures may be more graceful, more beautiful, more economical in their movement, dress, and gesture than the norm, but they are fully plausible.

What we experience viewing the *School of Athens* is an instant apprehension of the whole, which is never lost. We are made to sense not only unity but also harmony, as if each of these thinkers is searching for a part of the whole overarching truth that binds together the intellectual enterprise. And this harmony and unity extend to the entire room, for the parts cohere in a larger whole, expressed in the ceiling, where a personification of each of the four disciplines describes with her inscription her particular path to truth, whether it is divine inspiration, rational thinking, intuition, or a developed sense of justice.

POPE LEO X AND RAPHAEL

Leo X, like his predecessor Julius, was deeply interested in classical antiquity but, more than Julius, it was as an antiquarian, a connoisseur – with all the implications of preciousness, elegance, and dilettantism that term can imply. Perhaps in response to his patron's taste, Raphael became involved with antiquity more deeply and in different ways soon after Leo began his reign in 1513. In 1514 he asked Fabio Calvo, a physician and respected philologist, for assistance in translating Vitruvius's *De Architectura*. On 1 August 1514, following the death of

Bramante, a papal brief put Raphael in charge of the building campaign at Saint Peter's. In August 1515 another papal brief made him responsible for overseeing the preservation of any marbles bearing ancient inscriptions; heavy fines could be imposed for infractions.[82] An enormous project that would divert Raphael's attention from painting was also assigned to him sometime early in Leo's reign. He was to reconstruct graphically the cityscape of imperial Rome. Interest in scientific methods of mapping was growing in the first half of the sixteenth century. Only when reliable methods of measuring, plotting, and depicting had been developed was it really possible to record surviving antiquities, identify them, and begin to make order out of the chaotic, many-layered remains of Rome. We do not know how Raphael intended to represent ancient and contemporary monuments simultaneously,[83] but we do know from a famous letter he wrote to Leo that he proposed to use a method of architectural rendering that proceeded from measured ground plan to exterior elevation to section, a system that comes straight from Vitruvius.[84] He also described how he was using the mariner's compass *(bussola)* and adapting it for use in land surveying. The letter, probably first drafted around 1516–17, with a second version about a year later, makes clear that new technology and knowledge gleaned from ancient writers were being combined to enable Raphael to execute this most advanced archaeological project ever undertaken.[85] In fact, at the time of Raphael's premature death in 1520, much to the regret of many Romans, only one of the fourteen districts had been mapped. There was a long delay before his work was carried forward. It was not until 1551 that the first ichnographic map (vertical projection showing ground plan of buildings) was made by Bufalini. In it Bufalini depicted with precision the topographical features of the city.[86] This interest in the topography of ancient Rome and firsthand involvement with the archaeological remains would be reflected in the paintings Raphael made for Leo and his other patrons in the half decade of life remaining to him.

Leo was the second son of Lorenzo de' Medici, called the Magnificent and renowned for his advocacy of arts and letters. Brought up in Florence in the palace of the Medici, the city's leading family, the boy was surrounded with the family's enormous and valuable collection of antiquities. From statues down to gems, vases, and coins, the collection was inventoried on the death of Lorenzo

in 1492 at four thousand objects. It was natural, then, that Leo's taste ran to the antiquarian. When Raphael painted his portrait holding an eyeglass with a manuscript and small precious objects on the table, he was characterizing Leo as a connoisseur (Florence, Pitti). Poor eyesight may have contributed to Leo's preference for things he could enjoy with his magnifying glass.

One of the new pope's first acts reveals him as the consummate diplomat that he was. He requested the city of Rome to confer honorary citizenship on his brother. It was taken as a tremendous compliment to the weak city government and a signal that this pope, despite his Florentine origins, did not regard the city of Rome with the same disdain as did many Venetians and Florentines. Not recognized at the time, but certainly calculated by Leo, were the benefits to the Medici in Florence, for this alliance strengthened the family power base in Rome. The "Romanization of Florence," in Janet Cox-Rearick's apt phrase, dated from this moment.[87] Leo would shower his native city with his patronage, sending Michelangelo off to work for the glory of the Florentine Medici at San Lorenzo, not to embellish Rome. When Duke Cosimo took hold of the reins of power in Florence in 1537 he looked to Rome repeatedly and consistently to bolster his rule and confirm his position. Ultimately it was the papacy that granted him his coveted Grand ducal crown.

The conferring of citizenship was accompanied by ceremonies, in this case designed to coincide with Rome's birthday, the Palilia, the anniversary of the founding of the city (though in the event the ceremonies had to be postponed five months to allow time for the elaborate preparations). The Palilia was a secular and antiquarian celebration that the Roman Academy of Pomponio Leto had revived in the late Quattrocento.[88] Of course the site had to be the civic center, the Campidoglio. Although Michelangelo's piazza did not yet exist, there was a great open space in front of the Palazzo dei Conservatori and the Palazzo Senatorio, flanking the church of Santa Maria in Aracoeli. On this spot it was decided to build an enormous temporary theater *all'antica*. In the painted temporary decorations, preserved only in descriptions, were scenes from the mythical early history of Rome. We are told that people came from all over the city and surrounding countryside to see the theater and its decorations and that artists and architects came to draw and measure them. It is an indication of the importance of events like these – in

the days before movies and television – that major artists, like Peruzzi, are recorded as having worked on them.[89] Ripanda took part in the decorations for the funeral of Julius and the coronation of Leo.

The festivities, spread out over several days, included the presentation of citizenship to the gracious Giuliano and, *in absentia,* to Leo's nephew. Representatives of the city government gave speeches, enunciating the expectations for an era of peace and renewal for the city, following the years of war under the bellicose Julius. Then a banquet of some twenty courses, lasting more than four hours, was held in the theater. When the guests seated themselves they found napkins folded like tents. When they opened them tiny live birds flew out and many, being tame, remained for the feast. Even the cuisine was based on antiquity. Animals were skinned, then stuffed and roasted, then sewn back in their skins, so that when served they had a startlingly lifelike appearance. After a well-deserved rest in the Palazzo dei Conservatori, the guests assembled for a pageant of original skits performed by young men of prominent families. Some of these were satiric offerings giving opportunity to the citizens to gently present to the pope and the city officials some matters that could be improved. Finally, the celebration concluded with the staging of a Plautus comedy, directed by Tommaso Inghirami (known to us through his portrait by Raphael in the Pitti in which the painter has discreetly minimized his wall-eye by giving him an upward glance). The play was of course in Latin, and we may well wonder how many of those attending, other than the members of the Roman Academy, who were certainly responsible for this part of the program, actually understood very much of it.

In 1515 Leo gave Raphael the commission to make colored cartoons for nine tapestries to be hung in the Sistine Chapel on special occasions. Raphael recognized the opportunity to be compared with Michelangelo and warmed to the task. Based on the Acts of the Apostles, these cartoons principally represent events in the ministries of Peter and Paul (Fig. 23). With this commission Raphael's Classic style moved in a new direction. Nearly all the scenes represent preaching or oratory, as is appropriate for the chapel of the pope where the sermons by Egidio da Viterbo and others were regularly

Figure 23. Raphael, *Death of Ananias.* Tapestry cartoon, 1515. © The Board of Trustees of the Victoria and Albert Museum, London.

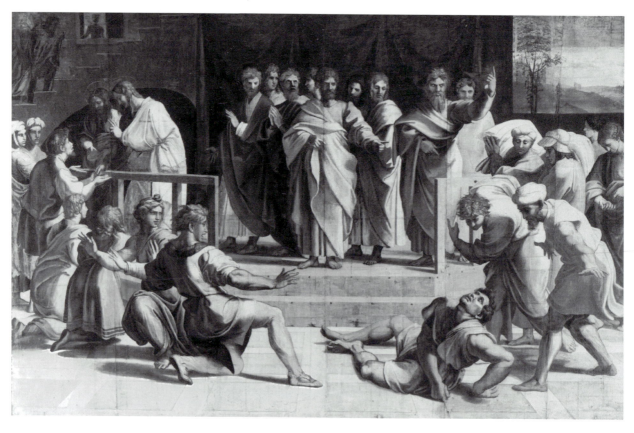

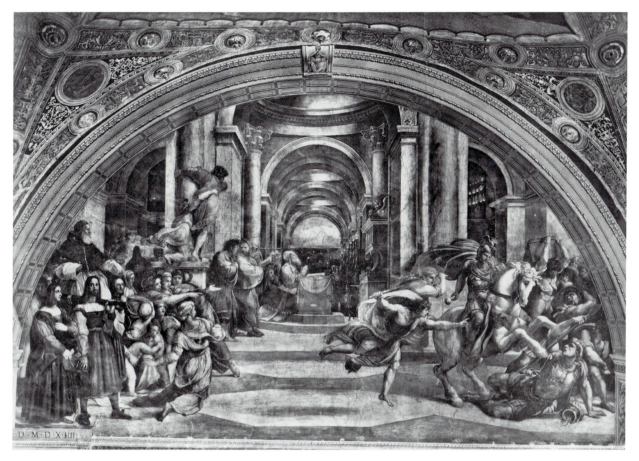

Figure 24. Raphael, *Expulsion of Heliodorus.* Fresco, 1512. Stanza d'Eliodoro, Vatican Palace.

preached. It is likely that this theme caused the painter to ponder the classical rhetorical theory in which three kinds of oratory were distinguished. Each had its own form and rules, according to its purpose, depending upon whether the orator was addressing the Senate or a court of law or a gathering such as a funeral. What Raphael took from rhetorical theory was the concept that the style should be suited to the situation and the audience. Both Cicero and Quintilian state it. Quintilian's formulation claims, "True beauty is never separated from utility" (*Institutio Oratoria,* Bk. VIII, ch. 3, no. 11).

Raphael had already been moving in this direction; around 1512, he began employing different modes of color in works executed more or less simultaneously but for different uses and different audiences.[90] The contrast between the 1512–14 frescoes of the Stanza d'Eliodoro (Fig. 24) and the c. 1512 *Galatea* (Fig. 14) is exemplary. In the Stanza d'Eliodoro, the historical narratives are given greater dramatic impact in relation to the earlier Stanza della Segnatura (Pl. II; Fig. 22) by shifting from the color mode of *unione* in the Segnatura

to chiaroscuro in the Eliodoro. At Chigi's Villa Farnesina, where the theme was love, the spirit was light-hearted, and the purpose was diversion, Raphael chose the gentle and harmonious *unione* as the color mode for his *Galatea.* For the tapestry cartoons (Fig. 23), where the drama is heightened and condensed still more than in the Eliodoro, he again chose the chiaroscuro mode. But he differentiated his manner in more respects than just color. Never before had Raphael conveyed his narrative with such clarity or concentration as in the cartoons. The nonessential has been distilled away, leaving the purified essence of the drama. In the *Galatea,* in contrast, the sea creatures embrace and cavort playfully and a triad of putti aim their love-arrows at the nymph, reinforcing the theme of love. With copious embellishments Raphael ornamented his presentation, to put it in the terms of rhetoric. He varied his mode of discourse according to the audience and intended use. We could describe the manner of the cartoons as abbreviated,[91] and distinguish it from that of the embellished manner of *Galatea.*

Among the embellishments eschewed by Raphael in the tapestry cartoons is the graceful serpentine coil, or even an elegant contrapposto. Rather than the feminine composition of the *Galatea,* curvaceous and sensuous, we find in the more masculine cartoons a severe rectangularity, dominated by verticals and horizontals. Raphael did not want to compromise the dramatic power of these biblical narratives.[92] In the *Death of Ananias* (Fig. 23), Peter stands on a raised dais surrounded by the elders of the community, accusing Ananias of theft. Exactly on the central axis, with his left hand extended in a gesture of condemnation, he is the stern embodiment of *virt.* Ananias falls to the ground as if in acknowledgment of his guilt. Spectators look on in horror as they observe his death throes. Enhanced by a stark chiaroscuro, the monumental figures are sharply distinguished in strong relief. They are visual formulations of the ideal of humankind conceived both in Christian terms and in those of Augustan Rome: stern, but righteous and just. Ananias, as Raphael conceives him, is as evil as they are upright.

By inverting and perverting the conventional association of contrapposto with grace, Raphael makes Ananias the embodiment of his guilt. Compare the twisting forms of Galatea and Ananias. The beauty of the nymph is conveyed not only by her idealized features but by the grace of her movement – a grace that the grotesque *Polyphemus,* by intent of course, lacks. There is no danger in the *Galatea,* as there is in the tapestry cartoons, of undermining the gravity of the message with a sensuous harmony, for such indeed is the message of the image. Ananias writhes on the ground, his neck distended, his legs splayed in a travesty of contrapposto. The contortions of his body are not a graceful *serpentinata,* but quite the opposite. In the language of the Classic style, grace in Galatea signifies beauty and goodness; evil is represented in Ananias by ugliness. Good men are permitted to die gracefully in Classic art – although any number of Christ figures could be cited, the exquisite example of Michelangelo's Vatican *Pietà* comes to mind – but Ananias's paroxysm gives physical expression to his spiritual torment.

Raphael's friend Baldassare Castiglione, whom he portrayed with so much empathy in the familiar painting in the Louvre, was writing *Il Cortegiano* at about this time. In it he gives voice to this view: "A wicked soul rarely inhabits a beautiful body and for that reason outward beauty should be considered a true sign of inner

goodness. And this grace is impressed upon the body in varying degrees as an index of the soul, by which it is outwardly known, as with trees the beauty of the blossoms is a token of the excellence of the fruit." He continues, stating the opposite, ". . . hence the ugly are also wicked and the beautiful are good: and we may say that beauty is the pleasant, cheerful, charming, and desirable face of the good, and that ugliness is the dark, disagreeable, unpleasant, and sorry face of evil" (Bk. IV, 57–8; Eng. tr., 342–3).

Ananias is not the sole villain to be treated in this way by Raphael. In his earlier fresco of the *Expulsion of Heliodorus* (Fig. 24), the thief, as he attempts to make off with the treasure of the temple, is thrown to the ground by the angels in a posture similar to Ananias's. But we can see that in the intervening three years Raphael had improved his rendering of the ugly. The effect of Ananias's disequilibrium is aided by the carefully directed shadow. His legs are drawn with distorted foreshortening. His supporting arm, with its backward-turning hand that nearly exceeds anatomical capability, is a dislocation that the beholder experiences as pain. It is as though Ananias's body has been disjointed, which is a visual metaphor for his disjuncture of character. Grace, as Castiglione uses it, has not lost its theological overtones: it is the outward sign of God's favor. The *disgrace* into which Heliodorus and Ananias have fallen is depicted by Raphael as a lack of pleasing proportion, beauty, and elegance of movement. Peter and the attendant Apostles have correct proportion and an austere beauty. (These attitudes little by little were secularized and became absorbed into our ideology; their pernicious influence in that watered-down form has only recently been challenged by feminists.) Appropriate to the high moral tone of the tapestry cartoons and their destined use, the kind of grace Raphael invented for his orators is more pondered, more deliberate, and more virile than could be attained with the serpentine twist. Rhetorical theory, although it had been a source of art theory since the Quattrocento, had never before been employed to rationalize the accommodation of manner according to use and audience, or to subject. Once again we see how Raphael's Classic style is revealed not merely in the imitation of the antique but in the deep assimilation into his style of classical antique ways of thinking.

Another three years later Raphael was commissioned to create a *Saint Michael* (1518) as a gift for the king of

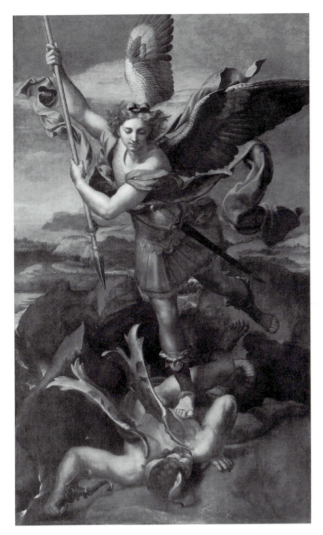

Figure 25. Raphael, *Saint Michael*. 1518. Louvre, Paris.

deep shadow. Against the dramatic dark landscape and sky the figures are mysteriously lit with a flickering illumination that enhances the movement. Color, restricted in range of hue to golds and blues, but in compensation, lusciously rich in value, contributes to the overall exquisite effect. To Galatea's lateral movement and counter glance, Raphael has added the third dimension of Michael's forward motion, countered by the Devil's backward glance. It is fluidity and ease of movement that best conveys grace. The *virt* of Peter, without his austerity, and the grace of Galatea have here been fused in a perfected equilibrium in Michael to create this image of an archetype of goodness and beauty.

Raphael's choice of manner does not follow a straight line development but is determined by the nature of the material. In his last painting, the *Transfiguration* (Vatican, Pinacoteca, 1520), Raphael broadened still further the contrast between the realms of good and evil, dividing his picture into distinct spheres to make an antithesis, or contrapposto of them. Contrasted modes of coloring – *unione* for the spiritual, chiaroscuro for the mundane – carry forward the opposition.[94] We are learning that in the sixteenth century stylistic development is not only a matter of chronology.[95]

It was during these same years that Raphael first took an interest in the *grotteschi,* perhaps at the behest of Leo. According to Vasari, he visited the "grottoes" on the Esquiline together with Giovanni da Udine (1487–1564). In 1517 Raphael had Giovanni execute the Loggetta of Cardinal Bibbiena in the Vatican entirely in grotesques, as if it were a corridor in an ancient Roman palace. This is the first time we see Raphael engaged in full-scale decoration *all'antica,* and it marks the moment at which the streams of antiquarianism and the Classic style began to flow together and merge.

Giovanni da Udine was so impressed with the stucco decoration he saw in the grottoes that he proceeded to experiment until he rediscovered the formula of the ancients for making these fine and delicate *stucchi* in low relief. We recall that in the early 1490s Pinturicchio had attempted to imitate the same ancient stuccoes in his frescoes in the Borgia Apartment, but his, in comparison to what Giovanni da Udine learned to do, were crude. The advantages of stucco over marble, which it resembles, were several. It was cheaper than marble and more rapidly worked. It could be molded so that multiples could be produced. Stucco was lighter in weight

France (Fig. 25). The recipient, François I, could be expected to appreciate a display of artifice. The subject of the Archangel overcoming the Devil, because it required a single dominant figure, excluded the possibility of compositional complexity and dictated that richness would have to be supplied by the light, the color, and the design of the figure itself. To satisfy these requirements the painter chose not to repeat the abbreviated manner of the tapestry cartoons but to return to the ornate manner. He again confronted the opposition of goodness and evil – a contrapposto in Renaissance terms.[93] Michael flies toward us as he alights on the back of the vanquished Devil, his spear poised in victory. The Devil, facing down, wrenches his head backward to peer at his opponent, while his lower body twists to the side and skyward in a parody of contrapposto. Raphael obscures the improbable distortion with

Figure 26. Raphael, Giovanni da Udine and workshop, 1518. Engraving, nineteenth century. Loggie, Vatican Palace.

The birds, animals, fruits, and garlands, in which he was already a specialist, provided the framework on the side walls the length of the loggia and in the corners of many of the vaults, where other members of the workshop painted biblical narratives. Raphael's design combined the traditional Renaissance narrative cycle with the antique treatment of the wall as a surface to be ornamented. This would become a much imitated model in the decades that followed.

It was at this point in his career that Raphael began to think more about giving variety to the rooms of the palace by inventing a different kind of decorative scheme for each. In Bibbiena's Loggetta he thought for the first time about treating the wall as a surface. In the Loggie he combined this new approach with the traditional perspectival space for the biblical narratives. The first three Stanze are basically similar to each other in their dependence on central-point perspective and in their decorative schemes, which gives them a pleasing unity. The Sala di Costantino was different in size, shape, and function, and for it Raphael not only departed from perspective but designed a new kind of decorative scheme. To appreciate its innovative qualities we need to study it in detail.

SALA DI COSTANTINO

The Sala di Costantino was the fourth of the Stanze, and the largest (Fig. 27).[98] Raphael gave his attention to it in what turned out to be the last years before his premature death at age thirty-seven. In the Cinquecento this came to be the most imitated room in Rome because of its brilliantly novel decorative scheme and the alternative to central-point perspective that it

than marble so that large figures with projecting parts could be made, reinforced, and supported with concealed iron bars. It could be polished to a mirrorlike sheen, as Vitruvius pointed out. Finally, it was pointless to waste expensive marble when the relief was to be painted or gilded anyway.[96]

Giovanni da Udine first assayed his Renaissance version of ancient stucco in Pope Leo's private loggia (the "Loggie"), known also as Raphael's Bible (Fig. 26).[97] He skillfully combined his stuccoes with painted grotesques, like those he had executed in the Bibbiena Loggetta.

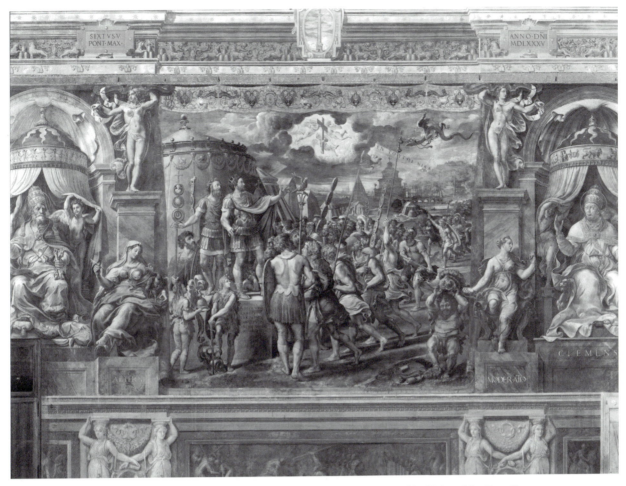

Figure 27. Raphael and workshop, *Constantine addressing his Troops and his Vision of the Cross.* Fresco, 1519–21. Sala di Costantino, Vatican Palace.

offered. It is curious, then, that the twentieth century regarded it until recently as the creation of the workshop after Raphael's death, revealing particularly the eccentric nature of Giulio Romano (c. 1492/99–1546). Looked at afresh (with the prejudices for and against Mannerism put aside), it can be seen to be another of Raphael's inventions in which he rethought the tradition.[99] Its importance to subsequent art requires that we examine it closely.

The problems the room presented to Raphael were both physical and iconographical; in confronting both together he arrived at a solution that broke new ground. What has not been understood is how the macroscheme and style arose out of his consideration of the iconographical program, on the one hand, and the elongated shape of the room, on the other. It is this novelty that led scholars in the past to interpret it as a break with the Classic style and a new departure, but what has previously been seen as whimsical and arbi-

trary can be explained as an expansion of High Renaissance Classic style in the direction of the style *all'antica*.

This room, more than the others in the suite initiated by Julius and continued by Leo, was a reception room where both cardinals and ambassadors would gather, and this public function conditioned the program of its decoration. What was illustrated here was the pope's authority as a political head of state, rather than as the spiritual leader of the Church. Two cycles were to be represented, and this at the outset is a clue to the complexity the artist was charged to deal with. One cycle was a narrative sequence dealing with Constantine, the first Christian emperor. The other was a series of allegorical portraits of popes, chosen to illustrate the tradition of the temporal authority of Christ's Vicar, descending from the fourth century to the contemporary Medici. In confronting the task of interweaving these two themes, Raphael invented a scheme to differentiate the two cycles by equating them with different

43

materials. The Constantinian narratives are depicted on pseudo tapestries, appearing to hang from the cornice and even to curl at the corners. The popes are placed in a feigned architecture of niches, flanked by their appropriate Allegories. The motif of fictive materials is then carried down to the *basamento,* where auxiliary stories of Constantine are represented on fake bronze reliefs in stone frames on colored marble revetment, with caryatids joined by garlands and cartouches, all painted in counterfeit stone.

Raphael had used many of these devices earlier, and so had others, but never had so complete an ensemble as this one been created, in which *everything* pretends to be some other material than it is. The *basamento* of the Stanza dell'Incendio depicted simulated stone caryatids. The tapestry idea had been used in the vault of the Psyche Loggia at the Farnesina. In the Sistine vault Michelangelo had created a similar kind of compartmentalization, introducing fictive bronze shields and marble figures. The illusionism of Peruzzi's Salone delle Prospettive (Fig. 17) anticipated that of Raphael's scheme. There, a fictive loggia opens onto views of Rome, creating a delightful simulacrum of the real loggie on the floor below, but fully enclosed and warmed by the fireplace, this one was suitable for the winter months. The illusionism of the Sala di Costantino, however, is not playful or arbitrary; rather, it was intended to convey the concept that was the keystone of the room's program concerning the role of the Church in the world and the tradition supporting it.

The events represented here have dual functions. They are both events in history, and they are the foundation on which the Church's claim to temporal power had been built. Constantine, as the first emperor to convert to Christianity, unified the Empire and the Church. This marriage of political and spiritual power he then later reinforced in the Donation of Constantine, his gift to the pope of the city of Rome and what became the Papal States (frescoed on the window wall in 1524) (Fig. 28). According to the traditional interpretation, the Emperor Constantine acknowledged the priority of the pope in spiritual matters when he asked to be baptized by the pope (a scene also eventually represented in this cycle). In the years immediately preceding the decoration of the Sala, Martin Luther had challenged the temporal authority of the pope, and some of the German princes, seeing this as the opportunity to liberate their states from the papal yoke, had endorsed him. The doctrine and tradition depicted here were very much the issue of the day. One can imagine that the German ambassadors, awaiting an audience with the pope, might be left in the Sala di Costantino a little longer than was strictly necessary, giving them ample opportunity to ponder the implications of its decoration.

Raphael's challenge, then, was how to indicate this dual level of significance in his depiction of the events. His solution in terms of fictive materials is a way of signaling to his viewer that things are not simply what they at first might seem. An event, Constantine addressing his troops and receiving his vision of the cross, is shown as if it has been recorded on a tapestry. The depiction of the event has been turned into a depiction of a work of art commemorating the event. But the model for the composition is the antique relief of *Trajan addressing his Troops,* from Trajan's Column, and the figures in this painted tapestry resemble their sculpted prototypes. When the critic of the recent past complained that the figures are more statuary than they are likenesses of real human presences, he was responding exactly as Raphael intended that he should. Not only are they actors in an actual event in past history, but they are memorialized as if in a sculptural relief, the kind of treatment given to events of great magnitude.

Why must it be at two removes from reality, we may ask. Why not just represent the Constantinian narratives in simulated relief, without the further complication of the fictive tapestries? Probably because the second cycle of the papal portraits needed to be distinguished as having another kind of meaning. They operate on a different system, in which selected popes symbolize particular virtues and are represented because of a particular contribution. In addition, certain of the popes of the past are identified with the Medici popes of the present. Thus Leo I has the features of Leo X; he is flanked by the virtues Moderation and Comity, which characterized both of them. (Later a portrait of the Medici Clement VII would be included.)

In the papal portraits it is again the disparity between our expectation of the material they will simulate (namely, marble statues) and that which the painting in fact feigns (namely, real presences) that startles us into prolonged contemplation. Placed as they are in niches under canopies and flanked by Allegories, we expect a marmoreal rigidity and coloring they do not in the least possess. The extreme liveliness with which they are painted and the vehemence with which they project

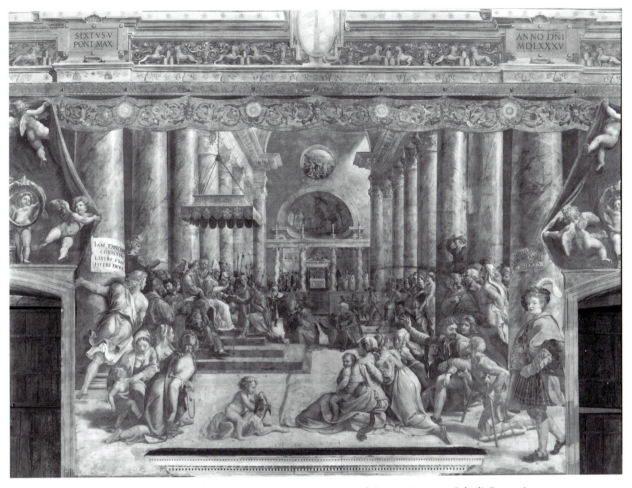

Figure 28. Giulio Romano and workshop, *The Donation of Constantine*. 1524. Sala di Costantino, Vatican Palace.

forward from the wall do not permit us to take them as mere commemorative statues. We confront a necrology, but it is more than that, Raphael tells us, for these popes were individuals who shaped events of history by dint of their personal virtues. The psychology with which the Constantinian narratives work on the viewer is reversed: there we expect to see history brought to life and instead find it frozen and rigidified into an artistic monument; here we expect a marmoreal statue and are confronted with the vitality of real presence.

The reader may think of some recent art that has raised the same issues, albeit in a more conceptual and less contextualized framework. For example, consider the discontinuities of a Cindy Sherman photograph of a historical person, dead long before photography was invented, who may in fact be the photographer herself, not quite fully disguised. In both the Raphael scheme and the Sherman photograph the disjunctions jolt us into questioning the image.

The surviving drawings for the Sala di Costantino, many of which have recently been restored to Raphael after having been considered the work of Giulio Romano or Gianfrancesco Penni (1496–after 1528),[100] do not permit us to state unequivocally that Raphael invented the whole macroscheme. For example, none of his drawings record the notion of fictive tapestries, but the coherence and the logic of the design, and the genius of it, lead us to attribute it to him. When, soon after Raphael's death, Sebastiano del Piombo made a bid for the commission, the artists of his workshop had only to produce Raphael's drawings to convince Pope Leo that they should continue the work.

In the interval of nineteen months between the death of Raphael and the death of Leo, the first two walls were executed. Then, during the pontificate of Adrian VI, nothing was done; but early in 1524, following the election of the Medici Clement VII, work resumed and was brought to completion by August of that year. However,

still during Raphael's lifetime, it would now seem, an experiment with oil mural was made, and two figures were executed in this medium that are still to be seen – the Virtues of *Comity* and *Justice*.[101] Possibly the idea was to simulate the muted tonality of tapestry, more easily done with oils than with the typically more colorful medium of fresco. Apparently the experiment was not approved and the walls were instead prepared for fresco. Surely there would have been concern over the possibility that the great expanse of wall painting, if executed in the traditional fresco palette, could become too dominating in what was then a room with a much lower ceiling. Although the walls were executed in fresco, the subdued color, with its dusty, grayish tinge, became a model for the next generation of what the color of *all'antica* painting might look like. We cannot credit Raphael with anything more in the way of the execution in this room than at most having put his hand to these Virtues. But the conception of how the designs were to be painted bears the mark, as we have said, of his genius.

The long wall, where we see the *Battle of the Milvian Bridge* (Pl. VII), set the painter a new kind of problem. In the past such a wall would have been divided into two or more scenes. One can imagine a treatment like that chosen by Vasari around midcentury in the Sala dei Cento Giorni (Fig. 101), where despite the strong influence of the Sala di Costantino, Vasari departed from his prototype and, on a similarly long wall, inserted allegories linking and separating two adjacent narratives. But Raphael chose instead to treat it as a unit. This meant that the traditional Renaissance treatment of space, with the central-point perspective system, and the centralized composition of the Classic style were both put under particular stress.

In the Classic style the composition of paintings was centralized, the focus at the center, coinciding with the most important action: the figure of Galatea (Fig. 14), the judgmental gesture of Peter against Ananias (Fig. 23), the prayer of the priest in the temple in the *Expulsion of Heliodorus* (Fig. 24). Note that Heliodorus is pushed off to the side because his arrest is consequent upon the priest's prayer for divine intervention. Nothing on the periphery was allowed so much visual attention that it would detract from the center. Hence, the shape of field preferred by artists working in the Classic style was the near square because it adapted well to centralized compositions. For altarpieces, an upward extension with lunette top or a slightly verticalized square was used. In the preceding Stanze, Raphael had shaped

his fields as lunette-topped and extended horizontally from the square. The Genesis narratives of Michelangelo's Sistine vault were designed in rectangular frames somewhat wider than high.

The problem Raphael faced in the Costantino, of an unbroken wall of extreme length in relation to its viewing distance, had confronted Leonardo in designing his *Battle of Anghiari* for the Palazzo Vecchio in Florence.[102] Leonardo appears to have divided his battle into three episodes, at the center of which was the climactic action, the famous *Battle for the Standard;* he placed the flanking episodes, showing less intense action, deeper in the picture space.[103] In this way Leonardo created the archetypal design in the Classic style for a battle, one that would have been familiar to Raphael, who came to Florence in 1504 while Leonardo was working on it.

Raphael chose a different solution; in fact, he jettisoned Leonardo's model of the Classic composition and turned instead to antique sculptural relief, where the movement is processional rather than centralized. For this Raphael had Michelangelo's precedent in his *Battle of Cascina* (Fig. 10), where the scheme comprising figures parallel to the picture plane had been pioneered. Relief is laid out to be viewed serially. Sculptors can, of course, bring focus with light, or with higher relief, or with the depiction of more vigorous action – with any number of devices – but typically they give something closer to equal attention to every figure.

Raphael's design is only barely focused on Constantine, and the expected confrontation with the Emperor Maxentius never occurs. Instead, in keeping with the story, the very appearance of Constantine with his cross caused the enemy to scatter. The model of the antique battle sarcophagus, with its directional, lateral movement, served Raphael's purpose here (Fig. 29). Near the center is Constantine, pointed out by the heavenly reinforcements in the sky. Even so, the melee of the battle swamps the image of the emperor, and the eye is engaged with the minutiae of antique artifacts and individual skirmishes, more in the manner of late antique battle reliefs than of Raphael's Classic style as he had developed it. We lose sight of the defeated Emperor Maxentius, whose inconspicuous crown fails to raise him immediately to our attention, and the distance between him and Constantine, whose forward sweep has driven him into the river, is simply too great for us to connect them visually. This is not the result of Giulio Romano's inability to make the composition cohere – as was argued by scholars who believed he, not Raphael,

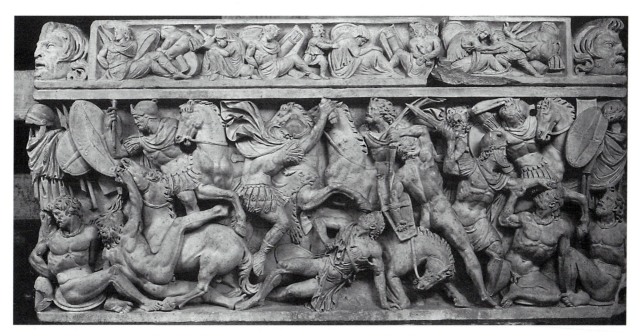

Figure 29. Late antique battle sarcophagus. Capitoline Museum, Rome.

was responsible for the design. Rather, it is the means of conveying the most important fact of this event: that Constantine did not defeat the enemy by virtue of his superior strength but by means of divine intervention. This battle is not a clash of equal forces, proceeding inward from the edges in a crescendo of mounting violence, like Leonardo's, but a triumphant forward march under the sign of the cross.

Because the room is too narrow to permit the viewer to take in the whole expanse of the battle from a single vantage point, everything about the way it is painted encourages us to move closer and experience each episode in series. The quantity of accurate archaeological detail and the intense facial expressions of individual engagements demand close inspection (Fig. 30).[104] We may dwell upon the pathos of the youthful fallen standard bearer tenderly attended by an older soldier, possibly his father;[105] perhaps we note the detail that his is the only regimental standard not adorned with the cross, and the only one that is fallen to the ground. Quite the opposite of the Classic composition, where the periphery is not allowed to draw attention away from the center, there is an evenness of focus across the whole extension here.

What Raphael jettisoned along with the centralized composition was the even more venerable Albertian central-point perspective system, which had been the organizing principle of space in Renaissance pictures since the beginning of the second quarter of the Quattrocento. He had used it to great effect in his early altarpieces and in the Stanze: in the *Disputa* (Fig. 22), the coincidence of the central vertical axis, running down through the Trinity to the Host on the altar, with the vanishing point also in the Host, is a textbook example of Renaissance perspectival composition. There is evidence, however, in the last of the previous rooms, the Stanza dell'Incendio, of a certain impatience with it. The perspective of the *Fire in the Borgo* (Fig. 180), though forcefully articulated in the receding lines of the pavement, is a pretense: the lines do not in fact converge. The savvy Raphael recognized that no one would notice. In the *Battle of Ostia* (Stanza dell'Incendio, 1516) there is an unmistakable premonition of the relieflike style we see later in the Constantinian *Battle,* with figures lined up along the picture plane, although the composition is still decidedly centralized and the buildings are arranged so as to suggest recession, as is the curving shoreline that leads inward toward the center. In the *Battle of the Milvian Bridge* there is no vanishing point. As in antique relief, there is nothing introduced to establish receding orthogonals. Landscape always presented this problem, to be sure, but the Renaissance painters typically introduced architecture, parallel to the surface, so that its receding planes could be designed to move toward a vanishing point; and these painters reinforced the sense of recession by varying the color of zones of landscape as it moved away from the surface. That nothing of the sort occurs here is evidence that Raphael intended to create an alternative mode of composition.

The same thing is not true of the fresco on the short

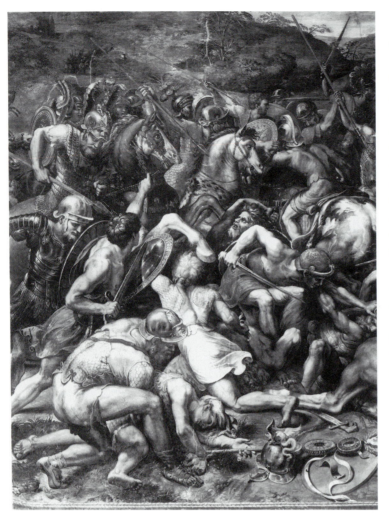

Figure 30. Raphael and workshop, *Battle of the Milvian Bridge*, detail, left. Fresco, 1519–24. Sala di Constantino, Vatican Palace.

tries, the *Battle* and *Constantine addressing his Troops,* imitates antique relief. Bulging, hard-edged forms have replaced the more painterly rendering seen in Raphael's earlier works. In the past this insistent plasticity has usually been attributed to Giulio Romano, but it is consistent with the design of the whole. It is logical to interpret it as Giulio's execution of Raphael's conception. The Cinquecento regarded the entire ensemble of the Costantino to be Raphael's – even though it was known that he had died long before its completion – and it carried the authority of his revered name. Conventions of the figure derived from late Roman relief[106] make their first appearance here. They will be much copied and developed by members of Raphael's workshop after his death. The *Battle of the Milvian Bridge* became the model for the relieflike style that continued to be developed in Rome in the 1520s and was carried far and wide by members of the Raphael workshop when they left Rome, and it would evolve into the Maniera style in the late 1530s. It was here in the Sala di Constantino that the Classic style and antiquarianism merged, and where, as we have seen, Raphael yielded some of the principles of his Classic manner to a new stylistic model based on antique relief. We will observe its elaboration, dissemination, and eventual codification into the conventions of the Maniera in the next chapters.

◆

EACH OF THE FOUR WORKS of Raphael we have examined closely is a different kind of commission from the others. *Galatea* (Fig. 14) was a secular and private work. *Saint Michael* (Fig. 25) was a sacred and private piece. The tapestry cartoons (Fig. 23) were sacred and public, and the Sala di Costantino (Fig. 27) was secular and public. Raphael distinguished his style according to function and audience. For example, wit and humor play a decisively important role in setting the tone of the *Galatea* and his other decorations for Chigi's villa. In the other secular work, the Sala di Costantino, humor is admitted judiciously as byplay and for animation, but it plays a very subsidiary role. Illusionism, as we have seen, is the very core of the macroscheme, but

wall, which he also designed, *Constantine addressing his Troops and his Vision of the Cross.* Combined with a composition borrowed from the antique, Raphael created a space receding to the right, where the vision appears. The repeated and overlapped forms of the tents lead the eye into depth, as does the repetition of the soldiers' legs and their shadows at the right. The focus is shared between the emperor and the heavenly vision he sees, and everything else is subordinated, unlike the *Battle,* where a sense of urgency is sustained across the whole surface. Clearly, Raphael did not intend the relieflike style he invented in the *Battle* to be the exclusive compositional model, but it could be another option, an alternative, together with those of the grotesque-covered wall displayed in the Loggie and the traditional Renaissance model of a perspectival space.

To give unity and consistency to the Constantinian narratives, the figural style of both these pseudo tapes-

it serves to convey the message of the program, so it is not used frivolously or merely to entertain.

Raphael was likewise judicious in introducing antiquarian elements. They are absent from the sacred works, except for just enough antique architecture or sculpture in those tapestry cartoons where it was relevant to identify the location. So in *Paul Preaching at Athens* or the *Sacrifice at Lystra* (London, Victoria and Albert Museum), the setting is unmistakably that of an antique urban center, but the antiquarian inclusions are restricted to what is essential to the narrative and are not permitted to distract the worshiper. In the Sala di Costantino quite the opposite is true. Here, where the intention was in part splendid display as a backdrop for gatherings of the papal court, it was deemed appropriate to load the frescoes with antiquarian artifacts and archaeological references to the sites. In the *Galatea,* the antiquarianism is more literary than visual, presumably because at this still-early stage of Raphael's Roman career his knowledge of, and interest in, antiquarianism had not yet developed. This distinction between sacred and secular commissions, so scrupulously maintained by Raphael, will continue to influence his heirs after his death, particularly in their recognition of the usefulness of antiquarianism in the secular context.

WORKING PRACTICES

A major revolution in the status of the artist began in the Quattrocento but was not fully achieved until the Cinquecento. In the medieval tradition, the qualification most highly valued in an artist was manual skill; by the sixteenth century it had become artistic intellect. Whereas the apprentice painter at the end of the Quattrocento was expected to learn to imitate and acquire his master's style, so that ideally his was indistinguishable and he would be able to "fake" the master seamlessly, in the Cinquecento the painter left his master and went, typically, to Rome to see and copy the wonders of antiquity and modernity.[107] There he forged his own style, based on multiple sources. Many stayed, annexing themselves to workshops either permanently or for an interim before setting up their own workshops Michelangelo had few pupils, but Raphael had an enormous *équipe:* it was said that in his later years he would be accompanied to the Vatican by an entourage of fifty.[108] Many were already mature artists who worked as assistants, not as apprentices.[109] Some became specialists, like Giovanni da Udine, who, as we have seen,

expanded his repertory from animals and plants to *grotteschi* and *stucchi,* which would remain his specialty the rest of his life. Another specialist was Polidoro da Caravaggio, who came to Rome from the town in Lombardy that gave him his name. He joined Raphael's workshop and became the specialist in simulated antique relief. After Raphael's death he developed his particular expertise to become the most popular painter of facades in Rome and, together with Michelangelo and Raphael himself, the most copied artist in that city.

For such a workshop to operate smoothly required first of all a supremely good organizer, which Raphael was. It also required working practices that would permit and facilitate the division of labor. In the Quattrocento before the invention of the cartoon and the widespread use of multiple preparatory drawings, the master would sketch out the composition on the wall in a *sinopia,* or underdrawing, and then rely on his well-trained apprentices to execute it, under his direction, in his style. His presence was required at least for the preparatory stage and for touch-up. It is thought that in the busiest workshops the master might execute only the most important figures, or even only heads, himself.[110] Early in the Cinquecento the full-scale cartoon emerged as an important innovation. It made its first conspicuous appearance in the *Battles* designed by Leonardo and Michelangelo in Florence beginning in 1503. Leonardo was allocated a large working space in the convent of Santa Maria Novella to prepare his cartoon for the *Battle of Anghiari.*[111] It no longer exists, of course, nor does Michelangelo's for the *Battle of Cascina,* but we have already noted that the latter was much studied for as long as it lasted. Raphael's cartoon for the *School of Athens* is the earliest cartoon to have survived (Milan, Biblioteca Ambrosiana). The new concerns with unifying the composition and dramatizing the narrative made a full-scale rendering valuable, especially to record the pattern of chiaroscuro. In the Quattrocento, when the light on each figure was studied separately, it was not necessary.

With the introduction of the full-scale cartoon the master could delegate more of the execution because everything except the coloring was predetermined. The master could assign assistants to different sections to work simultaneously, for the cartoon would be cut up into manageable segments; then after being transferred to the wall, either by incising or pouncing the outlines with black chalk, the cartoon was discarded.[112] The assistant no longer had to have extended training in

faking his master's style, because he could now copy it from the cartoon. This description oversimplifies the problem. There was, in fact, room left for the assistant to interpose his personal style, and we see in the Cinquecento that the hands of the assistants become more and more distinguishable. In very large projects, specialization could help conceal these differences. All the garlands and putti encircling a room might be the work of one hand, for example, while other specialists could give the same consistency to other aspects of the whole.

Raphael was so pressed with multiple commissions that he began to delegate the actual designing, at first of minor areas, but later perhaps on a more encompassing basis. This practice accounts for the fact that in the same Stanza we find a fresco of superb quality throughout, the *Fire in the Borgo,* opposite one that is thoroughly mediocre, the *Oath of Leo III.*[113] He seemed to learn from the limited success of that room that he should supervise and intervene at all stages of the production, even if he was not free to take full responsibility for any single stage, including that of invention.

It seems logical that such a wise organizer as Raphael, one who by all accounts was a genial and supportive master, would see fit to give more scope and freedom to the mature artists working for him than the traditional workshop system would have granted. On the basis of nineteenth-century criteria of connoisseurship, Raphael's late works have been censured because they reveal to us the hands of the assistants. There is no evidence that the patron shared this view. It is even possible that Raphael himself eventually came to reject Quattrocento notions of workshop and craftsmanship and organized his late projects on an innovative principle. Such an intention would explain the diversity of style Raphael permitted in the Vatican Loggie, which has otherwise been explained by connoisseurs, with some embarrassment, as evidence of the master's overburdened schedule. Perhaps when he divided responsibility for the bays among the more mature members of his *équipe,* he anticipated the diversity that would result but regarded it as desirable and appropriate. Certainly it would be more tolerable here, where each bay is quite distinct and the ornament around the narratives was designed to be individual, than it would be in other, more unified, spaces. We have been speaking here of fresco, where the large scale meant the demand for division of labor could be more easily met than in easel paintings. In oil paintings, too, the cartoon could liberate the master from the execution, and with oil he could touch up the work of his assistants far more successfully than in fresco.

What we can observe, then, is that the master has become less a hand and more a mind, exactly what he increasingly believed himself to be. The gentrification of the artist that was accomplished in the sixteenth century was in no small measure made possible by new working practices that separated conceptualization from execution. Michelangelo, who did so much in so many ways to elevate the artist's status, seemed to have no qualms about supplying a cartoon or drawings for other artists to execute. Sebastiano del Piombo took advantage of this opportunity in the well-known instances, among others, of *Raising of Lazarus* (Pl. III) and his *Flagellation* (Rome, San Pietro in Montorio). The drawings that Michelangelo supplied from Florence at his friend's request still survive.[114] Michelangelo made the cartoons for two paintings commissioned of him in Florence and then got Jacopo Pontormo to execute them.[115] What is new here is that there was no attempt to conceal the collaboration, as there had been in the workshop practice of the past, and unlike in the *bottega,* the collaborating artists were masters in their own right.

PRINTS

Prints played an important role in the dissemination of the Classic style of the High Renaissance and of images of antiquities. The *Laocoon* (Fig. 1) was engraved within a few years of its discovery, and its fame spread so quickly that imitations of it soon appeared in paintings north and south of the Alps by artists who had never visited Rome. Likewise, beginning in the 1520s, Michelangelo's inventions in the Sistine and many of Raphael's paintings were copied and sold as engravings. Printmakers represented a new kind of entrepreneur who made a living from engravings, at first based on drawings supplied by artists. Raphael took the lead, recognizing that engravings could spread his fame and make him money. He supplied drawings to his engraver and then had them sold through his dealer, Baviera.[116]

Marcantonio Raimondi (c. 1482–before 1534), a Bolognese who settled in Rome, was chosen by Raphael to be his principal engraver. It is of interest to study Marcantonio's style as revealed in an engraving of *Venus and Mars* of 1508 (Fig. 31), before his association with Raphael began. The god of War, who sits beside his armor, and the goddess of Love seem to have had a lovers' quarrel. Venus turns away as Mars, looking trou-

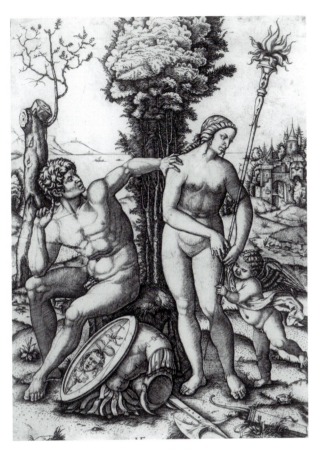

Figure 31. Marcantonio Raimondi, *Venus and Mars.* Engraving, 1508. © British Museum, London.

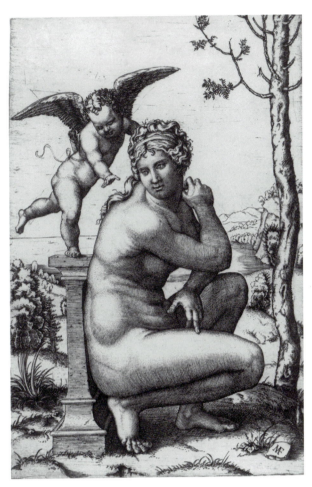

Figure 32. Marcantonio Raimondi after the antique statue, *Crouching Venus.* Engraving, 1509. © British Museum, London.

bled, tries to draw her back to him. A happy outcome is suggested by the *amorino* who thrusts the torch of love into Venus's still-unwilling hands. Marcantonio appears to have brought together several sources, not all of which can be identified, and adapted them to the needs of the narrative.[117] He owes much to his study of the prints of the northerners, above all Albrecht Dürer (1471–1528); the landscape and particularly the walled town are not Italian. The nude Mars is thought to be based either on a Michelangelo drawing of the *Torso Belvedere* or on Marcantonio's direct study of it. The modeling is harsh, however, executed entirely with parallel hatching in strokes of rigidly uniform length and touch and spacing, resulting in a decidedly sculptural, rather than painterly, appearance. Typical of Marcantonio is the separated treatment of foreground figures and landscape background, which strengthens the resemblance to sculptural frieze. We can already see here how the medium of engraving favored the relieflike style and how it might contribute to its dissemination.

Before his arrival in Rome, Marcantonio seems to have visited Mantua, where he studied the antique statue of the *Crouch-*

ing Venus.[118] The engraving that he made (Fig. 32) would help to make this figure a favorite of the painters, who quoted it repeatedly in their works in the following decades, for example, Sebastiano del Piombo in his *Nativity of the Virgin* (Fig. 86). What may be Marcantonio's first engraving after arriving in Rome was a collaboration with his fellow Bolognese, Jacopo Ripanda. In the *Triumph,* a rendition of an ancient Roman triumphal procession, the engraver adds his command of chiaroscuro to Ripanda's cluttered antiquarianism.[119]

His engraving of three figures from Michelangelo's *Battle of Cascina* (1510) cartoon would become an enormously influential record of this famous design, if even of only a small part of it. In the section chosen by Marcantonio, three soldiers are scrambling up the river bank and into their clothes as one points to the enemy hidden in the trees. Michelangelo's penchant for individual figures rendered with sculptural clarity is exaggerated by the engraver's hard-edged contouring and rigidly uniform strokes. Marcantonio's early training in classicizing circles in Bologna and his own taste for classical antiquities led

him toward a style that favored the plasticity of sculpture. As much as he admired and copied the prints of Lucas van Leyden (1489/94–1533) (Fig. 36), for example, he never achieved – nor did he seem to wish to – the atmospheric effect of Lucas that goes so far in enlivening his stories. Marcantonio used a landscape copied from Lucas for the background in the *Battle of Cascina*.[120] Unlike Dürer and Lucas, Marcantonio preferred a more or less even touch, varying little the quality of his line.

Soon after Marcantonio's arrival in Rome in 1510 Raphael began turning over drawings for Marcantonio to engrave. Sometimes they were of discarded ideas for projects, as the *Parnassus* for the Stanza della Segnatura. Sometimes they appear to have been drawings whose only life was as a model for a print. During Raphael's lifetime all the prints were made from drawings. It was not until after his death that reproductions of paintings and frescoes began to appear.[121] The *Galatea*, the *Ecstasy of Saint Cecilia*, one of the tapestry cartoons, *Paul preaching at Athens*, the *Madonna di Foligno*, and many others all were copied in varying degrees of faithfulness to the

original and through this means became widely known.[122] Interestingly, Marcantonio usually invented his own background and imitated only the figures.

A look at the *Massacre of the Innocents* (Fig. 33) reveals even more of a difference between Raphael's originals and Marcantonio's engravings. The subject here must have interested Raphael because it offered the opportunity to represent the supreme horror of mothers whose children are slaughtered before their eyes. In Raphael's several preparatory drawings we feel closer to the feelings of the women.[123] Marcantonio's classically correct background formalizes the scene and moves it toward formula. Comparison with the drawings or with Raphael's paintings reveals how the engraver suppressed the nuances of lighting to create a uniform pattern of light and shade. His regularized touch in the modeling gives a sense of hard substance that replaces Raphael's painterly vitality. The humanity of the painter's figures is chilled and made more distant. The composition has been purged of all the remaining irregularities of nature, made more abstracted and still closer to the per-

Figure 33. Marcantonio Raimondi after Raphael, *Massacre of the Innocents.* Engraving, 1510. © British Museum, London.

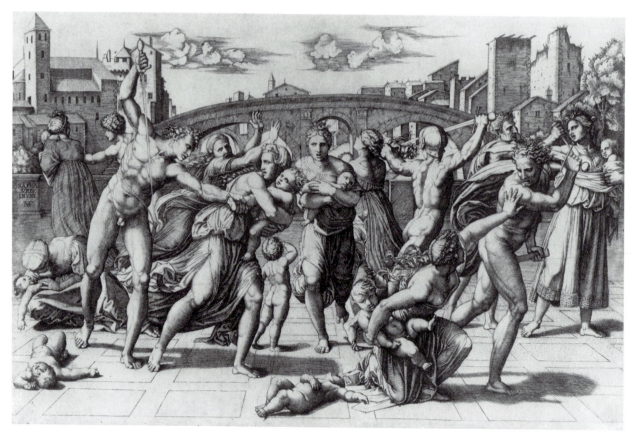

fected idea rather than the idealized, but still plausible, narrative as told by Raphael. The antiquarianism of Marcantonio is akin to that of his compatriot, Ripanda, and indeed they both had been formed in the ambiance of Bologna.[124] The Raphael designs thus broadcast through the medium of engraving put forward a hardened, classicistic – even Neoclassical – version of his style. It is worthy of note that nearly a century later, when Guido Reni was seeking the means to convincingly depict affect, he studied this engraving and copied many of his figures from it in his own painting of the subject (Bologna, Pinacoteca, 1611). The chilly academicism, but also the undeniable clarity, of Marcantonio's translation of Raphael appealed to Reni.

Even more than his late works, in which the imitation of antiquity and even of sculptural relief had indeed been introduced, the engraved Raphael gave the master's authority to antiquarianism. When in the succeeding decades the artists of Raphael's school traveled about and introduced an antiquarianism that took for its stylistic model sculptural relief, they were preceded by engravings that resembled sculptural relief. As noted already, this was particularly the case in secular commissions, where the tradition was far less well defined than in sacred art.

BETWEEN THE DEATHS OF RAPHAEL AND POPE LEO

During the nineteen months that Leo outlived Raphael, he continued to commission the workshop, now under the leadership of Giulio Romano, not only for projects begun by the master but for new ones as well. In the Villa Madama, the Sala dei Pontefici, and the Villa Lante on the Janiculum, commissioned by his friend Baldassare Turini,[125] the pope's antiquarian taste was more and more apparent.

The Villa Madama, though never completed, was Raphael's architectural masterpiece.[126] It appears from the documents that the construction was done before Raphael's death, but the decoration had not yet begun. The villa stands as a monument to the absorption of the Medici popes, Leo X and Clement VII, in classical antiquity, carrying forward on a much grander scale what was begun by Chigi at the Villa Farnesina. Commissioned in 1518 by Leo's nephew and closest adviser, Cardinal de' Medici, the Villa Madama was a project in which both nephew and uncle were both deeply inter-

ested. After Leo's death in 1521 and a hiatus during the reign of the Netherlander, Adrian VI, Cardinal de' Medici returned from Florence as Pope Clement VII and the work was quickly resumed in 1524.

When Raphael described his design in a letter, he used the model of Pliny the Younger's letters describing his villas at Laurentum (Pliny, *Letters*, II, 17) and in Tuscany (V, 6), borrowing phrases and using the Latin terms for various structures he had designed in imitation. Fra Giovanni Giocondo, the antiquarian authority who had translated Vitruvius (1511), also translated Pliny's letters. Until Fra Giocondo's death in 1515, Pope Leo met almost daily with him and with Raphael for scholarly discussions – a clear indication of the pope's priorities.[127] Like Pliny, Raphael made it his first concern to orient the apartments for summer or winter use, taking careful note of the direction of the sun, and for the views. Public spaces were carefully separated to ensure privacy. Indoor and outdoor were mingled, and gardens and courts protected from wind and hot sun. There were elaborate baths, much like those Pliny describes in his villa. There were provisions for swimming, dining indoors and out, theatrical entertainment, and accommodation for four hundred horses. One can imagine these sixteenth-century readers, still huddled in medieval structures designed more for protection than for comfort, poring over Pliny's letters, awed by the level of ease and comfort he describes. Today we tend to forget that the ancient Romans had attained a standard of living, destroyed when the Empire had to fortify itself against barbarian invasions, that was only beginning to be restored in the Cinquecento. The intention of Raphael and his patrons was clearly to reestablish the luxurious life of antiquity and, of course, to exceed it. Though Raphael died before the villa was ready for decoration, members of his *bottega,* Giulio Romano and Giovanni da Udine, carried it forward (Fig. 34). Cardinal de' Medici, when queried about the decorations, replied that he did not want anything obscure that would require inscriptions and explanations. Lighthearted mythological scenes from Ovid would do very well. "There are enough Old Testament scenes in the pope's loggia," he remarked, speaking of Raphael's Loggie (Fig. 26), the decorative program that most closely resembled the combination of fresco and stucco ornaments being planned for Villa Madama.[128] The scenes are accordingly based largely on Ovid and center on the theme of love.

Leo himself commissioned the room in the Vatican

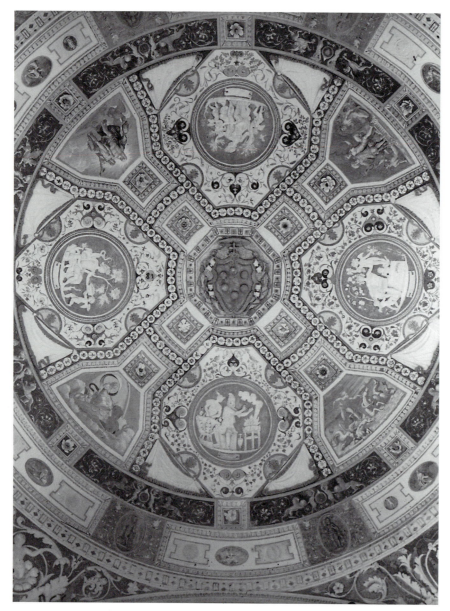

Figure 34. Giulio Romano and Giovanni da Udine, stucco and grotesque decoration. 1521. Loggia, Villa Madama, Rome.

and Perino was mainly responsible for the figures, according to Vasari.[129] Portrayals of ten papal predecessors of Leo were planned for the lunettes, but their execution was probably interrupted by Leo's death. The vault is filled with astrological symbols, in a manner similar to the horoscope Peruzzi had painted for Chigi at his villa (Fig. 13), and probably inspired by it. One sees the lion, referring both to Pope Leo and to the zodiacal sign, prominently displayed near the central roundel. Here, however, it is not simply Leo's horoscope that is illustrated, but a disguised message alluding to his predestined papacy and his destiny to rule a new Golden Age in Italy.[130]

The model here was thoroughgoingly antique: the vaults in the Domus Aurea, and specifically the *Volta dorata* (Pl. VIII). The geometric compartments, separated with stucco frames, were strongly colored to make a pattern of red, blue, and white, with touches of green and black. Although these colors have suffered some loss of intensity – the blue was originally ultramarine – the splendid effect is still to be seen.[131] The central roundel, Perino's creation, switches to a startlingly beautiful illusionism projected from below, in which we see through a framed opening to the sky a vision of four angels, proclaiming Leo's victory. One trumpets his fame, others hold censer, psaltery, and his tiara. This frankly ornamental display exhibits Perino and Giovanni da Udine at their best. Comparison with Peruzzi's still-quattrocentesque style in his vault at the Villa Farnesina shows us how far antiquarianism had developed in the intervening decade.

Palace known as the Sala dei Pontefici, which is adjacent to the Borgia Apartment and directly below the Sala di Costantino, where Giulio and Penni were then at work. Here two of Raphael's pupils who had worked in the Loggie, Giovanni da Udine and Perino del Vaga (1501–47) were charged with decorating the vault (Pl. IX), probably at the same time the frescoes in the Sala di Costantino were proceeding. They executed the stuccoes and animals, ornaments, and grotesques together,

The 1520s in Florence and Rome

FLORENCE

THE HIGH MOMENT IN FLORENTINE ART OF THE SIXTEENTH CENTURY came very early, between 1503 and 1508, when Leonardo (1452–1519), Raphael (1483–1520), and Michelangelo (1475–1564) were there and working on Florentine commissions. In fact, the end of the great moment was already foreshadowed in 1505 when Michelangelo answered Julius's call and transferred to Rome, as Raphael would soon also do in 1508. Leonardo departed, too, to return to Milan. They left unfinished great civic projects: Leonardo's and Michelangelo's *Battles* for the meeting hall of the Palazzo Vecchio and Michelangelo's sculpted *Apostles* for the Duomo. The younger Raphael had not yet received commissions on this scale, but his first altarpiece for a major Florentine church was also left incomplete at his departure.[1] The position that Florence had proudly enjoyed in the Quattrocento as the most cultured city in central Italy it now had to yield to papal Rome, and ironically it would be Florence that provided Rome with many of its best artists throughout the century: Michelangelo, Perino del Vaga, Cellini, Sansovino, Sangallo, Jacopino del Conte, Salviati, Vasari. Not only did the artists go to Rome, but so did their potential patrons. When the Medici pope was elected in 1513, Florentines flocked to the papal city in the hope of taking advantage of the new Florentine hegemony. Many of them, wanting to turn modest houses into palaces, commissioned Polidoro da Caravaggio to cover their facades with frescoes *all'antica*.[2] Some were invited by Leo to become members of his court, like Baldassare Turini, his datary, who built the Villa Lante on the Janiculum and had it decorated.

The Dominican Fra Bartolommeo (1472–1517) took leadership of the Florentine school until his death in 1517, to be replaced by Andrea del Sarto (1486–1530) until his death. Sarto and his former pupils Jacopo Pontormo (1494–1557) and Rosso (1494–1540) were the principal painters in Florence in the 1520s. The environment in which they worked was, and still is, a medieval city, with cramped narrow streets, lacking both Rome's monumental remains of antiquity and the open spaces between them, which invited expansive construction to those who could afford it. The Classic style was a stunted hothouse

plant in Florence, never achieving the grandeur of Raphael's and Michelangelo's and Sebastiano's creations in the second decade in Rome. If one seeks explanation for the insistent experimentation of Pontormo and Rosso, it may perhaps be found in Florence's confining environment, both physical and spiritual. As exquisitely beautiful as Sarto's saints are (Pl. X), there is still lingering in them the charm of Raphael's early Madonnas rather than the dignity of Michelangelo's Sibyls. Sarto's continuing preference for Leonardesque sfumato softens and sweetens his forms, but it deprives them of the authority of their Roman counterparts. Unlike Rome, where there was demand for large-scale fresco decorations, both secular and sacred, in Florence most of the commissions were small-scale, and there were more altarpieces than anything else.

When Salvi Borgherini indulged his newly married son and daughter-in-law with the gift of a sumptuous bedroom suite, the scale was not that of Chigi's bedroom at the Villa Farnesina (Fig. 18) but instead almost miniature.[3] The walls were not frescoed floor to ceiling. Rather, painted panels were set into the wall paneling and into the furniture, all in carved walnut. The furniture consisted of the marriage bed with painted panels for headboard and footboard, painted chairs, and twin chests to contain clothing (cassoni), the last decorated by Pontormo. As exquisite as the ensemble must have been when installed, it was in the medieval tradition of precious decorative arts. Typical of the difference between Rome and Florence was the subject chosen. Borgherini selected the Old Testament story, the life of Joseph, in contrast to Chigi's grandiose and self-referential life of Alexander the Great.

Pontormo's *Joseph in Egypt* (Fig. 35) was the last executed in the sequence and apparently was a separate item in the decoration. Several episodes have been combined here, as is true in the other panels as well. In the left foreground Joseph addresses the pharaoh. At the center he is seated on a chariot drawn by three putti and bearing a column with putto statue, listening to the petition of a kneeling supplicant. He is then seen at the center of the stair with one of his young sons. He, his wife, and both sons are shown finally in the bedchamber of his dying father, Jacob, who blesses his grandson. The disjointed narrative is made to seem more so by the leaps of scale Pontormo introduces between foreground, middle ground, and background. But if the subjects assigned him lacked drama, the artist has compensated with fantastic visual effects: the statues that are alive, the mysterious men who huddle around a boulder, the staircase that is improbably cantilevered to the side of the round building. Rather than to Rome, Pontormo turned north for inspiration, borrowing his background architecture from Lucas van Leyden's (1489/94–1533) print of the *Ecco Homo* (Fig. 36). Something of the northern sense of quasi-caricature has been infused into Pontormo's heads and figures.[4] This is an important index of his restless dissatisfaction with the models available to him at home.

Even though Pontormo's inventions are filled with wit and fantasy, however, because of the diminutive

Figure 35. Pontormo, *Joseph in Egypt*. 1518. National Gallery, London.

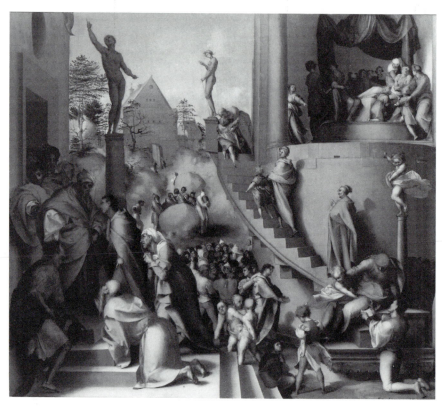

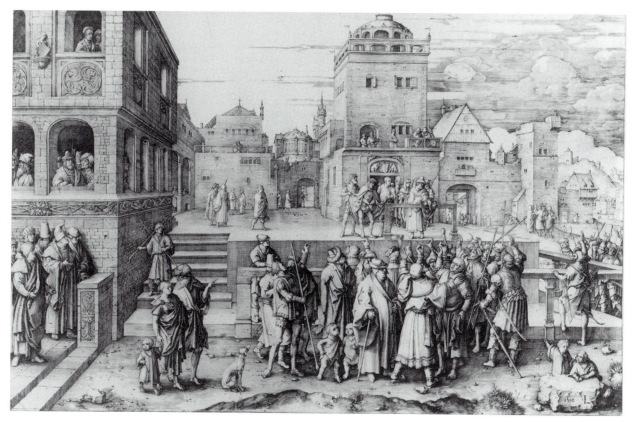

Figure 36. Lucas van Leyden, *Ecce Homo*. Engraving, dated 1510. © British Museum, London.

scale they can have nothing like the impact of Sodoma's (1477–1549) cavorting putti created for Chigi's bedroom. The luscious color would seem to be another aspect of Pontormo's exploitation of the jewel-like quality of this commission. What might be garish on a larger scale or inappropriate to the mood if this were an altarpiece would have shimmered within what we must imagine to have been the expanse of dark wood paneling of the bedroom. We are left to wonder how Pontormo came to approach so closely the *cangianti* in Michelangelo's Sistine vault, in particular the Ancestors of Christ in the lunettes. Also, in their coloring, Pontormo's contributions to the ensemble must have stood out among the more conservative and more Classic panels by Andrea del Sarto and the other painters.

Florentine patronage continued in this mold. When Giovanni Benintendi decorated the entryway in his palace a few years later, around 1523, he commissioned many of the same artists as Borgherini to collaborate. The same artist designed the room and, as in Borgherini's bedroom, the subjects for this secular room were again religious: Pontormo, *Adoration of the Magi* (Florence, Pitti); Franciabigio (1484–1525), the *Story of*

Bathsheba (Fig. 37); and Bacchiacca (1494–1557), *Legend of the True Son* (Fig. 38) and the *Baptism of Christ* (Berlin, Staatliche Museen, Gemäldegalerie). Andrea del Sarto's *John the Baptist* was probably the centerpiece of the ensemble (Pl. X).[5] This half-length, portraitlike image, though once the darling of the touring public, fell out of favor with the postwar generations. Straddling as it does the boundaries of genres, it has puzzled us. Should it be regarded as a sacred image or a secular one? What are we to make of its sensuousness, so contradictory to the familiar image of the ascetic saint who spent much of his life in the desert? The panel has suffered from an excessively zealous cleaning, probably at the beginning of the century, and the rocky background has all but vanished.[6] The contrast between it and the smooth flesh, softened with sfumato, the feathery fur of his animal-skin shirt, and the luxurious red robe would have been striking.

When we put Sarto's panel in the context of the room for which it was apparently intended, the ambiguity of its genre is less baffling. The iconography of the room centered on the name-saint of the patron, and this portrayal is, therefore, in some sense an evocation of

57

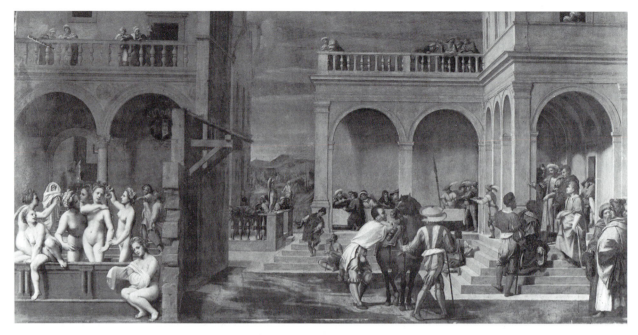

Figure 37. Franciabigio, *Story of Bathsheba*. 1523. Gemäldegalerie, Dresden.

him. One can accept that Benintendi would not have wanted the image of a gaunt and wasted scarecrow in the entrance hall of his home. The theme of the ensemble is the recognition of Jesus as the Messiah and the role of baptism in inaugurating the Christian era. Sarto's Baptist holds the cup with which he pours water over the heads of those who come to repent, the story represented in Bacchiacca's panel in Berlin. Among the neophytes approaching him, John recognizes Jesus as the promised Savior; Sarto has depicted that moment of recognition in the focused and attentive stare of the

young Baptist. He has known that he was the forerunner whose task it was to prepare the way for the Messiah, yet when the moment arrives, he is both gratified and astonished. His look is one of knowing, but it is ever so slightly tinged with surprise.

Bacchiacca's *Legend of the True Son* represents another moment of identity revealed. Among the contenders, the true son is the one who refuses to perform the required test of shooting arrows at the corpse of his father; when he throws his bow aside, the judge acknowledges him as the legitimate heir of his father.

Figure 38. Bacchiacca, *Legend of the True Son*. c. 1523. Gemäldegalerie, Dresden.

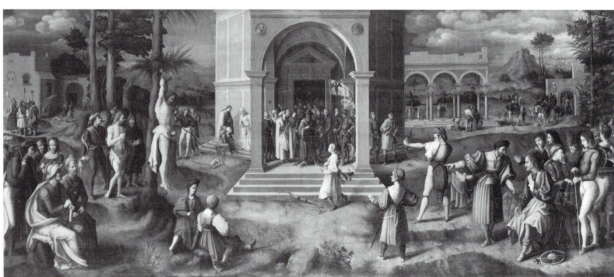

Franciabigio's panel shows Bathsheba, whom King David chooses when he spies her at her bath; this is likened to God's choice of Jesus, who was likewise revealed in a ritual of cleansing (Fig. 37). Pontormo's *Adoration of the Magi* represents the recognition of the Child as the Messiah by the Gentile kings. In each of these stories the chosen one is discovered.

Because of their shape and size, these panels are often identified as originally having been part of those long painted chests called *cassoni,* but it is more likely that they were installed in the wood paneling of the room. Nonetheless, they follow the compositional and stylistic model of the *cassone,* even to the inclusion of the byplay that belonged to the Quattrocento tradition of these marriage chests. Three of these painters – Sarto, Pontormo, and Franciabigio – had been selected for the prestigious commission to fresco the Medici Villa at Poggio a Caiano, which we will discuss. Although they had probably spent several months visiting Rome, presumably in the spring and summer of 1520,[7] shortly after Raphael's death, none of them recall the Roman experience in their panels for Benintendi.[8]

In these small panels, designed for domestic use, there was not the same opportunity to explore new subjects on a majestic scale as was offered at Rome. The Florentine painters, condemned by their patrons to continuing the conservative traditions of the Quattrocento, found the art of the north, as conveyed to them by means of prints, a more serviceable model than that of Rome. They imitated the northern artists' casual way of representing great historical events observed by ordinary people, some of whom scarcely take notice. Lucas van Leyden in his *Ecce Homo* (Fig. 36) placed Christ in the middle ground behind a crowd of onlookers, so that he must be reduced to quite a small scale. The burghers, responding to Pilate's question, chat among themselves and casually condemn Christ to death. This kind of irony is the opposite of Roman pictorial rhetoric, and it appealed to the Florentine middle class. The painters imitated from this very sheet not only the matter-of-fact spirit but specific details. Lucas's city gate at the right is the source of Pontormo's architecture in *Joseph in Egypt* (Fig. 35). The stagelike space and the view through the arch were used by Sarto in *Joseph interpreting Pharaoh's Dreams* (Florence, Pitti). The stage appears again in Franciabigio's *Bathsheba* (Fig. 37), though it is filtered through the intermediary of Sarto.[9] The device of displacing the central action to the middle ground is

often cited as a convention of Mannerism; it may in fact have its origin in Lucas's engraving. Bacchiacca borrowed it for the *Legend of the True Son* (Fig. 38), where the true son, like Lucas's mocked Christ, stands at the center but in the distant middle ground.

FLORENTINE PAINTINGS FOR SACRED SETTINGS

If there were so many borrowings from northern prints among the Florentine painters, why did Vasari condemn Pontormo for imitating Albrecht Dürer (1471–1528) in his frescoes for the Certosa at Galluzzo?[10] Walter Friedlaender saw what Vasari objected to as something fundamentally threatening to Renaissance art, a change of style that indicated Pontormo's rejection of the Classic style.[11] Vasari did not object to Pontormo appropriating motifs from Dürer's prints, which, as he said, everyone did, but "he should not have adopted that stiff style for everything" and substituted it for his former grace and beauty.

What Pontormo was seeking was something more than he had been able to find in the Florentine version of the Classic style. His master – and the *caposcuola* (head of the school) – Andrea del Sarto, was adept at creating harmonious and balanced compositions without letting them appear contrived. Sarto's handling of emotion, however, especially religious emotion, was reticent, restrained to the point of being bland. The spirituality of Dürer's style is what appealed to Pontormo – he must have felt it was required in his paintings for the Carthusian monks at Galluzzo. He removed himself to the Certosa to escape the plague that was raging in Florence in 1523. The Carthusians are a contemplative order of monks who live a life of extreme austerity and self-denial, renouncing the world in exchange for solitude, prayer, and meditation. At Galluzzo, just outside Florence, they lived in private cells opening off a central cloister and received their meals delivered through a hatch by lay brethren, with whom they were forbidden to speak. They left their cells only to attend church, where they would chant the offices without the unnecessary luxury of an organ to accompany their voices. Pontormo's frescoes were placed strategically at the corners of the cloister so the monks could focus upon them as they made their way silently to the church.

The subjects chosen are the most emotion-laden moments of the Passion: *Christ praying in the Garden,*

Figure 39. Pontormo, *Christ before Pilate.* Fresco, 1523. Certosa, Galluzzo.

when he experiences the moment of doubt; *Christ before Pilate* (Fig. 39), when he is humbled and resigned; the *Way to Calvary,* when he falls beneath the weight of the cross and Veronica offers him her handkerchief, observed pathetically by Mary and the women from behind the hill; the *Lamentation,* when the grieving mother and friends prepare the body for the tomb, and the *Resurrection,* the joyful triumph over sin and death. Despite his evident dependence on Dürer, especially in the *Resurrection,* Pontormo has not imitated the German by including a wealth of observed detail, in which Dürer's prints abound. Quite the contrary, he has excised all that is frivolous, worldly, distracting, or superfluous to focus on the emotion. In *Christ before Pilate* he shows Christ hemmed in by gesticulating and insistent onlookers. He has not followed Dürer's composition.[12] It is his own invention that Christ is placed lower than the seated Pilate, head bowed submissively, trapped at the center of a worldly throng. Six hands demand that he justify himself, but he remains silent, a response with which the Carthusians would have empathized. The frescoes have become more ethereal and spiritualized with time because so much of the surface has been lost due to their exposure to the elements in the cloister.[13] The loss of most of the modeling has made the figures appear flat and ghostly.

Despite Pontormo's focus on the emotion, he does not solicit the viewer's participation in it; on the contrary, he has placed half-length soldiers at the picture plane to prevent our crossing the liminal space.[14] These *repoussoir* figures, as they are called, will appear as a recurrent convention in later Maniera paintings, where they serve the dual function of defining the picture plane and excluding the viewer's empathy. The conflict Pontormo sets up between an exceptionally open expression of emotion and our impeded access may, in part, explain why his paintings are so haunting.

Pontormo lived in the community while he painted there. In this contemplative environment his thoughts might well have turned to otherworldly concerns, especially in the context of a plague that would eventually sweep up three of his fellow painters: Franciabigio, Puligo (1492–1527), and in 1530, Sarto. His frescoes are a meditation upon the Passion, much like that practiced by the monks alone in their cells. Vasari, in writing about these scenes around midcentury, may have been embarrassed by the untrammeled expression of emotion here, which he and his contemporaries probably considered to be in poor taste. Pontormo would not repeat it. It was a choice specific to this site and this audience and this use.

The present-day art historian finds interpretations based on the specifics of a commission more satisfactory than those based on concepts of changes in period style, offered frequently in the past in the absence of such specific information. When Friedlaender studied Pontormo's San Michele Visdomini altarpiece (Fig. 40), he saw it as a rejection of the normative values of the Classic style of the High Renaissance as expressed so successfully by Sarto in his *Madonna of the Harpies* (Florence, Uffizi), dated the previous year. Pontormo's shift of the Madonna off the central axis, which his treatment of light and shade enhances, threatens to destroy the composition's equilibrium.[15] The force of Friedlaender's argument seems to us today greatly diminished when we learn that the contract set the painter a novel challenge and that the aberrations of his composition can be accounted for as attempts to meet that challenge. A newly discovered document reveals that the dedication of the altar is, unusually, to Saint Joseph, to whom the patron gave special devotion. As there was no real cult of Saint Joseph at this time, there were no obvious precedents for the iconography. Such a dedication was sometimes handled as a *Marriage of the Virgin,* but this had the disadvantage of putting equal emphasis on the Virgin, as did other Holy Family–type representations. Pontormo, rather ingeniously if not altogether

successfully, created a *sacra conversazione* in which he then displaced attention from the Madonna to Joseph, to whom she has handed off the Child, and toward whom she looks and points.[16] Although the result may not be a fully resolved composition, it is easy to see how a young artist, keen to make his mark and challenged by the unusual subject, might have come upon this solution. This is a more plausible motivation, at least to the present generation of art historians, than Friedlaender's hypothesis of a rebellion against the Classic style.

Similar kinds of explanations have been offered in recent years for other of Pontormo's nontraditional altarpieces. We have been unsure what to call the work in Santa Felicita because it is so unconventional in its iconography. Is it a *Deposition from the Cross?* An *Entombment?* A *Pietà?* A *Lamentation?* It is helpful to know that the dedication of the chapel was to the Pietà. The action depicted has been described most accurately as "a severed Pietà,"[17] pointing to the movement of the bearers who have lifted the body of the son from his mother's lap and are carrying it away. It is certainly important to know that the stained glass window, which was an original part of the chapel decoration,[18] represents the Deposition from the Cross and the Entombment; in other words, the events on either side of that depicted in Pontormo's *Pietà*. As the painter conceived it, the grief of the mother is all the more poignant because she must say a final farewell to her son. Pontormo's panel was not simply a narrative but also a devotional image with liturgical significance: Christ's body looms above the altar, where the Body of Christ was revered in the Mass. The strange mixture of human grief and etherealized spirituality was the artist's way of spanning the spheres of historical event and religious symbol. The grief is only the mundane side of the story, for in Christian doctrine this sacrifice has redeemed humankind.

Vasari commented on the color, that it was virtually without shadows. The visual unity of the chapel depended on the treatment of light and color, for the patron had designated three different materials for the images in this small space: fresco, stained glass, and oil. The luminous color chosen for the altarpiece imitates the color of the frescoes and the window.[19] Had Pontormo repeated the chiaroscuro of his San Michele Visdomini altar, the visual unity of the chapel would have been threatened, if not destroyed. The color mode bor-

Figure 40. Pontormo, *Holy Family with Saints* (San Michele Visdomini altarpiece). 1518. In situ, Florence.

rowed by the painter from the fresco and glass returned to the early Quattrocento, when brilliant, celebratory color implied the divine. Pontormo's choice of coloring contributed to the spiritual symbolism of his altarpiece, removing it from this world to the sphere of the eternal, where different rules may be applied.

Pontormo's *Visitation* (Carmignano, San Michele, 1528) shows us the same event twice at one viewing.[20] Here he tries again to get beyond a mere believable rendering of the event in our space and time, to imply the spiritual dimension. Pontormo shows Mary and Elizabeth in profile parallel to the picture plane, then again in full face, perpendicular to the plane. The second pair are plausible as the accompanying servants, but they eerily echo the features of the others and suggest something otherworldly. His solution is, again, similar to that of an earlier age. In a Trecento altarpiece the absolute equivalence of hieratically symmetrical angels was an indicator of transcendence, like those in Duccio's *Maestà* (1308–11), where each angel has a twin in reverse on the opposite side of the Madonna's throne. Without tearing the veil of semblance to the real world, Pontormo evoked the transcendent.

In each of these images more information about the conditions of the commission enables us to understand

better the painter's intentions, and the strangeness of his formulation is consequently diminished. Yet we cannot entirely deny their eccentricity. Pontormo was clearly more willing than his predecessors and most of his contemporaries to seek new solutions not sanctioned by tradition. He was more experimental, less bound by the norms of the Classic style – and the same tendency was at least as true of his contemporary, Rosso Fiorentino. Why does the conservative and time-honored formula, and variations on it, satisfy one artist and not another? For Vasari, the answer lay largely in personality, and in the case of Pontormo he provided ample evidence of the painter's idiosyncrasy.

Vasari's Life of Pontormo is very complete and detailed, and it was clearly dictated by Agnolo Bronzino (1503–72), who was Pontormo's beloved pupil and friend. It sounds, in fact, as though for much of his career Bronzino helped to keep his master on an even keel and that when he was not available to assist, as in 1531 when he was at the court of Pesaro working for the Duke, Pontormo could not manage to get anything done. At several points Vasari describes Pontormo as being solitary beyond belief. He often took unreasonably long to complete a commission and appears to have been the kind of perfectionist who never wanted to let go of his work. He was certainly ambitious and anxious to surpass all other painters. Early in his career he got the commission, through Sarto, to paint a coat of arms on the facade of the Santissima Annunziata. He had finished it but was not satisfied, so he left it covered and worked at home on designs to improve it. The monks, noting that he was no longer coming to work on the fresco, went to Sarto, who in turn went to see Pontormo, but because he was closed up working and would not admit anyone, Sarto returned and uncovered the fresco. That evening when Pontormo went to the church, intending to destroy his work and begin on the new design, he found a crowd admiring it. He complained in anger to Sarto, who gave him what must have been a characteristically generous and soothing reply: "You are wrong to complain, for your work is so good I am sure you could do no better, and as you will have no lack of employment, use your designs for something else."[21]

Vasari's description of Pontormo makes him out to be a neurotic, and this picture is in some respects borne out by his diary.[22] Obsessive, anal-retentive, perfectionist, solitary, self-defeating, morbid: this is the portrait of

the artist that Vasari gives, apparently through the eyes of his fond pupil and assistant, Bronzino. He was claustrophobic, avoiding places where crowds collected for fear of being crushed. Sometimes when he was working he would fall into such deep thought that he came away without having done anything but think.[23] This frequently happened at San Lorenzo, where he worked for the last eleven years of his life, allowing not a single soul to enter. We have learned to beware of Vasari's anecdotes and to recognize that he was not equally objective in all of his *Lives*.[24] In this case, Vasari tried to account for the eccentricity of Pontormo's art in a kind of pre-Freudian psychoanalysis of his personality, the accuracy of which is difficult for us to assess.

Does the peculiarity of Pontormo's paintings mean that the style is post-Classic? Should his work be given a separate label, such as Mannerist, or as Shearman suggested, proto-Baroque?[25] These are questions that are not currently being examined, and there is very little sense of urgency about deciding them, but with the next swing of the pendulum they may resurface in some new formulation. Vasari and his contemporaries clearly did not see a new style here. They perceived no break between Sarto and his pupils that would warrant a new label; they saw their own era, Vasari's *terza età,* as a continuum with the past.

◆

IT WAS ROSSO FIORENTINO'S MISFORTUNE that he never received in Florence the kinds of commissions for which his temperament suited him. Instead, he was assigned a series of conventional altarpieces that allowed scant scope to his unorthodox inventiveness. He could not altogether restrain his creative wit in these altarpieces; it peeks out in touches of parody or caricature that no amount of pious art historical analysis can fully explain away. If scholars of the recent past rejoiced too much in Rosso's rebelliousness, the present trend, in reaction, is to deny the naughty wit that was an essential part of his nature and his art. In the works of his first Florentine period he sometimes got away with his perversity, but not always.

For the *Madonna and Child with Saints* (Fig. 41), his patron was the director of the hospital of Santa Maria Nuova. Vasari recounts how the patron took a dislike to the picture even before it was finished. Visiting the painter in his studio and seeing the underpainting, which Rosso habitually roughed in harshly and then

softened in the final painting, the patron rushed away declaring that he saw only devils. He was so dissatisfied with the finished painting that he called in assessors and reduced Rosso's contracted price by more than a third. Although the altarpiece was not actually rejected, it was never installed in the chapel in Ognissanti for which it had been intended; it was instead exiled to an obscure outlying church.[26] Such an action was rare in those days, and Rosso must have been somewhat chastened by it. When he returned to Florence after an expiatory sojourn in the provinces in and around Volterra, he expressed his eccentricity more subtly, at least in his altarpieces, which made it more difficult to find fault with them.

It is no wonder that the Santa Maria Nuova altarpiece received an inauspicious welcome. Rosso, evidently chafing under the conventional subject, sought to enliven it with invented narrative elements. It is as though John the Baptist and Jerome are pointing out to the Virgin and Child the singing angels at their feet. Everyone looks alert and questioning, but the motivation is unrevealed and undiscoverable. Formally, too, Rosso sought to disconcert, crowding his saints into too narrow a space, pushing them up to the very top of the panel and then insisting on a painful emaciation in his skeletal Jerome. Rosso would not receive another commission in Florence for four years.

At precisely this time Sarto's other pupil and Rosso's contemporary, Pontormo, was making his name, and at Poggio a Caiano he was even admitted as the colleague and equal of his former master. Rosso, in contrast, was compelled to seek employment in the countryside where the competition was far less severe and the patrons far less sophisticated. Curiously enough, this semiexile resulted in his being able to unleash his recusant nature without suffering the kind of reprisal he had experienced in Florence. The two altarpieces he executed in and around Volterra between 1519 and his return to Florence in 1522, including the famous *Deposition* (Volterra, Pinacoteca, 1521), are renowned for their eccentricity. These experiences seemed, however, to have matured him to the point at least that he suppressed his defiance of convention into latent channels.

The Dei altar for Santo Spirito (Florence, Pitti, 1522) was no less regressive a subject than had been assigned him four years earlier in the Santa Maria Nuova altarpiece. Raphael had been given the original commission, but had left his *Madonna del Baldacchino* (Florence,

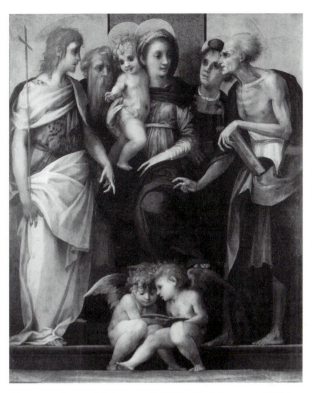

Figure 41. Rosso, *Madonna and Child with Saints.* 1518. Uffizi, Florence.

Pitti) unfinished when he departed for Rome. Since Raphael, the patron had raised the number of required saints surrounding the Madonna and Child from four to ten. It is no wonder that Rosso crowded them much as he had done before, although with what could be called a sweeter manner.[27] He has abandoned here, and in the *Marriage of the Virgin* (Fig. 42) that followed in 1523, the hard-edged style and abrupt modeling of Volterra and before, in favor of a return to a Leonardesque-Sartesque sfumato. The forms are softer, the contrasts of hue and of value reduced. The result approaches the example of his master, Sarto. Nevertheless, Vasari remarked that the piece was not very well received.

The *Marriage of the Virgin* represents Rosso's greatest effort to be ingratiating, but it contains elements that subvert its apparent orthodoxy. Charged with combining this event with three anachronistic saints, he successfully deployed them in the foreground as if they were spectators. Mary and Joseph and the priest take center stage, and her disappointed suitors are relegated to the obscure background. Beautiful, even harmonious, color effects abound. Quite unprecedented, however, are the youth and beauty of Joseph, who is usually represented as an elderly man who will not pose a threat to Mary's virginity. There is no indication in the documents that this

change in the traditional iconography was called for by the patron; indeed, these are matters that were normally left to the painter. It cannot be unintentional, then, that the upward-pointing gesture of the kneeling monk coincides with Joseph's groin.[28] What is surprising is that the patron's heirs did not take offense. It has proved easy in the past to deduce from such observations that Rosso was liberated from religious conviction, that he was blasphemous, and other anachronistic nonsense. The truth is likely to be tamer: he was simply undevout and disposed to irreverent wit.

The only commission that was suited to Rosso's skills and taste came to him shortly before he decided to transfer himself to Rome.[29] *Moses and the Daughters of Jethro* (Fig. 43) was commissioned by a man who helped keep a brothel outside Florence and repeatedly got himself involved in scraps, one of which resulted in his killing his opponent.[30] One can imagine that Rosso was more comfortable working for such a patron. Here, on what must have been some kind of domestic decoration, his phallic humor was more likely to be appreciated. It is unlikely that this work was designed for an altar, despite its Old Testament subject. Freed from the

Figure 42. Rosso, *Marriage of the Virgin*. Dated 1523. San Lorenzo, Florence.

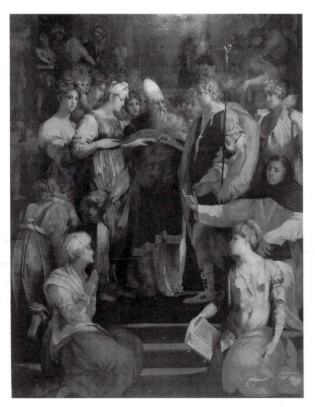

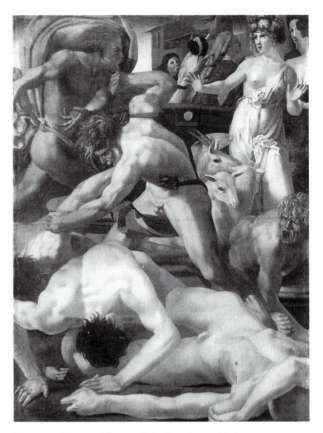

Figure 43. Rosso, *Moses and the Daughters of Jethro*. c. 1523–4. Uffizi, Florence.

constraints of the ecclesiastical establishment, Rosso reverted to his bold style, putting aside the appealing sfumato and rendering the modeling in harsh light that emphasizes the musculature. There is a kind of abstraction both in the modeling and the composition that recalls the Volterra *Deposition*. Similar, too, is the heightened level of violence: physical here, emotional there. This painting probably remained unfinished, though the fact that it was bought and shipped to France around 1530 would suggest that it was treated as a completed work. One wonders whether some of the "devilish" crudity that had troubled the director of the hospital of Santa Maria Nuova in the underpainting of his altarpiece, when he viewed it in its unfinished state, is not what one still sees here, and whether it would have been softened if Rosso had carried it further.[31] As we shall see, this painting was later sent to France and the collection of François I.

ROME COMES TO FLORENCE

When Pope Leo traveled to Bologna in 1515 to meet François I, king of France, he stopped off in Florence.

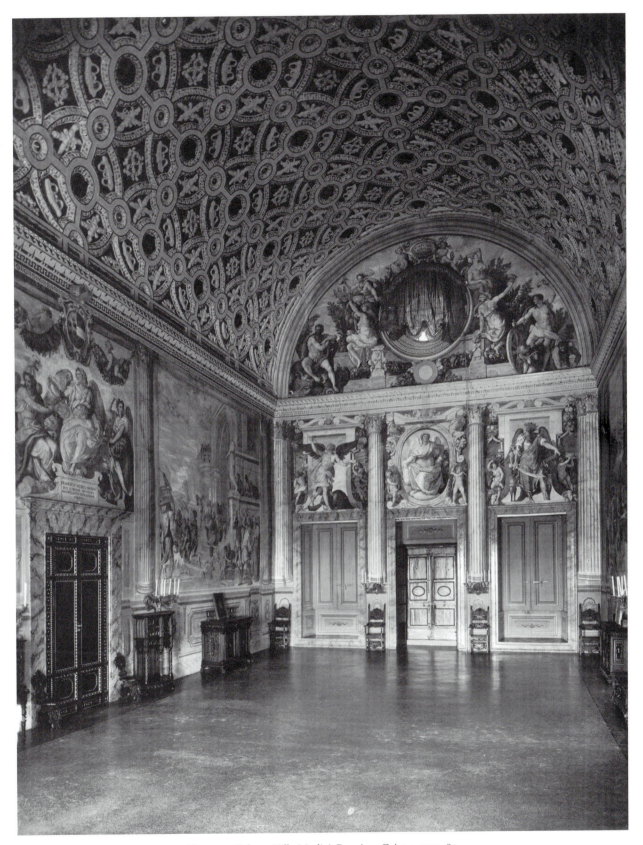

Figure 44. Salone, Villa Medici, Poggio a Caiano, 1520–82.

He was the first Florentine pope, and this was the first time a pope had visited the city since 1441, so even on very short notice the city and its artists turned themselves out to give him a grand reception. The papal apartment in the cloister of Santa Maria Novella, where Eugenius IV had stayed during the Council of Florence in 1439–41, was redecorated with frescoes. The *Veronica with her Veil* that Pontormo painted was a reference to Rome and to Leo. The veil was one of the relics preserved in Saint Peter's. The inscription, "This is your health/salvation," is one of many references to the Medici as the doctor *(medico)* who will restore health to Florence. In the vault compartments are Medici arms and a splendid display of *grotteschi* in which Medici emblems are interwoven by the Florentine grotesque specialist, Andrea di Cosimo Feltrini (1477–1548). They were carried down to fill the walls as well.[32] This much of Roman taste, and particularly Leo's, had already penetrated Florence.

We have noted that Pope Leo was at least as concerned with aggrandizing the name of the Medici in Florence as he was with embellishing the Vatican. He dispatched Michelangelo from Rome to design a new facade for the church with which the Medici were most closely associated, San Lorenzo. Then, when two members of the family died, the artist was transferred to the task of designing the New Sacristy in that church, which would serve as a family mausoleum, the Medici Chapel. These commissions would keep Michelangelo in Florence throughout the 1520s, during the brief reign of Pope Adrian VI and that of his Medici successor, Clement VII, who wished the artist to continue the project initiated under Leo.

Leo's next plan was to finish and decorate the Villa Medici at Poggio a Caiano, outside Florence, which his father, Lorenzo il Magnifico, had begun but which was left uncompleted at his death. The construction was carried forward, and the barrel vault of the Salone was stuccoed with emblems of Leo, although the crudeness of the stucco work makes it clear that no one yet in Florence was privy to the technique that Giovanni da Udine had invented for Raphael and used in the Vatican loggie, finished shortly before this commission in 1519. Sarto, Franciabigio, and Pontormo were commissioned to fresco the walls (Fig. 44). This project deviated from the normal conservative patronage in Florence, bringing a glimpse of recent developments in Rome. The burghers of Florence could never have envisioned for themselves anything like the self- and family-lionization that Leo concocted, nor had they before seen Roman history made to serve as its vehicle.

The artists probably traveled to Rome to discuss the project with their patron in 1520. Franciabigio and Sarto were each assigned a wall, and Pontormo was made responsible for the two end walls, only one which he executed. Work proceeded until the death of Leo late in 1521, when it was halted, not to be resumed until 1579. Paolo Giovio was responsible for the program. For the histories that celebrated the Medici family in the guise of events from ancient Rome, Giovio sagely chose heroes of republican, not imperial, Rome. Franciabigio painted the *Triumph of Cicero,* when Cicero returned to Rome from exile and was carried to the Capitoline and hailed as the father of his country *(Pater patriae).* This depiction recalled the return of Cosimo de' Medici *(il Vecchio)* to Florence from exile in 1434 and the fact that he was later called *Pater patriae.* In the manner of recent painting in Rome – in particular what was planned for the Sala di Costantino – Franciabigio reconstructed, somewhat fancifully, the Temple of Jupiter on the Capitoline and other buildings in the style of ancient Rome. Sarto painted the *Tribute to Caesar* (Fig. 45), representing the exotic animals presented to him in Africa as gifts,[33] including an elephant, monkeys, a parrot, a civet cat, a giraffe, and a chameleon, which was a play on Leo's name. Both Lorenzo il Magnifico and Leo had received such gifts, so the fresco could nicely do double duty.

Pontormo, who may have come into the project belatedly, was assigned a subject from mythology, *Vertumnus and Pomona.* This tale of rustic lovers comes from Ovid (*Metamorphoses,* Bk. 14), but Pontormo and the iconographer, Paolo Giovio, transformed the story, adding characters, so that all that remains of the original is the conceit of a rustic garden, enclosed by a wall, owned by Pomona (at the far right) that is invaded by Vertumnus in disguise (far left) to woo her. The theme is a celebration of the Medici Golden Age inaugurated by Leo. The laurel branch that arches over and connects the scene is a Medici emblem. The inscription at the center is from Virgil's *Georgics,* in a passage where he invokes the gods of agriculture and Augustus to bring peace to the land and implicitly a return to the Golden Age of Saturn.

Pontormo's disjunctive composition and enigmatic figures have defied decipherment until recently, but in

fairness to the painter, we should acknowledge that Giovio's program was as complex as his subject was unfamiliar.[34] What Pontormo represented can scarcely be described as a narrative; it is much closer to an allegory, and thus the figures seem all but unaware of one another. Pomona's garden is the refuge sought by the four who climb over the wall, grasping the protective laurel as they do. The laurel tree, which has been cut back severely at the top, has now sprung into new life, just as has the Medici family with the birth of an heir in 1519, Cosimo, who would eventually become duke

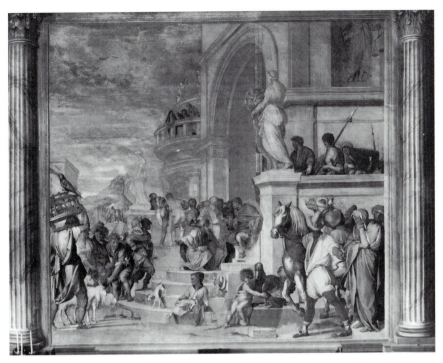

Figure 45. Andrea del Sarto, *Tribute to Caesar*. Fresco, 1520–1. (Enlarged by Alessandro Allori, 1579–82.) Salone, Villa Medici, Poggio a Caiano.

of Florence. The unclassical garb of the woman who climbs the wall marks her as a peasant from the surrounding countryside – that of the Villa Medici, in fact. The four figures on the low wall inside the garden are Allegories of the Seasons. Pontormo must have found it difficult to unify all these unassociated figures and to animate them. He imbued them with a nervous energy that conveys a sense of expectancy, but without the explanation that they are on the threshold of a new Golden Age, their emotion seems unwarranted. The images are not self-explanatory; they depend upon knowledge of Giovio's program to be intelligible.

Considered in the context of the decorations of Borgherini's and Benintendi's secular rooms, the Poggio Salone frescoes are startlingly innovative. Both in scale and in subject matter there had been nothing like this before in Florence. Yet when we compare the style of the Florentines to that of their Roman counterparts, we find nothing of the emulation of antique sculpture, either in compositional mode or figure style, that was then prevalent in Rome. If the painters indeed visited the papal city, they had either not been impressed by this aspect of the new Roman art, or had chosen not to adopt it.

The Florentine painters' first encounter on their own turf with what we will call the relieflike style would come when Perino del Vaga (1501–47) returned to his native city on a visit in 1522. His motives for the visit must have been several. There was plague in Rome,

which had not yet arrived in Florence, and he was fleeing it. The papal throne was occupied by Adrian, a pope whose dedication to reforming the Church excluded interest in the arts. Opportunities for patronage were accordingly diminished, and Perino must have hoped to find patrons in Florence who would be eager to make use of his knowledge of the Roman style. He must have been disappointed, for the only commission he received was for a fresco in a provincial church, far from the center, where his exhibition was likely to remain unseen and unknown. Vasari tells the story of how the Florentine painters, as anxious to see a demonstration of the modern Roman style as Perino was to provide it, arranged for him to fresco a Saint Andrew in the Brancacci Chapel in a space alongside Masaccio in open competition with the great master. Perino was ready to set to work when he received the commission for a fresco at Camaldoli for which he would be paid a small fee, so he transferred his efforts to the *Martyrdom of the Ten Thousand*.

The cartoon that he made has not survived, but his preparatory drawing (Vienna, Albertina) is enough to make clear that Perino intended here, as much as in the Brancacci Chapel, to exhibit the new relieflike style, demonstrated in Raphael's design for the Sala di

Costantino and painted only just a couple of years previous. Vasari tells us that Perino tired of doing this work, but if it had been anywhere but Camaldoli he would have finished it – in other words, if it had been in a conspicuous location.

Even more informative is another piece that Perino made in gratitude for his hospitality in Florence to the priest who had been his host. The *Crossing the Red Sea* (Florence, Uffizi) (Pl. XI) is a canvas executed in monochrome tempera to resemble a bronze relief, measuring about four feet by six.[35] Perino demonstrated the style that he had learned through his association with Polidoro da Caravaggio. Moses and the Hebrews, shown at the left, sit and stand in orderly ranks. They are severely stylized, as in relief, and seen either in profile or with their torsos twisted so they are parallel to the surface. Limbs, particularly arms, are emphasized, their almost-horizontal lines repeated as emphatically as the verticals of their bodies. On the right, by contrast, the floundering Egyptians are all confusion as they try in vain to make for the shore. Pharaoh's nearly mirror-reflection of Moses helps to flatten and to close up the spatial recession.[36]

Perino's choice of subject is interesting. For his friend the priest he has abjured pagan myth and history and instead chosen an episode from the history of the Hebrew people. We have seen that it was common practice to use Old Testament subjects for secular decorations in Florence. Even Florentine facade decoration, which was seemingly an imitation of Roman practice where the subjects were normally drawn from Roman history and mythology, sometimes represented Old Testament scenes.[37]

The Florentines must have been shocked by the cold formality of Perino's design, by the lack of naturalistic detail and even of setting. It is a style almost diametrically opposed to that of the engravings of Van Leyden and Dürer to which we have seen the Florentines so frequently turning in these years. To judge by the evidence of its influence, the Florentines were not enticed by what they saw of the modern Roman style. Certainly neither Pontormo nor Sarto nor Franciabigio nor Bacchiacca showed any reflection of it in their panels for Benintendi, presumably executed in the same year, or in any of their other works.

The only painting in the Florentine ambiance that might be interpreted as a positive response to Perino's exhibition is Rosso's *Moses and the Daughters of Jethro*

(Fig. 43), which, despite its high-pitched emotional key, is stylized in somewhat the same way.[38] The frozen, sculpturesque poses of Rosso's figures conflict with their violent rushing motion. The layering of figures, piled up to the horizon, is like Perino and like relief. Perino's canvas was presumably done in 1523, the same year as Rosso's. It seems likely that Perino's demonstration of Roman style contributed to Rosso's decision to transfer himself to Rome in 1524, but it would be nearly two decades before the Roman relieflike style caught on in Florence.

Another glimpse of the Roman style was introduced to Florence a couple of years later, but it, too, failed to convert the artists and patrons. Around 1525 Pope Clement commissioned Baccio Bandinelli to paint a *Martyrdom of San Lorenzo* in the choir of San Lorenzo. Close at hand in the New Sacristy, Bandinelli's rival, Michelangelo, was then working on the Medici tombs. The design is known to us and was widely disseminated through the engraving of Marcantonio Raimondi (Fig. 46). When the commission came to naught, Bandinelli must have turned over his design to Marcantonio, as Raphael had repeatedly done with his unexecuted projects.

The sculptor Bandinelli, who Vasari tells us had been in Rome and had just finished his copy of the *Laocoön,* was fully aware of the style developed by Polidoro da Caravaggio and practiced also by other former members of Raphael's *bottega*. He boldly undertook to apply this style to his sacred subject. His design is so insistent and doctrinaire in its use of the relieflike style, especially in Marcantonio's hardened version,[39] that Bandinelli must have intended it as a demonstration piece to the Florentines of what was going on in Rome and what was favored by papal taste. Every figure is as if a sculpture, studied separately and then assembled in this composition, which fairly bursts with energetic movement. The foreground figures, the men concerned with keeping the fire hot, all nude, form a frieze across the bottom. The Roman judge and his court, crowded on the central podium, face forward and solemnly observe. On the parapet of the second story are lay spectators assuming a range of deliberately studied attitudes. The resemblance to Michelangelo's *Battle of Cascina* (Fig. 10) – again especially as seen through Marcantonio's transcription – was certainly intended by the artist, drawing attention to the parallel between himself and that other Florentine sculptor-turned-painter. Even so, the style of

Bandinelli's invention was not imitated by the other artists any more than had been Perino del Vaga's.

ROME

After the death of Leo in 1521, the College of Cardinals was overwhelmed with the sense that something drastic needed to be done. Abandoning the tradition of electing one of the wealthy, worldly Italian cardinals, they turned to a foreigner who promised to undertake the much-needed reform and to deal with the Lutheran schism. The election of Adrian VI spelled disaster, however, for the Roman artistic establishment. Adrian has yet to find a defender among lovers of art. Vasari passed up no opportunity to point out that the artists despaired and nearly starved during his inimical reign. He quoted the pope as threatening to tear down the Sistine Chapel and of referring to Michelangelo's frescoes as "a bath-house of nudes."[40] Because a major purpose of Vasari's in composing his *Lives* was to point up the role of patrons – we might even say the obligations of patrons to support artists and artistic culture – Adrian's failure in this regard was an important exhibit in Vasari's gallery of patrons deserving praise and those earning censure.

The Netherlander was elected by the Sacred College out of a well-founded fear that if reform of the Church was not instigated, the problem of heresy and disaffection, which had already gained ground in Germany under Martin Luther, would flourish. It should have been no surprise that the ascetic Dutchman had neither understanding nor sympathy with the Italian system of artistic patronage. The prodigality of a Leo, who had left the Vatican coffers empty, was more to the taste of the artists and those who patronized them. What is interesting, and we see it repeated over and over again, is how the attitude of the reigning pope controlled the mood of the Roman patrons. Under Adrian, even those who could afford to spend held back, and artists were forced to leave, seeking subsistence outside Rome, where the influence of the pope was mitigated.

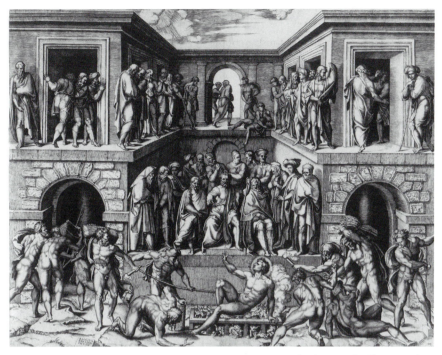

Figure 46. Marcantonio Raimondi after Bandinelli, *Martyrdom of Saint Lawrence*. Engraving, c. 1525. © British Museum, London.

All the works that had been under way ceased with the death of Leo and were left to languish. The Sala di Costantino, the Villa Madama, the Villa Lante all remained untouched during what turned out to be, for the artists, the blessedly short reign of Adrian, who proved to be ineffectual in bringing about reform as well. During these years Michelangelo must have been glad that he was in Florence, where the Medici Cardinal Giulio had also retreated. He was kept busy with the Medici Chapel under the direction of the cardinal. The election of the Medici cardinal to the papacy in November 1523 was received with rejoicing by the artistic community, and the works of his cousin Leo were resumed.

GIULIO ROMANO (c. 1492/99–1546)

Giulio Romano[41] had been Raphael's most talented assistant, so it was logical that he and the older but more pedestrian Gianfrancesco Penni were made the heirs of Raphael's workshop. Giulio was a strong and independent artistic personality. Despite his apparent youth, he did not hesitate to make significant changes when he took over the execution of the master's scheme in the Sala di Costantino. Comparison between Raphael's drawing (Fig. 47)[42] and Giulio's fresco of *Constantine addressing his Troops and his Vision of the Cross* (Fig. 27)

reveals that Giulio revised his master's designs to make them more stylized. For him, pattern takes precedence over naturalism. The pattern of light and shade, as he has adjusted it, brings figures to the surface and disrupts the spatial recession. He has twisted other figures to flatten them to the plane, like the man standing at Constantine's feet with his back turned. He exaggerated the diagonal established in the soldiers' legs by transposing to the distance the figure who runs and points at the sky. In so doing, what had been a plausible suggestion of military order in Raphael's lineup of soldiers becomes in Giulio's design a decorative configuration that loses its verisimilitude. The draperies have undergone a similar process of transformation into ornamental pattern: the slight flutter behind two of the soldiers in Raphael's drawing, expressing their forward movement, has become a curl improbably repeated by Giulio behind each of them. These adjustments make the composition more artificial – in the original sense of the word, as well as the modern sense. It is more evidently a work of art, and specifically, one that resembles a sculpted relief. In this respect Giulio was following, and helping to forge, the relieflike style taking shape during these years in Rome. To what extent Polidoro da Caravaggio led Giulio, or vice versa, it is impossible to say. It has frequently been suggested that Polidoro continued to work in the *bottega* and contributed to the Costantino decorations.

For Raphael it was crucial that his representation should be convincing, so that it would convey the content of a humanist idea. For Giulio the effect of ornament took precedence. His temperament drove him away from idealization and toward an almost obsessive delight in detail. His immense skill as a painter of still life was often utilized by Raphael,[43] but the master held it in check, never allowing the detail to distract from the central focus. Giulio took pleasure in the richness of detail for its own sake; the aesthetic values of *copiousness* and *variety* were accorded pride of place in his hierarchy.

Giulio clearly lacked commitment to idealization, that central tenet of the Classic style of the High Renaissance as it was practiced by Leonardo, Raphael, and Michelangelo. For them, what was supremely important was to convey the essential idea without allowing the viewer to be diverted. To better perform this function, forms were idealized, but they were not abstracted so much that they would lose their reference to human life. The purging of inessentials made it more possible to focus the spectator's attention. Giulio did not share this view of the purpose of art. Nor, for that matter, did a substantial portion of Roman antique art, which was his model. Ideality is intermittent in antique art, and the Renaissance made no such distinctions of style and period as we do now, which would have allowed them to value Augustan idealism higher than late antiquity energy. One wonders how much longer Raphael, if he had lived, would have been able to make use of Giulio's extraordinary talents without finding that his powerfully different mind was subverting his own purposes.[44]

The Florentines in the 1520s did not share an interest in the model of Roman antique art. They borrowed instead from northern artists, as we have seen, which provided an alternative to the Classic style. The sublimity of the Classic had become too rarefied, it would seem, for any except Michelangelo and Sebastiano del Piombo in this decade. The direction that Florentine art took was altogether different from that of the Romans, drawing as they each did on different models.

The figures Giulio created in the Sala di Costantino are closer to art than to images of inhabited human presences. Their surfaces are polished, their outlines lapidary. Because we are not intended to think we are observing a depiction of an actual event, Giulio felt at liberty to indulge his brilliant technique in the tour de force: he presents a painting of a work of art (a tapestry) imitating a work of art (a relief). To what extent the executed frescoes reflect Raphael's intention is impossible to determine, but we have seen that there was far less of the ornamental in his compositional drawing than in Giulio's rendering. Raphael had also, quite logically, omitted the archaeological detail from his drawing. We can assume that a compositional sketch was not intended to contain that kind of information, and by the same token the sketch might not convey the master's intention to imitate sculpture, even if he harbored it.

We cannot doubt that Giulio tailored his style for this commission, for in no other of his Roman works do we see quite the same degree of resemblance to sculptural relief. Although his manner is always more sculpturelike than Raphael's, we do not find the same chiseled style in his portraits and, least of all, in his altarpieces of the same period. It is in his mythological pictures, like the *Two Lovers* (Fig. 50), that he most closely approaches the style of the Sala di Costantino.

Giulio's works certainly include hallmarks of his wit. In the clouds in advance of the mounted Constantine as he rides into battle (Pl. VII) there is concealed the

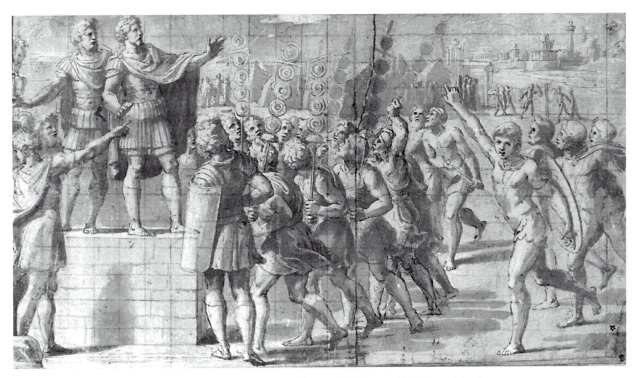

Figure 47. Raphael, *modello* for *Constantine addressing his Troops and his Vision of the Cross.* 1519–20. Devonshire Collection, Chatsworth. Reproduced by permission of the Chatsworth Settlement Trustees.

image of a lion, Pope Leo leading the forces of Christianity against the enemy, just as Constantine had done, and with the aid of divine support – a detail that would surely have delighted the pope.[45] The dwarf who dons a helmet in the foreground of *Constantine addressing his Troops and his Vision of the Cross* (Fig. 27) was absent from Raphael's sketch (Fig. 47), but he nicely fills the space created by Giulio's rearrangement.

Giulio's difference from Raphael can be clearly seen in another comparison. *La Fornarina* (Fig. 48), it is generally agreed, is a portrayal by Raphael of his mistress. She is pictured nude against an almost-black background so that nothing diverts attention from her. She is seated, and her sidewise glance suggests that in covering herself with a thin veil, she is responding to some intrusion. Her body is full and voluptuous, her movement slow; there is an easy, confident modesty about her. Giulio painted a nude *Woman with a Mirror* (Fig. 49) who resembles La Fornarina sufficiently so that some scholars have believed her to be the same woman. The differences, however, tell of the temperaments of the two painters. The worldliness of the *Woman with a Mirror* is conveyed not only in the choice of moment – she has apparently been interrupted at her makeup table – but in the inclusion of the loggia, the servant who hangs out her dress, the statue of Venus, and a monkey

on the balcony rail. Like La Fornarina this woman covers herself, but her gesture is more abrupt; it is as if she has been startled, and her expression is not the dreamy, contented one of La Fornarina but is instead tinged perhaps with annoyance. The natural ease with which Raphael's lady slipped into the Venus *pudica* pose has been replaced by a more angular and agitated posture. The monkey, which is the symbol of lust, together with the appearance of Venus, leaves little doubt that this is the portrait of a courtesan. The half-length nude portrait as a type originated in the early Cinquecento in Venice in the circle of Giorgione. Raphael's and Giulio's are early examples in central Italy, in fact perhaps the first.[46] The communication they make is very different from one another. Where Raphael's nude is modest and self-confident, Giulio's is knowing and self-conscious; where Raphael's is voluptuous, Giulio's is erotic. Raphael had chosen to infuse the image of his beloved with a sensuousness that bespeaks an integration of body and mind. Giulio's is less high-minded, but it is persuasive and witty.

It seems safe to surmise that like Rosso, Giulio Romano did not experience religious emotion deeply. His inclination is to turn it into theater. The *Stoning of Saint Stephen* (Genoa, Santo Stefano) (Pl. XII) was probably painted soon after Raphael's death. The composition

71

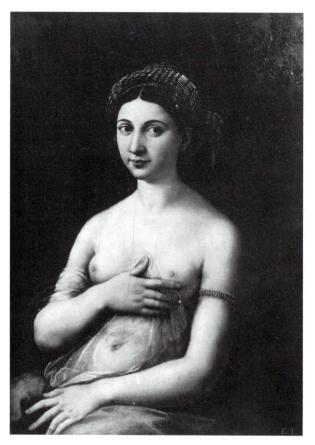

Figure 48. Raphael, *La Fornarina.* c. 1518. Galleria Nazionale, Rome.

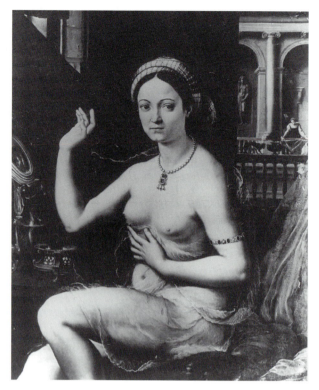

Figure 49. Giulio Romano, *Woman with a Mirror.* c. 1524. Pushkin Museum, Moscow.

and the coloring, in fact, echo Raphael's last altarpiece. Like the *Transfiguration,* it is divided into terrestrial and celestial spheres. Stephen is set apart from his tormentors by the spotlight that beams down on him from the heavenly vision above. Eager and vicious men surround him and hurl rocks at him. Others are seen in miniature on the hill behind among the shadowy ruins of ancient Rome, gathering more stones. It is characteristic of Giulio's taste for melodrama that the worshiper is placed with Stephen in the line of fire. However much we may be moved to pity, we cannot fail to discern the brutality of our fellow humans, who are more engaging than the bland saint and Savior. There is something akin to the spirit of the northern artists in this unidealized view of humanity, but its source is in Raphael's grotesquely contorted culprits, Ananias and Heliodorus (Figs. 23, 24). The dark chiaroscuro that pervades the terrestrial zone here is like that of the *Transfiguration,* but it is made more heavy and opaque. The silvery pinks, yellows, lilacs, and blues of the visionary Moses and Elijah in Raphael's upper zone have been repeated here, though they are somewhat grayer and weightier. The effect of Giulio's altarpiece is

more to spur distaste for the bestiality of human nature than to uplift the thoughts of the worshipers and help them detach themselves from this world. He is at his best in other genres, and it was his good fortune that within a few years he would be given an appointment at the court of Mantua that would allow him to practice what he excelled in.

Following the example of Raphael he turned over many drawings to be engraved. A new kind of audience was developing that appreciated the mythological subjects, which of course centered on love. It is for this audience that Giulio made a series of drawings, engraved by Marcantonio Raimondi (1482–before 1534), called *I Modi,* demonstrating the positions for lovemaking.[47] Pietro Aretino added a series of poems to the images. This was too much even for the liberal Clement VII, probably because prints could reach a wide, popular audience and were not restricted to a sophisticated elite as many paintings were. He put Marcantonio in prison and did not let him out until he agreed to destroy the plates and the prints, both unsold and sold. This first recall in modern history was remarkably successful, for not a single set has survived. All we have today are later copies. This occurrence may have hastened Giulio's departure from Rome. More likely, though, Giulio

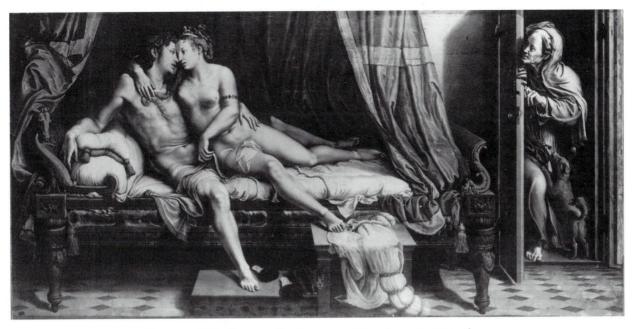

Figure 50. Giulio Romano, *Two Lovers.* 1524. Hermitage, Saint Petersburg.

surmised that he did not stand in Clement's favor, for the pope did not give the commission for continuing the construction of the Villa Madama back to him after the interval between Medici popes, but awarded it instead to Antonio da Sangallo the Younger (1484–1546).[48]

Giulio's *Two Lovers* (Fig. 50) was commissioned by Federico Gonzaga, the marquis of Mantua, but it may have been executed in Rome before Giulio's appointment as a test of his talents at the kind of subject the marquis would require of his court painter. It is enormous, more than ten feet long, and it surely represents a pair of mythological lovers, but without the help of contemporary sources we have been unable to identify the subject.[49] We are reminded of Mars and Venus, but there are no attributes to identify them. It shows the amorous pair embracing while an old hag, unobserved by the lovers, watches them from the door. She has perhaps just admitted them or has come to warn them. Her position suggests that she has just entered and scared the cat out from under the bed. It has been suggested that this work, like many paintings in the Cinquecento, might normally have been covered with a curtain. If the curtain had been designed so that as it was drawn back the painting was revealed from left to right, a quite clever joke – typical of Giulio's wit – would have been played upon the viewer. As the old hag peering around the door came into view, she would have turned the spectator into another voyeur,

just like her.[50] This is the kind of painting Giulio excelled in.

POLIDORO DA CARAVAGGIO
(1490–1536 OR 1499–1543)

The most visible formulation of the relieflike style, and the one most copied by artists, was in the facades painted by Polidoro da Caravaggio[51] all over Rome. It has been estimated that Polidoro executed between forty and fifty of these facades, together with his associate from Florence, Maturino (?–1528), in the years before the Sack brought an end to their business.[52] The idea was to make the surface appear to be encrusted with relief, so they painted in fresco using *terra verde,* yellow earth, or tones of gray to imitate marble. Although these exterior decorations have virtually all vanished, descriptions, some drawings, and engraved copies give us an idea of what they looked like. What Polidoro contributed was a true style *all'antica:* a means of representing antiquarian subject matter in a style approximating that of its source.

In these facades, the rectangular fields between the windows required nothing novel in terms of composition, but the long narrow bands between stories presented a very different kind of challenge. These horizontal strips the painters had to work with did not lend themselves to centralized composition like those Raphael and Michelangelo had evolved to fit the more

73

unified fields they designed. Problems such as dividing and connecting episodes of a narrative, manipulating the space where deep recession is limited by the height of the band, and achieving legibility at a distance had been infrequently addressed in Quattrocento painting or in that of the Classic style, so these examples provided Polidoro little guidance. However, the field was much like that of the sculpted frieze or sarcophagus (Fig. 29). It was similar to that of the historiated Columns of Trajan and Marcus Aurelius, too, except that there the narrative band spiraled around the column. Because the images had to be large enough to be legible from the ground, a high horizon, minimal background, and figures pushed to the foremost plane were called for. Legibility dictated that movements and actions be clearly articulated, picked out by the light, with overlappings arranged so as not to confuse. Polidoro's subjects were most commonly drawn from Roman history or mythology, and occasionally from the Old Testament. The confluence of subjects drawn from antiquity, the intention to emulate antique sculpture, and the shapes of the fields made the model of antique relief style irresistible. Sarcophagi and the historiated columns supplied artistic conventions that could be learned and imitated. Whereas Jacopo Ripanda (1490–1530) provided the copies and some variations on the theme of the Trajanic relief, Polidoro evolved a *style* based on antique relief.

We have noted that for all the accuracy of antiquarian painting before 1520, its style was still close to that of the Quattrocento, borrowing piecemeal from Raphael and Michelangelo but never achieving a Classic style in its own right. Polidoro's figures have acquired a grandeur more like that of Raphael's. Like the effective orator, they gesture with weight and significance. His compositions bear such resemblance to familiar antique formulas that it grants them an authority akin to that of the model. There is a kind of ritualized quality about them. Like the reliefs he imitates, Polidoro is never afraid to repeat shapes and forms, using the rhythm of the repetition to move the flow of the narrative along. This is different from Raphael, who composed figures in groups, making each character embody one of the possible responses. Ornament, copiousness, and grace are valued by Polidoro above psychological nuance. He is fond even of figures who turn their faces away, presenting only their backs, but in this anonymous way contributing to the drama. Polidoro

achieves such drama not only through swift-flowing movement but also through the sometimes exaggerated poses of his energetic figures, which make Ripanda's (Figs. 7–9) and Peruzzi's (1481–1536) (Fig. 13) look timid and stiff by comparison. He is quite able to deal effectively with impassioned states of emotion, avoided by Ripanda and Peruzzi, and with violence. Whereas Ripanda often allowed the eye to penetrate through gaps to the fictive relief ground, Polidoro creates a compact mass of overlapping figures, often occluding the ground altogether. Densely packed and lit so that the plane is emphasized, the relief seems to bulge out from the surface. Even so, he maintains such focus and control that it gives a sense of teeming life, not of confusion. It is no wonder that Rubens admired him and made profuse drawings after him.

If no drawing for a facade from Polidoro's hand seems to have survived, there are nonetheless multitudes of drawings and engravings after his designs, reflecting how much they were copied.[53] One is a pen-and-wash drawing for a house in the Piazza Caprettari (Fig. 51).[54] The lower story was decorated in fictive rustication. On the next level there are caryatid figures flanking the windows, and between there is a female allegorical *Victory* amid piled-up trophies. This figure anticipates one of Francesco Salviati's (c. 1509–63) most memorable creations a generation later (Fig. 150, over the door). Above is a frieze of a battle, at the right of which prisoners kneel before an enthroned emperor. In the window zone above, this presentation of prisoners occurs again at the center, flanked by single figures, most likely Allegories. A beautifully rich frieze of trophies of war runs along above, and at the top we see another highly ornamental pile of trophies, arms, shields, helmets, and two bound captives, flanked by winged Allegories, probably of Victories.

Comparison with Venice is informative. The Venetians painted their facades too, but unlike the Roman houses frescoed in chiaroscuro, their frescoes were colored, so that they must have seemed like real events, not simulated relief sculpture.[55] The wall surface was not respected as in the majority of Roman facade decorations; instead it was radically breached by dramatic perspective recession, framing equally audacious, foreshortened figures. The subjects were mostly of allegorical and mythological subjects, rather than Roman history, at least until the 1530s, when Il Pordenone (c. 1484–1539) arrived, fresh from Rome, and introduced the

Venetians to Polidoro's practice.[56] Polidoro's influence was, by all accounts, enormous. Vasari lavishly praised his accomplishment and reported that artists coming to Rome copied his work more than that of any other painter, and that he had done more to benefit painting than all the others together, from Cimabue on.[57] Even the Carracci, who advocated a return to drawing from life, recommended copying the facades of Polidoro.[58]

A letter of March 1524 from Naples, where Polidoro spent part of the difficult period of Pope Adrian's reign, described a facade he was working on there showing scenes that were taken from Trajan's Column.[59] On the whole, his motifs can be recognized as typical of antique relief, but they recall no specific source. Indeed, Vasari reported that there was not a vase, statue, sarcophagus, or relief, whether broken or whole, that Polidoro did not make use of.[60] Like Raphael and Michelangelo who assimilated antique classicism, Polidoro incorporated his classical models and fused them with his own style, so that the antiquarian manner he was practicing was a truly Renaissance restatement of the antique.

If this drawing is useful for conveying the overall effect of Polidoro's work, the multitudes of other drawings that have been identified as after his designs show us his individual scenes and figures. What we find is a whole new language of conventions for composition and figural posture, many of which are to be seen in antique reliefs, especially late antique battle sarcophagi (Fig. 29). We have already seen these conventions fully articulated by Perino in his *Crossing of the Red Sea* (Pl. XI); he had learned them from Polidoro, with whom he was in close contact in the early 1520s. They are less fully worked out in the fictive tapestries of the Sala di Costantino, but they already appear in some of the pseudo reliefs in the *basamento* of that room.[61] Conspicuous among these conventions is the tendency to flatten figures against the picture plane. Figures tend to be

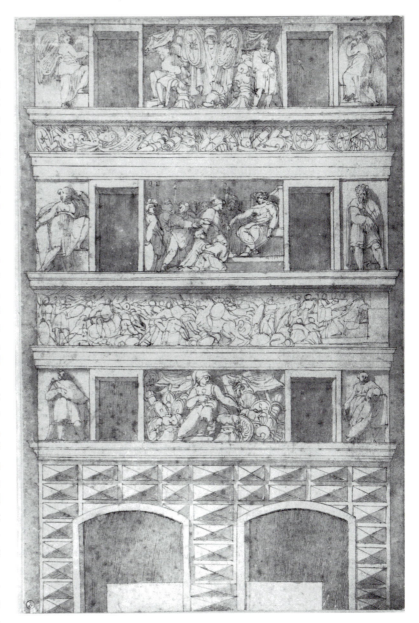

Figure 51. After Polidoro da Caravaggio, facade in the Piazza Caprettari. Drawing, c. 1524–7. Biblioteca Reale, Turin.

arranged in profile or in full-face, or they are twisted so that the principal parts assume one or the other of these positions. Limbs assume an unusual importance, especially arms, as we saw in Perino's *Crossing*. There is often a rhythmical repetition of elements, which contributes both to legibility and to ornamental effect. We saw this in Giulio Romano's execution of *Constantine addressing his Troops and his Vision of the Cross* (Fig. 27). These effects are enhanced by a flat light that strikes the foremost parts; shadow is reserved for parts that recede. Perino's cartoon of the *Martyrdom of the Ten Thousand* (to

judge from the surviving drawing at the Albertina in Vienna) used light to bring parts forward, even parts that should logically recede, such as the emperor's pointing hand.[62]

It was felt to be as appropriate to emulate antique relief in these instances as it was to emulate Raphael and Michelangelo in others. In fact, both of these masters had set their imprimatur on the practice of imitating sculpture under certain circumstances, as we have already observed. In the case of Michelangelo, not only the Sistine Chapel vault, which is often considered the translation into paint of his thwarted project to sculpt the tomb of Julius II, but also his earlier *Battle of Cascina* and the drawings or cartoons that he provided other artists to paint, like those for Sebastiano's *Flagellation* or the cartoons executed by Pontormo of *Venus and Cupid* or the *Noli Me Tangere,* could all almost equally well have been carved as painted.

Although all this is true, what we do not find in Michelangelo, or in Raphael for that matter, are the conventions of the relieflike style deriving from the antique. These appear to have been invented by Polidoro primarily and learned quickly by other members of the former Raphael *bottega,* like Perino. It may be impossible to fix the date, but we can be sure that by 1522, when Perino went to Florence, the vocabulary was formulated.[63]

These conventions belonging to the relief-like style were analyzed originally by Craig Smyth, to whom we owe the identification of their source in late antique relief. Smyth believed that they emerged definitively in Florence around 1540, having made intermittent appearances before then.[64] In those apparently random early appearances a rational pattern can now be recognized, especially if we separate Florence and Rome, and sacred and secular works. The conventions appear repeatedly in the 1520s and 1530s in secular works based on antique subjects, but not in works destined for a sacred setting. Such antique subjects were popular in Rome as an expression of the search for the city's past and its proper identity, but they at first had little appeal elsewhere. Facades were decorated in Florence during these years – it was almost as fashionable there as in Rome – but significantly, the images used were from the Old Testament or *grotteschi,* and not narratives from Roman (or Florentine) history, or even mythological scenes.[65] We have already seen how Florentine patrons preferred Old Testament iconography even for their palace interiors. The relieflike style was developed in

Rome for a certain kind of subject and a certain use, for which there was no existing Renaissance prototype. As we shall see, it made its way to Florence only around 1540, and was adopted for sacred painting in Rome only shortly before.

For sacred art, the well-established traditions provided a framework for the artists, ensuring that these works would remain more conservative. There are sometimes striking differences between what the same painter would do in the same time frame in a secular work and in a sacred one. Perino returned from demonstrating the relieflike style in Florence to frescoing the Pucci Chapel, where the compositional mode is traditional perspectival space (Fig. 54). We will see a similar case in Giulio's paintings in Mantua. Polidoro, when he painted in San Silvestro al Quirinale (Fig. 52), chose a manner different from that of his facades.

He was commissioned to decorate a chapel for his friend, Fra Mariano Fetti, before the Sack, which was probably left unfinished when Polidoro fled from Rome and Fra Mariano died. Unfortunately the chapel was remodeled at the end of the sixteenth century, so we cannot be sure of Polidoro's design. For his patron and fellow antiquarian, Polidoro painted landscapes on either side wall that are evocations of antique paintings. Innovative by disposition, Polidoro painted something that looks like nothing else in Renaissance Rome. Its novelty lies in the scale of the figures in relation to the surrounding landscape, for it reverses the usual sovereignty of the actors over their setting, making them tiny in landscapes that become the dominating feature, as happens in antique landscape painting. In Renaissance paintings a standing figure near the picture plane is usually scaled to occupy one-third to one-half of the total height of the field; Polidoro's are slightly more than one-sixth. The effect is remarkably different, for the heroic dimensions of the actors vanish and the narrative is distanced and made to appear as a normal event in the flow of human history. It is a brilliant device for the problem Polidoro faced here of integrating in a single field sequential episodes of a sacred history, a task often not handled very successfully. (Compare Pontormo's *Joseph in Egypt,* Fig. 35.)

A typical treatment was to place one event in large scale at the center and in the foreground and to scatter others around the background, which has the effect of privileging that one event and disrupting the scale.[66] Polidoro here maintains a unity of scale at the same time that he provides a plausible spatial separation. In the

scene dedicated to the life of Mary Magdalen, her encounter with the risen Christ in the garden is placed in the foreground. In the middle distance under the porch of a magnificently rendered Ionic temple is the Magdalen washing the feet of Christ, and in the distance, high up at the mouth of a mountain cave, we see Martha witnessing her sister's body being transported to heaven. The painter's familiarity with the look of antiquity gives his architecture the feel of authenticity, the late antique world reborn as the setting for the new Christian era.

Polidoro knew quite a lot about ancient painting. His source must have been either the Domus Aurea or other examples of Roman painting now lost, the same kind of landscape that inspired Giovanni da Udine (1487–1564) in Raphael's Loggie.[67] As in certain antique paintings, Polidoro's rendering is atmospheric; trees and water and light are in motion. The colors he has chosen are low-keyed neutrals, allowing the figures to blend into the landscape. The brushstrokes are quick and imprecise, almost impressionistic, the opposite of the sculptural renderings on his facades. Quite unlike the evident artistry of that highly ornamental genre, Polidoro here seems intent upon a credible evocation. He shows hardly less invention here than in his secular facades, but whereas they depend upon the artifice of the relieflike style, his work here is an exploration of a new kind of moody naturalism. In the late workshop of Raphael, master and assistants had certainly explored how to make the landscape background a dramatic backdrop to the events in the foreground – Giulio Romano was especially expert at manipulating chiaroscuro on ruins. Nowhere before, however, had the landscape moved out of the background to become the major element in the picture.

We have said that Polidoro's style here differed markedly from that on his facades, but in one respect, that of illusionism, his skills were uniquely suited to what the patron required. Fra Mariano had begun his career as barber and buffoon to Lorenzo il Magnifico in

Figure 52. Polidoro da Caravaggio, *Story of Mary Magdalen.* Mural, c. 1524–7. Fra Mariano Fetti Chapel, San Silvestro al Quirinale, Rome.

Florence. This only begins to tell his story, though, for he was beloved by Pope Leo and respected enough by members of the circle of Castiglione to be cited as an authority;[68] he was also reverent enough to have joined the Dominican Order. He obtained the church and convent of San Silvestro al Quirinale for the Dominicans of the Florentine San Marco from Pope Julius. Leo awarded him the office of *piombatore,* the keeper of the papal seal (later held by Sebastiano), which provided a lucrative stipend. Renowned for his pranks and for his wit, he is recorded as having quipped that he had discovered the secret of alchemy, for he had made gold out of lead *(piombo).* Certainly he was always willing to play the fool for the sake of making others laugh, but like the best of fools, he understood the healing qualities of laughter and the therapeutic benefit of mockery. It appears that Fra Mariano called upon his friend, Polidoro, the expert in illusionism, to apply his art in a new way in the service of the Church in what was a profound meditation in visual terms upon the doctrine of redemption.

There is a drawing for the altar wall of the chapel (Fig. 53)[69] showing a fictive architectural framework in which lateral niches house figures of *Saint Catherine* and *Mary Magdalen* (which paintings still survive in the

chapel) flanking a *Lamentation over the Dead Christ.*[70] The architrave is topped by a lunette that contains a *Resurrection.* There is a strongly articulated illusion surrounding the central scene: pilasters flank statues in niches projecting enough to make clear that we are meant to envision going through this passageway to where Christ's body appears.[71] The *Resurrection* above, by contrast, is removed by no such illusionism; it takes place in the "real" space in which the worshiper stands. What appears to be true – that Christ is dead – is the illusion, for in fact, Christ lives in the Resurrection. Mariano, the friar-buffoon, would have appreciated the

paradox and understood better perhaps than many what is sometimes called not the Christian tragedy but the Christian comedy because it ends not in death but in redemption. The subject artist after artist in the Renaissance attempted to resolve is handled here with the sophistication of Clementine Rome. It is altogether consonant with what we know of the patron's wit and culture and of the painter's predilection for illusionism that they should have come upon this beautiful conceit.

Interesting in connection with the illusionism in the Sala di Costantino and Polidoro's chapel is Quintilian's definition of *illusio:* what is expressed is contrary to what is meant. This is what we call "irony." It is apprehended in an oration, Quintilian says, by the introduction of contradiction, "either by the delivery, the character of the speaker or the nature of the subject. For if any one of these three is out of keeping with the words, it at once becomes clear that the intention of the speaker is other than what he actually says" (*Institutio Oratoria,* Bk. VIII, ch. 6, no. 54). Irony, then, is the verbal equivalent of illusionism. An illusion is something that appears to be what we know it is not (like Peruzzi's Salone delle Prospettive at the Villa Farnesina [Fig. 17] or the fictive tapestries in the Sala di Costantino [Pl. VII]). With both irony and illusionism, what is represented is not what is meant, and we are intended to reject the apparent truth of the appearance – in the case of Polidoro's conceit, it is the death of Christ.

PERINO DEL VAGA
(1501–1547)

Perino del Vaga, too, departed from the relieflike style he had demonstrated in Florence when he returned to complete the frescoes of the Pucci Chapel in Trinità dei Monti.[72] Pucci was a Florentine cardinal and a favorite

Figure 53. Polidoro da Caravaggio, sketch for the Fra Mariano Fetti Chapel, San Silvestro al Quirinale, Rome. c. 1524–7. Musée Condé, Chantilly.

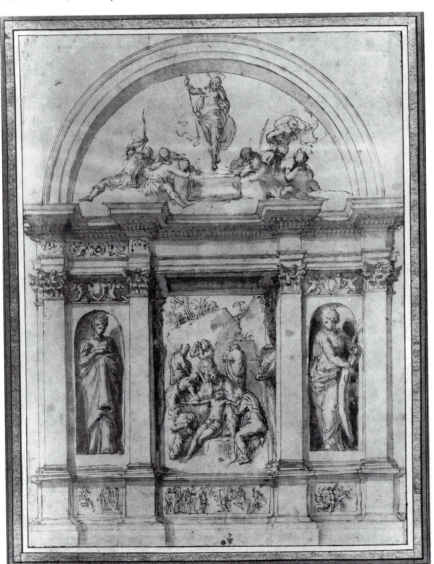

of the Medici, so much a favorite that Leo had borrowed a large sum of money from him and then died before repaying it. It may have been financial embarrassment, or it may have been the inauspicious atmosphere of Adrian's pontificate that discouraged Pucci from pursuing the decoration of his chapel in 1522 after it had been begun.

Perino's strength lay in design, in creating arrestingly graceful figures and combining them for ornamental effect. Perino never excelled in psychology, facial expression, gesture, or bodily movement that tell of state of mind or nuanced feeling. Perhaps this is why he apparently never undertook portraits. He was unsurpassed in his generation as a draftsman, and his drawings reveal his aptitude for creating patterns of light and shade, for inventing fluid patterns of drapery, for finding the elegant pose. In the narratives of the life of the Virgin in the Pucci Chapel vault, Perino is less at ease and less inventive than in the Sala dei Pontefici (Pl. IX), or even than in the Prophets on the outer arch of this chapel. The New Testament stories lack the extravagance of those frankly ornamental pieces, and although they are no less energetic, the energy is nervous and a little forced. These designs are essentially conservative, as were those of his other sacred works of this period: the surprisingly prosaic *Creation of Eve* at the center of the vault of the Chapel of the Crucifix in San Marcello al Corso,[73] or the *Deposition* for the altarpiece of Santa Maria sopra Minerva (to judge from the surviving fragments).[74] In these works Raphael's example was a powerful influence, but possibly equally important was the tradition of sacred decoration as a force reining in Perino's ornamental exuberance. The absence of the relieflike style he had shown in the Florentine demonstration pieces is appropriate, for it would probably have been deemed out of place in a religious context at this time.

The *Visitation* (Fig. 54) in the lunette is often said to resemble Pontormo's treatment of the same subject in the atrium of Santissima Annunziata, which is adduced as evidence that Perino had brought back with him from his

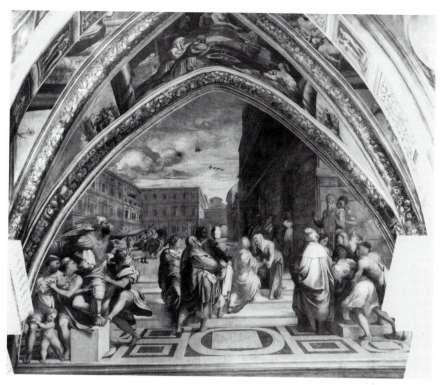

Figure 54. Perino del Vaga, *Visitation*. Fresco, c. 1524–6. Pucci Chapel, Trinità dei Monti, Rome.

visit to Florence some of the manner of Sarto's students. In fact, the stagelike setting, derived from Raphael's Stanze, with its framed space providing a monumental piazza for the meeting of the two expectant mothers, counts for more than any borrowing from Pontormo or Rosso. Perino's field with its ample space high overhead is not conducive to establishing the intimacy of the event, and he has felt the need to fill the empty spaces with overly movemented figures. These "extras" are cast in the role of making commentary upon what is a poignant, private moment, but not a very dramatic one. Thus they function largely as ornament, their febrile emotion generated for effect more than it is felt. Throughout his career Perino handled best those commissions that gave full freedom to his fantasy and allowed him to exercise his genius for creating graceful figures that he could manipulate for effects of surface ornament.

Rosso's "sweet" style, as displayed in his Florentine *Marriage of the Virgin* painted in 1523 (Fig. 42), was closer to Perino's style than Pontormo's manner was. We have already suggested that these two artists may well have established a rapport during Perino's stay in Florence. Rosso transferred to Rome and became part of the group of painters who worked and competed for the very few commissions that were given out in the little

more than three years between the accession of Clement VII late in 1523 and the Sack of Rome in May 1527.

"THE CLEMENTINE STYLE"

Because the artists looked upon Clement's papacy as a boon to art after the lean years under Adrian, too many of them came to the papal city for it to support them all. Parmigianino (1503–40), arriving from Parma in mid-1524, was accorded a warm welcome by Clement and his court, but in fact he apparently received almost no commissions, and Rosso, who must have come from Florence just a few months before, was eventually compelled to make his living selling drawings to the engravers.[75] The Golden Age of Clement, this brief moment before the Sack brought it all to an end, was more full of promise than of fulfillment, and Parmigianino's and Rosso's production was slim by any standards. Leo had emptied the coffers and Clement had very little to spend on artistic patronage.[76] The attempt to characterize pre-Sack Clementine Rome as a revival of Julius's and Leo's profuse patronage and to find a comparable flowering of artistic creativity fails in the face of the actual production.[77] There is nothing like the coherence of style that we saw in the previous decade; rather, these young painters were experimenting and trying out different manners in different circumstances. The options that Raphael had demonstrated in the Loggie and the Sala di Costantino were explored by those who had been in his *bottega*.

More than anything else, the meeting of Perino, Parmigianino, Rosso, and Polidoro in close and competitive circumstances provided an opportunity for an exchange of influence and for the forging of individual styles that would bear fruit principally after they were all forced by the Sack to flee far and wide. These young painters carried the style they each began to shape in relation to one another in the fertile breeding ground of Clementine Rome eventually to Genoa (Perino), to Bologna (Parmigianino, Marcantonio Raimondi, and Caraglio), to Parma (Parmigianino), to provincial central Italy (Rosso), to Fontainebleau (Rosso), and to Naples, then Messina (Polidoro).

PARMIGIANINO (1503–1540)

Parmigianino had spent his early years, before coming to Rome at the still-young age of twenty-one, in

Parma, where the scene was dominated by the figure of Correggio (1489–1534). From Correggio, Parmigianino learned a Leonardesque sfumato, which both painters used to eliminate harsh contour and to select areas for focus, concealing the unwanted in smoky shadow, much as Leonardo himself had done. Also from Leonardo, Correggio had learned how to stimulate affect. Whether his pictures were the visionary appearances of saints in the domes of Parmese churches or the loves of the pagan gods and goddesses, or altarpieces, their first and overwhelming appeal was to viewers' emotions rather than to their reason. Correggio's *Madonna of Saint Jerome* (Pl. I), painted while Parmigianino was in Rome, overflows with the open expression of love. The Magdalen's caress of the infant Christ's little hand has a sensuousness to it that is apparent also in the angel's smile. With Correggio's brush, Leonardo's techniques of softened contours, muted colors, and manipulation of light are raised to a new level of affect, by means of which Correggio intends to lift the worshiper out of the mundane to the realm of the spiritual.

Parmigianino assimilated some of this sensuousness from the older painter. Correggio was often characterized in the past as a provincial whose highly individual style resulted from his isolation, but this view has been challenged, and his knowledge of Raphael's Stanze and Michelangelo's Sistine by 1518 has been demonstrated.[78] John Shearman held that Correggio knew the Roman scene quite well but tailored his style, particularly with respect to his imitation of works of art fashionably prominent then in Rome, to his patrons' tastes.[79] Parmigianino must have felt his lack of familiarity with Rome all the more acutely in this case, and so he set out, in the company of one of the uncles who had raised him, to Rome to complete his education as a painter.

Among the pieces he took with him as his portfolio was one that would reveal how inventive he was. The *Self-Portrait in a Convex Mirror* (Vienna, Kunsthistorisches Museum), executed in Parma according to Vasari, is painted on a panel fashioned for the painter in the shape of a mirror. The fascination it shows with the distortions of proportion he saw in the mirror, exaggerated by the close-up hand that he pressed against the glass, is a harbinger of the direction the painter would take in Rome. Upon his arrival, the papal datary saw this and other works and was so impressed that he introduced Parmigianino to Clement, to whom the

Self-Portrait was presented as a gift. Clement too was stupefied, and hints of future patronage were dropped, but they were never followed up, as far as we know.[80]

Parmigianino had to content himself for the moment with studying the works of art around him. It was particularly Raphael to whom he gravitated, and again according to Vasari, he came to be regarded by many as Raphael reincarnated.[81] There is a drawing of his of the *School of Athens*[82] that proves his absorption in Raphael's style but also alerts us to how the young artist saw himself as capable of surpassing the esteemed master: he corrected the proportions of the figures, elongating them and narrowing them to accord with his own personal canon. Whereas the ratio of head to body in Raphael's figures is about 1:6, Parmigianino's is more than 1:7. Even more significant is his slimming of the torso, which makes the figures appear taller, lithe, and more fluid.[83]

His one major work of the Roman period that survives is an altarpiece now in London, a Madonna and Child with Saints, the so-called *Vision of Saint Jerome* (Fig. 55). The document of commission has recently been found, and although it leaves some important questions unanswered, it tells us a certain amount about the patron, the dating, and the subsequent history of the panel.[84] The contract is dated January 1526 and indicates that not only the altarpiece but the side walls of Maria Bufalini's chapel in San Salvatore in Lauro were to be decorated. This would seem to explain why Vasari said the commission was left incomplete at the time of the Sack, for although Parmigianino's altarpiece is certainly finished, there is no evidence that the side walls had been done. It is possible that these were to be painted by the artist's uncle, either in fresco or on panel. The church burned down in 1591 and nothing remains of the chapel, but the story of the vicissitudes of Parmigianino's altar is typical of what happened in numerous other cases at the time of the Sack. Before packing his nephew off, intending that they should both escape back to Parma, Parmigianino's uncle stored the panel with the friars at Santa Maria della Pace. It remained in the refectory of that church for many years until a relative of the patron removed it and had it installed in another family chapel in their native town of Città di Castello. Parmigianino never returned to Rome to recover his painting, but instead first spent some time in Bologna before returning home to Parma.

The contract revealed that the theme of Maria

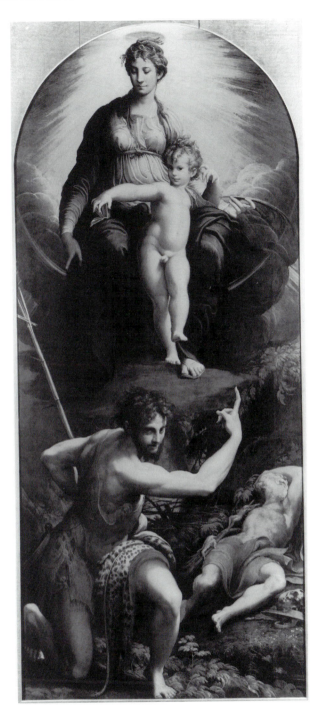

Figure 55. Parmigianino, *Vision of Saint Jerome*. c. 1526. National Gallery, London.

Bufalini's chapel turned on the genealogy of the Virgin and that the flanking scenes were to present the *Conception of the Blessed Virgin* on one side and the *Meeting of Joachim and Anna* on the other. This explains the barely visible half-moon, the traditional symbol of the Immaculate Conception, completing the circle of

which the lunette top of the panel is the upper part. What is still not explained is why Saint Jerome has been represented asleep, for no convincing text associating him with a vision of the Virgin has yet been found. Because Parmigianino only came to this solution in the course of planning the composition, and earlier drawings show Jerome upright, it is possible that the choice was a formal one to introduce an interesting asymmetry into the composition. It might also have been to allow him to quote Raphael's sprawling Diogenes on the steps of the *School of Athens* in his Jerome. The painting is a veritable *omaggio* to visual sources that the artistically informed patron and viewer were intended to recognize, foremost among them Raphael's *Madonna di Foligno* (Vatican, Pinacoteca), then hanging on the high altar of the Aracoeli, where, coincidentally, the Bufalini had another chapel that Pinturicchio had decorated in the early 1480s.[85] It would tax the inventive powers of even the most ardent iconographer to find a connection of content between each of Parmigianino's sources and his quotations; rather, the painter's interest in most of his models was formal. His citations are an acknowledgment of their authority, but there is also something competitive in it, as if in assembling such a rich array of references the sources themselves are surpassed. In his writing, Vasari made it clear that one way the new generation of artists surpassed their masters was in their ability to produce more of equally high quality.

We can trace the painter's process of creation and some ideas for composition and figure pose that he discarded in the twenty-five surviving preparatory drawings.[86] He began with the Madonna holding the Child in her arms, as specified in the contract, and only came late to the final solution of placing him between her knees. His thus unencumbered Madonna only then took on the air of elegance and sensuality that she has. Her remarkable breasts press through the diaphanous drapery. The Child, similarly freed, assumes an unchildlike posture and fixes the viewer with his knowing glance and smile. The exquisite charm of the soft flesh emerging from the shadow, his tousled curls, the elegant contortion of the pointing John the Baptist, combine to confront worshipers with an unaccustomed assault upon their emotions. As in Correggio, the appeal is made to the senses, not the intellect, and there is more of the sheerly aesthetic than we have previously encountered on the Roman scene. As in his drawing

after the *School of Athens,* figures have been elongated and slimmed according to an unnatural, but undeniably elegant canon of proportion.[87] Despite the verticality of the panel, Parmigianino's design is based upon curves. The vertical axis of John's body, for instance, has been concealed in the shadow, while the light picks out his curved arm and face and an ellipse of flesh on his thigh. Whereas in the Classic style the trunk is the static and dominant core, here its breadth is radically reduced and the focus is shifted to the limbs, which can be transposed more readily into rhythmic design.[88] In Raphael's *Madonna di Foligno,* John the Baptist plays a similar role, engaging the worshiper's eye and pointing upward to the vision in the heavens, but the difference is telling: Parmigianino's complexly posed and lighted figure introduces an element of conscious gracefulness not present in Raphael. This was already to be found in the source of the figure, Leonardo's *John the Baptist,* with his mysterious smile and finger pointing heavenward. The grace of Leonardo's figure, and above all, the sfumato that makes him beautiful, have been interpreted as a visual metaphor for that divine Grace that pacifies the tormented soul.[89] Leonardo's and Parmigianino's figures possess a beauty that goes beyond perfectly formed features and speaks of a quality of the soul. This is the point at which grace as an aesthetic quality and Grace as a divine gift converged in Renaissance thinking.[90]

Parmigianino sought to increase the grace of Raphael's style and to do so by a more elegant proportion, more rhythmic fluidity, and more sensual appeal, even at the expense of naturalistic correctness. In the language of Cinquecento criticism, the qualities he exhibited are *grazia* (grace), *venustà* (loveliness), and *leggiadria* (charm). These are new categories, scarcely to be found in Alberti.[91] Grace was discussed by Cinquecento writers first as a description of behavior; Baldassare Castiglione considered it the indispensable quality of the perfect courtier. A distinction was made in the ancient authors between beauty, which could be taught, and grace, which could not. According to Cicero and Quintilian, who identified grace as the indispensable attribute of the orator, it is an indefinable quality that accompanies simplicity, naturalness, and ease. It could not be obtained by following the rules, because too-close adherence to the rules begets stiffness and lack of grace. Beauty is attained by the exercise of reason and makes its appeal to reason. Qualities associated with beauty are grandeur, impressiveness, solemnity, and dignity, whereas

those that make up grace include persuasiveness, freshness, euphony, and sensuousness.[92]

Castiglione's adaptation for his discussion of behavior is the concept of *sprezzatura.* Just as divine Grace cannot be earned but is freely given, so the grace of the courtier or the orator cannot be learned but is the gift of God. Castiglione asks the question: how is the look of grace obtained? His answer is *sprezzatura,* a lack of contrivance, "nonchalance." He uses the metaphor of the bee, who goes from one flower to another gathering what it needs to make its honey. "So our Courtier must steal this grace from those who seem to him to have it, taking from each the part that seems most worthy of praise" (*The Courtier,* Bk. I, 26, Eng. tr., 42–3). We have seen in Chapter I that the apian metaphor was invoked by art theorists in the Renaissance as the prescription for how to create a beautiful figure, like Zeuxis gathering the most beautiful maidens of Croton and selecting their best features. It will be remembered that Castiglione, pretending to be Raphael, used this story to describe his painting procedure; however, he was describing how to go about painting a beautiful woman, not a graceful one. This new application of grace fits Parmigianino better than Raphael. Grace is a more flexible norm than beauty and allows considerably more license to the artist. It has aptly been compared to genius, because no amount of study can ensure it. As it came to replace beauty as the principal end of art, the artist became less bound to objective standards and more liberated to employ his own eye and his judgment.[93] This becomes the *non so che* of Firenzuola's description of the beautiful woman, and the *je ne sais quoi* of seventeenth-century French artistic theory.[94]

The shift from the Quattrocento to the Cinquecento is revealed in the difference between Alberti and Castiglione in their understanding of grace. Alberti, in *Della Pittura,* had counseled that grace could only be achieved by diligent study and careful imitation of nature – in other words, by the exercise of the intellect and the following of rules. Castiglione, following the ancients, declared that too much striving produces affectation, which is the opposite of *sprezzatura.* One should use art to conceal art, avoiding the forced, which always lacks grace. Vasari made this concept a part of his definition of the *terza età,* condemning Quattrocento artists as dry because they labored their works too diligently in order to attain exactness. He restored the distinction between beauty, a rational quality dependent on the rules, and grace, an indefinable quality dependent on judgment and therefore on the eye.[95] The origin of these definitions in the ancient writers' ideas on oratory and in Castiglione is evident.

Parmigianino's art seems the embodiment of grace and of *sprezzatura.* He finds more beauty in elongated proportion and gracile forms than in the more correct proportions of his predecessors. With his judgment and his eye, he can break the rules, and in so doing he attains grace. According to Cicero and Quintilian, grace does not make its appeal to the intellect but to the emotions, the heart. This is what Parmigianino understood faultlessly. The loveliness (*venustà*) of his figures is that quality in them that excites the emotions, in the same irrational way as love itself, and for this to take place, a certain degree of sensuality was necessary. Castiglione recognized that beauty alone can inflame the heart, but that the lover's emotion is enhanced by other qualities that the lover discerns in the beloved. "Many other causes besides beauty inflame our souls: such as manners, knowledge, speech, gestures and a thousand other things (which might, however, in some way be called beauties too)." (*The Courtier,* Bk. I, 53, Eng. tr., 82). The incipiently salacious quality of Parmigianino's *Madonnas,* which has been noted by many critics and would surely have troubled some of the more conservative churchmen in Clementine Rome, was his route to the worshiper's heart.

ROSSO FIORENTINO

In Rome, Rosso channeled the tendency of his personality to be impertinent, not to say outrageous, into a more subtle vein. The combined impact of experiencing antique and recent art, and the influence of his contemporary and rival painters, had a maturing effect that is visible in his two surviving panels of this period, the *Dead Christ with Angels* (Fig. 56) and the *Death of Cleopatra* (Pl. XIII).[96] The subtle sensuousness and gracile loveliness of Parmigianino's art had a salubrious effect upon Rosso, reinforcing one strain in his style and serving to help suppress another. We have seen that he vacillated between a harsh linearity (*Deposition* in Volterra, *Moses and the Daughters of Jethro* [Fig. 43]) and a sweeter manner (*Marriage of the Virgin* [Fig. 42]). The vehicle he employed to soften and dulcify his forms was a sfumato, as we have said, derived from Leonardo

through Andrea del Sarto. He shared this interest in sfumato with Parmigianino, who had derived it from Leonardo also, but through the intermediary of Correggio. This shared interest with Parmigianino gave Rosso a point of easy access to emulate aspects of his style. He chose, for his Roman period at least, to develop the seductive allure of mellow shadow and glowing flesh.

The *Dead Christ* has been characterized by some as bordering on the lascivious. Its sincerity has been defended recently on the grounds that the patron was a bishop who was renowned for his piety.[97] This important information serves as a warning that we can never safely read agnosticism or cynicism into sacred art of the Renaissance. Confronting this altarpiece with knowledge of the pictorial tradition that preceded it, we cannot help but be astonished, if not shocked. Surely some Renaissance viewers of less aesthetic sophistication would have been offended, but such was the atmosphere of Clementine Rome that there was an appreciative audience, however small, for audacious pictures such as this one. It pushes the interpretation of orthodox Christian doctrine to the limit. Like Michelangelo's Vatican *Pietà* – but not so chastely – it presents Christ as more asleep than dead, in anticipation of his Resurrection. The angels holding funeral candles regard him with restrained wonder; one, like the Apostle Thomas, is curious enough to poke a finger in his wound to assure himself of Christ's physical being. He sits upright on a sarcophagus, in divine denial of death, but conversely surrounded by symbols of his mortal suffering: he wears the crown of thorns; the nails and sponge are on the altar step at his feet. His enormous naked body fills the entire panel, viewed from an unaccustomed close vantage point. The worshiper is allowed no respectful distance, either physical or psychological, such as is usually given. Startling little details, like the teeth visible through smiling lips, red beard, pubic hair, add to the viewer's bewilderment and, at least initially, discomfort. Searching for justification, the theologically informed will recognize the eucharistic reference in the Body of Christ, which returns to the adumbrated Resurrection by another, liturgical route.[98]

But what are we to make of the obtrusive sensuality of this Christ, unprecedented in the tradition? Again, the painter has pushed at the boundaries of the orthodox and the acceptable, but here, too, justification can be found. The religious-erotic-aesthetic emotion is a continuum. More than a century would pass before

Gianlorenzo Bernini would make explicit the identity of religious and erotic ecstasy in his vision of Saint Teresa (Rome, Santa Maria della Vittoria, Cornaro Chapel, 1646), but he would use much the same means as Rosso, with the significant omission of nudity. This area had been explored both by Correggio and, regularly, by the Venetians, though in both cases it is made to seem a wholesome and life-enhancing connection, and the viewer is not made to experience the discomfort Rosso purposefully engenders.

That aesthetic emotion can trigger a religious response is an unspoken assumption in the Church's sanction of sacred art, though it is denied by some in the Counter-Reformation in the wake of such pictures as this one, or those of Parmigianino (Figs. 55; 77–79).[99] The premise of Renaissance idealizing art, when it applied to sacred images, was that Christ, Mary, and the saints were beautiful because their beauty expressed their divinity. Rosso's Christ is as beautiful as he can make him; Parmigianino's Madonna is the ideally beautiful woman. The criterion of beauty is constantly evolving, as we well know, and so the beautiful woman has developed from Fra Filippo Lippi's charming Florentine lady of the mid-Quattrocento, to Botticelli's etherealized maidens, to Raphael's sibylline matron of the *Alba Madonna* (Washington, National Gallery of Art). It is true that never before Parmigianino has she been permitted to be openly sexy, but her new embodiment reflects social change as surely in the 1520s as ever before.[100]

The Death of Cleopatra (Pl. XIII), though a secular painting, is remarkably similar to the *Dead Christ*. Not only does this similarity help with the dating, but it also points up significantly the interchangeability of sacred and secular for Rosso. We have seen, and will see more evidence of it, that this was not the case for Perino or for Polidoro, both of whom differentiated their styles according to use. Rosso's and Parmigianino's indiscriminate evocation of sensuality, regardless of subject or function, set the precedent that some in the next generation of painters, like Bronzino and Salviati, would follow. Although the censure of Counter-Reformation critics was initially directed at Michelangelo's nudity in the *Last Judgment,* as we shall see, it was merely the scapegoat for all the offenders, beginning with these.

Rosso has painted *Cleopatra*, like the *Dead Christ,* as a silent, close-up contemplation of death. The poisonous asp is wound around her upper arm like an ornamental

armband. The queen, who has taken her life rather than endure the public ridicule that Augustus has prepared for her on her arrival as his prisoner in Rome, rests her head in a languid pose quite similar to Christ's. Both support themselves with graceful composure, as if in repose. Similar too are the limited depth and the dark shadows that surround the tenderly revealed body, creating the feel of intimacy. Unlike Christ, whose rosy flesh contradicts his death, her color has already drained away and its whiteness contrasts with the healthy pink of her attendant. Luminous flesh is surrounded by a frame of rich color in both pictures, striking *cangianti* in the drapery of Christ's attendant angels, more delicate *cangianti* in Cleopatra's maid. Cleopatra's pose is based upon one of the best-known antiquities in Rome, the *Sleeping Ariadne* (Vatican, Museo Pio-Clementino), which was called in the Renaissance *Cleopatra*.[101] The changes that the painter has made – lowering one arm, tilting her head back – open her pose and increase her vulnerability. His is by far the more poignant, and the more graceful, figure.

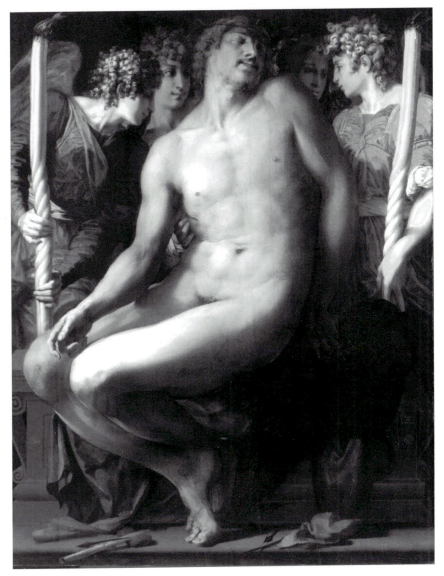

Figure 56. Rosso, *Dead Christ with Angels.* 1525–6. Courtesy, Museum of Fine Arts, Boston. Charles Potter Kling Fund.

It is interesting to compare Rosso's adaptation of an antique sculpture to those of Perino and Polidoro. His relationship to the relieflike style is complex, reflecting his affinity to Parmigianino's painterly sfumato at the same time that he is responding to certain features in Polidoro's and Perino's styles. There is more relief in these figures than in his Florentine works, and the way he presses his figures up to the plane and fills the whole space with them is akin to relief. Then, too, we see that increase in monumentality that affected all the artists who came to Rome – Vasari commented upon it with respect to Andrea del Sarto, saying that whereas his *disegno* was sweet and graceful, he would have enriched his composition and given more force and refinement to his

figures if he had stayed in Rome.[102] Rosso's painterly manner of handling light and edges denies this sculptural quality, as if in calculated contradiction.

Where would these paintings have been installed? We have no documentation on this point for either of Rosso's panels. In the case of the *Cleopatra* there is little doubt that it would have hung in some private palace, perhaps as part of a series. It need not have been a very grand setting, for the picture is only about three feet high. The *Dead Christ* is small for the altarpiece in a church, which suggests that it may have been intended for private devotion. Both the audacity of the conception and its intimacy bolster this assumption, which, at

present, can neither be proved nor disproved. All we know is that because of the Sack it never hung over an altar in Rome, and presumably never reached its intended destination. It is of some interest that it had a curtain, at least when it was being temporarily stored with some nuns in a Roman convent.[103] Possibly Rosso had hastily contrived a covering for his nude out of deference to the nuns, but in the rush to save life and property at the time of the Sack, this is perhaps less likely than that it was designed to be kept discreetly covered.

SEBASTIANO DEL PIOMBO (c. 1485–1547)

The dean of the Roman artistic community was Sebastiano del Piombo, who at thirty-eight was the oldest by more than a decade, and who was the clear favorite of the pope. He had been chosen by Clement when he was still cardinal to execute the *Raising of Lazarus* (Pl. III), an altarpiece intended for the church that was the seat of his bishopric in Narbonne. The wily Medici patron at the same time commissioned his arch-rival, Raphael, to make the *Transfiguration* for the same chapel, thereby assuring that both painters would apply their best efforts. When Cardinal de' Medici assumed the papal throne as Clement VII, Sebastiano was awarded the commission to make his portrait (Fig. 57). Sebastiano captured the elegance and arrogance of Clement in a bold and monumental painting. Imposing in scale (the panel is nearly five feet high), the pope turns his head and glances sideways, displaying his long straight nose to advantage. The pose, which in its twist is novel in portraiture, derives from Michelangelo's energetically posed Prophets on the Sistine ceiling, specifically *Isaiah*.[104] Compared to Raphael's portrayal of the aged Pope Julius, lost in thought (London, National Gallery, 1512), or his rendering of Leo X (Florence, Pitti) as connoisseur – with two advisers, including the future Pope Clement at the left – Sebastiano has given us an upright, powerful, solitary, commanding and worldly pontiff, one so sure of his own mind it comes as no great surprise that his miscalculations in policy soon led to disaster.

Sebastiano took up Raphael's role, after the latter's death, as the principal portraitist in Rome. Giulio Romano had some successes in the genre, and both Parmigianino and Rosso made some portraits while in Rome, but of conspicuously less important persons than Sebastiano's clients. Numerous cardinals and other men of prominence joined the pope in making use of Sebastiano's skills. Even Pope Adrian had been painted by him.[105] He was also in some demand as a painter of devotional images. His style bore closest affinity to his friend Michelangelo's in its bold relief and ponderous grace. Throughout the decade, while Michelangelo was in Florence and Sebastiano in Rome, the two artists kept in touch by letter, and because on various occasions Michelangelo had supplied Sebastiano with drawings, patrons who knew they could not acquire the services of Michelangelo directly came sometimes to Sebastiano as his surrogate. Alone among the painters in Rome in the 1520s, Sebastiano depended more on the example of Michelangelo than on that of Raphael.

In contrast to the younger painters, Sebastiano shows little sensuousness or softness and none of their self-conscious striving after affect and grace. In this sense Sebastiano continues the Classic style as it had been fashioned in the previous decade by both Michelangelo and Raphael, but even more than they, he practiced an austere

Figure 57. Sebastiano del Piombo, *Portrait of Clement VII.* c. 1525. Capodimonte, Naples.

style, almost entirely purged of ornament. We find nothing playful, diverting, or ingratiating in his pictures. Even his preference for dark chiaroscuro is austere, devoid of the romantic overtones of mystery that accompany Giulio Romano's use of the same device. Against his blackish backgrounds his robust figures emerge in colors we could call more descriptive than decorative.

Sebastiano's manner was hard-edged and sculptural, like that of his mentor Michelangelo. But as Michelangelo himself sometimes did, his figures might be flattened to the plane. In the *Raising of Lazarus* (Pl. III), Sebastiano's Lazarus, based on Michelangelo's drawing, moves close to the conventions of the relieflike style. The curious awkwardness of his pose makes sense when we recognize that while transfixed by Christ's gesture, the resurrected man is releasing himself from his shroud with understandable urgency. Thus his splayed leg, caught in the frontal light and flattened, has been raised to step out of the bindings, and at the same time he reaches across his torso to lift off another swath of cloth. Dramatic twists such as these abound in Sebastiano's pre-Sack art in emulation of Michelangelo's contrapposti, but the further he gets from the master and his example in the 1520s, the less we see of the conventions of the figure in his paintings.

Like his predecessors in the Classic style, Sebastiano has nothing against the graceful pose, so long as it conveys dignity. At times he imitates Raphael instead. In the *Holy Family with Infant Saint John* (Fig. 58) for Pope Clement, mother and father regard their sleeping child. The veil she so tenderly removes, as well as the altarlike table and shroudlike sheet, all allude to Christ's death and its sacramental meaning. There is more of nobility than charm in the Madonna. We catch the undercurrent of anticipated

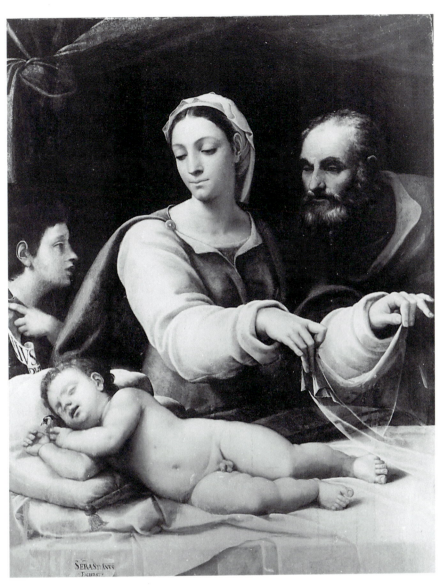

Figure 58. Sebastiano del Piombo, *Holy Family with Infant Saint John*. 1525. Muzeum Umení, Olomouc.

tragedy from the sedate rhythms and the coloring rather than from her expression, which is touching in its stoical restraint. Raphael's *Madonna di Loreto (Madonna of the Veil)* was the source of the motif, but Sebastiano has sobered the scene and removed the playful intimacy of mother and child that Raphael had created. Half-length devotional images such as these were generally intended for private veneration and are therefore usually characterized by vivacity and informality.[106] Sebastiano's is brooding and deliberate, but the stark intensity of the parents' emotion restores the sense of intimacy.

Appropriate to his prestige and experience, Sebastiano seems to have been kept busier with commissions

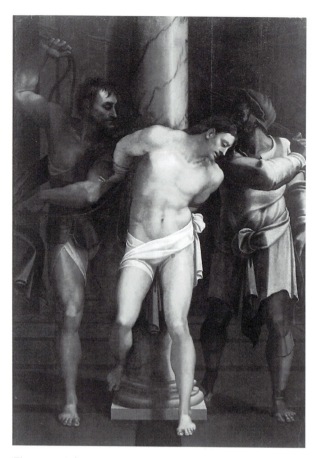

Figure 59. Sebastiano del Piombo, replica of the *Flagellation of Christ*. 1525–6. Museo Civico, Viterbo.

than the younger painters then seeking employment in Rome. In fact, he appears to have had more work than he could handle. An intimate of Pope Adrian, Cardinal Enckevoirt, commissioned him to paint his chapel in Santa Maria dell'Anima, but after long delay the commission was taken away from Sebastiano and awarded to Michael Coxie (1499–1592).[107] One of the most prestigious commissions given out in these years was that of completing the two Chigi Chapels with altarpieces. Chigi, like his artist, Raphael, had died in 1520, leaving both the chapel in Santa Maria del Popolo and the other in Santa Maria della Pace uncompleted. In 1526 his heir made a contract with Sebastiano to paint both altarpieces. Sebastiano had elaborate arrangements made to prepare the wall in the Popolo so that he could execute an oil mural, the same technique he had successfully pioneered in San Pietro in Montorio.[108] A *modello* (Amsterdam, Rijksprentenkabinet) is all that came of that contract, which was interrupted by the Sack. Another contract had to be drawn in 1530.[109]

For a church in Viterbo, Sebastiano created a replica

on panel of his oil mural in San Pietro in Montorio representing the *Flagellation* (Fig. 59). The commission came from the same patron, a cleric high in the papal court of Clement, who had ordered a *Pietà* a decade earlier.[110] Evidently the patron knew the painting in Rome and wanted a copy for his native city. This is by no means an uncommon occurrence at this time, but often we assume that the replicas were made by someone else. In this case Sebastiano must have welcomed the opportunity to redo it, for he made important changes and mentioned that he had finished it in a letter to Michelangelo in Florence in 1525. The changes move toward simplifying the composition, which had not been cluttered with inessentials to begin with. The figures were reduced from five to three, the columns from five to one. The rich pattern of light and shade, which had given depth to the pictorial space and a pleasingly active pattern to the surface, was eliminated in favor of a single focus on Christ.

This work is a clear indication of the direction that Sebastiano was moving in during these years, toward a still more austere style, and it is counter to the direction of taste and style in Roman painting generally at this time. Sebastiano is the sole adherent of this austere style in Clementine Rome, but it links him to the tradition of Giotto, Masaccio, Piero della Francesca, and Ghirlandaio. In the century and city where tolerance and appreciation for the ornate was universal, Sebastiano is strangely isolated. Despite his success, the other painters showed no indications of emulating his manner, nor is there recorded interchange of other kinds. Sebastiano had made a *Visitation* (Paris, Louvre), signed and dated 1521, which we might reasonably expect to have had some influence on Perino's fresco of that subject (Fig. 54), but they could hardly be less similar.

There is such a distinct difference between the temper of Sebastiano's painting and that of the circle of Parmigianino, Rosso, and Perino, one can readily understand how certain patrons would have been drawn to the one camp and others to the other, but with little crossover. The more overtly devout members of the papal court might have found Sebastiano's piety more to their taste and might well have been repelled by the emotion tinged with sexual innuendo that made the sacred images of the younger artists appealing to the more worldly, more sophisticated circle. As for antiquarianism, Sebastiano showed no particular interest, and the closest he came was the imitation antique relief at the

bottom of his portrait of *Andrea Doria* (Rome, Palazzo Doria-Pamphili), which was probably provided in response to the wishes of the patron.

The marquis of Mantua's request in 1524 through Castiglione for something of Sebastiano, as long as it was not about saints, suggests on the one hand how far his fame had spread, and on the other, that he was already being associated with sacred images. Despite the absence of anything but portraits and religious works from his oeuvre during this period, it is apparent from his reply (relayed in 1527, not for the first time, clearly) that he had not entirely given up secular narratives, for he promised to do "something stupendous" for Gonzaga.[111] It was never executed, and the events of the Sack intervened in a way that turned Sebastiano even more single-mindedly toward devotional images.

PRINTS

An important part of the Roman scene in which all of these painters except Sebastiano took part was the translation of their drawings into engravings. Competitors to Marcantonio Raimondi had taken up this new business already during Raphael's lifetime, and the audience of collectors appears to have grown steadily to support them. Interest in series created a new genre in which the painter invented new designs for the engraver, instead of turning over unused drawings, as Raphael had done, for the most part. We have already seen that Giulio Romano had been engaged in such a series, *I Modi,* which may have been responsible for his loss of Clement's favor. Northern prints were imported in large numbers and were known, admired, and studied by the painters, Dürer's woodcuts and engravings in particular. The Roman counterpart to the Passion series or the life of the Virgin or the Apocalypse were the subjects neglected by the northerners – stories from classical mythology.

Parmigianino formed a tie with the engraver Gian Jacopo Caraglio (c. 1505–65), the first of several printmakers with whom he would associate himself in Rome and then in Bologna. As Raphael had done, he turned over drawings either of discarded designs or aborted commissions or, in some cases, drawings made for the specific purpose of the print. Often we have no way of knowing the origin. Certainly these painters, hungry for recognition and for commissions, understood that the medium of prints could spread their

fame further and faster than paintings made for some secluded or private setting. Parmigianino's preferred graphic medium was pen and ink and wash; when heightened with white, such a drawing provided the engraver with the tonal scale he could imitate with his burin. Caraglio was very successful in capturing the fluid rhythm of Parmigianino's style. The drawing still exists[112] for Caraglio's engraving of the *Marriage of the Virgin* (Fig. 60), and comparison between the two is instructive. Despite the harshness still inherent in the engraved medium at this date, the elegance of Parmigianino's style is conveyed. Caraglio has carefully imitated the elliptical and serpentine shapes of the painter's highlights, for example, and he has preserved the sense of an overall pattern of light and shade that creates ornamental surface pattern. No less than in his paintings, it and the graceful elongation of his figures enthrall the viewer. Parmigianino worked also with Ugo da Carpi (c. 1450–1520?), a pioneer of the chiaroscuro woodcut who created his masterpiece, *Diogenes,* on Parmigianino's design. The medium is particularly apt for Parmigianino's painterly style as it produces effects like those of wash.[113]

Rosso was fortunate in receiving the commission to decorate a chapel almost as soon as he arrived in Rome. His sharp tongue and competitive spirit got him into trouble almost as quickly, so that when he bad-mouthed the respected architect of the chapel, Antonio da Sangallo, he was dismissed after only a few months of work, and no more major commissions came his way. Benvenuto Cellini (1500–71), who reported this in his *Autobiography,* said also that Rosso had so angered the followers of Raphael with his backbiting that they were ready to murder him. According to Cellini, who was given to exaggeration, and especially to exaggerating his own role, Rosso was saved only by his personal protection.[114] Rosso, who was a superb and facile draftsman, must have turned to prints in order to support himself. Working with Caraglio, he designed thirty-one engravings, beginning in the fall of 1524 with the eccentric sheet known as *Fury* and six plates of the *Labors of Hercules.* It has been suggested that there is an autobiographical basis to the *Fury* (Fig. 61), that it is an expression of his frustration over the difficulties that he continued to have with his patrons and his colleagues.[115] Although this may well be true, at the public level the *Fury* was certainly an allegory, as yet not fully understood. The unusual imagery relates

more to the northern fondness for the macabre than to Roman classical taste, though references to classical antique statues are contained in it. Surrounded by strange, unexplained allegorical beasts, the cadaverous nude, his arm wrapped by a serpent and holding a skull, strikes a pose that the Roman cognoscente would have recognized, with a wry simper, as that of the *Laocoon* (Fig. 1). The Trojan priest's response to death is restrained, however, in comparison. Rosso's wit has not deserted him here. The raging nude, railing against the

perils to his life, has been deprived of his penis, like so many antique statues – a trenchant way of expressing his sense of impotence. The sheet suggests a parody of antique art, presented as if by a northern printmaker. He has turned the classical world on its head: heroic nudity is transformed into pathetic emaciation; unflinching fortitude becomes clamorous frenzy; the rational setting of classical architecture has been replaced by a sinister dark wood. Rosso's capsized classicism must have appealed to connoisseurs who knew the alternative world of the north and who would savor the mockery in his inverted perspective.

In 1526 Rosso made drawings for twenty *Gods in Niches,* also to be engraved by Caraglio. The entrepreneur who had worked with Raphael, Il Baviera, commissioned them and evidently owned the plates.[116] Comparison between the prints and the two surviving original drawings for *Pluto* and *Bacchus* shows that Caraglio was very faithful to the drawings, and that Rosso used his red chalk and wash to facilitate the engraver's task, so that some of the parallel lines in the shading could be followed almost line-for-line by the engraver. It was a close and very productive collaboration. Caraglio's prints after Rosso constitute about half of the engraver's total production; Rosso's print designs were his greatest achievement in Rome.[117]

None of Rosso's prints dealt with religious subjects. Perino del Vaga found opportunity to design secular images only in prints during these years. A series of the *Loves of the Gods* based on Ovid was originally commissioned from Rosso in 1527, and he made two designs before getting into an altercation with Il Baviera and quitting the job. Perino was then engaged to complete the set and contributed sixteen designs. They served the same clientele as *I Modi,* but cloaked in the guise of illustrations of classical texts, theirs is a refined eroticism, rather than undisguised soft porn. They may have been made to fill the gap of the confiscated plates. In any case, they were so much in demand that five sets of copies were made, making it one of most successful series in the Renaissance.[118]

Perino's superb sense for filling the field with delightful ornaments gives his sheets a lighthearted exuberance and playfulness. They seem at times almost to mock the passions they represent. Jupiter's emblematic eagle, always required to accompany his boss on his amorous exploits, looks on with something like outrage as the king of the gods beds a willing Semele, or snaps

Figure 60. Caraglio, after Parmigianino, *Marriage of the Virgin.* Engraving, c. 1525–7. © British Museum, London.

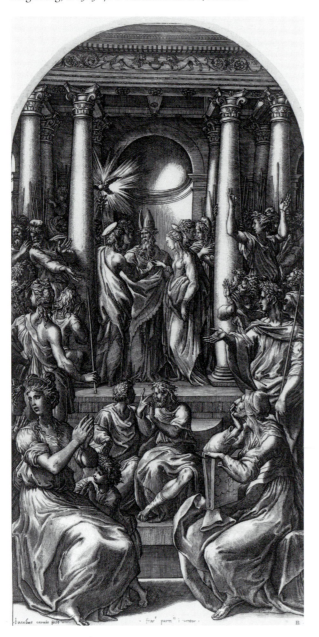

viciously at an assisting Cupid as Jupiter overcomes Io in a cloudlike disguise. Another Cupid, lolling at the feet of his mother, aims an arrow at her crotch as Mars draws her attention away from her mirror with an embrace. Though some of the scenes are quite explicit, the jocose spirit is sustained throughout. Unlike his conservative religious images of the same period, Perino was free here to explore the relieflike style again. In *Mercury visiting Herse* (Fig. 62), the god assumes a ridiculous, if delightful, pose, with legs in profile, frontal torso, profile head, and arms extended and kept in the plane. Like the twisted figure of Herse's sister he is stepping over, their contortions recall the conventions of sculptural relief – appropriately enough in the case of the sister, for Mercury has turned her into stone for interfering in his affair. These conventions are even more evident in *Vertumnus and Pomona* of the same series.[119] Far less severe than the *Crossing of the Red Sea* (Pl. XI), the style Perino explored here anticipated his own later manner, as he would develop it at the court of Andrea Doria in Genoa, before returning and reintroducing it in Rome a decade later.

Figure 62. Caraglio, after Perino del Vaga, *Mercury visiting Herse,* from *The Loves of the Gods.* Engraving, 1527.

Figure 61. Caraglio, after Rosso, *Fury.* Engraving, 1524. © British Museum, London.

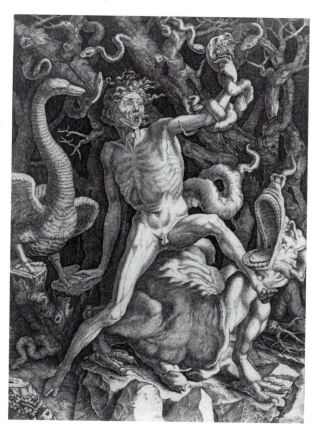

The importance of these prints in encouraging the taste for the relieflike style and disseminating it should not be underestimated. It is likely that Andrea Doria and Federico Gonzaga and François I, for example, were far more familiar with the prints of the artists they hired as their court painters than they were with the paintings these artists had executed in Rome or Florence.

THE SACK

The years of Clement's pontificate were troubled ones and he was ill-suited to the times. In the struggle between France and the Emperor Charles V for the domination of Italy, Clement tried to appear to remain neutral, while favoring first one side, then the other more or less secretly. This policy angered both and contributed nothing to settling or stabilizing the situation. In a letter to the emperor, the imperial ambassador to the papal court characterized Clement as timid and vacillating, truly in the hands of his advisers, although he wished to appear independent.[120] Sebastiano's portrait reveals precisely that haughty vanity that conceals irresolution.

Not only international politics but, even more pressing, the progress of Lutheranism required Clement's attention. After his excommunication in 1520, Martin Luther had thrown himself into the battle to win souls to his cause. With an energy wholly lacking on the Catholic side, he mustered every means to broadcast his message. Among the most effective was the illustrated pamphlet, making use of the medium of prints to reach the mass of the laity.

No less an artist than Lucas Cranach (1472–1553) undertook to illustrate the Lutheran position in a brilliantly conceived booklet called *Passional Christi und Antichristi,* published in 1521. Using techniques like those of the modern advertising industry, the message was presented graphically and simply, with no other text than that of the scripture, already familiar to his audience. On one page was an image of Christ, on the facing page an image of the pope as the Antichrist. The Antichrist appears in the Bible as the opponent of Christ who puts himself in Christ's place. He enjoyed widespread popularity in the Middle Ages as the harbinger of the Last Judgment; as such he is figured in Signorelli's frescoes at Orvieto.

Luther had enunciated the bold idea that the Antichrist had been on earth for centuries, unrecognized, in the form of the pope.[121] In the Lutheran pamphlet, not only is the Antichrist specifically identified as the pope, he even looks like Leo, especially in the image of the pope smugly enjoying a tournament of mounted knights among the well-dressed members of his court.[122] The contrast is drawn repeatedly between the humility of Christ and the pomposity of the papacy. On one side we are shown Jesus washing the feet of his Apostles; opposite we see a crowned king on his knees kissing the pope's foot. The contrast between the pretensions to temporal power of the papacy and Christ's consuming interest in the spiritual is the theme of several sheets. Whereas Christ when tempted with a crown refused it, the pope is shown with cannons and armed troops accosting a prince who rides in full armor. Christ suffered the mocking and crowning with thorns; the pope accepts the triple crown granted him, according to the contention of the papacy, by the Emperor Constantine in the Donation of Constantine. The claim to the temporal power of the papacy rested on a document called the Donation of Constantine, in which the emperor granted the pope the city of Rome. Christ cleansed the temple of those who had turned it into a market; the pope sits enthroned in church in front of the altar and dispenses indulgences while his clerics pile up the money on the table (Fig. 63). The climax shows Christ ascending into heaven while the pope, tormented by evil beasts, is thrust headfirst into the flames of hell! Even the choice of material, the unpretentious woodcut, was brilliantly matched to the intended audience. Cranach's designs, like the message, are legible and uncluttered. The northern use of prints for religious and political propaganda contrasts markedly with the kind of prints that were being made at the same time in Italy and underscores how separated the two worlds were.[123]

In the Quattrocento, using the new methods of textual criticism, a humanist had proven the document of the Donation of Constantine to be a medieval forgery. In the Lutheran camp this discovery was used as the centerpiece of an attack upon the political authority of the papacy, and that polemic is reflected in the woodcuts we have just been discussing. The Sala di Costantino, which had been left incomplete during the reign of Adrian, had originally been planned to show two further events in the life of the emperor. When the commission was taken up by Clement, the program was altered. The scenes originally planned were replaced by two others that reasserted the Catholic claim to temporal power based on the Donation of Constantine (Fig. 28). It was a calculated propagandistic reply to Lutheran polemics.[124] On one wall the emperor is subject to the pope as he, shorn of his imperial regalia, bows submissively to receive baptism from the hand of Pope Sylvester. On the window wall, the last to be executed, the Donation of Constantine is acted out in Saint Peter's. The emperor kneels before the pope, who sits enthroned beneath his canopy and receives the document from a nearly supplicant Constantine.

The woodcut images give a hint of the depth of hatred for the papacy that had been developing in Germany, which Luther tapped into. The issue over which the fires had broken out, it will be recalled, was the Church's effort to raise money for the construction of a new Saint Peter's by the sale of indulgences. The worldliness of the Renaissance popes, from the warrior Julius to the prodigal Leo, had alienated the largely middle-class society of German burghers, who had no more appreciation of Italian art and patronage than had the Dutch pope Adrian. Rumors of a style of life at the papal court that sounded nothing if not dissolute crossed the Alps, and the farther they traveled the more

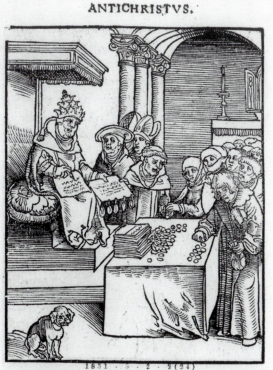

. CHRISTVS. . ANTICHRISTVS. .

Inuenit in templo vendentes oues & boues & columbas & nūmu-larios sedentes, Et cū seciffet quasi flagellum de funiculis, omnes eiecit, de templo, oues quoq; & boues & nūmulariorum effudit es, & mensas, subuertit. Et his qui columbas vendebāt, dixit. Auferte ista hinc, & no-lite facere domū patris mei, domū negationis. Iohā.ij. Gratis accepistis, gratis date. Matthei, x. Pecunia tua tecum sit in perditionem, Act, viij.

Hic sedet Antichristus in tēplo Dei, ostendens se tanquā sit Deus. Sicut Paulus ρdixit.ij.ad Theffa.ij. Cōmutat & subuertit omes diuinas constitutiones, queadmodū Daniel dicit. Opprimit sacram scripturam, vēdit dispensatioes, indulgentias, pallia, eρatus, bñficia, tollit thesauros sεculi, dissoluit matrimonia, grauat suis legibus cōscientias, sancit iura, & rursum eadē ρ pecunia rescindit, refert in nūerū diuorū sanctos, siue Canonizat, bñdicit & maledicit in quarta gñatione, & ρcipit suā vocē audiri tāquā vocē dei.c.sic omīs.dist. xix.Et nemini ē ρmissū de sedis Apłice iudicio iudicare vel retractare, xvij. dist. iiij.c, Nemini.

Figure 63. Lucas Cranach the Elder, *Christ cleansing the Temple* and *The Pope as Antichrist selling Indulgences,* from *Passional Christi und Antichristi.* Woodcut, 1521. © British Museum, London.

they tended toward hyperbole. The frequent demands for reform had been ignored by Leo. Adrian in his brief rule had attempted to rectify some of the abuses, but he had alienated nearly everybody and proved ineffectual. Clement showed little inclination to change, and in fact, returned to the absorption in dynastic politics of his Medicean predecessor.

Thus it was that the soldiers of the unruly army of the emperor, who had not been paid in many months and were spurred on by the promise of the rich booty that would be theirs when they took Rome, descended upon the Eternal City on 6 May 1527. There were many among them who were Lutherans, bent upon venting a hatred of the papacy that had been fanned by such propaganda as the Christ/Antichrist pamphlet. The pope, who believed his advisers when they claimed the city could not be invaded, was forced to take refuge at the last minute in the fortress of the Castel Sant'Angelo

with thousands of other refugees from the Vatican. The entire city was pillaged and the Vatican was ransacked and despoiled of its wealth, from Raphael's tapestries to the liturgical vessels of precious metal and jewels. Graffiti scratched into frescoes record to this day the obscenities of rampaging German soldiers. Those who could, fled, but not without abandoning their property; we have seen how Parmigianino and Rosso sought to secure their undelivered paintings in religious houses, in hopes that they would be able to reclaim them later. Many had to pay high ransoms to escape with their lives. The soldiers remained in possession of the city for nine months, finally withdrawing only in February 1528, by which time the pope had escaped to relative security, if not to comfort, in the episcopal palace at Orvieto. It is said that not a single palace, church, or convent eluded the looters. The life of the city was totally disrupted, the city a ruin. From having been the

capital of artistic production in Italy, Rome was deserted by artists and patrons alike.

But this situation following the Sack was only temporary for the arts, necessitated by the flight of the artists, the physical destruction of the city, and the postwar hardships that kept people either away from Rome or engrossed in the problems of subsistence. Art is always at the top of the economic pyramid, the last stone to be put in place. When conditions demand that attention be paid to the building blocks beneath, art is perforce neglected. It took almost a decade for the pyramid to be rebuilt to the point that patrons were ready to invest again in embellishing their palaces or their chapels, but it finally happened. The opportunity to work on the temporary decorations for the entrance of Emperor Charles V to Rome in 1536 attracted some artists back to Rome, and this event marks the turning point in Rome's recovery. What followed under the Farnese pope, Paul III, was more like the halcyon days of Julius II than like the decade following the Sack.

The Sack did not mark the end of the Renaissance, as is frequently claimed. It has been used as a convenient cutoff for those who want to conclude their studies before entering into the issues raised by the Counter-Reformation or the art of Salviati, Perino del Vaga, Vasari, Bronzino, and their contemporaries. The break it created has been exaggerated as a result. As we will see in Chapter 4, the papacy of Paul III is in many ways an intentional revival of Rome before the Sack, with the added factor of growing dissent within the Church and the defection of more and more of transalpine Europe to the camp of the Protestants.

CHAPTER THREE

The Diaspora of Roman Style

FTER THE SACK, WHEN PAINTERS FLED ROME IN SEARCH OF PERSONAL safety and work, several found positions at courts that provided them with job security. The long-term result of the Sack was not the collapse of Rome as the leading artistic center of central Italy, for Rome revitalized itself in the 1530s. Rather, it was the transfer of Roman style to centers in northern Italy like Mantua, Genoa, and Parma, and even to the French court of François I. Some, like Perino del Vaga, would eventually return and take up residence again in Rome. Others, like Francesco Primaticcio, after working alongside first Giulio Romano in Mantua and then Rosso Fiorentino at Fontainebleau, would visit Rome and introduce further developments that had taken place abroad. There were tragic losses, to be sure: Polidoro da Caravaggio's collaborator, Maturino, was killed in the Sack. Others suffered trauma from which they were a long time recovering, like Sebastiano del Piombo, and perhaps also Francesco Parmigianino. Some wandered for several years without any sustaining patronage, taking provincial jobs where they were offered, like Rosso. Others transferred to other cities, like Polidoro, who went first to Naples and then to Messina in Sicily, but never found an opportunity comparable to that of Rome before the Sack to form a workshop and create a corpus of work.

The style evolved in Rome was particularly attractive to princes, for whom the borrowed authority of classical antiquity could bolster the image of themselves and their states. For this purpose the style had no peer. But there were other courts that evinced no interest in the Roman style, like Ferrara, which turned northward for its painters, especially to the Veneto. The Roman style had little appeal in the republics of Florence, Siena, and Venice and was not welcomed there. It was not until the Florentine Republic collapsed and the city was converted into a duchy that Cosimo found it useful to import the style. The Sienese Domenico Beccafumi (1485–1551), after his visits to Rome, returned home and introduced Roman antique subjects and the occasional *grotteschi* in his paintings, but there was not the same kind of demand in the Republic of Siena as in the courts. The greatest successes of the Roman style on the Italian peninsula were in Mantua and Genoa, where canny rulers curried the favor of the emperor with lavish hospitality and gifts while maintaining the appearance

of independence with their subjects. The aura of imperial Rome imposed by them upon their local court provided a valuable tool of political publicity.[1]

After the troops of the emperor sacked Rome and marched through the Italian peninsula, the imperial domination of Italy was established. Although the princes maintained a show of power, they ruled their states by the consent of Charles V, who supported local rulers in order to prevent any one gaining enough power to oppose him. Even the French king, who had been Charles V's rival for election as emperor in 1519 but had been defeated at Pavia in 1525, taken hostage, and forced into a treaty, was in thrall to the emperor. This situation is everywhere reflected in the art of these courts. It is the emperor who lurks behind one lavish artistic project after another, never as patron, but as the audience for whom it was readied or as the recipient of it in the form of a diplomatic gift. We shall see this scenario again and again, as the emperor and his court, constantly on the move, visited first one court, then another. And if it was not a visit of the emperor that supplied the focusing event, it might be a wedding to a relative or courtier of Charles V, which had to be equally sumptuously prepared.[2]

MANTUA AND THE COURT OF GONZAGA

Most of the artists who went abroad and planted the seeds of Roman style had been either members of Raphael's large workshop or admirers of him and therefore self-styled followers. Thus it was offshoots of Raphael's style primarily that took root elsewhere in Italy and in France. Even before the Sack, Giulio Romano (c. 1492/1499–1546) had accepted the invitation, in the fall of 1524, of the marquis of Mantua, Federico Gonzaga, to become his court painter. As the heir to Raphael's workshop who had just completed several of the commissions interrupted by the master's death, Giulio seemed assured of a successful future in Rome. Various reasons have been proposed for his abandoning his native city, the trouble over the lascivious prints, *I Modi*, among them. Or it might have been Pope Clement's decision to give the commission to continue the work on Villa Madama to Antonio da Sangallo (1484–1546) rather than back to him that catapulted Giulio into the arms of Gonzaga, who had been negotiating for three years through Baldassare Castiglione to lure Giulio away. Whatever the reason for his decision, it proved a wise one, for after a two-year period of trial, Giulio's position in Mantua was affirmed, and when Rome was attacked, he escaped altogether.[3]

The patron and his artist were well matched. Federico was ambitious to enlarge his territories and his image. As a boy, he had spent time in Rome as a hostage at the papal court of Julius and was familiar with its art (his portrait is reportedly painted in the *School of Athens*[4]). Giulio, who as a native Roman was unsurpassed in his knowledge of classical antiquity, was well equipped to provide his patron with the buildings and the decorations that would clothe him in the aura of a classical ruler. The two were both young men when the artist arrived at the Mantuan court, and they were close in age. On the evidence of some of the frescoes at the Palazzo Te, Federico evidently appreciated Giulio's wit and shared with him a gusto for the lusty visual joke.

Gonzaga's purpose in bringing Raphael's heir and the principal painter in Rome to work for him was as much political as it was personal. When Vasari in 1550 described Mantua as a second Rome, he was writing the very words that Federico, if he were still alive, would have wanted to read. The palace that was built on the island Te was transformed from its initial conception as a country villa to a grand modern palace containing elements that imitated, and rivaled, specific recent Roman constructions. The Loggia di Davide resembles the loggia at Villa Madama, the barrel-vaulted entrance mimes the entrance to the Palazzo Farnese, then being constructed by Antonio da Sangallo. When Rome was sacked and pillaged by the emperor's troops, with whom Federico had allied himself, it must have seemed the moment to assert the power and prestige of the oldest ruling family on the Italian peninsula, the Gonzaga.

Federico's patronage was not limited to Giulio Romano, and the quality of his acquisitions and his commissions attests to his superior taste. There are records of his efforts to acquire works by Raphael (1483–1520), Sebastiano (c. 1485–1547), and even Michelangelo (1475–1564). Both Titian (c. 1490–1576) and Correggio (1489–1534) worked for him, the latter creating his magnificent series of four *Loves of Jupiter*, soon given as a handsome gift to Emperor Charles V and now spread among museums in Vienna, Berlin, and Rome.[5] The marquis may have come by his penchant for collecting art from his mother, Isabella d'Este, but he did not acquire with it her predilection for moral alle-

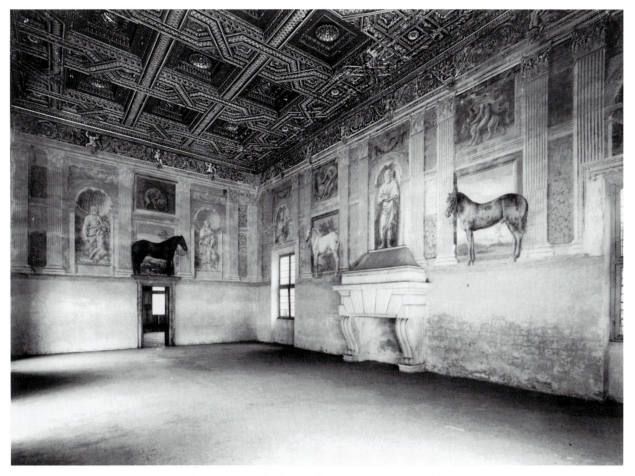

Figure 64. Giulio Romano, Sala dei Cavalli, view. Fresco, 1527. Palazzo Te, Mantua.

gories. His was a truly Cinquecento taste, ready to appreciate the sensuous delights of this world.

Giulio does not seem to have been put to work on the building that would receive his principal attention, the Palazzo Te, until mid-1526.[6] Like all court artists, he was expected to do everything. In those first months he designed silverware, provided a model for the marquis's now-destroyed villa at Marmirolo, and painted a portrait of Isabella d'Este (Hampton Court). There is a note from Federico asking him to design a tomb for one of his favorite bitches who had died giving birth to her litter.[7] According to Vasari, in his role as supervisor of streets Giulio was responsible for preventing further flooding from the marshes surrounding the city by demolishing a whole sector of low-lying buildings, raising the street level, and having it rebuilt in handsome new designs that he provided.[8]

The island Te was the site of the stable of the Gonzaga racehorses. Giulio's original commission, to make a now-lost addition to this building, was enlarged to include the construction of a whole new palace, which he designed and decorated. This was a rare opportunity and one to which Giulio's genius and varied talents were indeed equal, as the originality of the architecture and of its interior decoration bears witness. If the literature has insisted too much upon the idiosyncrasy of Giulio and his invention, it may be because it has not sufficiently taken into account how unique it was for a Renaissance artist to be given such a free hand over an extended period of time, working for a single patron. What resulted does indeed bear more deeply the marks of the artist's personality, and of the patron's, than other works of the period. The fact that, unlike the Vatican Stanze or the Galerie François I at Fontainebleau, it was more a pleasure retreat than an official reception space accounts further for the eccentricity of the decorations. Gonzaga felt free here to indulge his tastes and his sense of humor. In the Sala dei Cavalli (Fig. 64), one of the first rooms to be decorated, Giulio was instructed to paint portraits of the marquis's favorite horses, which

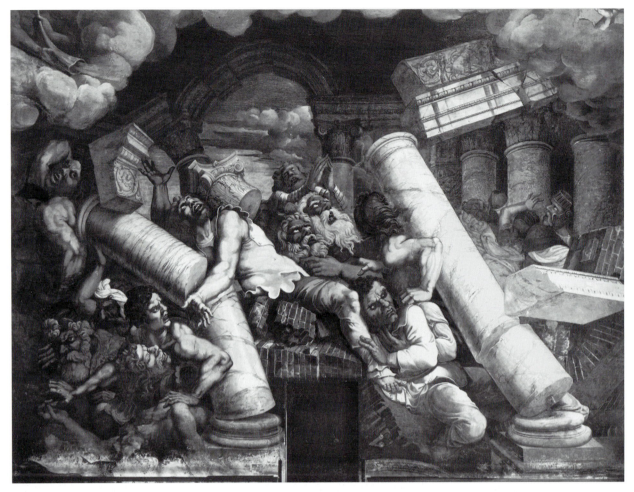

Figure 65. Giulio Romano, *Fall of the Giants from Mount Olympus.* Fresco, 1532–4. Sala dei Giganti, Palazzo Te, Mantua.

wittily referred to the origin of the island structure as a stable. Giulio, with tongue in cheek, painted an architecture of fluted Corinthian marble piers through which one glimpses the surrounding landscapes, as is also the pretense of Peruzzi's Salone delle Prospettive, in the Villa Farnesina (Fig. 17), which was certainly the model. Niches containing statues of the gods and goddesses continue another theme of Peruzzi's Salone. Above are fictive bronze reliefs with the deeds of Hercules, and projected in front of this classical scheme of high solemnity are the horses. If one fails to laugh, one has missed a good joke. What is presented with the seriousness of the Sala di Costantino is delightfully trivialized and becomes, instead, mock-heroic.

In this same spirit the most famous room, the Sala dei Giganti (Fig. 65), was created.⁹ One can imagine Federico bringing his guests here late in the evening, after they are dined and well wined, closing the doors so that the illusion is complete, and enclosing them in this space

in which, above their heads, Jupiter hurls his thunderbolt, the walls appear to be tumbling down around them and crushing the titans, the floor is a whirlwind of turning shapes, and every sound is magnified in an echo chamber. Both painted architecture and figures parody contemporary symbolic systems. The crumbling walls were supported on Corinthian columns of colored marble with gilded capitals, which stand for worldliness and vice. Those that support the structure of the Olympians in the vault are pure white Ionic. But in the symbolic hierarchy of the classical orders employed by Giulio, the austere Doric of the palace exterior represents the absolute superiority of the Christian patron over both the corrupt titans and the pagan deities. The figures play with moral symbolism as well. The giants are caricatures of Michelangelo's *giganti,* who were meant by their superhuman strength to convey moral superiority, but here become pathetic and grotesque.¹⁰

These are the two essential and complementary sides of Giulio's artistic personality, both containing elements of wit and hyperbole, whether in rendering the sternly classical or the grotesque. Parody and satire were Giulio's métier, and his patron must have delighted equally with him in them. We shall see this type of palace decoration appearing later in Rome, particularly in the art of Francesco Salviati (c. 1509–63). Giulio's outrageous inventions capture another aspect of the spirit of classical literature, more akin to the satires of Horace or Juvenal than to Cicero, and developing the esprit of Chigi's Villa Farnesina. "Laughter restores the spirit, gives pleasure, and for the moment keeps one from remembering those vexing troubles of which our life is full," Castiglione wrote in *The Courtier*.[11] Andrea Mantegna had understood this sentiment and left in the Gonzaga Palazzo Ducale one of the few examples of humor to have survived from the Quattrocento in his Camera degli Sposi (1474).

Raphael's Loggia of Psyche at the Farnesina (Fig. 19), where Giulio had worked, was the source for Giulio's superb invention in the Sala di Psiche at the Palazzo Te (Pl. XIV).[12] Like the Sala dei Giganti, it is a corner room and one of the principal showpieces of the palace. As Raphael had demonstrated in his loggia, the decoration of a villa has a decorum of its own. This was a room used for banquets; Charles V dined here when he visited in 1530. He could gaze at the fresco of the preparations for the nuptial feast of Cupid and Psyche and compare their sparse fare with the sumptuous dishes served him. Giulio makes it clear with his style that this text, which is sometimes taken as a Neoplatonic allegory of the passage of the soul from the earthly to the divine sphere, is here presented as a delightful love story, as it had been by Raphael in his Psyche Loggia.[13] If such a further meaning were intended, Giulio would have provided clues, but on the contrary, the style suggests

lighthearted entertainment. The inscription that runs around the room reads, "Federico II Gonzaga, Fifth Marquis of Mantua, Captain General of the Florentine Republic, ordered this place built for honest leisure after work to restore strength in quiet."

The ceiling is divided into compartments, where most of the episodes are represented, culminating in the *Wedding of Cupid and Psyche* in the central square, performed by Jupiter and taking place in the clouds (Fig. 66). Like the other scenes on the vault, it is shown illusionistically from below. The story continues in the lunettes on the side walls, and then down the side walls in two large fields representing the wedding feast. That we are to enjoy this scene as a love story is made clear by the continuation on

Figure 66. Giulio Romano, *Wedding of Cupid and Psyche.* Oil mural, 1528. Ceiling, Sala di Psiche, Palazzo Te, Mantua.

the remaining walls of other mythological stories of love, like *Bacchus and Ariadne*, or *Polyphemus and Galatea*.

Giulio has surpassed Raphael not just in his illusionism but in bringing off the technical feat of representing all the scenes of the vault as if they are taking place at night. The striking contrasts of light and dark, far exceeding what can be achieved with fresco, give an arresting theatricality. Giulio achieved this effect by painting it in oil, which permits such a strong chiaroscuro.[14] Although the Raphael *bottega* had abandoned the idea of painting the Sala di Costantino in oil, it would seem that they had developed a viable technique, for we will see that Perino del Vaga also used it in Genoa. The inspiration may have been Sebastiano del Piombo, who had demonstrated his oil mural of the *Flagellation* in the Borgherini Chapel at San Pietro in Montorio (1516–24) while Giulio and Perino were both still in Rome.[15]

Giulio conveys the lighthearted spirit of the *Psyche* illustrations by exaggerating or manipulating familiar artistic devices, like foreshortenings, to create amusing or even outrageous effects. The foreshortenings in the ceiling are so extreme that even such a solemn moment as the wedding of the couple in the central panel becomes comical. These recall Mantegna's ceiling in the Camera degli Sposi, but they push the illusionism further, to the point of parody rather than simple imitation. Giulio has made visual jokes, like the nymph who pours water on the heads of the spectators and the accompanying putto who pees on them. The fantastic monsters that rear up from Hades, impeding Psyche's task of bringing water from the river Styx, have an exaggerated grotesquerie similar to what Giulio would invent in the Sala dei Giganti a couple of years later. Over the fireplace is the gigantic cyclops Polyphemus, made even more impressive by the contrast in scale with Galatea and her lover beside him, who listen secretly and mockingly to his song of love for Galatea. The inscription that wraps around the walls has been designed so that "Gonzaga II" appears isolated above his head. The colossal nude has been discreetly posed to conceal his private parts, we note gratefully, until we recognize that his enormous club, placed between his legs and extending to his feet, has assumed a distinctly phallic shape – but then is playfully colored green. Positioned as he is at the end of the room he recalls the position of the prophet Jonah on that other ceiling, the Sistine, and his pose, too, imitates Jonah's (Pl. IV).

Whereas the Sale dei Cavalli, Psiche, and Giganti show

Giulio's humor and parodic wit, many other parts of the Te display Giulio the antiquarian, who is without peer in imitating the style of antiquity. As he had done in the Villa Madama, he designed relieflike *stucchi* and paintings *all'antica*. An outstanding demonstration of this other side of his talent, which would be much copied, is the Sala degli Stucchi (Fig. 67). This is an oblong room with a barrel vault, divided into coffered compartments. The same severe geometry rules the walls, which are encircled with a double frieze showing soldiers on the march and at the ends where compartments radiate from a lunette. Though inspired by the Column of Trajan, this work is not a copy of it. The style has been purged and brought into conformity with a more strictly defined classicism, approaching the neoclassical in its purity and discipline. Giulio has eliminated the architectural backgrounds of Trajan's scenes and the ground level that rises up to permit panoramas.[16] It is like the facade designs of Polidoro da Caravaggio (1490–1536 or 1499–1543), but instead of simulating relief, it is, in fact, executed in low stucco relief. The exuberance of Polidoro's designs has also been suppressed, certainly not because Giulio is incapable of this kind of invention, as we have already seen, but to create a sharp contrast in mood to those other rooms. Like the loggia with its similar decoration, this space was used principally as a passageway. Guests would not linger here and study the decoration, discovering its veiled references at their leisure, as they would in the Cavalli, Psiche, and even the Giganti rooms. This room makes its impression immediately by its pristine austerity and the tour de force of recreating an interior *all'antica*, more complete than any that had survived from ancient Rome. Giulio is the impresario who orchestrates the visitor's experience of the palace, almost as if it were a theatrical revue made up of acts sequenced for contrast.

It is generally believed, although there are no documents regarding this room, that the Sala degli Stucchi was executed beginning late in 1529 and readied for the visit of Emperor Charles V in April 1530. Francesco Primaticcio (1504–70), who would soon be sent to Fontainebleau and continue his career as a painter and stuccoist in the service of King François, is thought to have contributed to the execution of Giulio's designs.[17] The decorations are interpreted as a tribute to the emperor, who was just returning from a successful campaign that had included the Sack of Rome and climaxed with the signing of an agreement with Pope Clement at Bologna. The emperor rewarded the marquis of Mantua

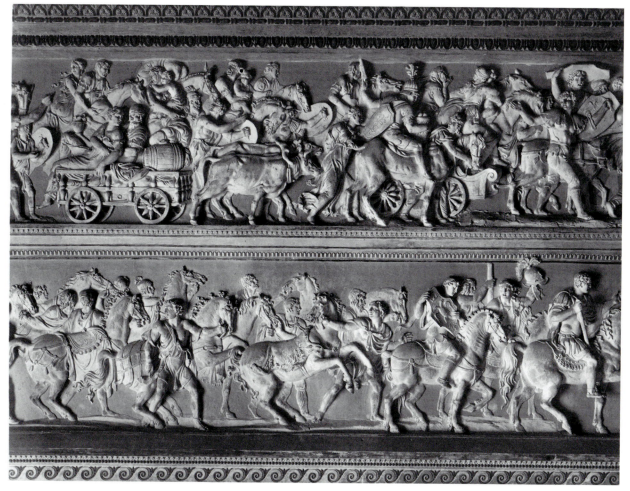

Figure 67. Giulio Romano (with Primaticcio), Sala degli Stucchi, detail. Stucco, 1530. Palazzo Te, Mantua.

at this visit by raising him to duke in gratitude for his aid to the emperor's troops on their march toward Rome.

Artists were honing and refining the prevailing style so that it could convey different moods, like the Greek modes of music. Making use of the multiple modes supplied by the late Raphael, the painter selected the one most suitable. On the model of classical literature the painter was learning to assume different personae, to don various masks. Just as in the last chapter we saw the artist adjusting his style when he came to paint an altarpiece, we can see Giulio speaking in different voices when he is painting a portrait of *Alexander the Great* (Geneva, Museum of Art and History) or, as here, when decorating the walls of a villa intended to delight and amuse the visitor, presenting a grandiose setting for portraits of esteemed quadrupeds or depicting mythological scenes to arouse the viewer's senses. In each of these instances Giulio has articulated the language of classical

antiquity with a different intonation. He paints in the relieflike style when it suits his purpose, and when it does not, he turns to other modes, such as playful exaggeration of the *ornamenti* of style, like foreshortenings, or illusionism, or the rendering of exquisite objects.

The Palazzo Te was never completed; its decoration petered out around 1535 and Duke Federico transferred Giulio's attentions to other projects, in particular renovations and redecorations in the Palazzo Ducale. Following a diplomatic coup on his part in which the emperor awarded him the marquisate of Monferrato in 1536, Federico directed his painter to decorate the Sala di Troia with scenes of the war between the Greeks and the Trojans (1538).

The frescoes on the ceiling represent portions of the battle, but unexpectedly, this cycle sides with the Greeks: the ignominy of the Trojans is shown in contrast to the nobility of the Greeks. This interpretation is

contrary both to what would be expected in Mantua, the native town of Virgil, author of the *Aeneid,* and to the usual Italian position that championed the losing side of Troy because that defeat brought its hero, the refugee Aeneas, to Italian soil. The creation of the hall as a celebration of the duke's victory over rivals might alone account for the unconventional pro-Greek bias, but the lineage of the duke's wife, Margherita Paleologa, who was descended from the ruling family of Byzantine Greeks, certainly clinched the decision.[18] Perhaps it was this very unexpectedness and novelty in the program that appealed to the duke. On one wall the famed Trojan archer, Pandarus, has wounded the Greek hero, Diomedes; while his companion helps Diomedes remove the arrow from his shoulder, the armed Athena materializes to assist him. Giulio's design followed the text of Homer very closely, even down to showing the severed arm of a warrior in the foreground, as described in the source.[19]

Rarely represented, these scenes challenged the ingenuity of Giulio to create new iconography. In a drawing for the adjacent scene, part of the battle on the ceiling, he made the *modello* in wash (Fig. 68).[20] All the vigor of Giulio's draftsmanship is still to be found here, bringing together his skill at inventing in the antique manner with his almost expressionistic energy. The chiaroscuro that he had used, not continuously, but intermittently

Figure 68. Giulio Romano, *modello* for *Diomedes's Battle.* 1538. Ceiling, Sala di Troia, Palazzo Ducale, Mantua. © British Museum, London.

since Rome, reappears here to express the violence of the emotion.[21] He had made impressive use of it earlier, particularly in the Sala di Psiche, where all the ceiling panels are represented as night scenes. The resulting contrasts of light and shade give wonderfully theatrical effects, all the more so because the device allowed him to simplify the modeling and suppress detail. Giulio's and Gonzaga's intention there had certainly been to surpass Raphael's model in the Farnesina, and they must have been satisfied that they had succeeded. The assistant who executed the ceiling fresco in the Sala di Troia, however, did not copy the chiaroscuro of Giulio's *modello* and there is a consequent loss of drama and intensity.

THE SCIPIO TAPESTRIES

In addition to large-scale frescoes, Giulio designed all manner of things. Among his most important contributions were the drawings for a series of twenty-two tapestries in two sets, the first dozen representing the *Deeds of Scipio,* hero of the Punic Wars, and then ten more depicting the *Triumph of Scipio,* for the king of France. The first set was apparently a collaborative effort in Mantua between Giulio and his fellow-heir of Raphael's workshop, Gianfrancesco Penni (1496–after 1528). The latter is documented as being in Mantua only in 1528, before he left for Naples, where he immediately died; thus the designs for the first series, for which there are some drawings by Penni, must date from that year.[22] The second series was designed entirely by Giulio, as we know from the surviving drawings, probably between late 1532 and 1534.[23] They were all woven in Flanders for King François, of silk and gold and silver threads. In 1532 it is recorded that three tapestries of the series were presented to him as a sample, and he then made the contract for the whole set. The weaving took three years, and in 1535 the last of the twenty-two pieces were delivered. When completed, they were the most expensive item in the king's rich collection.[24]

Pope Leo X's idea of having Raphael make cartoons for tapestries of the Acts of the

Figure 69. Giulio Romano, *Battle of Zama*. Drawing for *Deeds of Scipio* tapestries, 1520–4 or c. 1528. Louvre. Paris.

Apostles for the Sistine Chapel (Fig. 23) to be executed by Flemish weavers became a model all over the courts of Europe. These princes must have believed that Italian design and Flemish craftsmanship gave them the best of both worlds, north and south, and it undoubtedly provided a forum in which they could vie with one another for the most sumptuous and costly display of precious materials. Even in Florence in the mid-1540s we shall see Duke Cosimo diverting his painters from the time-honored and traditional Tuscan technique of fresco for wall decoration to design tapestries for the Palazzo Vecchio.[25]

The relieflike style was ideally suited for these antique histories. Giulio drew upon his familiarity with antique artifacts and style to render images filled with the look of antiquity. In the first of the *Triumphs,* the *Ascent of the Capitoline,* we recognize familiar bits of Rome, even the equestrian statue of Marcus Aurelius at the summit in the position it had not yet been awarded.[26] The painter has restored the temple of the Capitoline Jove to the summit. The detail and accuracy with which Giulio reconstructed antiquity was what appealed to his patrons, but his further ability to translate it into the appropriate style and add a component of animation and wit distinguished his work from mere doctrinaire antiquarianism. Compared to his Florentine contemporaries, however, Giulio had gone much further in developing the relieflike style.

Begun only four years after completion of the Sala di Costantino (Fig. 27) (where Penni had also worked), these tapestry designs resemble those fictive tapestries in the way they adapt the style of relief. Unlike Giulio's classicistic reliefs in the Sala degli Stucchi (Fig. 67), which are almost contemporary but where narrative was less the point than ceremonial display, these scenes reenact the events with exuberance. They breathe forth the same kind of energy as Polidoro's closely related facade designs. The series of ten *Triumphs* would have read, when installed, like a long relief, moving from right to left, recalling specifically Raphael's processional design for the *Battle of the Milvian Bridge* (Pl. VII), executed, we recall, under Giulio's direction. In this sense and some others, it also resembles Mantegna's *Triumph of Caesar* canvases (c. 1486–1506), then installed in the Palazzo Ducale.[27] One can see the vigor of Giulio's design in comparison with Mantegna's solemn procession. Giulio's figures are more animated and freer in their movements; he is not afraid to let them bend at the knees and dance a little. Frequently a figure turns back to talk and gesticulate with a companion, breaking the monotony but not the rhythm of the forward movement. Whereas Mantegna's design is based on straight lines, chiefly horizontal and vertical, Giulio used curved forms and diagonals. Mantegna's figures line up along the lower edge, but Giulio has admitted a shallow foreground. Despite all this, the sense of a relief is strongly felt in Giulio's designs. All the scenes have this processional quality, except the last, the *Banquet of Scipio,* which is centralized and must have been designed as the culmination, stopping the forward progress.

Giulio's ability to manipulate the relieflike format is shown brilliantly in the drawing of the *Battle of Zama* (Fig. 69) for the first series, the *Deeds of Scipio.*[28] Violating the compositional principle of parallelism to the plane, the elephants turn forward toward the spectators and threaten to thunder into our space. Only in order to depict the chaos of battle does Giulio transgress the

rules of his design and cross this liminal space, and precisely because it is a single exception it works so well.

CHAPEL OF SAINT LONGINUS

Most of Giulio's attention was taken up in planning various secular decorations for the duke. These included ephemeral constructions for the emperor's two visits in the early 1530s and preparations for the duke's marriage in 1531. After those particularly busy years, he occasionally turned his attention to religious works. The altarpiece that shows the most of Giulio's own hand is the *Adoration of the Child* for a chapel in Alberti's great church of Sant'Andrea, Mantua (Fig. 70).[29] The right wall of the chapel shows in fresco the *Crucifixion* at which the new convert, the centurion Longinus, is gathering up the precious blood of Christ, which, according to legend, he then brought to Mantua; after being lost for centuries, the relic was rediscovered when a vision of Saint Andrew pointed out the place where it had been hidden.[30] The basilica of Sant'Andrea was erected to display the relic, which is still preserved in the crypt. The *Finding of the Sacred Blood*, painted by an assistant, is the subject of the second fresco.

In Giulio's painting the Child is adored by Mary and Joseph, while the Annunciation to the Shepherds takes place behind on a distant hill in a night sky. Attending are the standing figures of Saint John the Evangelist and Longinus, in Roman centurion's uniform, who looks out of the picture and toward the fresco where the blood he is holding in a monstrance has been rediscovered. In his other hand he holds the lance with which he pierced the side of Christ, the lance that would become one of the four precious relics in Saint Peter's. Giulio has returned to the chiaroscuro mode of his Roman altarpieces, like the one in Santa Maria dell'Anima, or *The Stoning of Saint Stephen* (Pl. XII), which was sent to Genoa. What is striking here and in his other religious works is that there is nothing of the relieflike in them, as was also true of the sacred pieces we examined by Perino and Polidoro. Giulio relied upon the well-established iconography for the Adoration of the Child and animated it with his highly effective theatrical lighting.

WORKING PRACTICES

Giulio organized his work so that he was able to produce drawings for projects and get them accomplished

fast – not always fast enough to satisfy the impatient Federico, to be sure, but on the whole, with astonishing efficiency. His task was the invention, and he was endlessly prolific. But as splendid and fluent a draftsman as he was, he did not draw for the pleasure of it, or to keep his hand in, as did Parmigianino or Perino del Vaga; he always drew with a purpose.[31] When he worked as an assistant to Raphael his preferred material was, like Raphael, red and black chalks. At Mantua, however, he hardly ever used chalk, which was more suitable for studies from life, substituting instead pen and watercolor washes because they allowed him to put his inventions down swiftly and fluently.[32]

Giulio's shop was made up of specialists, like gilders and stuccoists, and none of them had received their early training with him. He had brought only one assistant with him from Rome.[33] His other assistants came from all over. They were largely responsible for the execution of projects, for Giulio seems to have painted very little himself, and less and less as time went on. He would only check and correct his assistants' work, but he paid them directly so that he could maintain control, both in terms of quality and of time. When the marquis was pressing hard to get the decoration of the Te ready for the emperor's visit, Giulio organized his shop into teams, which worked in several rooms at once. One team would bring the work to a certain point, then they would shift to another room and be replaced in the first by another team of specialists.[34]

Giulio must have learned a lot from Raphael about how to organize and operate a large workshop, and he was one of the most successful, along with Raphael's other pupil, Perino del Vaga, at doing it. Michelangelo did not surround himself with disciples, and his followers, like Sebastiano and Daniele da Volterra (c. 1509–66), became notorious with patrons for their slowness. The other painter who was successful at operating a large *bottega* was Giorgio Vasari (1511–74), and one has to ask how much he learned from Giulio.

Vasari recorded in the *Lives* that he had visited Giulio in Mantua and was invited to stay at his house in 1541.[35] Five years later, as we shall see, Vasari himself undertook a large fresco project for Cardinal Farnese that had to be done in a hundred days, the infamous Sala dei Cento Giorni (Fig. 101). Vasari had to put together a makeshift *équipe* overnight in Rome, where he was a visitor, not a resident; in other words, he did so under conditions that make one think of those Giulio

faced when he first went to Mantua. There was, after all, no painter in Florence running a large workshop whom Vasari could have observed: Jacopo Pontormo (1494–1557) and Rosso Fiorentino (1494–1540) were both loners, and the great workshops of the late Quattrocento, like Ghirlandaio's, Verrocchio's, and Perugino's, had been dismantled before Vasari's time.

The system in which the master designed everything but turned over execution to his assistants became the norm in central Italy for these large-scale cycles, but Giulio should be regarded as one of its pioneers – always, of course, on the model of Raphael. There was room for variation. Did the master execute the cartoons himself? Did he turn over certain intermediate phases of combining or enlarging drawings to assistants? Various divisions of labor were tried out by masters on different projects. The shift in working practices from a system in which the master was expected, or even contracted, to paint at least the figures with his own hand,[36] to one in which the patron regarded the master more as inventor and entrepreneur, was one of the principal developments of the period following Raphael's death. Paintings, especially the large-scale cycles that became popular in the Cinquecento, came to be produced with the same kind of collaboration between designer and executor as tapestries or engravings.

The difference in the quality of the product was noted, though this point is acknowledged only indirectly. Vasari remarked about Giulio that he was happier to express his ideas in drawing than in painting; writing about a particular drawing, he remarked that it was probably better than the painting. He claimed the drawing had more vivacity, vigor, and expression, being made in an hour in heat, whereas the painting took months and even years.[37] Thus Vasari appreciated the spontaneity of Giulio's creations and recognized that in their translation to paint by another hand they would often lose something. How much the patron regretted the loss, or noted it, is an interesting question. We have a few clues with respect to Vasari's Cento Giorni, which we will discuss in the next chapter, but as far as Gonzaga was concerned, the documents record only his interest in speed of production and his general satisfaction with Giulio and his workshop. Our modern obsession with "the original" and with works from the hand of the master alone has led to a situation in which the drawings of Giulio, Perino, and Vasari, the painters of midcentury who most successfully delegated the execu-

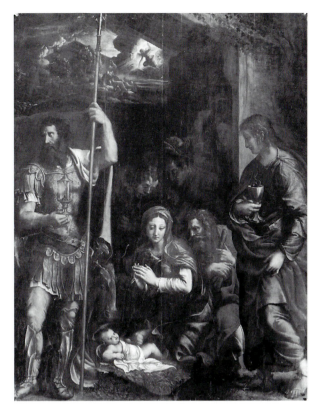

Figure 70. Giulio Romano, *Adoration of the Child*. Begun 1536. Louvre, Paris.

tion, are more appreciated than the cycles made under their supervision. This was certainly not the case in the Renaissance, despite the fact that the connoisseurship and collecting of drawings began in the Cinquecento.

Giulio was so much in demand by his Gonzaga patrons that he never left Mantua, and to be sure, he was well repaid for his service. Benvenuto Cellini (1500–71), in his autobiography, reported that he lived like a lord, and Cardinal Ercole Gonzaga told Vasari jokingly that Giulio was the real master of Mantua. When he was commissioned to decorate the apse in the Cathedral at Verona,[38] or in the Steccata at Parma, he made the drawings to be executed by local painters. This self-imposed isolation meant that although Giulio's style was copied and exported, he knew little of current artistic developments elsewhere. He had practiced the relieflike style selectively but regularly since he first came to Mantua, and he did not change. The adoption of that style for religious as well as secular works around 1540, which we will discuss in the next chapter, had no influence on Giulio. For his religious works he continued to work in the conservative tradition, drawing from his experience with Raphael. The *Assumption of the*

Virgin he designed for the Steccata at Parma, despite the extensive changes made the year after Giulio's death, clearly recalls the *Disputa* in the Stanza della Segnatura (Fig. 22). There is, to be sure, some evidence that he had been looking at Correggio's illusionistic domes in Parma, but on the whole Giulio remained remarkably self-sufficient, artistically speaking.[39]

It is not true, in contrast, that artists outside Mantua were ignorant of what Giulio had been doing. His accomplishments were well known and his style was carried abroad by the Scipio tapestries, which were admired not only at the French court but also through copies, eventually all over Europe. Although the original set was destroyed in the French Revolution for the gold thread the tapestries contained, surviving sets indicate how widely they traveled: there is a set in Rome at the Palazzo Quirinale, five of another set survive in Madrid, and one is in Florence at the Stibbert Museum, thought to be from a set made for Ippolito d'Este. There are engravings of several of the tapestries as well. Giulio's influence also spread with the export of his designs, and through prints, both reproductive and original.

Scholars have only begun to explore the world of the reproductive print in the larger context of painting in the Cinquecento and its role in disseminating styles and interpretations of subject. It is safe to say that many more artists were familiar with Giulio Romano through the engravings made after his paintings and drawings than would ever visit the Gonzaga palaces to view the originals. In addition, prints preserve for us designs that were never implemented, or designs that were made specifically to be engraved.

In the region of Mantua, Enea Vico (1523–67) was born and spent his youth, before transferring to Rome in 1541. He then made engravings after Giulio Romano, from whom he may in fact have learned drawing, as well as Parmigianino, Perino del Vaga, and Salviati. His *Venus and Mars* (Fig. 71), made perhaps before his arrival in Rome, records a drawing by one of Giulio's pupils, Ippolito Andreasi.[40] Clearly this pupil could recreate his master's wit. Mars, after a night of love, is impatient now to be off. Fully re-armed in helmet, sword, and cuirass, he wraps a reluctant arm around the clinging and still fully unclothed Venus and looks past her. Venus, lost to ecstasy, seems not even to notice the neglected Cupid grasping insistently at her breast, and turns her open-mouthed face to her clear-headed lover. Their expressions encapsulate the contrast between rationality and passion. The lovebirds beside the bed have no such conflict of temperament to overcome, but the dog and cat greet each other with their legendary antipathy. A marvelously energetic dolphin, symbol of love, we recall, decorates Venus's bed. Mars's glance has been attracted by the rays of sun entering the lovers' bower. The strange, feathered creature with sword sleeping in the upper left corner is Alectryon, whom Mars entrusted to guard the door whenever he had a tryst with Venus and to alert him when the sun rose. The guardian has fallen asleep, and this is the day Venus's husband will catch the lovers in the act of their adultery. Mars has already discovered Alectryon's lapse. The feathery helmet on his head, his body growing feathers, and his feet metamorphosing into bird claws show us that as punishment for his lack of vigilance the irate god has turned him into a cock who will henceforth crow every morning before sunrise.[41]

All this is executed with Giulio's accuracy, which is like still life. The recreation of the world of antiquity extends to the style here, which is modeled on relief: the figures are flattened to the plane, illumined on the surfaces closest to the plane with a strong flat light; their poses, particularly Venus's as she twists from a prone position to cling to her lover, are contorted and strained. We have seen the subject of Mars and Venus before, treated more circumspectly (Fig. 31), and we will see it again, handled still more boldly as the century goes on (Figs. 81, 142–3). The relieflike style was well suited to translation into engraving, and the dissemination of the prints in turn carried that style far and wide.

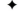

AFTER THE DEATH of Duke Federico in 1540, Giulio worked largely on architectural projects and religious commissions. He renovated his own house, made a design for the facade of San Petronio in Bologna, and renovated the church of San Benedetto Po and the cathedral in Mantua. Except for the visit to Bologna, he managed this work from his home, which he seemed reluctant to leave. When in 1542 patrons requested his presence in Parma because they were dissatisfied with the fresco Michelangelo Anselmi (c. 1491–c. 1555) had executed on Giulio's design in the apse of Santa Maria della Steccata, he refused, offering as excuse that he was engaged in an undertaking for Cardinal Ercole Gonzaga.[42] Vasari tells us that when Antonio da Sangallo died in 1546, Giulio was invited to return home to

Rome to take up the completion of Saint Peter's, but he delayed because his wife and friends did not want him to leave. Within three months he was himself dead.

GENOA AND ANDREA DORIA

Perino del Vaga (1501–47) was taken prisoner during the Sack and forced to pay a ransom to secure his release. He was so distraught, according to Vasari, that he could not put his mind to art. Indeed, one wonders whether there was anyone in Rome whose mind was on art in those days. He was rescued from his depression, fear, and destitution by the invitation in 1528 of Prince Andrea Doria (1466–1560) to come to Genoa to contribute to the building and decoration of his palace. The propinquity of Genoa to France made them natural allies, but like Gonzaga in Mantua, Doria recognized which was the side to be on. After observing the success of the emperor in central Italy, in which his army had brought the pope to his knees, Doria switched his allegiance from the French king to Charles V. As admiral of the emperor's fleet, he expelled the French from Genoa and founded the Genoese Republic in September 1528. A grateful senate named him *Pater patriae,* gave him his old family palace in San Matteo, and promised to erect a statue of him.[43] Following these successes, Doria must have decided to enlarge the building that he had already begun, known now as the Palazzo Doria-Pamphili (the same name as the family palace in Rome). It is really more a villa than a palace. Although it is today tragically inundated by the modern city – with railroad tracks running through the upper garden, an elevated highway, and Genoa's Maritime Station where there should be an open vista to the sea – it was built, like its Roman counterparts (e.g., the Villa Farnesina and the Villa Madama), on the model of an antique villa, this one the "villa on the sea." Pliny the Younger's description of his at Laurentinum inspired the U-shaped plan of Doria's with sun court in the middle and views of the sea from the rooms.[44] Opening onto the port, the south-facing garden originally extended right down to the water.

Doria was not like Gonzaga, his rival and friend, in coming from a long tradition of artistic patronage. A *condottiere* and a man of action, he had commanded in turn the fleets of François I, Clement VII, and Charles V. Although well traveled and familiar with the courts of the Italian peninsula, he did not seek the company of

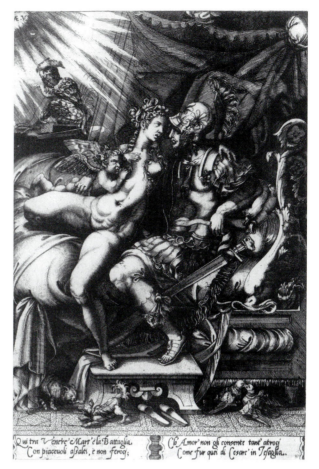

Figure 71. Enea Vico, after Ippolito Andreasi, *Venus and Mars.* Engraving, 1541–2. © British Museum.

scholars, artists, and learned men. One doubts that there were at his court the kind of intellectual resources available to Giulio at Mantua, to Rosso at Fontainebleau, or to any of the artists working at the Vatican. He sought to have a palace, properly adorned, to suit his new status in 1528 and his already advanced age of sixty-two. His principal concern was to impress the emperor when he came to stay at the palace.

One of Perino's first tasks was to arrange the decorations to receive the emperor on his first triumphal entry into Italy in August 1529. On this occasion, though accompanied by Doria, the emperor stayed at the Palazzo Ducale rather than at Doria's palace, presumably because it was not yet readied. When he returned in the spring of 1533 he was a guest at the Palazzo Doria for twelve days. Thus, we date most of Perino's decorations to the period between these two visits. The emperor returned in autumn 1536 and stayed for more than two months.

According to Vasari, the first room Perino undertook

was the Salone del Naufragio, which showed the shipwreck of Aeneas on the vault. It is known to us today only in a drawing because Perino chose to paint it in oil on the wall and it has completely disappeared. It is interesting that he resurrected here the technique that had been tried and then abandoned in the Sala di Costantino just before Raphael's death, as Giulio was also doing at about the same time in the Palazzo Te. One could speculate that Perino deemed oil the better medium to depict the wild drama of the raging sea, especially the effect of dark that pervades the drawing. Perino exhibited his cartoon and all Genoa marveled at it, according to Vasari, in a trope that is meant to remind us of Leonardo's exhibition of his cartoon on his return to Florence more than a quarter-century before.

The walls of this reception room were hung with tapestries woven in Flanders on Perino's designs, depicting the journey of Aeneas. Although the tapestries are no longer to be found in Genoa, descriptions and copies make it clear that Doria was determined to surpass his rival princes in the sumptuousness and costliness of his palace decorations and to impress his patron, the emperor, who especially loved tapestries.[45]

Perino proceeded to decorate two suites of rooms, now much damaged, in fresco and stucco. Genoa had very little in the way of artistic tradition and no experience of the modern manner of the Roman school, so Perino would have had to execute the stuccoes himself, or train local artists to do it. He must have learned a great deal working alongside Giovanni da Udine (1487–1564), first in the Loggie (Fig. 26) and then in the Sala dei Pontefici (Pl. IX). In Genoa, Perino proved himself to be a masterful stuccoist, and it was a skill for which he would be prized both there and later in the 1540s in Pope Paul III's Rome. There are fine stucco frames throughout the palace, rendered with great delicacy. In the Loggia degli Eroi he frescoed on the wall Doria ancestors, real and invented. He created on the vault a display of ornamental *stucchi* flanking narrative frescoes reminiscent of Raphael's Bible Loggie, and a worthy successor and even rival to it. In the Salone dei Giganti there is a frieze, encircling the room, with arms and trophies of the kind Polidoro painted in fictive relief on his facades, and below it a garland of fruits, of the kind invented by Giovanni da Udine. Ornament is where Perino was most at ease and where his unflagging invention showed him to best advantage. In other rooms, now almost lost due to war damage, he created

ceilings in the manner of the Domus Aurea, with compartments separated by fine stucco frames, filled with ornaments or miniature scenes from mythology either in stucco or fresco, against colored fields. These are the forerunners of his later Roman masterpieces, especially in the Castel Sant'Angelo (Figs. 98–100).

To give variety to rooms basically the same size and shape, and each requiring only vault decorations, Perino utilized all three compositional models of his master, Raphael. There are rooms where the vault is treated as a surface to be ornamented with *grotteschi*, like those just described;[46] there is a splendid display of the relieflike style in the atrium (Fig. 72); and there are rooms where traditional perspective is used, as for example in the vault scene of *Roman Charity* (Fig. 73).

If we examine the atrium vault more closely, we can see scenes of a Roman triumph depicted in the long fields at the four corners. Perino has chosen the processional composition of an antique relief, filled the space with the figures pressed toward the plane, and included ancient Roman artifacts heaped up and carried on the shoulders of the soldiers. For the *Triumph of Bacchus,* for one of the scenes on the atrium vault he utilized a drawing he had made in Rome of a sarcophagus representing this subject, introducing many of the same elements but freely adapting them in his own design.[47] Panels of beautifully delicate grotesques fill the interstices. Lunettes are filled with scenes from Roman republican history, suitable to the new Genoese Republic. Despite the fact that these are much damaged and repainted, the ensemble makes an impressive entranceway to the villa and sets the tone for its thoroughgoing evocation of Roman antiquity.

If the external decoration had been completed it would already have announced this antiquarian theme in the facade frescoes. Two splendid drawings are all that exist of the scheme for the north, or street, facade, which was never executed (Fig. 74). They were to show scenes from, again, Roman republican history. Of the frescoes on the south, or garden, facade, traces were still to be seen as late as the beginning of the twentieth century. The subject, stories of *Jason in Search of the Golden Fleece,* must have been suggested by the emperor's award to Prince Doria of the Order of the Golden Fleece in December 1531. Here is a fine example of Perino carrying Polidoro's style to Genoa. To judge from the drawings, Perino treated the wall in the manner of Polidoro's Roman facades, breaking it into

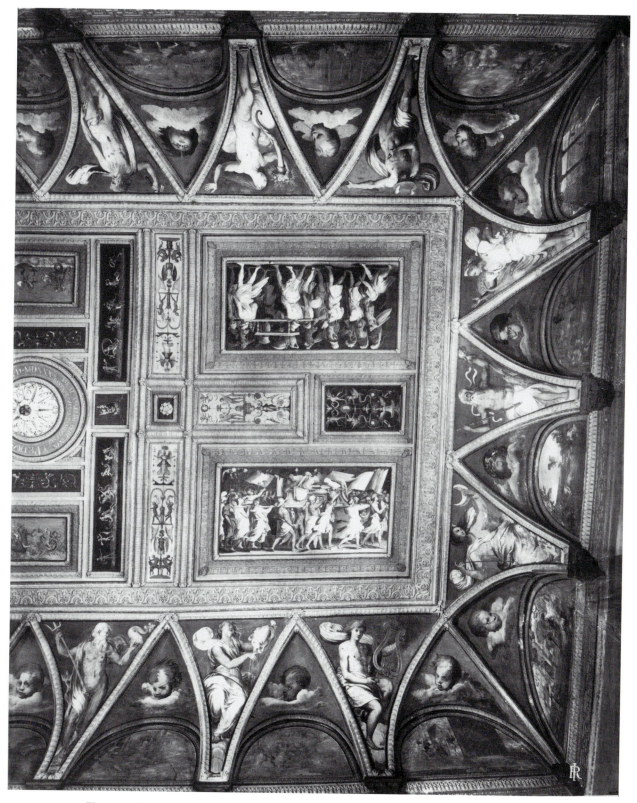

Figure 72. Perino del Vaga, Atrium vault, detail. Fresco and stucco, c 1530. Palazzo Doria, Genoa.

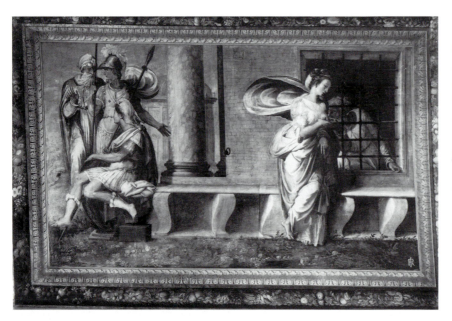

Figure 73. Perino del Vaga, *Roman Charity*. Fresco, c. 1530–2. Vault, Sala della Carità, Palazzo Doria, Genoa.

narrative scenes framed by the windows, alternating with smaller fields containing statuelike images. A frieze runs along the mezzanine, punctuated by its windows, a device that Polidoro had frequently employed. Presumably this was all painted in the sculptural relieflike monochrome of the Roman model, although Vasari says the plan devised and begun before Perino's arrival had been to do it in colors in the manner of Venetian facades. Considering how wholeheartedly Doria embraced the Roman manner, Roman subject matter, Roman models, and style *all'antica* brought by Perino, it seems unlikely that the patron would have wanted to hold to this original plan.

The climax of the Palazzo Doria decorations was the Salone dei Giganti, where *Jupiter destroying the Giants* is represented on the vault (Pl. XV). For the walls, tapestries representing the *Loves of Jupiter* were designed by Perino and woven in Flanders. Although the vault painting was ready for Charles V's visit in 1533, it seems likely that the tapestries were not in place until his next sojourn in 1536.[48] The story on the vault is the same as that depicted so effectively, and at about the same time, by Giulio Romano in the Sala dei Giganti (Fig. 65), though here the tenor of the decorations is more dignified as befitted the principal reception room of the palace. The association of Charles V with Jupiter, who put down the rebellious giants as told by Ovid (*Metamorphoses,* Bk. I), appeared in a number of contemporary

literary and visual sources. For example, in a letter to the emperor of 1537, Pietro Aretino likened the enemies of the empire to the rash and arrogant giants who were dispersed by Jupiter's lightning.[49]

In the upper register the Olympians have assembled, in answer to Jupiter's call. Seated on the clouds, they point toward Jupiter, assigning to him the task of subduing the giants. In the distance some giants are still gathering boulders to hurl at the heavens. Atlas supports the sky beneath Jupiter. At the far left a nude giant clutches a ram's skin; this is presumably the Golden Fleece and King Pelias, the evil king who had dispatched Jason and the Argonauts to bring it to him. Hesiod characterized him in his description of the battle of the gods and giants as an appropriate target of Jupiter's wrath, "overbearing Pelias, that outrageous and presumptuous doer of violence."[50] This detail would suggest that the ceiling was decorated after Doria was awarded the Order of the Golden Fleece and perhaps at the same time that the facade was being painted with the Jason story, that is, between 1532 and the arrival of the emperor in March 1533.

In the tapestries, now almost forgotten and preserved in only a few preparatory drawings and engravings, Perino took the illusionism of the Sala di Costantino and wittily inverted it. Whereas paintings there were made to look like tapestries, here tapestries look like framed paintings. As we can see in the drawing for the *Marriage of Jupiter and Juno* (Fig. 75), Perino invented architectural borders, which created a platform for the narratives with socles supporting Corinthian columns; these in turn support a cornice and an illusionistic coffered soffit from which garlands are hung. In front of the *basamento* relief was projected a cartouche held by putti with a coat of arms. Perino's decorous representation puts the emphasis not on their physical union but on the wedding vow, indicated by the ring the couple holds in their joined hands. The other cartoons similarly avoided the erotic and in each encounter showed Jupiter with a certain dignity, even reserve. Although it is the theme of Ovid's poem that Jupiter was disguised in every seduc-

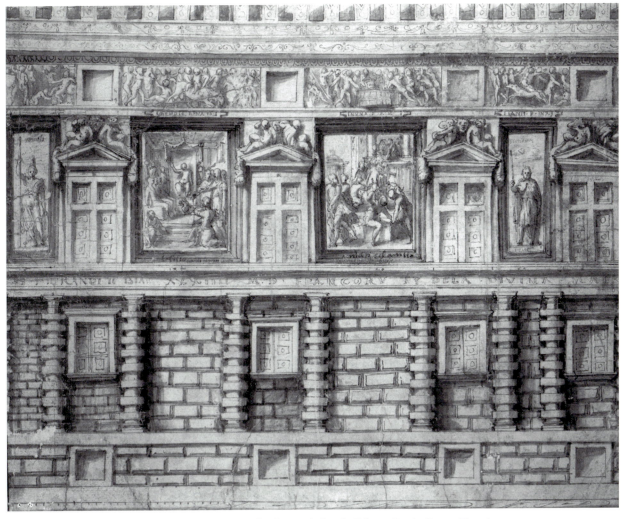

Figure 74. Perino del Vaga, frescoes for the north facade, Palazzo Doria, Genoa. Drawing, c. 1532. Rijksmuseum, Amsterdam. © Rijksmuseum-Stichting, Amsterdam.

tive approach he made, Perino showed him as a gentle, bearded, mature man, not transformed into a cloud or a shower of gold. A serious theme underlying Jupiter's amorous adventures is thereby suggested. The theme of the iconography has been described thus: "While the vault illustrated God conquering and punishing rebellion, ignorance and sin, the tapestries offered a contrasting example and message; mortals who seek union with God through love and obedience to his commands would be rewarded by honor and fame in this world and immortality in the next."[51]

Now that we know the subject of the rest of the decoration in the room, we understand why, in *Jupiter destroying the Giants*, *amorini* cavort so prominently, not only in front of Venus but all across the band of clouds in the vault fresco. Despite the graver iconography in comparison with Giulio Romano's *Fall of the Giants,* it

would seem that Perino did not want us to take this scene too seriously. The extravagantly ornamental postures of the sprawling giants prevent our identifying them as tragic heroes, and the terrestrial and divine zones are strongly differentiated. Darkness pervades one, celestial light the other. In fact, the painter has wittily applied different compositional modes to the two registers. Above, the clouds on which the gods are gathered form a receding semicircle, like the one in the upper zone of the very dignified model from which it derives, Raphael's *Disputa* (Fig. 22). The arc of the zodiac over Jupiter is strongly three-dimensional in its oblique placement. The overlapping of figures and the contrast in scale between foreground and background all encourage us to read this zone as receding in depth, as in normal perspectival space. The giants, on the contrary, are deployed in rhythmical patterns of flattened poses that

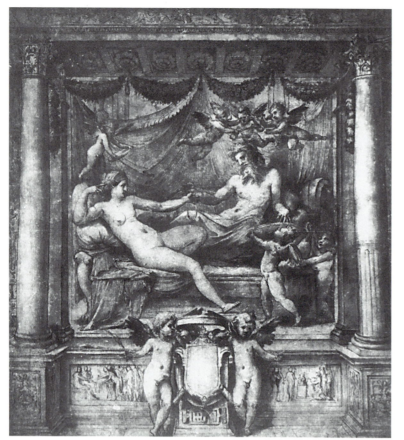

Figure 75. Perino del Vaga, *Marriage of Jupiter and Juno*,
drawing for the *Loves of Jupiter* tapestry. Designed c. 1530–2,
woven 1532–5.

emphasize the surface. Most are in profile, some in silhouette. It is as if Perino has decided to combine Raphael's separated models in the Sala di Costantino in a single composition: traditional perspective in the upper zone, relief in the lower zone. The two zones are united where the zodiacal arc is completed below by the limbs of the central giants and pulled into a flat oval on the surface. If perspectival construction invites the viewer's engagement and the relieflike mode thwarts it, then Perino allows us to be awed by the power of Jupiter, but we are not permitted to empathize with the foolish giants.

It seems that the palace functioned more as a seat for the peripatetic emperor to stop and conduct his business than as an abode for Andrea Doria and his family. The wording of certain documents suggests that the palace was considered an imperial residence,[52] and Doria's behavior suggests it as well. One of his artists, charged with providing the luxurious textiles throughout the palace, and also on Doria's galleys, complained that after the emperor left,

the staff was reduced to a skeleton and everyone's wages fell into arrears while the tremendous costs of hosting the imperial court were paid off.[53] It would seem that the palace sprang to life only in preparation for an imperial visit and during it, and the fires died and the shutters were closed when he departed. This would be consonant, in fact, with the absence of any ongoing cultural life at the court. It would also explain why Doria did not retain Perino and left him free to accept other commissions and to go to Pisa around 1534–6, between imperial visitations.

Domenico Beccafumi was said by Vasari to have come to Genoa from his Siena home in answer to the prince's reiterated invitation. The consensus is that this visit was made in 1532–3.[54] This dating would accord well with what we now know of the pattern of Doria's patronage, because it would mean that Beccafumi was engaged at the time of the big push to prepare for the emperor's second visit. We do not know what he painted in Genoa, only that he did not like court life and asked to return home when he finished a painting after a short stay. What we can observe is that his contact with Perino was reflected in the style of his frescoes for the Palazzo Pubblico in Siena, which were interrupted by his Genoese sojourn. (He completed them in 1535, six years after their inception.)

Beccafumi had visited Rome during the reign of Julius II, probably between 1510–1512, then returned in about 1519, when he probably encountered Perino. During that time Beccafumi studied the new works created under Leo X. He would have been particularly interested in the Villa Farnesina because Chigi was Sienese, we remember, and hired Sienese artists. Beccafumi may even have worked there himself, but his participation is not documented. He acquired a Roman patina, we might say, enabling him to paint Roman histories and convincing antique settings on his return to Siena, no later than 1522, but he never chose to practice the relieflike style. This continued to be true after his renewed encounter with Perino and the school of Raphael in Genoa. His *Sacrifice of Codro* (Siena, Palazzo

Pubblico, c. 1535) may borrow a pose from Perino,[55] but in his hands he transforms it from a strangely arresting, flattened and balletic pose to one that is thoroughly three-dimensional. Beccafumi's chief concern was always chiaroscuro, which he used to great effect to create volume as well as drama, and he was unwilling to compromise it. In republican Siena there was no ruler to require the style *all'antica* as an expression of his persona. The closest Siena came to wanting the Roman style was to commission frescoes of ancient Roman Republican heroes for the city hall.

THE BACIADONNE ALTARPIECE

Perino made few sacred images, but one altarpiece, the *Adoration of the Child* (Fig. 76), dated 1534, survives from his Genoese period. What is striking about this work is how traditional it is, in both iconography and style. Beneath a vision of God the Father hovering in the sky above, the Christ child on the ground is surrounded with kneeling saints: John the Baptist, Saint Catherine of Alexandria, and the Madonna. Standing behind are Saint Sebastian, Saint James Major, Saint Joseph, and Saint Roch, the first and last of these the traditional protectors from plague. It has been convincingly argued that the commission went back to the beginning of Perino's stay in Genoa, because plague in fact raged there in 1528. It would not be exceptional for him to have delayed the execution, as he frequently had done in Rome, completing it only in 1534 when he had fulfilled most of his obligations to Doria.

Like Giulio Romano's altarpiece for Sant'Andrea of about the same date (Fig. 70), the composition is based on the traditional *sacra conversazione* with the infant Child substituted for the enthroned Madonna and Child. The iconography is infused with the expected reference to the Passion. Details, such as the tasseled cushion beneath Christ's head and the white sheet on which he lies, make unmistakable the reference to the Body of Christ, celebrated in the Eucharist on the altar table below.[56]

Vasari remarked that Perino had used a dark manner for this panel, implying correctly that this practice was a departure from his usual mode of coloring. Perino may have done so as a result of his contact with Beccafumi, whose chiaroscuro coloring was both original and arresting. There is nothing of the relieflike style here, nor even any recollection of his taste and talent for

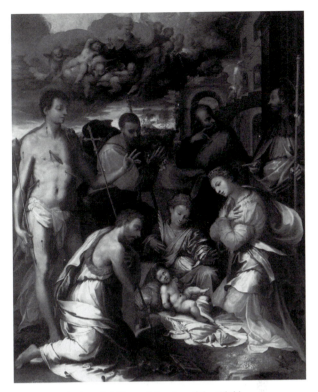

Figure 76. Perino del Vaga, *Adoration of the Child*, 1534. National Gallery of Art, Washington, D.C. Samuel H. Kress Collection.

ornament. The same kind of conservatism marks the other religious works Perino painted in Genoa, including the drawing for the altarpiece that was to have adorned Doria's mortuary chapel: a Madonna and Child enthroned flanked by two standing saints. Incidentally, Perino never executed this altarpiece.[57] Once again we find that the innovative conventions of the figure and relieflike treatment of space are reserved for appropriate occasions and are applied only selectively. Artists of this period continued to respect the relationship between the subject matter and style, as they had in the Classic style of the High Renaissance.

PERINO AND IMITATION

We do not yet know much about Perino's working methods. What we can learn from his numerous drawings is something about how he used his sources. It has been noted by several scholars that his quotations are not transparent and that it is often difficult to determine what he was imitating.[58] The problem that modern scholars have had in discovering Perino's visual sources was nicely anticipated by Armenini. Writing in 1586, he praised the kind of imitation Perino undertook because

"he changed sometimes one thing, sometimes another. Those which were broken or not very strong, he added to, removed from, enriched, and in sum adapted them in such a way with that graceful style of his that it was difficult even for knowledgeable men to identify his sources."[59] Armenini, whose purpose in writing was to give instruction to painters, took the opportunity to make the didactic point: thus "we may infer that once we have acquired our own beautiful style, we can facilely use another's inventions and make them our own with little effort."[60] This passage does indeed describe Perino and his manner of working. He is perhaps the most prolific draftsman of the Cinquecento, and he thought with his pen in hand. It is not uncommon to find sketches of schemes for vaults, for example, that were completely revised in the final version, not just in details but in the very pattern of the compartments. It corresponds to John Shearman's second category of imitation: assistance to the artist. This kind of imitation Armenini contrasted to what he called mimicry, the faithful copying of every detail without integrating it into one's own style.[61] Perino, though he may not have intended consciously to hide his sources, did so by using them as a point of departure for his own invention and as a spur to his creative imagination. It is clear that this process of invention is what gave him the greatest satisfaction, and that he was inclined to let the execution in paint languish unless he could turn it over to his competent assistants.

It would appear that after the visit of the emperor in 1533, Doria's interest in decorating the palace, and perhaps also Perino's, flagged. Perino departed from Genoa and bought a house in Pisa, where he transferred the wife and child he had left in Rome. Although he apparently intended to make Pisa his residence, in the event he seems to have stayed only about two years, from 1534 to 1536. He then returned to Genoa, presumably to make preparations for the emperor's long visit that autumn. It is not known exactly when he made his decision to return to Rome or exactly when he went.[62]

BOLOGNA AND PARMA

Parmigianino (1503–40) escaped from the havoc in Rome to Bologna, where he lingered for three, or even four, years, reluctant to return home to Parma, it would seem, as long as Correggio remained. Parma was a small town, without a lively artistic tradition, and Correggio's hegemony excluded opportunity for competitors. Since Parmigianino's departure for Rome in 1524, Correggio had developed his style in the direction of a fluidity of movement that runs through his pictures, effortlessly animating every surface yet with unfailing naturalness.

Little research has yet been done on the social context in which Parmigianino moved and worked once he left Rome. Judging from the little we know, it would seem that though he found a few commissions in Bologna, he did not link up with a community of patrons that could sustain him. His work habits did not help. His truest love seems to have been drawing, and he showed astonishing flexibility in his approach to composing. The example of the *Madonna dal Collo Lungo* (Fig. 77) is informative.

It was commissioned in December 1534, after Parmigianino's return to Parma.[63] There survive "at least twenty-seven" drawings for the altarpiece, which is presumably only a portion of those he made.[64] Parmigianino apparently began with a traditional *sacra conversazione,* in which he placed the Madonna and Child on a high throne at the center, flanked by the two saints.[65] This conventional scheme appeared not to satisfy him, and he moved through various transformations until at a certain point he decided upon the final solution of an asymmetrical arrangement with the Madonna pressed close to the plane and filling the whole height of the panel, with a crowd of angels at the left looking on and open space at the right. This quest for the perfect composition that would also be novel appears to have gone on for years, despite the fact that the contract specified the altarpiece was to be finished in five months. The key to his solution appears to have come to him when he pondered his patron's Christian name, Elena, and linked it to her name-saint, Helena, whose vision of the cross inspired Constantine to convert to Christianity. The angel holding the amphora turns it toward the Madonna so that she can see the cross inscribed upon it (now faded). She lowers her eyes and recognizes in her sleeping Child a prefiguration of the dead son she will one day hold on her lap. It is as though Parmigianino wished to make a proleptic version of Michelangelo's *Pietà.*[66] Curiously, to judge from the drawings, the idea of the sleeping Child was one of the last pieces of the puzzle to fall into place, for there are numerous sketches and studies that show him awake, but none asleep.[67]

Even after coming upon such a brilliant invention and bringing it to a state very near completion, the

painter was still dissatisfied, according to Vasari. His masterpiece was never delivered and was still in his studio when he died in 1540, more than five years after it had been commissioned. This example bespeaks a reluctance to bring work to completion that exceeds reasonable perfectionism and suggests, as do other aspects of his behavior, that he was not suited psychologically to pursuing his artistic career, despite his exceptional talent, at least after the trauma of the Sack. Vasari blamed much on his obsession with alchemy, but this solitary pursuit may have been more a symptom than the cause of his difficulties.

The commission in 1531 to paint the apse and barrel vault of the newly built church of the Steccata seemed a godsend and brought Parmigianino back to Parma, only to end eight years later in disaster. The patrons were clearly most interested in getting the huge apse decorated, but Parmigianino, after making a preliminary sketch, turned his attentions aside to the ornamental portions, where he felt more comfortable. He made numerous drawings for the elegant female figures he eventually painted at the base of the barrel vault. They embody the *leggiadria* and grace that was recognized as the ideal carriage of the feminine body in Cinquecento texts.[68] The lamps they hold identify them as Wise Virgins of the scripture, but this addition is clearly an afterthought, for they appear in almost none of the sketches and may have been imposed by the patrons to justify the inclusion of pagan dancing maidens in a sacred setting.[69]

The first contract expired after eighteen months with very little accomplished; another contract was drawn up, and again Parmigianino failed to perform, so the exasperated patrons had him arrested for breach of contract and thrown into jail.[70] He was released, presumably because he agreed to pay back the advance he had received, but before escaping outside the jurisdiction of Parma, he returned to the church and defaced some of his work. When the confraternity contracted with Giulio Romano to make a drawing for the apse

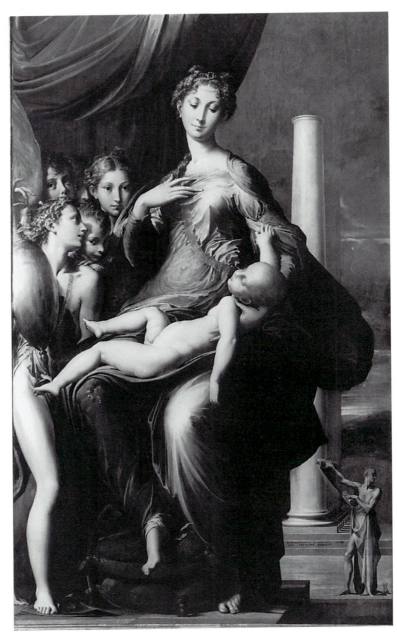

Figure 77. Parmigianino, *Madonna dal Collo Lungo (Madonna of the Long Neck)*. 1534–40. Uffizi, Florence.

to be then frescoed by a local artist, Parmigianino wrote to Giulio – they must have known each other in 1524 in Rome – and begged him not to take the commission away from him. The practical Giulio, after some hesitation, decided to proceed, although the fee he was being given for his design and colored *modello* was one hundred scudi, versus the three hundred Parmigianino claimed he was losing. Parmigianino could at least take comfort from the other side of the grave because the confraternity was thoroughly

dissatisfied with what they eventually got, executed on Giulio's design, and after his death in 1546, they had extensive changes made.[71]

When Parmigianino arrived in Bologna he seems to have thought he could best sustain himself by continuing to provide designs for prints, as he had done in Rome. The medium of etching, virtually untried at this date in Italy, attracted him because with it he could translate the fluidity and spontaneity of his drawings. After the Sack, Marcantonio Raimondi (c. 1482 – before 1534) returned to his native town of Bologna as well, and the two appear to have worked together, at least to the extent that Parmigianino depended upon Marcantonio's guidance as he began to experiment with etching his own designs. Marcantonio, too, had explored etching in Rome and had made some successful small images, but he had abandoned it before undertaking any large plates. Because he usually mixed engraving and etching in the same print, it would seem that his interest in the latter medium was for the savings in time and labor it could provide.[72]

Parmigianino's masterpiece in the new medium, the

Figure 78. Parmigianino, *Entombment,* first version. Etching, c. 1527–30. © British Museum, London.

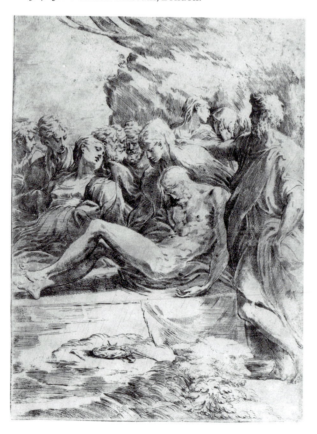

Entombment, went through several phases, which give us a rare glimpse of an artist experimenting, failing, and trying again.[73] The first state was pale and flat (Fig. 78), so in order to strengthen the contrast the artist put it back in the acid bath, probably left it too long, and destroyed it. The final version, in which the chiaroscuro he sought has been brilliantly achieved, has to have been made from a new plate. This time he was not so timid: he used a thicker needle and cut more deeply into the metal, resulting in an image of greater depth and mobility. Of interest to us is the extent to which the first version, especially, resembles a sculpted relief.[74] Although Parmigianino's style is painterly and flowing, his mode of composing, in tiers parallel to the plane against a shallow and indeterminate space, indicates how much he, like his contemporaries, sought to evoke the authority of antique relief.

Among the paintings he executed in Bologna is the *Madonna and Child with Margaret and other Saints* (Fig. 79). Not a really major commission, it was made for the small nun's church of Saint Margaret, now destroyed. The altarpiece, then, would not have gotten much visibility and could not be expected to do much to spread the painter's reputation. The composition was inspired by Correggio's recently made *Madonna of Saint Jerome* (Pl. I). It is characteristic of Parmigianino to collapse the space, move the figures toward the plane, and align them. This aspect of his composition is more akin to Raphael's *Saint Cecilia* altarpiece, which was in Bologna and exerted an important influence on our painter in these years. Combined with his continuing reminiscence of Leonardo, he made the becalmed sensuousness of these models the basis of his style.

Saint Margaret stares into the face of the Christ child in silent ecstasy. The figures at the center are painted with a refined precision that Parmigianino would continue to hone to its apogee in the *Madonna dal Collo Lungo,* but by contrast, those at the edges are treated much more loosely, leaving evidence of the action of the brush. The technique was evidently intended to prevent the figures on the perimeter from distracting attention from those at the center. In a kind of painterly shorthand, the forms are defined by dragging a broad brush across the surface, loaded with thick pigment and relatively little medium.[75] The bold handling of Saint Jerome, so distinct from the sweeping curves of the other figures here, suggests Rosso, also in his angularity. With this open brushwork the painter mingled strokes

of different pigment, inventing a technique that was unique to him. In his hands it was an extension of Raphael's *unione* mode (the color mode of the *Saint Cecilia* altarpiece), for he chose to juxtapose closely related tones, which vary not only in value but also subtly in hue. He sacrificed none of the harmony of his Raphael models, but he gained an activation of the surface that stimulates the viewer's emotional involvement and thus approached the affect of Correggio. It may have been his desire to work here in a narrow range of value that led him to sacrifice the sunlit landscape of his Correggesque model, such a striking achievement of Correggio's painting that it was nicknamed "Il Giorno" ("Day"). It seems more likely, however, that Parmigianino's purpose was to comment upon, and to surpass in his own way, his Correggesque model, which he succeeded in making look ingenuous.

The cast of the two paintings is similar. Parmigianino has added Saint Benedict[76] and substituted Margaret for Mary Magdalen. In Correggio's version, Jerome is accompanied by an angel holding up the saint's translation of the Bible to the Christ child, who reaches out with a babyish gesture that becomes a blessing. The Magdalen lays her head caressingly against the child and holds his foot, and the child touches her hair, acknowledging her effusion of tenderness but not distracted from his benediction. By depriving the Madonna of her throne and setting the scene in the landscape, Correggio grants the worshiper the easiest of access. Parmigianino has borrowed the natural outdoor setting, but instead of Correggio's flood of sunlight his picture is mysteriously and unnaturally lit. What had been staged by Correggio to attain the utmost in effortless naturalness has become tinged in Parmigianino's treatment with self-consciousness and evident artifice. Correggio's angel turns the pages of the book with his gaze focused on the child. Parmigianino's equally lovely angel addresses his gaze at us and, holding up the cross, asks us to contemplate the tragic future together with Jerome, who meditates upon the crucifix. Parmigianino's child turns to Margaret in what suggests a lovers' embrace, their faces almost touching as they exchange glances. Parmigianino would not allow his viewer the simple effluence of joy of Correggio's picture but must instead introduce a note of foreboding. He may intend our discomfort at the precociously erotic exchange between saint and infant, as if in that way to undermine the serenity of the scene and to activate our intellectual

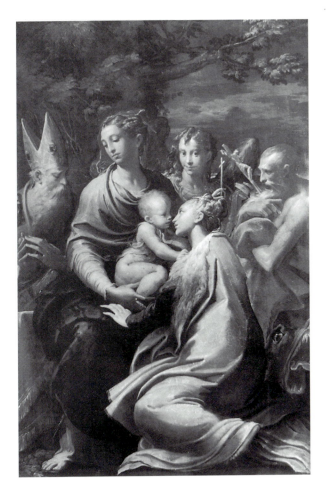

Figure 79. *Madonna and Child with Margaret and other Saints.* c. 1529. Pinacoteca, Bologna.

response. The introduction of the erotic serves the purpose of preventing a too easy or sentimental contemplation, such as – Parmigianino seems to suggest – Correggio's version permits.

Parmigianino moved away from his technical innovation in this painting, and the further possibilities it offered, and toward a much less painterly manner in his *Cupid cutting his Bow* (Pl. XVI). This striking painting was apparently executed c. 1531–2, toward the end of his stay in Bologna or shortly after he had returned to Parma. He presents Cupid in an unprecedented pose from the back, seen from below and at very close range, so that he looms over us authoritatively and we are on the level of the putti viewed through his legs. The most satisfactory explanation of these adorable creatures is that the nearer one, the boy, has taken hold of the little girl's wrist and is trying to get her to touch Cupid, but she, shy, squeamish, and uninitiated into the wonders of physical love, resists with typical girlish distaste. Cupid

tramples upon books, his triumph over intellect, and carves his bow out of what had been Hercules' club, his triumph over physical might.[77] This work is at the same time an imitation and a revision of the antique marble *Cupid stringing his Bow,* now in the Capitoline Museum and known in the Renaissance.[78] It is characteristic of the painter, and it probably reflects the taste of his patron, that the straightforward subject of the antique source has been turned into an intricate ratiocination. The viewer is captured by Parmigianino's boldly simple color composition, created out of contrasting flesh tones against a dark background. The gleaming flesh of Cupid is played off against the putti, where the hot flush of the little girl's face introduces a note of warmth. The viewer is further transfixed by the riveting gaze of Cupid, who has paused in his work and looked up, as if interrupted by our presence. The liminal space is crossed again by the putto who glances mischievously at us.

The brilliance of this piece leads us to regret that Parmigianino's commissions were overwhelmingly for sacred subjects, for he was evidently supremely qualified to conjure that mix of outré sensuality and cool reserve so appreciated by the sophisticated clientele of mythological paintings. We find here something of the wit of Giulio Romano, but in its most refined form. Giulio's sometimes raucous and bawdy humor was alien and polluting to the rarefied air Parmigianino breathed. Both, in their own ways, nevertheless, carried forward that ebullient appreciation of the pagan deities pioneered by Raphael in Chigi's Villa Farnesina, celebrating love and sensuality in the spirit of Ovid.

For Parmigianino the seam between the sacred and secular was gossamer and porous, if not indeed transparent and insubstantial. His *Madonna of the Rose* (Fig. 80) was made on commission for that cynical patron Pietro Aretino, but when Pope Clement visited Bologna to meet the emperor in late 1529 and early 1530, the painting was redirected to him as a gift, Vasari tells us.[79] An eighteenth-century legend, according to which it was begun for Aretino as a Venus and Cupid and then converted to Madonna and Child as a more appropriate subject for the pope, reads like an etiology to explain the worldliness of the image. The position of the Madonna's arms is borrowed from the *Venus pudica,* and she is draped in a flimsy see-through fabric revealing her nipples in a manner reminiscent of antique "wet drapery." Vasari, in an insightful description, remarked that Parmigianino captured here that naughty spirit little boys often have. The Child is, in fact, more mature and knowing than the darling *bambino* usually depicted – he is perhaps three, or even four, years old. Like Cupid, he fixes us with his gaze, almost as if we are intruding in their private quarters. His nudity, his indolent, reclining pose, and the centrality of his genitals gives it the air of a bedroom, although not the nursery.

Parmigianino has depicted here the woman who is the ideal of grace, beauty, and elegance, like the *Madonnas* of his mentor Raphael, but now these qualities have an explicit eroticism to them that has replaced the mere sensuousness of the Raphael prototypes. Raphael's sensuousness seemed appropriate and consonant with the Renaissance tradition that had always represented the Madonna as the model of the contemporary ideal of feminine beauty.[80] No doubt Parmigianino's *Madonna* continues the tradition and reflects the fashion of the day, when women at court were becoming bolder and freer in their dress. But the erotic strikes a discordant note, and we must recognize, as some of Parmigianino's contemporaries in the Roman Church would soon do (though not specifically with respect to this work), that an invisible barrier has been crossed here into a zone of the indecorous, if not the indecent.

As much as he utilized antique models and poses, Parmigianino's approach to the relieflike style was unique in its painterly quality, with the exception of *Cupid cutting his Bow,* which is firmly drawn, volumetric, and hard-edged. Parmigianino differs from Giulio, from Perino, and from Rosso. The Romanness of his style is Raphaelesque, but its tempering with the sensuous manner of Correggio meant that it remained a thing apart, quite distinct from the version of *Romanità* that was exported to those other centers. He shared with the relieflike style, however, a preference for a regularized abstract design, smoothing out the fitful discontinuities of nature and substituting sweeping curvilinear rhythms. As in the relieflike style, one finds in Parmigianino's work an emphasis upon limbs, which he often used to carry the rhythm of his compositions.

Parmigianino's influence outside Emilia, because of the circulation of his drawings and prints, both after his designs and by him, was enormous. Vasari estimated in 1568 that fifty copies of the *Madonna of the Rose* had already been made.[81] Salviati was impressed by the works of his he saw when he came to Bologna and worked there briefly in the late 1530s, and so also was the young Vasari, in the same years.[82] Andrea Schiavone

(c. 1510/1515–63) carried Parmigianino's style to Venice, which probably influenced Titian in the mid-1540s in the invention of his technique of open brushwork.[83] His admirer and follower, Girolamo Mazzola Bedoli (c. 1500–69), became the principal painter in Parma after Parmigianino's death and passed his style on to Jacopo Bertoia (1544–74), whom we will meet again in Rome in the 1560s.

Unlike Giulio Romano, Perino del Vaga, and Rosso Fiorentino, the other painters discussed in this chapter, Parmigianino never worked at a court; and it was probably a good thing, for he was temperamentally ill-suited to produce on the patron's schedule under pressure of time. The opportunities for such a career that did come along he let slip away, as illustrated by one of Vasari's anecdotes. According to Vasari, when the pope and the emperor met in Bologna in 1530 for the emperor's coronation, Parmigianino made a large allegorical portrait of the emperor after observing him at a meal. He then showed it to Pope Clement, who sent him with it to the emperor. This portrait is the painting in New York that was previously believed to be a copy but is now generally accepted as the original.[84] Charles V was very pleased with the portrait and would have paid for it, but Parmigianino said he had to take it back because it was unfinished. It was apparently never delivered and he was never paid, nor was he offered an opportunity to enter the circles of court patronage again.

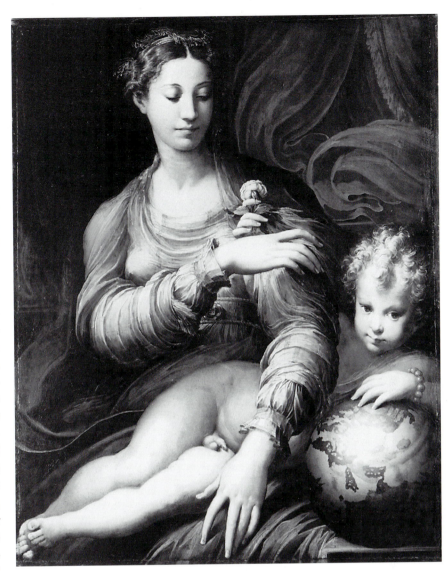

Figure 80. Parmigianino, *Madonna of the Rose*. 1529–30. Gemäldegalerie, Dresden.

ROSSO IN PROVINCIAL ITALY AND AT THE FRENCH COURT

Like Perino, Rosso had a harrowing experience at the hands of the imperial soldiers during the Sack. He escaped and headed to Sansepolcro, near Arezzo, where he sought refuge with the bishop Leonardo Tornabuoni, who had been his patron in Rome for the *Dead Christ* (Fig. 56). Four months later, in September 1527, through the good offices of the bishop, he accepted the commission to paint an altarpiece for a confraternity, his *Deposition* (Sansepolcro, San Lorenzo, Convent of the Sorelle delle Orfanelle). The modest fee to which he agreed is a clear indication that in these straitened circumstances he was grateful for any work. The patrons inserted a clause in the contract binding the painter to the fee to assure that he would not try to have it appraised when it was finished and demand more.[85] Evidently the confraternity did not have much to spend on its painting, for Rosso used no expensive ultramarine and invented a color

scheme that centered on an unconventional green drapery for the Madonna. A blackish night sky, to dramatize the darkness at noon mentioned in the gospel, allowed him to avoid blue in the sky as well. He then made another altarpiece for another confraternity, this one in Città di Castello.[86] For these commissions Rosso produced unexpected, personal interpretations of traditional iconography that were too sophisticated for his provincial patrons.

The penultimate stop on his odyssey was Arezzo, which was Vasari's hometown. Vasari's record of Rosso's wanderings and his works during the post-Sack period is very detailed and apparently accurate because he was in close touch with the artist and was much influenced by him in his own works of the early 1530s. Toward the end of November 1528, Rosso was contracted to paint some frescoes for the Aretine church of Santissima Annunziata. Though he left town before finishing them, some of his drawings that remained let us know what he had in mind.

The site was the atrium of the church where there were lunettes pierced by windows, which divided the fields to be painted into two separate half lunettes. Rosso's eccentric nature had not been altogether subdued by the hardships he had been experiencing, to judge from the iconography he invented. The cycle was dedicated to the Virgin in her Old Testament prefigurations as well as New Testament narratives. In one scene he figured the Virgin as the second Eve, in her role as curer of Original Sin. This is the doctrine of the Immaculate Conception, according to which her impregnation by God in the person of the Holy Spirit at the Annunciation broke the chain of sin connecting all humanity back to Adam and Eve. Rosso's extraordinarily inventive image shows Eve arising from Adam's side but entwined in the fatal Tree of Knowledge, while the upright Virgin, her foot on the head of the serpent, removes the apple from Adam's mouth. The upper portion of the field is filled with two more nudes, identified by Vasari as Apollo and Diana, symbolizing the sun and moon.

Although this drawing is sometimes called a copy after Rosso, it is more likely to be original.[87] It is an accurate record of his style, in any case, and as such an interesting document.[88] More than the Sansepolcro and Città di Castello altarpieces, this drawing recalls the assured grace of his Roman paintings. Here he appears to have recovered his equilibrium, upset by the Sack

and by quarrels with the patrons of the altarpieces he had been executing. The painter obviously took advantage of the nearness of Arezzo to Florence to visit his hometown and study works recently created there. Michelangelo's statues of the Times of Day in the Medici Chapel are reflected in the poses of Eve and Adam. The buoyancy and languor of these figures, so different from the staccato tautness of the two prior altarpieces, reminds us of Pontormo's recently completed *Pietà* in Santa Felicita.[89]

Rosso proceeded then to Venice where he encountered Pietro Aretino, whom he had certainly known in Rome and who would prove to be the agent of the change of fortune in his life. Aretino proposed Rosso to the king of France, who was looking for a distinguished artist from Italy willing to come to his court.

François I had been collecting Italian art, and Italian artists, since early in his reign.[90] His taste was remarkable, and his acquisitions, in no way limited to paintings, form the nucleus of the world-class Cinquecento collection in the Louvre today. By various means the three masterpieces of Leonardo da Vinci at the Louvre had come into the king's collection, the *Mona Lisa,* the *Madonna of the Rocks,* and the *Virgin and Child with Saint Anne.* He was given Raphael's *Saint Michael* (Fig. 25) and three other paintings by the master, or on his design.[91] He commissioned Sebastiano to paint the *Visitation* now in the Louvre. He had invited Andrea del Sarto (1486–1530) to his court in 1518. Leonardo had spent the last years of his life at one of the king's chateaux, where he died in 1519. This gathering of artists and commissioning of their work was all part of a concerted campaign to introduce the Italian Renaissance into a France that, artistically speaking, was still largely in the Gothic age. François was the first ruler outside the Italian peninsula to sponsor artists in this way and to recognize the potential usefulness of the style *all'antica* to the image and prestige of his regime. In 1529 his ambassador was in Venice, where Michelangelo also was visiting, trying to lure the great Florentine to come to Fontainebleau.[92] Years later, in 1546, the king paid Michelangelo the extraordinary honor of writing directly to him, asking that he send him any excellent example of his work he might have in his studio. He also asked permission for Primaticcio, who had returned from Fontainebleau to Rome on a mission, to make casts of his Saint Peter's *Pietà* and the *Risen Christ* in Santa Maria sopra Minerva.[93]

François treated his artists with unprecedented generosity. Documents substantiate remarks like those of Vasari, who reported that Rosso lived like a lord.[94] Artists in France reported back in Italy that the king paid lavishly for high-quality Italian paintings. After the king's release as a hostage in Madrid in March 1526 and his decision to spend more time in the area of Paris, he began enlarging his hunting lodge at Fontainebleau with the intention of making it his principal residence. He turned his attention from that point onward to its decoration, his zeal for collecting slackened, and he instead brought Italian artists to work on his palace. Rosso was recruited the year after his failure to obtain Michelangelo's services. It has been suggested that François had recently acquired, through his agent in Florence, Rosso's *Moses and the Daughters of Jethro* (Fig. 43), and that he was therefore already well disposed toward him.[95]

The highly finished drawing of *Venus and Mars* (Fig. 81) has been identified as a gift from Pietro Aretino to King François by way of introducing Rosso as a candidate for court painter. The drawing shows that Rosso was well able to shift into a courtly mode from that of his provincial altarpieces. In subject, spirit, and style it was everything the king could have hoped for. It shows that much-favored subject of the god and goddess, this time preparing to make love. Venus is already climbing onto the couch while Mars, looking troubled and unprepared for his Venereal encounter, is struggling out of his armor, assisted by Cupid. An interpretation of the drawing has been offered that shows it to be such an appealing parody that one hopes it is correct; it relates the drawing to François's forced marriage with the emperor's sister, which took place in 1530 as part of the humiliating accommodation thrust upon him following his defeat at Pavia.[96] In the allegory – and here one senses the satiric wit of Pietro Aretino – the reluctant king becomes the shrinking Mars, who indeed cannot get up for the occasion. There are other visual jokes that set the tone, like the maiden in *Venus pudica* pose behind Mars, or the foreground putto who holds Mars's sword between his legs. Mars-François is begrudgingly abandoning war to devote himself to peace and marital pursuits.[97]

Thus Rosso demonstrated his familiarity with things antique, with the style *all'antica,* and with the taste of his intended royal patron. Francois's predilection for racy pictures was already known. Always a brilliant draftsman, Rosso put on show his superb command of his materials. This drawing is as elaborate in its technique as it is

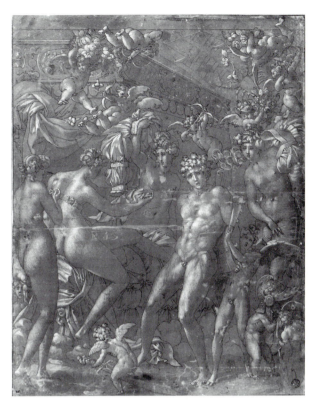

Figure 81. Rosso Fiorentino, *Venus and Mars.* Drawing, 1530. Louvre, Paris.

wry in its innuendoes. On paper prepared with a gray-brown tint, he has redrawn in pen and black ink over lines set down initially in black chalk. He has then added touches of brown wash and heightened it with fine strokes of white. The scene thus seems to take place in a darkened bedchamber. Mars, placed near the center, garners most of the light while Venus, her face averted and unlit, is more of a prop than co-protagonist. But she is elegantly drawn and subtly posed: one has to look closely to see her invitingly extended leg on the bed. The royal couple are strewn with rose petals and with the emblem of France, the fleur-de-lis (lily).

Rosso, who by this time had spent three and a half years as a peripatetic provincial painter, must have been thrilled when the invitation was proffered. He arrived in France by November 1530, where he would make his home for the decade remaining of his life. A year and a half later he was joined by Francesco Primaticcio, who came from Mantua in response to the king's request of the Duke Gonzaga that he send him an artist expert in painting and stucco. François must have known about Giulio Romano's creations in stucco at the Palazzo Te. Primaticcio had been assisting Giulio for six years when he was called to France in 1532, according to Vasari, and

is credited with the splendid stuccoes in the Sala degli Stucchi (Fig. 67). The two artists may have begun their work in the garden pavilion (now destroyed) in 1532–3, where they were able to try out the kind of stucco ornament and fresco narrative that each would then use – Rosso in the Galerie François I and Primaticcio in the Chambre du Roi (the king's bedroom).

How the new invention of the style of stucco ornament, called in Italy *alla francese,* was evolved is still somewhat a mystery. It is clear from the documents that the two artists worked separately and had different *équipes,* yet the new style appears in the rooms decorated by each.[98] Nothing like this kind of stucco, used to make virtually freestanding statues simulating marble, had been done, to our knowledge, in Rome or in Mantua. Because Rosso was probably not experienced in stucco – one suspects that François's request to Gonzaga specifically for a stuccoist was to fill this gap – Primaticcio seems the more likely inventor. And in fact, he took the credit when Vasari talked with him many years later, in 1563. Whatever the case, and whatever the still-undiscovered

precedents might turn out to be, the combination of bold stucco frames occupying a large part of the wall and surrounding fresco narratives was the fruitful invention that would make François's palace renowned across Europe and copied at home and abroad.

Rosso devoted his attention to the enormous Galerie François I, which is 190 feet long (Fig. 82). There are two cycles of decoration, the principal one monarchical, the subsidiary one mythological. The mythological cycle consisted of a scene at the center of each of the four walls.[99] Rosso treated each scene discretely, a decision made feasible by the division of the long walls into bays, each separated from the next by a floor-length window. The bays are grouped into two sets of three on each side by the cabinets, which originally interrupted the sequence at the middle of each long wall and contained a mythological scene from the other cycle. The design of each bay consists of fresco pretending to be a *quadro riportato* (a framed painting presented as if it is hung on the wall), flanked by symmetrical wings and surmounted by a salamander, the emblem of the king,

Figure 82. Rosso, Galerie François I, view. Fresco and stucco, c. 1532–9. Fontainebleau.

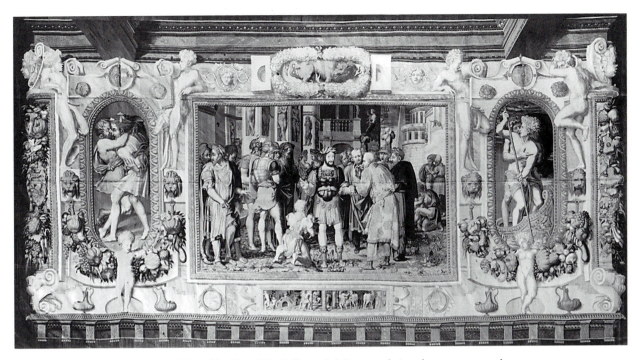

Figure 83. Rosso, *Unity of the State,* Galerie François I. Tapestry, designed c. 1532, executed c. 1540–7. Kunsthistorisches Museum, Vienna.

with a cartouche below. In the wings, fresco and relief alternate, keeping the same pattern across the bay, with the result that the groups of three bays form triads: stucco frame, fresco in frame, stucco frame. This much was determined by Rosso's macroscheme. Beyond this design, the diversity he allowed in the ornamentation is stunning and quite unprecedented.

The iconography is similarly diverse. The scenes celebrate the power and the person of the king, but the iconographical program is unusual in not being derived from a single source; therefore the stories do not make a continuous narrative. The diversity of the program extends to the way the king is represented: most often he appears only in allegorical guise as some mythological being, as he did in the *Venus and Mars* drawing, or as he does in the fresco of the *Education of Achilles,* where his education is likened to that of the hero of the Trojan War who received his training in warfare from the centaur, Chiron, a semidivine being. In only one scene, the *Unity of the State* (Fig. 83 and reproduced here in the tapestry made after the fresco), is François himself unequivocally portrayed: here he appears as Roman emperor, wearing a crown of laurel surrounded by classical buildings. The cycle presents throughout the analogy of the monarch to the heroes of the ancient world who were on speaking terms with the Olympian deities. François, too, is a superior being by birth and

training, a statesman able and obliged to lead his country in peace and war.

The interpretation offered by André Chastel of the very abstract program finds as its theme the privileges and duties of the king.[100] The program operates on three levels: that of allegory, fable, or emblem; that of doctrine; and that of the application to the king. The west half of the gallery focuses on the office of the king, the east half on his person. The doctrine of the power of the sovereign is proclaimed at the center of both triads in a pair of subjects, opposite one another across the gallery. The four adjacent scenes depict the duties of the king. Schematized, it looks like this:

OFFICE OF THE KING
official duty • Doctrine • official duty

PERSON OF THE KING
personal duty • Doctrine • personal duty

At the center of the official half, the *Unity of the State* is paired with the depiction of the *Royal Elephant* – the most powerful and revered of animals, symbol of piety, wisdom, and invincible power – decked in fleur-de-lis. Both are assertions of the official role of the monarch as ceremonial head of state. The adjacent narratives include the image of François – or better, his enlightened subject[101] – who, having turned his back on the blind and ignorant crowd, marches triumphantly into

the blazing light of the temple of Jupiter, which is also identified over its portal as the palace of the king (Fig. 84). François has provided his subjects with the means of overcoming the evils of ignorance by carrying out his duty to establish and sustain culture. Not insignificantly, culture and enlightenment are symbolized here as classical and antique. Thus the fresco might be called *François as Provider of Culture and Enlightenment.*

The center of the personal half of the gallery proclaims the privileges that equip the king to rule: his unsurpassable education (the *Education of Chiron*) and the *Loss of Perpetual Youth.* These works give justification to his superior role. In the flanking scenes the consequent obligations of the king are again shown, but this time they are duties that require personal courage and discipline: his duty to confront the horrors of war and to surmount disaster. The *Battle of the Lapiths and Centaurs* evokes the violence of war; opposite it, in a representation that inverts the message of the *Venus and Mars,* we see the hero abandoning the charms of Venus to take up Mars's call to arms, perhaps best titled *Venus Rejected.* Both refer to the resumption of war in the mid-1530s, after a few years of peace in the bower of Venus.[102] The most touching of all these frescoes is the *Death of Adonis,* which refers to the death of the king's son and heir. The dauphin died in 1536 at the age of eighteen. The gallery was being painted at the time, and the intended narrative was substituted with a scene that shows something of the sense of personal loss combined with the loss to the monarchy.

Just as the narratives are based on a medley of sources, so is there astonishing variety in the frames. One scene may be flanked by frescoed figures, with putto playing along the top *(Education of Achilles);* another may show a cornucopia of garlands, with niches containing stucco figures (the *Twins of Catania*); whereas yet another may turn those stucco figures into enormous nude Allegories who step out of their space over the cartouches, creating shadows with their bold relief. It appears that there was more than one mind at work in the design and, beyond the pattern established by the macroscheme, there was no attempt to enforce uniformity. Rosso must have recognized that in a space this long the danger lay in repetition, as Raphael had recognized in his Loggie. Rosso, following Raphael's example, introduced what in a more compact space might have been a rash diversity; here it provides needed diversion.

The timetable at Fontainebleau was determined by a visit of the emperor, as in all the other courts we have discussed. The Galerie was ready by December 1539 when Charles V stopped over and went on a tour of the palace. It is thought that at this time François offered to have the decorations of the Galerie copied to scale in tapestries as a gift to the emperor. In the event, six tapestries of the south wall bays were executed before the project was brought to a halt in 1547, apparently due to the death of the king. It is not known whether they were ever actually presented to the emperor, or even whether this hypothesis is correct, but it has the merit of explaining why François had copies made of his own gallery.[103]

The tapestries preserve the design better in some cases than the much-damaged frescoes. In the *Unity of the State* we can see how the wings, in this case in fresco, extend the meaning of the central scene. In large horizontal ovals are contrasted two pairs of men, one engaged in mortal combat, the other serenely propelling a boat as one points the direction and the other poles. The advantage of good government, such as that instigated by François, in creating an atmosphere of peaceful cooperation rather than civil strife is indicated. The enframement plays a more important role here than we are accustomed to seeing. Although it appears to be ornament, it in fact embellishes the meaning of the framed narrative. Such an inversion of our expectation may require a reassessment of our interpretation of the Maniera style, which, following John Shearman, we have understood to be satisfied with ornament for its own sake. Here we find the artist concealing meaning in what is apparently mere ornament. Is the pretense of superficiality another aspect of this sophisticated culture, which also abjured the direct expression of emotion and any semblance of moral preaching?

Rosso's macroscheme owes much, once again, to the Sala di Costantino, which he would have known from his years in Rome before the Sack, even though he did not work on it as Giulio, and perhaps Perino, had done. Rosso created two modes of composition like those used in the Sala di Costantino: perspective paintings, which are either in fresco or bas-relief, and ornaments, which are either paintings on faux mosaic or high relief. (Fictive mosaic of the same sort as here had been used by Raphael in the ceiling of the Stanza della Segnatura.)[104] Thus Rosso was able to do something like what Raphael had done, but in introducing stucco as a second material, he made a scheme that took a quantum leap in complexity. He added the factor of gen-

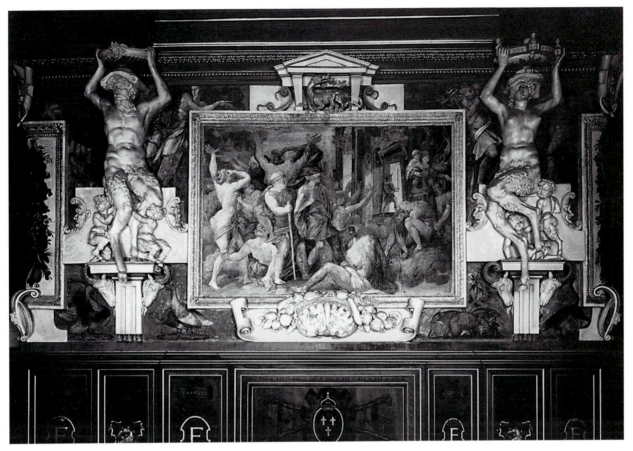

Figure 84. Rosso, *Enlightenment of François I.* Fresco and stucco, c. 1535–6.
Galerie François I, Fontainebleau.

uinely contrasted materials, whereas Raphael had used only faux materials, all painted in fresco. Rosso's plaster is also faux, for it playfully but convincingly simulates marble. Whereas Raphael played off a perspective picture (*Constantine addressing his Troops,* Fig. 27) against a picture that imitates relief (the *Battle of the Milvian Bridge,* Pl. VII), Rosso juxtaposed perspective pictures with sculpted ornaments, or sculpted relief in perspective with frescoed ornaments. The one stable element in the design is that the perspective pictures in both materials are always framed, and the frames of the frescoed narratives are always identical.

Despite the ingenuity and complexity of his invention, Rosso does not achieve an integration of ornamental scheme and iconographical program comparable to Raphael's. The different modes of representation do not correspond to, or distinguish, the different levels of the program, as they do in the Sala di Costantino. Here statements of doctrine, for example, are represented in the same way as examples of royal duty. They are distinguished only by being placed at the center of the triads

and not by a distinctive use of materials; as a consequence, they have proved difficult to interpret. It is in the invention of a new kind of ornament and in a new conception of enframement and its potential role in teasing out the meaning in the narrative that the unique contribution of Rosso's Galerie lies.

Michelangelo's Sistine ceiling was also a source for Rosso's scheme. The framework of compartments containing narratives and surrounded by ornaments or monumental figures recalls the relationship of the Genesis panels to the Seers in their niches. Rosso's disregard for consistency in scale also resembles Michelangelo's, even more than it does Raphael's leaps of scale in the Costantino. François was no doubt doubly thrilled to be presented with quotations of the rooms of the two greatest painters of Rome, and when that was then combined with subjects taken from classical antique sources and framed with ornaments that recalled antique sculpture and relief, the king must have felt he had indeed transferred Rome to the Ile-de-France and surpassed it.

To create the tapestry copies of the Galerie, François decided against having them woven in Flanders, as had been done with the Scipio sets designed by Giulio Romano, and had an atelier established at Fontainebleau. It is clear that he wanted native craftsmen trained by foreign experts in every medium, which would include bronze casting and printmaking. François imported printmakers and encouraged the production of copies of the art he patronized so that it would become widely known and readily available. His campaign to Italianize French culture was wide-reaching and successful. The printmaking enterprise began in 1542 after Primaticcio's return from Italy. He was probably the one who suggested it to the king, recognizing as he did so that printmaking was the best means to communicate from the provinces with his fellow artists, especially in Italy, and to disseminate his inventions from Fontainebleau. The undertaking had a very short life, for printmaking activity subsided around 1548, shortly after the king's death,[105] but thanks to Antonio Fantuzzi (active at Fontainebleau 1537–50), Léon Davent (Thiry, died after 1565), Domenico del Barbiere (1506–65), René Boyvin (c. 1525–c. 1630), and a few others, many of the executed and unexecuted designs of Rosso and Primaticcio have been preserved that would otherwise have been lost. Fantuzzi etched the frame of Rosso's *Venus Rejected,* but differences between the two versions indicate that the print was made from a preliminary drawing by Rosso that is now lost. Fantuzzi created a landscape to fill the center, probably left blank in the drawing.[106]

When Primaticcio came from Mantua to Fontainebleau, he brought a large number of Giulio Romano's drawings with him. They not only served to inspire the artists at Fontainebleau but were engraved there, especially by Léon Davent, thereby adding to Giulio's fame and spreading his style from another source, in addition to Mantua and to the prints being made in Rome at about the same time, as we have seen. Davent and Fantuzzi both copied a number of Primaticcio's designs. A superb example of his inventiveness is recorded in Fantuzzi's print of *Jupiter sending the three Goddesses to submit to the Judgment of Paris,* dated 1543, which has been connected with Primaticcio's lost decoration of the Porte Dorée (the Golden Gate).[107] The central oval is flanked by a goddess and god in niches, which is then framed with a splendid demonstration of ornament *alla francese,* with figures, cartouches, and strapwork, in which the material is shaped to look like strips of curled leather, all presumably in stucco. Fantuzzi's light touch with the burin was well suited to the delicacy of Primaticcio's style, which evolved increasingly toward Parmigianino's.

After the emperor's visit at the end of 1539, the king turned his attention to the sculptural adornment of his palace, inside and out. In 1540 Benvenuto Cellini arrived at the court. Hired as a goldsmith, he executed objets d'art, including the famous *Saltcellar* now in Vienna. At this same time François sent Primaticcio to Rome to acquire antiquities for him and to make molds of the most revered antique statues. This expedition was the first of two visits Primaticcio made back to Italy in the next few years under the king's direction. The importance of these visits for the development of the king's collection and hence for the importation of classical culture to France should not be underestimated. Not only did Primaticcio acquire 125 antique marbles,[108] but he made plaster molds that were then cast in bronze in the newly established foundry at Fontainebleau. François's palace was eventually adorned with copies of the treasures of the Belvedere Court: the *Laocoon* (Fig. 1), the *Apollo Belvedere* (Fig. 2), the *Commodus as Hercules,* the *Sleeping Ariadne (Cleopatra),* the *Venus,* and the *Tiber.* Primaticcio had even made a mold of the huge equestrian statue of Marcus Aurelius, although it was never cast.[109]

These visits to Italy were important also in establishing contact between the Roman artists and the School of Fontainebleau. It is believed that the drawings Primaticcio took with him were the first direct contact Perino del Vaga had with what Rosso and Primaticcio had been doing to extend the use of stucco ornament, although there may have been some earlier inkling of what was going on that reached Rome through the Cinquecento grapevine, perhaps via a traveling artist. Luca Penni (1500/1504–56) was one likely conduit: he was Perino's brother-in-law, and he worked with Primaticcio from 1530 on.[110] First Perino, and then other artists would incorporate the Fontainebleau innovations into Roman decoration in the Sala Regia *stucchi* (Figs. 112–13). Later, of course, the prints we have already discussed would become a source of inspiration and of models to the Roman artists as well, conspicuously to Salviati, who put them to use in his frescoes for Duke Cosimo's Sala dell'Udienza in the Palazzo Vecchio almost the moment they became available (Fig. 150).[111]

On his trip to Italy Primaticcio must have returned

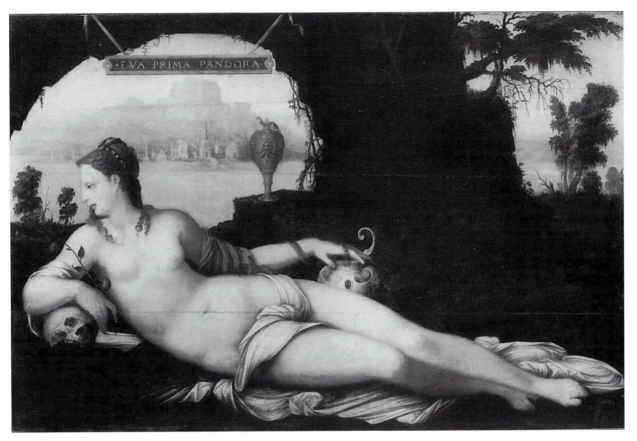

Figure 85. Jean Cousin the elder, *Pandora-Eve*. c. 1549. Louvre, Paris.

home to his native Bologna and been impressed anew with the art of Parmigianino, for when he returned to France, his style reflected Parmigianino's influence. While he was in Italy Rosso died, by suicide, according to Vasari. Primaticcio returned to take up the position of principal artist previously held by Rosso, leaving some of his molds incomplete. Beginning at this point, around 1542, the importance of the style of the Roman Renaissance diminished at Fontainebleau, yielding to Emilian style. An elegant loveliness – derived from Parmigianino and ideally suited to the amorous themes so popular with the king – replaced the relieflike style.

Erotic subjects were even more in evidence at Fontainebleau than in the courts of Gonzaga and Doria. Rosso's presentation drawing of *Venus and Mars* (Fig. 81) had set the tone, to be followed by the decorations of the pavilion that may have been only mildly tinged with eroticism but were later destroyed because of it. Primaticcio was particularly adept at handling such subjects with charm and sophistication. He contributed two Loves of Jupiter (*Semele* and *Danaè*) to the secondary mythological cycle in Rosso's Galerie, removed

at the beginning of the eighteenth century by Louis XIV because "the attitudes are not proper."[112] They were indeed altogether different in spirit from the *Loves of Jupiter* in Andrea Doria's tapestries designed by Perino del Vaga (Fig. 75). Primaticcio excelled more at depicting the lovely than the heroic, and this emphasis seems to have suited François in the last decade of his life, when he was more in thrall to Venus than to Mars.

The imported Italians had the effect on local artists that the king intended. The School of Fontainebleau became the basis for French Renaissance art. Such a French painter as Jean Cousin *père* (c. 1490–c. 1560) absorbed the style of Rosso and made it his own. Although his manner is not as fluid as Rosso's, and there remains in it a characteristic stiffness, a painting like his *Pandora-Eve* (Fig. 85) shows the degree to which foreign models and classical subject matter were assimilated. The very depiction of a reclining nude is startling, for before the king established the School of Fontainebleau no such subject existed in France. In Italy representations of the female nude become bolder and more frequent in the Cinquecento, but something like Botticelli's *Venus*

and Mars (London, National Gallery) can be seen as a Quattrocento predecessor, even if there Venus was still modestly draped. But in France there was nothing to prepare the way for such pictures, and their popularity is entirely due to the success of Fontainebleau and the dissemination of its designs.

Pandora enjoyed more popularity in France than in Italy. She was the first woman, created by Jupiter and given a sealed vase that she was charged on no condition to open. Of course she could not contain her curiosity, and when she broke the seal out flew all the evils of the world. She is the counterpart in classical myth to Eve, whose sin introduced evil and death into the world. There was a literary tradition in France around midcentury that associated Pandora with Rome, and the city in Cousin's painting through the arch in the background is without doubt Rome.[113] The Eternal City, viewed from the French perspective, was at once wonderful and the seat of the world's evils. This sentiment is akin to the spirit of the German woodcuts, associating the pope with the Antichrist and Rome with Babylon, which were discussed in the last chapter as part of the Lutheran movement. Although in the case of still-Catholic France, this sentiment was not necessarily religiously motivated, it reflects an attitude toward the papal city and its pretensions that was obviously widespread and was exacerbated by rising nationalist sentiments.

The Roman Restoration

T
HE SACK IN 1527 IS USUALLY TAKEN AS THE WATERSHED EVENT THAT
marks the end of an era: sometimes the end of humanism, certainly an
end to the optimism about man that was its tenet. The Sack offered the
opportunity for certain contemporaries to voice their long-held beliefs that
the culture of the Renaissance had become decadent and to reiterate the fre-
quently heard call for reform of the Church and the clergy. The catastrophe of
the Sack was viewed by some as a visitation of God's wrath, a demand from on
high for repentance and reform. Among the rash of writers blaming the vic-
tim, Baldassare Castiglione stands out as a voice of balance and sanity when he
uttered outrage at the atrocities visited upon the Eternal City by the uncon-
trolled troops of the Imperial army.[1] Certainly the ruinous state of the city was
cause for lament. The pope himself had fled, and with him, nearly everyone in
the Vatican. It was estimated that in the city of 54,000, some 10,000 had lost
their lives and another 10,000 sought refuge elsewhere.[2]

Art historians have viewed these developments somewhat differently. For
them the end of the Classic style of the High Renaissance is marked either by
the death of Raphael in 1520 or the death of Leo X in 1521. The importance of
the Sack for the world of art was the disruption it wrought in the careers of
many of the artists and the diffusion of the style of Rome all over Italy and
even Europe. An alternative periodization, and one that fits the history of art
more satisfactorily, sees the watershed coming a generation later, in the pontifi-
cate of Paul IV Carafa (1555–9). From the point of view of political history, it
was then that the era of Italian independence ended and the period of imperial
domination began. From the point of view of religion and Roman culture, the
ascent to the papal throne of a man who had been the highest official of the
Inquisition, the Inquisitor General, betokens a shift from humanist to Counter-
Reformation values.[3] Yet, as we shall see, even to oppose humanism and
Counter-Reformation is to oversimplify and to deny an important continuity.

Pope Clement's post-Sack years, until his death in 1534, were marked prin-
cipally by his commission to Michelangelo of the *Last Judgment*. The pope
who succeeded him, Paul III, was a humanist of the same circle as his prede-
cessors and one who shared their view of Rome and of the role of the pope. A

member of one of the leading families of Rome, Alessandro Farnese was born in 1468, even before Leo X and Clement VII. Educated by humanist tutors in Florence and a protégé of Alexander VI, he had been *papabile* (a papal hopeful) and a member of the inner circle for many years. By the time he was finally elected in 1534, conditions had already changed in Christendom, and Pope Paul III was called upon to meet new challenges. He was confronted in his old age and throughout the course of his long reign (1534–49) with the issues his predecessors had allowed by their neglect to fester. One senses that Paul would happily have devoted himself exclusively to building his family dynasty and to his artistic patronage, but the times would not allow it. Propelled by events, he took steps more decisive than any of his Renaissance predecessors to bring about reform of the Church and the clergy and to resolve the issues of faith raised by the Protestant schismatics. Although never neglecting his personal concerns such as the oversight of his architects, first Antonio da Sangallo (1484–1546) and then Michelangelo (1475–1564), who were to build him the grandest palace in Rome, he is the pope who finally convened the reform Council that had been so long put off. While caring for his family's future by flagrant nepotism,[4] he confirmed the Jesuit Order and instituted the Inquisition to check the spread of heresy. For a man granted a humanist training in the intellectually exhilarating atmosphere of Lorenzo il Magnifico's Florence, this move must have seemed an ironic necessity. Pope in the Renaissance tradition by preference, Paul was the harbinger of the coming Counter-Reformation by force of circumstance. Janus-like, the aged Paul looked back to the heyday of the Eternal City when antique past and Christian present converged and merged, and forward to a more austere and straitened future.

There can be no doubt that the Sack was a traumatic event for the city and for all those who lived through it. It should not be seen as the turning point for culture, however, for the outlook of the High Renaissance had been chastened, not defeated. The seeds of doubt had certainly been planted, but they would not come to flower for another three decades. Were it not for the very considerable artistic achievements of these decades we might settle for characterizing this period as a "brief reprise of the ambitions of the Roman Renaissance,"[5] or "a sort of pale Indian summer after the splendours of the 'High' Renaissance."[6] This is the period, however,

that produced Michelangelo's *Last Judgment* and Pauline Chapel frescoes; the decoration of the Castel Sant'Angelo by Perino del Vaga (1501–47); the frescoes by Francesco Salviati (c. 1509–63) in the Cancelleria, the Farnese Palace, and the Ricci-Sacchetti Palace; the decoration of the Oratory of San Giovanni Decollato; the rebuilding of the Campidoglio; the design by Baldassare Peruzzi (1481–1536) and the construction of the Palazzo Massimi alle Colonne, and much more, for this list, limited to Rome, is not complete.

SEBASTIANO DEL PIOMBO (c. 1485–1547)

Sebastiano was one of the first artists to return to Rome, in March 1529, trailing the pope by only about six months. Very few immediately followed his example. Benvenuto Cellini (1500–71), Giovanni da Udine (1487–1564), Battista Franco (1498–1561), and Baldassare Peruzzi are among those who did.[7] Sebastiano's loyalty was rewarded when a vacancy occurred in the office of Piombo, as Keeper of the Seal. This lucrative sinecure was conferred on him in 1531. Despite this evidence of continuing papal favor, Sebastiano did not receive any commissions from Clement during this period up to the pope's death in 1534. His portraits of Clement (Vienna, Naples) were apparently made for other patrons. In fact, Clement had very limited financial resources, and such that he had he put toward completing the family mausoleum and library in Florence at San Lorenzo.[8]

An exception was Clement's intention to make good on a vow he had made while captive in the Castel Sant'-Angelo. He brought the sculptor Baccio Bandinelli (1493–1560) from Florence and installed him in the Villa Belvedere. As a kind of ex-voto in thanks for the pope's deliverance, Bandinelli was to make seven colossal reclining figures of bronze, standing for the seven deadly sins; they were to surround the Archangel Michael, also of bronze, to be installed on top of the round marble tower facing the bridge.[9] Clement only finally mitigated his policy of showing first preference to Florence in his last years, when in 1533 he discussed with Michelangelo the commission to repaint the altar wall of the Sistine Chapel with the *Last Judgment,* and if John Shearman's hypothesis is correct,[10] he was only implementing a plan that had been intended from the time of Julius II.

Despite the ravaged state of the city, Sebastiano received an important commission in 1530. Decoration

of Agostino Chigi's chapel in Santa Maria del Popolo, designed we recall by Raphael, had been interrupted by the Sack. The contract with Sebastiano for the altarpiece and scenes around the drum was renewed with a new subject specified for the altar, the *Nativity of the Virgin* (Fig. 86). In the foreground attendant women are gathered around a basin and prepare to bathe the newborn. One pours water, another tests the temperature, another hands in a basket of swaddling clothes. The regal mother rests on her bed in the middle ground, receiving congratulations. Framed in the distant doorway are two figures, presumably the father, Joachim, being given the news of the successful delivery. The lunette top is filled with God the Father amid a host of angels, some of whom consult books.[11]

The painting has a gravity about it that separates it from the traditional treatment of the subject. Sebastiano clearly had no use for the Florentine device of engaging the viewer by making parallels to contemporary domestic interiors. There is nothing here of the Renaissance palace bedroom we found in Ghirlandaio (Florence, Santa Maria Novella, Cappella Maggiore, 1485–90), nor the contemporary costumes of Andrea del Sarto (Florence, Santissima Annunziata courtyard, 1509/1510–13). The accustomed homey chatter and cheery excitement of the birth chamber have given way to a stateliness that bespeaks the significance of this nativity. All Sebastiano's figures are delineated with that hard-edged clarity suggesting sculpture that had always characterized his style. He has made no concession to sentiment nor to the feminine character of the scene. His somber tonality is also unique for this scene.

Comparison between the painting and two preparatory drawings that are preserved[12] demonstrates a process typical of painters of this period: the artist has moved away from naturalistic poses to more artificial ones as his thinking proceeded. The foreground attendant at the left who pours from a jug has undergone transformation: in the final version she has assumed a stylized pose of self-conscious *grazia* that is quoted from the antique statue of the *Crouching Venus*. This figure was a favorite with painters in the first half of the Cinquecento, in part because Marcantonio Raimondo's engraving (Fig. 32) made it easily accessible.[13] We will see with increasing frequency in the next decade this kind of substitution of a quotation from a familiar work of art for a pose drawn from nature.

Sebastiano has used a new technique here, just

Figure 86. Sebastiano del Piombo, *Nativity of the Virgin*. On slate, commissioned 1530. Chigi Chapel, Santa Maria del Popolo, Rome.

invented by him, that made it easier to create the obscurity that solemnizes his scene and the chiaroscuro that lends it drama. He has painted this enormous picture – about eighteen feet high – in situ on stone, pieced together to make a smooth and durable surface. Though transporting such pieces would prove a problem because of their weight, they were impervious to insects and resistant to fire. Another advantage was aesthetic: it provided a dark ground without necessitating a preparation.[14] The dark ground is perfectly suited to Sebastiano's chiaroscuro mode of coloring, again an unconventional choice for this subject, though not for this painter. The somberness of this work mirrored the mood of post-Sack Rome, some would say, but the fact that such a commission was available so soon after the catastrophe – albeit a renewed contract and not a new one – is proof that the city was already stirring and beginning the process of restoration.[15]

Sebastiano was still in close touch with Michelangelo during these years and even asked him for a drawing for the *Nativity*. There is no evidence that Michelangelo complied, but he could have discussed the composition with Sebastiano in person because he returned to Rome for a ten-month stay from late August 1532 through June 1533. It was presumably during this period that Clement broached the subject of the *Last Judgment*. Michelangelo returned again from Florence to Rome in September 1534, this time to stay until his death thirty years later. Within days of his arrival Clement died, but Pope Paul was quick to confirm the commission for the *Last Judgment*. During his interval back in Florence, Michelangelo wrote his friend Sebastiano asking him to have the Sistine altar wall prepared before his return. Sebastiano, convinced that his invention of a technique for painting in oil on the wall had vanquished traditional fresco, carried out Michelangelo's request by having the wall prepared for oil. When Michelangelo eventually discovered it, he was furious, threw off the infamous comment that oil painting was for ladies or old and lazy people like Sebastiano, and had Sebastiano's preparation torn down and remade for fresco.[16] Thus ended the friendship between the two artists that had lasted since the teens and benefited both.

MICHELANGELO'S *LAST JUDGMENT*

Michelangelo's return in 1534 must have served as an important signal that Rome was coming back to life, to resume its position as the cultural leader of central Italy, and indeed of the world. The scale and location of the *Last Judgment* (Pl. 17) reinforced the message. The decision to treat this wall of the Sistine Chapel as a single scene involved significant structural and aesthetic changes in the chapel. Perhaps one of the reasons Michelangelo asked Sebastiano to prepare the wall was that he did not want to oversee the destruction of his own two lunettes with Ancestors of Christ, painted earlier as part of the ceiling project. When Michelangelo had finished the vault in 1512, the chapel appeared to be fully decorated. On the altar wall there was a large altarpiece of the *Assumption of Mary* (1481) by Perugino, with the *Finding of Moses* and the *Birth of Christ* on either side.[17] The series of popes painted in the same Quattrocento campaign continued across the wall, as did the clerestory windows. All this had to be demolished, and the windows bricked up, before the wall

could be prepared. The fresco took Michelangelo a total of five years from the commencement of painting to its unveiling at the end of October 1541.

The subject Michelangelo was assigned was the representation of the Second Coming of Christ, the final day, the end of terrestrial life, the universal resurrection. The subject was related to a theological problem that was being hotly debated at the time, and one in which Clement himself had been involved. That there was such a thing as personal immortality had been denied by the philosopher Averroes in the twelfth century and then forcefully reaffirmed through the efforts of the two Medici popes, Leo X and Clement (who was at the time still a cardinal), in a decree of the Fifth Lateran Council, 1513. Reward and punishment after death was obviously an important tool of the Church to enforce obedience. Belief in personal immortality was also a logical extension of humanist thinking, in which humankind was understood to share qualities with God. It is not a surprise, then, that the philosophical refutation of Averroes had come from a Florentine humanist, Marsilio Ficino. The fresco commissioned by Pope Clement represents the resurrection of the individual.

There is no single definitive account of the final day in scripture or in the theological literature; texts would have to be pieced together. Unlike other sacred narratives where there might be one or perhaps as many as three texts, here the references in the Old and New Testament are scattered, usually brief, and often contradictory. Michelangelo's program could have been very precise and directive in terms of which texts he should rely on, or it could have offered him a selection from which he could choose. Crucial in any case was the description of the resurrection of the body given by Paul (1 Cor. 15). There, in more specific terms than any other scriptural passage, personal resurrection is promised. What would have appealed to the patron in Saint Paul's text was his description of how each individual would receive a new "spiritual body" for eternal life.

The decision as to how to visualize the event would have been left to the artist. From his point of view, these concerns would be key: how to dramatize the scene and how to represent the participants. How can heaven be depicted? How should the angels be differentiated from humanity? How can demons be made to look evil, but not ludicrous? Should the damned look different from the elect? What does a spiritual body look like?

Whichever texts were selected, they offered a wide

range of emotions and responses to the final judgment, and Michelangelo evokes them all: rejoicing because the promised Second Coming, with its release from all the sufferings of life, has finally arrived; the joy of reunion with loved ones; awe and wonder at the splendor and power of the Lord; fear of damnation and the anxiety of uncertainty; hope of salvation; or despair at the certain knowledge of damnation. From the point of view of the Church as patron, the painter should stir these emotions in his viewers and, by making the scene vivid, spur them to live so that with God's Grace, they will be saved.

The *Last Judgment* had not been a particularly popular subject in the Renaissance, with the conspicuous exception of Luca Signorelli's monumental treatment in the cathedral at Orvieto at the turn of the half-millennium, where the events were divided up and represented in separate scenes on the walls of the Cappella Nuova.[18] The shape of Michelangelo's wall was more like the traditional *Last Judgments* that often decorated the inside of the facade, such as Giotto's in the Arena Chapel (1305–6), and it dictated a spatial organization different from Signorelli's and more like Giotto's.

Michelangelo followed the tradition in placing Christ at the center surrounded by the elect, the resurrection of the dead in the lower left, and hell in the lower right. Those on the left – Christ's right hand – are ascending to join the saved, those opposite are descending to eternal damnation. Theologically speaking, the proof that there will be a final resurrection is Christ's resurrection,[19] so Michelangelo's Christ is modeled on his earlier studies for a resurrected Christ.[20] His composition gained in dynamic energy as his thinking progressed, until he invented the brilliantly equivocal pose and gesture for his Christ. Striding forward, he raises his arm and looks without emotion toward the damned; his gesture is not simply one of condemnation but of command, for it is also the gesture that begins this final act. "For the Lord himself will descend from heaven with a cry of command, with the archangel's call, and with the sound of the trumpet of God. And the dead in Christ will rise first" (1 Thess. 4:16). Saint Michael has been excluded and his place taken by the angels who consult their books where the destiny of every person who has died has been written. In response to the trumpet's call, all are directed to their assigned place, some assisted by wingless angels, some thrust down by devils. The painter's innovative vision makes the event not a fait accompli, but a

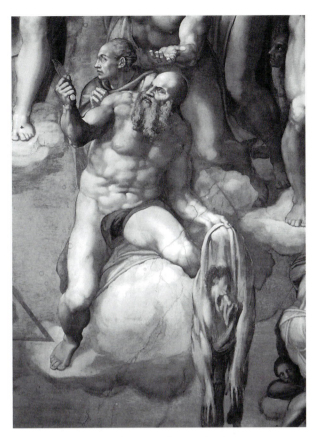

Figure 87. Michelangelo, *Last Judgment*, detail, Saint Bartholomew. Fresco, 1536–41. Sistine Chapel, Vatican.

drama unfolding before our eyes, involving the viewer in it as never before.

Where Michelangelo departs from the tradition is in his extraordinary figures. They are nude, and they do not reflect the full range of physical types and ages; on the contrary, they are all akin in their ideal strength and energy, representing Paul's concept of the spiritual, or glorified, body. The clue is provided by the artist, I believe, in a curious feature he has embedded conspicuously at the center. Just below Christ, we see the figure of Saint Bartholomew, who holds the knife with which he was flayed in one hand, and his skin in the other (Fig. 87). Although these are the traditional symbols of his martyrdom, it is unprecedented that his face should not match the one on the skin. Some have seen the features of Michelangelo himself in the skin. Even in the sixteenth century at least one copyist apparently believed it to be a self-portrait because he inscribed Michelangelo's name below it as a signature.[21] Attempts to explain the prominence of Saint Bartholomew, and Saint Lawrence opposite him, who form a conspicuous triangle with Christ at the center of the scheme, have so

far failed.[22] A variety of explanations for this figure of Bartholomew have been offered, but an obvious one, based on scripture, has been missed.

According to Saint Paul, all who have died, as well as those who are still alive at the Second Coming, will be granted a new and perfected body for eternity. For those who are to be saved, all deformities that we may have suffered in our mortal bodies will be remedied. (According to Augustine we shall all be given bodies of the age of Christ when he died, that is, thirty-three.[23]) Michelangelo's prominent display near the center of his fresco is the clue to why he has represented the elect as he has, in idealized, spiritual bodies. Bartholomew will not be raised in the mutilated body with which he left this life, but will be granted a beautiful new one.

If this is a self-portrait, Michelangelo, by putting his own distorted features on Bartholomew's discarded skin, expressed his petition that he will not have to spend eternity in his earthly body, which was already worn and failing. The artist's complaints about how his body was literally bent out of shape by his experience of four years painting the Sistine vault are often quoted. In the sonnet to his friend, Giovanni di Pistoia, he says, "I've already grown a goiter . . . Which sticks my stomach by force beneath my chin. With my beard toward heaven, I feel my memory-box atop my hump . . . My loins have entered my belly . . . In front of me my hide is stretching out and, to wrinkle up behind, it forms a knot."[24] It is not necessary to recognize the self-portrait or the personal comment it conveys, however, for the image to work. For it to provide the key to the interpretation of the fresco as the resurrection of the spiritual body the viewer need only note the disparity between the appearance of the risen Bartholomew and that of his terrestrial skin.

Michelangelo's love affair with the human body would have made the resurrection of the body as attractive a concept to the artist as it was – for theological reasons – to his patrons. Clement must have recognized that no other painter could match Michelangelo's ability to create the image of corporal and individual resurrection.

The Renaissance concept of the dignity of man and the doctrine of the resurrection of the body are compatible and complementary because both are based upon the *imago dei*. Paraphrasing Saint Paul: if we were made in God's image, then we will bear the image of God in heaven (1 Cor. 15:49). What is resurrected in

Michelangelo's fresco is the same race of ideal humanity based on antique models that inhabits his ceiling in the same chapel, finished more than twenty years earlier. Like those in the vault, each figure here is differentiated in what adds up to an astonishing variety of contrapposto poses. Each has dignity and awesome strength. Even the tragic giant, who covers his face in horror as he recognizes in his descent that he is bound for hell, has nobility. These are people who are motivated from within. In contrast to traditional *Last Judgments*, they are not ranged in serried ranks, obediently following angelic leaders; they act and move independently. The elect are not arrayed in orderly rows but are a seething band, some embracing in joy at their reunion and many crowding toward Christ. In the saints, who brandish the symbols of their martyrdom as tokens of worthiness, Wölfflin saw vengeance,[25] but it might rather be anxiety to know their fates. They are not seated smugly on their thrones, already certain of their salvation, but leaning apprehensively inward. Even the saints are not assured of salvation, for no one knows it in advance of the final day. The uncertainty Michelangelo depicted dramatizes for all of humankind, as no earlier rendering of the subject had, the awesome and fearful event. As splendid as this race of titans is, the message is that we do not control our fates.

If we turn attention to the macrocosm, the overall organization of the space, then another rich layer of meaning emerges. For all the individuality and inner strength of the figures, there is an ineluctable circular movement to which all are subject without their awareness. Rotating around the Apollonian Christ in his sunlike radiance, the composition moves like the planets around the sun in the Copernican cosmology.[26] The unorthodox beardlessness of Michelangelo's Christ, which later in the century drew much censure, can best be understood as a reference to the pagan god of the sun, Apollo; the painter certainly knew that some early Christian representations showed a beardless Christ. Around the fixed point of his solar radiance the movement of those resurrected flows. The orbit is preordained and immutable. With this inspired metaphor Michelangelo represents the paradox of human free will and divine providence. When the artist shows the bodies rising or falling, or already convened in heaven or hell without their knowledge of where they are or where they are going, he makes it clear that it is by God's initiative that man is redeemed. But man has

been free to reject redemption by leading a sinful life. Here, finally, the optimism of the High Renaissance humanists is tempered with the acknowledgment of human depravity and dependence upon divine Grace. Viewed from the vantage point of ultimate judgment, human dignity takes on a pathos not to be found when the vantage point is that of Creation, the perspective preferred in the High Renaissance.[27] Michelangelo's *Last Judgment* is an apt summary of the age of Paul III.

There is nothing to prevent us from supposing that Michelangelo elaborated on the scriptural skeleton of the program given him: indeed, his critics implied it and some even accused him of making inappropriate additions. It is unlikely, for example, that he was instructed to borrow from Dante's *Divine Comedy* the figure of Charon the boatman ferrying the damned to hell, or of Minos, lord of hell, included at the very bottom. Virtually every commentator in the sixteenth century noted Michelangelo's Dantesque images. It would have been normal practice in the Renaissance for an artist to embellish a scene, even a sacred subject, with additions not mentioned in his text but which he found useful in dramatizing the event. In the next chapter dealing with the Counter-Reformation we discuss the critical reception of the *Last Judgment* when this embellishment became an issue, but for the moment the practice of elaborating on the text is worth noting.

Michelangelo's decisions about how to represent the scene reveal his careful rethinking and frequently depart strikingly from the tradition. His angels are wingless and are therefore often difficult to distinguish from humankind. Demons are dark and ugly but few in number and kept from prominence. For him the spiritual body described by Saint Paul must be nude, both because we will shed distinctions of rank and position when we face the Lord, and because the resurrected body, as Michelangelo conceived it, is the ideal human form. To represent heaven the painter made use of a pigment that had scarcely appeared elsewhere in the chapel decoration, the blue of lapis lazuli, ultramarine, the most expensive pigment after gold and one that was rarely used in fresco. Until the restoration it was impossible to appreciate the blue of the background as anything special. With accretions of candle smoke and dirt, and as a result of previous cleanings, it had become chalky and grayish. The strength of the ultramarine holds the scene together and permits the painter to design wholly in terms of groups of figures, except for

the narrow band at the bottom where we see hell at the right and, at the left, the earth, out of which the skeletons rise to be clothed in their new bodies.[28] In these two sections we see a different kind of humanity, those before their resurrection and those damned whose spiritual bodies are still ugly, not perfected, and not impervious to pain, as are the elect.[29]

There is no indication of the picture plane; the figures seem to be projected in front of it. Another reason for limiting the draperies and representing the figures almost entirely nude suggests itself when we contemplate the wall in its present newly cleaned state. The need to discipline the variety of hues so that the coherence of the enormous whole would be maintained must have been uppermost in the painter's mind. In his ceiling, even though the scale of the figures is colossal, they are contained in compartments. The fictive architecture that frames each scene provides a structure lacking on the altar wall, where there is not even a frame around the perimeter. No one before Michelangelo, it is safe to say, would have dared so bold an innovation or had the confidence that he could hold it all together without any help from boundaries. The suggestion that the scene continues beyond the edges and that we are seeing only a part corresponds to our sense that this is too limited as a depiction of the resurrection of all humankind.

The same ultramarine is used to pick out the Virgin at Christ's side, but to distinguish her here uniquely, this blue is heightened with white. She had not appeared in an early drawing, when Perugino's altarpiece of her *Assumption* was still intended to be preserved. When the decision was taken to eliminate it, her presence in the fresco, as the dedicatee of the chapel, became obligatory. Color gives her prominence, but she clings to her son's side with her arms folded in resignation, her role as mediatrix now past.

There are no bystanders at the Last Judgment – the event may be unique in the way that it involves everyone present, including the spectators in the chapel. Michelangelo had to imagine an equal intensity of emotion for every single figure and translate it into body language, resulting in a dazzling array of contrapposto poses. Achieving the necessary uniqueness of posture for every one of the hundreds of figures taxed the ingenuity even of Michelangelo. Armenini, writing in 1586, following Vasari, related how it was said he made wax figurines, which could be shaped until the desired

Figure 88. Pellegrino Tibaldi, *Adoration of the Shepherds.* 1548 (1549). Borghese Gallery, Rome.

pose was found, then drawn; then he warmed the wax and reshaped it for the next figure.[30]

Michelangelo's younger contemporaries were naturally awed, and they viewed the fresco as a school, a repository of poses upon which they could draw, much like his earlier cartoon of the *Battle of Cascina* in Florence. The chapel was always peopled with artists drawing (see Fig. 127). The advice to young artists given by Armenini, and repeated over and over in Cinquecento sources, was that they should copy the great art of the past and present, especially the antique statues, Raphael, the facades of Polidoro da Caravaggio, and Michelangelo, specifically the *Last Judgment.*[31] Innumerable copies were engraved and the prints widely dispersed, so that secondhand knowledge of the fresco through these copies was far greater than the limited access to the chapel would have permitted.[32]

In some of the Maniera paintings that followed in its wake in the 1540s, space-filling spectators pose with elegant and studied contortion. What for Michelangelo had

seemed to be necessitated by the subject became for his copyists a source and justification to fill their compositions with complex postures, no matter what the subject. There was too often no distinction made between what was appropriate for the *Last Judgment* and what was appropriate, say, in a *Nativity.* An example of this kind of awed imitation, without proper thought to the suitability of the appropriations, is the *Adoration of the Shepherds* (Fig. 88) by Pellegrino Tibaldi (1527–96). Painted when the artist was only twenty-two years old, as he proudly inscribed on his panel, it conspicuously quotes Michelangelesque figures and their complex poses. Their monumental sculptural presences intrude on the scene and disrupt its accustomed intimacy in a way that can only be interpreted as motivated by the desire of the painter to show off his skill and express his admiration for the great master Michelangelo. The objections of those who were concerned with safeguarding the education of the faithful were bound to come.

ANTIQUARIANISM AND FOREIGN VISITORS

While Michelangelo was at work in the Sistine Chapel, a community of artists was assembling again in Rome, and cultural and antiquarian activities of all kinds were being revived. In 1530, Battista Franco had arrived, and in 1531 Baccio Bandinelli, who was installed in the Villa Belvedere and opened a school for young sculptors. Early in 1532 two young Florentine painters, Giorgio Vasari (1511–74) and Francesco Salviati, both students of Andrea del Sarto who had just died, came to continue their study of art. Many years later Vasari recalled in his autobiography how he and Salviati would go out every day, each to a different place to draw, so that in the evening they could exchange sketches and learn twice as much that way.[33]

In 1532 Martin van Heemskerck (1498–1574) arrived from Haarlem to study in Rome. He had been preceded by his master, Jan van Scorel (1495–1562). Following the election of the Dutchman, Pope Adrian VI, in 1522 there had been an influx of Germans, Flemish, and Dutch artists, hopeful that they would be able to displace the locals and receive important commissions. In fact, Adrian was so little interested in the arts that neither the locals nor the northerners thrived. We have seen that Sebastiano del Piombo fared best, having been commissioned to paint the pope's portrait.[34] Jan van

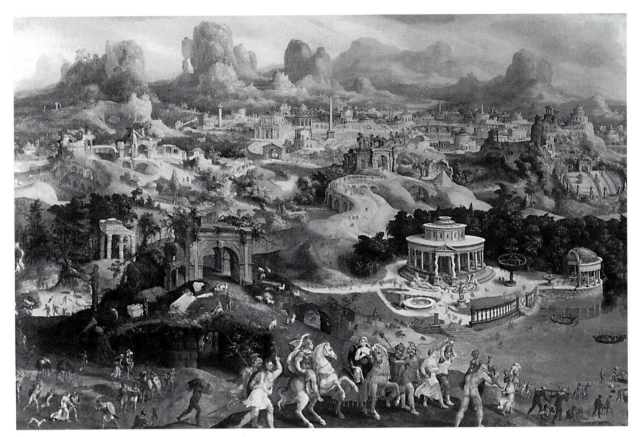

Figure 89. Martin van Heemskerck, *Panoramic Landscape with the Abduction of Helen,* detail. 1535–6. Walters Art Gallery, Baltimore.

Scorel had gone first to Nuremberg to study with Albrecht Dürer (1471–1528), but according to Carel van Mander (the Flemish Vasari), he had found the master so preoccupied with the "teachings by which Luther had begun to stir the quiet world"[35] that he proceeded to Rome instead.[36] His acquaintance with the pope's intimate friend and datary, Enckevoirt, assured Scorel good treatment. He was given lodgings in the Villa Belvedere, like Leonardo da Vinci in the reign of Leo and Bandinelli later, and appointed supervisor of the Vatican art treasures, the post previously filled by Raphael.[37] As soon as the short rule of Adrian came to an end, however, so did the propitious circumstances for Scorel. He departed when the pope died in September 1523 and returned to work in Utrecht. But he had been transformed by his experience. He believed that it was necessary for an artist to visit Rome and he proselytized his pupils.[38]

Heemskerck took his master's advice and stayed in Rome for four, perhaps five, years. He is best known for his prodigious output of drawings of Roman buildings, which are greatly valued for their archaeological docu-

mentation. He drew both ancient and modern Rome, so it is his views that record the progress of the construction of Saint Peter's and the look of the Villa Madama in the mid-1530s. He was joined by fellow northerners who shared his enthusiasm for the ruins. There is a graffito in the Domus Aurea that records the visit of Heemskerck, together with Lambert Sustris (c. 1515–c. 1584) of Amsterdam and Herman Posthumus (1512/1513–after 1566[39]), who had probably also been inspired by Scorel to make the Italian journey.

Equally as interesting as their drawings, but less studied, are two paintings of the years 1535–6 that attest to the northerners' enthusiasm for recording the ruins and the fantasies they engendered. One is by Heemskerck, the *Panoramic Landscape with the Abduction of Helen* (Fig. 89), a large, twelve-foot-long canvas representing a landscape in ancient times with miniature figures scattered through it. The painter dated it in two places, once 1535, elsewhere 1536, indicating that he worked on it over an extended period. It is filled with reminiscences of the antique, some quite accurate, some fantastic. In the foreground is a round building surrounded by a

colonnade. The entrance is flanked by two river gods like those the artist saw and drew on the Campidoglio, and supporting the entablature over the door is a pair of twisted columns like those in the old Saint Peter's. A pergola in the shape of a hemicycle provides a pleasant spot to enjoy a promontory to the sea. Heemskerck has reconstructed this charming spot, combining elements and completing fragments that he had observed and studied. In the distance overlooking a port is an enormous bronze statue, his legs straddling the entrance to the harbor, an evocation of the Colossus of Rhodes. The painter has given full rein to his imagination and, on the basis of the precise recording of what he had visited and drawn, created a fantasy of what the countryside might have looked like in antiquity. In the foreground are the figures that provide the title: Paris on his white horse is accompanying Helen to the ships for her abduction to Troy. Many of the accompanying soldiers are carrying off antiquities with them, in what must record a daily occurrence observed by the painter working in the ruins of Rome.

Heemskerck has adapted the type of Flemish landscape known as "world landscape," developed particularly by Joachim Patinir (c. 1480–1524) in Antwerp and spread quickly to Flanders and beyond. A broad segment of the earth's surface is depicted from an elevated point of view. In conspicuous disregard of Italian central-point perspective, the vanishing points do not align on the horizon. Human figures are miniaturized, in sharp contrast to the standard for Italian out-of-doors painting, where the figures are typically half as tall as the height of the picture. Thus the panorama of nature takes precedence over the human, in reversal of Italian priorities.[40] Heemskerck employed the coloring system of Patinir to unify his enormous canvas: the foreground is brownish, the middle ground greenish, and the background bluish. The only saturated colors are employed to pick out Helen, whose horse is caparisoned in vermilion and who wears the only deep blue in the picture, set alongside the white horse of Paris. Who the patron was is an interesting unanswered question. Was he a Roman antiquarian with an unorthodox taste for landscape?

Equally evocative is the *Landscape with Antique Ruins* signed by Herman Posthumus and dated 1536 (Fig. 90).[41] The artist has included pieces that could be seen in the private collections of Rome, prominent among them the sundial from the Delle Valle garden, which

signals the theme of passing time. The inscription is a lament quoted from Ovid (*Metamorphoses,* Bk. XV, 234–6), "Ravenous time and envious age, you destroy everything." Climbing around among the ruins are visitors who admire, artists who measure and sketch, and at the far right a pair who descend through the broken vault with torch held high to marvel at the frescoes appearing out of the obscurity. This is certainly a rendering – the only one that has come down to us from the Cinquecento – of those visits to the Domus Aurea that had so captured the imaginations of artists and antiquarians since the time of Pinturicchio.[42] Indeed it is scarcely possible to study these minutely rendered pictures that record, on the one hand, the appearance of some of the actual fragments and, on the other, inventions, hybrid combinations, and bits fragmented further by the painter in his imagining, and not catch the spirit of adventure and the romance of exploring the ruins. The underground porticoes, the mysterious inscriptions, the half-revealed structures conjure visions of toga-clad senators and merchants strolling through now-vanished forums. A visit to the well-ordered remains of ancient Rome today, where the ground has been leveled, the vines are disciplined, barriers and signs direct one's steps, and admission costs thousands of lire, can hardly evoke a similar excitement. There is a note of nostalgia running through these paintings, an anticipation of Piranesi, that seems to be typical of the antiquarianism that took shape in the 1530s and had not been present earlier.[43]

Both these paintings are reminiscent of Patinir's world landscapes and they represent an intriguing departure on the part of some unknown Roman patrons from the usual taste. Moreover, within the oeuvres of both of these painters, they are unique. It would appear that what they intended to evoke, in addition to the atmosphere of the ruins in Rome, was the look of ancient painting. We know very little about what they knew of ancient painting, but the examples we have, which have been discovered since the Renaissance, resemble these paintings in the same way that the murals of Polidoro da Caravaggio (1490–1536 or 1499–1543) in San Silvestro al Quirinale do (Fig. 52).[44]

In Rome itself there developed at this time a new taste for landscapes with ruins, and they began to be incorporated into the friezes of palace interiors. The most famous set is in the Villa Giulia by the painter who has been identified as Michiel Gast (documented

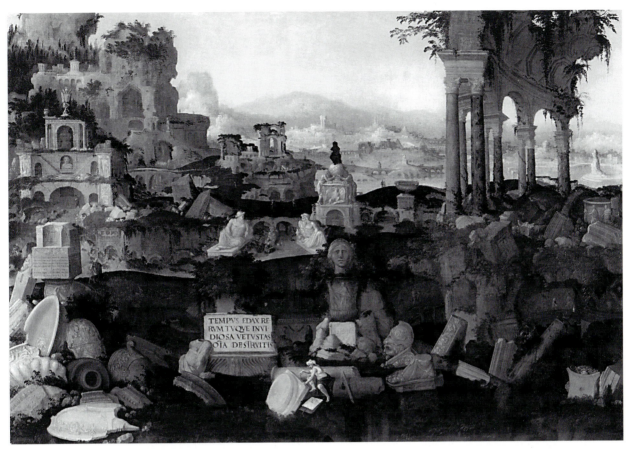

Figure 90. Herman Posthumus, *Landscape with Antique Ruins.* 1536. Prince of Lichtenstein Collection, Vaduz.

in Rome 1538–55).[45] It seems that the Flemish painters became the experts in this specialty and were allowed to practice it without competition from native artists. They perhaps developed this expertise because of the tradition for landscape painting in the Low Countries where they were trained, the conventions of which they could adapt to the needs of the Roman patrons.[46] Gast stayed in Rome for many years and continued to get work until about 1556, when he finally departed.[47] His departure coincided with hard times for artists in Rome during the pontificate of the harsh Paul IV (1555–9).

Rome was beginning to attract artists from everywhere in increasing numbers, a practice that continued until eventually it became an essential part of the artist's training to study and draw after the antique and modern masters in Rome. In the seventeenth century the French Academy established itself in the Villa Medici and, from Poussin to Ingres, was headed by leading painters of their day. In 1538 a young and well-connected painter from Portugal of Dutch descent named Francisco de Hollanda (1517/1518–84) arrived in Rome. He is known

as the author of the *Four Dialogues,* in which Michelangelo is a principal participant,[48] but it appears that he had been sent by the Portuguese king to study the fortifications all over the Italian peninsula, and he did indeed return home, probably in 1542, with a book full of drawings made for this purpose. He brought back as well, however, drawings of the antiquities, just as Scorel, Heemskerck, Posthumus, and others carried their sketchbooks to other destinations in Europe. Hollanda's drawing of the *Volta dorata* (Pl. VIII) in the Domus Aurea is the best record we have of the appearance of that now all-but-lost monument that was so influential in the Cinquecento.[49] And the visitors copied not just the antiquities but the modern masters as well, especially, of course, Michelangelo and Raphael. All the artists made drawings in the Sistine Chapel. One sheet of Heemskerck's, folio 35r (Fig. 91), shows a sketch from Raphael's Psyche loggia at the Villa Farnesina; he then turned the sheet to draw the fragment of a sphinx, some architectural ornaments, some headless matrons in marble, and on the reverse, other bits of antiquity.[50] These sketches,

together with engravings that were also being made in increasing numbers, carried the fame – and the appearance – of Roman art, ancient and modern, far and wide. If the first diaspora of Roman style occurred when the Italian artists fled as a result of the Sack, the "study tours" of artists returning home with their sketchbooks were a means and manner by which the process was continued.

It is worth noting that although the world of classical antiquity appears frequently in the works of those painters after they returned to their homes in northern Europe, and the Renaissance conceptions of space and of the figure were widely copied, there is little evidence of influence, except in landscape painting, left on the Roman scene by these visiting artists. It will not be until the last decade of the Cinquecento that northern art makes a substantial impression on central Italian painting.

In April 1536 Rome announced to the world that it had recovered from the Sack, in terms of its prestige as much as physically, when Emperor Charles V was given a triumphal entry in the classical manner on his return from his conquest of Tunis. Preparations began in 1535 when Pope Paul ordered the clearing of a number of archaeological sites along the emperor's route. According to Rabelais, who was in Rome at the time, two

Figure 91. Martin van Heemskerck, drawing after Raphael's *Psyche* and marble fragments. 1532–6. Berlin sketchbook (fol. 35r), Kupferstichkabinett, Staatliche Museen zu Berlin – Preußischer Kulturbesitz.

hundred houses and three or four churches were demolished.[51] Any Renaissance pope had to tread a narrow path between preserving antiquity and urban renewal, and Paul in particular took many initiatives, some of which angered antiquarians. Very soon after his election he appointed his personal secretary to oversee the preservation of antiquities, specifically to prevent further clandestine excavating and the theft of marble to turn it into lime. It was a signal that Paul was energetically committed to the enterprise, but what he destroyed for the construction of his family palace and what had to be removed to clear a route for the emperor's passage raised horrified cries of protest from some – especially the anti-imperialist French, including Rabelais, who left Rome in protest.[52]

The procession was a spectacle filled with political innuendo that reasserted the authority of the papacy and of Rome as much as it honored the emperor. The planners needed to exercise all their dexterity for this sensitive situation. It was *this* emperor's troops who had sacked the city only nine years earlier, after all, and many inhabitants of the city still had unhealed wounds. The pageant recalled the grandeur of Rome's past by casting the procession in the mold of an ancient imperial triumph. Just as the emperors of ancient Rome might be voted a triumph by the Senate to honor them for their conquests, Charles V was offered a triumph by the pope for his conquests in North Africa. The emperor's route was designed to take him through all three of the great triumphal arches, those of the emperors Constantine, Titus, and Septimius Severus, constructed in their honor to commemorate their victories. In Piazza San Marco, Charles passed under a temporary arch constructed for the occasion, commemorating his victory in Tunis.[53] The difference was that his were victories for Christianity. Monochrome paintings, presumably intended to simulate sculptural relief, showed him freeing his Christian prisoners while taking captive with him the infidel Turkish prisoners of war. When Charles reached the entrance of Saint Peter's, he kissed the pope's foot, reenact-

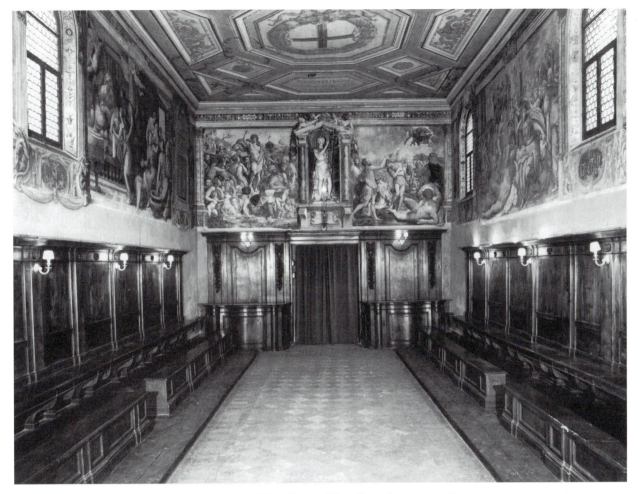

Figure 92. Oratory of San Giovanni Decollato, view. 1536–51. Rome.

ing the traditional obeisance of State to Church. Then the pope embraced him and led him into the basilica for the celebration of the Mass.[54]

Not only was this a reassertion of Rome's prestige, it signaled a revival of commissions for its artists. Antonio da Sangallo seems to have been put in charge. Battista Franco, Francesco Salviati, and even the northerners contributed to the decorations. Herman Posthumus has recently been identified as one of the documented artists,[55] and we can probably equate the Martino Tedesco mentioned by Vasari with Heemskerck, despite the objections of some.[56] It is sometimes suggested that artists known to be in Rome the following year, Jacopino del Conte (c. 1510–98) and Perino del Vaga, had come earlier in the hope of participating in the decorations for Charles V, but this theory remains undocumented. Daniele da Volterra (c. 1509–66) is another who arrived in these years. More likely, when word reached them of the splendor of the event and its

decorations, they decided to put the Sack behind them and to try their fortunes in the Eternal City.

ORATORY OF SAN GIOVANNI DECOLLATO

Further evidence that Rome was mending came the following year when members of the Confraternity of San Giovanni Decollato decided to fresco their Oratory with scenes from the life of their patron saint, John the Baptist (Fig. 92). They were a brotherhood of Florentines living in Rome who took as their duty to provide comfort to convicted criminals in their last hours. Four of the members would don their black robes and hoods (so that they could perform their good works anonymously) and go to the prison the day before the convict was to be executed. Their hope was to bring him to a good death, so that, like the Good Thief who was forgiven by Christ on the cross, he would go to heaven. In the altar-

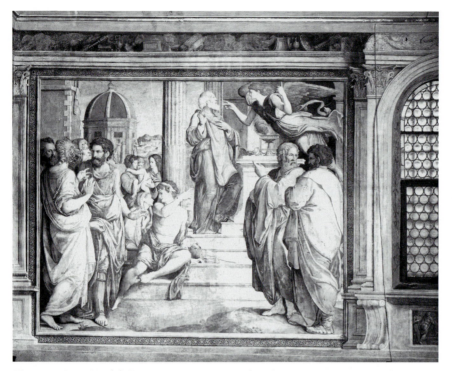

Figure 93. Jacopino del Conte, *Annunciation to Zachariah*.
Fresco, c. 1537. Oratory of San Giovanni Decollato, Rome.

The Oratory was, and still is, the private chapel where the members would meet and attend Mass. Around the walls are wooden stalls for seating and above them, in large fields between the windows, the frescoes appear. The painting campaign spanned more than fifteen years and involved several artists, so that rather than presenting an artistically unified cycle, it reflects the changes in style from the late 1530s through the early 1550s. The subject chosen was the appropriate one, for John the Baptist was the patron saint of Florence and he had been executed, like the prisoners they attended. The painters selected were all Florentines as well. The first to receive a commission was Jacopino del Conte, who eventually did three of the scenes and the altarpiece. Francesco Salviati painted two of the scenes and the two frescoed saints flanking the altar; his workshop, or at least one of his followers, was apparently also responsible for the *Beheading of John the Baptist,* which is the last, dated 1553. Battista Franco frescoed the *Arrest of the Baptist* in c. 1541–4, and Pirro Ligorio (c. 1510–83) executed the *Dance of Salome* in the mid-1540s. What interests us most are the juxtapositions of style and changes of style – in one case quite abrupt – displayed here.

piece of the *Deposition* (Fig. 121), painted in 1551 by Jacopino del Conte,[57] the thieves flank Christ conspicuously. At the prison they would set up a temporary altar and would undertake to persuade the prisoner to make a full confession and to be absolved by the priest so that he would die without sin. Even convicted men who proclaimed their innocence were urged to repent and put their faith in God. The prisoner was reminded that he was more fortunate than those who died suddenly without opportunity to be absolved of their sins. They stayed through the night, praying with the prisoner, and then accompanied him to the place of execution, holding before his face a painting of Christ's crucifixion and reminding him constantly that he would soon be with his Lord. They even climbed the ladder to the scaffold with him, shielding his eyes from the executioner and the gibbet and distracting him with prayers and reassurances. The handheld painting was part of the equipment of the confraternity, especially designed with a handle, small enough to be carried but large enough to shield the prisoner's gaze. After his death the whole company would go in procession, retrieve the body, and bring it back to their church to bury it at their expense. They would dispose of the man's possessions and care for his family, if necessary.[58]

Jacopino, who had recently arrived from Florence, painted his *Annunciation to Zachariah* (Fig. 93). Memories of his native town abound and must have appealed to the nostalgia of the brethren. The cupola at the left is of course that of the cathedral, but it is here transformed into a baptistery in reference to the saint whose conception is being announced to his aged, and thus skeptical, father at the right. Michelangelo's *Apollo-David* (now in the Bargello in Florence) decorates the building. The youth seated on the steps recalls an *ignudo* from Michelangelo's Sistine Ceiling, and the angel resembles Raphael's in his frescoes in the Chigi Chapel in Santa Maria della Pace.[59] As these references reveal, Jacopino is in fact more adept at clever quotation than at creating an arresting composition.

Thus the design of his *Preaching of the Baptist* dated the

next year, 1538 (Pl. XVIII), is all the more startling, for it is in an altogether different mode. Suddenly the space is filled with figures in self-consciously graceful poses, overlapping one another and pressed up against the picture plane. The spacious voids of the *Zachariah* are gone, and although the figures are not reduced in their proportions, the crowding makes them appear dynamically compressed. The dramatic presentation is no more urgent than in the *Zachariah,* but the aesthetic appeal in terms of ornament has been conspicuously enhanced. We are fortunate to have the evidence for how such a transformation of style could take place within a few months. Jacopino was evidently provided with a compositional sketch by Perino del Vaga, which he followed (Fig. 94). Perino, we recall, had fled at the time of the Sack, had spent much of the intervening decade in Genoa under the patronage of Andrea Doria and, like Jacopino, had just returned to Rome. Why he supplied a drawing to Jacopino we will probably never know,[60] but it turned out to be a landmark event, for the style Jacopino displayed here would become the style of preference, first in Rome and then in Florence and elsewhere, for the next two decades.

Comparison of the fresco with the drawing indicates that Jacopino carried still further what was suggested by Perino. His Baptist is far larger in relation to the frame, as are many other figures; those that might have receded in importance in Perino's original design come aggressively forward into prominence here. The splendid contortions of some of Perino's figures have been multiplied, their postures frozen so as to become more like sculpture and less like life. Perino's sketch has no indication of the light, but the flat light that Jacopino has invented assures that there is no subordination: each figure and each part of each figure vie for the viewer's eye. Color contributes to the lack of subordination here by its recessiveness. The scene is dominated by high-value flesh tones, resembling marble, and bright-hued passages are restricted to small areas, in marked contrast to the large, well-defined fields of color in his *Annunciation to Zachariah.*

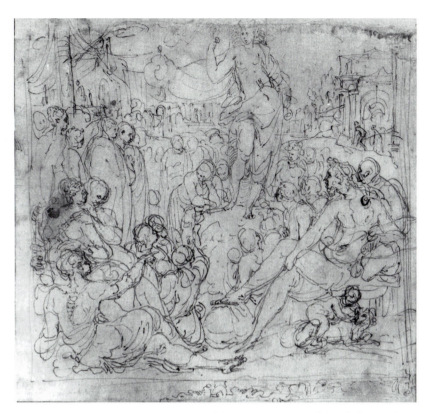

Figure 94. Perino del Vaga, compositional sketch for *Preaching of the Baptist.* 1530s. Albertina, Venice.

Jacopino was another student of Andrea del Sarto who had then come under the influence of Michelangelo. His *Madonna and Child* (Washington, National Gallery of Art, c. 1535–6) was apparently painted shortly before his departure to Rome. It reflects the Madonna executed by Michelangelo in the 1520s for the Medici Chapel. Although emulating sculpture in the round, rather than relief, it reveals a concern with sculpture as the preeminent model for painting that finds further expression here in his *Preaching of the Baptist.*[61]

It disrupts our art historical presuppositions to find an artist of the second rank pioneering a new style, but on the basis of present evidence we must credit Jacopino in largest measure with making here the first statement of the mature Maniera. The way had been prepared for such a statement, of course, in the preceding decade. We should be reminded of what we called the relieflike style of the pre-Sack decorations by Polidoro and by Perino himself: Perino's manifesto of it had been the *Crossing the Red Sea* made in Florence in 1523 (Pl. XI). The difference between the *Preaching of the Baptist* and the *Annunciation to Zachariah* is that Jacopino has abandoned the central point perspective he had

used in the earlier fresco, where the scene was projected rearward into a space that recedes from the viewer. In the *Preaching* the figures appear to project forward into the viewer's space. It is as if they protrude from the surface, as they do in antique relief sculpture. Thus Jacopino shows virtually no middle ground or background here, and the bulging figures all but fill the pictorial field. We will see this kind of richly embossed surface repeatedly in works that we call Maniera. Although central point perspective will not be abandoned altogether, it will not be the preferred mode of composition in central Italy for many years to come.

Here for the first time we find the relieflike style applied to sacred art and not just reserved for antique imitation or secular works.[62] The implication that will be discerned and developed now by the progressive painters is that this style is appropriate for any picture, regardless of function, location, or patron. The conservatism of style that had lingered in the sacred art of the past two decades since the relieflike style was first explored, was now to disappear, and sacred and profane art would be treated in the same highly artificial style. This development would turn out to be a fatal breach of decorum from the point of view of the gathering movement for reform.

On the surface of Pauline Rome little had changed, but the art tells a somewhat different story. Just as in our society today the relative unity of the Victorian era has yielded to competing political ideologies, conflicting systems of values, and contending religions, all claiming absolute truth, so was the unity of the High Renaissance splintered and the confidence eroded that made possible such a statement as Michelangelo's Sistine Chapel vault. What we discern is not pessimism but rather the awareness that truth is multifaceted. This is a culture for which the simple statement was no longer possible.[63] An analogy from our times is offered by Willem de Kooning's half-concealed *pentimenti,* the erasing of which became a part of his piece. The canny painter knew, however, that with time the concealing layers of paint will become increasingly transparent to reveal the *pentimenti* more clearly, making the image and its statement ambiguous. The artists of the Roman Restoration would likewise sometimes embed in their paintings layers of meaning, like archaeological strata, and, as may be true of the evidence of archaeology, they were not susceptible to integration. Closest to the metaphor of archaeology is their use of quotation.

Within the same piece we may find a pose imitated from a sanctioned High Renaissance master and another from an antique statue, but usually neither intends to refer to the content of the original, only to its form. Oppressed by their own artistic genealogy, the painters multiplied their acknowledgments to their ancestors. It should not be overlooked, of course, that the quoter displayed his learning and his skill, so that the quotation was intended to surpass the original. The homage is also agonistic.

There is quotation in the High Renaissance, to be sure, and it provided the precedent that impelled the later artists. In a piece like Jacopino's *Preaching,* the quotations come close to constituting the only statement the work can, or cares to, make. Charming but irrelevant details abound, like the child astride a dog, borrowed from the *Donation of Constantine* of the Raphael workshop (Fig. 28). To be sure, with some effort one can interpret the two men in the foreground who are consulting a book and disputing: one – recalling the Sistine Prophets – who is pointing to John and to the text, acknowledges him to be the promised precursor of the Messiah, the other remains skeptical. But other elegantly posed figures appear not to be attending to the sermon at all. John strikes a statuary pose, so graceful as to lack the force to persuade us of the fiery eloquence attributed to him in scripture. Beautifully rendered details, like the boots or turban, bait us and draw us in, and we are dazzled by the virtuoso display of art. But if we ask what interpretation Jacopino has given of the encounter of the Baptist and his listeners, the answer may be slow in coming.

This is not to say that all the painting of the Roman Restoration is empty at the center. It is to say that the absorption in ornament and artistic display may at times be substituted for a content of religious emotion, as if by stimulating the aesthetic response it is hoped that a religious response will be triggered. We know far too little about the Renaissance psychology of perception, and it is surely dangerous to speculate in this area, but from scrutiny of the art it appears that some such belief underlay their religious art.

There is no evidence within the Oratory decorations that anyone paid immediate attention to the innovation of Jacopino's *Preaching.* Salviati painted his *Visitation* (Fig. 95) in the same year, and according to Vasari, there was a vivid rivalry between him and Jacopino, so it is not surprising that he did not follow suit.[64] He chose

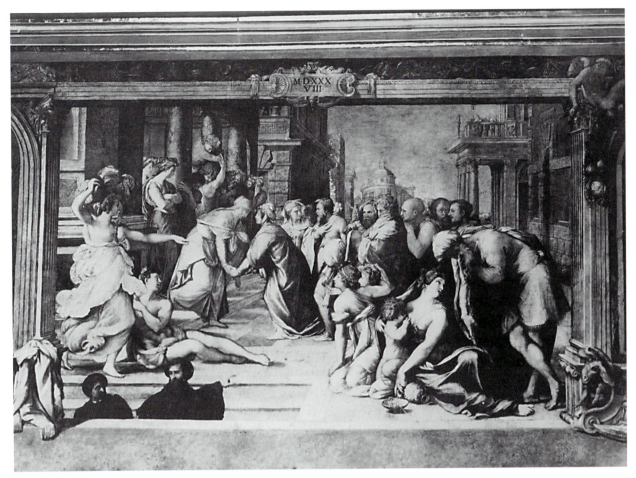

Figure 95. Salviati, *Visitation*. Fresco, dated 1538. Oratory of San Giovanni Decollato, Rome.

instead to use the traditional perspective mode, modeling his composition on an earlier Perino del Vaga and reaching back through the pupil to his master Raphael. There are not only explicit quotations from Raphael, such as the woman entering at the left from the *Fire in the Borgo* (Fig. 4) and the figures clinging to columns for a better view from the *Expulsion of Heliodorus* (Fig. 24), but the whole scenographic spatial organization is borrowed from the tapestry cartoons, either *Paul Preaching* or the *Sacrifice at Lystra*. Above all, the color recreates the close harmonies of the *unione* mode in the Stanza della Segnatura (Pl. II).

Although we do not find Salviati simulating relief in his *Visitation*, we do find here that other chief feature of the Maniera style, delight in ornament. This predilection for ornament, shared with Jacopino and Perino, predisposed Salviati ultimately to embrace the Maniera. The large field Salviati was assigned for this subject, which requires only the figures of the two expectant mothers, dictated he invent a large number of ornamental bystanders. Compar-

ison with his evident source, Perino's version in the Pucci Chapel (Fig. 54), shows Salviati surpassing his model in introducing elegant poses, regardless of whether they contribute to the narrative. Important for the future is his introduction of two half-length figures in black, clearly members of the confraternity, silhouetted against the picture plane, as Pontormo had done in his *Christ before Pilate* (Fig. 39). *Repoussoir* figures like these will have a long life in the paintings of central Italy, filling space, establishing the picture plane, and contributing to the ornamental pattern on the surface. Further, they function to impede the viewer's access, holding the viewer psychologically at a distance. The inexplicable nude seated on the ground at the left or the Charity-like mother and child conversing with the graybeard leaning on his staff seem quite beyond rationalizing in the context of the event depicted. Indeed, mystifying diversion appears to be a major purpose of the inventions of both our artists in the Oratory. Depending on our point of view, Jacopino's visual quotations and

the portraits he has intermingled among his marmoreal listeners, including the new Duke Cosimo of Florence under the Baptist's upraised arm,[65] either embellish the scene or distract from the narrative. It is clear in contemporary sources that at least the cultured clientele relished the embellishment.

The art of the Maniera was created for a visually sophisticated audience, an audience that could recognize the source of the quotations and enjoy playing the intellectual game, an audience that knew how the subject had been presented by artists in the past, and an audience that could be captivated only by a compelling novelty. And they appear to have been willing to sustain interest in multiple diversions within a single frame, both intellectual and aesthetic. Along with quotations and portraits to be recognized, there was a complexity of visual matter, intertwined, richly detailed, and ornamented, to be deciphered. The visual simplicity, however monumental, of the *Annunciation to Zachariah* looks heavy and irksome alongside the *Preaching* or Salviati's *Visitation*. In point of fact, it is the Classic style of the High Renaissance that is exceptional in its singularity of focus. The Quattrocento audience had apparently enjoyed byplay and genre inclusions in their narratives, as we have suggested. The difference is that the Maniera diversions are not usually transparent references to shared human experience, as in Quattrocento art, but are cryptic messages that, once deciphered, serve to reassure viewers of their exclusive membership in an elite cultural fellowship.

Salviati remained aloof from the stylistic innovations demonstrated by Jacopino-cum-Perino for another several years, but not so his close friend, Giorgio Vasari. Vasari came to Rome to visit in 1538, and upon his return to Tuscany he was quick to carry out two altarpieces in the new style (Fig. 147). Salviati left Rome for Venice in the middle of 1539.[66] An altarpiece of the *Entombment* made for a Venetian church shows him in a moment of transition.[67] Whereas the angel above is perfectly Maniera in its exquisite artificiality, and others of the figures move toward poses contrived to flatten them artfully against the picture plane, the Madonna preserves a naturalism of gesture, demeanor, and pose that holds her firmly in this world. Similarly, there is a sense of atmosphere and of plausible light, quite distinct from Jacopino's frontal illumination that flattens his figures and removes them to the sphere of art. Behind the tomb at the right we can see the failing light as the sun sets, and through the crown of thorns held up by the

angel a celestial radiance warms the grieving group below. It is tempting to associate this sensitive treatment of light and air to the influence of Venice. With his color, however, Salviati has continued to explore a subtle marriage of Michelangelesque *cangiantismo* with Raphaelesque *unione,* concepts foreign to the Venetian scene and more cerebral than its taste. Particularly lovely is the way he relates the colors of Christ's loincloth to the adjacent mourners. The figure closest to the Virgin shows a sleeve that is blue, shifting down to mauve in its shadows. The *cangiante* pair is repeated but reversed in Christ's cloth, which shifts from mauve down to blue in the shadows.

Salviati was doubtless responsive to the taste of his patron; in the Venetian environment with its preference for naturalism he appears to have held in check his predilection for stylization. By 1543 he would fully embrace the Maniera and its imitation of sculpture and become a virtuoso master of it, as he would demonstrate in his frescoes for Duke Cosimo of Florence in the Sala dell'Udienza (Pl. XXV; Fig. 150). This part of our story we must leave for a later chapter, however, and return now to Rome.

PERINO DEL VAGA AND DANIELE DA VOLTERRA

When Perino del Vaga returned to Rome from Pisa he was without any commissions and apparently without any introductions. According to Vasari, he remained without work for several months.[68] One wonders why he was not offered one of the frescoes in the Oratory of San Giovanni Decollato, especially as he was a Florentine. When Angelo Massimi offered him the opportunity to decorate the side walls of his chapel in Trinità dei Monti (c. 1537/1538-9), he took it as his chance to demonstrate to the Romans what he could do. In fact, his performance there and in the same patron's palace attracted the attention of Pope Paul III and he became the favorite painter of the papal court until his death in 1547.

Perino's work in the Massimi Chapel was dismantled in the last century, but we know from drawings that he created an opulent display of delicate stuccoes, executed by Gugliemo della Porta, painted grotesques, and frescoed narratives (Fig. 96).[69] It would seem there was no one in Rome at this time skilled in fine stucco work and decoration *all'antica* such as Perino and Giovanni da Udine had created for Pope Leo X in the Sala dei

Pontefici (Pl. IX) and Perino himself had perfected during his years working for Andrea Doria in Genoa (Figs. 72–3, Pl. XV). The kind of grotesque decoration and compartmentalizing Perino used here, derived of course from the Domus Aurea, is indistinguishable from what he would do in the papal apartment at the Castel Sant'Angelo (Figs. 99–100), or in any other secular setting. At the same time that Jacopino in the Oratory of San Giovanni Decollato was extending the relieflike style to sacred locations, Perino here boldly invents as the frame for sacred narrative what had previously been considered appropriate only in a secular setting. Bare-breasted women appear in large scale as caryatids at floor level, not tucked away high up in the vault. Perino has devoted more space to the exquisite ornaments of the framework than to the miraculous healing represented in the small compartment at the center.

One wonders whether what is reflected in the remarks of Francisco de Hollanda in his *Dialogues,* which took place at just about this time, 1539, is the first dawning of concern with the decorum of grotesques. He puts the question to the other participants, who include Michelangelo and Vittoria Colonna, whether it is not most appropriate to place grotesques in villas, that is to say, in secular settings. He then goes on to make the interesting point that they are more appropriate there than would be a *Penance of David* or a procession of monks.[70] Immediately following the Council of Trent in the 1560s we find a different solution being tried by cardinals in their villa decorations. To demonstrate their piety, they hastened to convert from pagan to religious stories, but they accompanied them with a rich enframement of *grotteschi.* Clearly the decorum of grotesque ornaments was open to interpretation.

Hosts of patrons, anxious to redecorate their palaces in the new style and even to commission chapels, awaited Perino now, but the pope monopolized his talents, leaving him little time to give to anyone not named Farnese. His former assistants, foremost among them

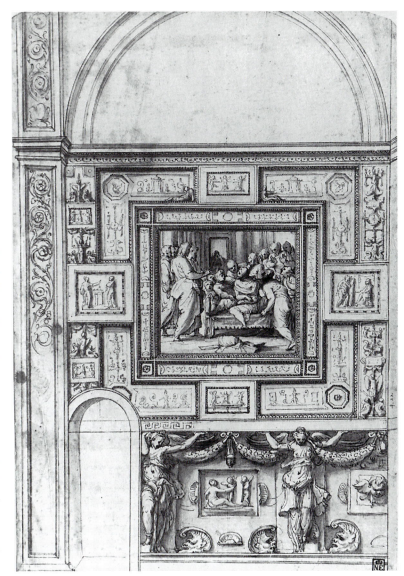

Figure 96. Perino del Vaga, preliminary drawing for the side wall, Massimi Chapel, Trinità dei Monti, Rome. c. 1537/1538. National Gallery, Budapest.

Daniele da Volterra, but also Marcello Venusti (1512–79), made themselves available to satisfy the demand.

Daniele's first work after his arrival in Rome was apparently as Perino's assistant: first in the Massimi Chapel and then, with more independence, in a chapel in San Marcello.[71] He was temperamentally almost the opposite of the serene and self-controlled Perino, and the moment he received a commission of his own he strove to express as vehemently as possible this difference. Because his chapel was in the same church of Trinità dei Monti as Perino's, comparison was inevitable. Although like Perino's, Daniele's Orsini Chapel (c. 1541–8[72]) has been largely demolished, enough

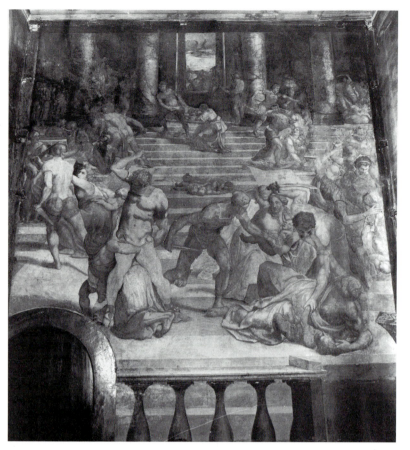

Figure 97. Daniele da Volterra, *Massacre of the Innocents.* 1548–53. Rovere Chapel, Trinità dei Monti, Rome.

remains of the *Deposition* fresco for us to discern that his aesthetic by this time owed more to Michelangelo than to Perino, both in form and in its aggressive *cangiantismo*.

In place of Perino's elegant restraint, Daniele's figures burst through the picture plane with abrupt foreshortenings and swell out with plasticity, both characteristics of style derived unmistakably from the *Last Judgment,* which was unveiled just as Daniele received his Orsini commission. Whereas Perino often miniaturizes the scale of his figures, Daniele enlarges the scale of his to fill the entire space. Even the decorative framework has a robust vigor and an unpredictable wit that is far from Perino's more orthodox and delicate inventions.[73] The tension and urgency of his theatrical interpretations owe much to Michelangelo, and he excelled at this kind of subject, whereas Perino appears to have shunned it.

On the side wall of his other chapel in the same church (Della Rovere, c. 1550–3[74]) he represented the *Massacre of the Innocents* (Fig. 97). Daniele's design strat-

egy is the inverse of Raphael's in his famous engraved version (Fig. 33), which had distilled the tragedy into a concentrated group at the center of mothers grappling with soldiers for their babies. Daniele's curious composition is centrifugal in its movement outward from an almost vacant center. There on the steps are two dead infants, so helpless and small as to be heartrending, abandoned by their stricken mothers who have vanished into the crowd. Like the *Last Judgment,* the space is filled with furiously active figures in every manner of contrapposto, their serpentine poses adding to the violence. Focus and subordination are not operative principles here. It is as though the painter wished to disperse, and thereby multiply, the horror, yet the rhetoric is no less vehement than Raphael's, or Michelangelo's, in its noble eloquence. Nevertheless, one notes that each group has arranged itself artfully, the flat light striking them in such a way as to enhance their resemblance to sculptural relief. The insight that Titian ultimately arrived at – that awkwardness represents the distraught state of mind more convincingly than any well-wrought pose[75] – was the antithesis of the Maniera. The central Italians, on the model of their mentors of the Classic style, sought to contrive an ideally graceful and energized posture for every situation, no matter how desperate.

Perino del Vaga, in the meanwhile, was at work on a variety of projects for the pope, including painting the *basamento* in the Stanza della Segnatura. The major undertaking that occupied him from 1542 until the middle of 1545 was the decoration of the newly constructed Sala Regia (Fig. 112), the reception room that links the Sistine and Pauline Chapels. The vault of this enormous Sala was covered with raised stucco decorations that took Perino and his thirteen assistants three and a half years to complete. Stained glass, designed by Perino and his shop, filled the lunette-shaped windows at the top of each of the short walls. The wall stuccoes that project boldly to frame the paintings were unfinished at the time of Perino's death in 1547; they are the work of Daniele who then inherited the commission. The fres-

coes were still to be painted when Pope Paul died two years later in 1549, and they remained undone for years to come.

These bold stucco creations that resemble sculpture are similar to what had been invented at Fontainebleau and reintroduced to Rome, perhaps by Francesco Primaticcio (1504–70) himself on his visit of 1540, and certainly through the medium of prints and by traveling artists. We know of one such immigrant artist, Ponsio Jacquio, who worked with Primaticcio in 1552,[76] then came to Rome. He was hired by Cardinal Ricci to decorate several of the less important rooms of his palace with friezes representing landscapes in stucco frames with grotesques.[77] Presumably it was his firsthand experience with French stucco work that got him the job.[78] Daniele, we assume, learned the technique from Primaticcio or some other intermediary.

Perhaps a principal reason that Paul III preferred Perino as his painter was his resemblance, artistically and temperamentally, to Raphael. He could produce an ensemble like that of his great master better than anyone else. He had Raphael's skill at organizing and managing a workshop, and he remained faithful to the spirit of his master's art. Pope Paul's choice of artists and commissions suggests his conscious intention to restore the days of Julius II and Leo X, when Raphael and Michelangelo were working a few hundred yards from one another in the Vatican Palace. On the one hand, he employed Michelangelo in the Sistine Chapel and then in the Pauline Chapel, and on the other, he put Perino to work in Raphael's Stanza della Segnatura. Just as Raphael had been assigned tapestries to hang on the walls of the Sistine Chapel, so Perino was commissioned to design a tapestry to hang below Michelangelo's *Last Judgment* there (Fig. 120). Then Perino was given the task of decorating Paul's papal apartment in the Castel Sant'Angelo (comparable to Julius's and Leo's Stanze of Raphael). Of course, Paul III's commissions were intended to surpass the models from the High Renaissance. The new Sala Regia was similar in function to Leo X's Sala di Costantino (Fig. 27).[79] It would be interesting if we could compare the Costantino as it appeared at the time, with its low wooden ceiling (later replaced by the present vault), to the Sala Regia with its high vault (nearly sixty feet) covered with elaborate gilded stuccoes. The Sala Regia outstripped the Costantino in scale and in opulence, and the differences tell us much about how taste had changed in the intervening generation.[80]

The Castel Sant'Angelo was the fortress to which Pope Clement had escaped during the Sack. Clement was virtually a prisoner there for months, together with many of the more fortunate members of the papal court. Although the enemy could not take it, those within it could not escape. It must have been a dingy place compared to the Vatican, though fortunately for him, Clement had had the foresight before the Sack to have installed a bath, the *stufetta* named for him, decorated *all'antica*. His successor now undertook extensive renovations, chief among them the sumptuous papal apartment, at the core of which was the Sala Paolina, named for him.

The decoration of the reception room, the Sala Paolina, occupied Perino from 1545 until his death in 1547 (Fig. 98). Its vault is rich in stucco and gilding, like the Sala Regia, but into its compartments are inserted not only *grotteschi*, emblems and arms of the Farnese, but also six frescoes representing scenes from the life of Alexander the Great (Fig. 99). The episodes are based on Plutarch's life, but they have been chosen to emphasize Alexander's military exploits.[81] Perino subcontracted the execution of the vault to Marco Pino (1517/1522–1585/1588), who presumably worked on Perino's designs[82] but with the pastel *cangianti* colors he had perfected while assisting Domenico Beccafumi in their native Siena.

The decoration of the walls was based upon the macroscheme invented by Raphael for the Sala di Costantino, where Perino himself may have worked (Fig. 27). The example it provided was of a fictive architecture that furnishes the framework for the pictorial elements, simulating a variety of materials. The frieze is supported by fictive Ionic columns with gilded capitals and bases. Between are six large bronze reliefs representing the deeds of Alexander the Great. Seated on the cornice, and overlapping the frames of the reliefs and the columns, are paired youths holding medallions, recollecting the *ignudi* of Michelangelo's Sistine vault. The four *Virtues* occupy niches flanking the center of each long wall; cartouches containing oval bronze reliefs decorate their pedestals. Garlands of fruit, flowers, and vegetables are suspended from the frieze, recalling Raphael's Psyche Loggia at the Villa Farnesina (Fig. 19). A *basamento* in carved marble inset with long bronze reliefs reminds us quite specifically of the Costantino. Above the six doors are bronze medallions held up by winged putti that contain episodes from the life of Saint Paul; seated below

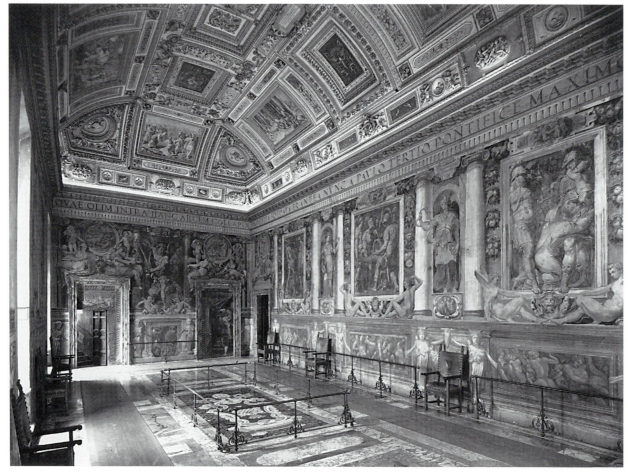

Figure 98. Perino del Vaga and assistants, Sala Paolina, view. 1545–7. Castel Sant'Angelo, Rome.

them on the door frames are paired female Allegories (Fig. 100). All the materials are simulated in fresco. Although there are no tapestries here, the scheme plays with materials and with space in a manner very like the Costantino.

The decor of the short walls alludes to the history of the Castel Sant'Angelo: the figures of Emperor Hadrian, who built the Sant'Angelo as his tomb, and Saint Michael, to whom it has been dedicated in its new life as Christian fortress. Thus the narratives of vault and walls refer to two historical figures, antique and Christian, one a temporal ruler, Alexander the Great, the other a spiritual leader, Saint Paul. Both in turn allude to Alexander Farnese, Pope Paul III, through his natal name and his papal name. On the vault Alexander is seen as a military leader; on the walls the fictive bronze reliefs celebrate his virtuous deeds. As the savior of the books of Homer he is the guardian and promoter of culture. When he cuts the Gordian knot it is an act of decisive justice, and he is shown

flanked by the virtues *Temperance* and *Prudence*. When he graciously pardons the family of Darius it is an act of clemency. For Plutarch, Alexander was the exemplar of virtue.[83] In the bronze *tondi* over the doors Paul is represented as the missionary who carried the faith far afield and died a martyr's death. In the scene illustrated, the *Sacrifice at Lystra* is shown, making reference to Raphael's tapestry cartoon of the same subject. Nowhere is there a portrait or an explicit allusion to Pope Paul, but the context in which these images were meant to be read is made clear by the many references to the Farnese. The coat of arms is placed at the center of the vault and on each of the long walls. The Farnese lily is a repeated ornament in the vault where the family motto *Festina Lente* ("Make haste slowly") appears several times. There are inscriptions in Greek as well, for we recall that the pope had been educated as a humanist and could read Greek, making the implied identification of him with the Greek Alexander all the more appropriate.

Figure 99. Perino del Vaga and assistants (Marco Pino), vault, Sala Paolina. Fresco, c. 1545. Castel Sant'Angelo, Rome.

Figure 100. Perino del Vaga and assistants, overdoor with *Sacrifice at Lystra*. Fresco, c. 1545. Sala Paolina, Castel Sant'Angelo, Rome.

scheme. His Michael and Hadrian, meant to be powerful presences dominating the long axis of the room, are rendered in highly contrasted and intense colors, made dramatic by the theatrical shadow on the alighting angel. Perino has imitated both the pose and light from Raphael's *Saint Michael* (Fig. 25), which he could have known from a copy.[84] But the intense and highly contrasted colors in Michael and Hadrian appear nowhere else. His lighting on the seated *Allegories* and the other ornaments is more delicate, as is the color. In the overdoors, it reinforces their ornamental character and their role as supporting actors rather than major players. The soft pastel *cangiantismo* maintains the unity of the surface. The shadows are not deep and are therefore not strongly recessive. This kind of color reminds us of Jacopino's *Preaching of the Baptist* (Pl. XVIII), where the alignment of figures across the surface was insisted upon, with little lost in the shadows. An ornamental unity, even uniformity, is attained, like that of sculptural relief.

The large bronze reliefs on the long walls, by contrast, are in a strong monochrome chiaroscuro that gives them a dramatic impact comparable to Michael and Hadrian, but of a different order. Here the lighting is that of the relieflike style again: flat and frontal. Comparison with his earlier fictive bronze, the *Crossing the Red Sea* (Pl. XI), is instructive because Perino has used the same ochre tones to simulate bronze. The mature painter now embellishes his surfaces as would a goldsmith, and he has taken the time to render them elaborately, but Perino's antiquarianism has not essentially departed from what he learned in Raphael's shop. The stiffness and a certain doctrinaire quality in the *Crossing the Red Sea,* as if rules only recently learned were being applied, has given way to a splendid fluidity and ease.

With the particular manner in which he painted, Perino sustained the distinction between the materials he pretended to be using. The bronze reliefs are hard-edged like sculpture, whereas the *Allegories* are much

Perino's ensemble is his personal masterpiece, and a masterpiece of the Roman Restoration and the Maniera. He combined antique classical sources, in the design of the vault, with imitations of Raphael and – though less prominent and important – of Michelangelo as well. These various sources he has woven together into a brilliantly unified, yet copiously varied, ensemble. By differentiating his treatment of each of the components he distinguished various functions of the images and various levels of meaning. Light and color are handled differently, depending on these factors.

For example, the vault is strongly colored like its model in the Domus Aurea, with some compartments in red, others blue, others white, all of which set off the rich gilding. It is one kind of ornament in Perino's

more painterly. He seems even to vary the figure proportions: the female *Allegories* have distended limbs and small heads, whereas the masculine actors in the bronze reliefs are more robust.[85]

Perino has abolished linear perspective here. He has projected everything in front of the plane of the wall, represented in gray behind the garlands and columns. He was the first to develop into an entire decorative scheme the relieflike style reintroduced to Rome by Jacopino del Conte in his *Preaching of the Baptist*. Although the Sala di Costantino was his inspiration, Perino has surpassed his model in the complexity and elaboration of the *concetto*.

The spirit of the whole is celebratory, even festive. Small witticisms entertain the attentive viewer. For example, each mask wears a different expression, and the bare-breasted caryatids in the *basamento* somberly perform their weight-bearing function, but two of these maidens have mustaches. The real opulence of the materials, from the gilding in the ceiling to the marble in the floor, is enhanced by the dense, ornate richness of the frescoes. Careful attention to cast shadows creates the illusion of relief. Though there is no sense of crowding, constraint, or *horror vacui,* the surfaces are covered and overlappings of one element by another increase the vitality. There is none of the tension that Michelangelo and his followers sought, but no lack of energy.

CARDINAL FARNESE AND THE PALAZZO DELLA CANCELLERIA

While Perino and his *bottega* were at work on the Sala Paolina and the other rooms of Paul's apartment in the Castel Sant'Angelo, and continuing their work on the stuccoes of the Sala Regia frieze, the pope's grandson and namesake was turning his attention to his own residence. Still a young man of twenty-six, the Cardinal Alessandro Farnese commissioned Giorgio Vasari to fresco a large Sala in the palace of the Cancelleria (Fig. 101). Raised to the cardinalate in 1534 by Pope Paul when he was only fourteen and given the powerful post of vice-chancellor of the Church the following year, Alessandro Farnese would become the leading patron in Rome until his death in 1589, and his patronage would evolve with the times, mirroring the radical changes that would take place in the Church during his lifetime.

Here the cardinal wished Vasari to paint scenes cele-

brating the accomplishments of the Farnese papacy, but because this building was not a Farnese property but a papal holding, they had to be cunningly conceived: they must seem to laud the papal office and only incidentally the person or family of this pope, lest successors would see fit to replace them with their own self-aggrandizing propaganda. The inventor of the program, the historian Paolo Giovio, must have succeeded, because the room has been preserved intact by ensuing popes. The Sala dei Cento Giorni was given its nickname because Vasari and his *équipe* executed it in one hundred days, beginning in March 1546.

As in Perino's Sala Paolina, the source for the scheme was the Sala di Costantino – that most influential room in Renaissance Rome. In this case it was not the simulation of materials that was imitated but the juxtaposition of narratives with personifications in tabernacles. Vasari departed from his model in dividing the long wall in two and thereby avoiding an unmanageably large field like that of the *Battle of the Milvian Bridge;* as in the Costantino the other long wall was broken by windows. In a nice invention, Vasari eliminated the *basamento* and created illusionistic steps that lead the viewer into the scenes. In the frieze above are Farnese arms supported by Allegories, and painted busts of classical heroes crown the tabernacles. On the end wall is represented the *Universal Homage to Paul III.* The seated pope receives gifts, including exotic animals like the giraffe, elephant, and camel, at Rome, symbolized by the river god Tiber with a wolf on the steps. Additional reference to the geographical reach of papal power is made in the busts of Julius Caesar and Alexander the Great (as in Perino's Sala Paolina), a message made explicit in the inscription. Also in the inscriptions are references to the Golden Age that Farnese would initiate.[86] The Golden Age is a theme that will recur a couple of years later in the Cappella del Pallio in the same palace, frescoed by Salviati (Figs. 102–3).

On the long wall are represented two aspects of papal patronage. First we see Pope Paul directing the construction of Saint Peter's, which appears in its half-rebuilt state behind. Allegorical figures present the plan for his inspection, and the personification of place is again found reclining on the steps, this time the Vatican Hill, surrounded by putti representing the other Roman hills, who offer him crowns. The bust above, of Marco Agrippa, who had built the Pantheon, puts those two buildings in parallel, the pagan temple with the Christ-

ian church. The bust opposite, of Numa Pompilius, reminds the viewer of the legendary king who had introduced religion to the Romans. Further down the wall is Pope Paul III distributing patronage in the form of benefices and cardinals' hats. The allegorical figure writhing on the steps and swallowing snakes was, no doubt, all too apt as a choice for the scene where papal favors were dispensed to his friends and loyal adherents: she represents Envy.

On the end wall is a scene that unlike the others refers to a historical event, the Treaty of Nice, which Paul had negotiated in 1538, bringing King François I of France and the emperor Charles V together. Yet even this scene is not presented as a historical narrative but is intermingled with allegory, thereby broadening the subject to refer to the papal role of peacemaker. Pope Paul is shown with olive branch in hand, carried on his chair by Allegories of Peace and Victory, among others. The Temple of Janus, whose doors were opened in time of war in antiquity, is shown at the left securely closed.[87]

The iconography here, combining history and allegory, was cited by Giovanni Andrea Gilio, some two decades later, as the first example of a specific genre of decorative scheme called "mixed," which was between pure poetic painting, as in the Farnesina Psyche Loggia (Fig. 19) and the two Vatican Loggie (Fig. 26), and history painting, by which Gilio means sacred narrative, as in the Sistine (Pl. V) and Pauline Chapels (Figs. 117–19).[88] This genre was ideally suited for the kind of generalized encomium needed here, where specific references to the deeds of the Farnese pope were to be avoided.[89] The model for this kind of conflation of history and allegory was to be found in imperial Roman sculpture, like the Arch of Titus or the statue of *Augustus Primaporta,* which would have made it all the more attractive to the Farnese.[90]

Vasari employed a large workshop and, because speed was of the essence, many of the artists were not his pupils but were recruited in Rome for the job.[91] As a result there is not the consistency of manner one is accustomed to in such projects. It is easy to separate hands, and it is evident that the window wall was hastily done, whereas the frieze at the top, frescoed first, is very sumptuous and beautifully painted. Nevertheless, the room is impressive and holds its own among the examples of its kind. Giovio reported to Vasari after he had returned to Florence that the cardinal was content.

"Certainly he would have liked the portraits to be better. But above and below the work has turned out more beautiful than he expected, given the short time allotted to you."[92] The frescoes are in fact full of portraits – in the *Distribution of Benefices* almost every figure is a portrait, as Vasari indicated in his description. Portraits take time, the very thing the patron was unwilling to grant, so it is not a wonder that they turned out to be schematic. The cardinal and the pope were perhaps a little spoiled by the experience of sitting for Titian, the greatest portraitist of the time, who was visiting from Venice just then, in 1545 and 1546, and painted the renowned portraits of the Farnese now in Naples and Vienna.

Interestingly, the patron did not criticize the quality of the execution otherwise, and one is led to ask how high a priority it had for him, or for other patrons of his time. It is clear in this instance that speed was important, and the cardinal wanted the images for the principal audience room of his palace for their publicity value. It was the pictures as illustrations of ideas, not their artistic quality, that interested him most. This may sound crude to the art lover accustomed to admiring these works for their aesthetic quality, but their pragmatic value should not be played down. Vasari for his part later admitted that he had learned a lesson about workshop management, saying that he had never again used so many, or such untrained, assistants.[93] However, he proclaimed elsewhere in the *Lives* the principle of facility: one of the ways the artists of his day surpassed those masters of the recent past was that whereas they took six years to paint one picture, the contemporary painter could now paint six pictures in one year.[94] Vasari tells the story on himself about how when he showed off the room to Michelangelo and told him proudly that he had accomplished it in a hundred days, the great man replied dryly, "It is evident," *(è si conosce).*[95] This story reveals the trajectory of Vasari's experience here, from initial euphoria to subsequent qualm.

Vasari was not the only one to learn from this commission to beware of too much facility. When another member of the circle of Cardinal Farnese, Annibale Caro, wrote to the painter a couple of years later asking for a picture, he told Vasari to take as much time as he needed and reminded him that he had earned a reputation "as a quick painter rather than as an excellent one." Caro's letter expresses very nicely the required balance

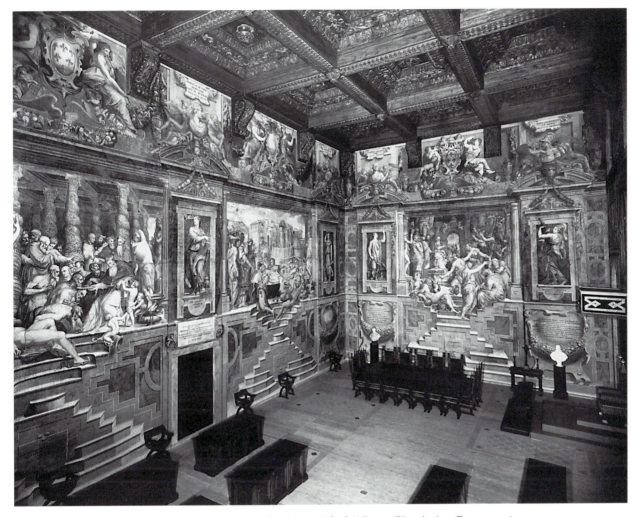

Figure 101. Giorgio Vasari and assistants, Sala dei Cento Giorni, view. Fresco, 1546.
Palazzo della Cancelleria, Rome.

between speed and care, representing one, perhaps typical, mid-Cinquecento view.

> As to doing it quickly or slowly I leave that to you, because I think that it is also possible to do things quickly and well when the frenzy seizes you as happens in painting, which in this respect as in all others is very much like poetry. It is certainly true that the world believes that if you worked less quickly you would do better, but this is a probability rather than a certainty. It might even be said that it is the works which are strained and not finished and carried forward with the same fervour with which they were begun that turn out worse . . . Even so I would want you to know that I say "take your time," use deliberation and application, but not too much application, as it is said among you of that other man who was unable to take his hand from the picture.

"That other man" refers to an anecdote reported by Pliny (*Naturalis historia,* Bk. XXXV, 80): Apelles criticized another painter to the effect that he did not know when to stop.

Caro softens the implied criticism of Vasari with the wonderfully diplomatic assurance, "Nor would I want you to think that my desire to possess one of your works was so lukewarm that I do not wait for it with impatience."[96] We note evidence that the status of the artist has risen: his comparison of the creative process of painting to that of poetry and his recognition that the painter's ingenuity as well as his craftsmanship is to be valued. Vasari is treated here as a fellow intellectual. Certainly the courtier Caro was concerned about quality, or

excellence as he called it, but this is because he was a collector. The use to which he would put his pictures was delectation; they had no publicity function other than to display his good taste.

◆

PERINO DEL VAGA'S DEATH in 1547 created an opening that Francesco Salviati, then in Florence, hoped to fill. In the autumn of 1548[97] he returned to Rome and was rewarded by Alessandro Farnese with the commission to decorate the private chapel of the cardinal, the Cappella del Pallio (Figs. 102–3; Pl. XIX).[98] This chapel is the quin-

Figure 102. Salviati and assistants, *Beheading of John the Baptist* and *Janus welcoming Saturn to Rome* (lunette). 1548–50. Cappella del Pallio, Palazzo della Cancelleria, Rome.

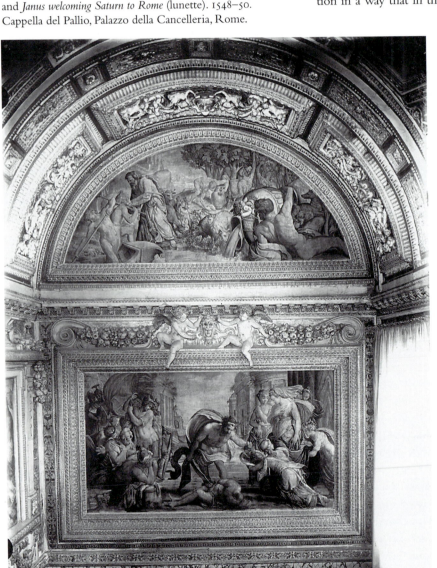

tessence of the pre-Reform culture of the Church, and perhaps the last of its kind. The iconography draws upon pagan myths, Latin literature, Roman legendary history, scripture, and Church history, treating them as equally valid sources and placing episodes drawn from them all side-by-side in a proud display of syncretism. The program could have been drawn up in the pontificate of Julius or of Leo, were it not for its references to new concerns raised by the Protestants of iconoclasm and the proper role of images. The situation in these years is well illustrated by Farnese's choices in this chapel. The intention to address and resolve the pressing issues of the day is the theme of the chapel's iconography. Pagan and Christian elements are mixed in the program and in the decoration in a way that in the future would be condemned by the Counter-Reformation. Clearly the position the Council and the Counter-Reformation would ultimately take on issues of art and pagan culture was still undefined. As yet, liberal-minded and humanistically inclined princes of the Church like Alessandro Farnese, the future pope Cardinal del Monte, or Cardinal Ricci, who would also patronize Salviati, had no reason to curb their taste for classical culture even in an ecclesiastical setting. The mixture of pagan and Christian elements we see in audience rooms like the Sala Paolina or the Sala di Costantino are still to be found at this time in devotional settings like the Oratory of San Giovanni Decollato or the Cappella del Pallio.

The iconography of the chapel is far from obvious, and it has taken until a few years ago for it to be understood at all.[99] Unfamiliar scenes are placed out of context, making identification difficult. Once they are identified, the significance may still elude the viewer. The theme is the fulfillment of the Golden Age, predicted in biblical and

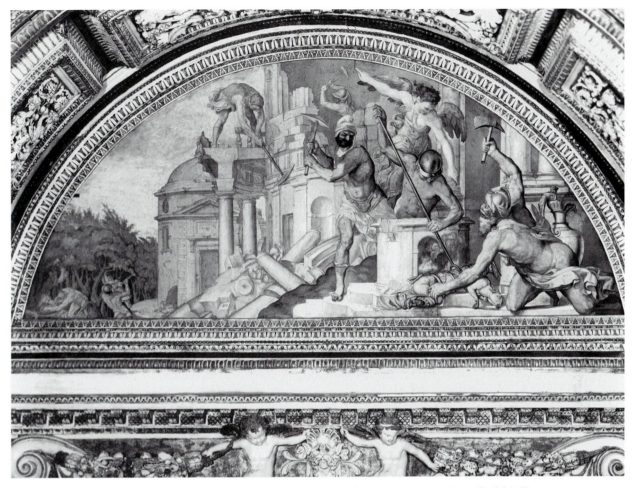

103. Salviati and assistants, *Destruction of the Pagan Temples.* Fresco, 1548–50. Cappella del Pallio,
Palazzo della Cancelleria, Rome.

classical sources, in the papacy of Paul III through universal conversion to the true faith and the overthrow of idolatry. On each of the three walls is a Christian narrative that announces the theme of the scenes directly above it in the lunettes and vault. The three narratives on the walls are the *Martyrdom of Lawrence,* the *Conversion of Paul,* and the *Beheading of John the Baptist* (Fig. 102). In the lunette above Lawrence is the *Destruction of the Pagan Temples* (Fig. 103), because his death initiated the decline of pagan worship, according to Prudentius. The fresco shows soldiers with pickaxes attacking classical buildings and shoveling marble statues into the furnace, as directed by an angel. A further scene of the *Destruction of the Idols* surmounts it in the vault. The Protestants, in particular the Calvinists, had challenged the use of religious images and had removed them entirely from their own places of worship. The Church's response, which would eventually be codified in the Decrees of the Council of Trent, was that images were

useful if they were employed properly. Here we see the images of the pagans being destroyed because they were improper images, improperly used.

Paul's *Conversion,* on the entrance wall opposite the altar, makes obvious reference to Pope Paul and to the task of the Catholic missionaries to convert the heathen. The lunette shows the Mass being celebrated, participation in which is the sign of conversion, while smoke rises from the abandoned and burning idols. In the vault is a biblical reference to the Golden Age, based on Isa. 11:6–8, "The wolf shall dwell with the lamb, and the leopard shall lie down with the kid."

In the *Beheading of the Baptist* (Fig. 102), John, who is the forerunner of the Messiah, is shown as the forerunner of the Golden Age. In the lunette above, the iconography unexpectedly shifts to classical Roman legend and we see *Janus welcoming Saturn to Rome* (Pl. XIX). Above in the vault is a representation of the Golden Age as described by Ovid (*Fasti* 1, 235–45) and

Virgil. A particularly nice touch in the lunette are the brightly colored sheep. This is based on Virgil's Fourth *Eclogue* (42–5), which tells us that in the coming age sheep will be multihued to save us the trouble of dyeing the wool cloth. The Farnese had used the Golden Age imagery before: we saw Vasari's reference to it in the Sala dei Cento Giorni, for example, and there were other instances as well.[100]

Without knowledge of this family iconography, interpreting the Pallio scenes would have been difficult. But the fact was that this very small chapel would never be seen except by intimates of the cardinal, and what he considered appropriate in his private chapel was quite different from what he would order for an altarpiece in a church. The altarpiece here, which has been sadly damaged, represents an *Adoration of the Shepherds* in which Pope Paul is represented as Joseph and Cardinal Alessandro appears as the patron.[101] It seems that Salviati had decided to try Sebastiano's technique of painting on slate, which he would repeat in his next altarpiece, the *Pietà* for the Margrave Chapel in Santa Maria dell'Anima.

The Cardinal's chapel is like a jewel box in its opulence and its small scale. The surfaces are covered with stuccoes, delicate and fine but in places so bold as to be almost in the round, as in the seated putti whose legs overlap the tops of the frames. Salviati had not been known as a stuccoist before this, and it has been suggested that he was assisted by members of Perino's now-disbanded *équipe* in both the stuccoes and the lunettes, which are clearly by other hands but on Salviati's designs.[102]

It is in the narratives of the three saints that Salviati himself can best be observed. The richness of the framework continues within the frames. Every figure is arresting in pose, in costume, in color. The *Beheading of the Baptist* contrasts the gory display of the headless corpse placed at the picture plane in the viewer's face with the extreme elegance of Salome and her entourage of courtly ladies at the right, who look as if they are witnessing nothing more alarming than the gardener felling an unwanted tree. The *Conversion of Paul* shows the giant contorted on the ground surrounded by a "corps de ballet in antique fancy dress," as it has been aptly described.[103] The dancing soldier reining in the rearing horse recalls the ancient sculpture now on the Quirinale, the *Dioscuri*,[104] though his action is more ornamental than effective. It is difficult to imagine that

startled people in real life would ever actually assume such self-conscious poses, but the effect of elegance is undeniable.

High Renaissance painters strove to express emotion in telling postures and gestures that were at the same time graceful; here the priorities have been reversed, and grace is more important than the communication of emotion. It is as if the direct expression of powerful emotion is embarrassing and must be masked; it is turned into ornament that is a surrogate for feeling. This becomes an abstract art, in some ways like that of our own time, in which the response required of the viewer is first to it as an aesthetic object. This is the age that also produced Cellini's exquisite *Saltcellar* (Vienna) and for the Cardinal Farnese the exquisite casket now in Naples. John Shearman's *Mannerism* is full of examples of the so-called decorative arts that occupied the attention of the wealthiest patrons and the leading artists of the Maniera. On the one hand, we expect the aesthetic response to be foremost when we confront a work of decorative art – the categorical name, unsatisfactory as it is, says as much – but we expect something different when we are looking at a Renaissance devotional object. On the other hand (as has been pointed out by Sydney Freedberg), a Byzantine icon dazzled the worshipers with its exquisite richness more than it moved them with a fresh interpretation of the subject.[105] Byzantine iconography had become crystallized into formula and was little varied, but the rarefied beauty the skilled artist created was a mirror of divine beauty and a spur to devotion, removing the worshiper from his or her mundane surroundings to a more elevated sphere.

Something similar seems to have been expected of the most sophisticated – and hence the most troubling – Maniera objects of devotion, like these of Salviati (Fig. 154) and the altarpieces of Agnolo Bronzino (Fig. 162). As with Rosso's *Dead Christ* (Fig. 56), Parmigianino's *Madonnas* (Figs. 55, 77, 79–80), and Jacopino's *Preaching of the Baptist* (Pl. XVIII), we come face-to-face with sensuality and aestheticism in religious art, which we have been taught to find inappropriate. But it was the Counter-Reformation that redefined the decorum of devotional images for us, after all the works were created. We can understand why the Tridentine reform found this approach to sacred art unacceptable for the *popolo* that it was concerned to woo. Highly aestheticized images like these might have the power to move Cardinal Farnese to devotion, but they would be more

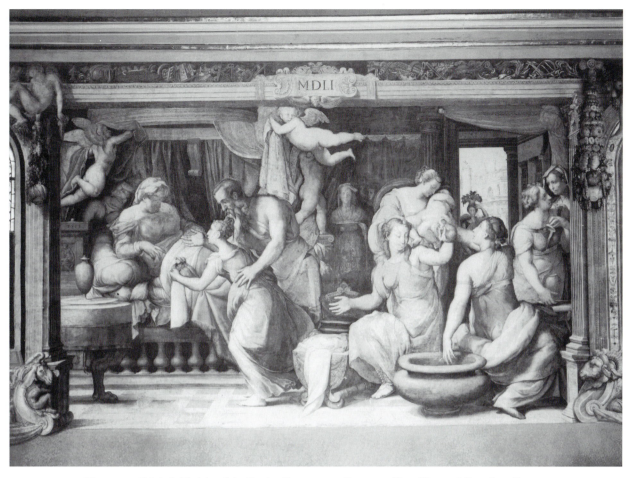

Figure 104. Salviati, *Nativity of the Baptist*. Fresco, 1551. Oratory of San Giovanni Decollato, Rome.

likely to move less sophisticated viewers to laughter or bewilderment.

WORKING PRACTICES AND ART WRITING

A shift of emphasis is reflected in the artwriting in the second half of the Cinquecento. Early in the century writers repeated the Quattrocento injunction to imitate nature; sometimes these statements included the recommendation that the artist should also copy the art of the great masters and the antique. The painter Armenini, in his how-to book for other artists, did not mention drawing from life, although he advocated copying from multiple sources: the most general and universal rule for acquiring a good manner he claims is frequent copying after diverse good masters.[106] The goal should be to glorify nature by achieving a mastery of *disegno* through the study of ancient and modern Roman works.[107] In the 1540s there is a noticeable shift away from the practice of

Leonardo, Raphael, Andrea del Sarto, and Michelangelo, who all drew from life. When we study the drawings of Salviati, Vasari, and their followers, one of the most striking differences is the relative dearth of life studies.[108] The High Renaissance master, after making a compositional sketch, would go to the studio and make figure studies of the model in poses he needed for dramatizing his narrative. The midcentury painter would go instead to his portfolio, pull out an elegant figure that would fit the spatial requirements, adjust a limb or an attribute as necessary, and insert it. Or he would insert a quotation of an antique statue, as we saw Salviati doing with his soldier modeled on one of the *Dioscuri,* or Sebastiano in his *Nativity of the Virgin* (Fig. 86), when he replaced his naturalistically posed midwife with the *Crouching Venus.*

An example that can illustrate the complex layering and innuendo of quotation in this style is Salviati's *Nativity of the Baptist* for the Oratory of San Giovanni Decollato (Fig. 104). The stylistic borrowing from Michelangelo is reinforced by specific quotation of a

159

figure imbedded here and surely intended to be recognized. The infant resembles the Sistine *Jonah* (Pl. IV), an appropriate reference because both were harbingers of Christ. Instead of the *Crouching Venus,* Salviati imitated another antique sculpture, conveyed through the mediation of a print after Giulio Romano's drawing for the *Nativity of the Virgin.*[109] Giulio had used that figure, which so intrigued the Maniera imagination, of one who faced one way, but whose feet turned the other way. The relief known as the *"Letto di Policleto"* (Fig. 105), after Polykleitos, the Greek sculptor believed to be its creator, had appeared already many times.[110] Giulio Romano had provided a motivation for her curious pose in his drawing, for the woman is drying a cloth at the fire behind her and twists to give her attention to the group around the newborn. Salviati omitted the motivation, but his bilevel quotation should have delighted the artistically literate viewer. This figure had been used first by Salviati in another context. In his *Deposition* (Florence, Santa Croce, 1547–8) she appeared as one of the women seated on the ground and attending the Virgin.

Salviati was known to be a good conversationalist who could discourse with his learned patrons about the project he was undertaking. He would show drawings that he had in his portfolio to give an idea of what he would do. In fact, he had such a collection of finished designs that he would frequently reuse a figure invented

for one composition in a completely different context, as we have just seen. Another example is the drawing (Fig. 106) used first for the leader of the procession of Camillus (Florence, Sala dell'Udienza) (Pl. XXV), who carries an enormous key; a decade later in the Palazzo Ricci-Sacchetti it reappears as the figure of Saul attempting to kill David with his spear (Fig. 107). In the second instance the murderous king's dancelike movement seems strangely unmotivated and the gesture of the left hand, now that the key has been removed, is inexplicable.[111]

A more surprising example of self-quotation is to be found in the Cappella del Pallio, where Salviati has recycled an entire composition of his for the *Conversion of Paul.* Originally engraved in 1545 by Enea Vico, it was an enormous print made from two plates and was widely circulated; Pietro Aretino praised it extravagantly.[112] What strikes us as brazen self-plagiarism must have been regarded differently in the Salviati's time, because there is great likelihood that Cardinal Farnese would have known the print and recognized that his fresco was another version.

The preference of midcentury artists to draw upon stock repertory can be related to the concept Vasari articulated of the artist's *concetto,* which is formed in the mind, of which the *disegno* is the visible expression. The *concetto* is the mental picture, the source of the artist's invention based on experience. It is an alternative to nature, which the Maniera artist regarded as flawed.[113] The artist is no longer merely the gatherer of "scattered beauty," as he was in High Renaissance artwriting. The artist's memory becomes a storehouse of images, which then can be combined to create a new *disegno;* alternatively, his portfolio of drawings can be his storehouse on which he draws when he needs to embellish a new composition. One of the virtues of the art of the *terza età,* according to Vasari's preface, was minute finish.[114] It would appear that for him and his contemporaries a carefully worked-up figure, once executed, became a filed treasure that could be called upon at a future date. It is certain that the expressive appro-

Figure 105. *"Letto di Policleto"* ("Bed of Polyclitus"), copy or Roman relief. Marble, sixteenth century. Mattei Palace, Rome.

Figure 106. Salviati workshop, drawing of young man holding a key. c. 1543. Uffizi, Florence.

priateness of a figure, so important to Raphael and Michelangelo, was less valued now than the exquisitely finished, graceful, and elegant figure. These midcentury artists now defined grace in terms of the conventions we have identified with the relieflike style, and not in terms of naturalism.[115] A possible result of this method of working was that at times their compositions, little more than pastiches of drawings from the repertory, could lack cohesion and dramatic impact.

Giovanni Paolo Lomazzo in his treatise on painting published in 1584, took Vasari's *concetto* a further step in the same direction. For him as a Platonist, matter is resistant to the perfection of the Idea and it is necessary for the artist to perceive, and then to represent, a beauty that nature itself never attains.[116] This theory opened a convenient gap between appearance and artistic representation. Thus Rafaello Borghini in Florence could write in 1584 of permissible liberties in figure proportion: although it is necessary for the artist to know the measurements of the body, it is not always advisable to follow them because in order to give figures grace it may be necessary to elongate some parts and shorten others.[117]

We have noted that Maniera compositions resemble sculpture and give importance to relief. Achieving these effects was made simpler by the practice of creating small figurines and arranging them on a flat board. Armenini recommended making clay or wax models in the scale of the final drawing in order to study composition, poses, lighting, and foreshortening. He indicated that he himself did it all the time, and he implied that it was a standard practice. He gave the practice Michelangelo's imprimatur, claiming that it was said that for the *Last Judgment* the great artist had used wax models he made and that we could tell this by looking, because many of the figures are the same bodies in different poses (Pl. XVII). He would immerse the model in hot water to soften the wax and then rearrange the limbs until he achieved the desired effect.[118] Vasari also mentions Michelangelo's use of models to study foreshortening because, unlike the live model, they remain still.[119] This is a practice that until recently was associated only with the Venetian painter Jacopo Tintoretto (1519–94) later in the century, but it would now appear that he learned it from the central Italians. Salviati is described by Armenini as approaching a stuccoist to

Figure 107. Salviati and assistants, *Saul attempting to kill David with his Spear.* Fresco, c. 1553–4. Salone, Palazzo Ricci-Sacchetti, Rome.

commission a wax model of a nude figure in one of his drawings so that he could study the "rilievo."[120]

The significance of this practice to the Maniera has largely escaped notice. For painters who were obsessed with sculpture, and with sculpturelike effects, it was logical. As Armenini indicated, the artist could manipulate his light source so that it would most enhance the effect of relief. Firm contours could be fixed without haste because the models did not move. There was the further advantage that the models could be reused, as Salviati and Vasari reused drawings, to provide an efficient source of the varied poses so much sought after in Maniera compositions. The relative lack of compositional sketches among Salviati's copious surviving graphic oeuvre, and Vasari's as well, might be explained by their preference for the stage with moveable mannequins, which they would then draw singly or in groups.

When Vasari wrote about Pietro Perugino (c. 1450–1523), he criticized him for repeating the same figures monotonously over and over. How could Vasari, standing in his glass house, afford to be critical? The difference between his own and Salviati's practice and Perugino's was that they never repeated a figure in the same context. It was not for them as it was for Perugino, who had fixed iconographical types so that his Saint George always looked the same; they constantly invented new compositions, demonstrating the "variety" that was highly valued at midcentury. The fact that those compositions contained reused figures only contributed to the effect of "copiousness."[121]

As walls got bigger and bigger and the painter was expected to cover more and more surface, the need for economical means of fulfilling these commissions with "facility" increased. Neither Vasari nor Salviati was as successful as Raphael or Perino del Vaga at building a workshop of assistants who developed specialties and stayed in the bottega for many years.[122] The importance for them, then, of precise and detailed cartoons increased, because the workshop assistants were not trained in the master's style. In fact, it may have been increasingly difficult for the master to assemble a large workshop of clones who could execute his designs seamlessly without interposing their personal manners. As we have seen, artists in this period increasingly completed their education by coming to Rome to copy from the antique and the modern masters, just as Armenini advised.[123] The result was that they developed a personal style, derived from multiple sources. The willingness to work anonymously as a member of the bottega may have decreased as acclaim for artists' invenzione increased.

SALVIATI'S FRESCOES FOR CARDINAL RICCI

Ricci had served a succession of popes before he was raised to the cardinalate in 1551 by Paul III's successor, Julius III (1550–5). His special talent for financial management and foreign diplomacy had led to extended appointments abroad, as papal nuncio to Spain in 1536 and in 1544 to Portugal. Upon receiving the cardinal's hat he immediately bought the palace that Antonio da Sangallo had built for himself on Via Giulia and left unfinished when he died in 1546. The palace is now in the hands of the family Sacchetti and so is known today as the Ricci-Sacchetti Palace. Ricci had not received a humanist education, nor was he of noble birth. His rise to power was the consequence of his talents; we would call him today a self-made man. Despite his lack of learning he was an avid collector, but more of rare objects than of paintings. On the one hand he had one of the best collections of antiquities in Rome, and on the other certainly the best collection of Chinese porcelains. These he had acquired, along with other rarities, while residing in the port of Lisbon at a time when treasures from the New World and the Indies were pouring in on Portuguese trading ships. The practical Ricci apparently regarded his collection as a source of prestige and as a trove of potential gifts to win favor or express thanks in his diplomatic and business dealings. Both the Farnese and the del Monte families made use of his talents, but when the severe Carafa pope, Paul IV, took office in 1555, Cardinal Ricci thought it wise to leave town and escape the examination of his finances that Paul IV was undertaking.[124]

Salviati was the perfect choice of artist to decorate the Salone of Ricci's palace (Fig. 108), for he could respond to the cardinal's love of the exotic and the ornamental – he was, after all, trained as a goldsmith. The exact date of his work is not documented, but it appears to have been between 1553 and 1554.[125] The subject chosen was scenes from the life of David. Why Ricci chose the exploits of the raciest hero in the Old Testament to decorate his reception room and why the most familiar episodes, like the Slaying of Goliath, are replaced by almost never-shown ones like the Death of

Figure 108. Salviati and assistants, Salone, view. c. 1553–4. Palazzo Ricci-Sacchetti, Rome.

Absalom, who, in the midst of battle, ignominiously got his long hair hung up in a tree, remains a mystery. (The Goliath story appears in a cartouche high up on the wall.) Because the scenes are of widely different sizes and are not arranged in chronological order,[126] one looks for an allegory or for a key as to why these particular events were selected. Perhaps the cardinal identified himself with the protagonist of his frescoes, and his personality as well as his taste and his personal convictions are expressed here. Like Ricci, David the shepherd boy was an unlikely candidate to reach the pinnacle of power, but Fortune smiled on them both. Despite the formality of the reception room setting, humorous touches emerge to undermine its high seriousness. Ricci took as his personal emblem not a lion, not a unicorn, but the lowly hedgehog, a pun on his name. This bristly little creature is to be seen on the lower parts of the wall receiving the bounty that pours from the sky upon him.

The key images of the cycle are on the short window wall where in the left corner we see a winged figure with scale identified as an allegory of Opportunity. The outrageous nude who has draped himself over the window is an allegory of Sleep, and above are two narratives that are about both sleep and opportunities seized. In the first, the hero David escapes the attempt on his life by the antihero King Saul by the ruse of placing a statue in his bed to bait the assassins while he climbs out his bedroom window to safety (1 Sam. 19:11–17). We see the three murderers sent by Saul in Salviati's characteristically ornamental poses, creating a spiraling *serpentinata,* while David runs away trailing the bedclothes but otherwise naked.

In the second scene, David, finding Saul asleep and unattended (the Lord has provided a deep sleep to aid his chosen one), refuses to kill the Lord's anointed king but takes the spear and water jug from beside his head instead, to show Saul later as proof of his magnanimity

(1 Sam. 26:6–12). In both cases opportunity is offered to David and he seizes it, in the one case to escape, in the other to spare the life of the undeserving Saul. The Lord has intervened in both stories on behalf of David, to warn him of his intended murder and then to make his enemy Saul vulnerable to him. A similar theme is illustrated in *Saul attempting to kill David with his Spear* (Fig. 107), where the Lord protected David from Saul's mad attack. One makes one's own luck, with God's help, is the moral here. This appears to be the expression of Ricci's personal philosophy of life: the propitious moment is offered only to the virtuous man who must know how to make use of it; the key concepts are Virtue, Opportunity, and Fortune.[127]

The scene that dominates the end wall, *David dancing before the Ark,* is more enigmatic, but it shows the quiddity of David: his independence and his lack of pretentiousness. David, celebrating, is "leaping and dancing" before the ark of the Lord, while his prudish wife Micah, the daughter of Saul, looks out the window reproving him. When Micah came out she rebuked him with irony for his unbecoming and immodest behavior, "How the king of Israel honored himself today, uncovering himself before the eyes of his servants' maids" (II Sam 6:20). Leaping with both feet off the ground, David's unbridled exuberance is conveyed in his flying drapery. Whatever Ricci's reason for including it, the prominence of this scene suggests that there was something of the unconventional in his own makeup.

The macroscheme is the finest invention of Salviati and of the Roman Maniera. On the one hand it recalls the illusionism of ancient Rome murals,[128] on the other, the model is once again the Sala di Costantino, but as in Perino's Sala Paolina, the model is embellished and surpassed. Dissembled materials are as important as in the Sala di Costantino, but here Ricci's personal collection played a part. The conceit is of a columned hall against a black background in front of which large paintings and smaller scrolls are hung. Fictive vases sit atop doorjambs flanking real niches with marble busts from the patron's collection. In fact, these vases have been identified as copied from a type coming from Southeast Asia and must have been inspired by actual rare objects in Ricci's collection. Equally rare is the authenticity with which the painter has simulated the Far Eastern scrolls suspended on wooden rollers on the Bathsheba wall and elsewhere in the room.[129]

The fictive architecture projects into the room in front of which are placed the framed paintings, scrolls, cartouches, vases, garlands. Figures even sit or lie on the frames and overlap them. Layer upon layer protrudes into the viewer's space in a brilliantly complex construction in the relieflike mode. But Salviati was not content to leave it at that. The game is extended to playing off traditional perspective compositions within the framed pictures. The wall is embossed with aggressive intrusions inward at the same time that it is excavated by recessive projections backward, but the two compositional modes are kept neatly separated so that no conflict or confusion is created. Instead of remaining static, the framing is imbued with as much dynamic animation as the narratives. The viewer slides with oiled ease from one level of reality to another, and there is an ebullient jocularity here that refutes a totally serious reading. As much as Ricci's reception room impresses, there is an undercurrent of merriment preventing it from becoming pompous.

This exemplifies what the Maniera style is superbly well suited for: the representation of power with a pleasing irony, illusionism that delights, hyperbole that we are then permitted to perceive as just that, and, above all, a banquet of ornament. This is why the style succeeded so well in courts everywhere, from Mantua to Genoa, to Fontainebleau, to Florence, to Vienna and Prague. The seeds that had been sown somewhat tentatively at the Villa Farnesina have come into full bloom by midcentury.

SALVIATI'S FRESCOES IN THE FARNESE PALACE

Pope Paul III succeeded in creating a legacy for his family, one that would endure for several centuries. An extremely lucky find in the Baths of Caracalla unearthed treasures of antique sculpture that were quickly annexed to the personal collection of the family, not to the Vatican, and were eventually transferred to Naples and ultimately to the Archaeological Museum there after the family died out in Rome. This collection of antiquities remains among the most renowned ever assembled. Paul's grandson, Cardinal Alessandro, continued in his powerful position as vice-chancellor of the Church and extended his patronage of art, building the enormous pentagonal Villa at Caprarola and decorating it with frescoes, which we will discuss in the next chapter. Today the Farnese Palace in Rome (now leased as

the French Embassy) and the Villa at Caprarola stand as two of the principal monuments of mid-Cinquecento Italian art.

In the Farnese Palace, and again at Caprarola, rooms are dedicated to the Fasti Farnesiani,[130] that is, the Deeds of the Farnese – the term itself borrowed from the ancients. After the death of Pope Paul III late in 1549 his grandson Ranuccio (1530–65), cardinal since 1545, inherited the palace and took up residence there. The prominence in Salviati's frescoes of the pope's grandfather, Ranuccio, who had led the papal troops of Eugenius IV in the Quattrocento, suggests that they were commissioned by his namesake, and not before. Salviati probably did not begin his work here until mid-1552.[131] The room was left unfinished, to be completed by Taddeo (1529–66) and Federico Zuccaro (c. 1541–1609) after Salviati's death in 1563. Again the model is the Sala di Costantino, and as in that room different spheres of history, allegory, and myth are represented in different spaces and as if in different materials. Like Vasari's Sala dei Cento Giorni, the scheme is what Gilio termed "mixed": in between history and allegory. On Ranuccio's wall the military exploits of the Farnese are celebrated; opposite on Paul's wall their leadership in religious matters. At the center of the left wall as one faces the windows, the enthroned Ranuccio is shown flanked by *Allegories* – clearly a symbolic representation (Fig. 109). In similar spaces at each end of the wall are tabernacles with *Allegories* on pedestals. On either side in spaces framed by stone pilasters are historical scenes. Over Ranuccio's head hangs a tapestry representing mythological figures where his arms are being made, as if he were Aeneas. Venus admires a sword, freshly forged by Vulcan, and cupids cavort with armor. With consummate wit Salviati denies the carefully constructed distinction of spheres, for the statuary hero looks up and receives his lance from a cupid. Allegorical myth and history merge, thwarting a factual reading but encouraging a poetic one and identifying Ranuccio as another Aeneas.

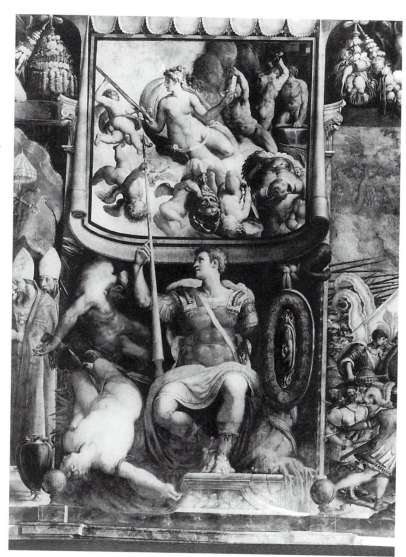

Figure 109. Salviati and assistants, *Ranuccio Farnese receiving Arms from the Gods.* Fresco, begun c. 1552. Sala dei Fasti Farnesiani, Palazzo Farnese, Rome.

On the opposite wall the scheme is repeated to celebrate Paul III, who is depicted making peace for the Church in both the temporal and spiritual realms (Fig. 110). He, too, appears enthroned at the center flanked by *Allegories,* on the left *Peace,* who torches the conquered arms piled up at her feet. Behind her is the Peace of Nice, in which King François I and Emperor Charles V were brought together by the diplomacy of the pope; in the background is the Temple of Janus, a chained Fury visible inside. The *Allegory* on the right is *Religion* and behind her are references to the pope's ecclesiastical diplomacy, which brought about the Colloquy of Ratisbon (1542), where Protestants and Catholics at last met and discussed their

differences. Two men standing on the steps appear to be trying to settle the religious disputes, for one is in ecclesiastical garb and the other looks to be a northern European and a Protestant (but not Luther, as is sometimes claimed).[132] The war against the Protestant league of Schmalkald, containing portraits of Emperor Charles V, Cardinal Alessandro, and Ottavio Farnese, takes place in front of a Christian basilica with twisted columns, whereas in the small scene above, Paul considers plans for Saint Peter's. The tapestry suspended above his head, pendant to the mythological scene above Ranuccio, shows *Christian Allegories* with the dove of the Holy Spirit crowning Pope Paul, just as Venus offers arms to Ranuccio. Several scenes that had appeared first in the Sala dei Cento Giorni reappear here, but whereas Vasari and Paolo Giovio had been carefully circumspect in representing Paul's deeds as exemplary of the papal office there, here in the private palace this restraint has been removed and a new order of self-tribute was reached.

The role of the patron in history paintings has changed in a significant way in the course of the Cinquecento. There is, of course, a long tradition for the patron appearing qua patron reaching back into the Middle Ages. That tradition was continued in the pious portrait of Alexander VI kneeling in his papal robes as a witness to Christ's Resurrection, included in Pinturicchio's decorations of the Borgia Apartment (Vatican, 1492–5). When, a few years later, Pope Julius had himself represented in the *Dispensing of Canon Law* (Raphael, *Jurisprudence* wall, Stanza della Segnatura, c. 1511–12), he appeared as a stand-in for Pope Gregory, to whom the historical event depicted refers. Julius's appearance updated history, making it clear that he was a defender and proponent of the law. Again in the *Mass at Bolsena* (Raphael, Stanza d'Eliodoro, 1512), Julius made a statement about his commitment to a theological doctrine when he appeared anachronistically as witness to the thirteenth-century miracle.[133] Pope Leo continued this kind of linking of past history with his policies in the scenes in the Eliodoro and Incendio rooms where he was portrayed.[134] In the Stanze we see history painting used to represent and justify papal policy, but not primarily to aggrandize the person of the pope.

The popes were sometimes associated with historical or legendary figures who might be regarded as their prototypes. We have seen that such associations were made between Julius and Leo and the first kings of Rome. Julius the warrior was likened to Romulus, and Leo, the analogy suggested, would resemble his successor, the pious Numa Pompilius, by inaugurating a longed-for Golden Age of peace. Leo was represented thus in the temporary decorations on the Capitoline in 1513 shortly after his coronation. These historical analogies probably did not originate with the popes but were created as coded messages *to* the pope expressing the hopes of his subjects.[135] In the vault of the Sala dei Pontefici in the Vatican, Leo's presence was again implied but not portrayed, where he had his horoscope depicted by Giovanni da Udine and Perino del Vaga (Pl. IX). A different kind of patron portrayal may have appeared in the *Wedding Banquet of Cupid and Psyche* on the vault of the Loggia di Psiche at the Villa Farnesina (Raphael and workshop, Fig. 19). The likeness of Agostino Chigi is said to be included among the feasting gods. It would make sense because the purpose of the frescoes was to celebrate Chigi's marriage, but there is no dynastic claim implied; the spirit is more fun than self-vaunting, and the setting was his private villa.

By the next generation, the propaganda value of frescoed images was increasingly exploited, and increasingly for the purpose of bolstering dynastic claims. The judicious tact we have seen being exercised gave way to bolder and bolder intrusions of personal portrayals and ever more hyperbolic associations between patron and antique prototypes. Paul III became Alexander the Great and Saint Paul at the Castel Sant'Angelo, although the allusion is indirect and his portrait never appeared. In the Sala dei Cento Giorni his portrait appears everywhere, but he is the exemplum of the papal office, rather than the hero.

In the Farnese private palace, all inhibitions were removed. It was a virtual apotheosis of the now-dead pope that Salviati was ordered to represent. This is the secular counterpart to the Cappella del Pallio, where there are Farnese emblems everywhere, but in the altarpiece, most brazen of all, Pope Paul appears as Saint Joseph. We have come a long way from the Quattrocento, where the most a patron was likely to have represented of himself were his family arms and perhaps his personal emblem. As late as the 1490s, Savonarola could object even to the display of coats of arms in family chapels, reminding patrons that it was a house dedicated to God's honor, not to theirs. Though the fiery Dominican is often dismissed today as a medieval throwback, the fact is that the Florentine citizenry took him seriously

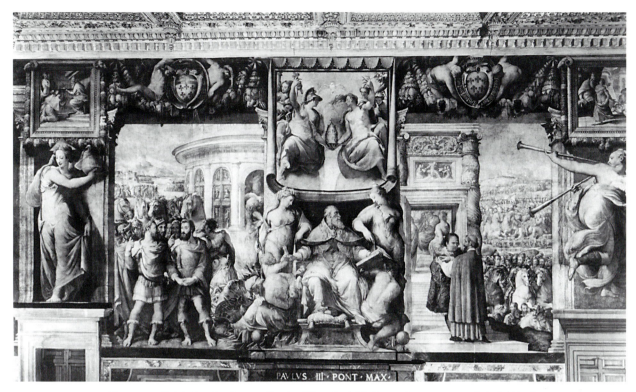

Figure 110. Salviati and assistants, *Deeds of Pope Paul III*. Fresco, begun c. 1552. Sala dei Fasti Farnesiani, Palazzo Farnese, Rome.

enough to put their Republic in his hands. For such a profound change in decorum to have taken place in half a century, some significant new influence must have been shaping Cinquecento modes of behavior. That new influence was, once again, classical antique models, visual but especially literary.

ORNAMENTS AND BEAUTIES IN THE MANIERA

The Maniera has been called the "stylish style" by John Shearman, and the "stylized style" by Sydney Freedberg; both terms certainly describe it. When we compare it with the Classic style, the proliferation of embellishments, the preference for complicated poses, the hardedged, sculpturelike rendering strike us as departures from naturalism. We have difficulty reconciling them with the intention to imitate nature, which the artwriters of the period continued to declare to be the purpose and end of art, although they may now speak of it as "the artificial imitation of nature."[136] When Cinquecento writers wrote about art, however, it was not in hedonistic terms. Art was valued for its moral efficacy, and the rediscovery and translation in the 1540s of Aristotle's *Poetics* gave new life and new language to this

view. Clearly the artificialities, as we define them, had a different meaning and function then. A clue is in the way ornaments *(ornamenti)* are discussed by Benedetto Varchi[137] and Vasari.

Varchi, when he returned to Florence from exile in 1543, had spent the previous five years in other major artistic centers, including Rome. He was therefore fully cognizant of the Maniera style as it had emerged there, and he had certainly given thought to the way it related to the art of earlier painting of the century. In his lectures delivered to the Florentine Academy he remarked that pictorial ornament is best exemplified in the Sistine Chapel and Raphael's Stanze.[138] Vasari said that ornaments and inventions of the painters both in figures and in other appurtenances lead "first the eyes, and then the soul to stupendous marvels."[139] These are large claims. Something more than mere decorative embellishment must be meant by *ornamenti*.[140] Ornaments seem to be charged with the task of multiplying beauty, not just in the numerical or quantitative sense, but qualitatively. Already Castiglione had said that contemplation of multiple beauties *(bellezze)* led the viewer to a sense of universal beauty.[141] There is a metaphysical function ascribed to *bellezza* in some Cinquecento artwriting and its sources in the philosophy of the

ancients. On the basis of Aristotle and a lingering but alchemized Platonism,[142] it was believed that if the artist through his intuition could perceive and then create beauty, it was because he was in touch with the ideal image concealed in the matter. The beholder of this beauty is, in turn, vaulted above nature and the imperfect mundane world to a perception of the divine, from which the ideal beauty derived. If "nature" is understood as the perfect idea embedded in matter, then our artist, in imitating nature, would seek the hidden beauty that lies below the skin of appearance. Michelangelo's sonnet, "Non ha l'ottima artista," about seeking the image hidden in the marble block, is a well-known statement of this conception of the artistic process. Varchi made an exegesis of it to propound his theory of artistic creativity in his first lecture to the Florentine Academy in 1547.[143]

Nowhere in the writing of this period is a distinction made between the beauty of Christian, pagan, or even neutral subjects (what we call ornaments). The efficacy of beauty to assist in the ascent to the divine did not depend upon subject. The multiplication of *bellezze* can be regarded as a substitution of form for content, but this is a pejorative view these Cinquecento writers did not hold. Does this theory help to explain why it was appropriate to represent John the Baptist in a graceful, almost effeminate pose, surrounded by a profusion of beautiful figures elegantly ornamented, as Jacopino did; or the quotation, or self-quotation, lifted out of context; or the profusion of gilded stuccoes and other ornaments in Cardinal Alessandro Farnese's chapel; or the encrusted surfaces of Salviati's walls in the Ricci or Farnese Salone? In this abstract conception, beauty is created for the sake of creating beauty. But this is not art for art's sake, it is art for the sake of spiritual elevation.

The underlying conception of what art is, what it can and should do, did not alter in a fundamental way between the Classic and the Maniera, but as it evolved, emphasis shifted. As Sydney Freedberg put it, "the conception of what makes maniera *bella* evidently changed."[144] Vasari made it clear in the structure and content of the *Lives* that he believed the art of his own age was a continuation and a perfecting of that of the great masters, Raphael and Michelangelo.[145] The challenge of improving upon them was daunting, but as Vasari pointed out, one way that his generation of artists surpassed their masters was in quantity. We have already

recorded his remarks about quantity in the sense of facility. Other facets of quantity are described by copiousness and variety. The multiplication of *bellezze* – of ornaments and inventions – contributed more copiousness and more variety.

The *paragone,* as the dispute over the superiority of painting or sculpture was called, became a near obsession in artwriting of the Cinquecento. It is not a topic that excites the modern mind, and this literature, which is usually passed over quickly, leaves us wondering what its fascination could have been.[146] The emulation of sculpture, the creation of the relieflike style, and the dependence upon the conventions of the figure derived from sculpture suggest an explanation for this concern with the *paragone* around midcentury. There is a painting by Daniele da Volterra of *David and Goliath* (Fontainebleau, formerly Paris, Louvre, 1555/1556) that is painted front and back, with the figure group viewed from front and back: a demonstration by a painter that even multiple views, usually claimed as the special advantage of the sculptor, could be achieved with painting.[147] We notice that the figures are, indeed, very sculptural, in fact very Michelangelesque.

One of the ways that the artists had sought to surpass their predecessors was by combining the models of Raphael and Michelangelo. Raphael's school had dominated Rome in the 1520s and 1530s, but in the 1540s Michelangelo's sculptural form began to be widely imitated. Raphael was emulated for his color and his spatial organization, as we saw in Salviati's *Visitation* (Fig. 95), but in the 1540s Salviati shifted his allegiance to Michelangelo. As we have seen, his *Nativity of the Baptist* (Fig. 104) owes something to Sebastiano's Michelangelism, in particular his *Nativity of the Virgin* (Fig. 86), and something to the master Michelangelo himself. But this shift to a sculptural, relieflike style had already occurred in Salviati when he painted for Duke Cosimo in Florence the Sala dell'Udienza (1543–5) (Fig. 150). When Jacopino came back to the Oratory of San Giovanni Decollato in 1541 to paint his *Baptism of Christ* (Fig. 111), his figures had become monumental and sculptural in the manner of Michelangelo. Presumably it was the experience of the *Last Judgment*, unveiled in that year, that he was responding to. It was also in the early 1540s that Daniele rejected Perino's style in favor of Michelangelo's (his *Deposition* for Trinità dei Monti, for example). Only Perino, the direct descendant of Raphael, remained untouched by Michelangelo fever.

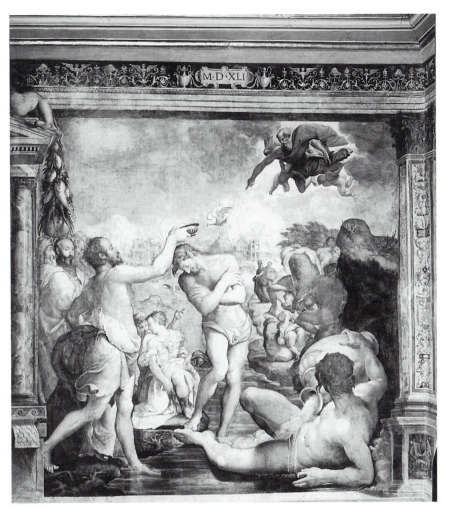

By the early 1540s the conventions of the figure, derived from antique sculptural relief, had become the norm for Maniera painting. Concurrently, the problem of the relationship of painting to sculpture took center stage and was endlessly debated.

THE SALA REGIA

The Sala Regia (Fig. 112), the grand reception room begun under Paul III, was allowed to languish by his successors, Julius III and Paul IV. The stuccoes of the ceiling by Perino and those of the walls by Daniele remained an elaborate framework for empty fields until Pius IV (1559–65) gave the commission for the frescoes to Salviati and Daniele to share in 1560.[148] This plan did not work out, and on Salviati's death in 1563 it was decided to parcel out the frescoes to individual painters. Even so the work dragged on, until finally it was brought to conclusion in 1573 by the decisive action of Pope Gregory XIII (1572–85) and Giorgio Vasari.

Figure 111. Jacopino del Conte, *Baptism of Christ*. Fresco, dated 1541. Oratory of San Giovanni Decollato, Rome.

The room was not just another audience hall, but the hall of state. Ambassadors, guests, and petitioners would be brought up the stairs into the presence of the enthroned pope, seated under the window at the head of the room. The decorations celebrated the primacy of the pope, but a special iconography had been evolved for halls of state that simulated the triumph or the triumphal entry that had become such a popular ceremony among monarchs of the sixteenth century.[149] Scenes showing the donations of sovereigns to the papacy and offering obedience to the pope line the walls. These events are shown as triumphal entries or processions through the city depicting familiar architectural landmarks; or, as the culmination of those entries, receptions taking place in rooms like the Sala Regia itself. On the end walls are battles and triumphs of the two popes who began and finished the rebuilding and decoration of the room. Opposite the throne around the door to the chapel built by Paul III, the Pauline Chapel, Pope Paul celebrated the battle of Tunis (1535). And at the right, surely the original plan called for a depiction of Emperor Charles V kissing Pope Paul's foot, on the occasion of his triumphal entry to Rome the following year. Because Paul III had died, Gregory XIII had another imperial foot-kiss referring to himself inserted. Scenes around the throne (now removed) at the opposite end likewise celebrated events in the reign of Gregory – the spoils belong to the patron who finally gets the work done! On the side walls in the remaining large fields Vasari represented the naval battle of Lepanto, believed at the time in 1572 to have been the decisive defeat of the Turks by the alliance of Spain, Venice, and the papacy. Thus we are shown contemporary events alluding to issues of the day: the defeat of

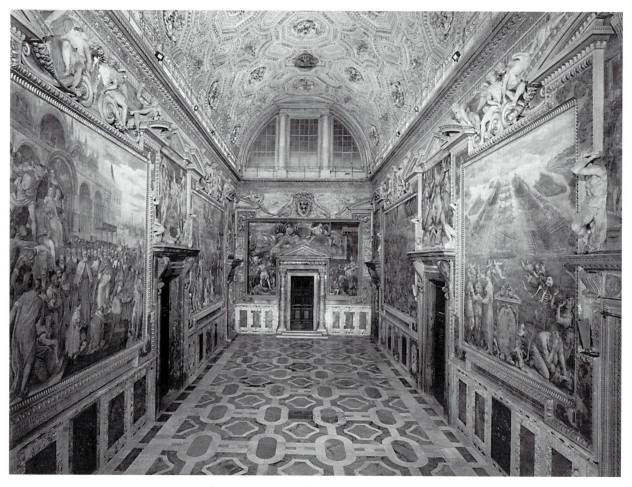

Figure 112. Sala Regia, view. Stucco and fresco, 1542–73. Vatican Palace.

heathens and heretics, the obedience of a German and a French sovereign to the will of the papacy, and a history of past events of like kind.

Because the actual execution of the frescoes involved thirteen painters over a period of nine years it should not surprise us that there is a lack of unity among them. When Pope Pius IV first turned his attention to the decorations in 1560 he put two cardinals in charge, who in turn chose their favorite painters.[150] Division of responsibility at both the management and execution level proved inefficient and detrimental. Finally, once he was called in, Vasari painted in thirteen months seven frescoes, including all but one of the large scenes. Unlike Salviati and Daniele, who were known as slow workers and who did not manage large workshops, Vasari had developed a system that was as efficient as Raphael's had been. Even more was demanded of him than of Raphael, however, in terms of the sheer size of the walls to be decorated. Vasari had to depend on a hive of assistants for the frescoing, but he maintained a tight control

over the design process, having learned his lesson in the Sala dei Cento Giorni many years earlier. The method had been worked out by him in the preceding decade when he was responsible for the Florentine hall of state, the Salone dei Cinquecento in the Palazzo Vecchio.[151] Vasari would make rapid compositional sketches that would be worked up into finished *modelli,* usually by an assistant, then squared and transferred either directly to the support or to a full-size cartoon and then to the support. Only the initial stage would necessarily require Vasari's hand, although he said in a letter that in the Sala Regia he alone had made the cartoons for the six large histories and expressed the intention to do as much of the frescoing himself as possible.[152] He remarked with satisfaction that whereas in the past these blind Romans had cut him to ribbons, this time they were covering him with praise.[153] In the event, because Duke Cosimo wanted him back in Florence to fresco Brunelleschi's cupola, he was compelled to rely more on his assistants. For projects of this kind, in which the message

was paramount, Vasari's system was highly successful and would be much imitated, both in the next decade by the painters charged with satisfying the ravenous iconodule, Pope Sixtus V (1585–90),[154] and later in the Baroque era.

Despite Salviati's role in the early stages he apparently did not create the macroscheme, for it shows no more indebtedness to his preferred model, the Sala di Costantino, than did the contemporary decorations by Taddeo Zuccaro at the Farnese Villa at Caprarola. It would seem that the taste for these splendid illusions was now a thing of the past, replaced by more sober conceptions. Also, the function of the room and of its decoration may have dictated a less fanciful scheme. The purpose here was not only epideictic, to praise the wisdom of those monarchs who have paid appropriate homage to the papacy, but also to state the unarguable fact that the papacy has primacy. An aura of certainty prevails here, and that certainty is being celebrated. In the decorations there is no playfulness to leaven the seriousness, as there is in Ricci's Salone, or the Fasti Farnesiani or Perino's Salone at the Castel Sant'-Angelo. The splendid illusionism in those schemes introduces an element of ambiguity unwanted here where absolute authority is the subject. In those other reception rooms, the purpose of the decorations was to persuade the viewer that the patron was both powerful and benevolent, and that he could be entrusted with power. A message containing humor can dispose the viewer to yield to the persuasion. But in the Sala Regia persuasion is not the tone the decorations intend to invoke. The scheme has been accurately calibrated for the message. The ornaments are restricted to the stucco frames of earlier date. The frescoes are treated as if they are pictures hung on the wall – *quadri riportati* – and because of their

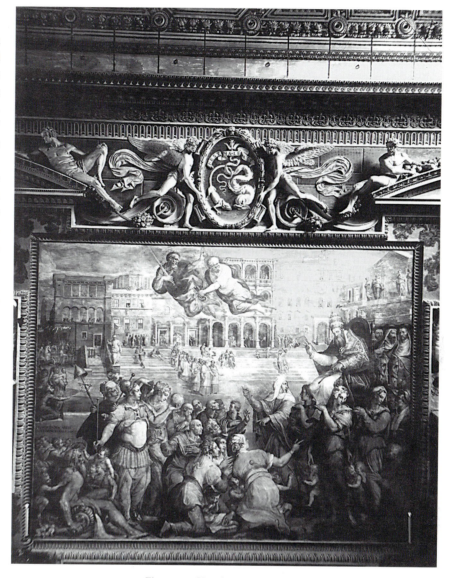

Figure 113. Vasari, *Pope Gregory XI returning to Rome from Avignon in 1376*. Fresco, 1573. Sala Regia, Vatican Palace.

size this impressive feat adds to the aura of importance. Rather than having the fictive materials usually depicted in the *basamento,* here the lower wall is sheathed in beautiful colored marbles.

Within these frames the style of the paintings is still Maniera. Even painters like Girolamo Siciolante da Sermoneta (1521–75), a former assistant of Perino's who by this time had embraced a Counter-Maniera for religious works (as we will see in the next chapter), returned here to the Maniera conventions of the figure and a relieflike treatment of space (*Donation of King Pepin,* 1565). Vasari, in representing *Pope Gregory XI returning to Rome from Avignon in 1376* (Fig. 113), used the

devices of the Maniera to operate in two time frames simultaneously, that of Gregory XI and of Gregory XIII. Gregory XI in the Trecento had brought the papacy back to Rome from France. Allegorical figures, like the Tiber with the wolf and Romulus and Remus, are mingled with actual witnesses in the crowd, but because all are posed equally artificially the juxtapositions are acceptable. The procession moves through Saint Peter's Square where some people in the crowd kneel – parallel to the picture plane – and gesture with conspicuous limbs to celebrate the pope's return to restore order and to protect Italy. Saint Peter's is shown as it was in the Trecento (we see the facade of the old Saint Peter's), but behind we glimpse Michelangelo's dome rising, as it was at the time of painting. Gregory XI has the features of Gregory XIII, who will sit enthroned at the end of the room and toward whom Vasari's procession is moving. Like his namesake, the present pope is dedicated to the protection of Italy and the unity of the Church.

By the time this room was being frescoed, the Counter-Reformation was seeking to institute a didactic mode for works in a religious setting. The Church recognized, however, that for political situations the language of praise, epideictic rhetoric, relearned from the ancients, was still the most effective mode of speech and of imaging, and it was therefore indispensable. The rhetoric of praise was the appropriate mode of address here, and Maniera remained the style best suited to this rhetoric.

We have seen that it is not true that the Renaissance artist did not cross the liminal space and make an appeal to the viewer. But we have also seen that sometimes that appeal was erotic, or at least sensuous, and that it was sometimes contradicted by impediments the painter constructed, like *repoussoir* figures pressed against the picture plane, to keep the enticed viewer at a distance. There was not in central Italian art, except in the paintings of Correggio, a direct, disingenuous invitation to the viewer to participate in the affect of the actors. The Counter-Reformation Church would find the complexity, paradox, and sophistication of these paintings unsuitable for religious images. Various new means to communicate with the worshiper, some didactic and disengaged, others more engaged, were already being sought while much of the art discussed in this chapter was still being created.

The Counter-Reformation in Rome

THE MIDCENTURY IS MARKED BY THE CONFLICT BETWEEN TRADITIONAL humanist values and those of the Reform, and by competing styles, Maniera and Counter-Maniera, existing side by side to serve both sets of patrons. To appreciate this situation we need to move back in time to see what was going on in religious art while the secular works we discussed in the last chapter were being executed.

In 1550 Pope Julius III, soon after his election, commissioned Giorgio Vasari (1511–74) to design his family chapel in San Pietro in Montorio (Fig. 114). The commission carried the provision that the design should be submitted to Michelangelo (1475–1564) for his approval. Vasari himself tells the story that when he showed his wooden model and drawings to Michelangelo – presumably one of them is the drawing now in the Louvre (Fig. 115)[1] – the old master told him to simplify it by removing all the surface ornaments with which Vasari, in typical Maniera fashion, had enriched the marbles.[2] Vasari reports that at first he thought that it would impoverish the effect, but eventually he willingly admitted that in fact once again Michelangelo was right, and that it had turned out better. Was Michelangelo's advice based sheerly on aesthetics, as is usually assumed, or does it instead reflect the new spirit of reform gathering focus then in Rome, as well as Michelangelo's personal change of direction? The chapel as it was executed by Ammannati (1511–92), who did the work in marble, including the flanking tombs, and Vasari, whose altarpiece shows the *Blind Paul brought before Ananias,* is more austere than anything that had been done in Rome in the previous decade.

We can observe this conflict of styles and patrons' taste by comparing the Del Monte chapel with one executed immediately before it by Francesco Salviati (c. 1509–63). In the Margrave Chapel in Santa Maria dell'Anima,[3] all the surfaces are enlivened with ornament in fresco and stucco, much of it just that: ornament, without religious content. Like Salviati's Cappella del Pallio for Cardinal Farnese, which he had just completed (Figs. 102–3), there is a free mingling of pagan, Christian, and ornamental components, including prominent portraits of the patrons surrounded by large fields of grotesques. Above the portraits on both side walls is as luxuriant a display of Maniera encrustation as the painter ever created. A giant Saint Maurice in antique armor bursts

Figure 114. Vasari and Ammannati, Cappella del Monte, San Pietro in Montorio, Rome, 1550–1.

statues in uncontorted poses, where nothing below the level of the vault is inessential or distracting, is the first chapel in Rome, save one – Michelangelo's Pauline Chapel – in the new style of the Counter-Maniera. That it should have been created by the arch-Maniera artist, Giorgio Vasari, who would continue to be a chief propagandist of that style until his death in 1574, is an amusing irony.

THE FORMULATION OF THE COUNTER-MANIERA

Michelangelo understood before his contemporary artists that the prevailing Maniera style did not suit the new religious movement within Catholicism, and that a new style was called for. This awareness grew out of his personal religious experience after his return to Rome in the group of reformers that formed around Cardinal Reginald Pole, Vittoria Colonna, and others. These *spirituali* examined their own faith, in part in light of Luther's attacks, and gained spiritual renewal in this process. A new devotional fervor took hold of Michelangelo. In the 1540s he reexamined his art and in his search for the means to represent the transcendental, he rejected the sensuousness, facility, and artifice of his previous work. He turned instead to medieval models,

the confines of his tabernacle, the staff of the banner held behind his head overlapping its frame. Saint Albert the Carmelite seated below overlaps the tabernacle, and the Allegory of Modesty,[4] whose head emerges at the lower right, creates yet another layer. The remaining surface is dense with an intricate pattern of allegories, garlands of fruit, and putti crowded within too-small spaces. This is in contrast to the treatment of the grotesques on the wall below which are in miniature scale, airy and linear, and which treat the wall as a surface instead of a plane from which to project overlapped layers protruding into the viewer's space. The lively surfaces that engage the eye with a wealth of *ornamenti* are similar to the effect that Vasari was seeking in his first scheme for the Del Monte chapel. Vasari's chapel as executed with its plain white Carrara marble walls, clean architectural membering, and

Figure 115. Giorgio Vasari, project for the decoration of the Cappella del Monte in San Pietro in Montorio, Rome. Drawing, 1550. Louvre, Paris.

where piety had been expressed more directly. He had copied Giotto in his youth in Florence and now he returned to him, imitating his block-like figures, their uncomplicated articulation, their stubby proportions, and their transparent emotions. Joannides has dubbed this denial of the sensuous by Michelangelo his "drab manner."[5] It was the first formulation of a Counter-Maniera, except for Sebastiano's post-Sack paintings. Michelangelo's abrupt shift in style was not understood by most of his contemporaries, who had not yet come to terms with the spirit of the Reform.

SEBASTIANO DEL PIOMBO'S DEVOTIONAL PICTURES

Sebastiano (c. 1485–1547) was the only painter to anticipate Michelangelo's turning toward a more pious art. Since the early 1530s he had made only portraits and devotional images of an austerity that was out of step with the mood of the Roman Restoration. There are reasons to believe that he was sympathetic to the Catholic Reform movement of the 1530s that included Vittoria Colonna, Cardinal Pole, and Giulia Gonzaga, all of whom sat for his portraits.[6] This was the same group of *spirituali* with whom Michelangelo was in contact. They continued to hope for reconciliation with the Lutherans, whose views they recognized as having some merit. It is worth recalling that Sebastiano was deeply affected by the Sack, by his own testimony. He wrote in 1531, five years later, that "I don't seem to be the same Sebastiano I was before the Sack; I can never return to that frame of mind. . . . After having gone through fire and water and endured unimaginable hardships, let us thank God and spend what remains of life as peacefully as possible."[7] Vasari, who was highly critical of Sebastiano because he transgressed one of his principal tenets of professionalism by producing very little in his late years and therefore wasting his talents, seemed unaware that there may have been a pious basis for what Vasari regarded as his laziness.

Sebastiano's art appealed to a few of the more devout and was particularly popular in Spain. His *Christ in Limbo* (Fig. 116), now in the Prado, Madrid, was appar-

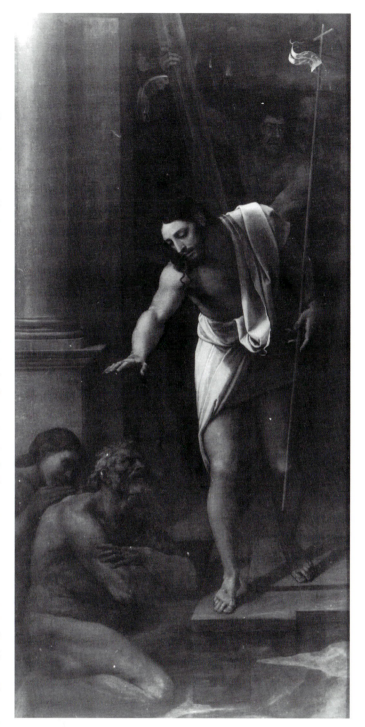

Figure 116. Sebastiano del Piombo, *Christ in Limbo*. Begun 1516. Prado, Madrid. © Museo del Prado.

ently begun as early as 1516 for a Spanish patron, probably with the help of a drawing by Michelangelo.[8] It anticipates the style he would develop after the Sack. His handling of a subject that would certainly have permitted more dramatic treatment makes apparent his

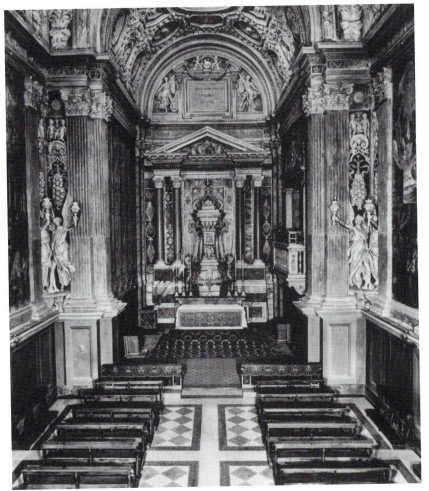

Figure 117. Michelangelo, Pauline Chapel, view. 1542–50. Vatican.

ture, a stark chiaroscuro, simplified, geometrized forms, and almost monochrome color. The historical moment, in which Christ falls under the weight of the cross, has been lifted out of context and isolated against a dark background. Veronica, solicitous with her veil, has been excluded. The worshiper is placed close and below, looking up into the pained but noble face of Christ. This could well be a small devotional image, but in fact it is large – almost certainly an altarpiece[10] – and its scale increases its impact. This work makes a fascinating contrast with Salviati's Florentine version of the same subject (Fig. 154), which is pure Maniera. The comparison makes Sebastiano's renunciation of all *ornamenti* all the more startling. The directness and affect of pieces like this were not to the taste of most of the sophisticated patrons of Rome, to whom, one supposes, this art would have seemed crude and simplistic.

preference for a less narrative and more devotional art. Instead of surrounding Christ with the pathetic inhabitants of limbo who wait for eternity, as Agnolo Bronzino (Florence, Santa Croce, 1552) and Alessandro Allori (Rome, Galleria Colonna) would do, Sebastiano simplified his composition to include only two shadowy men behind and two figures kneeling in the lower corner, toward whom Christ bends and reaches out a compassionate hand. The supplicants are intermediate between the worshipers and Christ, whose gesture of blessing includes them. Sebastiano's reduction of artifice includes light, which picks out Christ and leaves all else in dim shadow, and color, which is nearly monochrome.

Similarly spare images of Christ form the core of Sebastiano's late sacred art, for example, the moving image of *Christ carrying the Cross* in Budapest (Pl. XX).[9] Here emotion is intensified, but the means of representation are the same: plain surfaces rendered without tex-

MICHELANGELO'S PAULINE CHAPEL

To understand the Counter-Maniera we must turn to the chapel where it was pioneered: Michelangelo's last frescoes in the Pauline Chapel (Fig. 117). As soon as Michelangelo had completed the *Last Judgment* in 1541, Pope Paul III was ready with another project for him, the chapel that bears the pope's name, newly constructed to replace an earlier one that had to be destroyed when the new staircase to the Sala Regia was built. Just completed in 1540 by Antonio da Sangallo, the chapel was intended to be used for the papal conclave, where the College of Cardinals would assemble on the death of the pope to elect his successor. Although Pope Paul's expansion of the number of cardinals ultimately made it necessary to hold that event in the much larger Sistine Chapel, this function was nonetheless the purpose for which the Pauline Chapel was designed and decorated.

Michelangelo, by now an old man, worked slowly,

taking more than seven years (1542–50) to complete what has been shown to be 172 *giornate,* or daywork patches of plaster, or what it would be possible to paint in little more than nine months.[11] To be sure, he was kept busy with competing projects: the completion of the tomb of Julius II, so long delayed, and after the death of Sangallo in 1546, the administration of the ongoing construction of Saint Peter's, to name the most important. There is an intensity and an urgency to the images in this chapel that have led some to view them as a personal confession, forgetting how improbable that would be. Access to the chapel is closely guarded today because it is the pope's private chapel, and we tend to assume that it was always as private as it is now, and therefore a place where a personal statement would be appropriate. In fact, the site of the conclave would have required a decoration of high seriousness and broad applicability, of relevance to that august body in the context of the duty

Figure 118. Michelangelo, *Conversion of Paul.* Fresco, 1542–5. Pauline Chapel, Vatican.

they were gathered to perform – choosing a new pope. The selection of a Petrine subject was therefore foreordained; the logic of choosing a Pauline subject to commemorate the patron was equally manifest. Pope Paul's dedication to reform, which culminated in his convening of the Council of Trent in 1545, was reflected in the frescoes Michelangelo would paint.

On the two side walls the painter would depict the *Conversion of Paul* (Fig. 118) and the *Crucifixion of Peter* (Fig. 119), moments of truth in the lives and faith of the two leading apostles. The choice of the Conversion of Paul, or more correctly, the Conversion of Saul, is what we would expect, and we have seen that the Farnese pope would use it in other commissions, like Perino's Sala Paolina. The traditional pairing of subjects, however, called for Christ giving the keys to Peter, that is, the institution of the papacy; they were pendants in the tapestries Raphael (1583–1520) designed

Figure 119. Michelangelo, *Crucifixion of Peter.* Fresco, 1546–50. Pauline Chapel, Vatican.

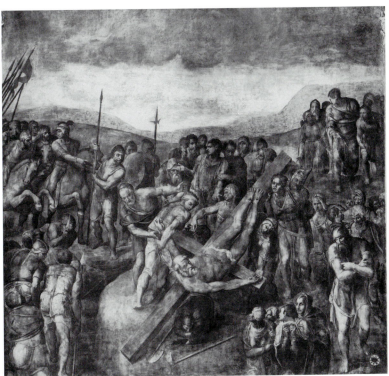

for the Sistine Chapel.[12] When Vasari described the frescoes in the first edition of the *Lives* published in 1550, he mistakenly identified the Peter subject as the Giving of the Keys. When he visited the chapel the second fresco would not yet have been begun, so it is thought either that he remembered incorrectly, or that the program was in fact changed.

The *Crucifixion of Peter,* the most ignominious moment in the career of the saint, was rarely represented, in part one suspects because of the difficulty it presented to the artist. Peter had asked to be crucified upside down, saying that he was not worthy to suffer the same death as his Master. The resulting image tended to lack dignity, to say the least, and it was difficult to show appropriate emotion in the inverted head of the apostle. The expression of humility at the core of this narrative is the key to the message of Michelangelo's frescoes.

In the Cinquecento the Pauline paintings had nothing like the impact of the *Last Judgment.* They were little discussed by artwriters, and few prints after them were engraved.[13] Few painters quoted the figures in their own works the way they did those in the Sistine. Leo Steinberg has characterized their reception as "embarrassed silence."[14] This appraisal, that it was the work of an old man who had lost his powers, has prevailed until recent times,[15] and even today the chapel has not found a place in the sequence of stylistic development that art historians describe.

In fact, Michelangelo's shift in style is not so abrupt as it at first glance appears. It was anticipated in the lowest zone of the *Last Judgment* and it surely resulted in part from the thinking of the artist as he pondered that subject. If we look at the *Judgment* not as a monolith but in the sequence in which it would have been executed, from top to bottom, we realize that at the lowest setting of the scaffolding where he had to depict the damned, the inhabitants of hell, the demons, Michelangelo was confronting a problem that he had scarcely touched before. Both those in the act of resurrecting, who have not yet received their new spiritual bodies (in the lower left corner), and the damned, whose spiritual bodies are not perfected, required a different treatment. The heroes of the Sistine vault and the resurrected elect of the *Judgment* share the important quality of a God-given Grace (Pls. IV, XVII). For all of them, the beauty and energy of Michelangelo's figure style was the perfect vehicle to convey their state of Grace. Searching his oeuvre for precedents for his inhabitants of hell, we come upon

Adam and Eve after the Fall, and the condemned in the *Deluge.* Adam and Eve of the *Expulsion* are very different from the graceful, agile creatures who idle in Eden in the left portion of the same fresco (Pl. V). They have become clumsy and lumpish, shown frontally without the alluring twists that articulated their movements as they reached for the fruit. The "damned" in the *Deluge* are also sinners who have been convicted. Michelangelo depicts them scrambling futilely to save themselves from the rising waters, competing brutishly for the high ground. Despite Michelangelo's compassion for their tragic plight, he has shown them as awkward, burdened by their bodies as much as by their families and their possessions. The *Last Judgment* demanded of the artist a prolonged reflection on the nature of damnation and how it should be represented. Michelangelo returned to the solution he had found in the *Expulsion from Eden* and the *Deluge:* physical grace and beauty as the visual metaphor for divine Grace, clumsy awkwardness for those who have fallen from God's Grace.

Moving directly from the lower zone of the *Judgment* into the Pauline Chapel, in the *Conversion of Paul,* Michelangelo was to depict Christ's enlightenment of one man in the midst of a crowd of uncomprehending witnesses. In the *Crucifixion of Peter,* not only are the witnesses unenlightened, they are indifferent and phlegmatic. In their ungainliness they are like the damned of the *Judgment.* Michelangelo carried forward his experience of the immediately prior lower portions of the *Judgment* in conceiving the figures of the witnesses here. His meditation on the problem of salvation and damnation, as part also of the intensification of his personal religious devotion taking place in these years, led the painter to a new view of humanity, radically different from his earlier conception in the Sistine vault, where the beautiful Adam resembled God himself.[16] The easy optimism, embodied in the concept of the *imago dei,* more characteristic of those years, is gone, to be replaced by a harsh recognition of the depravity of man and his dependence upon divine Grace. If the humanism of the High Renaissance had led patrons and artists to view humankind as perfectible, events in recent history like the Protestant Reformation and the Sack of Rome were reminding everyone, on the contrary, of human sinfulness.

Michelangelo was not alone in his repudiation of the *imago dei.* A Catholic theologian at Louvain and one of the major figures of the time, Michael Du Bay, called Baius, stated that in consequence of original sin man had

fallen not only from the state of innocence but also from his resemblance to God.[17] This view is the very opposite of Baldassare Castiglione's association of human beauty with his goodness quoted here in Chapter 1. The mortified heroes Paul and Peter are both more vulnerable and more plausible than glorious Adam at the moment of his *Creation* on the Sistine Chapel vault. The soldiers and spectators who surround them are a new breed of men and women, only rarely glimpsed before in the Sistine. Michelangelo has broadened the category of those who are not recipients of God's Grace to include all those who fail to demonstrate their goodness by their actions.

Although his figures now lack the sensuous appeal they formerly had, Michelangelo has found a new way to involve the spectator. He departed here in a fundamental way from the tradition of Renaissance art by adapting his compositions to the spectator's oblique view, which the narrowness of the chapel dictated.[18] When viewed in situ, many of the idiosyncrasies of Michelangelo's design disappear. We are intended to experience with Saul the blinding light that actually shines on him most of the day from the window opposite. We are meant to be transfixed by Peter's gaze, which follows us as we traverse the chapel. The viewer is invited to engage his or her emotions in the religious drama in ways that are akin to the fervor experienced and advocated by the *spirituali* of the Reform.

According to the book of Acts, Saul was a lawyer who delighted in persecuting Christians. As he was traveling the road from Jerusalem to Damascus, Christ appeared to him in a blaze of light and a voice demanded, "Saul, Saul, why do you persecute me?" Blinded by the light and terrified by the voice, he was thrown to the ground (Acts 9:4). In the representation traditional since the Middle Ages, his horse bolted and he was thrown over its neck, signifying the abasement of his pride. Although Michelangelo has separated horse and rider, his depiction of Saul at the bottom of the space in painfully ungainly pose makes it clear that humility is his theme.

As represented traditionally, those who accompanied Saul fled or stared in terror. Michelangelo's soldiers are spewed every which way, their lack of direction signifying their incomprehension and leaving a void around Saul. Only one companion attends him, solicitously kneeling to support him. Disorder reigns in this space, where the only organizing line of force is the arm of Christ beaming light onto Saul, who covers his face defensively. Saul is shown in an awkward and ignoble

posture, unlike the one Raphael had chosen for him in his tapestry design.[19]

Here is no celebration of the pomp and glory of the papacy, such as might have been represented in the heady decades gone by. As the cardinals gathered to choose one of their number to lead the Church, they were to be reminded of the sanctity of the office and the tests of faith to which its holder would be put.

Another difference strikes us: Michelangelo has represented Saul as an old man with a gray beard, contrary to the text, for we know that Paul was a young man, who after his conversion would carry out a long mission of founding and visiting new churches all over the Mediterranean world. Steinberg has traced two visual traditions and has found that Michelangelo was simply reverting to the medieval practice that had fallen into disuse after Raphael popularized the youthful Saul.[20] Michelangelo's use of the alternative tradition makes sense if we recognize that his purpose was to strengthen visually the analogy between the calling to the papacy of his patron, Alexander Farnese, already an old man, and the calling of Saul.

Saul's pose may remind us of those other malefactors, Heliodorus (Fig. 24), or even Ananias (Fig. 23), for whom Raphael invented the graceless postures we have already discussed. Saul is Saul the persecutor of Christians here, not yet Saint Paul. He is the improbable choice of God's Grace, recalling him from sin to redemption. According to the text it was not until three days had gone by in blindness that Saul saw the light and was converted to Christianity, the moment represented in Vasari's altarpiece for Del Monte's chapel (Fig. 114). The painter has attempted to show this state of transition in Saul's face, resisting enlightenment even as it forcibly dawns upon him. The only figures in the *Conversion* who embody Michelangelo's accustomed grace, energy, and beauty are Christ and the host of angels in the heavens. Compared to them the earthbound soldiers, held below the oppressive horizon in a barren landscape, are hulking and clumsy, stumbling and abrupt in their movements.

The same holds true for the witnesses in the fresco opposite (Fig. 119). Those present at Peter's *Crucifixion* are undocumented, but Michelangelo saw no reason to represent them as noble, saintly, or even concerned – with one exception. The officer on his horse at the left pointing inward gives orders to the soldiers behind him. He appears to be the prefect Agrippa, who, according to the apocryphal account, angered the emperor Nero by

ordering the hasty death of Peter when the emperor had intended prolonged torture. The prefect alone has the noble features of the elect. The others gawk with vacant stares, betraying a range of emotions from ignorant fear, to ogling curiosity, to hard indolence. The only courage here is Peter's. One man, directly behind the cross, points questioningly at Peter and turns to the prefect, as if to demand explanation, but he is restrained by one behind him, and another puts finger to mouth to silence him and points heavenward. The women huddled at the bottom below the hill can be assumed to be friends and followers of the apostle, but they fare no better in Michelangelo's interpretation than the men, quaking in wide-eyed terror as they turn away from Peter's fierce stare. Most of the figures are presented frontally as inarticulate blocklike forms. They move listlessly, more like automatons than creatures inspired by their own will. They lack the serpentine poses Michelangelo had so loved in the past to energize his figures and give them grace. Only Peter twists energetically, in agonizing defiance of the nails that hold him to the cross, to fix the viewer with his stare. No angel with palms of martyrdom and divine solace comes to offer comfort and assurance to the sufferer. The sky is conspicuously empty, making clear the measure of faith and courage that may be required of the Christian.

It is perhaps no wonder that these frescoes drew few favorable comments and were little understood in the world that still was producing works for religious settings like those we have discussed. The Maniera artists who had enshrined elegance, loveliness, and grace as the most desirable qualities to be represented in painting must have been bewildered and repelled by Michelangelo's creation and by the force of its emotions. The Maniera artist often suppressed emotion within a religious narrative, thereby preventing the viewers from identifying with it and distancing them. At the same time the sensuous and aesthetic appeal of his ornamented invention would draw them in subliminally. Michelangelo inverted the formula in his late work. Sensuousness is suppressed, but the emotion is expressed and offered to viewers as a spur to their own religious experience.

The style Michelangelo invented to convey his new content required the stripping of ornament, as he advised Vasari to do in his chapel. This meant surface ornament in the case of Vasari; in his own case, it meant ornament in the broad sense, including serpentine and all other artificial poses. Sebastiano had already begun

the move away from ornament. Nothing should distract from the religious message, as the Council of Trent would eventually state in its Decrees. Yet at a deeper level, men and women, dependent upon God's initiative and not on their own will, must appear in their humility, and without the energy that for Michelangelo had always signified self-direction.

In fact, the whole emulation of sculpture, the relieflike style, has disappeared in the Paoline Chapel. Yet, despite the fact he no longer conceives of space as in a relief – a narrow strip in front of which figures are projected in relief – these frescoes are in no way painterly. The figures are as firm in outline and as fixed in form as his figures have ever been. What is different is the treatment of space. It is an abandonment of principles of Renaissance symmetry, enclosure, harmony, and order. There is an apparent arbitrariness here in the off-centeredness of Paul, or in the women cut off at their waists in the corner of the *Crucifixion*. Throughout the Renaissance, picture space has expressed the sense of God's cosmos ordered for human enjoyment. This belief was represented as objective fact. Here, suddenly, one's experience becomes personal and subjective, conditioned by one's viewing position within the chapel and subject to change. It takes on the character of unpredictable possibility, as open and unknowable as the mind of God.

The experience of being in the chapel cannot be captured in reproductions, be they standard modern frontal photographs or sixteenth-century engravings. The distortions of scale and composition that led critics to regard these frescoes as artistic failures must have shocked and disappointed Cinquecento viewers, whose access to these paintings was largely limited to prints.[21] What Michelangelo intended here seems to have been misunderstood, except perhaps by such an artist as Caravaggio, who imitated the oblique view in his similarly narrow situ of the Cerasi Chapel (Rome, Santa Maria del Popolo, 1601–2).

The Pauline frescoes are echoed in Michelangelo's late *Pietàs*, which defy Renaissance tradition and differ from the Vatican *Pietà* (1498) in the same way these frescoes differ from the Sistine vault. What entered the mainstream and became the principle tenet of the Counter-Maniera was the austerity of Michelangelo's new manner, its rejection of *ornamenti* and of sensuousness. His return to medieval models was not imitated, but there would be interest shown by some painters in Quattrocento prototypes. Scipione Pulzone was probably following Michelangelo's example when he created

Figure 120. Perino del Vaga, preparatory drawing for the tapestry to hang below Michelangelo's *Last Judgment*. 1542. Uffizi, Florence.

his devotional-type paintings, like his *Annunciation* or *Marriage of the Virgin* (both in the Church of the Gesù), or his *Crucifixion* (Fig. 177) reminiscent of fifteenth-century prototypes, set outside the frame of time or place.[22] What was not pursued by any other artists was Michelangelo's antihumanist vision of sinful man in need o f redemption. It was Sebastiano's noble figures and their sincere devoutness that had the greatest influence on the painters of the Counter-Maniera.

ROME'S DIVIDED SOUL

The midcentury is a fascinating moment in Roman cultural history. On the one hand we see the impulse to reform, expressed in the pious devotional pictures of Sebastiano del Piombo; Michelangelo's *Last Judgment* and Pauline Chapel frescoes; the establishment of the Inquisition in 1542 to safeguard the purity of the faith and to stamp out heresy; and the repeated attempts to convene a

council where the Church would negotiate its differences with the Protestants and win them back to the fold. On the other hand, the Roman passion for collecting, displaying, and imitating antiquity continued unabated, and not only in secular contexts. Pope Paul himself must have sanctioned the commission given to Perino del Vaga in 1542 to design a tapestry[23] in his ornate style to hang below the *Last Judgment* (Fig. 120) in startling juxtaposition to Michelangelo's skeletal bodies rising from the grave and the damned crossing the river Styx into the mouth of hell. Here in a nutshell is to be seen the unresolved dichotomy of the age. In the cultivated circle of the Farnese there was no conflict between the two images. They simply could not see, apparently, what the reformers saw: that Perino's splendid frame would frivolize Michelangelo's apocalyptic image.

The two factions continued to grow apart during the 1540s and 1550s. Moderates hoped that by curtailing excessive display and paganisms in sacred settings the spirit

Figure 121. Jacopino del Conte, *Deposition*. 1551. Oratory of San Giovanni Decollato, Rome.

The Oratory of San Giovanni Decollato is an informative barometer. The decorations, which had been allowed to lapse, were resumed beginning with a new campaign of commissions in 1551. This previous stronghold of the Maniera continued to commission painters who worked in that style. Salviati came back to the Oratory in 1550–1 to fresco the *Nativity of the Baptist* (Fig. 104), and at about the same time Jacopino del Conte (c. 1510–98) was recalled to paint the altarpiece of the *Deposition* (Fig. 121).[124] Jacopino executed it on a drawing provided by Daniele da Volterra in the elegant ornate style, consonant with the rest of the decorations. The iconography, however, reflects the change that was taking place on the Roman scene.

The confraternity found that its mission in the 1550s included ministering to a new class of criminal, for the Inquisition was condemning heretics to execution with zeal. Pope Julius III, as one of the first acts of his papacy, had confirmed the Inquisition. Proceedings were brought against the bishop of Bergamo in 1551; the next year seven Lutherans were tried and condemned to death.[25] The brethren's task was, as always, to attempt to persuade the prisoner to repent. In Jacopino's altarpiece the Centurion, who converted when he saw how Christ died, was depicted with an unusual prominence: he stands at the base of the cross and embraces Christ's legs. According to the *Golden Legend,* he was healed of blindness when Christ's blood fell on his face. Blindness would have been understood as a metaphor for spiritual blindness, as it was in Vasari's contemporary altarpiece for Del Monte's chapel in which Paul's blindness was lifted, or in Michelangelo's Pauline Chapel (Fig. 118). Thus the Centurion represents the heretic who repents and embraces Christ. His inclusion in the altarpiece

of devotion in religious art could be revitalized and confrontation with the radical reformers avoided. This did not happen. The election of the fanatical Inquisitor General, Carafa, to the papal throne as Paul IV in 1555 polarized the situation and inaugurated a period in which there would be an alternation between reformers and moderates every five years or so, with each new papal election.

conveyed a timely reminder to the brethren of their mission to exhort the increasing numbers of those condemned to death for heresy to recant, to die repentant of their errors and reconciled to the Church.[26] The libertarian style of the Maniera is an incongruous vehicle for this content, which presages a new era of authoritarianism in belief.

Already at midcentury there were laments being voiced in Rome about the use of Maniera style for sacred images. The Sienese Dominican Ambrogio Catarino (1552) complained that painters did not imitate nature; he had seen "some images so extravagant that you can hardly recognize the human figure in them. . . . And elsewhere you see compositions made with so much artifice that at times among so many improper gestures they ignore the decorum of the figures, and do not have any dignity and do not excite any devotion at all."[27] But Catarino was writing for ecclesiastical circles – his text was in Latin – and it would be another decade and more until Gilio's *Dialogue* in the vernacular would aim such complaints directly at the painters and their patrons.

Even in lay artwriting of the 1550s, however, one finds suggestions that the Horatian concept of decorum might be applied to the question of what is appropriate in a sacred setting.[28] The Venetian Ludovico Dolce, in the dialogue he created between Pietro Aretino and a Florentine named Giovan Francesco Fabrini, introduced the question of the propriety of the nudes in Michelangelo's *Last Judgment* in the Chapel of the Pope. Fabrini, who is cast as the defender of Michelangelo, brings up the notorious *I Modi* prints of the 1520s, and asks, "Do you still consider that Raphael showed a sense of decency when he designed those cartoons of men and women embracing one another lasciviously and also indecently and had Marcantonio make copper-plate engravings from them?" This is a bold thrust, for we remember that the real Aretino had been involved in the project. Aretino responds, first by correctly identifying the artist as Raphael's pupil, Giulio Romano (c. 1492/1499–1546),[29] and then defending the decorum of the project, saying, "he did not put them on public display in the city squares or the churches." Rather, it was the greed of Marcantonio for profit in having them engraved that was the fault, he goes on.[30] A distinction is made both between private and public and between secular and sacred.

The decoration of the chapels in the newly rebuilt church of Santo Spirito in Sassia provides another index to the situation. The church, which had been badly damaged in the Sack, was rebuilt by Antonio da Sangallo in the new form of the hall church with flanking chapels (1539–45). It was intended as a model of what the modern church should look like. The first two chapels to be decorated, beginning in the mid-1540s, were commissioned by successive governors of the confraternity responsible for the church. Because these two chapels are quite similar to one another, it appears that they were intended to be models for future patrons to follow. They are in a conservative style that we may assume the confraternity hoped would prevail (Fig. 122). It is surprising, then, to find the lavish Gonzaga Chapel inserted between them almost immediately (Fig. 123).[31]

The aristocratic Gonzaga, a member of the sophisticated Farnese and Del Monte papal courts, apparently had no regard for the new sensibilities, and he took advantage of a brief interval of administrative chaos in the confraternity to impose his aesthetic preference for Maniera decoration. Important is the fact that Giulio Cesare Gonzaga began his chapel during the reign of Julius III and before the election of the reformer, Paul IV.[32] This chapel presents an interesting exception to the rule – at least a rule that seems to have been emerging in the 1540s and certainly in the early 1550s, when it was beginning to be recognized in some circles that certain kinds of decoration were not appropriate in sacred settings. There seems to be a conspicuous divide, however, between the opulence-lovers and the ascetic reformers. Gonzaga spent lavishly on rich stuccoes and paintings, executed by Livio Agresti (c. 1508–79) between 1554 and 1557.[33] Whereas the decoration of the earlier chapels is small in scale, tightly compartmentalized, and in low relief, the stuccoes of Gonzaga's chapel project exuberantly from the wall, overlap their frames, and proclaim the paramount importance of *ornamenti;* their scale in the case of the *Allegories* flanking the altar is over lifesize, and they are in the round, rivaling marble statues. They are in fact the first freestanding stuccoes in a sacred setting.[34] It is as if Agresti brought into church the kind of stucco that had first been executed in Rome by Daniele da Volterra in the Sala Regia in the late 1540s and was continued by his pupil, Giulio Mazzoni, in the early 1550s at the Palazzo Capodiferro-Spada.[35] Agresti's painted figures, especially those used to fill the spaces between the principal scenes, are similarly ornamental

Figure 122. Guidiccioni Chapel, view. 1547. Santo Spirito in Sassia, Rome.

and artificial in their poses. We have seen that the taste for Maniera was slow to die among members of the Farnese and Del Monte circles, but whereas Cardinal Ricci's Salone and the Sala dei Fasti Farnesiani were secular halls, this chapel was in a church that hoped to present itself as a model for the future.

By the time Agresti finished his commission in 1557, Paul IV had succeeded in changing the mood of Rome and putting a damper on artistic patronage. Agresti left the city, like Salviati who made a visit to France, like the Flemish Michiel Gast, who returned after eighteen successful years in Rome to Flanders,[36] and like Marco Pino (1517/1522–1585/1588), who moved to Naples in 1557. Girolamo Muziano (1532–92) was working in Orvieto in 1555–8.[37] It was an exodus reminiscent of the times of Pope Adrian VI in the early 1520s.

TADDEO ZUCCARO (1529–1566)

Taddeo Zuccaro came to Rome from the area of Urbino at the age of fourteen. He ground paints and did menial tasks in the workshops of a series of minor masters, all the while drawing after the facades of Polidoro and after Raphael, Michelangelo, and the antique. In fact, his education was exactly that prescribed by writers like Vasari, and it was recorded in a splendid series of drawings by his brother, Federico (c. 1541–1609) (Fig. 127).[38] Even so he had a very difficult time of it, nearly starved, and had to return home to recuperate before returning in about 1548.[39] His first commission repaid his careful study of Polidoro da Caravaggio (1490–1536 or 1499–1543), for it was to paint in chiaroscuro the facade of the Mattei Palace. His brother recorded that commission in one of his drawings, showing Taddeo working on the scaffolding and Michelangelo among a crowd of admirers below.[40] He was then engaged by Pope Julius III to fresco at his Villa Giulia (1553–5), and then to decorate Mattei's chapel in Santa Maria della Consolazione. As soon as he had

Figure 123. Livio Agresti, Gonzaga Chapel, view. 1554–7. Santo Spirito in Sassia, Rome.

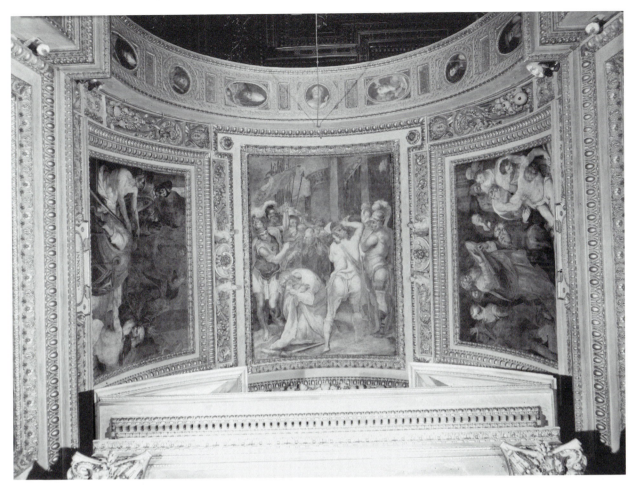

Figure 124. Taddeo Zuccaro, Frangipane Chapel, view of the vault. Begun c. 1557. San Marcello al Corso, Rome.

completed Mattei's chapel, according to Vasari,[41] he set to work on the Frangipane Chapel in San Marcello al Corso, presumably in 1557 (Fig. 124).[42] By this time, although not yet thirty, Taddeo was leaving behind the models of Salviati, Perino del Vaga (1501–47), and Pellegrino Tibaldi (1527–96) and developing a style that was a modified – we might even say a chastened – Maniera. He could not be said to have embraced the Counter-Maniera, but he had excised the most conspicuous artificialities and transferred the focus of attention back to the narrative. The fluency of his style must have left his patrons fully satisfied, despite the relative sparseness of *ornamenti*. In the chapel he worked without assistance, unlike the arrangement he would shortly make with Cardinal Farnese at Caprarola, where he was obliged only to oversee the execution and spend a few months a year. The Frangipane chapel, on which he worked for nearly a decade until his premature death in 1566, would have to be regarded as his masterpiece in his all-

too-short career. Although Vasari reported that it was left incomplete at the time of his death and was finished by Federico,[43] that same brother noted in the margin of his copy of Vasari that the glory was all Taddeo's because here he himself had done little or nothing of importance.[44]

The Frangipane chapel is one of the few commissions during the reign of Paul IV, who commissioned practically nothing himself and created an atmosphere inimical to artistic production. It seems likely, therefore, that the subject of the chapel, the mission of Saint Paul, was chosen for its relation to the name of the pope and the papal policy of missionizing the Protestants to bring them back to the Catholic fold. The special powers God granted to Paul to carry out his work, a theme of the cycle, would seem to refer to the pope in a flattering light and would thereby win his approval.

San Marcello was another church on the new plan, with side chapels projecting from the nave, that was

meant to present a model for the future. Taddeo's macroscheme broke with the current taste for a luxuriantly ornamented framework, and particularly for ornate ceilings. Even those models of moderation, the first two chapels in Santo Spirito in Sassia (Fig. 122) and Vasari's new-fashion Del Monte Chapel (Fig. 114), as well as its pendant for Cardinal Ricci in San Pietro in Montorio (Fig. 126) – begun at almost the same time as Frangipane's – retained the elaborate vault decoration and look ornate by comparison.[45] Taddeo continued the Pauline narratives from the walls across the barrel vault, divided into three fields large enough to be clearly legible. The narratives take up nearly all the space, leaving little that needs to be filled with ornaments. What ornament there is, however, is architectonic and dignified, but exemplary. Gone are the complexly layered surfaces, the exquisite intricacy, the fine stuccoes that had been in fashion since before Perino del Vaga's Massimi Chapel (Fig. 96). Taddeo has taken his cue from Michelangelo and Vasari's revised design for the Del Monte Chapel. The walls are a muted soft gray that sets off the gilding but does not call attention to itself. More even than the composition and figure style of the narratives, the sedate, classicizing style of the framework gives Taddeo's chapel a new look. It became a model for a new style of sacred decoration in Rome, which would replace the excesses of the Maniera in the coming decades.

On the altarpiece is the inevitable centerpiece of a Pauline cycle, the *Conversion of Paul,* painted on slate following the method pioneered by Sebastiano. Foremost in Taddeo's mind must have been the fresco of Michelangelo's Pauline Chapel (Fig. 118), unveiled only in 1550. His composition owes to Michelangelo the foreshortened image of Christ, beaming light down on Paul, and the attendant who embraces him, but in most other respects it departs from that model. Paul is again a young man; he has fallen on his back, head outward; the horse bolts to the side. Taddeo's independence is most evident in the conception of space, for it is densely packed and filled with soldiers, without any remnant of the significant void around Paul of Michelangelo's version.

For the scenes of the side walls, episodes from the journeys of Paul were selected in which he converted heathens to Christianity by displays of his powers of healing or by his access to the direct intervention of his God. In the *Blinding of Elymas* the prefect is converted because Paul calls down punishment upon the deceitful magician Elymas (Acts 13:6–12) (Pl. XXI). The story had been treated by Raphael, of course, in one of the tapestry cartoons (London, Victoria and Albert Museum). Taddeo arranged the scene differently, putting the proconsul off to the side and Paul opposite, addressing him, and Elymas near the center behind. He is shown at an earlier and more dramatic moment than Raphael had chosen, throwing up his hands as if to ward off the darkness descending on his eyes, staggering off-balance on one foot. Appropriately he is in the shadow and wears dark clothes, but his red and purple serve to draw the viewer's attention. Paul, closer and larger, seems to embody light in his green and gold garments, painted in high values. The colors in all the surrounding figures are suitably paled and subdued. We note again the metaphor of blindness to characterize the unenlightened heathen. Whereas Paul stands firmly with as much dignity as Raphael's Paul, the foreground is given over to those expressive onlookers in inappropriately ornamental poses and dress who had come to inhabit the zone of the picture plane in so many Maniera compositions (*repoussoir* figures). There is more that is reminiscent of Maniera in this scene than in the others.

The *Shipwreck of Paul at Malta* (Acts 27:9–44) (damaged) occupies the left field of the vault, the *Beheading of Paul* is at the center, the *Raising of Eutychus* flanks it on the right. On the other side wall is *Paul healing the Cripple* (Acts 14:8–18), where again we see Taddeo's independence from the Raphael model of the tapestry cartoon (London, Victoria and Albert Museum) while at the same time it reveals his study of Raphael's narrative style. The space is conceived and articulated in much the same way as Raphael's. This time the onlookers have been restrained, both in their position off to the right and in their poses, which are more natural.

There exists a splendid example of Taddeo's draftsmanship in a compositional study for the *Raising of Eutychus* (Fig. 125).[46] The story, told in Acts 20:7–12, is of Paul's resuscitation of a youth who had fallen asleep and tumbled out the window from three stories up and was believed dead. This unusual choice of subject continues the theme of the miracles of Paul, referring to the special powers granted God's chosen emissary. In the fresco, in contrast to the drawing, Paul holds up a book and looks and gestures heavenward, as if invoking divine aid. At the center of the vault the saint meets his death at the hands of the executioner. Kneeling humbly with his head lowered and his face in shadow, silence prevails, in telling contrast to the activity of the scenes

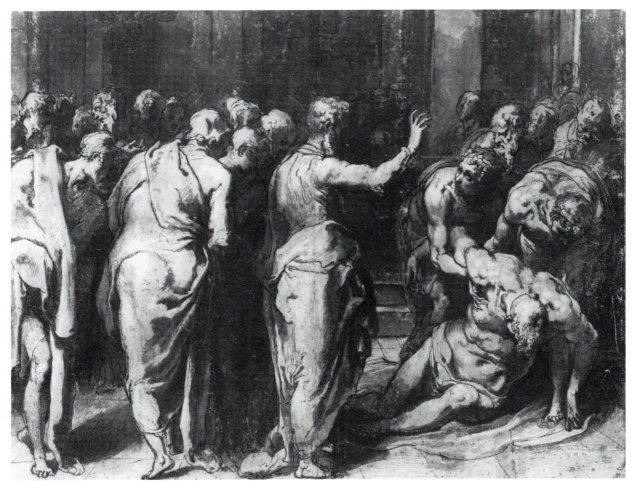

Figure 125. Taddeo Zuccaro, Frangipane Chapel, compositional sketch for the *Raising of Eutychus*. c. 1557. The Metropolitan Museum of Art, New York. Rogers Fund, 1967.

of his life. Two handsome Roman soldiers flank the scene, but the contortions of Maniera bystanders are replaced here by still-graceful but more naturalistically posed figures. The *repoussoir* figures embossed on the picture plane, which we have become so accustomed to seeing, have disappeared and we are given direct access to the action with no intervening or mediating figures.

Taddeo was no rebel. He studied the High Renaissance masters and learned from them, but he was never afraid to depart from their example and introduce his own innovations where he felt he could strengthen his presentation of the narrative. Unlike Michelangelo in the Pauline Chapel, he did not do away with grace and elegance, but like Michelangelo, he shifted his emphasis from *ornamenti* back to the narrative. He took from Raphael the fluency of his style and emulated its apparent ease, but he avoided the artifice and difficulties of his Maniera contemporaries. There is nothing relieflike or even sculptural here. For this reason he must have

appealed to those moderate patrons who appreciated that aesthetic quality, in the service of the sacred, enhanced the effectiveness of religious images.

PAUL IV

The 1550s was a decade of conflict and of transition in which the Reform movement contended with the old elite. One historian has characterized the years following the 1530s as an all-out war for control of the Church. The contending powers were the *spirituali* (led by Pole, Contarini, and Morone) and the zealots, captained by Carafa, and on several occasions the *spirituali* came close to capturing the papal throne. During the pontificate of Julius III the Inquisition gained power, as we have already noted, "becoming virtually a counter-government of the Church."[47] Once Carafa was elected pope, the tactic of attempting to liquidate the opposition by convicting them of heresy came out in the open.

Culturally speaking, it is a decade divided starkly down the middle. The first half under Julius III was a continuation of Farnese's dual commitment to cultural display on the one hand and to reform on the other. The second half under Paul IV brought a quixotic and impoverishing war, and a fanatical pursuit of reform. When Carafa was elected he took in gratitude the name of the pope who had created him cardinal. This was an auspicious beginning, but a false clue, for his resemblance to Paul III began and ended with his choice of name. Although the cardinals were well aware that they were electing the long-awaited Reform Pope, and they knew Carafa as severe, they were not prepared for his pitiless pursuit of the purity of the faith. Following the example of Venice, he forced the Jews to live in a designated area of Rome, and he extended still further the powers of the Inquisition. Nor were the cardinals prepared for his decision to plunge into a war against the emperor that the papacy could not hope to win. This pope regarded both the French and the Spanish as "barbarians" and was determined to throw them out of Italy and return to the conditions of the Middle Ages when the pope ruled supreme on the Italian peninsula. The war brought an increasingly heavy burden of taxation on the residents of the Papal States, resentment, devastation of the countryside, and the imminent threat of a second Sack of Rome. When Pope Paul was finally forced to negotiate, in September 1557, it was as a power greatly diminished in the secular sphere. The yoke of imperial domination was set firmly in place. He then turned his attentions, with equal obstinacy, to his spiritual duties. By encouraging pursuit and punishment of any whose religious convictions appeared in any way aberrant, or whose morality could be questioned, he created in his reign an atmosphere of fear, mistrust, and confusion. This point, then, is the moment we could choose to mark the transition from a humanist to a Counter-Reformation culture.

The abrupt shift left patrons and artists abashed. Whereas in the time of Julius III a Gonzaga might find his taste for Maniera resisted by some, he could nonetheless press the point and get his way for his chapel in Santo Spirito in Sassia. Just a year or two later, it is doubtful that he would have dared buck the tide of opinion so ruthlessly. As for the artists, Taddeo was still young enough to adapt, but a painter like Salviati, by now in his late forties, could not readily create a new style for himself to accommodate to new demands. No

wonder that he hastened away to try his luck in France! Daniele da Volterra, in contrast, always an admirer of Michelangelo and his close follower, attuned himself to the new times and attempted to adjust his style. We see the result in the Ricci Chapel in San Pietro in Montorio, begun in c. 1555–6 (Fig. 126).[48]

It seems true to character that Cardinal Ricci, for whom Salviati had just painted the life of King David, should have offered his homage to his patron, Julius III, by commissioning a replica of his chapel in the same church as a pendant to it. Daniele's altarpiece, the *Baptism of Christ,* his last, on which he worked until his death in 1566, is so unlike his earlier work that it has mistakenly been taken as the product of his *bottega.* Daniele has not abandoned the look of sculpture entirely, but he has moved closer to Sebastiano's classicistic manner and embraced the Counter-Maniera. He has

Figure 126. Daniele da Volterra, *Baptism of Christ*. Begun 1555–6. Ricci Chapel, San Pietro in Montorio, Rome.

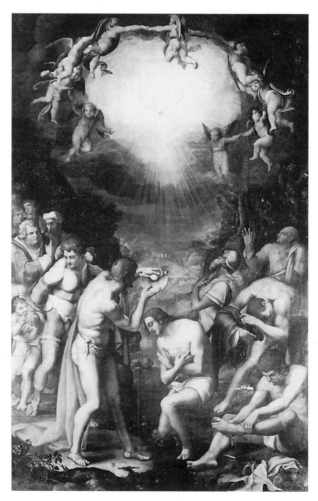

purged most of the *ornamenti* from his style. If he cannot resist a few athletic contortions in his nudes at the right, these figures can plausibly be explained as preparing themselves for baptism. They do not detract from the somber mood and the focus on the central encounter between the Baptist and Jesus. Color has become dark and sober, no longer the explosion of *cangiantismo* Daniele had given us in his *Deposition* fresco (Rome, Trinità dei Monti).[49] Comparison with Jacopino del Conte's version of the same subject (Fig. 111) of 1541 shows us how much things have changed. Gone are the exhilarating leaps of scale from river god to angels on the bank, the splendiferous foreshortenings, the Maniera calligraphy. The fragile confidence that the proliferation of *ornamenti* will somehow lead the worshiper to a state of religious exultation has been replaced by a more mundane purpose: to tell the story.

The didactic function of sacred images would be explicitly stated in the Decrees of the Council of Trent, promulgated in its concluding session in December 1563 and published the following year. Another of the concerns the Decrees addressed, the propriety of nudity in religious images, was already being much discussed in the 1550s, and the focus of the debate was Michelangelo's *Last Judgment*.

RECEPTION OF THE *LAST JUDGMENT*

There had been objections to the nudes in the fresco from the time of its unveiling. A letter to Cardinal Ercole Gonzaga attributed such objections to the Theatines; because Paul IV was a co-founder of that new Order, his election did not bode well for Michelangelo and his fresco.[50] Capitalizing on this current of dissent, Pietro Aretino wrote a letter to Michelangelo in 1545 feigning to deplore the indecency of his images "in the most sacred chapel upon the earth." The painter has made a spectacle of "martyrs and virgins in improper attitudes, men dragged down by their genitals, things in front of which brothels would shut their eyes in order not to see them. Our souls need the tranquil emotions of piety more than the lively impressions of plastic art," intoned Aretino. "May God, then, inspire His Holiness Paul with the same thoughts as he instilled into Gregory of blessed memory, who rather chose to despoil Rome of the proud statues of Idols than to let their magnificence deprive the humbler images of saints of the devotion of the people."

It is the height of irony – and one can hear the irony in Aretino's tone – that the man renowned for his own lascivious writings was the one to launch such an attack. It is quite clear from a certain passage that the writer was attempting to blackmail the painter into giving him a drawing, a request made earlier that Michelangelo had ignored. When a few years later Michelangelo had still not complied with his request, Aretino published the letter.[51] It was a strange anomaly that the artist most revered in Italy, called "Il divino," and as devout as any artist of the century, should become the scapegoat of the zealous reformers. Certainly Aretino was not among their number, but he understood how to fan the flame of growing discontent with the sophisticated art of the Maniera and make Michelangelo, undeservedly, its target. Aretino's motives were anything but pure. Correctly assessing the change in the spiritual climate, he doubtless recognized that his writings made him vulnerable to censure. He used his attack on Michelangelo to separate himself from his own past. Reborn as the spokesman for reform, he was positioning himself as a candidate for a cardinal's hat, a prize that no pope saw fit to grant him.[52]

The discussion was taken up in Dolce's *Aretino* in which, as we have already noted, the same Aretino, who had just died, is ostensibly a speaker. Condemning Michelangelo's nudes as unworthy of a place of such sanctity, the fictional Aretino calls for censorship: "Notice that the laws forbid the publication of indecent books – how much the more should pictures of the same kind be banned. For do you by any chance consider that they act on the spectators' minds as a stimulus to devotions or elevate them into contemplating the divine?"[53] This seems a timely remark in 1557 when the *Aretino* was published, during the rule of Paul IV.[54] It was little noted that Aretino's dialogue partner made the level-headed reply, "Sound eyes, sir, are not in the slightest degree corrupted or shocked from seeing the facts of nature in pictorial form."[55]

Pope Paul seriously considered having the fresco destroyed. Vasari reported that the pope asked Michelangelo to fix (*acconciare*) the nudes himself; the painter replied, "Tell the pope that it is a small matter, but let him fix the world, pictures are quickly mended."[56] The decision to correct some of Michelangelo's errors and thereby to save the fresco apparently resulted from lively discussion in the last, rushed session of the Council of Trent, for it was high on the agenda of the

secretary of state, Carlo Borromeo, the month following its adjournment.[57] Ordered even before Michelangelo's death in February 1564, the changes made by Daniele da Volterra (Pl. XXII) were only the beginning of repeated campaigns to add loincloths to the offending parts throughout the seventeenth and eighteenth centuries. Even in the cleaning, completed in 1994, the decision was taken not to remove these additions, despite the fact that it was technically feasible (with the exception of Daniele's corrections, made in *buon fresco* and impossible to remove) – because, it was argued, they had become a historical part of the painting.[58]

The issue of the appropriateness of images and what their role should be had been under debate by theologians ever since the Protestants launched their attacks and declared that images violated the second commandment, "You shall not make for yourself any graven image." Erasmus and some Protestants declared that decorations in churches were a superfluous luxury and that instead of spending on works of art, the money should be given to the poor.[59] Protestants in parts of northern Europe were removing all the altarpieces and statues from their churches in waves of iconoclastic fury.[60] The Catholic defense was couched in the terms of the traditional justifications, that images were helpful both in the instruction they could give the illiterate and as an aid to devotion. The Council of Trent's formulation was a succinct summary, stating that images of Christ, the Virgin, and the saints were to be placed in churches; although due honor should be paid them, they were to be venerated, not worshiped.[61] Trent's decrees state that the orthodoxy and the decency of all images should be guarded by the bishops, "all superstition shall be removed, all filthy quest for gain eliminated, and all lasciviousness avoided, so that images shall not be painted or adorned with a seductive charm."

Shortly after the publication of these Decrees and Michelangelo's death, the theologian Giovanni Andrea Gilio dedicated a treatise to Cardinal Alessandro Farnese. The title foreshadowed the didactic tone: *Dialogue on the Errors and Abuses of the Painters . . . with many notations on the Last Judgment of Michelangelo . . . with clarification of how they should paint sacred images.* Gilio centers his argument on the Horatian concept of decorum, asserting that the style of paintings should suit the subject, the place, the time, the figure, the dignity, and the epoch. By this he meant the obvious point that the pope should not be represented in a Moslem turban, but he broadened his meaning as he went along.[62] An event from Christ's Passion or a scene of martyrdom should be shown in all its horror to evoke the pity of the worshiper. For showing the delicacy of the body, the beauty, *leggiadria,* and muscles we have such subjects as the Nativity, the Circumcision, the Adoration of the Magi. It is just as great a challenge to the painter to display "the force of art" by making vivid the sufferings of Christ and the martyrs.[63] Sebastiano del Piombo's *Flagellation* (Fig. 59) was given as the example of a Christ who is too beautiful,[64] which is an ironic choice because Sebastiano had later become a pioneer of the kind of devout image Gilio was soliciting.

Suddenly, without preparation, Gilio quoted from Horace what he might have put on the title page of his book:

In ancient times, this was wisdom:
To separate the private from the public
And the sacred from the profane.[65]

It might have been put at the head of this chapter, as well, for it states the essence of the reform of painting that the Counter-Reformation called for. This is not to say that there were no attempts at all to regulate secular art or private art, but as we shall see, these efforts were of limited duration and were not the focus of concern.

We have seen that the application of a single style to sacred and secular art has been the accepted norm up until this point, and that this practice brought forth some images that were problematic. As early as the 1520s the *Madonna of the Rose* of Francesco Parmigianino (1503–40), which could be exchanged with a Venus and Cupid (Fig. 80), or the sensual *Dead Christ* of Rosso (Fig. 56) were discussed in terms of what *we* might question as their appropriateness; at the same time, we do not read of any rejections, objections, or indictments from *contemporaries.* The secularization of the sacred had taken another leap forward when, around 1540, it became the norm to apply the conventions of the relieflike style in religious paintings as much as in secular (Pl. XVIII). Protests were certainly being made by that time – witness the objections to the *Last Judgment* reported at the time of its unveiling in 1541. Yet it was another quarter-century before the position of the Church was fully defined and codified. Most writers were not adept at putting into words what they objected to in terms of style, so Michelangelo's nudes

became an easy repository of complaint reflecting a general discomfort with the Maniera style in sacred art.

Gilio has yet to find a champion among art historians, or even a sympathetic reader. His niggling criticisms of Michelangelo's departures from scripture in the *Last Judgment* are quoted, such as the fact that Christ has no beard, although he has one in the *Conversion of Paul* in the Pauline Chapel, and other figures are shown bearded; or his complaints that various stages of the process of resurrection and judgment are shown as if they were occurring sequentially, whereas it says in scripture that it will all happen in an instant. Anyone at all attuned to the painter and his problem recognizes that it is a reasonable part of his license to paint the moments surrounding the climax of the event. One has to ask just what Gilio's motive really was in taking such an intolerant position. It is clear that his text was to be taken as a warning to the painters, and to the patrons, of what was to be expected of them in the future. He had to cite Michelangelo for his errors because he provides the norm for all the painters who are and who will be.[66] If the Divine Michelangelo can be faulted, then no one will escape judgment. The same strategy of selecting a prominent and prospering painter of whom to make an example was used in the case of Paolo Veronese (1528–88). He was brought before the Inquisition in Venice in 1573 for including in his *Last Supper* superfluous and distracting details, such as dogs, dwarfs, German soldiers, and a man with a nosebleed. His excuse was the painter's one, "I needed to fill the space." He was ordered to remove the offending parts, but the point was never pressed and Veronese got away with only changing the title to *Feast in the House of Levi*. Nevertheless the patrons and the painters got the message.[67]

The intended audience for Gilio's treatise was indicated by the dedication to Cardinal Farnese, the leading patron in Rome, and by his choice to write in Italian. Although a theologian, Gilio was perfectly at home with antique culture. He approached the artistic establishment speaking the language they were accustomed to, but with a message from the Church. He used Horace and other ancient writers to support his claim that contemporary art had fallen into decadence from which it required rescue.

The underlying purpose was, in fact, even more ambitious: it was no less than a redefinition of decorum as it was applied to sacred painting. He signaled that this was his brief when he described how he had tried to

convince painters that they should show the signs of Christ's suffering on his body so that Christians would be made to contemplate the baseness and humility he was brought to and with what shameful offense he died. Whenever Gilio tried to reason thus with painters they had all with one voice responded, "This has nothing to do with painting; it would be against decorum."[68] Gilio adduced the example of the ancients, who in a splendid statue like the *Laocoon,* showed the anguish, the pain, and the torment he felt when attacked by the serpents (Fig. 1). Certainly it would be something new and beautiful to see a Christ on the cross transformed by his wounds, the spit, the mocking, and blood.[69] It is interesting to hear the *Laocoon,* so much admired by Michelangelo and constantly imitated and quoted by other artists, turned around and used as a criticism of these same painters.

It is wrong to become so absorbed by Gilio's criticisms of iconographical details that we miss the important point: he opposed the Maniera style for sacred art. He enunciated what we may call the "principle of economy of energy." He found fault with the strain and exertion of Michelangelo's figures. Figures should show only as much exertion as necessary for the act they are performing, he claimed.[70] He criticized the unnatural proportions of figures in modern painting.[71] The painters "appear to think that they have paid their debt when they have made a saint and have put all their genius and diligence into twisting awry the legs, or the arms, or the neck; and in a violent manner that is both unseemly and ugly."[72] A painting like the *Adoration of the Shepherds* by the young Pellegrino Tibaldi (Fig. 88) may have been what Gilio had in mind as he wrote. He remarked at the very outset in his dedication that the modern painters seem to have as their first concern to twist the head, the arms, the legs of their figures so that they appear forced, and they put little or no attention to the subject[73] – in other words, they use the artificial conventions of the figure, which include excessive exertions, instead of natural poses. It is this kind of concern with artistic virtuosity that was the real target of Gilio's attack. What Gilio was calling for was a more humble painter, one who interposed himself less egotistically as the interpreter.

A later critic, Bishop Gabriele Paleotti, quoted Michelangelo when he cited Fra Angelico as the model of the proper spirit of the painter, he who could not paint a crucifixion without crying, it was said.[74] The

painter was called upon to put himself in touch with his own piety and paint from the heart of it. Once again, it is ironic that Michelangelo should have become the whipping boy, for he was reported by Francisco de Hollanda as saying, "[Painting] is so high an undertaking . . . that in order to imitate in some degree the venerable image of Our Lord, it is not enough to be a great and skillful master; I believe that he must further be of blameless life, even if possible a saint, that the Holy Spirit may inspire his understanding. . . . For often badly wrought images distract the attention and prevent devotion, . . . while those which are divinely fashioned excite even those who have little devotion or sensibility to contemplation and tears and by their austere beauty inspire them with great reverence and fear."[75] Although reportedly spoken in 1539, long before Gilio's treatise or the Decrees of the Council of Trent, no more perfect statement of the Counter-Reformation position can be imagined. It reflects the renewal of Michelangelo's personal piety in the context of the discussions of the group of *spirituali* of which he was then a part.

Just what did Gilio and the critics of the Counter-Reformation object to in Michelangelo's fresco? First, they objected to any artist who appeared to value the creation of energetic, graceful, and beautiful figures above devotion, that is, his own artistic ego above the message. "The history painter is nothing else than a translator from scripture to painting," says Gilio, and if the translation is not faithful it will make one laugh or go to sleep, as Horace says.[76] Second, they opposed the display of nudity that they feared would distract and make the image ridiculous. Third, they deplored the sophistication, which did not address itself to the taste of the "ignoranti," that is, those who cannot read, the *popolo*.

This final point is generally disregarded, but it is of primary importance. A full reading of the Decrees, not just those pertaining to art, makes it evident that a major concern of the Tridentine reforms was to move away from the elitism of the Roman Church and its celebration of its own hierarchy and to address the people. In Dolce's *Aretino*, Michelangelo's defender, Fabrini, tried to justify him by saying that the *Last Judgment* "embodies allegorical meanings of great profundity which few people arrive at understanding." Aretino responds that if that is so, and Michelangelo did not want his inventions to be understood except by a few intellectuals, "then I, who am not one of the intellectual few in question, leave thinking about them to him."[77]

In other words, what is the use of allegory unless it can be generally perceived and understood? This strikes at the heart of Maniera iconography that frequently found delight in layering meanings or in apparent paradoxes that could not immediately be resolved. It is doubtful, in fact, that there were any such concealed allegories in Michelangelo's fresco – unless the skin of Bartholomew could be read that way – but the point is nonetheless an important one. Sacred art was to be clearly and immediately comprehensible to the illiterate for whom it was a substitute for the written word.

The *Last Judgment* was one of the most copied works of art in all of Europe. Not only were there always young artists there in the chapel drawing it, as Federico Zuccaro depicted his brother Taddeo doing (Fig. 127),[78] but it was repeatedly engraved. There were seventeen different versions made by the end of the century.[79] These prints were disseminated widely and cheaply, so that they reached a very broad audience that was not necessarily an art audience. Many people who were unfamiliar with the style of the Maniera and with the enjoyment of the "difficulties of art"[80] must have used these prints as devotional objects. Michelangelo had created the fresco for those with access to the papal chapel, largely prelates who, for the most part, would be familiar with the scriptural accounts and the theological discussions of the Final Resurrection. Instead, through the relatively newly invented medium of the print, the work reached a different, much larger, and much less sophisticated audience. In Gilio's commentary he mentions more than once the possibility that the worshiper would laugh, instead of being moved to devotion. It is unlikely that the prelates would have made such a response. One can more easily imagine that Gilio was recording the laughter of the viewers of the prints. Their inappropriate responses must have played an important part in prompting the Church to condemn the painting and to censor it.

The section that Daniele was instructed to change had been particularly worrisome (Pl. XXII). Saint Biagio stood behind Saint Catherine and looked down at her as she leaned over to lift the broken wheel, symbol of her martyrdom, and turned her head back to look toward Biagio. As the speaker in Gilio's dialogue remarked, it looks as if she is saying to him, "What are you doing back there?"[81] Daniele removed the incentive to lewd jokes by adding drapery to the upper body of Catherine and turning Biagio's head away so that he

looks at Christ and ignores Catherine. Nevertheless, the nudes remained, and for an audience trained by the Church to refer to private parts as one's shame *(vergogna)*, they diverted attention away from the serious subject of one's ultimate destiny and bewildered the simple, pious Catholic, precisely the ones the Church was most concerned now to reach. Prints had now to be taken into account. It was the Jesuits, as we shall see, who would later turn this lesson to the Church's advantage and exploit the potential of prints for reaching and instructing a large audience.

GRACE AND BEAUTY

The definition of how grace and beauty are achieved underwent a significant reformulation in the years of the Counter-Reformation. Gilio stated that order *(ordine)* is what gives beauty and grace to everything.[82] If placed within the tradition of the discussions of Castiglione, Varchi, and Vasari, then Gilio's remark takes on a greater significance.

For Castiglione and the High Renaissance, beauty and grace were evidence of divine favor; they were the mark of the good and moral man, and if these qualities were not inseparable, they at least belonged together. But Castiglione opened the door to the separation of grace from beauty when he emphasized the indefinability of grace and its unteachability, making it a flexible norm that admitted license, whereas beauty, a fixed norm, did not.[83] We have seen how in the art of Parmigianino and his followers a more arbitrary vision of grace appeared: it is no longer identical with a normative canon of proportions, for example. The elevation of grace to the premier position and its indispensability to beauty was stated by Benedetto Varchi, in his treatise written in 1543.[84] He remarked that if it were possible to have beauty without grace, he would prefer to be graceful to being beautiful.[85] According to his definition, beauty is the right proportion and relationship of all the members among themselves, to which is added sweetness and suavity of color. One can see women who are well proportioned and colored, but not beautiful because they are not graceful. A body that does not have grace, even if it has all the other necessary ingredients, cannot, "according to me," be called beautiful.[86] Vasari, speaking of works of art and not beautiful women, made the same point. Aware that correctness cannot produce grace, he made a clear distinction

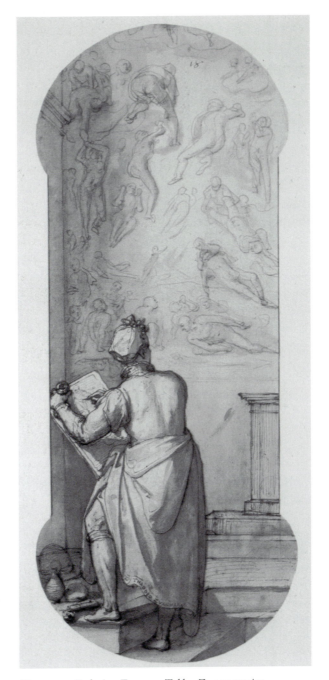

Figure 127. Federico Zuccaro, *Taddeo Zuccaro copying Michelangelo's Last Judgment*. Drawing, c. 1590s. Courtesy of Sotheby's Inc., New York.

between beauty, "a rational quality dependent on the rules," and grace, "an indefinable quality dependent on judgment and therefore on the eye."[87]

For Gilio, for whom grace and beauty are the product of order, not even beauty is any longer a fixed norm, nor is it necessary for a figure to have conventional signs of beauty – right proportion, among other things – to be

beautiful. This definition allows him to require the artist to represent the brutality of the martyr's torture, for example, without excluding it from the category of a beautiful painting. The identification of ugliness with evil, which we found to be a part of the aesthetic practice of the Classic style, has been jettisoned.

For Vincenzo Danti, writing in 1567, grace can be an internal quality of the soul that one perceives by the intellect rather than the eye.[88] This grace, which one can see often in men of imperfect composition, is a hidden part of corporeal beauty that is made known by means of intellectual powers. Sometimes one sees a man who has grace only by means of his beautiful soul. Men who are ugly and ill-proportioned in their exterior parts can show graceful movement. This beauty of the soul results from the beautiful disposition of interior parts that then produces sound intellect and good judgment. Lomazzo (1538–1600) signals to us that the Classical conception of beauty is indeed dead when he puts into the mouth of Leonardo da Vinci, in his dialogue

Figure 128. Siciolante, *Pietà*. c. 1542–4. Museum Poznan.

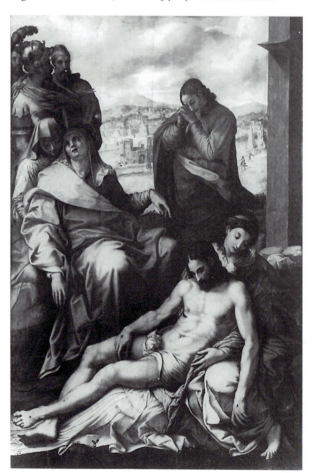

with the ancient sculptor Phidias, the extraordinary statement that if he were painting his *Last Supper* now he would show the apostles with rumpled manes, down to their shoulders, and suntanned skin and dusty feet because that is the way they were.[89]

COUNTER-MANIERA

We have already seen how Michelangelo pioneered a stylistic alternative to the Maniera in his Pauline Chapel frescoes to express his evolving view of man in relation to God. This effort and Sebastiano's devotional style of the 1530s preceded explicit statements of dissatisfaction with the Maniera by writers such as Gilio; but Trent, and Gilio, and those who succeeded them, merely codified what was already in the air in the 1540s. Although no one chose to follow altogether Michelangelo's rejection of the humanist model of a dignified and noble human creature, Gilio's definition of the source of beauty and grace in order *(ordine)* provided the painters with a justification for representing less elegant and less elevated figures who more closely approached normal human beings. Well in anticipation of these written codifications, some painters, like Girolamo Siciolante, had moved in this direction.

Born in 1521, Siciolante bridged the generation of the Maniera painters, like Salviati, Vasari, and Bronzino (1503–72), all born around 1510, and the artists of late Mannerism in Rome like Taddeo Zuccaro, Girolamo Muziano, and Pellegrino Tibaldi, born around 1530–5, and the Florentine followers of Vasari like Alessandro Allori, Battista Naldini, and Santi di Tito, among others. Although Siciolante (1521–75) worked with Perino del Vaga at the Castel Sant'Angelo, his temperament did not dispose him to sympathy with Perino's ornate style. He seems from the start to have been predisposed to the direct expression of sincere religious feeling. For his early altarpiece of the *Pietà,* originally for Santissimi Apostoli (Fig. 128), he turned to Sebastiano del Piombo, in particular his *Pietà* (now in Saint Petersburg, Hermitage). He imitated the large, blocklike forms, but what most attracted him was Sebastiano's handling of emotion. "One senses an intellectual and emotional concentration on the brooding atmosphere of tragedy, a concentration that excludes rhetorical gestures such as Sebastiano's, or graceful posturing such as Perino's, that might detract from the mood of grief. In Siciolante's painting, the attitudes of the figures seem

the direct and natural expression of their sorrow and are not imposed upon them by external formal considerations. They are not shaped and twisted to create complex patterns or flattened to make a design on the surface plane; the artist does not – as Perino would – interpose between his figures and the spectator the screen of some ornamental device." Bernice Davidson's analysis, quoted here, is a succinct statement of the difference between Maniera and Counter-Maniera, and the shortcomings of Maniera as a style for sacred art.[90]

In a chapel in San Luigi dei Francesi, which Perino did not have opportunity to execute before his death, Siciolante frescoed the *Baptism of Clovis* (c. 1548–9).[91] Although the ornaments and contortions and exertions of the Maniera are absent here, so too is the emotional content we found in his earlier *Pietà*. Although this painting would presumably have satisfied Gilio in the clarity of its narrative and the absence of distractions, it is prim and prosaic. In Siciolante here Gilio has found his meek, faceless vehicle of sacred truth, but we see what happens when style is purged of its offending features and nothing new is offered to replace them.

The frescoes of the Fugger Chapel in Santa Maria dell'Anima representing scenes from the life of the Virgin have been convincingly redated to 1561–3, and thus correspond to the final sessions of the Council of Trent.[92] The mood of reform evident in the *Baptism of Clovis* hangs heavily over these works. Siciolante was perhaps a logical choice of painter for a northern European patron like Fugger, who may have had little enthusiasm for the elitist sophistication and peculiar calligraphy of the Maniera. He may well have preferred the unadorned, more bourgeois style in which Siciolante rendered the familiar scenes. The *Nativity of the*

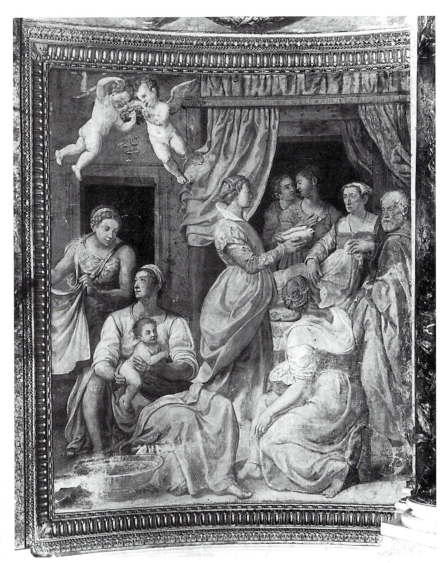

Figure 129. Siciolante, *Nativity of the Virgin*. Fresco, 1561–3. Fugger Chapel, Santa Maria dell'Anima, Rome.

Virgin (Fig. 129) reminds us of Sebastiano's version (Fig. 86). It contains many of the same elements, although fewer because the scale is reduced. The figures are clearly legible, deprived of contrapposti and serpentine twists, with one notable exception. The woman in the right foreground recalls Salviati's woman pouring water in his *Nativity of the Baptist* (Fig. 104), and like her prototype, she evokes a memory of the *"Letto di Policleto"* (Fig. 105). Like the occasional *repoussoir* figure elsewhere in the chapel, leaning up against the picture plane or filling the foreground space, she demonstrates that Siciolante did not always choose to abandon all ornaments. His position as a bridge between generations meant that he had been trained as a Maniera artist and had to

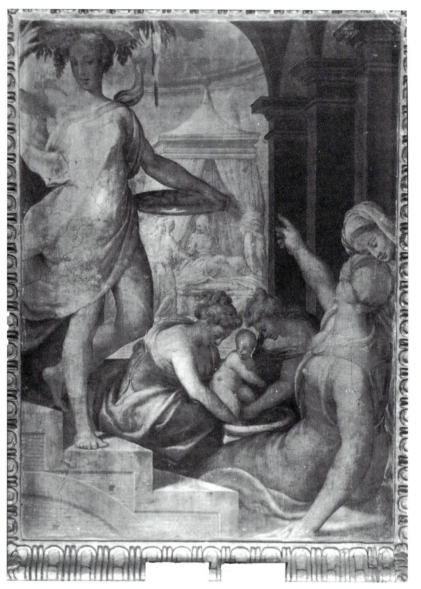

Figure 130. Salviati, *Nativity of the Virgin*. Fresco, c. 1562. S. Marcello al Corso, Rome.

enlightening comparison. His frescoes in San Marcello al Corso are probably his last works, completed before his death in 1563 and thus of the same moment as Siciolante's (Fig. 130). The contrast is striking. Salviati's Maniera has become lithe and lyrical, the mood carried by his curvaceous, gracile figures who serve as ornamental border to the scriptural event, which is displaced to middle ground or distance. Undaunted by the new strictures against nudity, he gives us bare legs, bare arms, bare breasts. The color is delicate pastel, as sensuous as his forms and, like them, intended to generate a surfeit of loveliness.[95] By contrast Siciolante's homely parents of the newborn, surely portraits, bring us back to earth with a thud. Yet there can be no doubt that the Church had good reason to complain that interpretations like Salviati's were remote from the scriptural account and bewilderingly irrelevant.

The rhetoric that had been such an important part of painting was not the tone the Counter-Reformation wished to support. A didacticism, pedestrian if necessary, suited the requirements of the moment. Telling the story in straightforward, unembellished form became the artist's task. Emotion was either repressed or represented with a directness that spoke of the simple devotion of the protagonists. This was in fact only a passing phase as it turned out. By the time Sixtus V takes the papal throne in 1585, the Church is ready to embrace the rhetoric of praise as the ideal mode for presenting the Church Triumphant.

In this first phase, alongside other stylistic options, we see the pursuit of a Counter-Maniera that satisfied the most conservative and doctrinaire of the reformers. It rejected the relieflike style, the ornaments, and the artificialities of the Maniera and returned to a normative figure canon as well as to more naturalistic poses and treatment of space. Genres were not mixed. In history

retrain himself to become a Counter-Maniera artist. He was capable of simulating the Maniera, as his various palace decorations of the 1550s bear ample witness, or as his fresco of the *Donation of King Pepin* for the Sala Regia of a couple of years later than this chapel does.[93] For all its narrative directness, no one would mistake this *Nativity* for the work of late Quattrocento painters, like Ghirlandaio, though there does seem to be some ambition to return to that style.[94] The style Siciolante uses here is based on Maniera and is connected to it – another link in the chain going back to the Classic style; it is not a new departure.

Salviati's version of the same subject offers an

painting, by which Gilio meant sacred narrative, no allegories were permitted, because the moment they appear in a scene the response of the viewer is changed: there is no longer a need to treat it as a historical event.[96] Although this Counter-Maniera style was more Classicizing, it did not admit even the degree of rhetoric common in the High Renaissance; in this sense it resembles more the model of the late Quattrocento.

Girolamo Muziano had the advantage of having come from the north of Italy, arriving in Rome in 1549,[97] and of not having been trained as a Mannerist, so he did not have to purge his style before connecting with the Counter-Maniera. One of the talents Muziano brought with him from his training in the Veneto was the painting of atmospheric landscape. In a fresco dating from the first half of the 1550s, the *Rest on the Flight into Egypt* (Fig. 131), the effect is arresting because of the eerie light on the countryside.[98] The composition may have been based on a drawing given him by Taddeo Zuccaro, but the chiaroscuro and the naturalistic landscape are Muziano, reminding us of his knowledge of Venetian painting.

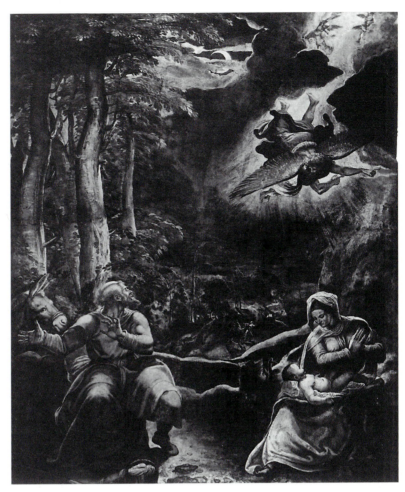

Figure 131. Muziano, *Rest on the Flight into Egypt*. Fresco, first half of 1550s. S. Caterina della Rota, Rome.

The picture should really be called *Joseph's Vision:* an angel dives from the sky in an aureole of light and points emphatically to the right. Joseph looks up startled, but the Madonna with the Child on her lap appears not to notice (nor does the donkey). The progress of their journey is depicted in the middle ground. As satisfyingly dramatic as this fresco is, it was managed without recourse to the conventions of the Maniera. Muziano demonstrated here that a plausible and atmospheric landscape can provide as much aesthetic interest as any Maniera caprice, while at the same time contributing to the impact of the narrative. As his Roman style developed, Sebastiano del Piombo became his principal model, which perhaps was natural because they had both come from northern Italy, although Sebastiano was already dead before Muziano arrived in Rome. On Sebastiano's example Muziano gives us strong, noble images of Christ, which nonetheless convey a quiet humility. His figures stand firmly, without

any unexpected twists or contortions, and they are of normal proportions. Gestures are invented to be clear without being theatrical. He maintains the focus on the principal action and the principal figures, whom he generally places foremost, with nothing intervening, and at the bottom of the picture. Emotion, as we saw in Siciolante, is not avoided as it often is in Maniera works, nor is it conveyed with self-consciously artistic effects. The mood is serious, and when appropriate, melancholy. Although such a description might apply to a late Quattrocento altarpiece, the grandeur and nobility of the figures, following Sebastiano's model, exceed what one finds in the preceding century.

During the artistic drought of Paul IV's rule, Muziano accepted the commission for two altarpieces for the Duomo in Orvieto. Here he drafted a new format for the altarpiece in a style that was very much in keeping with the requirements of the reformers. Even more removed

from Maniera artificialities than Siciolante, Muziano pioneered here a formula that he would practice with success in Rome for the next three decades, and that would be influential on a number of other painters. The young Cesare Nebbia (c. 1536–1614), a native of Orvieto, worked first with Muziano here, then returned as an autonomous master to contribute four more altarpieces to the Duomo in the late 1560s. Later Federico Zuccaro would contribute to this series, which eventually, around 1575, would be reconceived as a cycle of Christ's Passion. Unfortunately the chapels were demolished in a late-nineteenth-century renovation of the Duomo and the paintings transferred to the Museo del Duomo, so there is nothing surviving in situ of this historically important project.[99]

Muziano's *Raising of Lazarus* (c. 1556) exemplifies the new canon. In a large lunette-topped field the figure of Christ stands prominent and close to the viewer, performing the miracle of restoring life with a simple gesture. Reminiscent of Sebastiano's Christs, he is noble, serious, dignified, and unpretentious. The crowd expresses appropriate emotions, but with a new restraint in their gestures and above all in their poses. When in November 1568 Federico Zuccaro was commissioned to paint a similar event, *Christ Raising the Son of the Widow of Nain* (Fig. 132), for another of the chapels, he imitated Muziano's formula, abandoning most of the remaining residues in his style of his brother's Maniera. His style is at this point remarkably close to Santi di Tito's "reform" style in Florence in the 1570s (Fig. 164, Pl. XXVII). Here the focus is on the narrative, without distractions and without unnecessary elaborations as the reform critics had been calling for; but in the case of Muziano, this solution anticipated the Tridentine Decrees and Gilio's strident critique and offered prototypes for other painters to follow.

With maturity Muziano discovered a formula for the kind of story from the life of Christ that he was repeatedly commissioned to paint. Christ appears standing at the center, surrounded by attentive onlookers. The setting is usually provided by some classical columns, a landscape perhaps dotted with a few ruins, and an interesting but not distracting sky. With a modest but dignified gesture Christ heals the cripple or the man born blind, or consigns the keys to the kneeling Peter. This last was a popular subject, referring to the foundation of the papacy; Muziano painted it in at least three churches in Rome.[100] As he conceived it, it emphasized the simplicity and humanity of the apostles and of Christ, recalling the spiritual vocation of the papacy rather than its claim to temporal power.

A NEW KIND OF SACRED IMAGE

What the Counter-Reformation called for was a fundamental redirection of the artist's approach to sacred images. The tone of the post-Tridentine writings is authoritarian and even monitory. The Decrees of the Council were so succinct as to be laconic, but they laid the foundation and provided the framework that was elaborated in the following decades. The most energetic reformer, Cardinal Carlo Borromeo, laid out very precise instructions for the correct form for every- thing in the ecclesiastical buildings in his diocese of Milan and then published his directives in 1577 as guidelines to the other bishops.[101] How many steps leading to the altar and how high they should be, the size and material of the altar table, how a barrier to divide the men from the women should be designed and installed – these and every other conceivable detail are set out clearly in his treatise. The Council had charged the bishops with enforcing the Decrees; thus it was left to their judgment to decide what was an appropriate image and to ensure that all images in their diocese met the standards. According to Borromeo, the way to make certain of enforcement was to call a mass meeting of artists and inform them of their obligations. In his strict reading, it was the responsibility of the bishop to see that no painter or sculptor produced any sacred image publicly or privately without consulting the parish priest.[102]

Borromeo's friend and fellow reformer, Gabriele Paleotti, bishop of Bologna, wrote a treatise on images, published in 1582. Although he had planned for five books, only two were published, but they were sufficient to make clear that the Church, in opposition to the iconoclastic Protestants, strongly supported the proper use of images and considered them an important tool of faith. The image was a tool that had a purpose, which Paleotti carefully defined, and the artist was the artificer of that tool. Whereas Gilio dedicated his book to Cardinal Farnese and addressed the patrons, Paleotti directed his treatise to the painters.[103] As he conceived it the artist's calling was a high one, for his image was an instrument to unite man with God.[104] He should "recall men from vice to the true cult of God,"[105] but his artis-

tic excellence was always to be in the service of his devotion. It is not enough to be a good artist and to show the "excellence of art." The artist is also a Christian and is therefore obliged to seek to show in his images a Christian soul.[106] Much as Michelangelo had defined it, the artist of the sacred image was to be a pure vessel to convey religious truth.

Within a generation the goal of a new kind of sacred art had been accomplished. By the time Armenini was writing in 1586, giving instructions to painters, the artist's task in secular and in sacred painting was clearly distinguished. Whereas the purpose of secular works was the delight of human senses, it was believed that sacred paintings had the power to move men to piety and divine worship and were therefore advantageous to the immortal soul.[107] Despite the fact that it is in this kind of how-to book for painters where we would most expect to find defended the right of the artist to show off his skills, Armenini endorsed the principles that display of artistic excellence for its own sake was inappropriate in sacred art and that nudes in this setting should be discreetly covered (although with dexterity the painters can display their understanding of the nude figure).[108] By this time new painters on the scene like Federico Barocci (1535–1612) (Fig. 179, Pls. XXIX–XXX) were forging styles that could satisfy the reformers and the aesthetic tastes of painters and patrons.

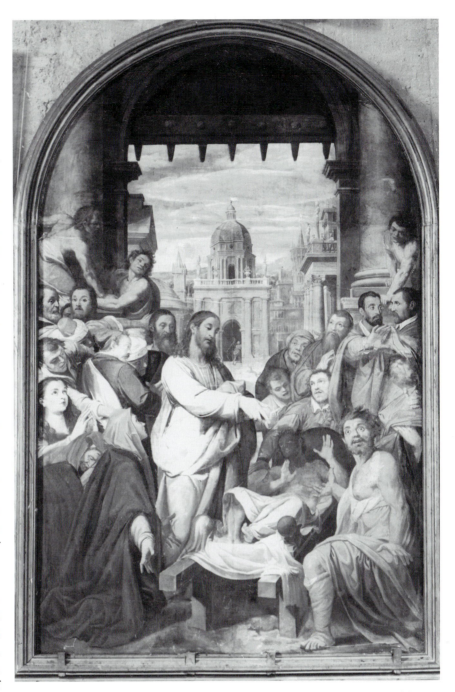

Figure 132. Federico Zuccaro, *Christ Raising the Son of the Widow of Nain*. c. 1568. Museo dell'Opera del Duomo, Orvieto.

PIUS IV AND PIUS V

No less a transformation was required of the churchmen and their patronage than of the artists. The decisions taken at Trent revitalized the Church, setting it on a track that engendered a new spirituality and a new energy. Churches were built, renovated, and decorated in astonishing numbers beginning in the early 1560s, and much of this activity was under private patronage.

Following the disasters of the rule of Paul IV, the more liberal, but still reform-minded Pius IV took the throne (1559–65). Pius IV's reign has aptly been characterized as a brief Indian summer for the liberals in the Church before another former head of the Inquisition returned to the rigors of zealotry in 1566 and took the throne as Pius V.[109] Pius IV was a distant relative of the Florentine Medici, and he wished to appear a patron of the arts on the same scale as they. He had Pirro Ligorio (c. 1510–83) build the Casino in the Vatican garden, perhaps the most thoroughly pagan of any of the papal villas in its splendid encrustation of stuccoes, but inside it, the frescoes represented biblical iconography, executed by the young Federico Barocci, Federico Zuccaro, and Santi di Tito (1536–1603). Another sign of the times was the facade for a cardinal's palace that bears Pius IV's arms. When Taddeo Zuccaro was asked to paint it he passed the commission to his young brother Federico, who executed it to everyone's satisfaction but with a sacred subject instead of the conventional historical and mythological scenes *all'antica* derived from Polidoro da Caravaggio's repertoire.[110] Pius returned the Villa Giulia and other properties, which had been confiscated for the state by Paul IV, to private hands. Nevertheless, he was diligent in working to bring about the conclusion of the Council and to implement reform. In 1561 he urged the cardinals to have their titular churches renovated.[111] The leading cardinals responded promptly; some, in fact, had already anticipated it. Carlo Borromeo, who was the pope's nephew, had the early Christian basilica Santa Prassede extensively remodeled between 1560 and 1565. Cardinal Truchsess had the mosaic at Santa Sabina replaced with a fresco by Taddeo Zuccaro in 1560. The cardinal of Portugal gave a magnificent wooden ceiling to Quattro Coronati; Borromeo, again, paid for one at San Martino ai Monti.[112] There was a noticeable shift in the piety and lifestyle of the cardinals. Immediately following the conclusion of the Council a number of cardinals were ordained: Farnese, Este, Carafa, and Gonzaga, all in 1564.

There was initiated in Florence under Duke Cosimo's leadership a movement to renovate monastic churches; in the next quarter century it spread across all of Italy and eventually all of Europe. Luther's attacks upon the Roman Church as being elitist, veiling the truth in mystery so that it was inaccessible to the ordinary layperson, had hit the target. In the spirit of the Tridentine reform Gilio led an attack upon sacred images that shrouded the doctrine in mystery. The reforms of the liturgy and of church interiors that were implemented in the decades following the close of the Council of Trent were designed to remedy this fault. The rood screens and monks' choirs, which blocked the view of the high altar and kept the laity at a remove from the Mass, were torn down; the side chapels were made more accessible, and the images that adorned the altars were made legible and their purity and orthodoxy assured.[113]

Cardinal Farnese, who still held the lifelong office of vice-chancellor, lived in the Palazzo della Cancelleria and was second only to the pope. He was considered *papabile* at every election from 1565 on, and he was ambitious to succeed. He took a leading role with his religious patronage beginning in the early 1560s, shifting his attention from the decorative art objects and secular commissions that had mostly occupied him up to that point. Gilio, in dedicating his *Dialogue* to Farnese, challenged him to take the lead in reestablishing the trust between patron and artist and to provide a new model for the sponsorship of sacred art and architecture in the face of Protestant attacks.[114] Urged also by the pope to set the example with his patronage, the cardinal undertook to renovate and to care for the spiritual life of his titular church in the Cancelleria, San Lorenzo in Damaso. He gave it a new roof, new campanile, new door, and commissioned an altarpiece for the high altar from Taddeo shortly before the painter's death in September 1566. (It was executed by his brother, Federico, two years later, a *Coronation of the Virgin adored by Saints Lawrence and Damasus.*) When a new fashion to decorate the nave of churches above the entablature with sacred narratives was begun around 1580,[115] Farnese quickly followed suit in 1587, having scenes from the life of Saint Lawrence painted. Although these decorations are no longer to be seen, they were the work of the cardinal's favorite painter, Giovanni De' Vecchi (1537–1615) (see Fig. 140), of Nicolò Circignani,[116] the specialist in martyrdoms, and of the young Cavaliere d'Arpino (Giuseppe Cesari) (1568–1640), who would come to dominate the scene at the turn of the century (Fig. 188).[117]

New church construction flourished, and it was enhanced by the rivalry among cardinals. When Cardinal Federico Cesi, formerly best known for his collection of antiquities, decided to build Santa Caterina de' Funari in 1560, it seems to have spurred Farnese to

undertake to build a grander church for the same order of the Jesuits, the Gesù, in 1561. Farnese stipulated that the fathers were not to accept any other patronage, which is a clear indication that he considered the Ges his personal achievement. Nor would he permit the Jesuits the flat wooden roof they wanted for acoustics, but insisted on the more monumental barrel vault.[118] Cesi's heir then agreed to sponsor the building of the Chiesa Nuova, the Oratorians' new church, and so it went, to the benefit of the Roman ecclesiastical establishment and urban environment.

Church building and church decoration occupied center stage in the 1560s. When the moderate Pius IV died in 1565 the pendulum took another swing and another Inquisitor General was elected. Pius V (1566–72), who had been promoted by Paul IV, surpassed all the others in asceticism. A Dominican friar of humble origins, he imposed his austere way of life on the papal court and set an example of abstemiousness calculated to shame the cardinals into curbing their lavish lifestyles. The self-righteousness of the saintly can be frightening: Pius decreed that a doctor could not treat any patient who refused confession for more than three days.[119] Whereas Paul IV had confined the Jews to the ghetto, Pius enacted a bull that expelled all Jews from the Papal States, except those in Rome and Ancona. Vasari commented in his letters on what he saw when he visited Rome in 1567. The city had fallen on very distressing times, its former splendors replaced by parsimony. Everyone was garbed in a mediocre manner, and simplicity seemed to be the order of the day. In fact, if Christ loved poverty and Rome wished to follow him, the city could scarcely do better, for it was well on its way to beggarliness, opined the unreformed Vasari.[120]

Almost immediately upon taking office, Pope Pius V decided that the antique statues surrounding him in the Vatican were unseemly decor for the papal palace. He made a gift to the city of Rome of many of the antiquities in the palace, and he intended to dismantle the Belvedere Court, the pride of Julius II. Only the energetic objections of some of the cardinals saved the Belvedere, but solely on the condition that it be closed to the public.[121] He stripped the antiquities from the villas of his predecessors, the Villa Giulia and the Casino of Pius IV, and made gifts of several of the pieces to avid collectors, like Francesco de' Medici in Florence. Vasari's prediction of a few years earlier came true. He had written to Prince Francesco, who had commissioned

him to look for antique statues that he could buy: "If this pope lives long there can be no doubt that statues will go begging in Rome and many such things will be thrown on the market."[122]

CARDINALS' DOMICILES

Those cardinals who were in the midst of decorating sumptuous country villas for themselves, like Alessandro Farnese and Ippolito II d'Este, must have found these undertakings somewhat of an embarrassment when compared with the style of life Pius V was following in the Vatican Palace. We have seen that Farnese had become generous in his patronage of ecclesiastical establishments already in Pius IV's pontificate, which, of course, he kept up, as he continued to spend on the villa at Caprarola.

Planning and construction of the villa dated back to 1555 when Vignola began building on the pentagonal foundations of an old fortress about thirty miles north of Rome. By 1561 it was ready for decoration to begin. Farnese's first choice of painter was Muziano, but the artist preferred to work for Este on his rival villa at Tivoli, about twenty miles to the east of the city. When Taddeo Zuccaro was offered the job he was able to arrange very favorable terms for himself as inventor and overseer because he was much in demand in Rome. When he died suddenly in 1566, his brother Federico took over, until the cardinal fired him three years later. Federico, who was busy finishing all the work left by his brother, seemed to lose interest in the villa and neglected it. When, in July 1569, Federico tried to hold the cardinal to a promise of a large sum for his sister's dowry in return for ten years' past service on the part of his brother and himself, the cardinal responded with an ultimatum that Federico refused.[123] He was replaced with Jacopo Bertoia (1544–74), who had to be pried away from the Oratory of the Gonfalone, where he was in charge. When Bertoia left in the summer of 1572 he was followed by Giovanni De' Vecchi assisted by Raffaellino da Reggio (1550–78). The decoration was finally completed by 1579.

Caprarola is presented here rather than in the previous chapter because it makes an interesting comparison in a Counter-Reformatory context with the near-contemporary decorations at the Palazzo Farnese. The villa was the showpiece of Cardinal Alessandro Farnese, not the Cancelleria, which belonged to the Holy See, and

not the Palazzo, which had been left to Ranuccio, his younger brother. Alessandro, with Este and Borromeo, was the most influential, and most-watched, cardinal in Rome. How he and Este decorated their villas would be scrutinized by others who were uncertain how to proceed in these difficult times. Even in the paintings of the Farnese family histories, Taddeo's scheme is more restrained than Salviati's at the palace had been, demonstrating that the taste for high Maniera extravagances even in palace decoration was already past, replaced by a sobered and more reportorial manner. As the decade of the sixties proceeded and the example of Pope Pius V weighed more heavily, even mythological subject matter disappeared. Changes in the iconography at Caprarola and at the Villa d'Este reflect the increasing influence of the Counter-Reformation. The impact of the movement on secular decoration, at least when it pertains to cardinals, can be observed here.

The rooms at Caprarola are divided into three sections. The ground floor, which was the first to be readied, is where Taddeo began. Vignola contributed a few frescoes here, taking the opportunity to show that he could paint as well as build. The *piano nobile* is divided into two wings around the central circular court. The summer apartments are to the east and the winter apartments to the west, joined by a dining loggia centered over the entrance. In this loggia, called the Sala d'Ercole, fantasy and extravagance make a rare appearance at Caprarola. This is the only room to be given a stucco frieze, complementing the fountain of stucco and mosaic, with marble statues, some antique, some contemporary. Without ever going out-of-doors, the cardinal and his guests could dine with the gentle music of flowing water. Each apartment consisted of five rooms, the public rooms at the front adjoining this loggia, followed on each side by a bedroom, a wardrobe, and a study. The summer apartments were the first executed, on the designs of the Zuccari.

Here Alessandro had Taddeo make the famous counterpart to the Sala dei Fasti Farnesiani painted by Salviati in the Farnese Palace (Figs. 109–10). He would have been familiar with Salviati's design, for after Salviati's death in 1563, first Taddeo and then Federico were called in to finish frescoing the room. Although many of the subjects replicate scenes at the palace, there is nothing here of the illusion of fictive materials or the stratification of layers that gives Salviati's room its air of opulence. The model of the Sali di Costantino has been

rejected. In Taddeo's scheme (Fig. 133), each scene is neatly contained within its frame and allegorical personifications are restrained within their own separate compartments. There is none of the confusion of genres that Gilio would complain about.[124] The overall impression is both more serious and more plain – un-fancy, as Sydney Freedberg termed it. Grander than the Palace Sala dei Fasti Farnesiani, however, is the barrel vault, covered with more framed histories. Restrained but beautiful white stuccoes fill the corners. The scheme is extended into the smaller adjacent room, the Anticamera del Concilio, which takes its name from one of the frescoes, a representation of the Council of Trent that conspicuously quotes Raphael's *Disputa* in the Stanza della Segnatura (Fig. 22). The bishops are gathered around an altar studying books and discussing them. In the upper left Pope Paul III is shown ordering the Council to convene.

Despite its noble prototype in the Classic style, there is a dryness to this and the other of Taddeo's histories. This effect is often in notable contrast to the preparatory drawings, which are splendidly full of vigor and verve. This diminution of aesthetic appeal in the finished work is all too often apparent in the large-scale works of the second half of the century, and sometimes even earlier – we noted it in Vasari's Sala dei Cento Giorni, also for Cardinal Farnese. Perhaps the patrons are partially at fault in demanding speed and quantity. Federico complained that when he worked briefly for Este at Tivoli, the cardinal just wanted paintings cranked out.[125] A large workshop supervised only at a distance by Taddeo, who was at work on other projects in Rome, executed the master's drawings. There were specialists of all kinds – grotesques, gilding, stucco – but no one who breathed the same life that was in the drawings into the painted narratives. Even Federico, who was adept at imitating his brother's style, was absent, working in the Vatican and in Venice.[126]

There is no want of invention in the designs or in the programs. Particularly ingenious is the program for the wardrobe, the Stanza dei Lanefici, where the vault and upper portion of the walls are covered with mythological scenes that relate to the craft of weaving and the invention of clothing (Fig. 134). We see wise Minerva distributing animal skins to naked men at the center of the vault; flanking her are Hercules discovering that purple dye can be made from certain sea creatures (murex), and the contest of the unfortunate Arachne

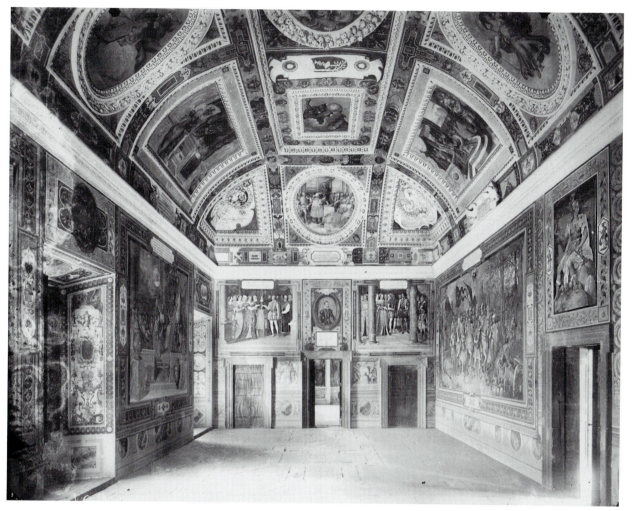

Figure 133. Taddeo Zuccaro, Sala dei Fatti Farnesiani, view. Fresco, 1562–3.
Palazzo Farnese

with Minerva to spin the most cloth in a day. In each of the rooms the interstices between the scenes are filled with grotesques, much in the manner of Perino del Vaga in the Castel Sant'Angelo (Fig. 99). But unique here is the invention of grotesques to coordinate with the iconography of the mythological scenes. In the Lanefici we find women spinning or a figure braiding threads.[127] Grotesques have never been more inventive or more delightful.

The programs for several of the rooms at Caprarola have been preserved, and we are able to learn from them a great deal about how programs had evolved from earlier in the century. In answer to the demand for more and more precise means of giving visual form to ideas, manuals of mythology began to appear around midcentury that could be used like a dictionary.[128] With these manuals the painters – or in the case of Far-

nese, the learned men like Annibale Caro charged with inventing the programs for the decorations – could find a wealth of references with very specific attributes to illustrate any concept. Before the manuals appeared, even as well read a classicist as Caro might have been hard-pressed to multiply the stories concerning clothing, or solitary contemplation, depicted in the cardinal's study, or sleep, the theme of the cardinal's bedroom, the Camera dell'Aurora.[129] Some of the scenes would never be recognizable without the written program, despite the accurate and clear rendering given them by Taddeo; for example, there are the bizarre extremes to which some of the philosophers represented in the Stanza della Solitudine went to attain a peaceful atmosphere for contemplation, such as gouging out their own eyes or throwing stones at intruders![130] The introduction of the manuals opened the way for a kind of

Figure 134. Taddeo Zuccaro, vault, Stanza dei Lanefici, detail. Fresco, c. 1564. Palazzo Farnese at Caprarola.

precise and erudite iconography that some critics have found arid compared to the allusive, and sometimes elusive, references in the programs of the earlier Cinquecento.

When the corresponding rooms in the winter apartment were executed by Jacopo Bertoia beginning in 1569, mythological subjects were banished and religious ones took their place. In this wardrobe the delightfully frivolous exploration of the mythic history of clothing in the other apartment was replaced by a sober contemplation of justice (Stanza dei Giudizi), now apparently deemed a more appropriate subject to concern a cleric while dressing. At the center of the vault Solomon decides who is the true mother of the surviving child. Around are shown other decisions similar to ones a cardinal might have to make, such as building the temple at Jerusalem or selecting a priest to elevate above the others.

The study, corresponding to the room for meditation in the summer apartments, has become now the Room of Penitence (Stanza della Penitenza) (Fig. 135). The program has recently been found and we now know

that it addressed the debate between Protestants and Catholics over monasticism. To the Protestants, monasticism was not based on scripture, and its vows and rituals were therefore no more than empty superstition.[131] In defense of the tradition of monasticism, Bertoia painted gloomy little vignettes of emaciated saintly hermits alone in the desert, refusing food that has been brought to them or praying ardently. The insistence upon the merits of the eremitical life would have pleased Pope Pius V, whose personal asceticism we have already noted. Not only did the author of the program, Cardinal Guglielmo Sirleto, provide a scholarly and detailed set of images and inscriptions, which were scrupulously followed by Bertoia, he also sagely chose examples that Cardinal Farnese could show off to the pope as examples of his own rightmindedness.

The spirit of the room is brightened by the exuberant grotesques and Farnese emblems that fill out the space. It is difficult not to think that there was ironic humor intended by the painter when he juxtaposed the Abbot contemplating a skull with winged tritons gleefully riding bucking dolphins and an urn emitting

clouds of smoke out of which emerge fish-tailed putti.

At Caprarola frescoes executed in the 1560s were almost entirely secular in subject matter, whereas those of the following decade were very largely religious.[132] Even the room with maps of the world, the Sala del Mappamondo (1574), made reference to the world hegemony of the papacy and the Roman Church.

By the late 1560s the other cardinals were also shifting to religious iconography in their villas and palaces. Cardinal Ricci had three rooms in his villa on the Pincian Hill, now known as the Villa Medici, decorated with friezes showing Old Testament episodes. It is true that Ricci had used the David story as the subject of his reception room frescoed by Salviati in the previous decade, but the subjects chosen there were among the raciest in the lively life of that king and hardly seem to have been intended as exempla of moral conduct. At the Villa d'Este a shift in iconography occurred almost contemporaneously with that at Caprarola. Until 1567–8 the rooms there were decorated with mythological subjects, but after that date the iconography of the later rooms was all religious.[133] This shift, then, was the accommodation the cardinals made with the spirit of the saintly Pope Pius V.

What little secular decoration was being done in these years was chiefly at cardinals' distant country villas, out of sight of the Vatican, perhaps by careful choice. An exception was Medici, but for reasons that can be understood. In 1572 Cardinal Ferdinando took up residence in the center of the city near the Tiber in the Palazzo Firenze, which had formerly belonged to Julius III and then been presented to the Medici by Pius IV in 1561. Because none of the existing decoration referred to the cardinal, he felt it necessary in 1574 to hire his fellow countryman, the Florentine Jacopo Zucchi (1542–96), to decorate two rooms for him. Zucchi had been an assistant of Giorgio Vasari and had come to Rome with Vasari to paint three chapels in the Vatican for Pius V in 1570 (that pope's principal, and nearly sole, commissions).

Figure 135. Jacopo Bertoia, vault, Stanza della Penitenza, detail. Fresco, c. 1570. Palazzo Farnese at Caprarola.

Here we can see how classical mythology could be metamorphosed into acceptable decoration. Instead of biblical scenes, Cardinal de' Medici had Zucchi fresco allegories of the Four Elements on one vault and the Seasons on another. Zucchi based his design for the Sala degli Elementi on Vasari's room of the same name in the Palazzo Vecchio in Florence, the home of the cardinal (Fig. 136). At the center of the vault is the Creation, and on each side is one of the Elements, framed with lively painted caryatids. Of course, this subject matter had to be represented with the appropriate deities from mythology: Neptune for Water, Jupiter for Air, and so forth, and the interstices were filled with very rich ornaments of the conventional type: garlands, cameos,

putti sporting with the cardinal's hat. In the Sala delle Stagioni, the Seasons are represented as allegories in four large medallions, flanked by mythological scenes explaining the origin of the relevant zodiacal signs. Garlands hung above each contain fruits and flowers of that season. In the center of the vault is the Sun on a chariot drawn by winged horses and led by Aurora, and surrounding it is a very rich frieze of putti, garlands, and cameos. The frieze is interrupted with four oval medallions in which appear the zodiacal signs of the months in which the seasons change: the solstices (June and December) and the equinoxes (March and September).[134] The fact that the same subject was being painted at the same time for another cardinal at the Villa Lante at Bagnaia, and in the Sala del Mappamondo at Caprarola as well, indicates that it was regarded as irreproachable subject matter. Pagan gods and goddesses appear, but as emblems, not in amorous pursuits as in earlier villas and palaces.

Like the decorations at Caprarola, these depend upon the mythological manuals for the invention of the recondite details of the iconography. Quite the opposite of what was happening in the sacred images of the Oratory of the Gonfalone or at the Gesù, Zucchi was engaged here in an almost entirely cerebral exercise, avoiding any possible appeal to the emotions. Classical mythology in the context of allegory, where it functions to give visual form to ideas, was acceptable, at least to the moderate reformers. Paleotti, on the contrary, called for the removal of all images of the "false gods," especially from the premises of ecclesiastics, saying that it gave the heretics, that is the Protestants, pretext "for accusing us of idolatry."[135]

GROTESQUES AND PAGAN CULTURE

Although the cardinals obviously felt constrained in the use of pagan mythology to decorate their abodes, they had no such compunctions about pagan ornaments in the form of grotesques. These grotesques have the same prominence, and display a similar ingenuity, in the winter apartment at Caprarola as in the earlier summer apartment. They continued to be used to decorate the later rooms at the Villa d'Este, and they are tucked into Zucchi's vaults. Even Pius IV used them to cover the vault of the Sala Ducale in the Vatican Palace.[136] Yet in 1577 Cardinal Borromeo condemned their use as framing devices in any ecclesiastical setting. Under the heading: "Accessories and additions for ornamentation," he states that borders, like those painters and sculptors add to images for the sake of ornament, should not be profane, extravagant, unconventional, or unsuitable for sacred pictures. For example, they should not portray grotesque human heads, commonly called *mascaroni,* nor small birds, nor the sea, nor green pastures, nor other things that are designed for pleasure's sake, for delightful views, and for decoration. These ornaments may be used only if they validly agree with the sacred story that is represented.[137]

Borromeo represents an extreme position to which perhaps relatively few would have subscribed in Rome. His good friend Bishop Paleotti, in Bologna, however, took an equally harsh stand. Based on the fact that grotesques were found in buildings that had been buried, like the Domus Aurea, he deduced they must have been used in antiquity to decorate underground caverns, which could only have been dedicated to the worship of the devil; they were therefore completely inappropriate to churches. This utterly wrong conclusion, from the point of view of history, is interesting and important in the distrust of fantasy that it reveals. It is rooted in the belief that the imagination and dreams may emanate from the sphere of evil, the underworld, the chthonic.[138] The Counter-Reformation wanted to deal with the known and the knowable in this world, and with the divine.

This period under Pius V and following turned out to be the most authoritarian and restrictive moment of the epoch, and when a measure of success in turning back the gains of Protestantism was experienced and fear receded, the mood changed again. Within a few years, under Sixtus V (1585–90), grotesques would be advocated, in sanitized form for sacred settings, and without scruple in secular ones.

The policy toward classical culture during these years was full of contradictions and vacillations depending, above all, on the persuasion of the presiding pope. One can be sure that those educated by humanists, like Cardinal Farnese, never lost their enthusiasm for collecting statues and books, but the prominence these activities had previously been given was now somewhat cloaked. Classical antiquity was, of course, so imbued in the culture of Rome that it could not be excised. No one wanted to return architecture to the barbarism of the Gothic, for example.

The son and successor of Emperor Charles V, Philip

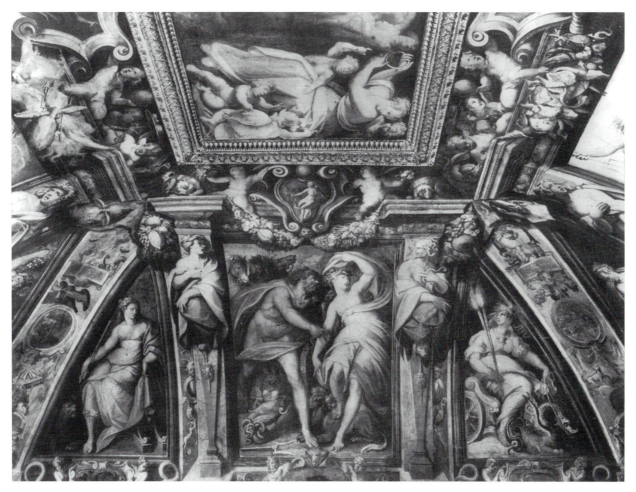

Figure 136. Jacopo Zucchi, vault, Sala degli Elementi. Fresco, c. 1574. Palazzo Firenze, Rome.

of Spain, that most fervent of reformers, made an interesting accommodation when he came to build his palace, the Escorial in Spain. The architectural style proposed and ultimately chosen for the king's palace has been described as a purification of Classicism, a style that paradoxically separated Renaissance Classicism from antique classical culture. Leon Battista Alberti's treatise on architecture was used extensively because his concern with the moral aspect of architecture coincided with Philip's moral, reforming Catholic piety. But the Escorial as built was much more rigid, even puritanical, than Alberti. Privately endowed chapels were viewed by these Spanish as ego trips for patrons, and collective patronage was preferred, in keeping with the spirit of humility the Counter-Reformation was trying to foster. What is remarkable is that there was to be no decorative carvings in friezes, pilasters, or window frames. It was a stripped Classicism in which the humanizing elements of ornament were

eliminated and only the skeleton remained, a Classicism that transcended antiquity and put paganism behind it. This style can be, and indeed has been, associated with that of Vignola, the architect of the Ges.[139] It might remind us of the use that more recent totalitarian regimes, like Hitler's, have made of a stripped classical architecture.

The conundrum in which the strict reformers found themselves is illustrated here: the foundation of the vision of the Church as the capital of the world, *Roma caput mundi,* was rooted in the precedent of ancient Rome. What Julius II had established no one wished to sacrifice. When the Jubilee was celebrated in 1575 it brought an unprecedented number of pilgrims to Rome – to celebrate the pagan city reborn as the sacred city. The Church sought the source from which to revive Christian liturgy, practice, and art in the early Christians. Mosaic was revived to decorate churches, for example, with the chapel of Saint Gregory in Saint Peter's leading

the way. Yet it was not possible to ignore the classical roots of early Christian art and iconography.

ORATORY OF THE GONFALONE

Whereas the Counter-Maniera enjoyed the approval of the most conservative reformers, many patrons with more sophisticated aesthetic sensibilities must have found it simplistic in its narrative economy and insipid in style. Alongside the Counter-Maniera there continued to flourish a more moderate late Mannerism, such as we saw Taddeo Zuccaro shaping in his chapel decorations. His brother Federico continued to develop the family style but moved toward the Counter-Maniera. Others like Livio Agresti, Marco Pino, and Cesare Nebbia adjusted their styles enough so as not to give offense and continued to paint sacred art in a subdued Maniera. They all contributed to the fresco cycle of the Oratory of the Gonfalone, begun in 1569 to be ready for the Jubilee in 1575.[140]

The Confraternity of the Gonfalone numbered among its protectors prominent cardinals, including Farnese. Its principal activity was the staging of a Maundy Thursday penitential procession through the city to the Vatican Palace in which other confraternities also participated. Many members who marched flagellated themselves with knotted ropes through backless shirts as they processed. When they eventually arrived back at the Oratory their bloody wounds were washed and tended. This kind of imitation of Christ and reenactment of his suffering was encouraged by the Counter-Reformation Church. It appears also to have been the incentive for the Oratory's decorative cycle.[141]

Christ's Passion was represented in twelve scenes, beginning with Jacopo Bertoia's *Entry into Jerusalem* and concluding with Marco Pino's *Resurrection*. Given special prominence inside the entrance wall were Christ's *Flagellation* by Federico Zuccaro (Fig. 137) and the *Mocking of Christ* by Cesare Nebbia (Pl. XXIII). There is a tenor of high emotion in all the scenes, as if the worshiper is being to called to participate in a way similar to that prescribed in Ignatius Loyola's *Spiritual Exercises*. Different from earlier sacred art, this cycle makes its appeal through the senses and the emotions. Different also from the reticence of some Counter-Maniera paintings, these frescoes use rhetorical and theatrical devices borrowed from the Maniera. Indeed, the whole ensemble is startlingly reminiscent of midcentury in its illusionism. Twisted columns covered with vines support a fictive architrave between which are placed the *quadri riportati*. Illusionistic garlands are draped from the cornice on which are seated Prophets and Sibyls (Fig. 138). Their poses and color are pure Maniera – some could almost have been invented by Salviati. At the center of the entrance wall King Solomon presides, making clear the identification of these columns as those of his temple in Jerusalem. Because the Lord himself, according to the Old Testament, had ordered the temple to be decorated, Solomon's temple was the principal justification for images offered by Catholic theologians in response to Protestant iconoclasts. Thus the Oratory became a Counter-Reformatory declaration of the purpose and correct use of images. The decoration is an interesting mix of old and new. Color throughout revives the fantastic juxtapositions of Maniera *cangiantismo*. One finds spectators in the narratives who stare out of the scene vacantly, not always seeking the viewer's eye, in costumes as theatrical as any invented for pre-Reform paintings.

Yet the total effect is not that of a retrospective Maniera. Despite the features recollected from the past, the intensity of unmasked emotion transmutes it into a style that has been rethought and reinvented. The closest precedent is the moderated Maniera of Taddeo, though with a greater infusion of feeling. In the setting of the Oratory, which was collective but not public, the members of the confraternity evidently felt free to experiment. The style they chose preserved from the past the appeal of a rhetoric employed to persuade, coupled with a more direct confrontation with emotion than was normally found in Maniera painting. In this heightened emotional content and serious rhetoric of persuasion we can perceive the seeds of the Baroque.

Several of the oratory artists were also employed at Caprarola. The still-young Bertoia was apparently in charge and invented the scheme before Farnese commandeered him to replace Federico Zuccaro at Caprarola. The brilliant but short-lived Raffaellino da Reggio – his Roman career lasted only six years – also worked on both commissions, executing *Christ before Pilate*[142] in the Gonfalone, probably in 1572–3 (Fig. 137). Amid a crowd, the humble Christ is brought before Pilate, who with flamboyant gesture demands what fault can be found in him. The focused attention of the arresting soldiers contrasts, on the one hand, with the bored and elegantly posed one who ceremonially holds the fasces, symbol of Roman authority, and on the other, with the friends of Jesus at the lower left. A young man with

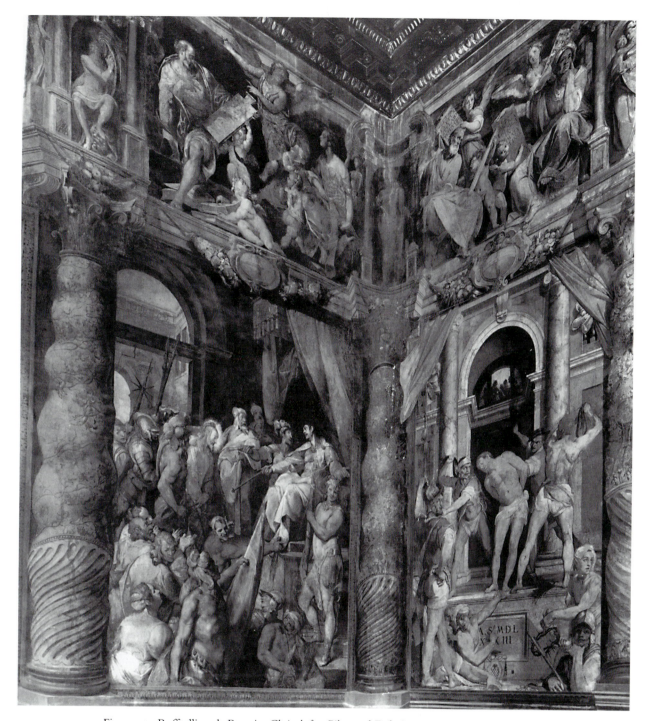

Figure 137. Raffaellino da Reggio, *Christ before Pilate* and Federico Zuccaro, *Flagellation*. Fresco, early 1570s. Corner view, Oratory of the Gonfalone, Rome.

long hair, perhaps the Apostle John, looks solicitously to the woman who clasps her hands in fervent prayer. Perhaps she is Mary Magdalen. In sharp contrast again are the half-naked men next to them, soon to be called to perform their job as flagellants, who muse sadistically, one chewing on his instrument of torture, the other gesturing toward the next scene with a grotesque enthusiasm of anticipation. The same figure appears in the next two scenes, recognizable by his turban, his narrow mustache, and his thin, divided beard. Despite a change of painter for each scene, Zuccaro and Nebbia have taken care to carry forward this narrative thread,

giving the drama an additional dimension of continuity. Federico's *Flagellation,* which follows next, contains two of those distracted spectators on the step below the stage, and a man holding the crown of thorns in preparation for the next scene, Nebbia's *Mocking of Christ.* Federico has not made the mistake for which Gilio had chastised Sebastiano del Piombo: his column is a replica of the short column preserved in a Roman church and venerated as the very one to which Christ was bound.[143] Curious but disengaged onlookers peer down from balconies of the palace surrounding the courtyard, making vivid the cruelty of some and the indifference of nearly everybody else.

On the other side of the entrance and the banner *(gonfalone)* of the Madonna of Mercy carried in the Jubilee processions in 1575,[144] Nebbia's *Mocking of Christ* is equally theatrical. It shows, instead of Zuccaro's bravely suffering Christ, a shrunken Christ, surrounded and overwhelmed by his torturers. Where the one gives us his nobility, the other shows him degraded and diminished.[145] The colors form a pleasing confection, ornamented with *cangianti* in imaginative combinations of tones. The paintings in the Gonfalone represent another of the several stylistic possibilities being tried during this period of transition.

EL GRECO IN ROME

In 1570 El Greco (1541–1614) came from Venice, where he had been working with Tintoretto. He was introduced to Cardinal Farnese by Giulio Clovio and apparently resided in the Farnese Palace for a while. Two of his paintings made in Rome survive, one a genre piece now in Naples, the *Boy lighting a Candle,* and the other a small devotional canvas that also was part of the Farnese collection and is now in Parma, the *Christ healing the Man born Blind* (Fig. 139). The metaphor of blindness cured once again represents those who have been restored

Figure 138. Jacopo Bertoia, *Prophets and Sibyls.* Fresco, 1569. Oratory of the Gonfalone, Rome.

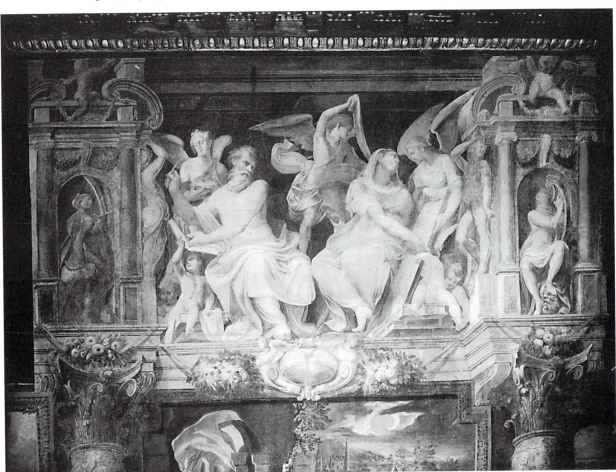

to the true faith, that is, the Roman Catholic Church. There is no evidence whether Farnese commissioned the painting or whether it was presented to him in the hope of receiving commissions.[146] El Greco had made an earlier version on panel, now in Dresden. Clearly he was impressed by what he had been seeing in Rome, for he added a nude quotation of the Farnese *Hercules,* a head next to it that recalls the *Laocoon,* and ruins in the background that look like the Baths of Diocletian.[147]

It is a beautiful little piece, glowing with Venetian color, full of spiritual energy, and emanating a reverent air. El Greco's adaptation of Venetian technique, in which colors are glazed thinly over a white underpaint, creating a scintillating effect, combined with his rapidly diminishing perspective and the windswept clouds, give his picture an excitability that conveys the mystery of the miracle. He was not apparently successful in Rome and returned to Venice by 1573.[148] One can understand why an artist of his temperament would have been drawn to Counter-Reformation Rome, away from the less reform-minded Venice, and we can imagine that even a few years later his inclination to mysticism might have found support from some patrons. But Romans were perhaps not overly tolerant of eccentricity, and El Greco's style might have seemed too willfully personal, even at this early stage in his artistic development. Or they may have been repelled by the Venetian qualities in his style. In any case, his Roman stay turned out to have been of greater significance to him than to Rome.

MYSTICISM

In the years following the Council of Trent we see the Church moving away from the intellectual approach to religious practice and toward a greater concern to engage the layperson. New religious orders, like the Jesuits and the Oratorians (which will be discussed in the final chapter), addressed themselves to the layperson

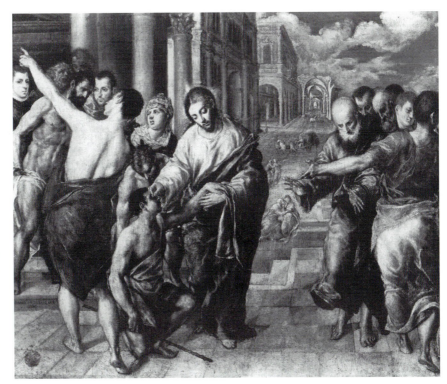

Figure 139. El Greco, *Christ healing the Man born Blind.* c. 1570. Galleria Nazionale, Parma.

and made use of affective appeal to engage that audience. A new kind of image began to appear in the 1570s that moved beyond the simple didacticism of the first reform paintings, like those of Siciolante, to invoke an emotional response. There is a fine example in the Dominican church, where the patron was not a wealthy individual but a confraternity.

During the 1570s Giovanni De'Vecchi discovered that his particular talent lay in creating this new kind of sacred art. He had worked at Caprarola in the last phase, by which time its decoration had turned entirely to religious subjects. He painted the walls of the Sala degli Angeli and the figured scenes in the Sala del Mappamondo with the younger Raffaellino da Reggio, to whom he seems to have delegated the more ornamental portions of the decorations. Then, sometime in the 1570s,[149] he was commissioned to fresco the walls of a chapel in the Dominican church of Santa Maria sopra Minerva. The patrons were the Confraternity of the Rosary, which was enjoying special prominence because the rosary was credited with a decisive role in the victory over the Turkish fleet at Lepanto in 1571.

Beneath an elaborate stuccoed vault with scenes of the fifteen mysteries of the rosary by Marcello Venusti

(1512–79), De'Vecchi painted the life of Saint Catherine of Siena. Saint Catherine is the Dominican's rival to the Franciscan's Saint Francis as a mystical saint.[150] De'Vecchi's is not simply a straightforward narrative of the saint's life, such as we saw in Siciolante's frescoes of the Virgin fifteen years earlier (Fig. 129). This cycle is decidedly mystical, based upon the *Dialogue of Divine Providence* that Catherine wrote in 1377/1378. Scene after scene represents the visions she related there. In the *Dialogue* she described how one must pass three levels of perfection of love to reach the goal of union with God, each level being represented in one of the frescoes.[151] The final means of ascent is through identification with the body of the crucified Christ, represented in the scene of her *Miraculous Communion* (Fig. 140). In the foreground Christ feeds her with a piece of consecrated bread that had mysteriously disappeared from the altar; we see the priest with his back to us, searching in vain for it. At the back of the picture is the bier with Catherine laid out in the very church where these frescoes are to be seen, where her funeral had actually taken place in 1380.[152]

Figure 140. Giovanni De'Vecchi, *Miraculous Communion of Saint Catherine of Siena*. Fresco, c. 1574(?). Capranica Chapel, Santa Maria sopra Minerva, Rome.

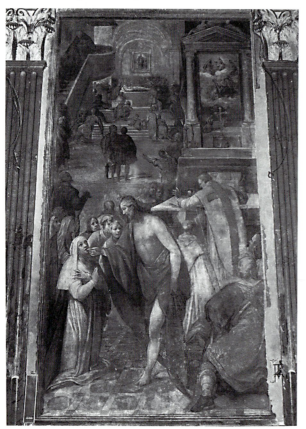

De'Vecchi has created a concatenation of realism and mysticism that serves to make the miraculous visions more plausible. To further their appearance of authenticity, the painter made all her visions take place on the ground on a level with her, not in the clouds as had been the norm in earlier representations.[153] Christ was shown lightly draped so as to emphasize the identification with the body of the crucified Christ that Catherine declared was the necessary final step to full mystical union with God. At some later date Christ was demurely covered up (removed in the restoration of 1979), apparently because later generations of Dominicans no longer understood the intended meaning and its relation to Catherine's writings, and took Christ's bared torso and leg to be the kind of artistic license condemned in the Tridentine Decrees.

When Saint Catherine's life had been represented in the Quattrocento it was her miracles that were most often depicted. The emphasis upon her visions fits with the Counter-Reformation interest in visions as proof of a saint's holiness.[154] De'Vecchi was careful to depict the scenes as they were described in the written sources, with the locations, for example, as authentic as possible, unlike earlier artists who had taken the usual Renaissance liberties. His style, even more than the older Siciolante's, is free of Maniera eccentricity. Like Muziano, De'Vecchi aimed for lucidity and legibility in his compositions, dignity in his figure style, and authenticity and accuracy in his settings. But more than Muziano, De' Vecchi represented an undisguised fervor of piety. This component of intense religious feeling had not been a part of the early Counter-Maniera, which accounts in part for its aridity. We have found it in an increased degree at the Gonfalone. We should note that Federico Barocci, whom we will consider in the last chapter, was already making a mark outside Rome with altarpieces that seemed intended to overwhelm the viewers' senses, pulling them into the painting in a manner that leads the way to the Baroque.

De'Vecchi was apparently known as Farnese's favorite painter, for when the Oratory of the Crocifisso hoped to lure the cardinal into increasing his support and taking responsibility for the decorations, they hired De'Vecchi as one of the principal painters. The strategy failed, for Farnese was committed to the Jesuits and "his" church of the Gesù. He commissioned De'Vecchi to paint its dome and pendentives, but they remained incomplete because the cardinal died and his

heirs showed no interest in continuing his patronage.

PRINTS

There is perhaps no more telling index of changes that took place in the last third of the Cinquecento than the print. It was the Jesuits who first recognized the potential for instruction and for propaganda that the medium of the print offered. When in the 1520s the Lutherans were exploiting the woodcut and the engraving to polemicize against the papacy and the ecclesiastical establishment (Fig. 63), no one had retorted from the Catholic side in the form of a print. When in 1563 the Protestant John Foxe published his book commemorating the Protestant martyrs in England with more than fifty woodcuts – increased to 150 in the second edition of 1570 – the Jesuits responded with two books celebrating martyrs, which were engraved after the frescoes they had commissioned for three of their seminaries in Rome.[155] Nicolò Circignani had begun the first of this series in 1582 for the English College, the church of Saint Thomas of Canterbury. The martyrdom of Edward Campion and thirty-eight other Jesuits in England was recorded on the walls for the edification of future priests who might follow in their footsteps. The scenes as they were depicted were gruesome enough, but the horror must have been intensified by the fact that it was an event that had occurred only a year before, and some of those murdered must have been known to the novitiates. These images are preserved today only in the prints, but Circignani's scenes of martyrdom in Santo Stefano Rotonda are still notorious for their explicitness. We, who are cool connoisseurs of cruelty on the screen, provided it is fantasy, are unable to comprehend how these gory depictions could have moved Pope Sixtus V to burst into tears upon visiting the church and seeing them.[156] The Jesuits recognized the didactic and affective benefits of such

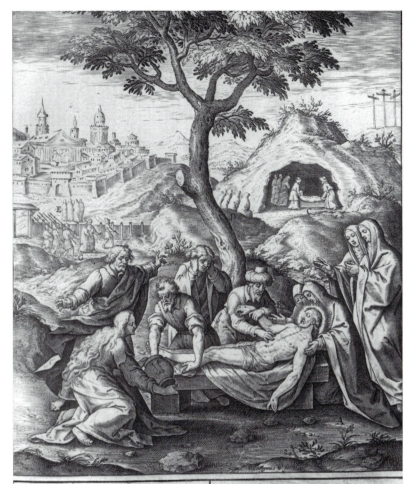

A. *Pie meditamur depositum è cruce filium, gremio Matris exceptum, quod non exprimit imago.*

B. *Stratum corpus super planum lapidem vngunt, obuoluunt sindone, & sudario.*

C. *Sepeliunt in horto, & sepulcro Ioseph; sepulcrum lapide occludunt.*

D. *Mulieres obseruant, vbi ponatur.*

E. *Maria Virgo Mater cum mulieribus redit domum.*

F. *Iudæi impetrant à Pilato, vt adhibeatur custodia sepulcro.*

G. *Veniunt ad sepulcrum: obsignant illud publico signo; apponunt custodiam.*

Figure 141. Hieronymus Wierix, *Entombment.* Engraving from Jerome Nadal, *Evangelicae historiae imagines.* 1595. Antwerp.

images, both for their priests in training and to combat Protestant heresy among the lay public.

Ignatius Loyola, the founder of the Jesuit Order, himself had asked his second in command and close associate, Jerome Nadal, to write a book that would serve as an aid in the visualization of prayer. Based on the same principle as Loyola's *Spiritual Exercises,* the engravings illustrate each of the Gospels read at Mass on Sundays throughout the year. The illustrations are keyed to explanations printed below by means of letters inserted in the printed image (Fig. 141). The second part of the book consists of scholarly exegetical notations on each of the

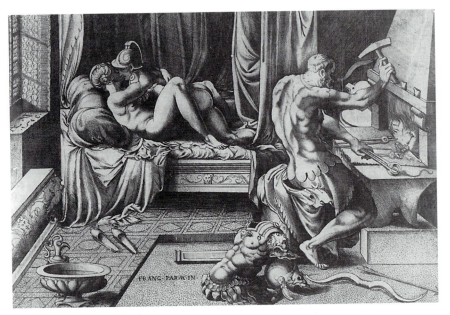

Figure 142. Enea Vico, *Venus and Mars.* Engraving after a design by Parmigianino, 1543, original version. © British Museum, London.

lettered incidents, which are then followed by a meditation.[157] This kind of guided meditation is typical of Jesuit didacticism, and books of this kind proliferated in the next century when Jesuit fathers took them on their missionary expeditions to the corners of the earth as aids in teaching and converting people to whom Western civilization, to say nothing of the Christian gospel, was

Figure 143. Enea Vico, *Venus and Mars.* Engraving after a design by Parmigianino, 1543, censored plate. © British Museum, London.

totally alien. The *Entombment* shows in the foreground the body laid out on a stone and a linen shroud being prepared for burial. In the background people are carrying it to Joseph of Arimathea's sepulcher as the Maries look on, while in the upper left (F) the Jews are entreating Pilate to set a guard on the tomb and below (G) we see the soldiers approaching, as the legend explains. At the top the texts are cited: Matt. 27, Mark 15, Luke 23, John 19.

This was the kind of print that replaced the mythological scenes so popular earlier in the century. After the Tridentine Decrees stated that everything lascivious was to be avoided, prints of mythological subjects were almost abandoned in favor of sacred images.[158] In the middle decades the engravers in Rome had sometimes reproduced designs of painters who were working in other centers, like Giulio Romano in Mantua or Parmigianino in Parma. In this way their images traveled back to the center and became widely known. We have seen that one of the most popular subjects of mythological prints in the Cinquecento, beginning with Marcantonio Raimondi (1482–before 1534) (Fig. 31), was *Mars and Venus.* As time went by, the treatment became more and more explicit.

Enea Vico (1523–67) engraved the version from the circle of Giulio Romano in the late 1530s or early 1540s (Fig. 71). By this point the couple has reached the bed, and Venus has shed her clothes, but Mars is fully dressed in his armor.[159] Vico's version, dated 1543 after Parmigianino (Fig. 142), which depicted the adulterous couple in bed behind the back of the cuckolded husband Vulcan, was too much for the Counter-Reformation. The plate was ground down and recut, to show Venus chastely sleeping and no sign of Mars remaining (Fig. 143).[160]

Ducal Florence

WHEN COSIMO DE' MEDICI WAS ELECTED SECOND DUKE OF THE Florentine state in 1537 he was a youth of seventeen who had no expectations of assuming such a role and no training for it. Only disastrous circumstances, such as in fact occurred, could have brought the leaders of the former proud Republic of Florence to elevating another Medici by their own choice, but it was clear to all that the alternative would be absorption into Charles V's empire. The moment Pope Clement VII had imprisoned himself in the Castel Sant'Angelo in May 1527 to escape the Imperial army, the Florentines seized the opportunity to throw off the yoke of the papal Medici rule and reestablish their republic. For three years the reborn republic survived, though under ever-increasing threat as Clement escaped, allied himself with the emperor, and reasserted his hold. The Imperial army, when it finally withdrew from Rome, made its way to Florence, where in October 1529 it encamped outside the walls and laid siege. When the city finally capitulated, an adolescent illegitimate Medici son, Alessandro, was declared duke of the Florentine republic with the right of male succession.[1] As Eric Cochrane remarked, "Florence had now become a monarchy in all but name."[2]

The consequence of these political upheavals for the arts was a period of sparse commissions, corresponding to the same barren decade in Rome following the Sack. Michelangelo (1475–1564) abandoned the Medici Chapel and threw his energies into working for the republic that was so close to his heart. He designed the fortifications that were built, even traveling to Ferrara to study the famous fortifications there. Jacopo Pontormo (1494–1557) and his pupil Agnolo Bronzino (1503–72) were the principal painters active in town, together with Andrea del Sarto, who died in 1530.

Pontormo continued the highly personal style of his Santa Felicita chapel in his *Madonna and Child with Infant Saint John* (Fig. 144). His composition and design draw the viewer in, inviting participation in the pathos of the mother who clings to her child as the young John, whose forlorn expression tells us that he has seen the tragic future, whispers questioningly in her ear. The child, looking away from both his mother and the boy, whose loving touches seek to restrain him, separates himself with a sad look of acceptance of what he, too,

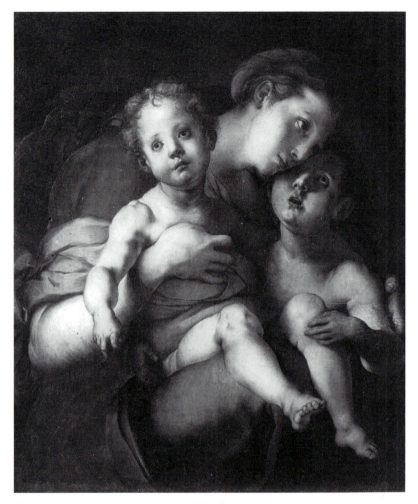

Figure 144. Pontormo, *Madonna and Child with Infant Saint John*. c. 1527–8. Uffizi, Florence.

younger Bronzino, in his search for his own personal style, was affected by Michelangelo's example.

During the late twenties and the thirties Bronzino moved away from Pontormo's experiments with a heightened spirituality, replacing his master's distortions of space and figural proportion and febrile line with his own cooler, more ordered, more regulated manner. Despite his stylistic independence, however, he remained his master's close friend, always at Pontormo's beckon.[4] The portrait style he began to define at this time, and for which he became justly renowned, shows his objective, distanced perspective. We need only compare Pontormo's poignant, haunted *Halberdier* (Malibu, J. Paul Getty Museum of Art, 1529–30) with Bronzino's self-assured *Young Man* in the Metropolitan Museum, of perhaps nearly the same date, to understand the difference in temperament between the two painters that was manifesting itself in these years.[5] Pontormo's soldier is a vulnerable youth of only about fifteen, whose equivocal gaze seeks ours with insecure hauteur.[6] Bronzino's young man, who has interrupted his reading to cast a stony glance in our direction, does so with an aloofness that we are not invited to pierce or circumvent. He is made all the more impenetrable by the disconcerting cast of his left eye, so that we are not able to discern whether he is actually looking at us or off to the side. So many of Bronzino's sitters in the following decades will exhibit this peculiar characteristic we must conclude it was a device he invented to interrupt the exchange between sitter and viewer, as if to permit his patrons to guard their privacy, or to suggest their determined intent to do so.

His *Lamentation over the Dead Christ* (Fig. 145), painted in 1529,[7] shows Bronzino's deliberately methodical rendering. He has chilled the fervor of Pontormo's Santa Felicita version of the subject and presents instead a more distanced and formalized interpretation. It is as if he is seeking to formulate for himself the rules that Pontormo could so effectively and affectingly break. Christ's body, placed on the ground, is attended by the Madonna, heav-

foresees. The note of foreboding had been sounded before in many a *Madonna and Child* since Leonardo's, but perhaps never with such poignant intensity.

When the siege was broken and the city was compelled to accept the Medici duke, Michelangelo received a commission from one of the emperor's leading generals. He was granted an unusual degree of freedom, to choose the medium and the subject himself. The *Noli Me Tangere* that he designed has survived in several versions, but what is of particular interest is that he turned over the execution of his cartoon to Pontormo, as he would again with his cartoon of *Venus and Cupid*.[3] In the course of executing these two paintings for Michelangelo, Pontormo was exposed firsthand to the style that Michelangelo took up at this period – flattened sculptural figures turned into the plane. Although it would not make a lasting impression on Pontormo, the

ily draped in a nunlike brown habit, and Mary Magdalen. Although the picture is certainly not lacking in feeling, it is legible and readily accessible as Pontormo's Santa Felicita *Entombment* is not. For Pontormo's weightless, intertwining, curvilinear shapes, Bronzino has substituted a firm geometry, enhanced by the rational illumination. Although his style has become more sculptural and his figures more weighty, in response to Michelangelo's influence, one cannot properly speak here of the relieflike style. Nothing like Perino del Vaga's demonstration in the *Crossing the Red Sea* (Pl. XI), which Bronzino must have known, is to be seen here. Bronzino is not yet moving in the direction of defining new artistic conventions; rather, he seems intent upon discovering for himself a less eccentric and fanciful style than his master's.

His achievements in these years were sufficient to attract the attention of the duke of Pesaro, and Bronzino spent a substantial number of months in 1530–1 at that court, and would have stayed longer if Pontormo had not summoned him to return to assist on frescoes for Poggio a Caiano (which were never carried out). Pontormo received commissions in the succeeding years both from the young Duke Alessandro and later from Duke Cosimo for fresco cycles to decorate Medici villas, but he worked so slowly and in such secrecy that he achieved rather little and exasperated his patrons. Bronzino proved more reliable.

During the mid-thirties, after his return from Pesaro, Bronzino several times explored adapting sculptural models, particularly antique sculptures, to his painted images. His portrait of *Andrea Doria as Neptune* (Milan, Brera, c. 1532–3) was based on a sculpture by Baccio Bandinelli (1493–1560), which had been commissioned in 1529 as an expression of Genoa's gratitude for Doria's role in the events of 1528. Bandinelli's statue was never completed and remained in Carrara where it had been executed. There had never been a more sculpturelike portrait painted in Florence than this one by Bronzino, as Smyth remarked.[8] Bronzino followed this work with

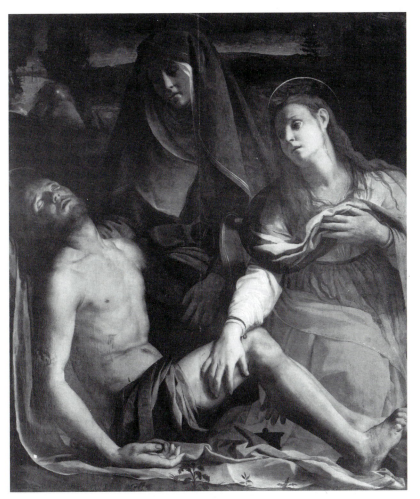

Figure 145. Bronzino, *Lamentation over the Dead Christ*. 1527–9. Uffizi, Florence.

the lovely Panciatichi *Holy Family* (Fig. 146), for which he chose a new type of secular beauty for the Madonna. Her head, now undraped, reveals hair that falls into regular waves like that of an antique marble goddess. As we will see, a few years later still, when he had entered the duke's employ, Bronzino based his portrait of *Cosimo I de' Medici as Orpheus* (Fig. 148) on a specific, well-known antique marble figure.

Like his earlier *Holy Family with Saint Anne and John* in the National Gallery of Art, Washington (c. 1527), the Panciatichi *Holy Family* fills the surface and the figures press toward the plane. The landscape is a mere distant backdrop. Less intimate, tender, and informal than Pontormo's earlier *Madonna and Child with Infant Saint John* (Fig. 144), Bronzino's looks almost formulaic in contrast. Gone are the excavated recesses we saw in Pontormo, the movement toward and away from the plane

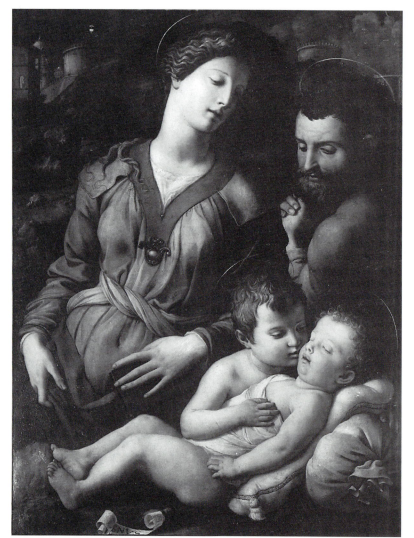

Figure 146. Bronzino, Panciatichi *Holy Family*. 1533–7. Uffizi, Florence.

figure, first through the influence of Michelangelo, then through his interest in sculptural models. He was thus already inclined toward the Maniera when he was actually exposed to it on a visit he probably made to Rome around 1538.

◆

DUKE ALESSANDRO DID LITTLE to endear himself to his subjects. His amorous escapades were known all over the city. One night in January 1537 his dissolute and ambitious companion of the night, Lorenzino de' Medici, murdered his depraved cousin the duke and was then forced to flee himself, leaving the city with no one to succeed except Alessandro's infant bastard son. Cosimo, a teenaged cousin from the collateral branch of the family, was the city's only hope.[10]

The young Cosimo revealed a surpising instinct for political strategy, coupled with a devotion to his native Florence that surprised no one. He recognized from the start that the survival of Florentine independence relied on his demonstration of unequivocal allegiance to the emperor, a policy he pursued until his death in 1574. The emperor accepted his accession within a few months but decided against awarding Cosimo his daughter Margherita, the widow of Alessandro, who was married instead to Pope Paul's grandson, Ottavio Farnese; she became the mistress of the Villa Madama (and Palazzo Madama) in Rome, we may recall. Familial ties with the emperor would, of course, have consolidated Cosimo's position beyond question, but the wife he got instead proved to be a remarkably successful choice. Eleonora was the daughter of one of the leading families in imperial Spain, and her father was viceroy of Naples. Quite unexpectedly in an age of marriages arranged for political advantage, the couple fell in love and became very close.

When Cosimo was elected, Florence was an indigent shadow of its former self. From a population of ninety thousand in the time of Lorenzo il Magnifico, it was reduced to fifty thousand.[11] By exercising his talent for

and the foreshortened limbs. Pontormo's curving shapes have been replaced by a rectilinear pattern, disciplined into a sterner geometric pattern, and his surging emotion has also receded. Bronzino, here as in his *Lamentation* (Fig. 145), has flattened his figures to the plane as part of his attempt to define a more methodical style.

The figures, except for the children, lack an easy organic relation with one another despite their proximity to each other,[9] which was already true in the Washington *Holy Family*. This detachment seems a harbinger of Maniera, where figures often seem to have been studied separately and then assembled in the composition. Yet the artificial poses in which the Maniera would delight do not yet appear. It would seem that for Bronzino the way was prepared to accept the Maniera conventions of the

organization, Cosimo created a bureaucracy that functioned with such efficiency that even without specific incentives, the economy slowly improved and people began to return. Following his decisive defeat of the rebel exiles at the Battle of Montemurlo (1537), many of those who had fled came to recognize that Cosimo's rule was benign and beneficial, and they eventually began to filter back. Cosimo was able to restore confidence because he never undertook to be an absolute ruler. His theory of governance was guided by his obsessive enthusiasm for efficiency: he left in place those institutions of the republic that operated effectively and intervened only when they did not. Advocates of the republic were compelled to admit that the duke's government functioned with justice and a greater measure of equality than the republic ever had.

Much as in Rome where patronage followed the pope's lead, under the new regime in Florence it was the duke who set the pace and tone for artistic patronage. Cosimo actively sought to reestablish the decimated artistic and intellectual community, and though he never succeeded in luring Michelangelo back to his beloved native city, his other successes were sufficient so that by midcentury Florence could again claim to be a major cultural center.

When Cosimo first came to power there was no tradition in Florentine visual culture on which he could draw to express his authority. His advisers turned to Rome and to classical antiquity to provide these "metaphors of power."[12] We will see how well-known images, like the *Belvedere Torso* or the *Liberalitas* relief, were quoted to lend prestige and dignity to him and his regime. We will observe also how carefully Cosimo's assertions of power were balanced with his insistence upon continuity with the Florentine republican past. Some of his early and most sagacious borrowings were from republican Rome, like the Camillus cycle in the Sala dell' Udienza, his first large-scale commission. We can watch over the course of the next thirty years how the young duke assimilates himself to the classical antique past and takes on the identity of Roman heroes until finally, in the last decade of his life, he can be openly represented as Emperor Augustus himself in a monumental sculpture.[13] The strategies of enlarging the claims, of escalating the prototype from hero of the Roman republic to Roman emperor, were orchestrated with circumspect care so that with the aid of these images, the Florentines in one generation were eased

from citizens of the republic to subjects of the grand duke – the equal of a monarch.

Bolstering the explicit antique subject matter was the application of style borrowed from the antique, which could work in a more subtle, perhaps even a subliminal, way. The relieflike style, transformed in Rome into the Maniera almost at the moment Cosimo assumed power, would be imported to Florence for the political purpose of elevating the image of the duke. The style *all'antica* as it had been demonstrated in the Oratory of San Giovanni Decollato would provide Cosimo with the visual language he needed. Feeding Florence's identification of itself as a city founded by the ancient Romans, the style based upon Roman relief could best convey that association.

Giorgio Vasari (1511–74) visited his friend Francesco Salviati (c. 1509–63) in Rome in 1538 and must have then seen Jacopino del Conte's *Preaching of the Baptist* (Pl. XVIII). The new style may have been tried out for the first time in Florence in the temporary decorations for Cosimo and Eleonora's wedding in June 1539. Salviati, passing through town on his way to Venice, designed one scene (although it was executed by a local colleague because he had to leave) and Bronzino another.[14] When Salviati was hired a few years later to decorate the Sala dell' Udienza in Cosimo's new residence, the Palazzo Vecchio, he showed himself to be a master of the new Roman Maniera.

Vasari experimented with the new way of constructing pictures in his *Deposition* for Camaldoli, commissioned in June 1539 and sketched then (Fig. 147).[15] Compared to his own earlier works, especially the paintings of the same subject in Arezzo,[16] he has moved away from the example of Rosso Fiorentino (1494–1540) and Baccio Bandinelli, which had previously influenced him. His figures here are more statuary, less agitated. Feverish activity has given way to greater solemnity, especially in the lower zone. In figures like John at the right, the Madonna, or the Magdalen who clasps her hands with elegant eloquence, the rhetoric of Rome has become prominent.

Although he had visited Rome in 1532, when he and Salviati drew obsessively day and night copying antique and contemporary art, it was this second trip in 1538 in which that experience gelled.[17] To be sure, in his paintings from the period between his two Roman visits there are premonitions of the posed and artificial *grazia* of his mature style, but it is in this *Deposition* that we see the surface filling up with figures flattened to the

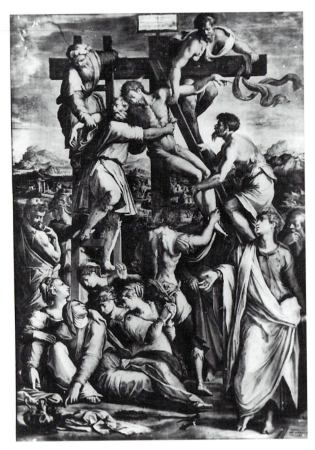

Figure 147. Vasari, *Deposition*. 1539–40. Camaldoli, monastery church.

picture plane; those surfaces parallel to the plane illuminated with a strong, flat light; secondary figures competing with the principal actors for the viewer's attention; and a shift away from emotion associated with the narrative toward more formal concerns.[18] Here we see at the far left for the first time that bare-armed man who will appear repeatedly in Vasari's oeuvre.[19] Not really involved in the action or the emotion of the scene, he is a self-absorbed ornament who conveniently and decoratively fills the space.

At about the same time (1540–1), Vasari's friend Bindo Altoviti provided him a prominent Florentine showcase in which to exhibit the new style, the altarpiece for the Altoviti family chapel in the church of Santissimi Apostoli of the *Immaculate Conception*.[20] Vasari rose to the occasion and invented an iconography that matched in erudition his learned new style. He was probably familiar with Rosso's unexecuted design of the same subject for the lunette in Arezzo, Vasari's hometown, which he then elaborated in his own composition. To represent the abstract doctrine of the Immaculate Conception,

Vasari placed the Virgin's foot on the crescent moon, symbol of her virgin birth, pressing down the head of winged Satan with serpent tail, who presides over the gloomy limbo below. It is inhabited by Adam and Eve and other heroes of the Old Testament who were born before Christ. They are all bound to the Tree of Knowledge, the result of our first parents' sin. The inscription on the scrolls links the sin of Eve with the saving grace of Mary.[21] Several drawings are preserved that record the progress of his composition, but most interesting to us is the wash *modello,* squared for transfer, in which Vasari has studied the effect of light and shade. We see that flat light striking the foremost parts of the figures, which Craig Smyth has isolated as one of the crucial characteristics of the Maniera style, and the lack of subordination, so that the whole surface is ornamentally filled.[22]

The first application of the Roman style in Cosimo's court to have come down to us is Bronzino's portrait of *Cosimo I de' Medici as Orpheus* (Fig. 148). It is a striking and curious image. The young prince is shown nude, his back to the viewer, holding a bow and a musical instrument. A reddish glow in the distance suggests the hellish underworld, and the figure is approached by what appears to be two great docile mastiffs (actually two of Cerberus's three heads). The features of Cosimo, with a slight growth of beard and dim mustache, are unmistakable. This work is evidently another allegorical portrait, like that Bronzino had made a few years earlier of *Andrea Doria as Neptune*. But as Cosimo was never known as a musician, it has proved difficult to discover why he chose to have himself represented as the mythological Orpheus, famed for his music.[23]

The story of Orpheus is a tragic one as told in the ancient sources. His beloved bride Eurydice died, and grief-stricken Orpheus followed her to the underworld to plead for her release. With his music he gained entrance by charming the guardian dog, Cerberus, and persuaded Pluto and Persephone to let Eurydice follow Orpheus back into the world, on condition that he not look at her until she reached the light. The loving husband could not resist a glimpse over his shoulder, and Eurydice slipped back into the underworld, lost forever.[24] The late Middle Ages revised the story to create a happy ending, which is the version frequently referred to in Renaissance imagery, and presumably here. It seems likely that Bronzino's allegorical portrait was made in connection with Cosimo's wedding in 1539 to Eleonora di Toledo. The lavish celebrations were well documented and, as it happens,

descriptions have come down to us.[25] They contain numerous references to the fecundity of the ducal couple, for, of course, a male heir was the hoped-for outcome. (The seventeen-year-old Eleonora did not disappoint: she bore eight children who survived infancy, four in the first four years, two of these boys.) In the portrait Cosimo is represented as the faithful lover who will dare hell to retrieve his lost wife, but as with all such portraits, there is more to the imagery.

Orpheus had entered Florentine Medici iconography with a statue by Bandinelli commissioned by Pope Leo X around 1517 for the courtyard of the Medici Palace. Because Orpheus was described by Horace as able to tame savage men by means of his soothing music,[26] he was regarded as a civilizing agent and a reconciler. Leo's carefully chosen image suggested that he would be such a healing force in Florence, which had undergone so much political turmoil before Medici rule had again been imposed. The parallel situation in Cosimo's time must have suggested returning to the image of Orpheus, which would have been still prominent in the minds of Florentines.[27]

Bronzino has copied Cosimo's pose from the *Torso Belvedere* (Vatican, Museums), to which he has appended the portrait head in uneasy juxtaposition. In the Renaissance, this famous antiquity was identified as Hercules, and Cosimo had adopted Hercules as one of his first emblems.[28] The last of Hercules's tasks was to capture the ferocious dog Cerberus, which Orpheus-Cosimo has done in Bronzino's painting, not by force but with his music.[29] Thus Cosimo here is the hero who will emulate the strength and virtue of Hercules and the peaceful means of Orpheus to bring another Golden Age to Florence. Because Lorenzo il Magnifico had been frequently associated with Hercules, Cosimo's image as Hercules allowed him to stress continuity in the political regimes. The two prototypes unite the republic (through Hercules) with the Medici rulers (through Orpheus).[30] The association with the arts, and

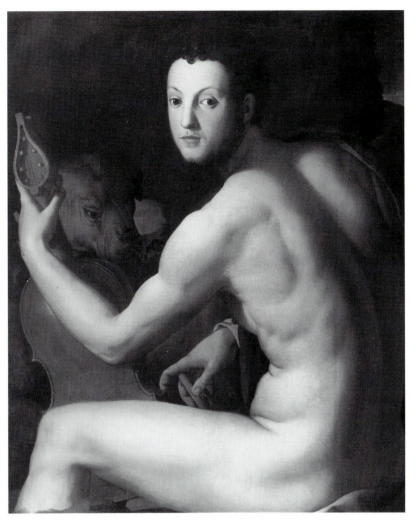

Figure 148. Bronzino, *Cosimo I de' Medici as Orpheus*. c. 1539. Philadelphia Museum of Art. Gift of Mrs. John Wintersteen.

with love and faithfulness, are appropriate to the context of the wedding, which was at one and the same time a political and a personal celebration.

Technical examination of the painting has revealed interesting changes made in the final version.[31] In the first version the figure's back was partially draped and the pose was less unmistakably that of the *Torso Belvedere*. This suggests either that the painter did not originally conceive the figure as based on that model or, more likely, that the reference was deemed to be too well disguised, and the changes were to make it easier for the viewer to identify the quotation. In addition, the position of the *lira da braccio* and Cosimo's hand holding the bow have been shifted, so that now the bow lines up precisely with the prominent pegbox. The position of the pegs suggests the Medici coat of arms, but the

shape of the pegbox, not to mention the bow, is con-
spicuously phallic. In keeping with another of the
themes of the wedding decorations, the union being
celebrated is physical as well as political.

The Medici were among those in the Cinquecento
who understood best the usefulness of visual propa-
ganda. Cosimo's iconographers must have kept them-
selves busy searching out new emblems, developing
new allegories, assessing ones already used, and discard-
ing those that did not work. (Cosimo did not appear
again as Orpheus.)

Bronzino seems to have become acquainted with the
contemporary Roman scene, for in his Cosimo he not
only quotes the pose of a Roman antiquity – which he
could have known from an engraving – but also employs
the style of the new Maniera. He pushes the figure
against the plane and flattens it with frontal lighting. Uni-
form modeling, the prominence of limbs, and the abrupt
twisting of the legs, torso, and head are all here to be
seen. In fact, the painting, with its shallow space and mar-
blelike flesh cannot but remind us of marble relief. The
unnatural hot blush of the cheeks serves to heighten the
artifice of the too-white flesh. It seems likely that
Bronzino visited Rome in an undocumented trip in 1538
or 1539.[32] It is clear that his style found favor, for
Bronzino would receive the first major commission for
the duke and duchess's new home in the Palazzo Vecchio.

The traditional home of the Medici, today known as
the Palazzo Medici-Riccardi, had been claimed by Ales-
sandro's widow, so that Cosimo had to pay rent on it,
despite his status as duke. His decision to move into the
city hall of the republic and to make it over into his resi-
dence was not only practical under these circumstances
but also political. His intention was to show the continu-
ity of his regime with the Florentine past, and if the move
looked arrogant on the one hand, it could be viewed as
respectful to tradition on the other. Cosimo's visual pro-
paganda, the decoration of the Palazzo Vecchio that would
occupy him, his advisers, and his artists for the rest of his
life, would be marked by the same perspicacious duality.

BRONZINO'S CHAPEL OF ELEONORA

Bronzino was commissioned to decorate the newly con-
structed little chapel in the duchess's wing of the palace,
beginning in 1541 with the vault (Pl. XXIV). The walls
followed over the next two years, reaching completion
in late 1542 or early 1543. The altarpiece, the *Lamentation*

now in Besançon (Musée des Beaux-Arts), was not
completed until 1545, and Cosimo promptly gave it
away as a diplomatic gift. Bronzino did not make the
replica, which is in the chapel today, until 1553.[33]

The frescoes represent scenes from the story of Moses
on each of the three walls. The choices are not always
the obvious ones – the giving of the tablets of the law is
excluded, for example. Close scrutiny reveals a pattern to
Cosimo's personal mythology. All three of the early
cycles he commissioned represent saviors of the people.
For the set of tapestries soon to be discussed, of which
Bronzino would be the principal designer beginning in
1545, the Old Testament *Story of Joseph* was chosen.
Rejected by his brothers and sold as a slave, Joseph rose
to prominence in Pharaoh's court in Egypt; his foresight
saved both Egypt and the Hebrew people from famine,
and he returned in triumph to his native land. *Camillus*
was the subject chosen for Salviati's cycle in the Sala
dell' Udienza, begun shortly after Bronzino commenced
work. He was a Roman general who was recalled from
exile to defeat the enemy and then returned in triumph
to his native city. Moses was the Hebrew child, born an
exile in Egypt, who led the exodus out of Egypt to the
Promised Land. The theme of the return of the exile, a
favorite Medici topos, runs conspicuously through all
three subjects. As an extension of the theme, Bronzino's
frescoes all illustrate episodes where the people rebel
against Moses and then reverse, turning to him again as
their chosen leader.[34] Thus, on the wall to the left of the
altar is represented the *Crossing the Red Sea and Moses
appointing Joshua* (Fig. 149). With wonderful understand-
ing of human nature, the story tells how Moses, with
God's help, has led his people out of bondage in Egypt
and has turned back the Red Sea to let them cross it,
then released the waters to drown Pharaoh's pursuing
army. Then, once free and safe, the people complain
mutinously because they cannot find sufficient food or
drink (Exod. 14; Deut. 31). On the opposite wall of the
chapel are represented Moses' acts of rescue, one with
water, the other with food: *Moses bringing Forth Water
from a Rock* (Exod. 17:1–6) and the *Gathering of Manna*
(Exod. 16).[35] On the entrance wall opposite the altar is
represented the *Brazen Serpent,* another story of rebel-
lion, punishment, and forgiveness. The people are again
complaining, so the Lord sends a plague of poisonous
snakes that bite and kill many of them. When the
remainder come to Moses begging him to intercede, the
Lord orders him to put a bronze serpent on a pole and

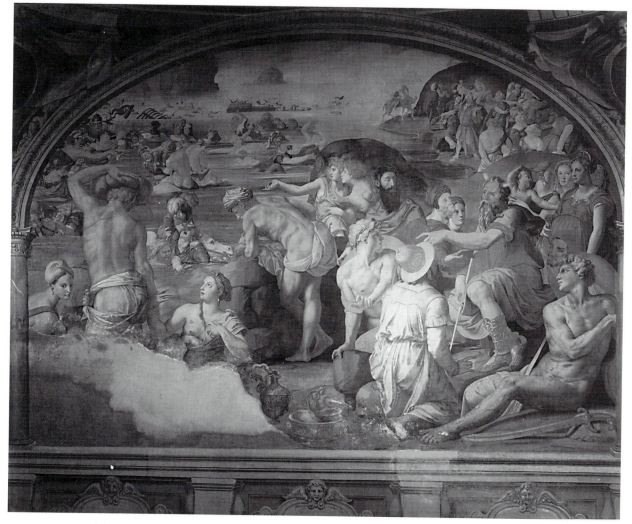

Figure 149. Bronzino, *Crossing the Red Sea and Moses appointing Joshua*. Fresco, 1542. Chapel of Eleonora. Palazzo Vecchio, Florence.

bring those bitten to look at it, and they will be healed (Num. 21:4–9).

The primary meaning of these frescoes is, of course, the evident biblical one. They are rich in allusions to the New Testament and to the liturgy, which was the hidden subject of the altarpiece, the *Lamentation,* painted in oil on panel. There the body of the crucified Christ on the lap of his mother is mourned by his friends. Two angels, mixed inconspicuously in the crowd, hold the chalice and the veil and point to the Body of Christ, signifying its meaning in the Eucharist as the means of redemption.[36] The *Gathering of Manna,* shown to the left of the altar, was a familiar Old Testament prototype for the Bread of Life in the Eucharist because manna, a mysterious, edible, breadlike food, suddenly began to appear in the desert every morning and saved Moses' people from

starving. *Moses bringing Forth Water from a Rock,* again to save his people, foreshadowed the saving water of Baptism. The *Brazen Serpent,* which when installed took a form that resembled a cross, was seen as a prefiguration of the Crucifixion because it likewise had the power to redeem the repentant. (It was with this meaning that it was included in Michelangelo's Sistine Chapel on one of the corner spandrels, where each spandrel represented a prototype of Christ.)

Clues, both of motifs and of style, that there is a second level of meaning are evident throughout. Let us note only a few prominent examples. The stories are drawn from widely dispersed texts and are not given in chronological order. The *Crossing the Red Sea,* for instance, combines the earliest episode with one of Moses' last acts, the appointment of Joshua. That the *Crossing* refers to the

defeat of Cosimo's enemies at the Battle of Montemurlo is made explicit by the inclusion of the arms of Strozzi, the leader of the rebels, on the banner of a drowning man.[37] Cosimo and Eleonora are present in the scene, though not in portrait likenesses, in the figures of Moses and the pregnant woman behind him. Moses is shown in the act of appointing his successor, Joshua, referring to the establishment of a Medici dynasty. The duchess had in fact given birth to a male heir, Francesco, a few months before the fresco was painted.[38]

Bronzino has chosen a style here abounding in artifice and exceeding in its degree of remoteness from nature anything that he, or anyone else, had done in Florence up to this time. That he was familiar with developments on the Roman scene, in particular Michelangelo's recently unveiled *Last Judgment,* is abundantly clear.[39] The fresco was uncovered at the end of October 1541, when Bronzino was already at work on the vault of his chapel. It is on the walls, and particularly in the color and sculptural delineation of his figures, that one sees the impact of Michelangelo's fresco. The extensive use here of the blue pigment, ultramarine, is exceptional in frescoes. Bronzino employed it all around the altar: in the Saint Michael, the draped cloth in the spandrel to the right of the altar, and then throughout the scene of *Crossing the Red Sea.* The pigment, made from the semiprecious stone lapis lazuli, was exceeded in costliness only by gold. It was used primarily in altarpieces, where it was reserved for limited fields of great symbolic importance, such as the Madonna's robe.[40] In modern times it used to be said, inaccurately, that it could not be used in fresco, a deduction from its virtual nonexistence in that medium. It was, in any case, difficult to work in fresco. But it appears, we will recall, as the background blue in Michelangelo's *Last Judgment* (Pl. XVII).

As we can see that fresco today, freshly cleaned, it has the same impact that it must have had on Bronzino and his contemporaries. In his frescoes for Eleonora's chapel, the brilliant purity of the ultramarine and other colors, used often with relatively little modeling, combined with jeweled figures and lavish objets d'art, creates an aura of splendor quite removed from the ordinary world. Enhancing its preciosity is the repertory of theatrical pose and consciously rhetorical gesture Bronzino has invented, or imitated from antique sculpture. Each of his figures gives the impression of being individually studied – as indeed they were – and then artfully combined with an eye to creating abstract pattern rather than convincing narrative or naturalism. This quality is to be found more in contemporary Roman art, and particularly in the *Last Judgment,* than in Bronzino's master, Pontormo, or in his own earlier works. Like Michelangelo, Bronzino isolates each figure with a firm sculptural contour and makes each gesture and pose tell. Bronzino's dependence upon Michelangelo is perhaps less surprising when we take into account that he had not previously worked in fresco on his own. Certainly he studied Michelangelo's earlier frescoes in the Sistine Chapel, as well as the altar wall. The *cangiante* colors he sometimes uses for striking effect come more from the Ancestors in the lunettes than from the *Judgment.*[41] Bronzino continued throughout his career to rely on Michelangelo's example for his fresco style – much more than for his paintings in oil – as we can see in his last fresco, the *Martyrdom of Saint Lawrence* (Fig. 159).

Bronzino's sculptural style, like Michelangelo's, is less like relief than like sculpture in the round, but the conventions we have identified with the relieflike style are to be seen. Particularly characteristic is Bronzino's delight in foreshortenings, at the same time that he flattens figures against the plane with bent limbs. The tension between two dimensions and three, between restricted flatness and poses suggesting the need for freedom and flexibility, produces some of the *difficoltà* that was highly valued by this generation, as Vasari makes clear to us.[42] His line, which creates smooth contours devoid of irregularities, removes his figures further still from the natural realm.

Bronzino constructed the artificial world in his chapel for a sophisticated and very restricted audience. The chapel is so small that it can accommodate very few people, and we must imagine that it was visited only by members of the family and an occasional intimate of the court. His abstracting and aestheticizing style matched well the rarefied air of precious materials, of elegant pose, of concealed reference, and of private meaning. In his works for a public religious setting, he adjusted his style, at least to some degree.

SALVIATI'S FRESCOES IN THE SALA DELL' UDIENZA

Salviati's commission, unlike Bronzino's, was for one of the large public audience rooms in the palace (Fig. 150). Shortly before he was awarded the commission in October 1543, Cosimo had at last negotiated the return

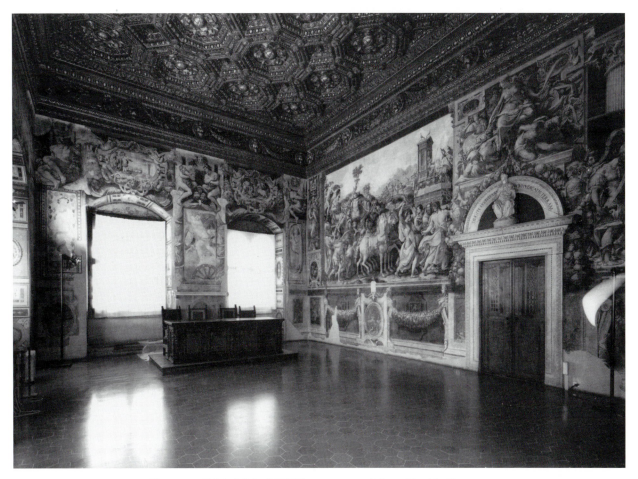

Figure 150. Salviati, Sala dell' Udienza. 1543–5. Palazzo Vecchio, Florence.

of all the Florentine fortresses, which had been held by the emperor, and the withdrawal of his Spanish soldiers from the Florentine territory. The stability of his realm was the reward for the duke's patient courting and insistent diplomacy. The subjects chosen for the audience hall, which was the first public room in the palace to be decorated, celebrated this and earlier victories of Cosimo in a complex mix of scenes drawn from Roman history, the Bible, classical mythology, and Christian allegory. The principal walls are given over to the Roman hero Marcus Furius Camillus, who Livy said was hailed as the second founder of Rome [Bk. V, 49] for his defeat of the Gauls. Cosimo had also defeated the French and made a successful alliance with the emperor. Camillus's victory at Veii had its counterpart in Cosimo's defeat of the exiles at the Battle of Montemurlo. Cosimo further resembled Camillus, who had been recalled from exile, in that he had been called unexpectedly from a kind of political oblivion, if not exile, to the role of duke. The principal wall depicts

Camillus's triumphant return to Rome after the battle, which is represented in the background (Pl. XXV). His chariot follows behind the shrine containing the famous statue of Juno that he has captured and is transferring to Rome. The representation reenacts the ancient triumphs that were voted by the Roman Senate to honor a conquering hero, the kind of celebration that had been staged in Rome for Charles V on his return from Tunis in 1536, while Salviati was still in Rome.[43] Over the central door is depicted *Peace burning Arms,* an image made popular by Polidoro da Caravaggio in his Roman facade decorations (Fig. 51). As Vasari tells us, this image was associated with the *Pax augustae,* the era of peace established by the emperor Augustus, and was one of the most important qualities of the Golden Age.[44] Thus its inclusion here implies that Cosimo is inaugurating a Golden Age for Florence.

The scheme Salviati invented in this, his first large-scale fresco cycle, owes much to the Sala di Costantino (Fig. 27). As he does in his later cycles in Rome, Salviati

here treats the walls as unified fields that he then divides with fictive architectural membering. We have seen that this method would become the characteristic macro-scheme of colossal rooms in Rome around midcentury, but we should recall that these all postdate Salviati's invention here. Compared to Salviati's later schemes at the Palazzo Ricci (Figs. 107–8) or the Palazzo Farnese (Figs. 109–10), his wall-membering system here is relatively straightforward. The play with fictive materials and other kinds of illusionism are only cautiously essayed, but the effect is nevertheless dazzling.[45] The histories, and in particular the *Triumph*, consciously emulate sculptural relief. Salviati displays the Roman *all'antica* style for the first time on a large scale for Florence to enjoy. The choice of style is, of course, perfectly matched to the subject, and Cosimo is linked with the antique world not only by literary means but also visually. Style and literary allusions mesh to reenact classical history in contemporary Florence. Take the figure of Camillus seated in his chariot, for example. His features are a thinly disguised portrait of Cosimo. His lower body in profile twists to give us full view of his torso, and his head turns again into profile. In relieflike fashion, all the surfaces parallel to the picture plane are illumined with a strong flat light, as is generally true in these frescoes. The *quadriga,* the four horses drawing the chariot, are taken directly from the most accessible surviving representation of a triumph in Roman art, the relief inside the Arch of Titus.

The decision to use Camillus as Cosimo's prototype is interesting in more than one respect. The ancient sources made it clear that Camillus was not popular with the people. Machiavelli had even commented that they particularly disapproved his use of four white horses to draw his chariot because these were properly and traditionally reserved for a divinity.[46] It is typical of Cosimo that rather than dodge the issue he confronted it head-on: not only does he stand in for Camillus, but the chariot bears his personal emblem, Capricorn. The choice of his astrological sign is significant, for it implies that it was written in the stars that Cosimo would be cast in the role of duke and savior of Florence. It matters not at all, then, that there are critics and those who oppose him, for his destiny has been determined by divine providence. The crucial element of the horoscope in Renaissance astrology was the ascendant sign. It was considered portentious that Cosimo shared Capricorn as his ascendant with Augustus and Emperor Charles V.[47] This assur-

ance is what enables Cosimo to undertake actions that may appear presumptuous, like Camillus's choice of horses – or Cosimo's decision to preempt the Palazzo Vecchio. In Cosimo's personal iconography there is always a careful balancing. The hero chosen here is a hero of the Roman republic and one whom the Florentines had associated in the past with his revered ancestor and namesake, Cosimo il Vecchio (the Elder). Camillus's image had been included in the adjacent room, the Sala dei Gigli, among the famous Romans that the republican government had commissioned in the 1480s of Domenico Ghirlandaio, a room that Cosimo chose to preserve as it was, so that his Udienze might be seen as an extension and continuation of what was represented and enacted there. Cosimo is also a figure who undertook sometimes harsh and even inexplicable actions, like those represented on other walls in the room, but who is greatly honored in the summing up. The room was formerly and continued to be a hall of justice, so there are references to justice. The *Sacrifice of Isaac,* for example, would seem to refer to the inscrutability of God's justice, which must nonetheless be obeyed.[48] Is this an assertion of Cosimo's absolute authority, as it is sometimes interpreted? Does it mean that Cosimo must be obeyed without question, or that Cosimo, acting with divine guidance, must be obeyed? There may be intentional ambiguity here, but the main message is clear: Cosimo is the predestined ruler of Florence who will bring peace and stability through the exercise of justice and prudence, but sometimes by means that are neither understood nor approved by all.

Camillus brought the cult statue of Juno to Rome. In Salviati's fresco the hero and the statue exchange glances. Cosimo-Camillus points to her and looks at her, and she peers winsomely round the edge of her tabernacle. Janet Cox-Rearick noted that Eleonora was associated with Juno iconography; here the future duchess is being brought back as a trophy following his battle at Montemurlo.[49] In fact, the emperor had agreed to Cosimo's marrying Eleonora because he was impressed with the young duke's early successes, especially his victory at Montemurlo. The Medici arms are all but concealed on the entablature of Juno's shrine, as if this were something of a private joke. At the public level Cosimo's message was that the arrival of the protector of marriage, Juno, promised domestic tranquility, in which marital and family life could thrive unmolested by further wars and political upheavals.

Salviati brought his intimate knowledge of Rome, especially ancient Rome, to Florence. The viewers could not but be impressed by the antiquarianism on display, from the costumes, to the artifacts, to the ruins of ancient buildings and statues. In fact Salviati matched his Flemish colleagues, Heemskerck and Posthumus, in the detail of his landscape with ruins, and even in their minuscule scale. The best-traveled of Cosimo's court would have recognized the Pantheon-like structure, the round temple at Tivoli, and the Torre delle Milizie at the far right, as well as the *Crouching Venus* in the niche on the temple and the mutilated *Discobolos* marking the end of its balcony.[50]

Salviati drew also upon prints of the Galerie François I at Fontainebleau, a source that must have pleased Cosimo for its royal association. The prints were newly minted – some that he used are dated 1543 – so their trendiness would have pleased the duke as well. The kind of ornamental frames that had been invented by Rosso and Primaticcio in France (Fig. 84), especially the distinctive and elaborate cartouches, were imitated in some cases quite directly by Salviati.[51]

Salviati learned a great deal from study of the Sala di Costantino, which would have been the closest precedent in scale and subject available to him in 1543 (Pl. VII). He borrowed its color scheme, in particular the dusty gray tonality that served there, as here, to unify the walls. The keynote is set in the *basamento* that continues around the entire room, creating the impression of gray stone. The same tonality is carried up into the grisaille relief of *Peace burning Arms* that is strategically placed over the Quattrocento door, preserved for political reasons, but which breaks into the space of the frescoes in what would have been an awkward way in the hands of a lesser planner than Salviati. This same grayish marble becomes pilasters that frame the narratives, so that the scenes appear to pass behind them and the *Peace* relief. The same tone is carried behind the front tier of figures as a dark foil to them, almost as if it were the ground of the relief. Above it in the distance there is an abrupt shift to minute scale where the colors are muted and desaturated, as is the pale grayish sky, again reminiscent of the Costantino's color.

By keeping a relatively even focus, Salviati maintains the impression of relief parallel to the plane. The points of concentrated color intensity are on either side of the central door. Camillus-Cosimo at the far left edge is given prominence not only with color but also because

his head and the Victory crowning him are the only figures allowed to break above the horizon and be silhouetted against the sky. Juno's shrine is likewise elevated against the sky, reinforcing the connecting glances and gestures between them. A second concentration of color comes in the group in front of the shrine, where the painter uses a strong blue drapery and a *cangiante* one – pink shifting down to blue in the shadows – to draw the eye. This man who is leading the procession holding the giant key to the city is the elegant invention that Salviati would reuse in other contexts later, as we have already observed (Fig. 106). Salviati keeps the movement going across the plane with highly animated surfaces: fluttering draperies, striding figures, motifs or figures repeated, and rich modeling that allows no large patches of unmodulated color. His is quite the opposite of Bronzino's way of imitating sculpture, in which the figures become immobilized by their firm contours, demarcating the boundaries of each stationary form. Bronzino suggests by means of his deliberate artifice that one should search beneath the first level for a hidden meaning. Salviati creates a relieflike composition and then contradicts its sculptural qualities by imbuing his figures with qualities of movement possible only with the medium of paint, which could be intended to suggest that the ancient story (stone relief) is a metaphor for a contemporary one (fresco). The *paragone*, the contest between painting and sculpture as to which was the superior art, was a pressing question in the 1540s in Florence. Bronzino and Salviati both demonstrate in their different ways that painting can achieve the best of each.[52]

TAPESTRIES FOR THE PALAZZO VECCHIO

In 1545 Cosimo switched his patronage from frescoes to tapestries as the preferred wall coverings in the Palazzo Vecchio. Tapestries were considered more luxurious – they were also more expensive – and were revered in courts all over Europe, whereas fresco was a central Italian novelty. The duke decided to found a tapestry-making atelier in Florence, shortly after François I had done the same thing at Fontainebleau, so that instead of having to send away to Flanders, the designs of his artists could be executed locally. To this end he hired two experts in tapestry weaving in 1545 who had been in the employ of rival courts at Ferrara and Mantua.[53] They immediately

set to work executing designs by Bronzino and Bachiacca (1494–1557), Pontormo and Salviati. Bachiacca designed a series of *spalliere* with grotesques to cover Salviati's *basamento* in the Sala dell' Udienza. Once again the model was the Vatican Sala di Costantino, where Pope Clement had commissioned *spalliere* with cavorting putti by Giovanni da Udine (1487–1564) to cover the *basamento*.[54] The grandest set of tapestries Cosimo ordered was the *Story of Joseph* for the walls of the Sala dei Dugento, for which Bronzino made most of the designs. These and the other early tapestries of Florentine manufacture were of luxury quality, of fine weave with a high quantity of silk, gold, and silver threads mixed with the wool. The *Joseph* series took eight years to produce. These delicate weavings were intended to be used only for special occasions, to dress up a room for some special event, and then were returned to storage where they were protected from fading. Stronger wool tapestries of coarser weave were manufactured beginning in the 1550s for more regular use. The twenty hangings of the *Joseph* cycle could cover the windows of the Sala or be pulled aside to admit the light, and they hung all the way to the floor, with cutouts only for the doors.[55] The effect, with life-sized figures seen at floor level, would have been magnificent indeed.

It is characteristic of the games of one-upmanship played by the rival princes of the Italian states that Cosimo's son and heir, Prince Francesco, planned to take the first six of these tapestries with him when he visited Genoa to adorn his own quarters, which were not at the Palazzo Doria. Prince Doria's tapestries, woven in Flanders on Perino's designs and the most sumptuous in any Italian palace, would thus have been upstaged by the Florentine suite that had actually been woven in Italy.[56]

Bronzino would design sixteen of the twenty *Joseph* tapestries, the masterpieces of Florentine manufacture.[57] In the same slow and careful way that he had executed the chapel he supervised the production of the tapestries. Several of his drawings survive, one especially beautiful one is for the lower left portion of *Joseph recounting his Dream of the Sun, Moon, and Stars* (Fig. 151).[58] He gives us an unusually expressive study of emotional responses, as the elderly father and ill-disposed brothers listen to Joseph ingenuously describe how he has dreamed that the celestial deities will pay him homage, a dream he might more wisely have kept to himself. His elderly father stares with credulous doting, a marvelous image of uncritical parental awe, while

Figure 151. Bronzino, *Joseph recounting his Dream,* drawing for the *Story of Joseph* tapestries. c. 1545. © Ashmolean Museum, Oxford.

the brothers look on with faces that range from doubt to mean-spirited envy to downright abhorrence. Bronzino's style was especially well suited to tapestries, which, as he soon learned himself after the first few pieces, are most successful when treated as a surface to be filled and ornamented. The conventions of the relieflike style could be accommodated nicely to the requirements of the medium. Following the lead of the rich decorative borders invented in Flanders and imitated in Florence – a *horror vacui* approach to design – we see here densely overlapped bodies, which acknowledge the surface and are more pleasing than sweeps of perspectival depth. Typically Bronzino placed his figures at the center of the space, filling the foreground with *repoussoir* figures and closing off the background with architecture. When multiple episodes needed to be included, he placed his principal figures low in the field and close to the plane, then deployed secondary actions high in the distance, as if on steeply rising ground.

Salviati also contributed some designs for tapestries

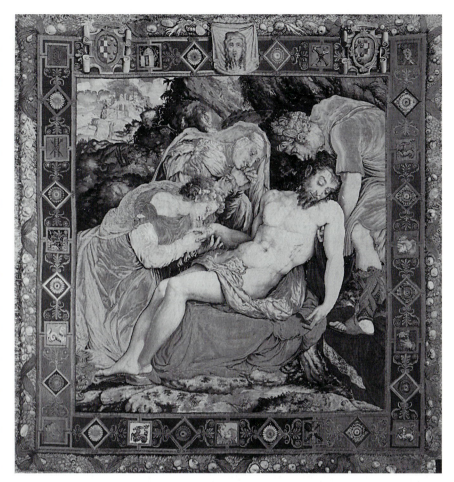

Figure 152. After Salviati, *Lamentation*. Tapestry, c. 1545. Uffizi, Florence.

before his return to Rome in 1548. Particularly instructive is the *Entombment* that was designed to hang over an altar (Fig. 152).[59] For this purpose he adapted his earlier design of the same subject, made while he was in Venice, converting it into his new Maniera. The square format of the tapestry required that he exclude all but the four principal figures. They are clustered around Christ, who is now wholly in the light so that he is flattened against the plane. Other indications of the three-dimensionality have been removed, like the Madonna's hands that are now clasped under her chin, and the shadow on the bending figure's face and shoulders. The sense of naturalistic light and atmosphere has been carefully excised, and an abstracting relieflike mode replaces it. Salviati has conformed his design to his new style, and that of the Medici court, with remarkable efficiency.

During the middle decades of the century Bronzino continued his career as a portraitist and created several mythological pictures, the most famous of which is, of course, the *Allegory of Love* in London, which has proved to be both iconographically inscrutable and morally ambiguous to modern scholars.[60] It was sent as a diplomatic gift by Duke Cosimo to François I – an inspired choice for him as it was precisely the kind of lascivious image he loved.[61] The composition of figures that fill the surface is so like Bronzino's tapestry designs it is not surprising that at one time it was identified as originally a design for a tapestry that was then converted to a painting.[62] In fact, what we see is no more, or less, than the quintessence of the Maniera. The formal complexity – the flattened contortions of Venus and Cupid – create a tension in us that mirrors our discomfort with this unnatural image of mother and son.

Less familiar, and less disturbing, are two other versions of *Venus and Cupid* by Bronzino, one in Budapest, the other in Rome (Pl. XXVI). In the latter, Venus reclines on a bed, playfully holding Cupid's bow out of reach over her head. In her other hand she holds one of his arrows, which she has presumably stolen from his quiver, as she is shown doing in the London *Allegory*. As he lunges they exchange an affectionate glance. Leaning over the end of the bed, a delighted Pan peers in. His ruddy skin and hairy animal extremities contrast with Venus's snowy white flesh, which like Cupid's, is hardly modeled at all. This juxtaposition makes clear the intended confrontation of bestial and spiritual love. Both Venus and Cupid twist so as to present their bodies to the plane; this must have been a very enticing image before the drapery "modifying" Venus was added. A curtain like that in the London *Allegory* closes off the space, this time a deep crimson rather than ultramarine. The precious blue is used here for the sheet instead and is then picked up, like the crimson, and repeated in Cupid's wing. A brilliant green completes the triad of blue, rosy red, and green that sets off the flesh tones.

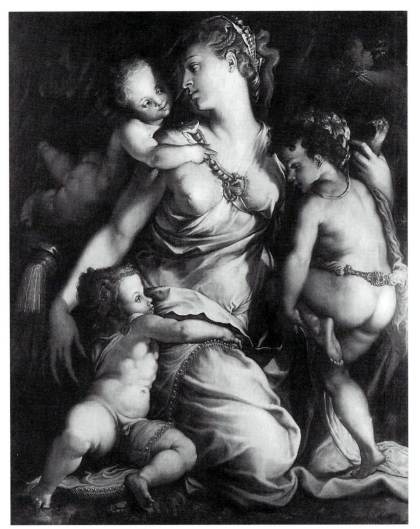

Figure 153. Salviati, *Charity*. c. 1545. Uffizi, Florence.

for various patrons. Striking among these is his *Charity* (Fig. 153), in which he adapted the Maniera style to the allegorical mother surrounded by insatiable children. This brilliant piece could serve to exemplify the conventions of the style. Almost five feet in height, it is large for an easel painting. Shown kneeling on the ground, the mother is larger than life-size, filling the entire picture. She is pressed close to the plane and flattened against it. All the space remaining is charged with the insistent children who clamor for her attention. Although they overlap her they are each sharply delineated, so that hardly anything is subordinated or lost from view. The active modeling of drapery and flesh further animates the surface. Filling so bountifully and ornamentally the space, she wonderfully embodies the plenitude and generosity that she symbolizes.

A small devotional picture, Salviati's *Christ carrying the Cross* (Fig. 154), translates Christ's agony into something exquisite, of such refined beauty that it transmutes his head from one merely human into one transcendent. Unlike Sebastiano del Piombo's ponderous and somber version (Pl. XX), where we are moved to a simple compassion by Christ's nobility, here our response is being manipulated in a more complex way. Our compassion is triggered by Christ's evident suffering, but in the next instant we are emotionally distanced by the aesthetic display. Hair becomes gilt ornament, and compassion edges toward awe. Salviati preferred easing his viewer through a sequence of responses, perhaps even contradictory responses, rather than the direct, unequivocal address Sebastiano's piety makes to his audience. One senses that the Maniera artists felt embarrassed in the face of a bald statement of simple piety – like some modern viewers – and that they therefore substituted an appeal to aesthetic emotion.

The color is as sensuous as the figures, but in a way that is characteristically central Italian. One thinks by way of contrast of Titian's reclining nude, the *Venus of Urbino* (Florence, Uffizi). The closely harmonized and neutralized tones preferred in Venice are not to be found here. Bronzino creates a different coloristic harmony, made up of brilliant saturated colors. These are not the colors one finds in nature; they are manufactured, artificial, as much as the conceit of contrasting the two facets of human nature by means of antique mythological gods.

◆

DURING THE THREE YEARS Salviati remained in Florence after completing the Sala dell' Udienza, he not only contributed designs to the tapestry projects but also executed portraits, altarpieces, and easel paintings

Despite these desultory commissions, Salviati recognized that there was not sufficient work for him in Florence. Several events converged to help him to decide

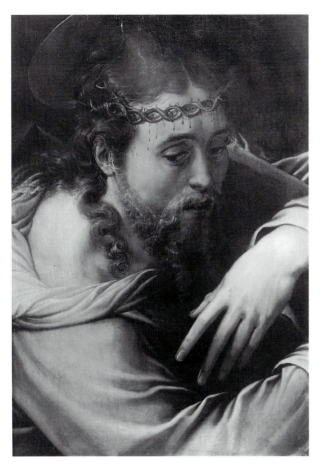

Figure 154. Salviati, *Christ carrying the Cross*. c. 1545. Uffizi, Florence.

to leave the service of Cosimo. In Rome, opportunities seemed to be opening up with the death of Perino del Vaga in 1547 and the assassination in the same year of his inimical former patron with whom he had had a falling out, Pier Luigi Farnese. In Florence, meanwhile, Bronzino had assumed the role of court painter, and Salviati had lost the commission to paint the choir of San Lorenzo in his favorite medium of fresco to Pontormo. Vasari makes it clear there was an acrimonious rivalry between the artists of his and Salviati's generation, who had studied in Rome, and those of the previous generation, who had not. It can be seen as a struggle between the new Roman style *all'antica* and the traditional Florentine style.[63] The competition between Roman and Florentine styles already adumbrated in the 1520s at the time of Perino's visit to Florence evidently continued in the decades that followed, and not everyone endorsed Cosimo's choice of painter for the Sala dell' Udienza frescoes. Cosimo could be interpreted as placating the adherents of the native style with his

choice of Pontormo, but it is certainly no accident that he made this conciliatory gesture with a religious commission and not a commission for his palace. In 1548 Salviati left Florence and soon took up the Cappella del Pallio in Cardinal Farnese's Palazzo della Cancelleria (Figs. 102–3).

VASARI'S DECORATION OF THE PALAZZO VECCHIO

By the mid-1550s Cosimo was ready to remodel the apartments of the Palazzo Vecchio and decorate the walls, and he was in a hurry. Eleonora had purchased the Palazzo Pitti, and by 1553 it had been sufficiently renovated so that it was possible for the family to reside there while the work on the Palazzo Vecchio proceeded. Recognizing that the manufacture of luxury tapestries such as had so far been undertaken under Bronzino was too slow to fulfill his goal of covering all the walls of the palace, the duke turned to coarser-weave wool hangings that could be produced more rapidly. At the same time he wanted the ceilings and friezes painted and some rooms frescoed. In Giorgio Vasari he found the man who could bring all this about.

Vasari had proven his ability to organize a large workshop and turn out frescoes when he worked for Cardinal Alessandro Farnese in the Sala dei Cento Giorni (Fig. 101). He had gained prominence by publishing his *Lives of the Artists* in 1550, which he had pointedly dedicated to Duke Cosimo. He left the service of Pope Julius III, for whom he had designed the family chapel in San Pietro in Montorio (Fig. 114) and the Villa Giulia. When Cosimo's architect of the Palazzo Vecchio, Giovanni Battista del Tasso, died in May 1555, Vasari took over as the new architect, as head of the tapestry project, and as artist in charge of the decorations. He began his work in December in the Quartiere degli Elementi (Apartment of the Elements) on the second floor, where he was engaged until 1558. Each of the rooms was dedicated to a mythological deity, and stories of that god or goddess were represented on the ceilings and sometimes in fresco on the walls.

While work was still going on upstairs, Vasari began the restoration of the six rooms and chapel directly below, the Apartment of Leo X, which occupied him and his team until 1562. Here the subjects shifted to personal history of each of the important Medici family members. The suite is cleverly laid out as a diagram of

the duke's double legitimacy through both sides of the family, with the Sala di Duca Cosimo flanked by the room of his father on one side and those of Cosimo il Vecchio and Lorenzo il Magnifico, from whom he was descended through his mother, on the other.[64] Vasari worked closely with the duke and with his adviser, Cosimo Bartoli, to select the key scenes, then drew the designs and filled them with portraits.

For this undertaking he plundered the art of the previous century and a half, searching avidly for likenesses he could copy. For example, in the Sala di Cosimo Vecchio, the center of the ceiling shows that favorite Medici theme, the Return from Exile, this time of Cosimo Vecchio, containing twenty-one portraits of the family and

Figure 155. Vasari, *Cosimo with his Architects, Engineers and Artists*. Fresco, c. 1560. Sala di Cosimo I, Palazzo Vecchio, Florence.

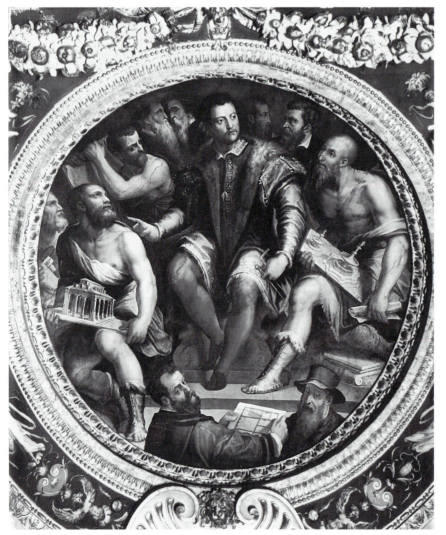

of supporters. As this event had occurred in 1434, it was no small task to find an image that could pass for a likeness of men who lived so long ago.[65] Medici patronage of the arts is another theme that recurs repeatedly. In the same room we find *Brunelleschi and Ghiberti presenting to Cosimo the Model of the Church of San Lorenzo;* in the background the church is being constructed.

In the room dedicated to Lorenzo il Magnifico he is depicted on various ambassadorial missions as the representative of the Florentine republic, and then, in a lunette, he appears at the center of a group of philosophers and literati, including Marsilio Ficino, Leon Battista Alberti, Agnolo Poliziano, Giovanni Pico della Mirandola, and eight others.

In his room, Duke Cosimo is shown in his political and military victories and then, like Lorenzo, at the center of the artists of his court (Fig. 155). Here is a case where the *all'antica* style makes its source explicit: the composition and the iconography of *Cosimo with his Architects, Engineers, and Artists* was based on a relief from the Arch of Constantine called the *Liberalitas,* where the emperor, Marcus Aurelius, appeared as a munificent ruler and protector of the arts, as does Cosimo, who borrows the emperor's authority by use of the quote that was meant to be recognized. As in the relief, Cosimo is scaled much larger than the figures around him.[66]

It is safe to say that by means of these images – combined with Vasari's interpretation of the history of Florentine painting in the *Lives,* in which he exaggerated the Medici patronage of the arts – the myth of the Medici as the founders and leaders of Florentine culture was established. So successful in planting this idea were the duke, Bartoli, and Vasari that it was accepted and repeated for centuries, and it has only been in the past generation that it began to be questioned and reexamined.[67]

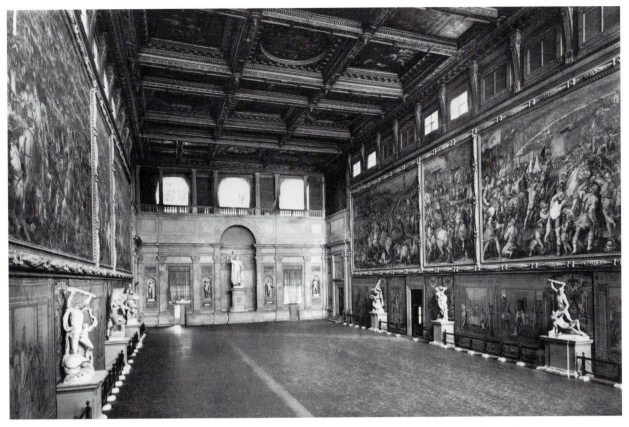

Figure 156. Vasari and workshop, Salone dei Cinquecento, view. 1563–72. Palazzo Vecchio, Florence.

At the same time (1559–62), Vasari undertook the remodeling of the four rooms of the Apartment of Eleonora on the second floor, on the opposite side to the Quartiere degli Elementi. These rooms connect with the chapel Bronzino had decorated and the two other rooms completed in that first campaign (Camera Verde and the Scrittoio). The remodeling of the Salone dei Cinquecento came next, which would involve raising the roof and installing clerestory windows before the painting of the ceiling (1563–5) and eventually the frescoing of the walls (1567–72) could take place (Fig. 156). This enormous room, measuring 75 by 174 feet,[68] was to be the capstone and the grand center of the palace. Only a great prince could have an audience hall such as Cosimo envisioned, and eventually got.

In strong contrast to the grandeur of the Salone dei Cinquecento was Vasari's last project in the palace, the building and decorating of the little Studiolo for the prince, Francesco, begun in 1570 and completed in 1575 (Fig. 160). In April 1574 Grand Duke Cosimo died, and barely two months later his faithful Giorgio followed him. They had worked together – and we shall see, this is the right expression – for nineteen years.

Duke Cosimo had resisted suggestions that he tear down the old palace and build a splendid new one, Vasari tells us, just as he had not destroyed the old republican government.[69] The Sala di Consiglio, as it was then called, had been the central meeting hall of the republic, built to accommodate close to two thousand citizens.[70] At the beginning of the century it was to have been decorated with the frescoes of Leonardo's *Battle of Anghiari* and Michelangelo's *Battle of Cascina* (Fig. 10), we recall, but because neither artist completed his commission, the decoration of the hall had languished. In accordance with Cosimo's plan it would now become an audience room surpassing those of "all the kings and emperors and popes that ever were," according to Vasari.[71]

By raising the roof Vasari transformed the old Sala di Consiglio from a low, dark space to a well-illumined and truly monumental audience hall that could compete with the Vatican's Sala Regia (still incomplete at this date) and the Venetian Sala del Maggior Consiglio, which was in fact chosen as the prototype. It was a shrewd choice, as well as a practical one. The room where the duke would receive his honored guests,

which had formerly been at the heart of the Florentine republic, was modeled on the reception hall of another republic, not on that of an absolute ruler, like the pope. To be sure, the medieval building Cosimo was dealing with, irregular in plan as it was, would not have permitted the construction of a vault like that in the Sala Regia, which in turn ruled out the Domus Aurea-type of ceiling we might have expected the duke to choose, knowing his taste for the antique.[72] The advantage of the flat wooden compartments of the Venetian type was that it permitted the rendering of truly legible scenes, which would be exploited to tell a version of Florentine history culminating in the rule of Duke Cosimo.

Initially Vasari had allotted three and a half years for the execution of the enormous ceiling. The program was worked up by the learned Don Vincenzo Borghini, with whom Vasari would work closely for the rest of his life on successive, and overlapping, projects. When the program was submitted to the duke, instead of the carte blanche approval one usually finds patrons giving, he came back with specific objections requiring changes. In addition he requested that the whole ceiling be completed in time for the wedding of Prince Francesco to the daughter of Emperor Ferdinand, a diplomatic coup that had just been arranged. Vasari had to speed up his timetable, hire extra assistants, and complete the work by 1565, in only two years. This challenge, however, is exactly where Vasari excelled: in structuring a system and organizing those working for him so that the task could be completed. Instead of the endless delays one reads about so often in which artists failed to produce work in the agreed-upon time, Vasari's projects were delivered on schedule. The duke stated this fact in a letter to his son Francesco, telling him about how to deal with artists: they always take more time than they say they will "except Giorgio who is most prompt."[73] If he had to sacrifice refinement in the process, he took the time restraints of the patron to be the first priority.

In the case of the ceiling of the Salone dei Cinquecento, Vasari depended heavily on his assistants, especially Giovanni Stradano (1523–1605) and Jacopo Zucchi (1542–96), and allowed them to prepare the final compositional designs. The system was that the assistants developed the master's first sketches into finished compositional models. Vasari was evidently not always happy with the results because he went over them and occasionally redrew sections himself. Thus he reimposed his control over the final form of the compositions in his own detailed studies, drawn after the cartoons were made but before the panels were actually painted. The execution of the painting, of course, had to be left to the assistants. When in the succeeding years the *Battles* were painted on the walls, and there was no longer the pressure of a deadline, Vasari, always flexible, revised his system.[74] He allowed the assistants to make life studies and to sketch details, but he made the *modelli,* the final compositional studies, himself.[75]

In the tondo at the center of the ceiling, Cosimo appears on the clouds being crowned (Fig. 157). In recent years controversy has swirled around this image, which some modern scholars have called the *Apotheosis of Cosimo,* as if he were representing himself turning into a god, like some of the bolder and more abrasive of the Roman emperors. It is all the more significant because this portrayal was substituted for two earlier designs of Vasari's in which Florence was symbolically represented first as a personification, then with its insignia of the white lily. Considering the care with which Cosimo had persistently cultivated the image of himself as the heir of the republic, it is unlikely he would have felt suddenly so secure that he would abandon himself to egocentric self-adulation.

By 1563 Cosimo found himself in control of a prosperous and peaceful realm, with an heir about to ally the family with the most powerful ruling family in Europe. He turned his attention to a project in which he had so far failed, that of obtaining the status of monarch for himself and his dynasty. Relations with the papacy were at last cordial, now that a distant relative of the Medici had been elected – with indispensable help from Cosimo's agents – as Pius IV. In 1560 Cosimo traveled to Rome and was warmly received and entertained at the papal court for more than a month. The time seemed ripe to press his case with the pope, who had the power to grant him his crown. His strategy would eventually succeed, but not until 1569 under Pope Pius V.

He began by abdicating, passing the reins to his son, in a gesture that was meant to allay fears that he lusted after power. A careful reading of the tondo has shown that, in fact, Cosimo has once again brilliantly balanced his claims. As in the past, his imagery boldly asserts his power but shows how it fulfills the aspirations of the republic and is bolstered by republican structures, social and bureaucratic. It is not a Roman emperor who is his model here, but Octavian at the moment he is in fact about to

become emperor. He had abdicated – as Cosimo has just done – in order to be free of the stigma of power-grabbing, and then had his powers restored to him by the Senate. He had been crowned with oak leaves, as Cosimo is here, who receives his crown from Flora, representing Florence. Beside him is the ducal crown (not the Grand ducal crown, as is sometimes said). Surrounding him are the shields of the guilds placed between eighty balusters, standing for the constituencies of the Florentine populace under the Republic, called the *compagnie del popolo*. The guilds and the *popolo* taken together symbolize the citizenry of Florence.[76] Supporting details and inscriptions were all studiously laid out by Borghini and made legible by Vasari to the viewer standing below.

Comparing the Palazzo Vecchio decorations with the palace decorations of Perino del Vaga (Pl. XV, Figs. 72–3, 98–100), or Salviati (Figs. 107–10), or Giulio Romano (Pl. XIV, Figs. 64–7), one must admit that although they certainly match the others in scale and grandeur, Vasari's are somewhat tedious. The wit and humor that enlivens the other cycles is lacking here, where there is often the sense of a gentle derision, even self-derision, generated by the patron or at least tolerated by him. Cosimo and Vasari were well matched in that they both seem to have lacked humor. Shakespearean tragedies turn on the failure of self-knowledge in otherwise great men – or at least powerful men. But comedy is the ability to see and appreciate human weakness, which is indeed a very important attribute in those who wield power. Humor suggests tolerance, forgiveness, patience – qualities one hopes to find in a ruler, and qualities one hopes the ruler would want to suggest he possesses. The rhetorical mode of the Maniera style was ideally suited to hyperbole, and hyperbole extends easily into humor. Was Cosimo too

Figure 157. Vasari and workshop, *Cosimo crowned by Flora.* 1563–5. Ceiling tondo, Salone dei Cinquecento, Palazzo Vecchio, Florence.

insecure to recognize the value of humor in his imagery, or was it that Vasari was too rushed by his schedule to notice its absence? Looking back to the undeniable wit embedded in Salviati's *Triumph of Camillus* (Pl. XXV), we may be forced to fault the painter more than the patron in this case.

Cosimo's intent was to transform the old republican palace into a princely residence, at the same time proclaiming his dynastic mythology on the walls. Vasari was more than happy to oblige, for he was a master courtier who well understood the value of art to politics. He had his own agenda as well, as he had in the *Lives,* for as much as he could extol and enlarge the role of the

Medici in Florentine history, so much greater would appear the artists whom the Medici had patronized. To assure that the full import and innuendo of the decorations would be understood, he composed (but never finished)[77] an explanatory text in the form of a dialogue between himself and the young prince Francesco. The *Ragionamenti* purport to take place over three days in 1558, when Francesco was seventeen, still young enough to be curious but not yet fully informed about the paintings in his home. Vasari undertakes to explain the decorations to Francesco, whose remarks in the main are limited to asking questions and praising the ingenuity or the beauty of what he is looking at. Even the format of the *Ragionamenti,* then, is calculated to enhance the image of the artist, who speaks to the prince and future duke without the obsequious tone of a servant but as an equal and an authority. We should not interpret Vasari's purpose as merely self-serving; rather it is the social status of the artist as a class that concerns him.

There is debate among scholars today as to how much literary freight visual images in this period were intended to carry. There are those who interpret mythological cycles as allegories, and those who claim that a myth can be just a myth at times.[78] Even Vasari's *Ragionamenti,* which would seem to lend considerable weight to the side of those favoring hidden meanings, has been shown to have been composed after the fact and to claim more in the way of carefully planned, coded meanings than Vasari is actually able to demonstrate. For example, Vasari tells Prince Francesco that there are relationships between the rooms on the second floor and those directly below (which are identical in plan), but he makes only one reference to such a parallel and then leaves it to the prince to figure out all the others for himself. The implication would seem to be there was no such grand design when the iconography was devised.[79] Moreover, Vasari apparently felt that it was entirely appropriate to ascribe such metaphorical meanings to his images even when he had not planned them. He could do it, and others could as well. This practice is something that we today, in our insistent quest for the original meaning, have difficulty encompassing.

One audience targeted by these images were the representatives of other states who would be received under this roof. A particularly important message to them was the antiquity of the Florentine state and its uninterrupted continuity. Cosimo was engaged in a struggle with his ancient rival, Ferrara, over whose ambassadors would be received first in the courts of Europe. The precedence dispute, as it is known, was more than a childish quarrel, for it impinged on Cosimo's efforts to obtain the Grand ducal crown. It was with an eye on this issue that Cosimo insisted there be no hint in the decorations that Florence had ever been destroyed and abandoned. The city's history had to be continuous and unbroken, so when Borghini proposed the rebuilding of the city under Charlemagne, Cosimo rejected it. Borghini instead used the scene illustrating the construction of the third circuit of city walls.[80] This scene, representing the architect *Arnolfo presenting the Plan for the Enlargement of Florence and the Construction of the Third Circuit of Walls,* was one that particularly interested Vasari and Borghini. To reconstruct the city for this painting they chose a moment in the first half of the Trecento, then Vasari climbed over rooftops and used compasses and orthogonals to plot the relative distance between buildings. He scrupulously represented buildings in the state of construction they had reached and omitted whatever had not yet been begun.[81]

Vasari, like Salviati and Bronzino, was expert in the imitation of sculpture. Everywhere one looks at the scenes from Florentine history on the Salone dei Cinquecento ceiling panels one is reminded of antique reliefs. Florence as represented here to Cosimo's subjects had acquired a patina of statuesque grandeur calculated to boost civic self-esteem. To cite a single example, the theme of the triumphal entry, represented by Salviati in the Udienza, reappears in Vasari's *Triumphal Return to Florence after the Victory over Pisa* (Fig. 158), symbolically represented as a female figure mounted on a chariot drawn by the four white horses, all arranged parallel to the plane and flattened against it by a scouring light. Emulation of sculptural relief *all'antica* was the style of Cosimo's regime, and it perdured without interruption in both secular and sacred art into the 1560s, long after the reformers' opprobrium had discredited it in Rome, for sacred images at least.

Florence was remarkably insulated from the Roman Church. When the inimical Pope Paul III named a long-standing enemy of the Medici, Antonio Altoviti, as archbishop of Florence in 1548, Cosimo responded by refusing him entry into the diocese and threatening to confiscate his revenues.[82] When the zealot Paul IV in 1559 ordered the burning of books that had been put on the recently expanded Index, Cosimo ordered his

agent to make a show of burning some books but then to let the matter drop.[83]

What curbed the Maniera in sacred painting in Florence was not the censure of the Tridentine authorities, whose voices seem hardly to have reached Florence in the 1560s. Rather it was the coming of age of a new generation of painters and their experience of visiting Rome in the late fifties and early sixties as part of their artistic training. Alessandro Allori (1535–1607) had gone apparently as early as 1554 and returned for good in 1560.[84] Santi di Tito (1536–1603) followed in 1558 and stayed for six years because he was fortunate enough to get work. Battista Naldini (c. 1537–91) went in 1560–1, followed by Girolamo Macchietti (1535–92) in 1562–4. All returned to Florence, several to work as assistants to Vasari in the Salone dei Cinquecento. These artists recognized in the works of Taddeo (1529–66) and Federico Zuccaro (c. 1541–1609), in Girolamo Muziano (1532–92), and in the other painters in Rome just slightly their seniors, the style of the future, and they brought it back with them to Florence.

Figure 158. Vasari and workshop, *Triumphal Return to Florence after the Victory over Pisa.* 1563–5. Ceiling, Salone dei Cinquecento, Palazzo Vecchio, Florence.

ACCADEMIA DEL DISEGNO

In February 1564 an event of magnitude to Florence and particularly to the Florentine artistic community occurred, the death of the greatest of them, Michelangelo. It was a matter of civic pride that he should be buried in the city of his birth that had nurtured him, especially because he had been lost to Rome for the past three decades, that is, the whole of Cosimo's rule. It was hastily decided that a grand memorial service should be staged laying claim to him and honoring him in an appropriate fashion. The infant Accademia del Disegno, just founded the previous year on the initiative of Don Vincenzo Borghini and Vasari under the protection of the duke, was the institution to organize it. When Vasari had written Michelangelo informing him of the birth of

the academy he told him that the members had unanimously elected him as its spiritual guide.[85]

The site chosen for the event was San Lorenzo because of Michelangelo's and Medici associations, and the duke agreed to fund it, if sparsely. It was determined that a huge catafalque for the coffin should be built in the nave that would be covered with paintings representing key moments in Michelangelo's long career. It was further decided to entrust these paintings to the young members of the artistic community, who would be provided with the program and perhaps also with drawings, and thus to turn the event into a kind of high-level and very visible competition to demonstrate the importance of the new institution.[86] Borghini, whose idea this was, anticipated that it would accrue considerable prestige to the nascent academy, and his expectations were certainly credited when, in 1566, a letter asking for membership was received from some of the leading artists in Venice, including Andrea Palladio, Titian, Jacopo Tintoretto, and Paolo Veronese, who said that they had heard of the catafalque.[87] Immediately

following the ceremony, which took place on 14 July, the academy voted to accept the seventeen young artists who contributed to the decorations as fellow members, many of whom Vasari would soon choose to paint the altarpieces in Santa Maria Novella and Santa Croce and to decorate the Studiolo of Prince Francesco.

In instituting his program to restore the prestige of Florence as a cultural center, Cosimo had established in 1542 the Accademia Fiorentina for the literary arts. The Accademia del Disegno proposed by Vasari and Borghini in 1563 was a parallel institution that gave state recognition to the novel idea that the arts of design also constituted a profession based in the liberal arts and equivalent to the noble arts of letters.[88] With this new academy Cosimo could proclaim the primacy of Florence in the visual arts, and thus everyone gained. From Vasari's and the artists' point of view they had at last shed the opprobrium of manual laborers and achieved the status of professionals, because the academy was in effect the equivalent of a university faculty. And from the duke's point of view, there was the added practical advantage of having a useful organ at hand when it came to organizing his ephemeral celebrations, like the wedding of Prince Francesco in 1565.

The subjects of the paintings for the funeral decorations reveal the agenda behind the stated and sincere intention to honor Michelangelo. Several paintings showed the artist as the equal of popes and princes, as for example the scene in which Michelangelo is seated next to Pope Julius III, whereas cardinals, bishops, and courtiers remain standing. The status the artist had achieved – and by extension his whole profession – was thereby indicated.

The cult of Michelangelo in Florence in the 1560s presents an interesting perspective on the differences between the Roman and the Florentine scenes. At the moment when Paul IV was threatening to have the *Last Judgment* torn down, Alessandro Allori returned to Florence from his sojourn in Rome and was commissioned to paint a chapel in Santissima Annunziata for the Montauto family. He represented on the altar wall excerpts from Michelangelo's imperiled fresco.[89] The year after Michelangelo's death when Daniele da Volterra (c. 1509–66) had been ordered to replace one of the offensive passages, the Saint Biagio and Saint Catherine (Pl. XXII), Bronzino took the duke's commission for a *Martyrdom of Saint Lawrence* (Fig. 159) as the opportunity to turn it into a colossal homage to Michelangelo.[90] The

enormous fresco, the aging Bronzino's last major work, which took him four years to complete, is filled with quotations of Michelangelo and with nudes. Most significantly, despite its dependence on Baccio Bandinelli's design for rudiments of the composition, the engraving of which had been widely circulated (Fig. 46), Bronzino has conceived it in the style of Michelangelo's *Last Judgment*. Here are the contorted poses, the energy in excess of what is called for, the nudity, the mixing of allegorical figures with historical ones – all the features, in short, that Gilio had singled out and condemned in his treatise.[91] This fresco must be the last major sacred work that was painted in the Maniera style, and it would have been unthinkable in the Rome of Pius V, whose example of asceticism, we recall, had intimidated even such powerful cardinals as Farnese and Este into commissioning only biblical subjects for their villa walls at Caprarola and Tivoli. Can we interpret this work as anything but a potent defense from his native turf of the divine Michelangelo and a defiant response to the attacks he had suffered in Rome?

Yet what is equally interesting is that the young artists seem to have received Bronzino's panegyric-in-paint with indifference; their own works in the Studiolo of a couple of years subsequent show a collective disregard for Michelangelo's and Bronzino's styles, and the same is true of the altarpieces many of them contributed to the cycles in Santa Maria Novella and Santa Croce in the sixties and seventies.[92] How this generation of painters reconciled their undoubted reverence for Michelangelo with their avoidance of his style is an important question that has not yet been asked.

When in 1570 Vasari was required to create one last room in the palace, the Studiolo for Prince Francesco, he called upon this new generation of painters to decorate it.[93] The style of their exquisite little panels is no longer that of their masters, principally Vasari and Bronzino, and it owes little to antique sculpture or to Michelangelo.

THE STUDIOLO OF FRANCESCO

The Studiolo is a tiny, barrel-vaulted chamber with no visible windows or doors but with numerous cabinets concealed behind the oval panels (Fig. 160). As Don Vincenzo Borghini explained in his letter to Vasari, in which he laid out the program, it was a place to keep rare and precious objects, natural and artistic, like jewels, medals, cameos, carved crystals and vases, and other small things,

Figure 159. Bronzino, *Martyrdom of Saint Lawrence*. Fresco, 1565–9. San Lorenzo, Florence.

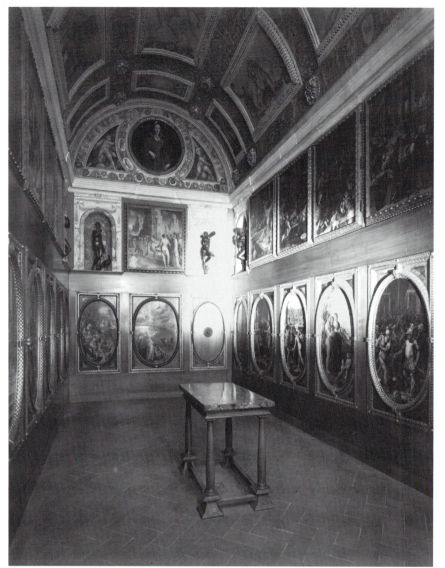

Figure 160. Vasari and others, Studiolo of Prince Francesco, view. 1570–4. Palazzo Vecchio, Florence.

northern Europe, of the *Wunderkammer,* or Wonder-Room, but it bears a special Florentine imprint. As Borghini conceived it, it was a mirror of the order of the universe. The theme was Nature, represented at the center of the vault, because all the objects derived from nature, whether they remained in their natural state, like some of the medicines, or were worked into objets d'art. The four elements, Air, Fire, Earth, and Water, were placed in each segment of the vault, and the cabinets below had to correspond. At the four corners were niches for small bronze statuettes of gods and goddesses chosen also to symbolize the elements as, for an obvious example, *Vulcan,* executed by Vincenzo de' Rossi (1525–87) for the Fire wall. The duke and duchess each presides in a portrait roundel over an end wall. The panels in the top rank of rectangles represent each of the materials being collected or harvested in its raw form; in the ovals of the lower rank a specific application in myth or legend is shown.[94] An especially successful pair is that of the *Baths of Pozzuoli,* which were waters with healing powers, and *Medea rejuvenating Aeson* (Fig. 161), both by Girolamo Macchietti. According to Ovid (*Metamorphoses,* Bk. VII, 163–8), Jason persuaded Medea to restore the youth of his dying father, Aeson, with her cauldron of magic herbs. The cabinet on the Fire wall must have housed precious remedial herbs that were boiled to release their powers. On the Earth wall, the cabinet containing objects of gold shows, above it, the extraction of the mineral from rock (by Jacopo Zucchi), and on its oval door, in a pleasing conceit by Andrea del Minga (c. 1540–96), is *Deucalion and Pyrrha* (whom we have not seen since the Villa Farnesina [Fig. 17]) repopulating the earth after the mythic flood by throwing rocks over their shoulders. There must have been more

arranged in their own cupboards according to type. Much is revealed about Francesco's personality and taste in this secretive little room. There was originally no door connecting to the Salone dei Cinquecento. It was accessible from the prince's adjoining bedroom and it gave access to a hidden staircase by which he could escape from the palace without being observed. Everything here is of a private and personal nature, in striking contrast to the Salone dei Cinquecento and the other large public rooms to which his father had given so much of his attention, and which address the visitor with the message of their decorations.

The Studiolo belongs to a genre, originating in

than enough objects of gold to fill one cabinet, for another pair of scenes, this time on the Fire wall, represent goldsmithing and a scene of sack, in which objects of gold are the quarry. The *Goldsmith's Workshop* of Alessandro del Barbiere (or Alessandro Fei, 1543–92) shows an artist at work on the grand ducal crown, which had indeed been designed by a Florentine goldsmith just a couple of years before, early in 1570.

The twenty-two painters who participated did not have a common background, nor were they all of the same generation. In the main, however, they were born around 1535, and many of them had worked on one or several of the projects Vasari had organized and overseen in the 1560s. Most had been admitted to the Accademia del Disegno. The differences of style do not offend, probably because of the small scale, and the room sparkles in its diversity. There is a quality of the exquisite, well suited to the function of the room and its hermetic, jewelbox atmosphere. The small scale of the panels (some of which were painted on slate, in fact, and not on wood) and the allegorical subject matter seem to have liberated both the mind and the brush of many of the participants.

Fantasies abound, to be sure, but they are of a different quality, on the whole, from those of Bronzino and Vasari. There is very little of the *difficoltà* that was always indispensable to those painters. What is not lacking is ornament, which is what the room is all about; there is an abundance of beautiful objects *on* the cabinets, as well as *in* them. Here, too, there is a departure from the recent past, for the *ornamenti* are not those of the serpentine figure or of the quoted pose that does not quite fit its new context. One can find such features – in Allori's *Pearl Fishers* for example[95] – but they are exceptional. Figural proportions have returned to normal. *Repoussoir* figures still occasionally fill up the foreground, but they are not compressed against the plane. Space is clearly defined and rational, and lighting, too, has been rationalized, even when it is used to create a dramatically unfamiliar setting, as in the *Goldsmith's Workshop,* the *Alchemical Laboratory,* or the *Cannon Factory.*

This style, then, is purged of many of the conventions of the Maniera, and in that sense it is more naturalistic than what preceded it. Yet the real world is not what these allegories are about, nor what they represent. Emotion on the whole is muffled, not vehement, and the world is as distant in its pictorial decoration as the Studiolo itself is claustral and secluded. Compared to

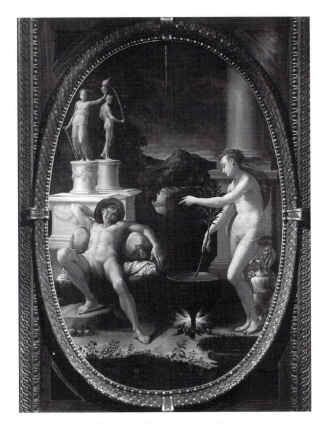

Figure 161. Macchietti, *Medea rejuvenating Aeson.* 1571–2. Studiolo of Prince Francesco, Palazzo Vecchio, Florence.

Rome in the 1570s, for example Jacopo Zucchi's ceilings for Cardinal de' Medici (Fig. 136) or the continuing decorations at Caprarola under Jacopo Bertoia (Fig. 135), we are struck by the diminutive scale here and the absence of references to the antique world such as abound in those Roman counterparts. The Studiolo might remind us more of the Florentine works of the 1520s, where there was a similar turn to northern European prototypes and preference for the miniature.

VASARI'S *LIVES* AND HIS VIEW OF CONTEMPORARY ART

Vasari included in his new edition of the *Lives* in 1568 a section on the artists of the Accademia del Disegno, together with his own autobiography, thereby giving wide dissemination to this innovative idea for the organization of artists and presenting Cosimo de' Medici as the model patron of the artists. Because the academy was intended to be a school, replacing the medieval workshop tradition, Vasari wanted to show that art could, in fact, be taught and that the genius of the artist, whether of high order or low, was released by instruction. This

thinking is opposite to the idea of the nineteenth century, to which we are heir, that academic training shackles genius. Vasari had to balance this concept with his premise that the truly great artist has innate qualities like intuition and judgment (*giudizio dell'occhio* he called it) that could not be instilled by precept.[96] It was to answer all these needs that Vasari and Borghini gave prominence in the funeral decorations to the garden school of Lorenzo il Magnifico, which Vasari presented as the first Medicean art school in Florence and the precedent for Cosimo's academy. Michelangelo was its greatest success, having received instruction in drawing the antique and modern works there from the master Bertoldo under the guiding eye of Lorenzo.[97] Even such a genius as the young Michelangelo had required instruction, and it was the duty and pleasure of patrons to provide opportunities to developing artists.

Much attention has been given in the past generation to the critical reading of the *Lives*. What was previously regarded as a chaotic assemblage of information gathered by Vasari from oral sources and his inspection of works of art, and then provided with prefaces in which he attempted to impose some kind of order, is increasingly understood in the light of its models in antique literature. It is now recognized that Vasari was writing literature, not history, and that we are misled when we take him literally. His book is full of devices borrowed from classical antique literature, ranging from ekphrasis – the descriptions of paintings that has as its real purpose to make the narrative vivid to the viewer, rather than literal describing – to anecdote.[98] Anecdotes recur constantly in Vasari's *Lives*, giving liveliness to the text and the impression that one is getting insight into the personality of the artist whose life is under study. Usually these anecdotes demonstrate Vasari's genius and are borrowed from the great tradition of epideictic or panegyric rhetoric.[99] The same conventional stories are used over and over again, the details altered to fit the circumstances. As disappointing as it is in any given instance, we are learning to give up the disingenuous belief that Vasari was recording some tidbit of oral history and to recognize his fictions for what they are. His purpose was to give instruction to artists and pleasure to his other readers.[100]

The *Lives* celebrated the primacy of Florence as the principal artistic center, at the expense of Venice and Rome. In response it called forth in the last quarter of the Cinquecento a whole literature in which other regions asserted their own important artistic patrimonies.[101] Vasari further claimed that art had reached perfection in the *terza età* in the *invenzione* of Raphael (1483–1520) and the *disegno* of Michelangelo. This achievement created, or contributed to, another problem that was hidden beneath the surface of his biological metaphor. According to Vasari, art was born in the century of Giotto (Part 1), grew and diversified in the century of Masaccio, Brunelleschi, Donatello, Ghiberti, and finally Leonardo (Part 2), and reached full-blown maturity in his own time (Part 3). The implication was that it could only decline and die in the future. Vasari, of course, denied the inevitability of such a course, changing his metaphor to say that once perfection had been reached it became the possession of those who followed, who needed only learn it and then improve on it with their greater facility. Yet there are poignant moments when Vasari appears to acknowledge that the art of his own day does not measure up, as when he speaks of the fear of decline after perfection has been reached.[102]

Some scholars have argued that the art of midcentury reveals the anguished recognition of its makers that they are the epigones who are not able to surpass their great predecessors. The sculptor Benvenuto Cellini (1500–71) wrote his autobiography with a mixture of bragging and defensiveness that can hardly indicate complete self-confidence and peace of mind, according to one critic.[103] It is tempting to psychologize the writings of Vasari and Cellini, and to empathize with the situation of these successors to Raphael and Michelangelo who must try to equal their stature. One of the responses these artists made was to exercise their sense of irony. The mock-heroic can be difficult to interpret because irony is like the tone of voice in which a remark is made: it is easily missed unless one understands very well the language, the context, and the speaker. There is surely a touch of irony in Salviati's encomiastic allegories of David-Cardinal Ricci (Palazzo Ricci-Sacchetti), or even Camillus-Cosimo (Palazzo Vecchio). It is that quality of wit that we have suggested is lacking in Vasari's cycles, the presence of which makes the others tolerable and even appealing. An object like Cellini's *Saltcellar*, which reduces the great gods Neptune and Amphitritis to miniature scale as a table ornament, is either ridiculous or self-mocking, and if self-mocking then it is the essence of what an ornament for a court dining table should strive to be: clever, extravagant, and

entertaining. To understand Vasari and his contemporaries in this way is to offer a middle course between the Scylla of trivializing their response to their situation and the Charybdis of weighing them down with psychological complexes.

SACRED ART

When the painters of this generation undertook to paint an altarpiece, the accommodation was fraught with perils because what worked brilliantly in court art could not readily be adapted to the requirements of sacred images. The *ornamenti* and *difficoltà* of which they were so fond distracted the worshiper from the narrative or the mood of devotion the image was supposed to evoke. The conflict, which we have discussed before in relation to Parmigianino (Figs. 77, 79) and to Jacopino (Pl. XVIII), is perhaps most acute in the altarpieces of Bronzino. His *Resurrection* was painted for Santissima Annunziata and is signed and dated 1552 (Fig. 162). Unlike chapels in Roman churches of the midcentury, the arrangement here is typically Florentine in having no side walls or vault, so that the only decoration is the altarpiece, which is charged with carrying the entire message.[104] Bronzino's Christ is arising slowly out of the tomb behind him, toward a host of angels and putti in the sky around him. Below, the Roman soldiers guarding the tomb explode outward in a centrifugal motion that leaves a small dark void beneath Christ's feet, the only empty space in the complexly filled surface. Flanking him are two exquisite nudes who draw attention by their self-contained lack of surprise; their wings, half-concealed, reveal them to be the angels who have opened the tomb.

The creative inspiration of Michelangelo's *Last Judgment* has been assimilated by Bronzino but is subtly apparent. The panel is dominated by nude flesh, interspersed with a few touches of brilliant color, like the

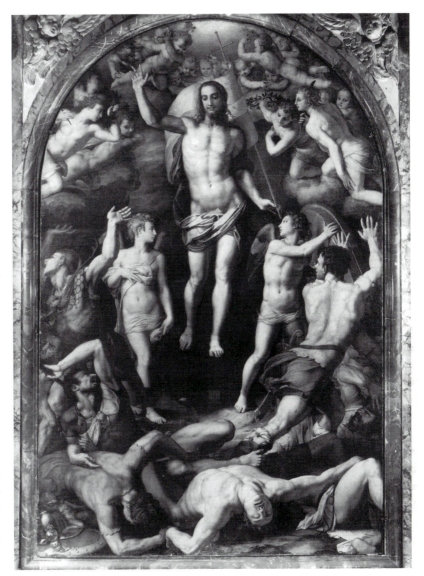

Figure 162. Bronzino, *Resurrection*. Dated 1552. Santissima Annunziata, Florence.

Judgment. The angels in the sky, wingless, bear a generic resemblance to Michelangelo's, though they have been feminized here. The soldiers assume contorted postures and are intertwined and overlapped in the manner of composing Michelangelo had invented. There is a drawing from life for the soldier reclining in the lower left, which used to be attributed to Michelangelo and was taken to be a study for his Jonah above the altar in the Sistine vault.[105] This drawing indeed is the source of the pose Bronzino has asked his model to assume. In the foreground there is a figure whose total nudity is hard to explain for a Roman soldier on watch. He is a

quotation of the *Dead Niobid,* an antique statue much copied by artists in the Cinquecento, then in the Maffei collection in Rome.[106] Bronzino has rearranged the arms but preserved the distinctive arch of the back, and he has drawn it headfirst, showing off his skill at *scorcia,* or foreshortening, one of the *difficoltà* often mentioned by midcentury writers who admired artistic virtuosity. Dolce, for instance, has his interlocutors discuss the subject. One says naively that because he has been told it is one of the leading problems of art he would think that the more often it appears, the more worthy of praise it is. "Aretino," his dialogue partner, responded, in effect, that it is quite possible to have too much of a good thing.[107] Paolo Pino suggested to the painter that he include at least one foreshortened figure, mysterious and difficult, in every painting so that he would be recognized as skillful by those who understand the perfection of art.[108] In the Renaissance the *Niobid* was thought to be the figure of the sleeping Endymion, so Bronzino's inclusion of him as a sleeping soldier is apt, as well as elegantly witty. A splendidly ornate plumed helmet adorned with a female nude fills the lower left corner of the picture, one of those exquisite ornaments so realistically painted that it serves as bait to persuade the viewer to swallow the total fiction.[109]

The iconography of the Resurrection in which Christ levitates from the tomb is an invention of the early Cinquecento, probably originating in Raphael's circle.[110] It replaced the earlier kind of representation, which was less dramatic and more hieratic, in which Christ stepped from the tomb and stood on the ground. (Piero della Francesca's fresco in Sansepolcro, c. 1458, is a familiar example.) Michelangelo made a series of highly finished drawings in which Christ bursts out of his sarcophagus with startling drama.[111] Bronzino here shows a hovering Christ, who seems suspended a few feet above the ground in order to deliver his blessing. His stillness contrasts with the violence of the soldiers. In the *cartonetto* for the painting Bronzino had depicted clouds under Christ's feet and the legs of the sarcophagus in the tomb that provide a pedestal for him to stand on.[112] The resemblance of his Christ to a devotional image, posed hieratically at the center, was stronger before he decided to delete the pedestal and cloud, but the sense lingers even after the change that he wished to combine the narrative and the devotional here, and even the old iconography of the Resurrection with the new. In Christ's pose Michelangelo is again recollected, but it

would seem that the quotation this time is a bearer of meaning. In the shadows at the left and right edges are grotesque, distorted faces that recall the damned in the *Last Judgment.* This *Resurrection* foreshadows the Second Coming when the resurrected Christ will appear again and we will all be participants. The visual cues Bronzino has embedded are intended to remind the devout that not only has Christ's death redeemed humankind but when he returns, it will be to assign us to our final places in heaven or in hell. The message is at the same time admonitory and consoling. Receiving the message depends upon familiarity with Michelangelo's *Last Judgment,* which Bronzino assumed of his viewer, in much the same way that familiarity with ancient texts and antique statues was assumed in the works for Cosimo's court.

◆

PONTORMO'S FRESCOES for the walls of Brunelleschi's choir of San Lorenzo, begun in 1546, were still incomplete when he died on 1 January 1557. The eccentric painter had closed himself and his paintings off from the world for the whole decade while he worked on them. Vasari tells how the young artists who were copying Michelangelo's statues in the Medici Chapel, the New Sacristy of the same church, climbed over the roof and, lifting the tiles, peered down to get a secret glimpse of what the mysterious Pontormo was about.[113] Pontormo paid the price for his antisocial behavior and consequent isolation from developments in contemporary Rome. Bronzino finished the frescoes on Duke Cosimo's order, and they were unveiled on 23 July 1558, but they were not well received. Vasari said that Pontormo had hoped to surpass all other artists, except perhaps Michelangelo, but instead he fell short of his own previous work. When in the 1730s structural repairs on the choir was required, the frescoes were destroyed without regret.[114]

Evidently unaware of — or determined to defy — the new demands of the Counter-Reformation, Pontormo produced in these frescoes what may well be the most extreme expression of the Maniera in sacred art. They embodied all the faults, as Raffaello Borghini, writing in 1584, pointed out: nudity, artifice, and obscurity of subject matter.[115] Had they been unveiled twenty years earlier, or even ten, it might have been a triumph, but coming when they did, in the midst of Paul IV's papacy, even in Florence the reception could only be chilly.[116] Vasari stated that he did not understand them, and that he

thought Pontormo had sought to bewilder both himself and the viewer, and he made no attempt to explain them.

What remains of these frescoes today are the extraordinary preparatory drawings of Pontormo, which give us a hint of their style. The drawing for the lower part of the Noah wall shows the *Benediction of the Seed of Noah* (Fig. 163), which followed the safe landing of the ark and the covenant the Lord made with Noah that he would never again destroy the earth with water.[117] Here we see tangled, overlapped, and intertwined bodies like those of Michelangelo's *Last Judgment*, which was certainly the inspiration. But Pontormo's figures seem pneumatic, like ethereal, weightless creatures, and not the solid sculptural bodies of Michelangelo, or of Bronzino, for that matter. He alone has retained the elongated proportions of the 1520s – large torsos, small heads, and slender limbs – with which Michelangelo had experimented then in the Medici Chapel sculptures but had subsequently abandoned.

Vasari, like Pontormo, Bronzino, and in Rome, Salviati, remained resistant to the new wind that was blowing through the Church. He modified a few passages in the second edition of the *Lives*, paying lip service to the demands of Trent,[118] but he did not alter his approach to painting an altarpiece. It is interesting, even rather poignant, to see his close friend, the theologian Don Vincenzo Borghini, trying to warn him toward the end of his life. In a letter of 1572 he tells Giorgio that he should be clear and unambiguous in his representation, and to be understood by the viewer he should use inscriptions and citation.[119] Inscriptions Vasari was willing to add, if Don Vincenzo devised them, but complexity and ambiguity, both iconographical and stylistic, he could not do without.

In the wake of the Council of Trent, Duke Cosimo, who was wooing the pope, decided to undertake the renovation of the two principal churches in Florence to accommodate them to the demands of the Council that the Mass should be accessible to the laity. He accordingly ordered Vasari to have the enormous rood screens that separated the lay church from the friars' choirs in

Figure 163. Pontormo, drawing for *Benediction of the Seed of Noah,* for San Lorenzo choir frescoes. 1546–57. © British Museum, London.

both Santa Maria Novella and Santa Croce removed, and the high altar moved forward, so that the choirs could be transferred from the upper nave to behind the high altar. The side chapels were to be reorganized in a coherent plan, with one altar per bay, and there were to be new altarpieces, of uniform shape, size, and framing installed above each altar.

In Santa Croce, the second church to be renovated (begun 1565), the plan was bolder in calling for a cycle of Christ's Passion to be represented in the altarpieces encircling the nave. This plan required more aggressive intervention with the patrons than had been the norm in the past, when the patron had made all the decisions concerning his chapel and merely gave a contribution to the friars to endow the chapel and pay for Masses to be said there. The authority of the duke was needed to impose such a scheme, but Trent had made it clear that the churches were no longer to be regarded as the domain either of the clerics or of the patrons, and Cosimo was quick to respond. The patrons were informed not only that they would have to remodel their chapels according to the new plan drawn up by Vasari, but also what the subject of the altarpiece would be. The result must have pleased the Tridentine reformers because it swept away the chaotic individualism that had ruled in the family chapels, joined them together thematically and visually, and made accessible to the worshiper a coherent series of images that could serve as a

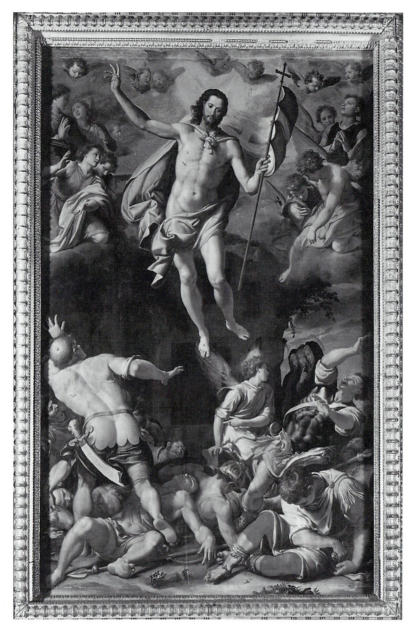

Figure 164. Santi di Tito, *Resurrection*. c. 1574. Santa Croce, Florence.

orations, the wedding of Francesco, and the prince's Studiolo. Chief among them were the painters who had gone to Rome and brought back the style of their contemporaries there. Thus we have the curious situation of Vasari choosing painters for the most prestigious jobs available in Florence who did not follow his stylistic lead but instead created their own local version of the Counter-Maniera. There is no evidence that the style was imposed from above. Vasari himself contributed six altarpieces to the cycles in his accustomed Maniera.[122]

The style of the altarpieces on the whole conformed to the requirements for reform. When they were discussed some years later by the Florentine spokesman for the Counter-Reformation, Raffaello Borghini, there was little for him to find fault with in the work of the younger painters, in contrast to Vasari's pieces, which were heavily criticized, as we will discuss. But the Florentine Counter-Maniera retained more from the past than its Roman counterpart. The new generation of painters forged a compromise between the new Roman Counter-Maniera and the Florentine tradition. They were willing to sacrifice the nudes, the quotations, the *difficoltà,* the complex multiple meanings, in favor of straightforward narrative, but theirs remained a more aristocratic art, more refined, more devoted to *ornamenti,* less aggressively pious. Even the most reform-minded of them, Santi di Tito, drew heavily on Florentine prototypes. His revision of Bronzino's *Resurrection* (Fig. 162) is indicative (Fig. 164). Although he preserved the basic layout, he omitted the nude quotation, untangled the soldiers so they do not intertwine confusingly, draped all the figures, and instead of the ambiguously hovering Christ, his bursts energetically upward, his legs slightly bent and his banner and drapery swirling to show his movement. There is no hint left that we should take this scene as a premonition of the Final Judgment. Vasari, though, in his *Resurrection* in Santa Maria Novella

basis of meditation on Christ's death and resurrection. A few years later this kind of uniformity in the side chapels was codified as the recommended norm by Carlo Borromeo in his book on sacred art.[120] In this way the duke was able to take the lead in implementing the Tridentine reform and demonstrate his interest to the newly elected Pius V, whose asceticism would so much impress Vasari a couple of years later when he visited Rome.[121]

Vasari selected the painters for the new altarpieces from the young academicians. Many were the same painters who had worked on Michelangelo's funeral dec-

(Fig. 165), introduced four saints and turned it into a kind of devotional image, for which he was later criticized by Raffaello Borghini.[123]

RAFFAELLO BORGHINI AND *IL RIPOSO*

It is symptomatic of conditions in Florence that the spokesman for the Counter-Reformation, Raffaello Borghini, was a layman who wrote his dialogue, called *Il Riposo*, from two distinct points of view, examining individual paintings first as works of sacred art, then a second time in aesthetic terms. In Book I he can sound very much like his clerical counterparts, Gilio and Paleotti, and his criteria, like theirs, are derived from the Tridentine Decrees. He criticizes the same faults, such as a Christ who is shown without sufficient evidence of his suffering[124] or the addition to a narrative of people who were not alive at the time. This kind of confusion of subject he blames primarily on the patron, but he claims the painter who is more interested in pleasing the patron – and in being paid – than in observing the sacred text is also at fault.[125] Portraits in the person of saints are censured, but in one particular case, that of the patron's son, it is allowed because he was represented as a humble shepherd adoring the Christ child.[126]

In Book II a second set of criteria is defined and then applied. The aesthetic is distinctly post-Maniera, and it is as if Borghini wants to prove that paintings that fail as *arte sacra* also do not meet the standard as good art. On the whole, what was condemned in Book I is then faulted in Book II for different reasons. There is the occasional moment, however, when Borghini's lenient attitude created a conflict, as in the case with Bronzino's *Resurrection* (Fig. 162).[127] The exquisitely sensuous angel standing next to Christ was condemned as lascivious, of course, but then it was praised as a work of art that one would love to have in one's home – a position we do

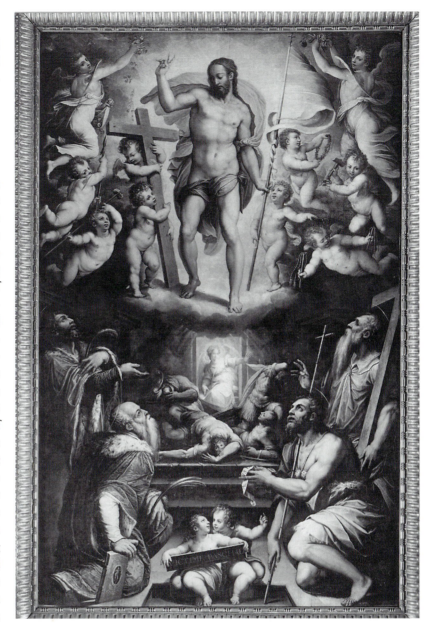

Figure 165. Vasari, *Resurrection with Saints*. 1568. Santa Maria Novella, Florence.

not find articulated by his clerical counterparts. Contrast this opinion with Paleotti, who would prohibit even the private collecting of mythological paintings.[128]

Il Riposo reads as a much more gentle and appreciative approach to painting than Gilio's work. The dialogue takes place in a villa; the speakers discuss the beautiful surroundings; and a whole section at the beginning of Book II is devoted to a discourse on the techniques of painting and sculpture. Borghini intends his reader to understand that Gilio is his model, and he quotes Trent's and Gilio's criteria for sacred painting, mentioning him

twice.[129] But the opening discussion centers on secular painting, and the purpose seems to be to show that the same requirements of plausibility should be applied to "poetic" works as to sacred. When Sirigatto, the spokesman for the artists, remarks that sometimes one wants to show the excellence of art, the spokesman for the Counter-Reformation, Vecchietti, replies not with the harshness of Gilio, but with praise of Michelangelo's *Battle of Cascina,* where he displayed his virtuosity in an appropriate subject.[130] Another of Borghini's purposes is to soften Gilio's attack on Michelangelo by showing that "Il Divino" did great things, too, just as we Florentines have always claimed. The justice of Gilio's demand for clarity, purity, and piety is acknowledged, but it is not, as Gilio and especially Paleotti implied, that it is inappropriate for the artist ever to show the excellence of art; only that he should choose the proper subject, even if he has to invent it, as Michelangelo did in the *Battle of Cascina.*

The discussion in Book II of how an artist should proceed offers the opportunity to embed the criticism of Maniera in this general advice and to avoid attacking painters too specifically. The exception is Pontormo's fresco cycle in San Lorenzo, of which Borghini says it is hard to understand how an artist who had done so much wonderful work could lose himself as he did here. The harshness of this judgment is mitigated with a remark about how it is possible for artists to lose their powers when they grow old.[131] Vasari, too, comes in for criticism for his forced and unnatural poses[132] and for his overcrowded composition, in which the figures are said to seem stuck to each other.[133] Figures should not be cut off or entangled but shown in their entirety, so as not to be confused.[134] The painter is advised to avoid forced poses and foreshortenings unless he is painting a battle, where they are appropriate.[135] That favorite device of the Maniera of repeating a face or a pose or a drapery pattern is specifically forbidden. Do not give a delicate woman the limbs and muscles of a ferocious man, nor the softness of a woman to a man, the painter is told. The modeling of muscles should not be exaggerated.[136] Although it is never stated, these last faults resulted from imitating Michelangelo.

The imitation of Michelangelo is treated very obliquely. When they come to discuss Alessandro Allori's copy of the *Last Judgment* in Santissima Annunziata, in Book II, the speakers pass over it, Sirigatto saying only that because Vecchietti does not like it he will not say anything except that it is very well done. In fact, in Book I it had not been mentioned at all, and Vecchietti's dislike was not even recorded there.[137] The impression is allowed to remain that Sirigatto would like to praise it at greater length. When they come to Bronzino's *Martyrdom of Saint Lawrence* (Fig. 159), one of the participants lashes out, faulting it for bad composition, for lacking relief, for poses that are not pleasing, and for weak color, but no one voices assent.[138] With respect to both these pieces one senses a self-imposed restraint.

On the whole, the aesthetic values enunciated by Borghini mirror the revisions of style the Counter-Maniera painters themselves had made, and the criticisms leveled at their pictures were of small lapses, rather than pointing to major differences of opinion. There was certainly less tolerance for license in Borghini's time than previously, especially when it comes to proportions. The Maniera artists were reproved for figures that are out of scale and for departures from naturalism: Salviati's Madonna would be a giant if she stood up;[139] the Madonna's arm in Vasari's *Madonna of the Rosary* belongs to a giant;[140] the two saints in the second tier are out of scale in Vasari's *Resurrection* (Fig. 165);[141] Bronzino's soldiers and angels in his *Resurrection* are not naturalistic enough (Fig. 162).[142] Nevertheless, there is much more appreciation for the excellence of art, that is, for virtuoso display, than one finds in the clerical writers of the Counter-Reformation. A fault that Gilio or Paleotti would not have complained of, lack of grace, is often mentioned in Borghini, even in the figures of the Maniera artists − an indication that the concept of *grazia* has been altered. Pontormo, Vasari, Bronzino, and Salviati are criticized for those conventions of the Maniera that painters were enjoined to avoid, but these faults were not to be found, on the whole, in the Counter-Maniera artists.

FRESCOES IN THE CUPOLA OF THE CATHEDRAL

Cosimo's other great commission of sacred art was the frescoing of Brunelleschi's cupola in the cathedral. Great indeed: it is 4,800 square yards of painting. Brunelleschi had assumed it would be decorated, probably with mosaic, and had left holes so that a scaffolding could be installed, but almost a century and a half[143] had gone by before the huge project was undertaken in 1571.[144] The team was in place: Vasari, advised by Don Vincenzo Borghini, and the painters who had

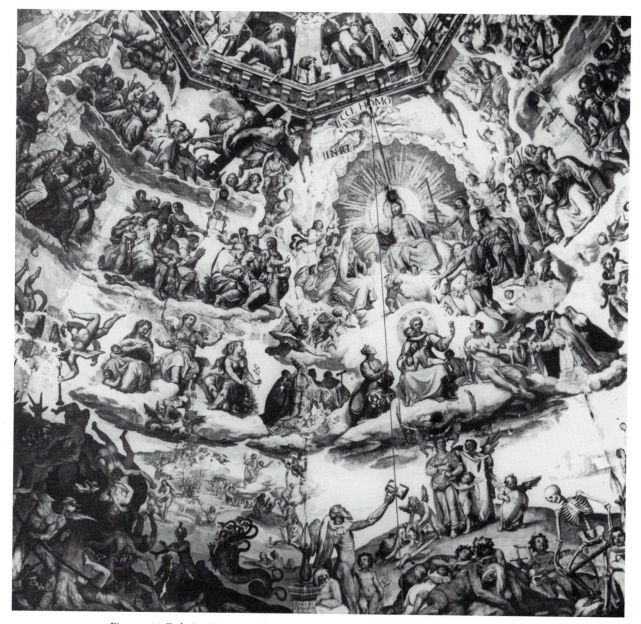

Figure 166. Federico Zuccaro, *Christ as Judge,* segment. Fresco, 1576–9. Cupola, Florence.

worked with him in the Palazzo Vecchio. The project was so important that once begun, even the deaths in 1574 of the artist in charge and the patron could not derail it. Grand Duke Francesco I, though he showed very little interest otherwise in public patronage of art, deemed it necessary to continue the commission. The subject chosen was the *Last Judgment.* What gives it particular interest for us is that here in Michelangelo's hometown is a painting that could be nothing other than a critique of his ill-starred fresco. Not surprisingly, every figure is clothed, and the plan is spelled out with irksome apprehensibility.

Vincenzo Borghini devised the program. In his letters to Vasari we can observe him thinking it through.[145] Recognizing that the eight segments of the dome should supply the organizing principle, he was at first vexed by the problem of numbers. The favorite number of doctrine is seven: seven gifts of the Holy Spirit, seven virtues, seven beatitudes, seven mortal sins. These could be deployed easily, but how should the eighth segment be filled? His solution was brilliant. The segment over the high altar was reserved for Christ as Judge in the celestial court (Fig. 166) descending to the triad of cardinal virtues, Charity

flanked by Faith and Hope, down to the Church Tri-umphant. Running around the dome there would be five superimposed bands and in each of these bands a different population would be represented. Hell is at the bottom, the lowest circle, divided into the seven mortal sins, and in the eighth segment, below Christ, is Chronos, Time, holding up his broken hourglass to a woman who has shed her armor. She is the Church Militant and is being crowned and decked in the man-tle of the Church Triumphant.[146]

The image presents a glorification of Paradise and the message is a truly Tridentine one: triumph. The cru-cified Christ returns triumphant. Over his head are the only words that can be read from the floor: *Ecce Homo,* "Behold the man," the words spoken by Pilate when he presented the flagellated Jesus to the people for their judgment, "Should he be crucified?" Christ, the man who died as a result of human judgment, is now the resurrected Lord, come a second time, this time to judge humankind.

Vasari began at the center with the innermost ring. There around the base of the lantern he painted in splendid illusionism a fictive tabernacle, symbolizing the ark of the covenant in which are placed the twenty-four elders, as in the Apocalypse of John. He made designs for the entire vault. His drawing for the seg-ment depicting Christ (Fig. 167) shows his dependence upon Michelangelo, despite the recognized necessity to correct his "errors." The poses of his Christ and the shrinking Virgin recall Michelangelo's unmistakably. One of Borghini's most ingenius inventions shows how Time will be stopped at the Final Judgment: a little angel is driving a spike through the globe on which Christ stands, which will stop its turning. The seven archangels and John the Baptist encircle Christ. Adam and Eve, demurely clad in circlets of fig leaves, kneel at his feet. An eschelon of the blessed kneel in an arc on the clouds below, led by a pope and a bishop. The three cardinal virtues, Faith and Hope flanking Charity, are to be seen at the center below. He completed three of the segments (though not this one), about a third of the total dome, before his death in 1574.

Who his successor would be must have been the sub-ject of much speculation. In the event, Grand Duke Francesco chose a non-Florentine, Federico Zuccaro, who came all the way from England in 1575 in order to take charge of the project. Although Vasari's designs for the whole composition existed, and Federico was

charged to follow them, he in fact took vast liberties, as is evident when we compare Vasari's drawing (Fig. 167) with the segment as painted (Fig. 166).

Zuccaro began work in 1576 and directed his large workshop for three years. He brought the project to completion in such a remarkably short time by having much of it executed not in the demanding but durable medium of fresco, but with the much quicker means of painting *secco,* on dry plaster.[147] The advantage was that the painting could be carried on all year long and not be hampered by the extremes of hot or cold weather. Moreover, it is easy to make corrections by overpainting in *secco,* so assistants could be assigned the execution of the cartoons, prepared by or under the direction of Zuccaro himself. Although it was well known that *secco* does not hold up as well as fresco, when the grand duke's representative, who was charged with the suc-cessful outcome of the project, expressed his concern that too much *secco* was being used, he was silenced by reassurances from Borghini and a court painter. In fact the recent cleaning revealed that the *secco* portions had suffered much more damage than those by Vasari in *buon fresco.*

Alessandro Allori, who was Bronzino's pupil and heir and who became Francesco's favorite painter, might have harbored keen hopes that he would inherit the commission.[148] He had demonstrated his ability to han-dle fresco in the Montauto Chapel in Santissima Annunziata, and again in the altarpiece of the artists' chapel in the same convent.[149] His skill at combining the style of his master, the pure Florentine Bronzino, and his knowledge of Michelangelo would have seemed to him strong qualifications. It has been suggested that the drawing of *Christ in Limbo* was originally a project for the cupola[150] and was only later reused in the small painting today in Rome in the Galleria Colonna (1578). It is certainly a monumental composition, which makes better sense on a large scale where some of the details that are all but lost in the reduced version would be legible.

Zuccaro's contract stipulated that he should make use of the drawings Vasari had left and of Borghini's pro-gram. His attitude toward his predecessor was summed up in his remark, "Poor Giorgio who only knew how to work fast, and to stuff the walls with figures." He modified Vasari's model in a series of drawings in which his Christ becomes more and more benign, with increasing emphasis upon his clemency, in keeping with

Figure 167. Vasari, preparatory drawing for Florentine Cupola frescoes. 1573. Louvre, Paris.

Counter-Reformation doctrine and the spirit of the whole vision. In the final version (Fig. 166) he is seated and the saints plead with him for the sinners. In the Byzantine iconography of the Deèsis, from which Zuccaro derived his image, God should appear above, but as there was no space to insert him, he showed Christ looking upward, with a gesture that commends the intercessory prayers to his Father and a golden light that signifies God's presence.[151] Christ has become a hieratic image, seated as though enthroned and now almost entirely draped, adored by Mary and John.

Zuccaro preferred Raphael to Michelangelo, coming from the region of Urbino himself, and his iconographical model here is Raphael's *Disputa* (1509), but he has executed it in a summary manner quite different from Raphael's. The energy of Vasari's version, derived from Michelangelo, has been drained away, poses have been simplified and made more symmetrical, their psychology more single-minded. Here we can see the difference between the Maniera of Vasari – albeit already tamed – and a doctrinaire interpretation of the Tridentine Decrees. It is clear that Zuccaro intends to offend no one and to produce the perfectly orthodox painting.

In contrast to Michelangelo's version, here everything is clear, all the participants have their assigned places. There is nothing of the shifting movement of Michelangelo's composition or the jumbled uncertainty of his figures under judgment.

Zuccaro's frescoes did not meet with universal approval when they were unveiled. One critic in fact called for their immediate whitewashing, and they have been treated harshly by critical opinion ever since, until the recent cleaning.[152] They are perhaps the quintessential example of the Counter-Maniera, made at that moment of uncertainty in the Church regarding sacred imagery. Not that sacred images were not affirmed, on the contrary. But the didactic function was regarded as paramount in importance, and the usefulness of artistic excellence was denied. We have seen examples in Rome by Girolamo Siciolante da Sermoneta of this same period of transition (Fig. 129). It is instructive to compare the ceiling decorations in Roman Baroque churches, like the Gesù or Sant'Ignazio. There the solution that the Church has not yet come to in the 1570s is displayed: the ceiling is opened up as if to a heavenly vision and the worshiper is overwhelmed with ecstatic emotion.

Florence retained from the Maniera generation its deep-seated cultural preference for the verbal meaning and a concomitant discomfort with the expression of emotion. Don Vincenzo Borghini had contributed the programs for the historical cycles in the Palazzo Vecchio throughout the 1560s, and then moved easily into a role that accorded well with the Counter-Reformation demand for truth to scripture. As a theologian he was ideally equipped to invent the programs for some of Vasari's late altarpieces,[153] his chapels in the Vatican, and the frescoes in the cupola. Raffaello Borghini put into the mouth of his spokesman for the Tridentine reform the warning that painters should seek the advice of theologians when they wanted to paint sacred subjects, and mentioned approvingly the contribution of Don Vincenzo to the cupola frescoes.[154] These frescoes, like many other Florentine works of the Counter-Maniera, remain essentially intellectual enterprises, making their appeal to the mind of the worshiper through the verbal program that gives them their shape. This approach was preferred in Florence, despite the opposition of the Counter-Reformation writers to hidden allegory, like that first pronounced in the 1550s by Dolce's Aretino against the *Last Judgment*.[155] Borghini's Vecchietti

takes Vasari to task for combining narrative and devotional images and for weighing down his painting with allegory. The cupola frescoes contain many allegorical figures, but nothing is concealed or obscure, which may have been part of the reason the Florentines disdained them. What Zuccaro shared with the Florentines was a reticence with respect to expressing emotion. Those in the Church who favored the strongly affective as the way to stimulate devotion eventually won out, but there was no one in Florence until the very end of the century practicing or advocating this approach, not the reformer Santi di Tito, and not Borghini either, and certainly not Grand Duke Francesco or the other patrons.

SANTI DI TITO (1536–1603)

The painter who went furthest in the direction of rejecting the conventions of the Maniera and the one most associated with reform is Santi di Tito. After his extended stay in Rome he returned to Florence and introduced a style modeled on that of Girolamo Muziano and Federico Zuccaro at Orvieto in the 1550s and 1560s. The unornamented style developed by Federico in his altarpieces is particularly relevant (Fig. 132); if Santi did not know these works he must have known others.[156] When Santi was in Rome in the early 1560s, he had worked together with Federico in the Casino of Pius IV at the Vatican, and of course Federico's presence in Florence in the late 1570s, working on the most prestigious commission, would have reinforced his authority.

In Santi's *Raising of Lazarus* (Pl. XXVII) he has rejected the relieflike style and almost all traces of the Maniera. The formula is like that developed at Orvieto: *repoussoir* figures have been eliminated, and the major actors stand closest to the plane at the bottom of the picture. The onlookers are arranged in an ascending space punctuated by architecture with balconies or columns, on which people climb to get a better view. The upper space is filled with buildings and landscape. There are no angels or intrusions from the divine sphere to undercut the plausibility of this as an event occurring in this world. The miracle is shown in a very straightforward fashion, almost understated, and the spectators express surprise but not astonishment. Christ is dignified and noble but not much removed from the other participants, who are represented as common

people, completely unadorned. The fantastic costumes, or the ornaments to be found in the altarpieces of Vasari and Bronzino, are nowhere to be seen. There are no quotations intended to be recognized, no hidden allegory. No homage to Michelangelo is embedded here. There are no serpentine figures, no *scorcie*. What is presented is fully consonant with Tridentine prescriptions; Lazarus is encased in his shroud and opportunity has not been taken to show off the nude body, as earlier painters of the Renaissance, even such sober ones as Sebastiano del Piombo, had been wont to do (Pl. III). Santi's, like Muziano's and Federico's, is an easy and pleasant style that seeks to present the narrative without evoking much in the way of emotion, even of an aesthetic kind.

Santi's prosaic aesthetic is apparent particularly in his color. The jewellike sparkle of Bronzino, the pastel harmonies of Allori, the gentle sfumato of Naldini (derived from Andrea del Sarto), the *cangiante* feast of Barocci (Pls. XXIX–XXX), the deep richness of Cigoli (Pl. XXVIII) – none of these is to be found in Santi's art. He showed little interest in color, except for a rapprochement with Venetian light and color around 1573–4, noticeable in his *Supper at Emmaus* and *Resurrection* in Santa Croce (Fig. 164).[157] A trip to Venice in the early 1570s has been hypothesized to explain the sudden interest in light and color and inventive composition, but it turned out to be a passing infatuation that Santi did not sustain. Raffaello Borghini noted the difference in the color of those works in Santa Croce. He criticized the color of the later *Lazarus* altarpiece at the same time that he praised its reverent and devotional mood and the propriety with which the narrative was presented.[158]

Some critics have related Santi's style to the High Renaissance. The healthy, quiet, unsophisticated mood he achieved has been compared to Fra Bartolomeo (1472–1517).[159] But the stripping away of all *ornamenti* is at odds with the style of the mature High Renaissance. Raphael and Michelangelo were, after all, particularly devoted to the tradition of ornament, and in this respect there is a real discontinuity. One senses, reading between the lines, that Borghini did not like Santi's paintings very much. He could not see the need to give up displaying the excellence of art to such an extreme degree, and one suspects he found these works simpleminded. What Santi did have in common with the Classic style, a reserve about evoking the emotional participation of the

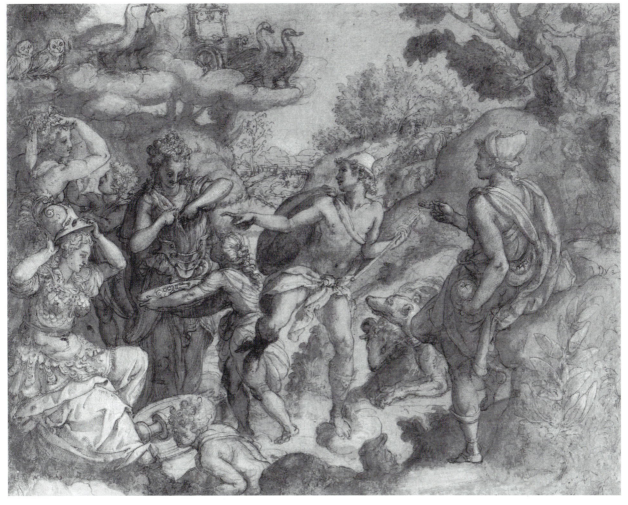

Figure 168. Allori, *Judgment of Paris*. Drawing for a tapestry, early 1580s. Metropolitan Museum of Art, New York. Rogers Fund, 1963.

viewer, is what held him back from exploring the affective – the untilled, fertile ground that would take his pupil Cigoli to genuine reform and into the realm of the Baroque.

ALESSANDRO ALLORI (1535–1607)

The reform of painting in Florence is more like a purging of the offensive aspects of Maniera than it is a positive new statement. In their altarpieces this group of painters paid lip service to the new norms, with which they were completely familiar, but they lacked any expression of commitment to a new kind of sacred image. There is a dreamlike quality, a remoteness from this world in nearly all of them that makes Santi's matter-of-fact rendering, by its contrast, appear to belong to a different order. Alessandro Allori, as the heir of

Bronzino, was the most successful and prominent of the painters in Florence in his generation. His altarpieces are perfectly composed and exquisitely rendered, but the people in them hardly seem physically present. They are soulless, uninhabited bodies, existing only as the patterns of design the painter created. Allori's delicate *cangiantismo* makes his representations still more removed.[160]

Allori excelled as a decorator, and this skill recommended him to the taste of Grand Duke Francesco, whose interests lay in this arena rather than in religion or political propaganda. Francesco turned his attention at last back to the family villa at Poggia a Caiano, which we remember had been left unfinished in 1521 when Pope Leo died (Fig. 44). He decided not only to complete the cycle of frescoes in the Salone partially executed by Franciabigio, Andrea del Sarto, and Pontormo

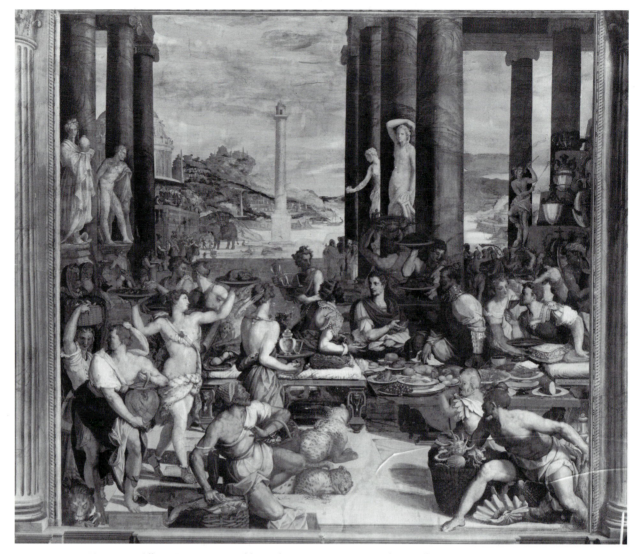

Figure 169. Allori, *Scipio entertained by Syphax.* Fresco, 1579–82. Salone, Villa Medici, Poggio a Caiano.

(1520–1), but to commission tapestries to cover the walls, as his father had done for the Palazzo Vecchio. Allori's unwillingness to move far beyond the Maniera of his teacher equipped him well to continue what Bronzino had excelled in, and his tapestry drawings may be Allori's best work. Like his master, Allori was a superb draftsman and his drawings convey the spirit of his art.

A set of four studies for tapestries center on the story of the golden apples from the Garden of Hesperides.[161] In the *Judgment of Paris* (Fig. 168), the young shepherd holds the apple he will award to the goddess he judges the most beautiful, while the ladies prepare themselves for the contest. Allori's rendering is not without gentle humor, as for example the eagerness with which Juno is unbuttoning her dress. Mercury

tries, successfully, to influence the judge by pointing to Venus, who lingers modestly in the background. Apparently Allori and his patron did not feel entirely safe from the purview of the stern reforming prelates, for the opportunity to present three scrumptious nudes was not taken. In many respects of style the design differs little from what might have been done for Duke Cosimo a generation earlier. The aesthetic preference for statuary forms has been replaced by a more painterly manner, but many of the old conventions of the figure have been revived and several figures, especially Venus and Minerva, are flattened to the plane, with limbs picked out by a flat light. It is hard to imagine that the subjects chosen for Francesco's tapestries have any of the allegorical double entendre of those ordered by Cosimo. These are pure mythology for pure

enjoyment, as much as the contemporary sacred images are pure religious narrative.

Allori worked on the frescoes at Poggio a Caiano between 1579 and 1582. He enlarged Sarto's and Franciabigio's scenes, removing the painted column that had divided the wall and executing them as single unified fields. He painted the allegory on the end wall, which had originally been assigned to Pontormo, and then frescoed two scenes from Roman history to complete the cycle as planned by Paolo Giovio in 1520. Two events from Roman republican history had been chosen to eulogize the accomplishments of Lorenzo il Magnifico. In the *Oration of Titus Flaminius,* the ancient hero induced the Greeks to support the Romans against Philip V. This rendering was intended to recall the rhetoric of Lorenzo, who persuaded Pope Sixtus IV to change sides and come to the rescue of Ferrara against the Venetians, who intended to rule all the Italian peninsula.

In *Scipio entertained by Syphax* (Fig. 169), the Roman general visited an African leader; as a result of his diplomacy, Syphax allied himself with Rome against Carthage. Lorenzo's stunningly successful diplomatic mission to Naples is recalled, as the result of which the king of Naples switched his allegiance to Florence and saved the city from certain conquest by the papal forces and their allies.[162] Allori has spared nothing in representing the luxury of the court. As the king and general recline at the table, servants rush in with all manner of dishes to lay before them. Exotic animals lounge in the palace or can be seen outside. Marble statues adorn the hall, and, as if to assure that we do not miss the further analogy to the present grand duke and his court, the famous dwarf, Morgante, appears in the lower right. Both Scipio and Flaminius resemble Grand Duke Francesco.

Allori's style is grander and more monumental than that of his predecessors in this cycle. The difference is apparent if we compare Andrea del Sarto's portion of the *Tribute to Caesar* at the left with the extension added by Allori at the right (Fig. 45). (The seam is visible to the left of the statue.) Allori's figures are larger and more broadly modeled. They move and gesture more confidently. In settings, too, Allori has learned much, first from Rome and more recently from Venice, in particular, Paolo Veronese's feasts. But unlike the Venetian prototypes, Allori's fresco here proudly retains from the Maniera and his master, Bronzino, the stylized and self-conscious poses with emphasis on the limbs. It is as if

without their grandiloquence Allori would find the narrative trivialized.

CIGOLI (1559–1613)

The principal painter to bring the Baroque to Florence was of the next generation, a quarter century younger than Allori and his contemporaries. Cigoli began in Allori's *bottega* and then went over to Santi di Tito's, a change of allegiance that tells us much about Cigoli's intention to ally himself with the most progressive forces. He then acquired by study of Federico Barocci (1535–1612), in particular his *Madonna del Popolo* in nearby Arezzo (delivered 1579, now in the Uffizi), understanding of the value of appealing to the emotions of the worshiper. He imitated Correggio (1489–1534) – he was even called by the seventeenth-century artwriter Baldinucci, who held him in highest regard, "the Florentine Correggio." Perhaps it would be more accurate to call him the Florentine Barocci, because like him, he learned from Correggio the means of affective appeal. Cigoli developed a color style far from Santi's prosaic description that is deep, rich, harmonious, and splendidly sensuous.

In his *Pietà* (Pl. XVIII) we see a straightforward composition and figure poses that preserve the directness of Santi and avoid the artifice of Maniera. The dark surrounding the central group intensifies the grief expressed in the faces. There is that quality of sincerity Santi and Barocci are capable of conveying, so different from the masked emotion of most Florentine sacred painting of the period. Cigoli's color here surges beyond Santi's and rivals Barocci's and Correggio's in its sensuous appeal, although it is very different. If Santi regarded ornamental color with distrust because it appeals to the senses and not the mind – according to the *colore-disegno* debate[163] – Cigoli knew better. A darkness in which the opening of the tomb is faintly discernible surrounds the central group, closing them off. Christ's ultramarine loincloth is a whitened version of the Madonna's robe; the repetition binds them together coloristically as powerfully as her grieving face and her hands, tenderly cradling his arm. There is a pale echo of the blue on Joseph of Arimathea's shoulder. His hat is a rich red velvet, repeated in less intense tone in the Madonna's dress. Two angels stand behind, one in the shadow, the other catching the light on his sleeve, giving another glimpse of brilliantly painted texture.

Looking up from the implements of the Passion he holds in his arms with pained expression, the angel extends the mood of grief. There is as much attention to creating a beautiful painting as in any Maniera work, but nothing detracts from the intensity of the compassion expressed by each of the figures. If the Maniera artist baited the viewer with ornaments executed with surreal precision, Cigoli entices with his colors and textures, and his viewer is hooked into sharing the emotion of the event.

When finally in 1604 he went to Rome, Cigoli brought back to Florence on his return acquaintance with the Carracci's and with Caravaggio's styles, and he then created two of his masterpieces, the *Ecce Homo* and the *Deposition,* both now in the Pitti.[164] But these belong to the next century and another period and style.

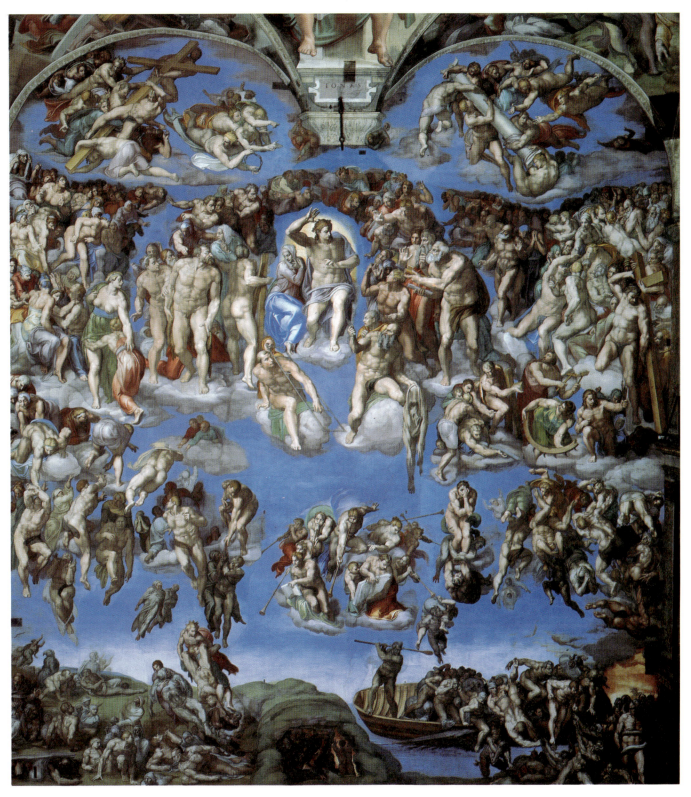

Plate XVII. Michelangelo, *Last Judgment*. Fresco, 1536–41. Sistine Chapel, Vatican Palace.

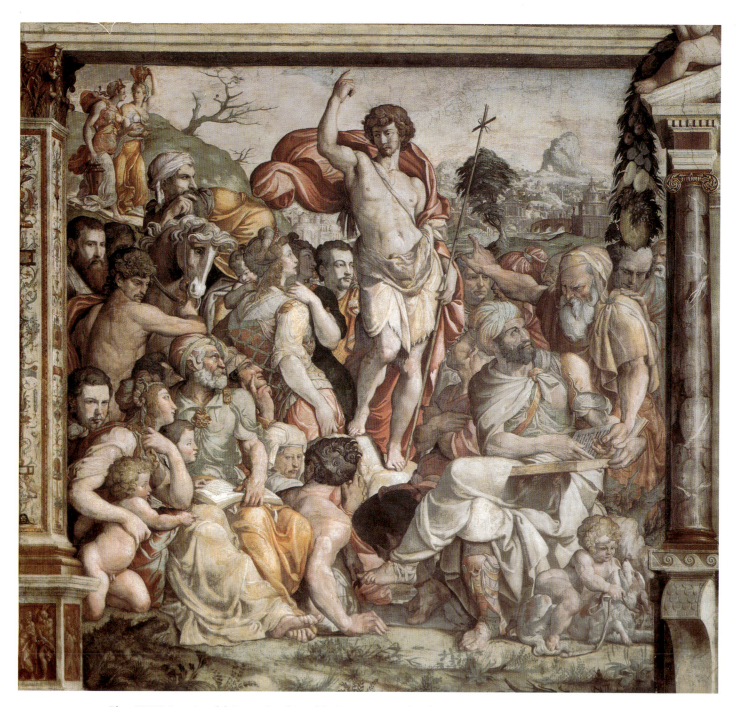

Plate XVIII. Jacopino del Conte, *Preaching of the Baptist*. Fresco, dated 1538. Oratory of San Giovanni Decollato, Rome.

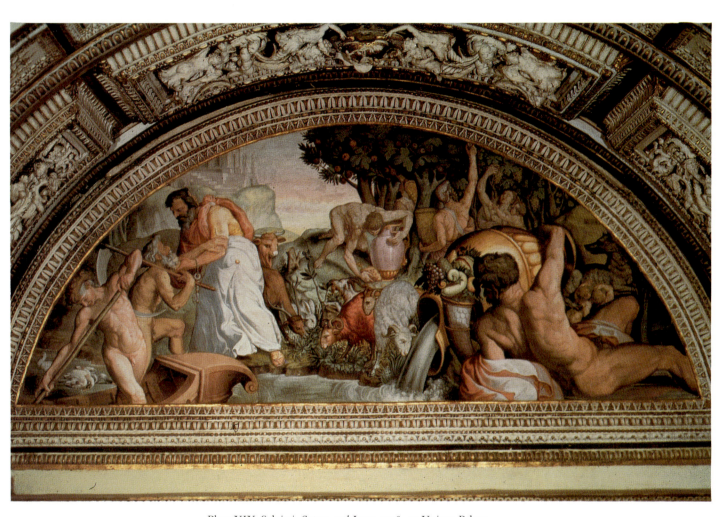

Plate XIX. Salviati, *Saturn and Janus.* 1548–50. Vatican Palace.

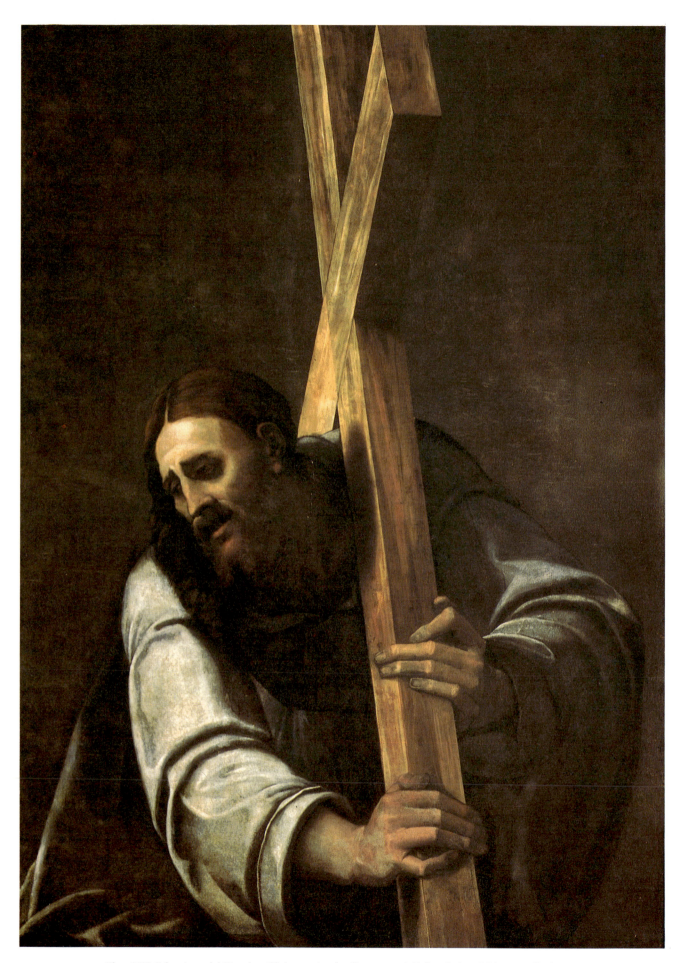

Plate XX. Sebastiano del Piombo, *Christ carrying the Cross.* c. 1538. Szépmüvészeti Museum, Budapest.

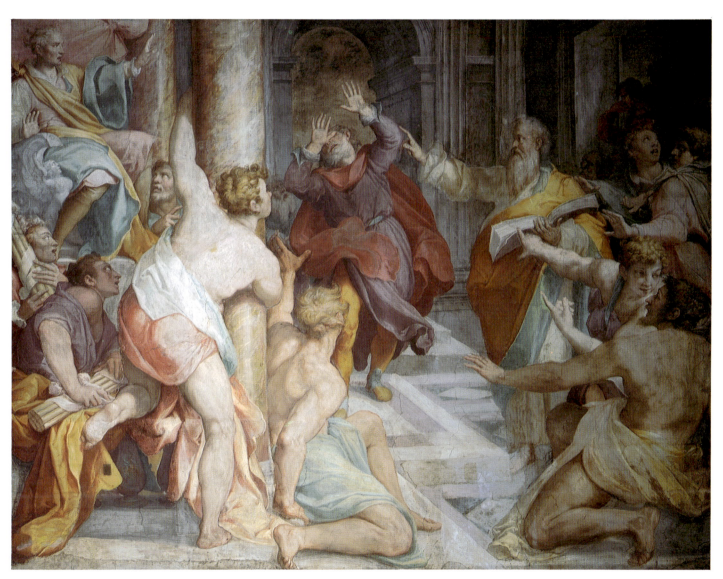

Plate XXI. Taddeo Zuccaro, *Blinding of Elymas.* Fresco, begun c. 1557. Frangipane Chapel,
San Marcello al Corso, Rome.

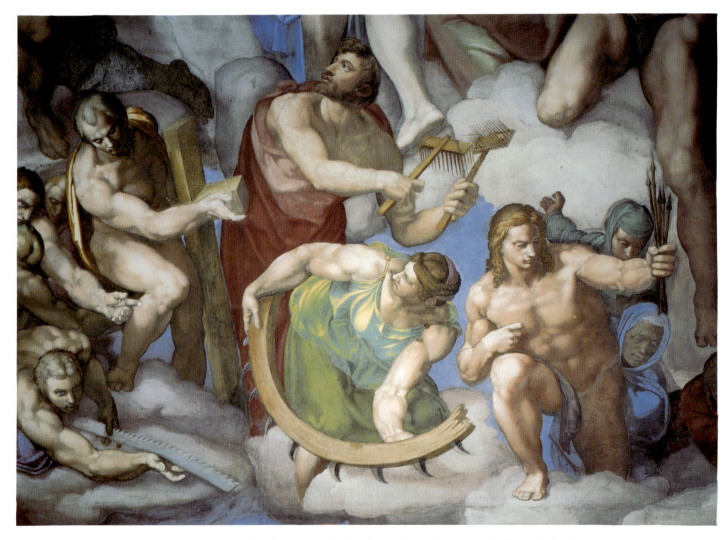

Plate XXII. Michelangelo and Daniele da Volterra, *Last Judgment,* detail of Saint Catherine and Saint Biagio. Fresco, repainted 1565. Sistine Chapel, Vatican Palace.

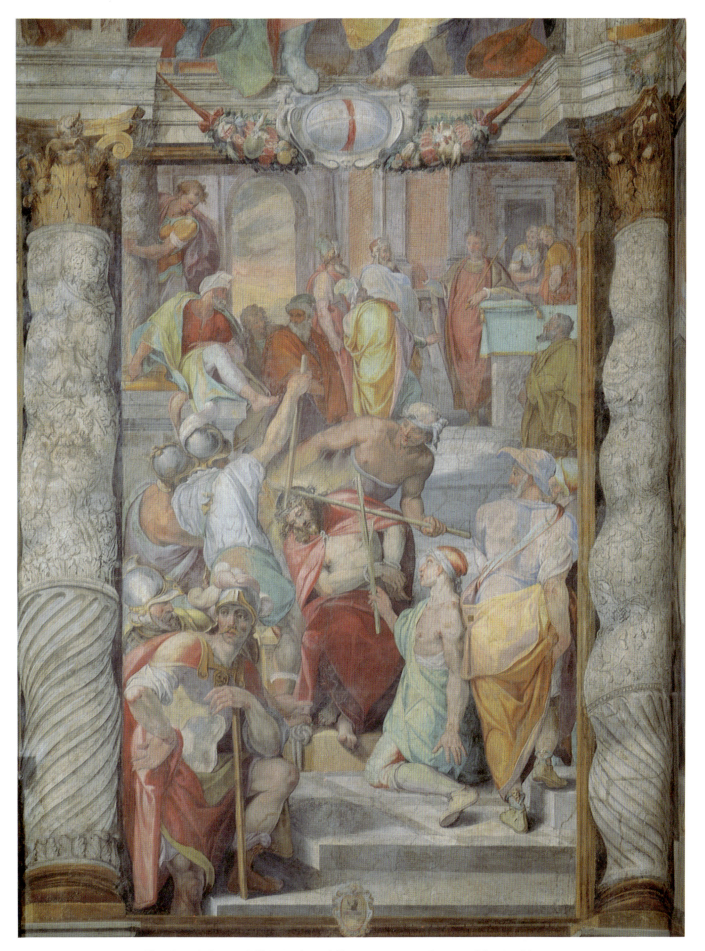

Plate XXIII. Cesare Nebbia, *Mocking of Christ*. Fresco, 1575. Oratory of the Gonfalone, Rome.

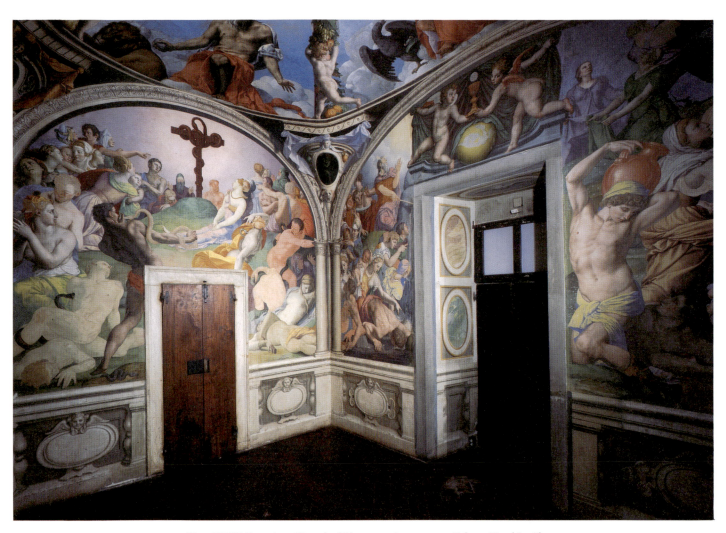

Plate XXIV. Bronzino, Chapel of Eleanora, view. 1541–3. Palazzo Vecchio, Florence.

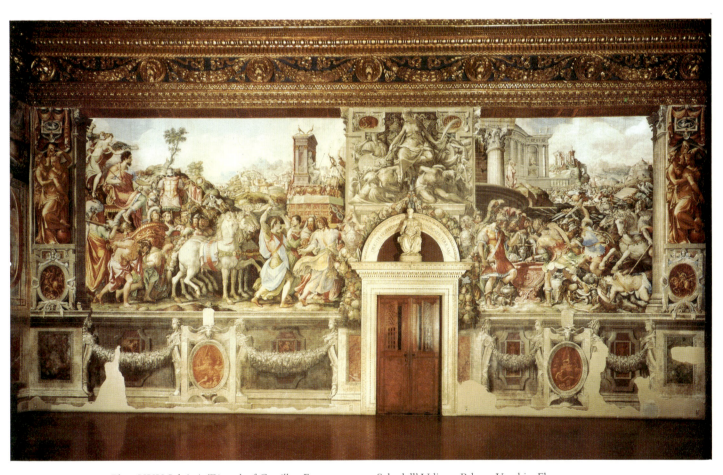

Plate XXV. Salviati, *Triumph of Camillus.* Fresco, 1543–5. Sala dell' Udiena, Palazzo Vecchio, Florence.

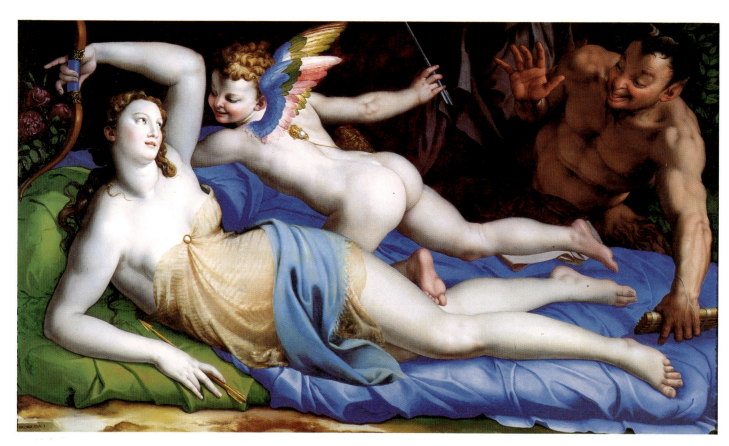

Plate XXVI. Bronzino, *Venus and Cupid with Pan.* c. 1555. Galleria Colonna, Rome.

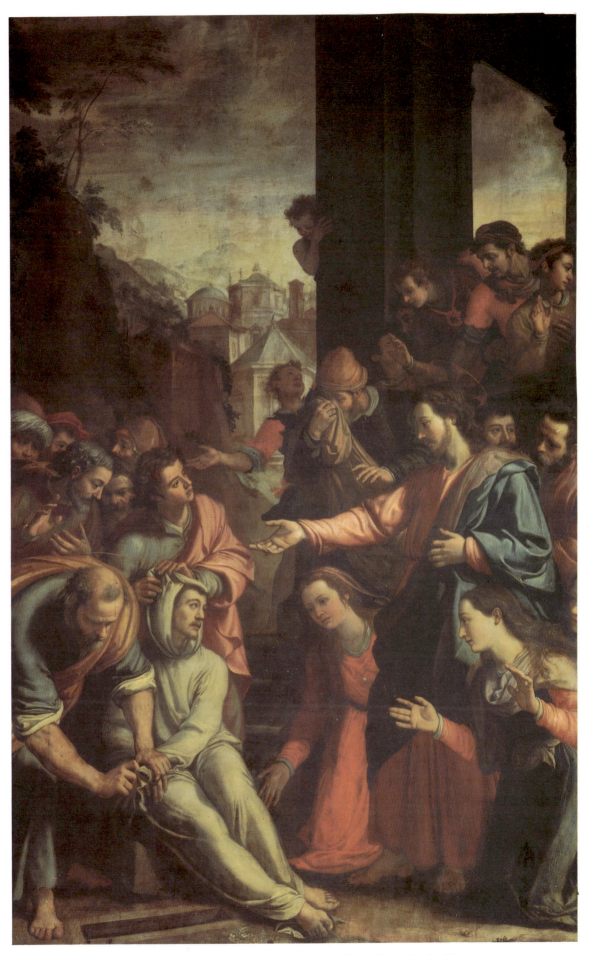

Plate XXVII. Santi di Tito, *Raising of Lazarus.* 1576. Santa Maria Novella, Florence.

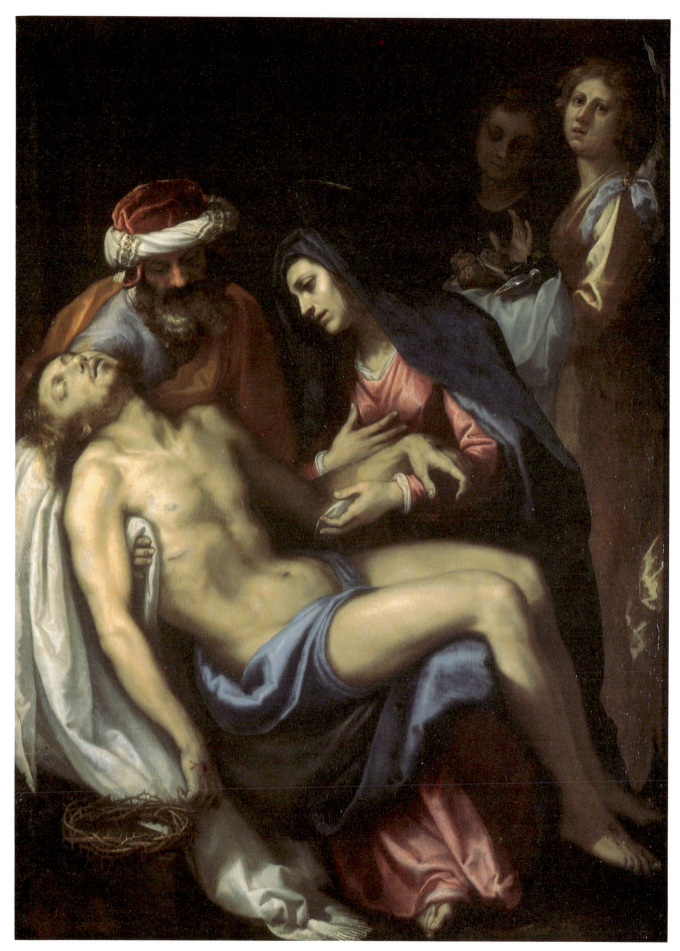

Plate XXVIII. Cigoli, *Pietà.* 1599. Kunsthistorisches Museum, Vienna.

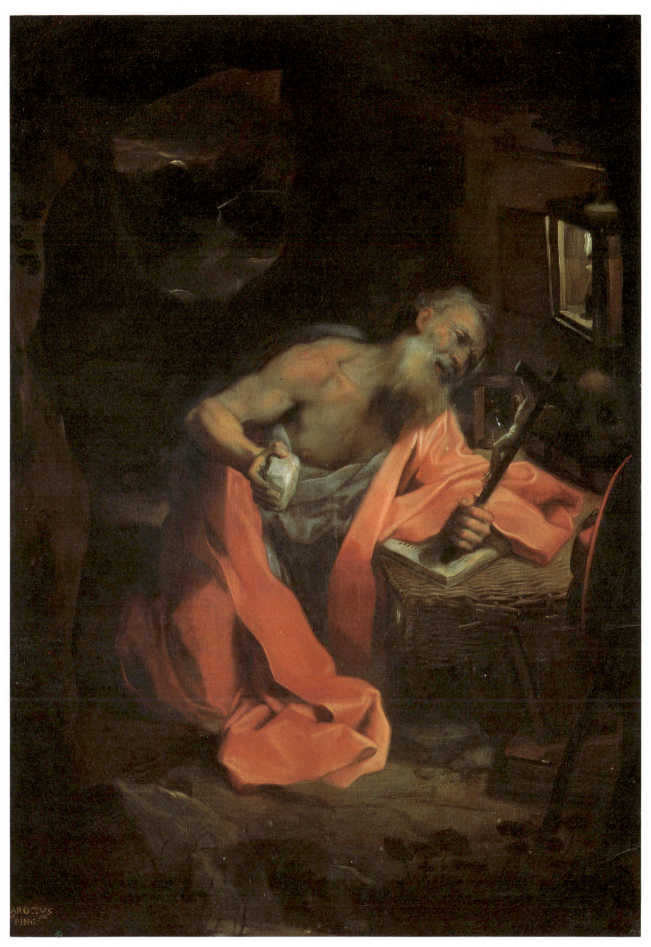

Plate XXIX. Barocci, *Saint Jerome in Prayer.* c. 1590. Borghese Gallery, Rome.

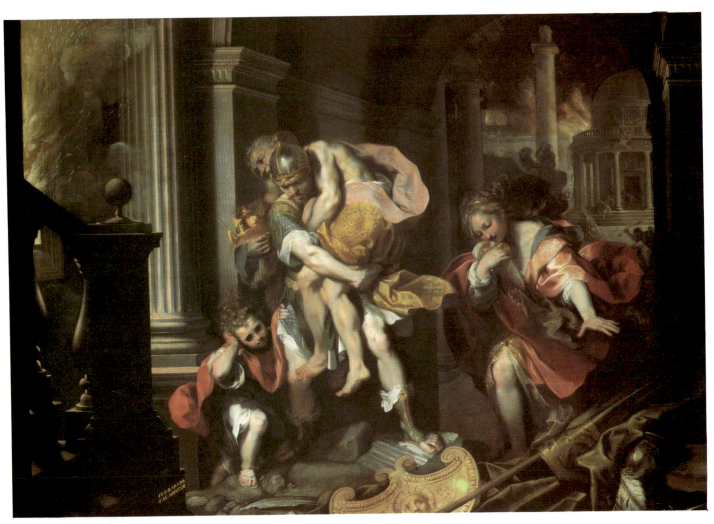

Plate XXX. Barocci, *Aeneas's Flight from Troy.* 1596. Borghese Gallery, Rome.

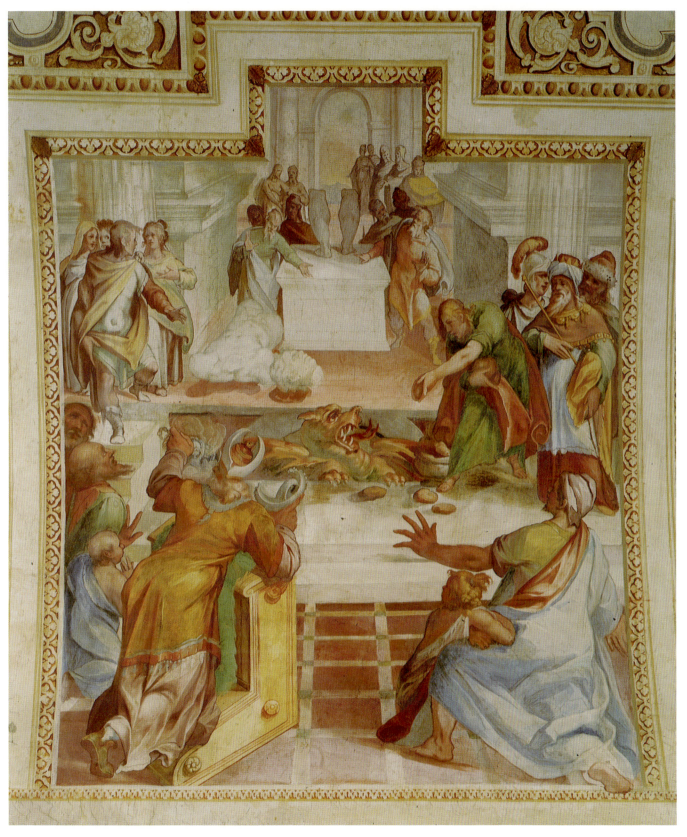

Plate XXXI. Giovanni Guerra, Cesare Nebbia, and assistants, *Daniel, Bel and the Dragon*. 1589.
Vault, Salone di Daniele, Lateran Palace, Rome.

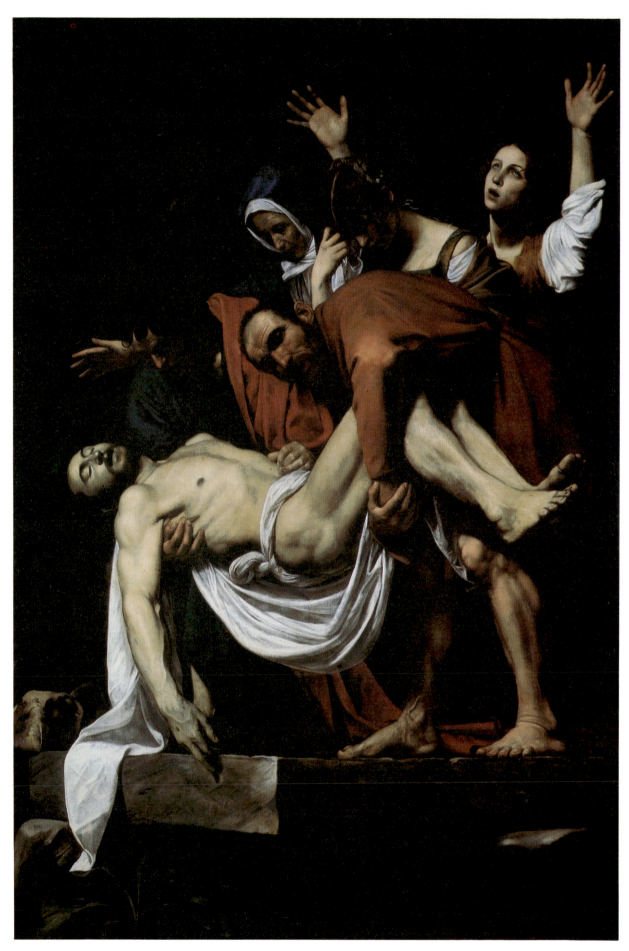

Plate XXXII. Caravaggio, *Entombment*. c. 1602. Pinacoteca, Vatican.

CHAPTER SEVEN

The End of the Century in Rome

THE CATHOLIC RESTORATION

THE COUNTER-REFORMATION ENTERED A NEW PHASE WITH THE pontificate of Sixtus V (1585–90). It moved beyond a defensive position to seize definitively the offensive and declare the Church triumphant. One scholar has found that the rhetoric regarding the city changed at just this point. In the funeral oration for Gregory XIII in 1585, no longer was Rome merely a morally reformed city, nor just a physically beautiful one. The transformed Rome had become a refuge for people fleeing from other lands endangered by heresy, a massive training ground for the Catholic offensive, a symbol of Catholic strength for the world, and a citadel of religion. For those in Rome, the city had grown not merely peaceful, prosperous, and physically attractive; it had also become the glorious recapitulation of a once-lost Roman and Christian past.[1]

Gregory XIII (1572–85) had continued a process of urban renewal inaugurated by Pius IV,[2] in preparation for the huge influx of pilgrims in the Holy Year 1575, building streets to connect the principal pilgrimage churches. By pursuing town planning, his successor, Sixtus V, would transform the pagan city into the Christian capital, putting the stamp of Christianity on surviving pagan monuments, and he would build an astonishing amount and see it all decorated. What had been initiated by Julius II at the beginning of the century was brought to fruition under Sixtus. Many have seen Sixtus in a different light, as inimical to classical culture and anxious to suppress it. They cite his decision to remove antique statues from the Capitoline and, of course, his destruction of the theater in the Cortile del Belvedere designed by Bramante for Pope Julius (Fig. 20). But this interpretation is to misunderstand Sixtus and his intentions. No better index of his strategy can be found than the fresco at the center of the newly raised vault of the Sala di Costantino (Fig. 170). Here in a classical interior the statue of Mercury has been tottered and shattered, and in its place the crucifix raised up. To the devotee of classical culture this development looks ominous, but within the context of its time it takes on different meaning.

Sixtus came to the papal throne on the tail of iconoclast riots in the Netherlands where images in churches had been torn down and destroyed by

the radical Protestants who proclaimed them idolatrous. Such outbreaks had been occurring since the 1520s in northern Europe, a violent and popular expression of the attacks of the Protestant leaders on the use of images in the church.[3] The position of the Roman Catholic Church had been defined by the Council of Trent, as we have already noted: Images are good, but we should honor them, not worship them. This is the double-edged message of this fresco in support of images. The pagan idol, which was worshiped, must be replaced by the Christian image which is venerated but not worshiped. And the cross, above all other images, merits the veneration of the faithful.[4] Reinforcing the message of unbroken succession between pagan past and Christian present is the choice of classical Roman architecture for the hall, projected in a Renaissance single point perspective.

The choice of Mercury was not arbitrary; it refers to a concern of Sixtus's addressed in a papal bull early in his reign. Those elements of paganism that conflict with Christian doctrine and practice must be suppressed, he asserted. Mercury was the pagan deity who symbolized belief in magic and superstition.

The pattern of patronage defined by Sixtus was carried forward by Pope Clement VIII (1592–1605), who was similarly concerned to proclaim the continuity of Roman culture from antiquity, through the early Christian and medieval Church, and up to his own day. What the Protestants lacked, a history and a tradition, is what the Church reborn in the Counter-Reformation chose to glorify. The dark period of uncertainty, of apology, and of repudiation was passed, replaced by a new energy and a new sense of mission. In terms of sacred art, this shift meant embracing the past and at the same time searching for new ways to reach the worshiper. In retrospect, the period of retrenchment lasted no more than a generation. By the time Sixtus ascended the throne the demands of Trent had won the day: the display of nudity had been banished from sacred images and the justice of requiring a special decorum for religious art was everywhere acknowledged.

There were painters at hand (Barocci) and in the wings (Caravaggio and the Carracci) who had the capability of giving fresh and forceful formulation to the new spirit in the Church and to its new concerns. Interesting confirmation of this change is found in a letter of 1596 to Federico Barocci from a patron thanking him for his altarpiece and expressing why it is satis-factory. In terms that might remind us of Raffaello Borghini's double set of criteria for evaluating sacred images in Florence, the patron expressed appreciation for the virtuosity of the painter's artistic performance while at the same time lauding the image's transparency to spiritual truth.[5] In a single generation the reformers had succeeded in turning the patrons around to their point of view.

SIXTUS V

The visitor to Rome today is constantly reminded of Sixtus V. It was he who put the statues of Saints Peter and Paul atop the columns of Trajan and Marcus Aurelius, and he who erected the most prominent of the Egyptian obelisks that serve still to punctuate important piazzas and vistas. The obelisks had lain broken and half-buried all over Rome, relics of the empire, brought to the Eternal City by Augustus and other proud conquerors as proofs of imperial power in annexing Egypt to the Roman Empire. The one that had been erected in the circus of Nero was still standing in the late Cinquecento alongside Saint Peter's, and the link between the church and that obelisk was a strong one. The basilica had been constructed over Peter's tomb, and according to early Christian sources the site of his martyrdom had been Nero's circus adjacent. Thus the obelisk had come to memorialize Peter's martyrdom, and for this reason it had not been knocked down in the Middle Ages like all the others. Sixtus's decision to have it moved to the center of the piazza in front of the still-unfinished church seemed altogether appropriate. In fact, it had been discussed by one pope after another since Nicholas V in the middle of the Quattrocento. It was typical of Sixtus that he carried out what so many of his predecessors had considered doing. The technical achievement of moving this colossal monument would be discussed all over Europe.[6]

The giant bronze ball atop the obelisk was believed to contain the ashes of Caesar. (When it was removed it was examined and this claim proved not to be true.) In what would become the established pattern of Sixtus's treatment of these ancient monuments, he replaced the gilt ball with a bronze cross, supported by his personal emblem. When the cross was installed a bishop performed a ritual exorcism of the obelisk, cleansing it of its paganism by sprinkling it on all four sides with holy water – almost literally baptizing it.[7] There is an ambi-

Figure 170. Tommaso Laureti, *Triumph of the Cross*. Fresco, 1586. Vault, Sala di Costantino, Vatican Palace.

guity inherent in this act, allowing it to be interpreted in opposite ways. Was Sixtus cleansing Rome of its pagan monuments to make way for Christian ones? If that had been his sole purpose, surely he would have destroyed them and replaced them with modern Christian equivalents. As much as Julius II and many of the intervening popes had, Sixtus recognized the value to the papacy of the Roman past, and, like Julius, his purpose was to build on it, exalting the Church as the new conqueror of Rome and successor to the Roman Empire. The message of the obelisk was the same as that of the fresco on the Sala di Costantino vault. Sixtus was making as emphatic a statement as he could in defense of the proper use of images. A contemporary who wrote a book on the obelisks, Michele Mercati, regarded them as trophies or spoils of war won from paganism by triumphant religion; he emphasized that Sixtus's purpose was to demonstrate how true religion had subjugated idolatry.[8] It was the issue of idolatry that was central

to Sixtus's concerns, coupled with the rejection of paganism.

Sixtus confronted the problem of the decorum of images with a lack of hesitancy that characterized his other patronage. He commissioned frescoes to cover the walls of all his new buildings with such an unstinting commitment to pictorial decoration that it was undoubtedly programmatic. To demonstrate that the Church believed wholeheartedly in images, he had them used everywhere – there was hardly a bare spot of plaster left on any of the buildings that received his patronage. At the same time, he had devised a program that differentiated the decorations according to function, whether it was devotional, didactic, or dynastic (propagandistic), and according to their site, sacred or secular, and audience, private or public. At no time in the century had a program so diversified been devised in which the requirements of function, site, and audience were taken into account.

Awareness had been growing throughout the Cinquecento, we recall, that what was appropriate in a palace was not necessarily appropriate in a church. This problem had caused the conservative reaction in the early Counter-Reformation that had very nearly won the day. Ever since the Decrees of the Council of Trent had been published and the first discussions of how they should be enforced had taken place, there had been a nervousness among patrons and an apparent diminution of secular commissions. Carlo Borromeo's admonitions that any sacred image, even those for private use, had to be approved by ecclesiastical authority threatened the freedom of patrons and artists alike and cast a pall over creativity, even in the secular sphere. There had been some finger-shaking at cardinals for spending too much on their villas. For example, the rampaging Borromeo took Cardinal Gambera to task for spending so much on birds and fish and animals in his spectacular Villa Lante at Bagnaia but giving nothing for poor Catholic pilgrims.[9]

A system was codified under Sixtus that made clear categories and permitted fantasy and creativity, opulent materials, even Maniera rhetorical extravagance, so long as they appeared in the appropriate site. Although the program has not survived in any written form, the images themselves are the evidence, as they were meant to be.

In his five-year papacy Sixtus undertook and accomplished an astonishing amount of building and urban renewal.[10] In addition to setting up obelisks all over the city, moving the one into Saint Peter's square, depaganizing it and the columns of Trajan and Marcus Aurelius, he continued construction and decoration of his Villa Montalto, begun before he was elected pope but now destroyed. Besides new roads connecting the major churches of Rome, he built his mortuary chapel in Santa Maria Maggiore. Three of his most ambitious projects are the ones that concern us here because they and their decoration survive. He moved and rebuilt the Scala Santa, demolished and rebuilt the Lateran Palace, and built a new structure to expand the Vatican Library. These three public constructions were the focus of the pope's campaign of decoration. Taken together they span the whole of Christian history, from Christ's Passion, in the Scala Santa, through the early papacy, centered in the Lateran Palace, to the library where that history could be studied.

All these projects were going on simultaneously under the same team: the architect, Domenico Fontana, the programmers, and the painters, Giovanni Guerra and Cesare Nebbia and their *équipe*. Exactly because there was so much overlap it was possible for so much to be accomplished, and possible as well to demonstrate the new system of differentiated decoration.

Let us examine them one by one. The Scala Santa was the building surrounding the relic believed to have been brought to Rome from Jerusalem by Saint Helena, the mother of the emperor Constantine. These were the stairs from the Praetorium of Pontius Pilate, venerated because they were believed to be the steps Christ descended, leaving traces of his blood, after his flagellation. The Sistine plan moved the Scala Santa so that it leads now to the Sancta Sanctorum, the chapel at the top, so-called because it houses so many relics. These stairs, which can only be ascended on one's knees, were built into the central staircase of what became five parallel staircases in Fontana's design. The walls and barrel vault over the central Holy Stair were frescoed with scenes from Christ's Passion; the staircases on either side, used for descent, show Old Testament stories. (The outermost stairs, less frequently used, were decorated only with the papal coat of arms.) Christ's Passion is depicted in far greater detail than is usual, in thirty-three episodes.

The function of these images is to stimulate the devotion of the worshipers as they work their way, step by step, on their knees, to the top (Fig. 171). There is little to distract the devout either within the scene or outside the frame. The focus is held strictly on the principal action; the ornamental borders are repetitive vegetal arabesques that provide a smooth transition from one scene to the next. These frames are not visually impoverished, but they do not distract or break up the narrative flow. There is no ornamental fill, figural or grotesque, between or around the narratives. Raised stucco, the pride of Cinquecento artists, is nowhere to be seen. This framing is simpler even than Taddeo Zuccaro's in San Marcello (Fig. 125; Pl. XXI), or the scheme invented for the Oratory of the Gonfalone (Fig. 137), both of which were distinguished for their relative austerity. Signs of rapid execution are evident, but it is not only speed, as is usually supposed, that accounts for the unadorned character of these frescoes. These narratives conform in every respect to the requirements of the Decrees of the Council of Trent for sacred images: truth to scripture, legibility, and decency. Their simplicity and lack of ornament is an important part of their decorum.

The Passion cycle follows the Gospels closely, excluding accretions of tradition and of the Apocrypha.[11] The sequence, starting at the bottom where the pilgrims

would begin their penitential ascent, reflects the rigorous redaction of the texts that was then taking place, and it does not correspond exactly to any previous sequence. Thus attention to strict historicity, which was one of the principal concerns of Trent, is demonstrated here.

On the two flanking staircases Old Testament scenes emphasizing the sinfulness of humankind and the need for redemption were represented. The sequence is here reversed and starts at the top to accompany the visitors, now in a more analytic frame of mind, on their descent. The cycle begins at the left with Adam and Eve, the Temptation and the Expulsion from Paradise, followed by Cain murdering his brother. The Noah story shows Yahweh's decision to destroy the rebellious human race and his compassion for righteous Noah. Included are all those scenes traditionally interpreted as prefigurations of Christ, making it thus more appropriate for intellectual examination than for prayerful devotion.

The central stair recreates the *Via Crucis,* the dramatic reenactment of Christ's suffering along the road to Calvary that the pilgrim to the Holy Land could experience. Like Federico Barocci's paintings, the Passion cycle here should call forth the empathetic participation of the devout, rather than making its appeal primarily to intellect.[12] Yet despite the devotional function, there is no particular appeal made to the emotions. Regrettably, there was no attempt to imitate Barocci's affective style. The rush to complete the cycle allowed for only a simple narrative treatment.

Part of the indication of speed of execution is that there is considerable diversity of style from scene to scene, but they all conform to certain guidelines that we can deduce. They are not designed for prolonged contemplation. The narrative is the focus and there is no inessential byplay; thus it is easy to make out what the action is. The setting, if architectural, is also kept simple as a rule. The mode of composition, as one would expect, is perspectival, and we find nothing here to suggest the relieflike style. The compositions are centralized, but there is an effort made to lead the viewer on to the next higher scene. Note, however, that these frescoes are not in the stripped style that we saw in the early Counter-Maniera. In the *Ecce Homo,* Christ is in the light, flanked by only two figures. The crowd is depicted dimly, without any of the interest in individualizing them or caricaturing them that we saw in Lucas van Leyden's engraving (Fig. 36). The two foreground figures who direct the worshiper's eye are scarcely more than silhouettes. The style here

Figure 171. Giovanni Guerra, Cesare Nebbia, and assistants, *Ecce Homo.* 1588–9. Central stair, Scala Santa, Rome.

resembles midcentury Maniera more than it does the late Quattrocento, but without the extreme of ornament and artifice. The Oratory of the Gonfalone, where Cesare Nebbia had contributed, may be the closest analogy.

Precision in the iconography was achieved by employing specialists for each of the programs. The theologian Angelo Rocca, who was the secretary of Sixtus's commission to revise the Vulgate text of the Bible, was charged with the program for the Scala Santa, whereas the learned Latinist Silvio Antoniano was responsible for the inscriptions and probably made the final selection of subjects for the Lateran Palace and the Vatican Library.[13]

The Lateran Palace across the road was built on Sixtus's order to replace the dilapidated medieval palace that had served as the papal residence until the Renaissance popes moved to the Vatican. In restoring the Lateran, Sixtus was symbolically renewing the early Christian Church and asserting the perpetuity of the Christian tradition, in the same way that restoring the obelisks celebrated continuity with classical antiquity.

The rooms of the palace were frescoed at the same time as those of the Scala Santa under the direction of the same team and executed by many of the same painters, yet these decorations are very different. Here the rooms were to serve much the same function they do today, as ecclesiastical offices and reception rooms. None, except the chapel, were devotional in function.[14] The overall theme of the decorations, which range from Old Testament stories to pontifical history, exalts the spiritual and temporal power of the pope. Another Sala di Costantino repeats the story of the first Christian emperor told at the Sala of the same name in the Vatican Palace, including still the Donation of Constantine; once again the episodes were selected to emphasize the subjugation of the empire to the papacy.[15]

The design of each vault is different, but they resemble one another in their ornamental vocabulary and their opulence. Gold and stucco, which were absent in the Scala Santa, abound here, as well as profuse ornamentation, painted and occasionally in stucco, filling the space around and between the narratives. A wealth of detail greets the eye, much of it derived from the classical vocabulary. Allegories fill niches as they have done in similar decorative programs throughout the Cinquecento, but in the frames where we might expect to find grotesque masks or monsters we see instead lion heads, the eight-pointed star, the triple mountain, the triple crown – all emblems of Sixtus. In an inspired solution to a long-standing problem, the Sistine program has substituted his personal devices for the conspicuously pagan motifs. Other motifs that derive from the standard Roman ornament – like victories, garlands, vines, birds – have been retained, along with the format of grotesque ornament as it had evolved in the course of the Cinquecento. The look of lavish profusion of earlier palace decorations is achieved, but with sanitized and still-charming motifs.[16]

Flamboyant pictorial devices, such as illusionism and foreshortening, which had been suppressed at the Scala Santa, contribute here to the exuberant effect. In the Sala di Daniele, the room dedicated to the story of Daniel (Pl. XXXI), these pictorial devices have been exploited to enhance the

drama already present in the story. The biblical story told here is that recounted in Bel and the Dragon, a significant choice because these chapters had been omitted from the Protestant Bible (Dan. 14.) It concerns Daniel's ruse to reveal the fraud of the priests of Bel (Baal) and his destruction of the dragon, or snake, which was sacred to Bel. King Cyrus, impressed by the magic appetite of the statue of Bel, asked Daniel why he did not worship him. Daniel replied that the statue was only a statue and that the banquet laid out for him, which mysteriously disappeared each night, was being consumed in an all-too-human way. Accompanied only by the king, he secretly covered the floor of the temple with ashes. The next day when the sealed temple was opened, the ashes were disturbed with many footprints; they led to a trap door through which, Daniel showed the king, the priests and their wives and children admitted themselves each night for their evening repast (Fig. 172). Daniel then proceeded to kill Bel's sacred dragon by feeding it a concoction of

Figure 172. Giovanni Guerra, Cesare Nebbia, and assistants, *Daniel showing King Cyrus the Footsteps in the Ashes.* 1589. Vault, Sala di Daniele, Lateran Palace, Rome.

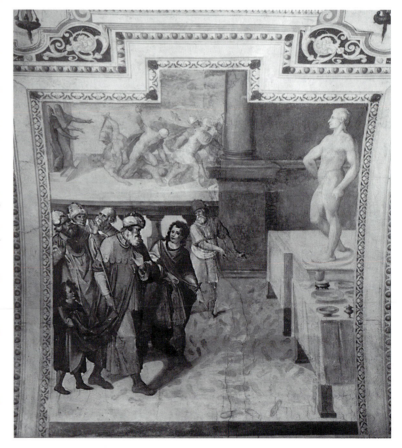

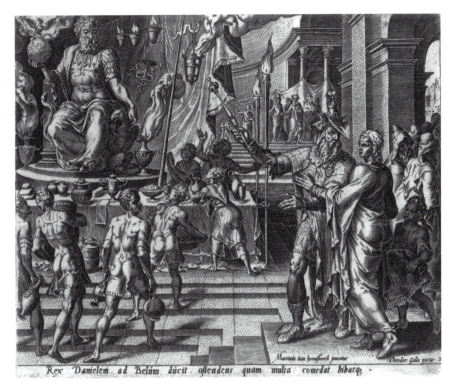

Figure 173. Cornelius Cort (?) after Martin van Heemskerck, *King Cyrus and Daniel before Bel,* from the *History of Bel and the Dragon.* Engraving, 1565. Rijksmuseum, Amsterdam.

pitch, hair, and honey until it split. Daniel proved impervious to the lion's den and was rescued by the intervention of the Lord; his false accusers, when pitched in with the lions, did not enjoy the same immunity. The center of the vault shows Daniel in the den of lions. Lions rim the frame, illusionistically presented as if we were in the pit looking up at them, silhouetted against the sky, where we see departing the unharmed Daniel, rescued by Habakkuk and the angel. The lions are, of course, Sixtus's ubiquitous emblem, so the implication is that this pope knows whom to attack and whom to protect. Their anthropomorphic faces are at once ferocious and amusing, but the position of the viewer below reminds us of the papal power and with gentle humor admonishes us to stay on the side of the angels.

In the scenes surrounding the center, we see the statue first from the front as Daniel, observed by the king, scatters the ashes. In the next scene, as we move around to the side, we view the statue in profile, with the footprints being pointed out by Daniel. Another rotation takes us behind the altar of Bel and we see the toppled statue from behind, where Daniel offers his cakes somewhat cautiously to the fanged dragon. A final rotation puts us at floor level of the pit with the hungry lions feasting on the enemies of Daniel and his God. The clever device of showing us the statue from three different views, and the mildly humorous behavior of the beasts would not have been allowed in the Scala Santa, but here the function of the images, though they derive from a biblical source, is not devotional but political. Sixtus, once again, was insisting upon the difference between idolatry and the proper use of images.

The statue of Bel looks suspiciously like a classical antique nude, the more so when it is contrasted to Martin van Heemskerck's engraving of the same subject made in the 1560s in the Netherlands, which may have suggested the subject to Sixtus's advisers (Fig. 173). Heemskerck's statue of Bel is armored and seated and very exotic in appearance, to suggest his Near Eastern

origin.[17] The resemblance between the toppled statue of Bel and the Mercury in the Vatican Sala di Costantino ceiling (Fig. 170) shows us that not only the pagans but also the heathen of the Old Testament were idolatrous. The same point is made in the adjacent room, where we see *Elijah reproving King Ahab and Queen Jezebel for their Idolatry,* again indicating the worship of Baal, whose statue appears in the distance surrounded by priests sacrificing to him.

A number of the rooms are decorated with stories from the Old Testament and contain unfamiliar episodes that would have set even the experienced sixteenth-century viewers searching their memories. Unlike the straightforward, one-level narratives at the Scala Santa, these stories contain political and policy statements, aggrandizing their patron and the power and authority of the papacy.

The Salone Sistino of the Biblioteca Vaticana (Fig. 174) was built to provide needed additional space for the expanding library. The choice of site, however, was as significant symbolically as any of the other undertakings of Sixtus. After examining many proposed sites, he chose the one that would cost the least but that had the added attraction of allowing him to destroy Bramante's theater in the Cortile del Belvedere, where sumptuous

Figure 174. Anonymous, *View of the Salone* Sistino, 1860s. Vatican Library.

entertainments, like mock sea-battles and tournaments, had been staged in the heady days before the Counter-Reformation (Fig. 175). The substitution of library for theater announced in dramatic terms the reform of the papacy.

On the walls, in addition to ornaments on the vaults that resemble those at the Lateran, we find another kind of narrative. In the Salone Sistino, accessible from the corridor used nowadays for exiting from Raphael's Stanze and the Sistine Chapel, frescoes representing the great libraries of antiquity are depicted opposite the ecumenical councils of the Church. The Sistine Library, founded originally in the 1470s by the previous pope named Sixtus, takes its place among these repositories of learning. In glorifying the councils, so often the source of friction with the reigning pope whose power they were attempting to curb, Sixtus presents himself as a liberal and a reformer. As is appropriate to a place of study, the function of these pictorial cycles is seen as didactic, and they are properly sober and pedagogical in spirit. They report historical events in a straightforward manner, with less opulence, less humor, less allegory than in the Lateran.

The humor and wit lurking in the vaults of the Lateran are not found here, any more than at the Scala Santa.

This is not to say that there is no editorializing. Though Sixtus wished to be remembered as fostering study and research in the library renowned as the place where many of the humanists had worked, he wanted also to be recorded as the pope who put an end to those inappropriate secular spectacles within the Vatican walls. In the scene accompanying the representation of the First Lateran Council, one of its lesser decrees is depicted: the one that forbids tournaments. Sixtus's devotion to images and his position on idols is referred to in three little images that accompany the Second Council of Nicea, the eighth-century council that condemned iconoclasm.

The decoration of the vaults is quite similar to the Lateran, employing a similar vocabulary of motifs, a similar mixture of allegory, emblems, and expurgated antique classical motifs, but the differences are significant. Gold appears, which was not used in the Scala Santa, but there is no stucco, such as abounded at the Lateran Palace, indicating that this space is given an intermediate position on the scale of ornamentation. There is a touch more free-

Figure 175. *Cortile del Belvedere with Tournament.* Unknown artist, second half of the sixteenth century.

dom to these grotesques than to those at the Lateran Palace where virtually every motif was tied to a Sixtus emblem. Could the closer approach to the antique models allowed here have been a bow to the erudite audience of the library, which could be expected not only to know the originals but also to be disposed to appreciate, rather than to take offense? There are also scenes of Sixtus's Rome, deemed to be of historical importance and therefore appropriate in the context of this iconography, but also incidentally celebrating, in the Cinquecento tradition, the greatness of the patron.

The Vatican Library and the Lateran Palace are more similar to each other than either one is to the Scala Santa. The two secular programs should be regarded as variants of the same basic scheme; their different functions determine the specific content of the scenes, but the ornaments filling the spaces between the narratives are distinguished only in detail.

All three programs were executed in the incredibly short span of less than two years, between February 1588 and November 1589. The breakdown of who did what among the iconographers differed slightly from one site to another, but for the decoration the same working practices were applied, with slight variation. Giovanni Guerra was in charge of finding the iconographical means to realize the subjects established by

the programmer, then Cesare Nebbia made the drawings and the cartoons. It was also Guerra's responsibility to hire and oversee the artists. The two masters were paid by the Apostolic Treasury, and they in turn paid the painters whom they hired. Consequently we have no official record of their names, and attribution has proved difficult. Our only source is the writing of Giovanni Baglione, who was a young contributor. Years later he described the projects and named some of the participating painters.[18] It is clear that efficiency and speed were the priorities. In the Lateran Palace alone more than ten thousand square meters were frescoed in seven months![19] In the library, one contemporary reported that a hundred people had been working there. Even though this doubtless included the boys who ground the paint and other apprentices not yet experienced enough to be allowed to take up the brush, it is still quite astonishing. Seventeen painters was something like the norm there. For the library there are drawings by hands other than Nebbia, indicating that he allowed some of the artists to work up the final drawing themselves, probably on the basis of his quick sketch.[20]

The system developed by the Guerra-Nebbia team was based on those of Giulio Romano, Giorgio Vasari, Taddeo Zuccaro, and other large-scale artistic entrepreneurs earlier in the century. The executants in the Sala

dei Cento Giorni, or the Palazzo Vecchio in Florence, or at the Farnese Villa at Caprarola were no less anonymous than these. It might be assumed that Vasari's tour de force in the Palazzo della Cancelleria provided the model for Sixtus's organizers, who would have recognized that their patron shared with Cardinal Alessandro Farnese the trait of impatience. Guerra had the opportunity to experience Vasari's workshop firsthand: he had worked on the completion of the Sala Regia in 1573. The scale of what Guerra and Nebbia were responsible to organize had never been approached before, and it set a new standard for efficiency and a model for the great Baroque decorative projects that would follow. Sixtus wisely chose artists who were especially expert administrators but who also practiced a simplified style, purged of courtly artifice and taking no particular delight in complexity, either intellectual or visual, for its own sake.[21]

The diversity of style allowed from one fresco to the next, most easily studied in the library, suggests that there was not the intention of disguising personal differences or of creating the impression of a single unified style. This approach is more like the treatment given the Sala Regia, where each painter designed and executed his own fresco, than that of Vasari's Sala di Cento Giorni, where the intention was to suppress the individual manners of the executants and conform them all to Vasari's style. Here there is a wide range of modeling styles, for example. In terms of color, the pigments were probably supplied to the painters, which assured a reasonable degree of congruity, but beyond that there is little uniformity. One artist may use strongly contrasted *cangianti*, another delicate and closely related shifts of hue, another no *cangiantismo* at all. One artist preferred the primary colors, another the secondaries. One works in a loose, painterly manner, another has a much tighter style. All the frescoes are thinly painted with rather little time-consuming detail, as we might expect of a project carried out with such dispatch.

We know something of Cesare Nebbia, whom we have encountered before, first, alongside his master Girolamo Muziano at Orvieto, where that important formulation of a Counter-Maniera style was made in the 1550s. Nebbia contributed the *Mocking of Christ* (Pl. XXIII) and the *Ecce Homo* to the Oratory of the Gonfalone cycle. He had worked again under the direction of Muziano, Pope Gregory's favorite painter, in the Galleria delle Carte Geografiche in the Vatican Palace, where his task was directing a team of painters and creating drawings, based

on Muziano's inventions, from which the artists worked.[22] Not finding Muziano to his taste, Sixtus shifted his patronage to Nebbia and Guerra. Muziano may have been too much of a perfectionist for the hard-driving Sixtus, or it may have been that Sixtus disliked his cool, neoclassical style, reminiscent of Sebastiano del Piombo. Whatever the reason, Muziano was left free to execute altarpieces, some very prestigious, like the one for the Chiesa Nuova and the high altar for the Ges.

◆

THREE DECORATIVE PROGRAMS, then, were undertaken simultaneously by the same team responsible for all, yet they are quite different from one another. Although the two that are secular share more with each other than with the religious series, there is a similar seriousness in the Scala Santa and the Vatican Library. Each program has been designed with its audience and its function as the guiding principle: devotional at the Scala Santa, doctrinal and dynastic propaganda at the Lateran Palace, didactic at the Biblioteca. No doubt Sixtus's impatience with delay and his seeming oblivion to artistic quality can be explained by the urgency he felt to present this system in its entirety as a model for the future.

The strategy of differentiated decoration was not limited to these three sites. An interesting variant can be seen in the chancel of Santo Spirito in Sassia, decorated by Jacopo Zucchi (1542–96) (Fig. 176). In the areas of the wall not covered with narratives, the new pseudo-grotesques, with emblems of Sixtus V, crosses, the dove of the Holy Spirit – to whom the church is dedicated – and other appropriate symbols, fill the framework all'antica.[23] They were admitted here, but not at the Scala Santa, presumably because the function of the chancel decoration is in part ornamental and the worshiper is not in the same attitude of intimate personal devotion as on the Holy Stairs.

Sixtus understood the value of the visual arts and the usefulness of ornament. He was not afraid of opulent display, as some of his predecessors had been, as long as it was clearly shown to be in the service of the Church. The clarity of his vision allowed him to differentiate between lavish entertainments for the pleasure of the pope and his court – tournaments and mock sea-battles – which were inappropriate and opened the papacy to opprobrium, and embellishments that proclaimed the status of the Church as a temporal and spiritual leader.

His personal mortuary chapel in Santa Maria Mag-

giore, large enough to be a church on its own, was as richly ornamented with sculpture, painting, and stucco as his public commissions. Here he added a new feature, colored marble revetment, so that no portion of the wall remained unadorned or uncolored. The marbles themselves came in large part from the old Lateran Palace that was being torn down. This gesture is too often misunderstood. For the pope it was symbolic of the continuation of the antique and medieval into the Renaissance present; the very idea of using marble veneer came from antiquity and carried forward an early Christian practice. The Pantheon was the most conspicuous surviving monument of ancient Rome where the marble sheathing was still intact, and early Christian churches where the practice had been taken over were numerous.[24] In the Renaissance, only Raphael's Chigi Chapel had imitated this manner of ornamenting the walls, and it had had no progeny until Sixtus's predecessor, Gregory XIII, had clad his chapel in Saint Peter's with colored marble in the 1570s. As Steven Ostrow has shown, Sixtus's purpose went beyond mere embellishment. The intent was to turn the interior of the chapel into a celestial paradise, a place removed from the mundane, transfiguring it into a transcendent realm. The polychrome encrustation was not designed to reinforce the logic of the architecture, as it was in the Chigi Chapel and would be again when Bernini used it.[25] Here instead is the aesthetic of the mystical that we have been encountering in these later years of the Cinquecento, given yet another form of expression.[26]

Sixtus's clear-minded strategy to proclaim the Church's position on images and ornament put an end to Counter-Maniera reticence and the "aesthetic of austerity" that Michelangelo had promoted and practiced, beginning with his suggested corrections to Vasari's design for the Del Monte Chapel in 1550 and even earlier in his painting, in the frescoes of the Pauline Chapel. The Church was now launched in a direction

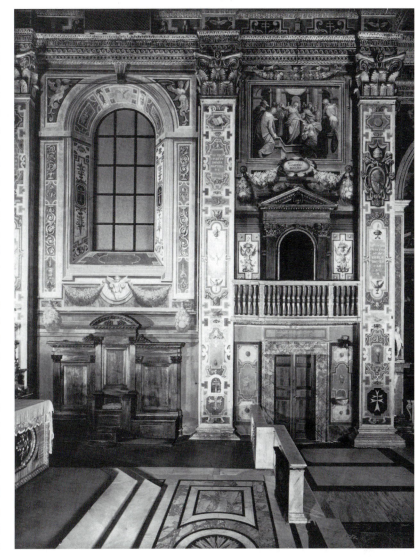

Figure 176. Jacopo Zucchi, pseudo-grotesque decoration with emblems of Sixtus V. Fresco, c. 1588. Chancel, Santo Spirito in Sassia, Rome.

that would carry it forward into the High Baroque with an arsenal of weapons, some old, some new, in the context of the Cinquecento. They included a renewed rhetorical style, affective appeal, and opulent display, weapons with which to turn back the tide of Protestantism and proclaim the style the Church had chosen for itself, in calculated opposition to the Spartan puritanism of the schismatics.

THE NEW RELIGIOUS ORDERS

We noted in Chapter 5 that already in the 1570s a new importance was granted to mysticism in the frescoes of

De'Vecchi depicting the spiritual life of Saint Catherine of Siena. This development was a reflection of the Counter-Reformation's program to address the laity and search for new ways to revitalize the faithful. The search led to an appeal not only to the head but to the emotions and the senses.

One of the most reliable clichés in the teaching of art history – that the self-sufficiency of Renaissance art was replaced in the Baroque by a direct appeal for the viewer's participation in the narrative – has recently been made moot by John Shearman's exposition of Renaissance artists who sought a more engaged spectator.[27] Vasari regarded the appeal to the viewers' senses as one of the improvements of the art of the *terza età,* as we noted in analyzing his vocabulary in the Introduction. However, the painting of the Maniera created a paradoxical situation for the viewer. The relieflike style took as its model the mode of narrative that makes the least possible acknowledgment of the spectator, and the Maniera painters regularly constructed barriers with *repoussoir* figures preventing trespass into the liminal space. Yet ornament, so prominent a feature of the Maniera, makes appeal to the viewers' senses. Thus the viewers' access to these paintings is enticed and hindered at the same time. To create such a sophisticated conundrum the Renaissance artist had to be very much aware of his spectators, even when he chose to exteriorize them. It is not surprising that the Counter-Reformation Church sought alternative, and more unambiguous, means to engage the worshiper. What occurred in the last quarter of the Cinquecento, although prepared by earlier explorations, was different in that the address is not just to the viewers' senses but to their emotions. These artists intended to arouse the same feelings of joy, of ecstasy, of suffering, as the actors in the painting. There is a long tradition of mysticism that the Counter-Reformation revived. Ignatius Loyola, the founder of the new Jesuit order, was a pioneer, leading the way to a revised appreciation of the place of mystical experience in the Christian life.

The Society of Jesus became the right arm of the papacy and the prime instrument in turning the Counter-Reformation Church around from being imperiled to triumphant. Loyola's new order was confirmed by Pope Paul III in 1540. The Jesuits did not belong to the extreme, strict wing of the Counter-Reformation. It is reported that when he heard that Carafa had been elected pope in 1555, Loyola remarked, "Every bone in my body trembles at the news."[28] Loyola and his order favored wooing the believer rather than using brutal repressive measures like the Inquisition and the Index of Prohibited Books.

Loyola, like many other Spaniards, was profoundly interested in medieval mysticism. He wrote a handbook for novitiates called the *Spiritual Exercises,* which was designed to deepen their spirituality. In the four-week course the exercitant is instructed to contemplate various mysteries, utilizing all his senses to experience for himself the fires of hell, for example, or the sufferings of Christ. In the system of self-sanctification Loyola invented, the exercitant moves to contemplation of ever higher and more abstract mysteries, strengthening his discipline and intensifying his devotion. In a similar way, the Jesuits aimed in their ministry to reach the emotions, the human heart, and to move people to lead a more devout life.

It had been pointed out by Erasmus earlier in the century that a separation had taken place between theology, on the one hand, and spirituality and ministry on the other. Loyola and his Jesuits asserted the compatibility of reason with revelation and dedicated themselves to putting theology in the service of preaching and pastoral care. They held that it is necessary to cooperate with divine Grace in order to achieve salvation, thus endorsing the doctrine of good works, as had the 1547 Decree of the Council of Trent, which rejected the Protestant position of justification by faith alone. The Jesuits identified as the goal of their preaching to persuade the worshiper to positive action. Thus the techniques of classical rhetoric as taught by Cicero and Quintilian were studied in Jesuit seminaries.

Images, like sermons, should persuade. Bishop Paleotti had argued that the orator and the painter had the same tasks: to persuade. The painter of Christian images had as his purpose to "move men to proper obedience and subjection to God, or to penitence, or to voluntary suffering, or to charity, or to disdain of the world, or other similar virtues which are all instruments to unite men with God. This is the true and principal goal to be undertaken in these images."[29] Although we have been taught in the past to think of the Counter-Reformation critics as the antithesis of the humanists and as their bitter enemies, in fact, the Jesuits, and even Bishop Paleotti, understood the value of humanism's commitment to teaching how to live a happy and socially productive life for the benefit of oneself and others. By making use

of the methods of classical rhetoric in their sermons and in their schools, the Jesuits kept alive Renaissance humanism, putting it into the service of revitalizing Catholic Christianity. Nevertheless, it is a subtly revised humanism practiced and preached by the Jesuits and advocated by Paleotti. The premise with respect to both the effect of preaching and of contemplating images has been corrected. In keeping with the first vow of the order to obedience, the Jesuits believed in submission to authority and not in the humanist ideal of the freedom of individuals and their capacity to resolve all questions through the application of the rational critical faculty. Contemplation of sacred mysteries by means of images became a way of disciplining the will and exciting devotion.[30]

It is not surprising that the Jesuits and another new order, the Oratorians, exercised more control over the decorations of their churches than had been normal before the Council of Trent, but what they controlled and how it evolved over a period of time was much less clear-cut in the case of the Gesù than might be expected. The reasons seem to have to do with practical issues of patronage. As long as Cardinal Alessandro Farnese was alive, he regarded the Gesù as "his" church, and his ideas about images we should perhaps characterize as old-fashioned. The fathers had little to say about the choice of artists or styles for the altarpieces in the church before Farnese's death in 1589; even after that date financial exigency continued to limit their power to command. What we find is that there is no such thing as a Jesuit style discernible in the first decorations of the church.[31] (It is much easier to discern Oratorian preferences in the Chiesa Nuova.) But what the fathers could and did control from the start was the iconography, and there specific Jesuit concerns are reflected.

In the Gesù the patrons chose the artists who would decorate the side chapels, but there was a program for the subjects of the altars that was devised before patrons were found and was therefore imposed on them as a prerequisite to patronage.[32] The high altarpiece was commissioned of Girolamo Muziano by Cardinal Farnese two years before Farnese's death, in 1587. It represents the *Circumcision,* the moment in which Jesus was given his name, to which the Order of the Society of Jesus was dedicated.[33] The other principal moments in Christ's life, the Crucifixion and the Resurrection, were designated for the transepts; Farnese did not get around to them, but they were eventually completed in the next century in accordance with the scheme. In the chapels, there was an order imposed that connected the subjects across the nave but also in a descending hierarchy from the high altar to the entrance. "The scheme seems to project on the walls and domes of the church a gradual, systematic, and logical progression from the profane outside world to the glory of heaven, which can be achieved through work, belief, and prayer."[34] As Howard Hibbard, who is quoted here, pointed out, this scheme reflects Jesuit belief in a combination of Grace and good works as the means of achieving salvation.

Eventually the Jesuits would draw many of the artists they used from among their own ranks, as was the case with Padre Giuseppe Valeriano (1542–96), who designed the decorations of two of the chapels in the Gesù, although they were executed by other painters. The text of the *Spiritual Exercises* was closely followed, indicating that the subject matter, at least, was controlled by the Jesuit fathers. Valeriano evidently sought to express a high degree of emotion with a minimum of intellectual apparatus. Scipione Pulzone (c. 1550–98) created the altarpiece of the *Lamentation* (1591, now in New York, Metropolitan Museum of Art[35]), which demonstrates a becalmed grief, enacted by figures who show no awareness of being observed. A lucid and unencumbered composition has replaced the complex, self-conscious, and intentionally artificial renderings of the subject preferred a few decades earlier.

The contrasts between the Jesuits and the followers of Filippo Neri, the Oratorians, are many and great, but what they had in common was this higher degree of involvement in the decoration of their churches. The saintly Filippo Neri never intended to found a new order and resisted attempts to institutionalize his Oratory. He was dedicated to an ascetic life and regarded humility as the first of the virtues. But by 1575 the Oratorians had become so popular they had outgrown their quarters, so the church of Santa Maria in Vallicella was rebuilt for them and called, therefore, the Chiesa Nuova. The fathers determined that they would make its decoration accord with their beliefs and conform to norms they defined. Despite the fact that they depended economically on the benefactors and patrons of the various chapels, they played an active role in the execution of the paintings for their church, not only in the formulation of the iconography but also in the choice of artists, unlike the Jesuits, who did not interfere in the patrons' choice of artist.[36]

Following the example provided under the leadership of Vasari and Duke Cosimo in the Mendicant churches of Florence, the design of each chapel was predetermined, the tabernacles had to conform, and the twelve altars of the side chapels had to treat the Mysteries of the Virgin, though more latitude was allowed in that they did not have to follow a prescribed sequence, as in the Passion cycle in Santa Croce.[37] The Virgin was particularly venerated by Neri, as the Council of Trent had urged that she should be to counteract her denigration by the Protestants. Certain prohibitions, such as the inclusion of portraits or any historically anachronistic figures, were rigorously enforced, even against the objections of the most powerful cardinal in Rome, Pope Clement VIII's favorite nephew, Pietro Aldobrandini.[38]

It would seem that the Oratorians put a premium on quality, for the list of who painted their altarpieces reads like a *Who's Who* of the best artists in Rome at the turn of the century. When Peter Paul Rubens was given the commission for the high altarpiece in 1606, he wrote to the secretary of the duke of Mantua that the Chiesa Nuova was "the most celebrated and visited church in Rome, situated at the very center, because it is adorned with the paintings of all the worthiest painters of Italy."[39]

The painters chosen were, on the whole, very adept at invoking the worshiper's participation, although the means they employed could be as different as those of Barocci and Caravaggio, whose contributions to the series we will study in the context of their other work (Pls. XXIX, XXX, XXXII). They shared a rejection of the aristocratic appeal of the Maniera and its taste for ornament. In keeping with Neri's own appreciation for the presence of the sacred in the diurnal, they paint with a kind of unaffected realism that makes it easy for the viewer to enter into the emotions of the actors in the narrative.

Scipione Pulzone was commissioned to paint the *Crucifixion* (Fig. 177). There is a document of 1583 recording the decision of the priests to require the artist to hang up a cartoon of his intended design in situ.[40] Apparently they wished to study its effect before allowing the artist to proceed with the painting – sure evidence of a new degree of involvement in the actual execution of the decorations on the part of an order. In his painting Pulzone gave them a rendering stripped of everything but the essentials. The sky is black, perhaps to suggest the darkening of the sky that the gospel says occurred at Christ's death. The rough wood of the cross and the textures of the draperies address

our sense of touch. There is no setting, except a skull to suggest Golgotha, and only three figures beside the cross. The focus is entirely on their emotions. Other artists and patrons of the time might have found it impoverished and naive, but Filippo Neri treasured poverty and rejoiced in the direct expression of feeling.

Girolamo Muziano was given the commission for the altarpiece of the *Ascension,* finished in 1587 (Fig. 178). Like Pulzone's *Crucifixion* and unlike Muziano's accustomed style, there is no indication of setting. The painting is dominated by the large figures, among whom the Virgin appears by express request of the fathers.[41] Here, as in many other of the altarpieces, the figures are shown in attitudes of prayer, which must again have been dictated by the Oratorians, whose very name

Figure 177. Scipione Pulzone, *Crucifixion*. 1586. Santa Maria in Vallicella, Rome.

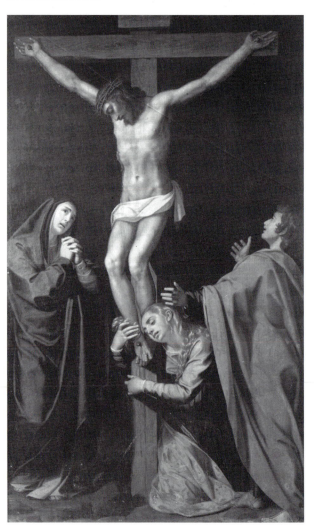

expressed their focus on prayer.[42] But Muziano seems to have been uncomfortable with direct address to the viewer, and this work is less successful than his others, where the emphasis is on a serious and dignified rendering of the narrative.

It is difficult to define a style that would encompass Barocci, Cavaliere d'Arpino, Caravaggio, and these works as well, but what they have in common – and it seems to be one of the things the Oratorians sought – is an understanding that the worshiper's affective participation must be solicited. One effect of the Tridentine reform, then, was to curb the autonomy of the patrons within the church and to impose on them various forms of control, either of subject or form or style, or of all three. This control paved the way for the kind of unified and harmonious treatment of the interior that characterizes many Italian Baroque churches.

FEDERICO BAROCCI (1535–1612)

Barocci was of the same generation as Santi di Tito. Like him, Barocci made the trip to Rome – the sojourn that had become by that time indispensable to any ambitious painter – as the final phase of his training and at the beginning of his independent career. Also like his Florentine contemporary, Santi, he arrived in Rome during the pontificate of Paul IV. The impact of Reform thinking must have been strong on the artists who came to Rome in the second half of the 1550s when the uncompromising pope was seriously threatening to have Michelangelo's *Last Judgment* torn down. It was difficult for them to ignore the fact that new criteria for sacred art were being put in place. Compelled to consider such issues at the very moment he was formulating his personal style, Barocci and the others like him – Santi and the slightly younger Federico Zuccaro in particular – embraced the principles of the reform of sacred images more unequivocally than any other of the painters.

Barocci had been born in Urbino.[43] Like his fellow countryman Taddeo Zuccaro, he revered Raphael, and from his earliest work one can see the influences of both Raphael and Taddeo. The young Barocci was exceedingly fortunate in getting the commission to paint in the Casino of Pius IV, the villa this pope built in the Vatican gardens, where he was paid in 1561–3.[44] Following this auspicious opening to his career, Barocci suffered a reversal of fortune and fell seriously ill. He

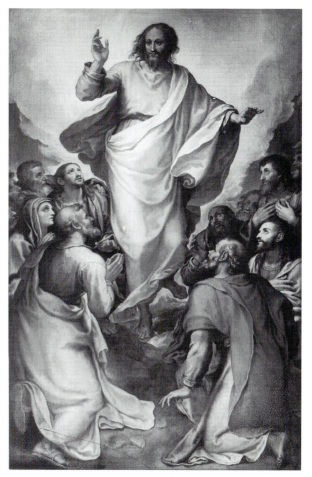

Figure 178. Girolamo Muziano, *Ascension*. 1587. Santa Maria in Vallicella, Rome.

returned home to Urbino where several years passed before he was able to paint again.

He must have spent considerable time studying the paintings of Correggio (1489–1534), for when he appeared again on the scene with his *Deposition* for the cathedral in Perugia in 1569 (Fig. 179), he presented a style deeply influenced by Correggio's. What he took from Correggio was what no painter in central Italy was offering and what the Counter-Reformation Church was then on the brink of recognizing was the most fruitful direction for sacred images to explore, namely, appealing to the viewer's emotions. With the help of Correggio, what Barocci reintroduced was the rhetorical mode of addressing the worshiper, which had been made suspect by the strict reformers in the Church. Like Taddeo who never sacrificed the rhetoric he learned from Raphael, Barocci resuscitated the art of persuasion.

The style that delighted in the sensuous and used chiaroscuro and color to solicit the viewer had really

been pioneered by Leonardo da Vinci early in the century, and Correggio's debt to him has always been recognized. What Correggio had learned from Leonardo about the seductive mystery of shadows, Barocci in turn learned from his study of Correggio's paintings.

But Correggio had gone beyond Leonardo in the depiction of untrammeled emotion, and it was this aspect that Barocci introduced to the central Italian scene in the 1570s. The emotion his figures express verges on the sentimental. It was an area the sophisticated artists, in particular the Florentines, were careful to avoid. The ingenuousness of Barocci, however, is contagious, and it is easy to become caught up and transported by his pictures. Spiritual ecstasy seems to be within easy reach. By contrast the didacticism of the Counter-Maniera painters, who considered it their task merely to put the narrative before the viewer, looks arid, as does the *arte sacra* of Scipione Pulzone and Giuseppe Valeriano, which Federico Zeri tried to persuade us was the true expression of the Counter-Reformation and the most promising product of the movement.[45] Both fall far short of Barocci, however, in terms of aesthetic quality and of future influence.

Barocci's *Saint Jerome in Prayer* (Pl. XXIX) combines several Counter-Reformation themes, and it can serve to exemplify the appeal of his style.[46] The importance awarded to venerating the cross in these years gave prominence to such subjects as Saint Francis receiving the Stigmata in a vision of the crucifix and Jerome moved to penitence by contemplating the cross. These subjects begin to appear frequently, as do others in which the cross speaks, as for example to Saint Thomas Aquinas. (Santi di Tito made an altarpiece of this subject for the Florentine church of San Marco, where it is still to be found.) The power of the cross to heal and to inspire was emphasized to refute its denigration by the Protestants.[47] The Catholic Church responded also to the Protestant rejection of certain of the sacraments, including Penance, by having related subjects represented with increased frequency in art. This reaction provided further incentive to represent the penitent Saint Jerome.[48]

The subject of the hermit saint, who has removed himself from the world so as to castigate his flesh, was probably no more attractive to the worldly Roman of the Cinquecento than it is to the worldly contemporary viewer. Jerome holds a rock in one hand, with which he intends to beat his breast, and the crucifix in

the other. His gaze, an ecstasy of agony, speaks to us of his inner state, but the tenderness and nobility in his face draw us to him. The skull in the shadow and the hourglass catching a glint of candlelight remind us of what we would rather forget: how fleeting life is and how imminent the Judgment, but Barocci's color and light pull us into the scene, whereas the harsh treatment of so many other painters only repels. Barocci has rejected the formula that equates the ascetic and penitential subject with the suppression of sensuous and aesthetic appeal. With a sleight of hand that no Counter-Reformation prelate would call him to account for, he renders Jerome's red robe as if it were made of gleaming satin, and where we expect from other renditions of the subject a hair shirt, he shows a warm gray tunic that reflects the glowing red. The pinkish tone is picked up in Jerome's flesh, depicted with a ruddy health quite alien to the tradition of the subject. Subtly the viewer is allured by the color scheme that moves the warm pink tones out into the shadowy cave and the moonlit landscape. Barocci does not invite such analysis; in fact, he probably expected his picture to operate at a subliminal level, enticing us to empathy. If we share Jerome's emotion we, too, may be moved to penitence. But as in a successful oration where the listener should not be aware of the rhetorical devices employed to persuade him or her, so the painter concealed his rhetorical art. He was so successful in this that aim no one in the Church took up a Gilio-style attack on Barocci for his "error" in depicting Jerome in the desert with glowing flesh and a red satin robe. Barocci found the means to represent a state of emotional elation like that described by the great mystics, in which the mind is no longer totally in charge, and the emotions carry one to a transcendent sphere. In Barocci's pictures we are in a world of ecstasy, a state out-of-body, or at least out-of-intellect.

Correggio had shown how to create a visual excitement in the picture that would inflame or transport the viewer's emotions. Barocci, in imitating Correggio, depicts movement in excess of that expected or required; this movement is a visual equivalent for emotions that are moved. Like Correggio he opens the way for the viewer to cross the liminal space into his pictures, never making use of *repoussoir* figures, for example. His first full demonstration of the new style was in the *Deposition* he painted in Perugia in 1568–9 (Fig. 179). Movement in the picture, often not entirely rationally

motivated, is created by wind that swirls the draperies, by the exaggeratedly swift thrust of the woman who rushes to the aid of the swooning Madonna, and by arbitrary shadow. It would be difficult to construct a wax model of this scene, as the mid-century painters like Salviati had done, and Tintoretto in Venice was doing, in which a shadow would fall in this fashion across the middle of Christ's body, for example. Yet no one would deny its pictorial effectiveness, and no one seems to have quibbled with the license the painter has taken in this and other respects. In the intimidating atmosphere of the 1560s created in the wake of Gilio's treatise published only five years previous, and of Carlo Borromeo's insistence upon the strictest construction of the Decrees of the Council of Trent, Barocci displayed an admirable courage and self-assurance.

His fellow painters recognized that Barocci had made an important discovery. When his *Visitation* was installed in the Chiesa Nuova in Rome, it was reported by a contemporary that it pleased everyone, particularly those in the profession, and that for three days there was a line to see it.[49] Several of the Florentines made a pilgrimage to Arezzo to see his *Madonna del Popolo* after it was installed in 1579 and were so impressed they then made another excursion to see his earlier altarpiece in Perugia. The leader seems to have been Ludovico Cigoli, who we remember departed from the Counter-Maniera of his master, Santi di Tito, in favor of a more affective style inspired by Correggio and Barocci.[50] At a time when deep, gloomy chiaroscuro was the fashion in Florence, these painters must have been impressed by Barocci's high-value palette. Barocci's color is unabashedly cheerful and

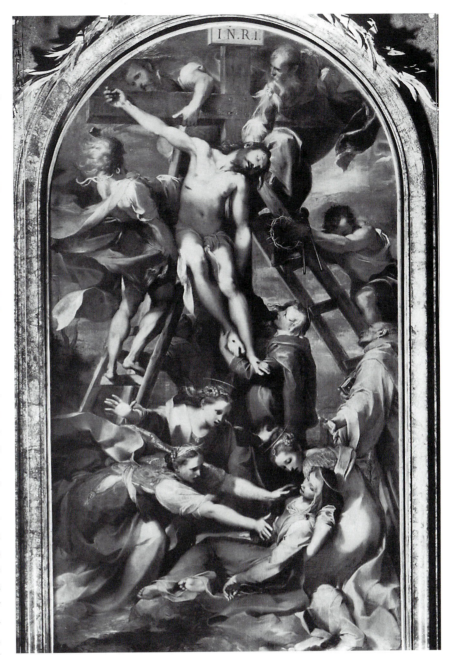

Figure 179. Barocci, *Deposition*. 1569. Cathedral, Perugia.

ornamental, seemingly in contradiction to the mood of suffering one expects in a *Deposition*. But what the Church censured in Maniera paintings as ornament inappropriately designed to serve art has here been harnessed in the service of devotion.

What Barocci created provides the formula that would evolve into the visionary style of the Italian Baroque and be carried to northern Europe by Rubens, who was deeply impressed by Barocci during his

Roman sojourn at the beginning of the new century. Rubens would have been very much aware of Barocci through his two altarpieces on display in the Chiesa Nuova, his *Visitation* (1586) and the *Presentation of the Virgin* (1593–1603).[51] It was fortunate for both Barocci and for Filippo Neri that they found each other, for they were well suited. Not just the directness of Barocci's manner but its joyousness appealed to Neri, who would sit prayerfully before the *Visitation* for hours. Although the prettiness of his style, and particularly of his color, recalled the Maniera, what made Barocci's manner acceptable where someone like Salviati's was not was the evident sincerity of his piety. Salviati and the others of his generation could not give expression to emotion, pious or otherwise, with the ingenuousness and exuberance that inspired Barocci.

Barocci devoted himself exclusively to sacred images and a few portraits. The only surviving exception is his painting of *Aeneas's Flight from Troy*. The original version, now lost, was made in 1586–9 to be exported to the court of Rudolf II in Prague, and the surviving replica is signed and dated 1598 (Pl. XXX).[52] It is of great interest to see how he treated a mythological subject and to recognize that it is exactly the same style that he used in his sacred works. The compositional model of relief is in no way suggested here. On the contrary, on the example of Correggio's mythological paintings, he used oblique lines to draw the viewer in and cross the threshold between the picture and the viewer's space. Aeneas, still in his armor, struggles toward us with his father on his shoulder and his young son clinging to his thigh. The rubble of the battle in the foreground and the receding building carry us into the inferno of the burning city. The flames are reflected on the marble column and balusters at the left, rimming them with pink. The unnaturally rosy complexion of Aeneas's wife would seem to be caused both by the heat and the excitement, if one were to stop to analyze it, but instead, we are caught up in the flutter of her drapery and her disheveled hair. Her sensuous flesh is tinged with a warm gray, like the tone of the background. Movement, physical and emotional, is conveyed by the strong yet delicate shadow that cuts across her body. Chiaroscuro is, in fact, used in a way quite distinct from central Italian practice, deriving here from Correggio and, it should be noted, from Titian. Light has an arbitrary life of its own, as we saw before in his Perugia *Deposition*.

This kind of naturalistic chiaroscuro had never appealed to the central Italians, who were often more interested in emulating the clarity of sculptural relief. Nothing of the relieflike style remains in Barocci, even when he undertakes a subject chosen from ancient literature. Here, if anywhere, we would expect to find Barocci looking at sculpture and looking at the models of classicizing painting from earlier in the century, for example, the *Fire in the Borgo* (Fig. 180), of his mentor, Raphael, where a similar family group had been represented. The comparison is informative. Barocci makes Raphael look almost pedantic in the perfectly composed harmony and sculptural balance of the group, whereas his Aeneas, feet awkwardly spread, staggers a bit under his burden. There is an immediacy and a seeming spontaneity quite removed from the cool and studied perfection of either Raphael or his followers.

The careful divorce of affect from intellect that characterized Classic and Maniera painting has broken down; the barrier has been crossed and the road opened to a new relationship between spectator and image. Barocci's paintings call for a "suspension of aesthetic distancing"[53] on the part of the spectator. The kind of empathetic relationship with the event that he undertook to establish was very much what the Church would see as the way of the future.

CARAVAGGIO (1571–1610)

When we come to Caravaggio we leave the world of the official art of Popes Sixtus V and Clement VIII. Michelangelo Merisi was born in the town of Caravaggio in northern Italy near Milan, from which he took his name, and came to Rome probably in 1592. He was not trained by a distinguished painter and he did not arrive with letters of introduction to potential patrons. In his early career he was one of those artists who practiced a new marketing technique: he made still-life and genre paintings on speculation, as artists do today, hoping to sell to a buyer who happened to like his work. His earliest known works, half-length single-figure paintings, usually of a boy, often with a vase of flowers or a basket of fruit (e.g., Rome, Borghese Gallery), were the kind of small paintings he made for the market. They were of a kind of subject more familiar in his native Lombardy than in Rome, and therefore their novelty made them more apt to attract attention.

The source of their iconography was a kind of image

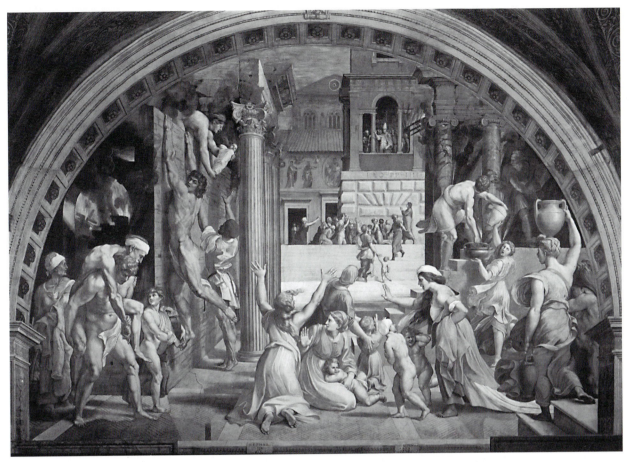

Figure 180. Raphael, *Fire in the Borgo*. 1515. Stanza dell'Incendio, Vatican Palace.

that had become popular in northern Europe in the second half of the sixteenth century, the genre scene that concealed an allegory. These double entendres of conventional subjects could have been known in Italy through prints. Caravaggio, putting his inventive powers to work, offered appealing and imaginative variations on his Netherlandish prototypes. Instead of using five figures to represent the five senses, as had Cornelius Cort in his series of five engravings after Frans Floris, Caravaggio combined them all in the single arresting image of a *Boy bitten by a Lizard* (Florence, Roberto Longhi Foundation).[54] Other of his early genre paintings, which seem so novel in an Italian context, can be interpreted as allegories on the model of northern paintings, although in Caravaggio's images there is an ambiguity that suggests rather than defines. Whereas in the 1530s the northern painters in Italy took away with them more than they left in terms of influence, now the exchange between Italians and northern Europeans was beginning to flow in both directions.

There must have been many such painters in Rome making pictures for the market of whom we know nothing, but Caravaggio was fortunate. His work caught the eye of a cardinal-collector, Del Monte, and he was invited to live in the cardinal's palace. The cardinal must have been attracted to Caravaggio's genre allegories, for several are known to have been in his collection, as for example the *Cardsharps* (now Fort Worth, Kimbell Art Museum, but originally bought by Del Monte), which could be understood as a representation of Vice. In Caravaggio's winning treatment the message seems more nuanced: one might better call it an image of innocence duped by duplicity. Around 1596 Caravaggio began to earn commissions for easel paintings, and eventually, at the end of the century, for altarpieces and chapel decorations. Rebellious and nonconformist by nature and frequently in trouble with the law, he would never become comfortably a part of the establishment. What he and his patrons represent is a different and new mode of discourse, responsive to the ministry to the common people that the reform-minded Filippo Neri and Carlo Borromeo, in particular, had initiated. Although the

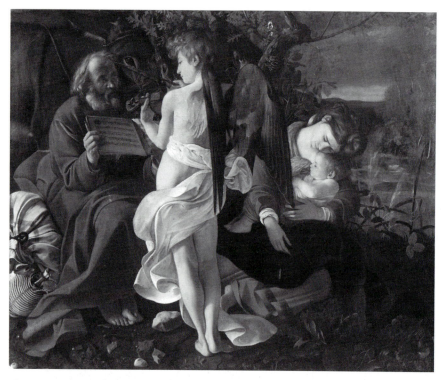

Figure 181. Caravaggio, *Rest on the Flight into Egypt*. c. 1594. Doria-Pamphili Gallery, Rome.

Oratorians became an influential node of power at the end of the century, their style seemed to many conservatives to breach decorum and good taste.

Caravaggio's early experience with genre painting would serve as a source of borrowings for him when he came to work on his large religious pieces. When he copied a figure from his genre paintings and transferred it to his history paintings it infused those works with unexpected life and immediacy, but it scandalized the Romans, who found this mixing of modes inappropriate. When Caravaggio copied the young dandy he had painted in the *Cardsharps* and included him at the table where Matthew was also seated in his *Calling of Matthew* (Rome, San Luigi dei Francesi, Contarelli Chapel, 1599), he brought the gospel into the world of the everyday. The idea that the future apostle would consort with people who cheated at cards offended some, who found it irreverent, but it pleased others, who saw this kind of realism as a bridge to the scripture that the common people could readily cross. The term "realism" is often applied to Caravaggio's work – it is a term that can be applied to every new style because each one represents a different view of reality. Caravaggio's realism and the novelty of his art lie in his

disregard for the artistic traditions and his personal confrontation with his subject.

Caravaggio went to live in the palace of Cardinal del Monte about 1594–5 and appears to have stayed until about 1601.[55] The cardinal was fond of music and hence we see a shift in Caravaggio's paintings of this period to genre scenes involving music. The *Four Musicians* at the Metropolitan Museum of New York is an example. To one of the first works in which he assayed a religious subject, the *Rest on the Flight into Egypt* (Fig. 181), he gives an unprecedented musical theme. The Holy Family, stopped in the countryside, is unexpectedly visited by an angel. A weary Joseph holds up the part book while the angel, facing him, his back to us, plays the music on a violin. The idea that music restores the spirit would have been current in Del Monte's circle. The Madonna rocks the child to the sound of the music, which is carefully painted so that it can be read. The learned audience for whom this work was painted would have recognized it as a motet on the text of the Song of Songs. The conceit is a beautiful one. The text celebrates the love of a bridal couple, ostensibly Mary and Joseph but symbolically in Church doctrine, Mary and the Christ child. On her side of the picture is the lush vegetation associated with her in the text (7: 6–8, 10–13), which Caravaggio has contrasted with Joseph's arid surroundings.[56] The artist is playing with contrast here – contrapposto – between the mother and child, flooded in light, and the worn Joseph, his face mostly in shadow, broken up with patches of strong light, and between the domestic scene and the heavenly intruder. Caravaggio's angel looks as if he has been plucked from a late Maniera painting. Indeed he could have been painted by Cesare d'Arpino, in whose shop Caravaggio had been an assistant for about eight months after arriving in Rome, probably in 1593. There is nothing else like this figure in his entire oeuvre.

It is fascinating to see this practical painter's mind at work. For him the style of the Maniera had nothing much to do with the real world, but it could serve him

here to represent the divine. He has borrowed the Maniera conventions of grace and beauty and ideality for his angel, has clothed him in celestial light, and has contrasted the quality of the earthly and heavenly draperies, displaying as he does so his command of this style, which he has otherwise rejected. The Madonna, by contrast, is an earthy peasant woman.

The same woman model was used for his *Penitent Magdalen* (Fig. 182), which must be close in date to the *Rest on the Flight into Egypt*. The sacrament of Penance and the act of penitence were being given particular prominence at this moment in the Church, as we have discussed, and the Magdalen, as well as Jerome, were examples frequently chosen to represent it. Mary Magdalen could further represent conversion because she had forsaken her harlotry, and so, like one who had gone astray into the heresy of Protestantism, could stand for the return from sin to a state of grace.[57] When she made an appearance earlier in the century in central Italy it was usually as the emaciated counterpart of John the Baptist in the desert, in hair shirt and with bedraggled coiffure. (We see her thus, being carried off to heaven, in Polidoro's mural [Fig. 52].) Caravaggio represents her at the moment of her repentance, when she is overwhelmed with the sense that she has lost her way. She is seated alone in an empty room, very small and isolated. She is not voluptuous but chubby, and she seems much too young to be worldly-wise. Her worldliness looks as if it has been put on, like the fancy clothes she is wearing and the jewels she has taken off and laid beside her. Her poignancy arises from the dislocation between her costume and her humble bearing and features. Rather than truly genteel she looks like a peasant girl who has been given finery she does not know how to flaunt. Her hands are folded in her lap, not with the elegance of one of Parmigianino's women, but with the awkward gesture of a farmer's daughter who is unaccustomed to sitting with her hands empty.

The painter's compassion and humanity replace the conventional decorum. When Gilio defined decorum he said that a figure should be appropriate to its setting.[58] What that meant was that a saint should look saintly, a hero should look heroic, and a whore should look like a temptress. But no theologian could have found fault with Caravaggio's depiction of the Magdalen as a child-woman who has fallen into sin, or with the forgiveness implicit in his compassionate rendering. The shock was more to the art collector and patron

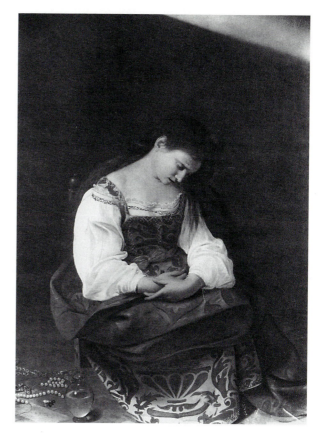

Figure 182. Caravaggio, *Penitent Magdalen*. 1594. Doria-Pamphili Gallery, Rome.

whose expectations were assertively violated. The "realism" that shocks is Caravaggio's sensitivity to social class and his willingness to paint a model who does not conform to the traditional definition of a beautiful woman in the role of the Magdalen or even the Madonna.

One of his most moving paintings, the *Madonna of the Pilgrims*, still in the Roman church of Sant'Agostino (1605), shows her as if she were a Roman housewife. She has been called to her door by dirty-footed pilgrims who have walked barefoot to pay homage to her child, whom she has slung on her hip in a posture familiar to every mother. That rush of familiarity is exactly what Caravaggio sought. Like Barocci, but with different means, he seeks to elicit the identification of his viewer with the scene he represents.[59]

The painting on the vault of the Camerino of the Casino Ludovisi, the *Jupiter, Neptune, and Pluto*, has not been universally recognized as the work of Caravaggio, though since its recent restoration more scholars agree in accepting it.[60] Because the painter never did any other painting on the wall and almost no other mythological subjects, there is nothing with which to compare

it. Yet there is every reason to associate it with Caravaggio. The Casino was bought by Caravaggio's patron, Cardinal del Monte, in 1597. He never painted a fresco, and even when that would be the expected medium, as on the side walls of a chapel, he avoided it and substituted oil. Here, too, on the ceiling where fresco was certainly indicated by tradition, the painting is in oil, this time an oil mural. It has been dated to 1599,[61] when Caravaggio was living in the cardinal's palace, and so he would have been the logical choice of painter at hand. Bellori mentioned that Caravaggio had painted a ceiling on this property, and he referred to it as a tour de force of foreshortening, which indeed this painting is. "It is said that Caravaggio, hearing himself maligned for not understanding planes or perspective, took the opportunity of showing the figures viewed *sotto in s* [from below] so that the most difficult foreshortenings are exhibited."[62]

One can easily imagine that Caravaggio rejoiced at the opportunity to represent the classical deities stripped of their accustomed aura of aristocratic ideality. Here he extended his repertory of humble types to include a black-bearded Neptune and a Pluto audaciously shown with a bush of black pubic hair. This action alone would have scandalized his audience, who were habituated to seeing their nudes, male and female alike, as glabrous as satin cloth. (It had been carefully painted out until the recent cleaning.)

Caravaggio had no use for ornament of any kind, either within or around his paintings. The whole concept that we have observed evolving in the course of the century he threw out. There is nothing in his art of the concept of an ornamental pattern on the surface. On the contrary, not only does he return to the simple Albertian view of the painting as a perspective space, but he repeatedly moves across the picture plane with oblique lines, rupturing the surface to draw the viewer into the space. As his style matured he did so increasingly, until it had become a compositional mode of his own and one of his principal devices for involving the worshiper. It would be much copied by his followers.

If Caravaggio was not particularly adept at creating the kind of setting, either landscape or interior, that was conventional, he compensated brilliantly with his invention of a dark background that obscures the setting and focuses on the figures. His figures are larger in relation to the picture field than was the norm, and they have often been moved closer, both physically and psychologically. Nothing could be more at odds with his purpose than those *repoussoir* figures that had so often been introduced into the foreground to distance the central action taking place in the middle ground. This device was still being used in Caravaggio's time both in Florence and in Rome. His *Entombment* (Pl. XXXII) addresses the subject we have seen so many times, the mourning over the dead Christ, with astonishing freshness. Nothing of the setting is indicated: where the crosses and Calvary would be he gives us darkness. Attention focuses on the six figures, arranged in an oblique wedge, who are moving toward us to lower the body into the tomb. There is debate over whether the body is being lowered into the space at the front and therefore symbolically onto the altar, or whether it is being moved toward an invisible cave opening at the left.[63] We look up, our viewpoint level with the lid of the tomb and close enough to see the veins in Joseph of Arimathea's ankles and the underside of Christ's body.

The *Entombment* is the painting Caravaggio made for the Chiesa Nuova, where a copy can be seen in situ. Although Neri did not live to see it, we can imagine that he would have approved Caravaggio's conception: the humble types he chose for his figures, the absence of any but essential elements, and the urgency of the feeling expressed. Whether Neri's taste was limited to the sweetness and near-sentimentality of Barocci we cannot know, but one might hope that he would have approved of Caravaggio's unconventional handling of color and light, because it enhances so effectively the emotional intensity.

The painter, his mature style now achieved, has manipulated the color and light in a revolutionary way. He has cast aside the convention of continuous modeling and reinvented the chiaroscuro mode of coloring.[64] This use of color is one of the most important and influential contributions of Caravaggio, and it deserves to be analyzed in detail.

The convention of continuous modeling was as old as the Renaissance itself: we can see it being worked out by Giotto and Duccio in the early Trecento, and we read about it in Cennino Cennini's how-to book for artists, *Il Libro dell'arte*, based on Giotto's system.[65] Although refinements and variations were introduced, the basic principle that white added in graduated quantity to the pure pigment would create the impression of volume and simulate the fall of directional light had

remained unchanged. High Renaissance painters working in the chiaroscuro mode would sometime abridge the sequence, jumping abruptly from very light to very dark, omitting the midtones for a more dramatic effect. Sebastiano del Piombo, in particular, explored the expressive potential of this mode. A few years before Caravaggio arrived in Rome, Armenini described in his how-to book for painters (1586) an updated version of Cennini's method for modeling, in which he prescribed, besides adding white for modeling up, the addition of graduated quantities of black for modeling down into the shadow. The underlying principle, however, stayed the same.

Caravaggio rejected this tradition. He uses virtually no white for modeling, though he models down with black toward his already blackish background. He instead discovered new means to create the impression of volume, having recognized that continuous modeling was not indispensable.

If Caravaggio needed a high value he used white as a color, which in contrast with his dark background gave an almost unprecedented value range (lightness to darkness) to his paintings. White, in our perception, tends to move forward, so it was predictable that he would use it in quantity for the figure of Christ at the front of the picture. What we would not have anticipated is the white on the two women at the back of the group, on the Mary's sleeve and around the face of the Virgin. The Mary's upraised hands, brightly lit, have the same effect, which is to press the figure group forward. Advancing color is again used in the red drapery judiciously placed behind Joseph's head. The strategy of moving the mourners closer to the worshiper works psychologically to make their grief more urgent to us.

Caravaggio's picture differs from the chiaroscuro mode not only in the absence of white for modeling but also in the saturation of the pigments. Painters working in the chiaroscuro mode typically used fully saturated pigment in order to achieve the strongest possible contrasts and therefore the most dramatic effects. The difficulty was that the unity of the picture was threatened. Caravaggio's colors appear to be much more saturated than they in fact are.[66] The white of Christ's winding cloth, for example, is very thinly painted and falls into fine pleats, allowing dark modeling in the folds. The most saturated pigment in the *Entombment* is the ultramarine blue of the Virgin's robe, an ingenious device to give her her rightful place in the hierarchy of

importance, despite her location at the back. The blue is so low in value, however, that it advances rather little and does not disrupt the careful construction of the figures in space. His red appears saturated, but Caravaggio has chosen a red ochre, which inherently has a brownish cast, instead of the more brilliant vermilion. It appears so saturated here because he has placed it beside its complement, the green of John's tunic. The largest expanse of a single color, after the white in the foreground, is Joseph's tunic at the right. The dangers of disrupting the balance and destroying the unity are avoided by the choice of a mixed tone, a reddish brown that extends into Joseph's weather-beaten, suntanned skin. The only white used for modeling appears here in his protruding elbow to make it project toward the picture plane. The result is a picture of very satisfying unity that gives the impression of verity because it is accurately observed. Like his rejection of rhetoric, Caravaggio avoided every kind of visible artifice. He has of course excised the ubiquitous *cangianti* colors because they defy rational analysis; he excluded fine fabrics, preferring matte textures that suggest humble materials; and his colors have an earthy quality because, in fact, many of the pigments he chose and featured prominently are the earths. The artifice that he practiced he kept carefully hidden, but more than any other painter of his time, he approached color and light in a revolutionary manner.

In some respects Scipione Pulzone (Fig. 177) anticipated what Caravaggio would do with his simplified compositions, dark background replacing a more elaborate setting, and direct expression of emotion. But Pulzone's pictures look like a stripped and reduced version of the Maniera, lacking the richness and aesthetic appeal of that style. What is absent is the startling novelty of Caravaggio, who makes us feel with his peasant types that he is reinterpreting familiar stories and telling us something we had forgotten. Pulzone's bright, clear palette is pleasing enough, but it is, again, a simplification of existing conventions rather than Caravaggio's rethinking and reshaping of them. It was not Pulzone's but Caravaggio's style that captured the imagination of many of his contemporaries and led them to imitate him.

Caravaggio remained in Rome and received some important public commissions, like the Contarelli and Cerasi chapels, after the turn of the century, where our study properly ends. In 1607 he was forced to flee because he killed a man. He lived only another three

years, dying prematurely, like Raphael, probably at the age of thirty-nine.

ART WRITING

Caravaggio depended less upon Raphael than any other important painter in central Italy. That very fact disqualified him from greatness in the eyes of Giovanni Pietro Bellori (1613–96), whose criticism defined Classicism and deified Raphael for the future. Bellori, writing in 1672 from the perspective of nearly a century's distance, found fault with the art both of Caravaggio and of the late Mannerists. For him Caravaggio's realism was crude – in a word, Caravaggio was not a Classicist on the model of Bellori's hero, Raphael. Bellori's often quoted criticism of Mannerist painting does, indeed, apply to the production of Guerra and Nebbia: the painters fell into artifice, substituting *fantastica Idea* for the imitation of nature and of antiquities. "The artists, abandoning the study of nature, vitiated art with *maniera,* or we would say with *fantastica Idea,* depending on *pratica* rather than on imitation."[67] *Pratica* means here the kind of working practice Guerra and Nebbia and their assistants employed, in which the drawings were created entirely from the head, without recourse to the study of models. Certainly there was no time in Sixtus's plan for the patient study of models, either in nature or in ancient art. Bellori does not specify when this process of deterioration began, nor to what art he is referring. Although some modern writers have taken it to mean essentially everything after Raphael, the painting that truly answers Bellori's description is the rapid production of the Sixtus factory.[68]

Federico Zuccaro turned at the end of his career to the writing of art theory. His book *L'Idea de' pittori, scultori e architetti,* published in 1607, is regarded as the final statement of Italian Renaissance art literature. In it there is no longer any discussion of the artist selecting the most beautiful from nature. Zuccaro regarded the origin of the artistic idea to be divine, arriving in the artist's mind through inspiration, or intuition. In the depiction of the allegory of *Disegno* that he frescoed on the ceiling of one of the rooms of his Roman palace in the 1590s, he represents *disegno* as a light deriving from the ultimate light of divine Grace. The inscription defines *disegno* as the light of the intellect, thus even higher than intellect itself. In fact, he claims *disegno* is the highest of all spiritual principles, according to which all creation,

human and divine, is realized.[69] From this elevated source the artist derives the idea for his painting. What is significant for our purposes is that the artist's idea derives not from the imitation of nature, or even the selective imitation of nature, as had been the case in the theory earlier in the century, but more as Bellori suggested, from the artist's imagination.

Zuccaro was not speaking of the art of Caravaggio. For the origins of Caravaggio's brand of realism we must turn to his native region of Lombardy where, in the writings of Giovanni Paolo Lomazzo (1538–1600), we find a similar commitment to realism. Because they were both Lombard we should expect some consonance between them, and it seems safe to assume Caravaggio was familiar with Lomazzo's theory. We have already seen how the Counter-Reformation had destroyed the High Renaissance linkage of beauty with goodness – recall Lomazzo's remark, spoken by his Leonardo da Vinci, that today he would paint the apostles with long dirty hair and dusty feet because that is the way they were.[70] It is as if Caravaggio remembers and paints Lomazzo's remark. It opened the way for Caravaggio's new visualization of the spiritual hero: he must be devout, but he should be humble in demeanor and origin. Going even beyond the formulation of Vincenzo Danti in the 1560s, discussed in Chapter 5, in which a good man may be ugly but by moving with grace reveal his goodness, in Caravaggio's conception, beauty and grace play little part.

For Bellori the savior of art was Annibale Carracci, who returned it to its proper course through the study and revival of the Classic style of the High Renaissance.

THE CARRACCI

In Bologna in 1582 three members of the Carracci family, Ludovico (1555–1619) and his cousins, the brothers Agostino (1557–1602) and Annibale (1560–1609), began an academy for their fellow painters. The recently founded Accademia del Disegno in Florence was the inspiration for the Carracci as it was for the academy established in Perugia in 1573 and the Roman Accademia di San Luca, founded by Federico Zuccaro in 1593. The Florentine academy did not provide a model for systematic teaching, as far as we can tell, because its founders, Vasari and Borghini, believed more in the effectiveness of the trained judgment of the eye than in rules and measurement.[71] Replacing the medieval

workshop system with academic training was an idea that was in the air. We do not know the program or the course of study at the Carracci academy; what we know is that it was dedicated to study from the model, a practice that had become rare in central Italy since the days of the High Renaissance. The Carracci academy should be understood as an alternative to the traditional workshop, and it was unusual in its structure in having in charge three men in their twenties, rather than the usual hierarchy of father and sons. It differed also in having in its membership a large number of adults who were past the age of apprenticeship.[72]

One principle the academy endorsed was that the education of the artist was an ongoing process, a principle embodied in the name the Carracci chose, the Accademia dei Incamminati, that is, those setting out on the road – and also leading the way. As befits an institution founded and operated by young men, the atmosphere of the Carracci academy seems to have been more exploratory and less authoritarian than was the norm of the day in the education of artists. The attitude they fostered was that we are searching for the means to revitalize art, which will come about through experimentation, discussion, and debate, and the study of not just one model, such as the master's, but many models.

The year of the founding of the Carracci academy was the same year that the bishop of Bologna, Cardinal Paleotti, published his treatise, which took as conservative a position on images as any Counter-Reformation publication. The stern Paleotti must have had an influence on the artists in Bologna, at least to the extent of stimulating thought about what was, and was not, appropriate in sacred images. Paleotti's insistence on the obligation of the painter of sacred images to adhere to visible reality and to move the emotions of the worshiper may well have had a formative effect on the Carracci.[73]

In other respects the situation in Bologna in the last third of the century was not conducive to innovation. The shadow of Florence loomed, especially the shade of Giorgio Vasari. He had as his assistants at various times several of the leading painters of Bologna. Prospero Fontana (1512–97) had worked at the Villa Giulia in the early 1550s when Vasari was the architect in charge, and at several other moments in his long career he had assisted Vasari. Later, Lorenzo Sabbatini (c. 1530–76) had worked for Vasari on the Florentine cupola frescoes in 1572, until Vasari returned from Rome and discovered he had been executing them primarily in *secco*. Sabbatini went to

Rome, where he continued to practice in a Vasarian style. His friend, Orazio Sammacchini (1532–77), applied the Vasarian formula in Bologna in its most desiccated and rigidified form on every commission for an altarpiece. Vasari had painted in Bologna himself in 1540: his three paintings in San Michele in Bosco remained available as models.[74]

Then, too, the publication of the second edition of the *Lives* in 1568 changed forever the way the development of art was perceived. One did not have to agree with Vasari's opinions as stated in his book to be profoundly affected by his having turned into history what had been an imperfectly understood jumble. We know that the Carracci did not always agree with Vasari: we have their annotated copy of the *Lives* with Annibale's marginal notes, sometimes quite angrily dissenting.[75] Nevertheless, Vasari's historicization of art objectified it, made it accessible, and laid the groundwork for a response that would make use of the best of the past to reform the present. In addition to Vasari, the availability of reproductive engravings, many of them produced in the academy by Agostino, provided firsthand models that could be studied and copied.[76]

The Carracci fell into disrepute, and the label "eclectic," which had long been used to describe their method of borrowing from other painters, became a term of derogation when the modern concept of artistic creativity took hold. The whole idea of academies, and the precept that creativity could be trained, became repugnant to us once Impressionism and the other anti-academic movements began to receive public recognition. Debate raged in the third quarter of the twentieth century over how we should interpret the relationship of the Carracci to their Cinquecento predecessors. Today we need to see in historical perspective the effort that erupted in the mid-1900s to divorce the Carracci from the concept of eclecticism and to deny the formality of their academy.[77] What is interesting is that whereas one side of the debate claimed that the Carracci were not eclectic, and the other side insisted that they were, both sides were proceeding on the assumption that eclectic practice necessarily produces art of low quality.

In the past quarter century we have learned a great deal more about artistic imitation in the Cinquecento and have recognized that whereas today we may reserve our highest praise for the new, the Cinquecento honored the creative reuse of sources. The Carracci extended the concept of

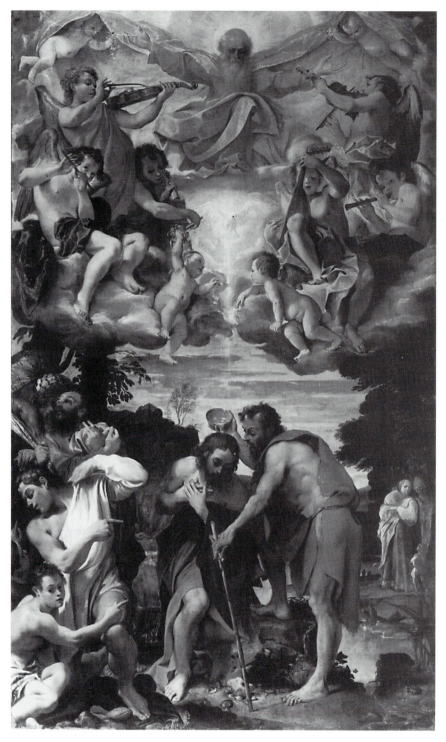

Figure 183. Annibale Carracci, *Baptism of Christ*. 1585. San Gregorio, Bologna.

Now that the taboo on eclecticism has fallen, it is becoming possible to see how that procedure led them to truly creative results.[78]

Annibale was the youngest and destined to be the most successful of the family. Equipped with enormous artistic talent and an irreverent attitude toward tradition and convention, he set himself on a quest for the artistic means to express his emotive response to his subject. Like Barocci, he found his way to that master of the recent past who had dealt most effectively with human feeling, Correggio. In his *Baptism of Christ* (Fig. 183) and *Pietà* (Parma, Galleria Nazionale, 1585), we see Annibale casting aside the veil of artifice that Maniera threw over its paintings, separating them from the realm of the viewer's experience. He learned from Correggio how to beautify his image without the stylization of the Maniera. The model of Raphael, in particular his *Saint Cecilia* altarpiece, which was in Bologna (now in the Pinacoteca), set a standard of beauty, of clarity, and of economy of means that Annibale emulated. But what sets his paintings of this period apart from Raphael's is the diminished psychological distance from the viewer that Annibale sought to establish. With his cool, rational light radiating on Cecilia and her companions, Raphael removes them to an ideal sphere that is not continuous with the spectator's realm. The light that flickers over Annibale's scene of Christ and the Baptist, the impromptu gestures, and an urgency of feeling bring the *Baptism* closer to the mundane and make its emotional content more accessible. It is likely that the example of Barocci's revival of

imitation when they advocated and practiced selective study of other artists' styles. They intended to assimilate the solutions to problems discovered by other artists and to recast those solutions in terms of their own personal styles.

Correggio played an important part in guiding Annibale, although the short distance between Bologna and Parma made Correggio's pictures directly available to him.[79]

When one sees Annibale in private moments, as in his drawings, or when he is working in less formal, less convention-laden genres than the altarpiece, one senses both his wit and his instinct for capturing spontaneity. His genre paintings, like the *Bean Eater* (Rome, Galleria Colonna, c. 1583) or the *Boy Drinking* (Oxford, Christ Church, c. 1583/1584), spurn the high-minded modes of expression available to the Italian artist of the Cinquecento to follow the lead of certain northern European painters. Nevertheless, Annibale understood that the reform of painting could be brought about only from a position within the tradition, and he consequently worked to find the satisfying formula within the conventional mode of the altarpiece.

It was in Annibale's next move, around 1586, that we see the effect of Vasari's historicization. With a unique freedom and disregard for the traditional restrictions of regionalism, he turned his attention to Venice. Whereas earlier painters would draw upon the local masters or follow the newer pattern of going to Rome and studying Raphael, Michelangelo, Polidoro da Caravaggio, and antique sculpture, Annibale took his quest to invigorate Bolognese tradition first to nearby Parma and then to Veronese and Titian. And when he transferred to Rome around 1595 with Agostino, his biographer Giovanni Battista Agucchi (1570–1632) said that he proposed to unite the design of the Roman school with the color of Lombardy.[80] It is evident that as a result of Vasari's writing, there was a new sense of the strengths and weaknesses of the various regional schools that had never been so clear before, and there was a new willingness to draw upon those strengths whatever their origin.

The appeal of the Venetians, like that of Correggio, was their sensuous light and color, which could create an aura of immediacy and of felt content. An indication of the difference between central Italian and Venetian concerns is found in the writing of Ludovico Dolce published in Venice in 1557, where he emphasized the importance of appealing to the emotions of the beholder. Dolce added to the canonical triad of the parts of painting, *invenzione, disegno,* and *colorire* (invention, drawing, and coloring), a fourth, the depiction of *affetti,* the emotions, without which, from his Venetian perspective, the painting remained cold and lifeless.[81]

This approach was not the attitude current in central Italy, and we saw this difference when Girolamo Muziano brought the Venetian attention to affect to Rome around midcentury.

Annibale's *Madonna of San Ludovico* resembles Titian in the moisture-laden atmosphere that surrounds the figures and unifies the space. His color is the murky, mixed, neutral tonality of Titian's late style, very different from the clear light colors of Correggio or Barocci. The texture of the brushstrokes, borrowed also from Titian and very different from Correggio's polished surface, supplies Annibale here with a new means to bridge the distance to the viewers and bring an intensity of emotion to them. But as Annibale became more sophisticated, he combined disparate sources, drawing here also on Raphael's *Sistine Madonna* (Dresden, Gemäldegalerie) and his *Madonna di Foligno* (Vatican, Pinacoteca).[82] He would have needed to experience Titian firsthand to gain an appreciation of his textured brushwork, but the designs of the Raphael compositions he could study from reproductive engravings.[83] There is frankness, even a naiveté, in the expressions of devotion depicted here, showing us how far Annibale has already traveled away from the fetters and repressions of a Sammacchini or a Sabbatini altarpiece.

The rapprochement with Venice would also recede, as had that the impact of Correggio, but the lessons learned in both cases were retained and assimilated. By the time of his move to Rome, Annibale had developed a style free of Maniera conventions, with the balance, harmony, and clarity of Raphael but a more direct address to the viewer's emotions.

The Carracci were invited to Rome by Cardinal Odoardo Farnese in 1594 to paint in the Palazzo Farnese. The patron's initial plan, which he abandoned, was to have the Carracci fresco the Sala Grande with new Fasti Farnese (as painted by Salviati elsewhere in the palace and by Taddeo Zuccaro in the family villa at Caprarola) updated with the deeds of his father. Ludovico decided to stay in Bologna, where he was doing particularly well, and Agostino did not arrive until 1597, but Annibale was already installed in the palace in November 1595. Before his brother's arrival, Annibale painted the Camerino, the cardinal's study, with mythological scenes. When Agostino arrived in the fall of 1597, the two of them set to work on the vault of the Galleria, which would turn out to be the Carracci masterpiece and the crown of Annibale's career.

The work extended over eight years taking place in two phases. The vault was completed by 1600, by which time the brothers had fallen out and Agostino had departed to work for the Farnese in Parma. Annibale fell into melancholia – today we would call it chronic depression – and was able to work only intermittently. With the assistance of Domenichino and Lanfranco who would become important painters in the Seicento, he executed the scenes of Perseus on the end walls, and then finally the remaining scenes on the walls, bringing them to completion only in 1604. We will concern ourselves chiefly with the part that belongs, literally speaking, to the Cinquecento, the vault.

The Galleria is at the rear of the palace facing onto the garden and the river, in the part where construction had just been completed. It was to house in niches on the walls a selection of the Farnese's antique statues, which was the best collection in Rome. Annibale's conceit was to extend the gallery to include framed paintings *(quadri riportati)* exhibited in his invented architectural and sculpted framework. Many of the paintings recreate works described in antique literature, as if they had been excavated for display alongside Farnese's statues. The conceit is, then, that it is a gallery of masterpieces of ancient art.[84]

In the tradition of Cinquecento palace decoration it was a tour de force of illusionism in feigned materials. From the perspective of the Cinquecento it is not so much a decisive break with earlier Roman decorative schemes (as some historians of the Baroque would have it). On the contrary, it is decidedly, and consciously, retrospective. It refers back to Michelangelo's Sistine ceiling, Raphael's Psyche Loggia at the Villa Farnesina (owned by this time by the Farnese), the Sala di Costantino, the Galerie François I, Salviati's Ricci Palace; a tradition of frieze frescoes and of *quadri riportati;* as well as precedents in his native Bologna, in particular Pellegrino Tibaldi's Palazzo Poggi. It is a (partly playful) attempt at synthesizing them, a recapitulation of the high moments of Roman palace decoration. It is a masterpiece of allusion, or in sixteenth-century terms, of imitation. Besides quoting all these sources, it refers to the relationship between painting and sculpture in historical terms, as in the influence of antique sculpture on painting, and in terms of relative superiority, as in the *paragone* debate.

Any viewer would immediately have recognized in Annibale's fictive architectural framework the quotation of that other famous ceiling in Rome. Like Michelangelo he has used flesh-colored *ignudi* to frame the scenes. But Annibale has replaced the simple clarity of Michelangelo's scheme with a play on levels of reality that capsizes the grave solemnity of the Sistine model. This approach accords entirely with decorum, for Annibale's theme is the loves of the gods, and his site is not the first chapel in Christendom but a palace. It is worth noting as a sign of the times, however, that it *is* the palace of a cardinal, and that the notion of what is appropriate decoration has loosened up since the days when the present Farnese cardinal's predecessor, decorating the family villa at Caprarola, decided that Old Testament stories had better be substituted for mythology.[85] In another swing of the pendulum, later ages would revive the prudery of the Counter-Reformation and condemn the nudity and frivolity here as inappropriate to a prelate's abode.[86]

Annibale reveals that the mode of discourse here is mock-heroic in the way he treats the decorative framework and in the interpretation of the stories. The macroscheme itself is a grandiose parody of all his sources, but it is a parody that seriously intends to surpass each and all (Fig. 184). The vault is divided into three parts, with a frieze running above the cornice of the walls, framing the center. In the frieze, relief sculptures alternate with paintings inserted into stone moldings; at the center of each long wall a framed picture has been hung in front of some of the reliefs. Terms and atlantes in monochrome divide the reliefs and paintings. On the short walls two more framed pictures, these in vertical format, are given the center. The corners open up to reveal the sky. Across the center two large tapestries are stretched to protect us from the sun, and at the center is a heavily molded stone frame around a painting.

The reader will recognize some of the allusions, for example, to the tapestries Raphael had used as a canopy in the Psyche Loggia (Fig. 19). The very idea of fictive materials used to suggest levels of reality hails from the Sala di Costantino (Fig. 27). The terms and atlantes play the same framing role as in the Galerie François I, but there they had been in monumental stucco (Fig. 84). Annibale wittily demonstrates the superiority of painting to sculpture in simulating those stuccoes in paint. The combination of *quadri riportati* and fictive sculpture had also been explored in the Galerie at Fontainebleau and by Salviati in his masterful Salone at the Palazzo Ricci-Sacchetti (Fig. 108). But Annibale has refined Salviati's

macroscheme and has overcome the randomness of display, which had been Salviati's solution to the asymmetry of the room, by creating a rhythm in his frieze that culminates and focuses in the center in the emphatically framed *quadro*. The overlapping forms create a subtle movement toward the center, where the eye comes to rest on the stable painting of the *Procession of Bacchus,* placed in front of everything else.[87] Thus he imposed a classicizing order on the complexity of Maniera invention. The decorative scheme is carried far beyond the High Renaissance prototypes in complexity, richness, and allusion, but it rivals those High Renaissance models in clarity, as no Maniera scheme had done.

The very idea of creating a frieze makes reference to the other great invention, together with vault decoration, of Cinquecento palace decoration. The frieze had been used in rooms that were lived in, where furniture needed to be placed against the walls and the warmth of tapestries was useful in the cold months. Because these rooms were often not public they did not receive the principal decoration, and hence they are neglected in survey studies.[88] The visitor will see them at the Palazzo Doria in Genoa, where there is a decorative frieze even in the Salone because Perino's tapestries were to adorn the walls. There are important examples in the papal apartment at the Castel Sant'Angelo, decorated again by Perino and his workshop; at the Villa Giulia; at the Palazzo Ricci-Sacchetti; at the Palazzo Vecchio in Florence; in the Villa at Caprarola, to name only examples in some of the palaces discussed here. Annibale had dealt with the frieze in his own palace decorations in Bologna. His solution here is a kind of monumentalizing and definitive statement of what the frieze can be.

Nothing in Annibale's Galleria vault is anything but paint, but there are visual jokes everywhere that play

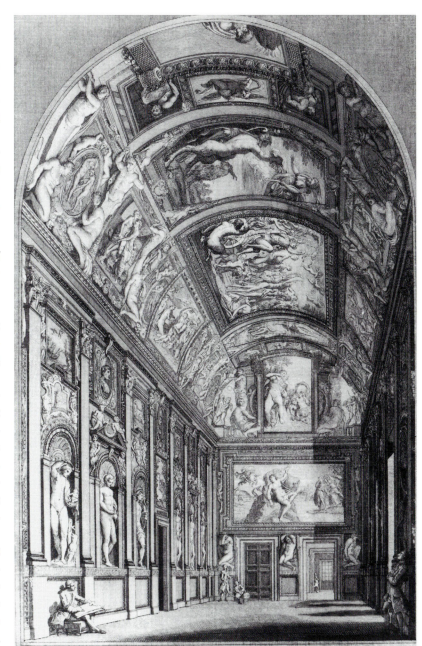

Figure 184. Gallery, Palazzo Farnese, Rome. Engraving by Giovanni Volpato, eighteenth century.

upon the fictive materials. The herms and atlantes, which are supposed to be stucco, do not play their roles convincingly: they frequently come to life to comment upon the scenes they frame, in one case one wraps himself in his cape against the cold draft. Sometimes they flaunt the superiority of painting to sculpture in an evocation of the *paragone* debate that had had such a long life in the course of the Cinquecento.

There are jokes about flesh turning to stone. In the

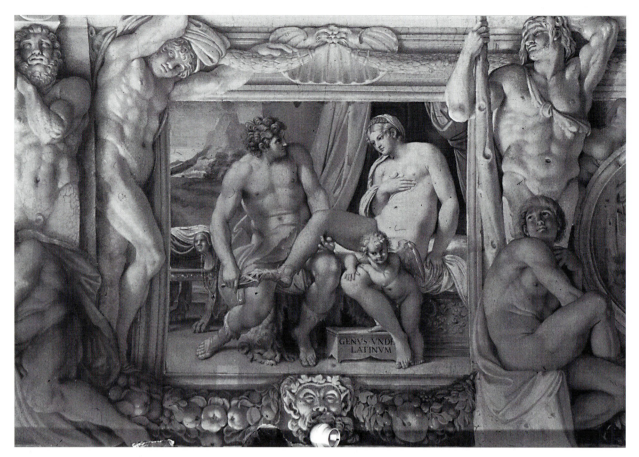

Figure 185. Annibale Carracci, *Venus and Anchises*. Fresco, 1597–1604. Vault, Gallery, Palazzo Farnese, Rome.

Perseus stories on the end walls, the head of Medusa, which turned whoever looked at it to stone, was used to great advantage. Here Perseus, instead of killing the dragon with his sword as is usual, transforms him into a statue by holding up Medusa's head. The rarely represented story of *Perseus and Phineas* on the opposite wall shows Andromeda's former suitor, who has turned up at the wedding banquet and is threatening Perseus in a jealous rage, responding to Perseus's display of Medusa by slowly turning from flesh into the *Torso Belvedere*. The joke is capped by Perseus's pose, which is that of the *Apollo Belvedere*. The cyclops Polyphemus, in his agony at seeing Galatea depart with her lover, assumes the pose of the *Laocoon* (Fig. 1). Thus some of the great antique statues still in the possession of the Vatican find their place in the Farnese gallery of antique masterpieces.

At the center of the vault the *Procession of Bacchus* is represented in a composition unmistakably based on those antique sarcophagi that had inspired so many Cinquecento representations of processions. (Recall, for example, Perino's in the atrium at the Palazzo Doria

[Fig. 72]) There is an irreverent note typical of Annibale in showing in the central image of the room a drunken and lascivious parade. The scene was certainly given this prominence in response to the selection of three Dionysus statues from the Farnese collection to fill niches on the walls.[89] Only this scene has been depicted in the relieflike style. Functionally the choice relieved the painter of the obligation to represent it illusionistically from below, the logical outgrowth of the illusionistic scheme. Artistically, Annibale included in his compendium of Cinquecento art the important stylistic mode of imitating relief and yet another use that painting has made of sculpture.

The theme of the loves of the gods was certainly not a new one, but Annibale's interpretation of the theme is thoroughly irreverent. In fact what he represents is the foolish state to which sensual love reduces us. The bedding of Venus by the father of Aeneas alludes to this rather silly encounter as the founding of the Latin race in the inscription (Fig. 185). Not even the sovereign lord Jupiter, whose love affairs had been represented as noble

by both Perino and Correggio, escapes with his dignity. The great philanderer is shown being approached by his wife, intent on seduction. He has dropped his thunderbolt and his eagle looks aside disapprovingly as he reaches ardently for Juno in the pose (once again) of *Laocoon*.[90] The open-mouthed marble mask below shouts a warning; the herm rests his arms on the molding and covers his head in despair.

What differentiates Annibale's treatment from his predecessors' is that same concern with the *affetti* we saw engaging him in his sacred paintings of the pre-Roman period. His gestures and body language have a freshness and directness, freed of Maniera contortions, which allow the humor to be projected to the viewer. It is the daft and dewy-eyed expression on Jupiter's face, more than anything else, that makes the scene of his seduction comic. The awkwardness of the giant Hercules, playing a tambourine, his legs entwined with Iole's who wears his lion's skin and has taken away his club, is much more laughable than the elegant and sophisticated poses he normally strikes. Annibale captured again and again a lack of the poise expected in these dignitaries, gently lampooning them and, with them, all humanity that finds sensual love irresistible. Since Raphael's Psyche Loggia, painters had presented the pagan deities in the spirit of Ovid, as subjects of delight and sensuous enjoyment. Annibale brought them down from the Olympian clouds, made them accessible, and showed them to be more like humanity than ever before.

What saves Annibale's ceiling from being pretentious, which his imitation of the antique, of Michelangelo, and of the Classic style of the High Renaissance would certainly seem, is the mock-heroism he conveys, not just in the iconography but also in the illusionistic macroscheme he invented.

AGOSTINO CARRACCI AND THE PRINT

Beginning already in the late 1570s Agostino had focused his talent on the engraving of selected paintings of the High Renaissance, of Venice, and of Correggio. He used his burin, as his brothers did their brushes, to bring works he considered important to the fore. By making them available in reproduction Agostino gave them prominence – an early instance of influencing taste by manipulating access through the media. When he went to Rome in 1595 he made a copy of Barocci's *Aeneas's Flight from*

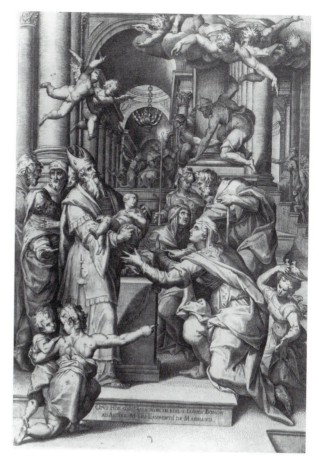

Figure 186. Agostino Carracci, after Orazio Sammachini, *Presentation in the Temple*. Engraving, c. 1579–81.

Troy. He also copied the works of his fellow Bolognese, like Orazio Sammacchini, in a clear indication that despite their widened search for new models of style, the Carracci's interest was still strongly centered in the region of Bologna. Agostino copied Sammacchini's altarpiece of the *Presentation in the Temple* (Fig. 186) in the Bolognese church of San Giacomo Maggiore in c. 1579–81, a few years after the painter's death. The origin of Sammacchini's late Maniera style in Vasari is evident.[91] This work can represent for us the state of painting in Bologna just before the founding of the Accademia dei Incamminati.

Reproductive engraving is regarded as mere copying today, but in the sixteenth century it was recognized that the engraver was making an interpretation in black and white of the colors in the painting, which required great skill if it was done well. Technically Agostino was among the best, and to acquire that expertise he studied the technical innovations of northern printmakers, in particular Cornelius Cort. Cort came from Antwerp, a thriving

center of engraving. It was probably he who engraved Martin van Heemskerck's Daniel series in the mid-1560s (Fig. 173). He settled first in Venice in the late 1560s and then permanently in Rome in 1572. He invented a new use of the cutting instrument, the swelling burin line, which enables the engraver to simulate far more effectively the tonal effects of paintings. The line begins delicately, deepens and spreads out, and then tapers down, ending in a dot. The swelling and curving lines of Cort were adopted by Agostino from the start to give depth, movement, and light and shade hereto not seen in Italian engraving.[92] The woodenness we so often find in engravings is replaced by a curvaceous grace that captures the spirit of Italian painting.

Agostino's study of the prolific production of prints in northern Europe led him to learn from and borrow their subject matter as well. The more bourgeois subjects that were produced for the less aristocratic markets there appealed to the Carracci's populist interests. Moralizing subjects, a common genre in the north, make their appearance in Agostino's art, as for example his adapta-

Figure 187. Agostino Carracci, *Gold Conquers All*. Engraving, c. 1584–7.

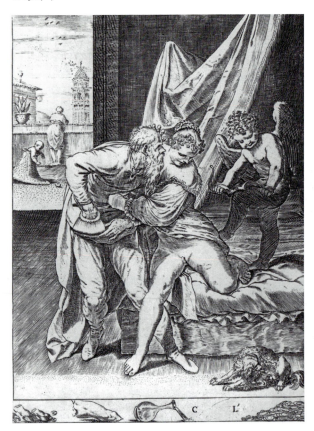

tion of the theme of the ill-matched couple: usually a rich old man and a beautiful young woman. Under the title *Gold Conquers All* (Fig. 187), Agostino shows a hoary old man reaching into his pocketbook as he presses a lovely virginal nude onto the couch, where Cupid stands, breaking his bow over his knee.[93]

In prints as in other media the strictures of the Counter-Reformation were quietly relaxed toward the end of the century. Despite Bishop Paleotti's attempt to regulate private and secular art, his *Discorso* seemed on the brink of being already out of sync with the times when it was published in 1582 in Bologna. By 1590 Agostino was making engravings appropriately entitled *Lascivie*, showing sexual intercourse in as blatant a manner as Giulio Romano's notorious *I Modi* had done. Like Marcantonio Raimondi, who engraved *I Modi*, Agostino was rebuked by the pope,[94] but there was no attempt to confiscate the prints or the plates as there had been in the 1520s. The subjects of the thirteen engravings that seem to belong together are mythological, that is, nymphs and satyrs in erotic activities. Of particular interest are the two Old Testament scenes included in the series: *Susanna and the Elders* and *Lot and his Daughters*. Neither story is particularly uplifting. The incestuous seduction by the daughters of their aging father Lot so that they might bear sons has little to recommend it as religious education, so one must suppose that it is an instance of using a scriptural text as a pretext to represent a prurient story.[95]

ROMAN ANTIQUITY

A few months after he ascended the papal throne, Clement VIII (1592–1605) announced that he intended to undertake renovation of the Lateran basilica, extending work inaugurated by Sixtus V. His hope, he declared in words that summarize the spirit of his papacy and the final decade of the century in Rome, was that in that venerable location a new age of piety would begin, spread to the clerical and lay populations in the city, and ultimately encompass the whole world.[96] This program was a part of the revival of early Christianity, now understood as the heir and continuation of ancient Roman culture. The Church had finally reached a solution on the troubled question of how to regard pagan Rome. We have seen how there had been nearly constant contention between the purist reformers who advocated an ascetic style and a strict construction of

what was appropriate in Church decoration and the liberal view, exemplified first in the Cinquecento by Julius II but anticipated at the end of the Quattrocento by Alexander VI and shared by many, but by no means all, of their successors.

Attitudes toward grotesque decoration provide an index. These, to us harmless, little inventions evoked passionate debate because they represented the world of imagination, of dreams, and of fantasy. The fantastic was suspected of rising up from the underworld, emanating from the sphere of evil.[97] It was the opposite of the rational, which was believed to reflect the divine. The opposition, as Eugenio Battisti pointed out, is between the classical and the capricious, or the fantastic. When Bellori championed Classicism and the art of Raphael, he set it against Caravaggio's vulgar naturalism, on the one hand, and the fantastic inventions of some Seicento artists, like Borromini, on the other, both of which he heartily censured.[98] The *fantastica Idea* that Bellori condemned in Maniera art referred to this same non-Classic, nonrational source of artistic inspiration. The extreme position against the use of *grotteschi* taken by Bishop Paleotti was based on precisely this fear of the fantastic as arising from the realm of the devil.[99] A consensus seems to have been reached sometime late in the century that grotesques were acceptable in secular sites but not in sacred ones. This position was stated by Comanini (1591) and by Federico Zuccaro, who has a high appraisal of *fantasia,* in his *Idea* (1607).[100]

Cesare Baronio, a close associate of Filippo Neri and confessor to Pope Clement after Neri himself became too ill to continue in that role, had undertaken the monumental task of writing a history of the Church, the *Annales Ecclesiastici,* in response to a need expressed at the Council of Trent and in response to a specific Protestant document.[101] This scholarly work was the first attempt to sort out truth from legend. His research provided him with an understanding of the early Church and a deep conviction that the way to reform lay in a return to early Christianity. When Pope Clement appointed the reluctant Baronio cardinal on pain of excommunication in 1596, he chose as his titular church the one most in need of repair, the neglected and impoverished early Christian church of Santi Nereo e Achilleo near the Baths of Caracalla. He set to work immediately on returning it to its former state, paying for the work from his own, not very deep, pockets. When the building was ready to receive the relics

that he was transferring there, he staged a ceremony that tells us a great deal about attitudes toward pagan antiquity at the end of the century. The model the learned Baronio chose for his procession was the triumph of a Roman emperor. The relics were carried on a route similar to that taken by a conquering emperor, up the Capitoline and through the three imperial arches decorated with inscriptions.[102] We are reminded of the triumphal entry of Emperor Charles V that had taken place in 1536 (see Chapter 4). What this symbolic enactment said to Baronio and his contemporaries was that the Church stood on the shoulders of the early Christian Church, which had integrated into itself the old pagan Rome.

CAVALIERE D'ARPINO (1568–1640)

Giuseppe Cesari, more often known by his title Cavaliere d'Arpino, became Clement VIII's painter of choice and received the principal commissions in the 1590s, culminating in the paintings of the renovated Lateran transept, which he planned and oversaw in 1600–1. He invented a style for large-scale decorations, particularly in fresco, that moved decisively beyond the Maniera. His vault for the large Olgiati Chapel in Santa Prassede is exuberant in a way that looks forward to the Baroque and has none of the aridity of the Counter-Maniera. It had become clear already under Gregory XIII that the Church would not endorse the position of the most conservative reformers regarding the decoration of churches. The Altemps Chapel in Santa Maria in Trastevere, executed during Gregory's pontificate and dated 1579, commemorated the Council of Trent in one of the frescoes on the walls. At the same time, however, it also provided a luxurious display of stucco and gilded ornamentation on the vault, thereby indicating the liberal interpretation of the Council's Decrees on Art that was being endorsed here.[103]

The young Cavaliere d'Arpino took this equally large chapel as his model for the Olgiati Chapel vault. Before Annibale had arrived in Rome, and at the moment the newly arrived Caravaggio was working as his assistant, d'Arpino had already turned his attention to his own reforming style. His reform would not be based, as was Annibale's, on the study of Emilian and Venetian alternatives; therefore, it contained less potential for new solutions. Like Annibale, however, he returned to the High Renaissance masters, in particular Raphael. He wished

to preserve and to continue the grandiloquent tradition of Renaissance rhetoric, but he spurned the artificial conventions of the Maniera. Whereas Guerra and Nebbia, when working at breakneck speed for Sixtus V, had not concerned themselves very much with the style of the narratives produced by their large and varied *équipe* and consequently tolerated an occasionally high component of Maniera, Cavaliere d'Arpino attentively trimmed Maniera excesses from his own style and that of the painters working for him.[104]

Caravaggio must have been uncomfortable in his workshop because his sensibilities drove him in a quite opposite direction. Where he must have found the ornament of this tradition bombastic and distracting from the proper focus on the inner feelings of the actors, for the Cavaliere, one supposes, it gave a proper celebratory air to the decoration of the Church triumphant. Bernini and the High Baroque would agree with d'Arpino more than with Caravaggio.

The Cavaliere's position of prominence and his skill at large-scale decoration made him the choice of the municipal authorities when they decided to decorate certain rooms in the Palazzo dei Conservatori – the very rooms in fact that Jacopo Ripanda had first frescoed at the beginning of the century (Figs. 6–7). In order to have the Sala Maggiore ready for the Jubilee Year of 1600, Cavaliere d'Arpino received the commission in 1595, with a deadline of 1599. In the event, only two of the scenes were completed before the Jubilee, and the project dragged on for many years, in part because the painter was in constant demand. D'Arpino was an excellent technician in fresco.[105] He moved along rapidly and with assurance, as the medium requires, but took greater pains and gave more attention to the quality of his execution than had been the case in the Sixtus fresco factory. There is a juiciness to his style, which when combined with his energy makes a pleasing effect.

As had been the case with Ripanda, the subject was early Roman history, in fact the origins of Rome. D'Arpino began with the story of Romulus and Remus, showing the infant twins being suckled by the wolf, the story represented in the ancient bronze statue that Sixtus IV had given to the municipality in 1471 and that was, and is, displayed on the Capitoline Hill. The painter chose as the model for his decorative scheme the Sala di Costantino. A painted *basamento* with fictive stone cartouches, garlands, and bronze reliefs set in colored mar-

ble frames encircles walls on which feigned tapestries hang. A nice variation on this now familiar theme was introduced on the end wall where doors break into the picture field: the tapestry appears to be draped over the intruding door frames. On the long wall where two battles were depicted side by side and in front of the borders of the tapestries where they come together, d'Arpino invented a splendid trophy, like the antique *Trophy of Marius* installed on the Capitoline stairs just outside, dominated by a life-sized cuirass. Fruit and vegetable garlands, as luscious as any painted by Giovanni da Udine, are hung above. Although the painter's choice of this model could be interpreted as revealing a lack of invention, it should rather be seen as a conscious decision to link up with the grand tradition of Cinquecento reception rooms, so many of which took the Costantino as their model.

There is an innovation in his treatment of distant view discernible here that will have an important life in the century to follow. D'Arpino used acuity perspective in his landscape, diminishing the sharpness of focus and the saturation of his colors to represent the distance.[106] This device had not been a part of fresco technique in the preceding generation. We would probably be more disturbed by its absence in landscape representation were it not for the evident artifice of Maniera style in other respects. D'Arpino signals his interest in a new opticality that is analogous to the innovations of Barocci, the Carracci, and Caravaggio, though not deriving from any of these.

The other scene readied for the Jubilee, the *Battle of Tullus* (Fig. 188), reveals just how carefully the Cavaliere had studied Raphael, for here, on the model of the *Battle of the Milvian Bridge* in the Sala di Costantino (Pl. VII), he revived the relieflike style. The battle he represents is described in Livy's history (Bk. I, chap. 27, 5–11). The treacherous Albans, putative allies of Rome, incited two tribes to rebel against the Romans, promising to come to their aid. Tullus, as leader of the Romans, called upon the Albans and led the combined forces into battle. The moment represented in the fresco is the crucial one when an aide gallops up to Tullus to inform him that their allies were deserting. The quick-thinking Tullus, to stave off panic in his troops, responds by announcing loudly the fiction that they had been ordered to circle round and attack from the rear, thereby inspiring his brave soldiers with sufficient courage to save the day. D'Arpino's *Battle* is not like

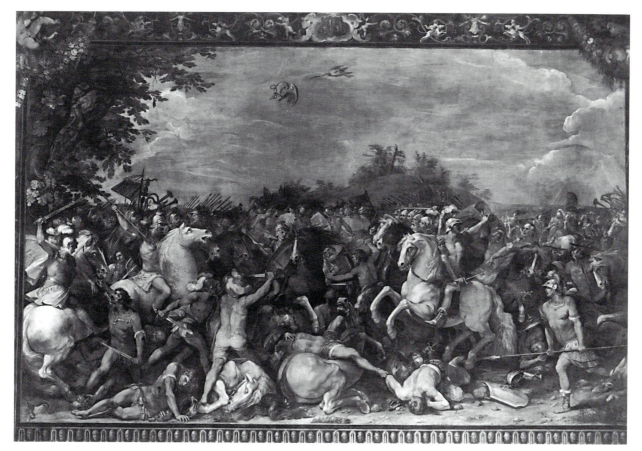

Figure 188. Giuseppe Cesari (Cavaliere d'Arpino), *Battle of Tullus.* Fresco, commissioned 1595. Palazzo dei Conservatori, Rome.

Raphael's, a sweep of the enemy, but more like Leonardo's, a clash of forces in which the outcome is not yet decided. Nevertheless, the painter has filled the surface with actors who break with their stance parallel to the plane only to signal dramatic content. We see the aide riding his black horse directly toward the plane and Tullus, twisting in contrapposto, his arm raised to indicate where the allies have been redirected. D'Arpino, like Raphael, has omitted the middle ground and kept perspective recession to a minimum, showing only the diminishing shapes of the deserters as they move away behind the hill. D'Arpino understood fully the implication of Raphael's dual models of composition provided in the designs for the Costantino frescoes, and he

repeats them side by side in his two frescoes here in a kind of silent tribute.

This fresco may be the last appearance of the relief-like style. D'Arpino was a knowledgeable antiquarian who had the benefit of the entire century's accumulated learning on which to draw. His *Battle* makes an interesting comparison to Jacopo Ripanda's *Triumph of Rome over Sicily* (Fig. 7) at the beginning of the century. One supposes that the reason the Conservatori had for ordering the Cavaliere to overpaint Ripanda was that those frescoes now looked primitive, no more than first, timid steps on the long road that had recovered and incorporated so much of antiquity into Roman culture in the course of the century.

Notes

A NOTE ON STYLE LABELS

1. Introduction, written in 1989, to the second edition of Smyth (1992).
2. My position on Early Mannerism is close to that enunciated by Campbell.
3. Gould, in his monograph on Parmigianino (1994), emphasized the lack of cohesion among the works of the painters of the 1520s and 1530s. He remarked that neither Parmigianino nor his contemporaries had any important influence on Florence or Rome. Rather, Parmigianino's important influence was on North Italy, France, and northern Europe, 11.
4. Smyth (1992, first ed., 1963).
5. Friedlaender's essay, "Die Entstehung des antiklassischen Stiles in der italienischen Malerei um 1520," first published in 1925, was given a new lease on life when it was translated and published in English in 1957.
6. Smyth in his unpublished dissertation (1955) carefully analyzed this period and referred to it as "interim mannerism."
7. Grendler, especially 227, 235–41, 249.
8. These are the terms Giovanni Andrea Gilio applied to sacred images in the Maniera style in his treatise published in 1564. See Chapter 5.
9. The term is Malvasia's: *Felsina pittrice,* Bologna, 1678, I, 358. He saw the decline beginning earlier, around the time of Ludovico Carracci's birth in 1555, and names as its instigators Salviati, the Zuccari, Vasari, Andrea Vicentino, Tomaso Laureti, and the Bolognese painters Samacchini, Sabbatini, Calvaert, the Procaccini, and the like.

INTRODUCTION

1. On the Renaissance rediscovery of the Domus Aurea, see Dacos (1969).
2. The scene was recorded more than sixty years later in a letter by Francesco da Sangallo, the then six-year-old son of the architect Giuliano da Sangallo who was taken along riding on his father's shoulders; dated 28 February 1567, and published by Carlo Fea, *Miscellanea filologica, critica e antiquaria* (Rome: 1790), 1:cccxxix–cccxxxi, and cited by Haskell and Penny, 243.
3. On the *paragone,* see Leatrice Mendelsohn and the discussion here in Chapter 4.

4. Important studies on Cinquecento rhetoric include those by Fumaroli, O'Malley (1979), and McGinness.
5. More accurately, we could say that Vasari popularized the idea of a rebirth of classical culture, which had been explored by writers in the Quattrocento. For recent discussions of the concept of the Renaissance, see Rubin (1995), 164, bibliography in n. 80; Barolsky (1990), (1991), (1992), (1994), (1998); Jacks (1998).
6. See B&B, 4:3–13; Eng. ed., 2:151–5.
7. B&B, 4:5–6; Eng. ed., 2:152.
8. B&B, 4:6; Eng. ed., 2:152.
9. B&B, 4:10; Eng. ed., 2:154.
10. B&B, 4:12; Eng. ed., 2:155.
11. Preface to the third part, B&B, 4:7; Eng. ed., 2:153.
12. Quintilian makes a similar remark about overattention to the niceties of style, *Institutio Oratoria,* Bk. VIII, Preface, 23, "For those words which are obviously the result of careful search and even seem to parade their self-conscious art, fail to attain the grace at which they aim and lose all appearance of sincerity."
13. B&B, 4:5; Eng. ed., 2:152. Cicero and Quintilian recognized that grace cannot be acquired through the rules of the rhetoricians; see Monk.
14. Vasari was speaking here of Raphael's invention of draperies, B&B, 4:9; Eng. ed., 2:154.
15. The fundamental discussion of the influence of Horace on art theory is Lee (1940/1967).
16. Baxandall traced the relationship of Alberti and the ancient writers. He has shown that the language of Early Renaissance art criticism depended upon the rhetorical literature and borrowed from it so heavily that most of the comments are, in fact, rhetorical commonplaces; see 121–39. Blunt summarized Vasari's preface but did not recognize the antique sources; see 86–102. Goldstein (1991, and esp. 644–7) and Rubin (1990, 1995) discuss Vasari's dependence on Cicero and Quintilian.
17. Preface to the third part, B&B, 4:10; Eng. ed., 2:154. Italics mine.
18. Preface to the third part, B&B, 4:9; Eng. ed., 2:153. Italics mine.
19. Gombrich (1966) made the useful distinction between imitation and assimilation, although today we would add the further refinement of distinguishing between copying (what Gombrich called imitation) and imitation.

20. Aretino was writing to Giulio Romano: Pietro Aretino, *Il secondo libro delle lettere,* ed. F. Nicolini (Bari: 1916), 2:2, 186; quoted by Gombrich (1966), 127.

21. Fermor points out that in sixteenth-century books on dance and movement, as well as art criticism, *leggiadria* is a term specifically applied to women and to the lightness of bearing that was regarded as appropriate to them.

22. See Emison, 432–3, who has explored the term in its Cinquecento usage, and Chap. 2, p. 163.

23. Bell (in Hall, 1997), 88.

24. Fermor contrasts these terms and shows how they were used in some texts as an antithesis, or contrapposto.

25. Emison, 450. See further discussions here, especially in Chapters 1 and 2.

26. Golzio, 30–1. Shearman (1994) has demonstrated that Castiglione himself wrote the famous letter of Raphael addressed to him, a not-unprecedented practice in the Renaissance, Shearman also shows. The same method of gathering "scattered beauty" (see Chap. 1) was attributed to Michelangelo by his biographer, Condivi, writing in the early 1550s. He says, "Anyone who thinks to arrive at some level in this art without this means (whereby true knowledge of theory can be acquired) is greatly deceiving himself." Condivi, Wohl ed., 105.

27. Vasari also painted a variant in his Florentine house. See Jacobs, and especially 407–8; Rubin (1995), 240 and pl. 86.

28. Panofsky (1924) traced the concept of idea and ideal through its culmination in the seventeenth century; on Vasari, see 65ff.

29. Burckhardt was a professor of history and the new discipline of art history in Basel.

30. Wölfflin called his book *Classic Art* in an attempt to distinguish it from "classical," which term he reserved for antiquity, and I have followed him here.

31. Freedberg (1961, 1971).

32. This has been nicely demonstrated anew by Jacqueline Lichtenstein, *The Eloquence of Color: Rhetoric and Painting in the French Classical Age,* trans. Emily McVarish (Berkeley, Los Angeles, Oxford: University of California Press, 1993); original French ed., 1989.

33. See Bell in Hall (1997), 92.

34. For a more complete discussion of the modes of color, see Hall (1992), "The Modes of Coloring in the Cinquecento," 92–148.

35. Wölfflin, 225.

36. The census of antiquities known in the Renaissance, an ongoing project, has contributed much to our understanding. See the works of Phyllis Bober, particularly the Introductions to both *Drawings after the Antique by Amico Aspertini,* 3–4, and *Renaissance Artists and Antique Sculpture,* 31–42.

37. We must remember that from 1516 to 1534 Michelangelo had been directed to return to Florence and to sculpture. Although he continued to be regarded by artists as a model, very little of the work he did at San Lorenzo was brought to completion or put on display until years later.

38. This was admired by Vasari, B&B, 6:48; Eng. ed., 4:130.

39. See especially D'Amico, O'Malley (1979), and Stinger.

40. See the publication of Phyllis Bober and Ruth Rubinstein; the three-volume anthology on the recollection of the antique in Italian art, edited by Salvatore Settis; the work of Agosto Farinella, and the interdisciplinary study of Philip Jacks (1993).

CHAPTER ONE

1. Brentano, 55.

2. On the urban renewal of the Quattrocento, see Torgil Magnuson, "Studies in Roman Quattrocento Architecture," *Figura* 9 (1958).

3. According to Bonner Mitchell (1973), the population in 1526–7 was 53,897, about the same as Florence, but only 17 percent were native Romans; most were Tuscan and northern Italian; see 38–9.

4. Weiss (1969), 91.

5. On the Palilia and Leto's Academy, see Jacks (1993), chap. 3.

6. Particularly useful are Stinger, Jacks (1993), and Settis; the principal overview before these recent contributions was Weiss (1969).

7. The attribution was first made by Adolfo Venturi ("Romolo e Remo di Antonio Pollaiuolo nella Lupa Capitolina," *L'Arte* 22 [1919], 133–5), although Leopold Ettlinger (*Antonio and Piero Pollaiuolo,* Oxford: Phaidon; New York: Dutton, 1978) did not find the evidence convincing enough for either Pollaiuolo brother.

8. For a reinterpretation of the influence of Savonarola on the Florentine artistic scene in the 1490s and early years of the Cinquecento, see Hall (1990).

9. On Ripanda, see Ebert-Schifferer (1988a, 1988b) and Oberhuber (1984), 334; Faietti and Oberhuber (1988a, 1988b) reassigned the disputed drawings known as the Frizzoni-Wickhoff group from Peruzzi to Ripanda, thereby clearing the way for a reassessment of his contribution.

10. B&B, 3:571; Eng. ed., 2:114.

11. Dacos (1969), 63, identified the Bufalini Chapel as Pinturicchio's earliest use of *grotteschi*.

12. Hall (1992), 47.

13. On the iconography of the Sala dei Santi, see Parks.

14. On the problems of *secco* as it was used in the Quattrocento and Vasari's consequent advocacy of true fresco, see Hall (1992), "Alberti, Flemish Technique, and the Introduction of Oil," 47–91.

15. Vasari-Milanesi, 3:519–22; cited by Dacos (1969), 68.

16. There is a documented payment to Ripanda in the Vatican, and it is probable that he worked there with Pinturicchio in 1493, but from April 1494 until February 1495 he is recorded in Orvieto working on the Cappella del Corporale in the Duomo. There is no documentation for 1495–1505, though it is thought likely that he returned to Rome. See Faietti and Oberhuber (1988b), who give the best chronology of Ripanda's career. They accept the attribution of the apse of Sant'Onofrio to Ripanda rather than to Peruzzi. They date it immediately prior to the frescoes of the Sala dei Guerre Puniche in the Palazzo dei Conservatori, which are

Ripanda's only documented works. They also accept the attribution of the frescoes at the Episcopal Palace in Ostia to Ripanda. The importance of Ripanda was made clear to me by Hellmut Wohl in several lectures he gave in the early 1990s.

17. Ebert-Schifferer (1988b), 138.

18. Farinella, 124–31, and especially 128.

19. See Farago.

20. Nesselrath (1992).

21. Farinella, 100–23.

22. Suggested as early as 1744 by Ridolfino Venuti in *Numismata Pontificum praestantiora,* xii, as cited in Weiss (1965), 180, n. 163.

23. Weiss (1965), 180.

24. B&B, 4:317–18; Eng. ed., 2:294.

25. Vasari's reference to Peruzzi suggests him perhaps as the architect and designer of the whole decorative scheme. For a review of the literature and attributions, see Farinella, 132–3.

26. Farinella, 139. See also his reconstruction diagram, 142–3.

27. On Riario, see Schiavo, 37–65, and Farinella, 145–8.

28. Hall (1990).

29. This was the opinion of Agostino Chigi, stated in a letter to his father; quoted by Hirst (1981), 12.

30. As related by Vasari, B&B, 3:609–10; Eng. ed., 2:132.

31. On the *David,* see Seymour.

32. The letter of Pietro da Novellara to his patron, Isabella d'Este, is in Luca Beltrami. *Documenti e memorie riguardanti la vita e le opere di Leonardo da Vinci* (Milan: Fratelli Treves, 1919), n. 107. This cartoon was an earlier version, now lost, of the cartoon currently in London, National Gallery, for the painting in Paris, Louvre. See Kemp, 220–6.

33. Analysis of Claire Farago (1994), based upon her joint study of Leonardo's writings and paintings, 320.

34. The reconstruction of Johannes Wilde (1944) has been only slightly amended. See Farago.

35. Rubens' copy, made a century later, is the most familiar. See Farago for other copies.

36. Wilde (1978), 43, suggested that the copy by Aristotile da Sangallo was influenced by the *Last Judgment,* which had been recently unveiled, and that the original was less rigid, less still, showing more of a movement, like that of Michelangelo's relief of the *Battle of the Centaurs.*

37. Antonio Natali in *L'officina della maniera,* 140, no. 34. He therefore dates the tondo 1507, after the discovery of the *Laocoon,* a little later than has been usual.

38. For discussion of Raphael's Florentine Madonna and Child pictures, see Pope-Hennessy, chap. 5.

39. The painting, belonging to the Duke of Northumberland, was examined at the National Gallery, London, in 1992 and discovered to be the original version of a much-copied Raphael. See Nicholas Penny for discussion of the stylistic and technical evidence and a color reproduction. He dated it 1507.

40. Penny, 68, who cites E. Wolffhardt, "Beiträge zu Pflanzensymbolik." *Zeitschrift für Kunstgeschichte* 7 (1954), 177–96.

41. On the Chigi Chapel, see Shearman's seminal article (1961), and now, *Only Connect* (1992), 178–81.

42. On Chigi, see Rowland (1984), and her forthcoming book. That this is precisely the imagery intended is confirmed by the absence of eagles in the corresponding places of the frieze on the entrance side of the chapel; here little grotesque heads have been substituted. The eagles imitate the Trajanic relief of the *Eagle in an Oak Wreath,* to be found in the portico of SS. Apostoli; it was installed there by Cardinal Giuliano della Rovere, the future Pope Julius II. See Bober and Rubinstein, no. 186.

43. On the Farnesina, see Frommel (1967–8); Coffin (1979), 87–110, with bibliography.

44. The document was found by Ingrid Rowland (1984). The bibliography is reviewed by Kristen Lippincott, 186–7.

45. Seznec, Bk. I, pt. 1, chap. 2, "The Physical Tradition," 37–83.

46. Alessandro Farnese had a similar ceiling decoration made in the 1570s at his villa in Caprarola in the Sala del Mappamondo; see Lippincott, who also makes the connection to the Domus Aurea, 207; and Partridge (1995b).

47. Barolsky (1978), 87, captures the spirit of the Farnesina decorations in his discussion, 79–95.

48. Hirst (1981), who observed the frescoes from the scaffolding during the cleaning, 32–7 and especially 35.

49. Leonardo's design is known to us only by means of versions by pupils and some drawings. He had been exploring the Leda subject in drawings for several years, first in a kneeling pose and then standing, while he was working on the *Battle of Anghiari.* (See Kemp, 270–5.) Raphael's drawing at Windsor Castle (308 × 192 mm; pen and ink over a sketch with the stylus) copies Leonardo's composition and contrapposto.

50. Kinkead, cited by Barolsky (1978), 79.

51. In his *Imagines.* See Jones and Penny, 97 and 100.

52. See Introduction, 5.

53. Hall (1992), 150. See also Battisti; Muller. For a discussion of varieties of imitation in Renaissance literature and theory, see Pigman.

54. Shearman (1992), "Imitation and the Slow Fuse," 227–61, and especially 239.

55. After Chigi's death the Farnese bought the villa because of its convenient location across the Tiber from the Palazzo Farnese. It has been called the "Little Farnese" ever since.

56. B&B, 4:317; Eng. ed., 2:294–5.

57. B&B, 4:320; Eng. ed., 4:296.

58. Coffin (1979), 103.

59. Hayum, 165–77. Two of the walls were executed later and have been damaged. Sodoma painted the fireplace wall with the *Family of Darius.*

60. Oberhuber (1986), 204–5, considers that Raphael first began on the Psyche Loggia in c. 1514/15 but was frequently unavailable, and that its execution therefore stretched over a period extending to its known completion date, January 1519.

61. Dempsey (1968), 367, who reminded us to see the humor in these frescoes, cites Philippus as the second source of the images, based on Bellori.

62. Coffin (1979), 108.

63. Coffin (1979), 82.

64. Felice Freddi, who died in 1529. The tomb is located outside the Chapel of the Madonna di Loreto, which is near the left transept.

65. Brummer; Haskell and Penny, 10.

66. Ackerman (1954).

67. See Stinger, especially on Bramante's plan to reorient church to obelisk, 185–6.

68. Frommel (1977), 38–9.

69. Shearman (1986), 32, based on the diaries of the Masters of Ceremonies. The first discussion with Michelangelo of the project to decorate the vault apparently took place in 1506.

70. Hibbard (1979), 61.

71. London, British Museum, inv. 1859.6.25.567r.

72. See Kathleen Weil-Garris Brandt's reconstruction of the evolution of Michelangelo's designs (1992). On the ceiling: S. J. Freedberg (1961), 92–112; De Tolnay, The Sistine Ceiling, vol. 2 (1945) of Michelangelo.

73. Schröter, 229–30.

74. O'Malley (1979), 40.

75. Schröter; Stinger, 296–9. For a bibliography on the Golden Age, see Mandel, 32, n. 14.

76. See Rowland, and Verdon, in Hall (1997).

77. On the architecture of the School of Athens, and Bramante's alleged role in its design, see Lieberman, in Hall (1997).

78. On the identification of the figures, see Hall (1997), "Introduction," in the same volume, and the diagram, fig. 1.

79. For an analysis of Raphael's use of color and chiaroscuro in the fresco, see Bell, in Hall (1997).

80. Oberhuber and Vitali.

81. Raphael used the shape of the field with equal skill in the Disputa, where the framing arc is repeated in the gilded circles and partial circles that set off the three persons of the Trinity and the Host on the altar, which mark the central vertical axis.

82. Golzio, 38–40, 113.

83. See Howard Burns and Arnold Nesselrath, "Raffaello e l'antico," in Christoph Luitpold Frommel, Stefano Ray, and Manfredo Tafuri, eds., Raffaello architetto (Milan: Electa, 1984), 379–421.

84. For a translation of the significant passages of Raphael's letter, see Jones and Penny, 199–202, and especially 201.

85. See Nesselrath (1986).

86. For discussion of the mapping project, see Jacks (1993), 185–91; Stinger, 67.

87. Cox-Rearick (1984), 98.

88. The ceremonies of 1513 are described by Mitchell (1973), 61–74; Jacks (1993), 175–6.

89. For example, see Vasari, Life of Baldassare Peruzzi, B&B, 4:324; Eng. ed., 2:295.

90. See Introduction; also Hall (1992), "Modes of Coloring in the Cinquecento," 92–136.

91. Obviously the need to translate to tapestry would also have played a role in this tendency toward clarity and simplification, Shearman (1992), 217.

92. S. J. Freedberg (1961), 283–4.

93. Summers (1977a), 352, referred to this painting in terms of contrapposto.

94. See Hall (1992), 131–6, for discussion of the contrapposto of modes of coloring in Raphael's Transfiguration.

95. Exploration of this issue in Quattrocento art has only just begun, but William Hood's examination of Fra Angelico's frescoes in the convent of San Marco presents an early and interesting case of style adapted to function and audience. See Fra Angelico at San Marco (New Haven: Yale University Press, 1993).

96. See Vasari on Technique, chap. 6 (13), 72, "Modelled and Stamped Plaster Work," 170–2.

97. See Davidson (1985).

98. The ceiling was raised in the later Cinquecento. The portion above the cornice was installed in the 1580s by Gregory XIII; his arms are marked together with those of his successor, Sixtus V, who carried forward the decoration. Dumont discusses the decorative scheme of the Costantino and its importance in mural decoration in the first half of the Cinquecento. Quednau (1979) studied the iconography; see also Quednau's survey of his principal points (1986).

99. I am indebted to Philipp Fehl's sympathetic reading of the Costantino (1993) for stimulating the interpretation given here.

100. On the history of the attribution of the disputed drawings for the Sala di Costantino, see the summarizing note in Fehl, n. 11. Several scholars consider now that some of these drawings were done by pupils while Raphael was alive and under his guidance. Konrad Oberhuber has in recent years reconsidered his earlier attributions to the pupils and believes now that Raphael himself was responsible for at least some of the surviving preparatory studies. He published the squared modello for the Battle of the Milvian Bridge (Paris, Louvre, no. 3872) as "Raphael (?)" (1992), no. 130, 307. Shearman (1984) credited Raphael with the invention of the Costantino, 262.

101. Sebastiano had invented a technique for painting in oil on the wall, and it was probably in response to the challenge he offered that Raphael and his workshop undertook this experiment. See Hall (1992), 104 and 137–42, on Sebastiano's invention and his rivalry with Raphael.

102. As Claire Farago (1994), 309, has pointed out, Leonardo recommended to painters that the viewing distance should be three, ten, or even twenty times the width of the picture; for his own Battle of Anghiari, however, it could be only one and a half times the width. The situation in the Sala di Costantino was much worse: to view the Battle of the Milvian Bridge, the viewer can get no farther away than about half the width of the fresco.

103. The mural was never executed, but an idea of its design has been reconstructed from drawings. See Cecil Gould, "Leonardo's Great Battlepiece: A Conjectural Reconstruction," Art Bulletin 36 (1954), 117–29, fig. 18. On the discoveries made during the project to strip Vasari's fresco off to reveal the remnants of Leonardo, see H. Travers Newton, "Leonardo da Vinci as mural painter: Some

observations on his materials and working methods," *Arte Lombarda* n.s. 66 (1983/3), 71–88.

104. Vasari, who was impressed with the quantity and quality of archeological knowledge displayed here, noted that the painter had learned much from the columns of Trajan and Marcus Aurelius. B&B, 5:60; Eng. ed., 3:100.

105. Suggested by Fehl (1993).

106. Gombrich (1966) traced a number of the motifs in the *Battle* to their sources in antique relief, 124–5.

107. On Quattrocento workshop practice, see Anabel Thomas, *The Painter's Practice in Renaissance Tuscany,* Cambridge: Cambridge University Press, 1995, especially "The workshop and stylistic development," 213–55.

108. William Wallace (1994) has discovered that Michelangelo was not so solitary as we have thought: "Although it is a cherished myth, and one Michelangelo himself encouraged, that he worked alone, it is not so. He had thirteen assistants on the Sistine ceiling," 4. Even so, Michelangelo did not build a school and a following in the same way as Raphael. On Raphael's entourage, see Vasari, B&B, 4:212; Eng. ed., 2:248, as mentioned in Jones and Penny, 197.

109. Shearman (1984), 259, pointed out that Raphael was the first artist to make use of assistants in the graphic preparatory stage and the first to run a very large workshop.

110. Often it is found in fresco that a separate patch of plaster has been applied for the principal heads, which might indicate such a practice.

111. For a survey of the use of cartoons in the Quattrocento and a discussion of the innovative character of the *Battle* cartoons, see Borsook (1985).

112. This of course brings up the question of how cartoons like that of the *School of Athens* came to survive. The issue of the substitute cartoon has been explored in recent literature; particularly useful is Rosenauer, 149–53 and especially 152; Bambach Cappel, and her forthcoming book.

113. See Shearman (1984), 261.

114. Vasari reported that Michelangelo had supplied drawings for the *Raising of Lazarus:* B&B, 5:91; Eng. ed., 3:114. On the Borgherini Chapel and the *Flagellation,* see Hirst (1981), 49–65.

115. See Chapter 6.

116. On Raphael's business arrangements, see Landau and Parshall, 121.

117. On Marcantonio, see Shoemaker and Broun, and Faietti and Oberhuber (1988a), especially 158–61.

118. Marcantonio evidently drew the version of the statue then in Mantua, now in London, British Museum, probably on his journey from Venice to Rome in 1509, the date the engraving bears. A headless version of the statue was in the Medici Collection at the Villa Madama from 1505, where it was drawn by Martin van Heemskerck. See Holo, and Bober and Rubinstein, 62–3, no. 18.

119. Landau and Parshall reproduce Ripanda's drawing in the Louvre and Marcantonio's engraving, 119, figs. 110–11.

120. *Mohammed and the Monk Sergius,* 1508, Bartsch VII, 126.

121. Landau and Parshall, 121, confirmed Oberhuber's statement that the reproductive print did not exist in Raphael's lifetime.

122. See *Raphael Invenit.*

123. Landau and Parshall reproduce three preparatory drawings by Raphael, 125, figs. 118–20.

124. See Faietti and Oberhuber (1988a).

125. On Turini, appointed Leo's datary in 1518, the Villa Lante, and the frescoes by Polidoro da Caravaggio, see Stenius, O'Gorman, Marabottini, 67, and Jacks (1993), 179.

126. This is the judgment of Jones and Penny, 226. There is no doubt that other architects worked on it, and some scholars credit Giulio Romano with much of the design; see Frommel (1991), 132.

127. Letter published in Golzio, 32, and cited by Nesselrath (1986), 361.

128. Document published by Adolfo Venturi. "Pitture nella Villa Madama di Gio. da Udine e Giulio Romano," *Archivio storico dell'arte* 2 (1889): 157–8.

129. B&B, 5:116; Eng. ed., 3:123.

130. Cox-Rearick (1984), 188–98, has explicated the imagery.

131. Parma Armani, 253, reported that the restorers found that the ultramarine had been replaced with a Prussian blue at some unknown date; from a typescript report on the 1969–73 restoration.

CHAPTER TWO

1. This altarpiece is the *Madonna del Baldacchino* for a chapel in Santo Spirito for the Dei family, now in the Pitti. Rosso was later commissioned to make a substitute. See below, n. 27.

2. Marabottini, 1:105–6.

3. The bed has been reconstructed by Braham. For color illustrations, see Berti (1993), 196–203. It was commissioned in 1515 for the marriage. Vasari tells us that the furniture was designed by Baccio d'Agnolo. The panels have been disbursed to several collections: Sarto's in the Pitti, a Granacci at the Uffizi, Pontormo's four, with others of Bacchiacca, now at the National Gallery, London, and four of Granacci's at the Borghese Gallery, Rome. The *cassoni* panels are 36 cm high, the tall panels, 96–99 cm. See also *L'Officina della maniera,* 248–52, nos. 82–4.

4. As observed by S. J. Freedberg (1961), 527.

5. The association of Sarto's *Baptist* with this commission was made by Shearman (1965), 2:259, and reconfirmed by Costamagna, 148–50.

6. See *Andrea del Sarto,* 126–8.

7. As deduced by McKillop, 13.

8. One critic sees in Sarto's *Baptist* a recollection of the antique statue of the *Doryphorus* by Polyclitus: Antonio Natali, quoted by Alessandro Cecchi in *Andrea del Sarto,* 128.

9. These and other borrowings are noted by Shearman (1965), and McKillop, and widely in the literature.

10. Vasari in his Life of Pontormo, B&B, 5:320; Eng. ed., 3:244–5.

11. Friedlaender (1957), 4.

12. *Christ before Herod,* in the *Little Passion,* 1509, Bartsch 32. A

beautiful compositional drawing in the Art Institute of Chicago has been associated with the fresco, in which Pontormo chose from an apocryphal account of Christ's Passion the unusual moment in which Pilate, frightened by the miraculous homage to Christ shown by the crowd, turns to flee through the door. See Giles.

13. We know something of what these frescoes looked like from the sixteenth-century copies by Jacopo da Empoli, reproduced by Cox-Rearick (1964); they never contained a great deal more detail.

14. John Shearman (1992) broke new ground when he analyzed numerous instances in Renaissance art of intrusions into the liminal space, previously thought to be an invention of the Baroque.

15. Friedlaender (1957), 21.

16. Franklin (1990).

17. By Steinberg, which he describes as "a stage midway between Pietà and Entombment." See Leo Steinberg, "Pontormo's Capponi Chapel," *Art Bulletin* 56 (1974), 389, n. 18.

18. The window by Guillaume de Marcillat has now been reinstalled in the chapel; reproduced by Costamagna, 62.

19. "Luminous" is the word chosen by Rubin (1991) to describe it, 185; see also Hall (1992), 174–9.

20. Summers (1977b), 76, called it "an image of impossible equivalence." He analyzed this image in the context of changing forms of symmetry as the conveyor of spiritual content that he traced from the Dugento to this picture.

21. B&B, 5:309; Eng. ed., 3:237.

22. As noted by Elizabeth Piliod, who is preparing an English edition of Pontormo's diary: "Representation, Misrepresentation, and Non-Representation: Vasari and His Competitors." In Philip Jacks, ed., *Vasari's Florence: Artists and Literati at the Medicean Court. The Symposium. 16–19 April 1994* (New York: Cambridge University Press, 1998), 30–54.

23. B&B, 5:334; Eng. ed., 3:255.

24. See Barolsky (1990, 1991, 1992) on Vasari as a teller of tales.

25. Shearman (1967), 50–1.

26. Its history has been reconstructed by Franklin (1994), chap. 2.

27. Both Raphael's and Rosso's altarpieces were enlarged in the seventeenth century.

28. Noted by Barolsky (1978), 107.

29. Creighton Gilbert (1992) has remarked that Rosso's Florentine career was "unsuccessful to a spectacular degree," 221.

30. See Elam (1993), especially 64–5.

31. The unfinished *Holy Family* (Los Angeles County Museum) reveals Rosso's underpainting before he applied the final layers and can be compared to the *Moses and the Daughters of Jethro*.

32. See Thiem (1961). For a color illustration: Costamagna, 117.

33. Actually Giovio had to invent the episode to create a parallel to the Medici, according to Charles Hope (1988), 7.

34. See Cox-Rearick (1984) for the most complete and coherent account, part 2, chap. 5.

35. Parma Armani, 53, 338, and 340.

36. Noted by Davidson (1963), no. 4, 22.

37. Vasari described scenes from the life of Samson on the Ginori facade; see the Life of Ridolfo, David, and Benedetto Ghirlandaio, B&B, 5:442; Eng. ed., 4:6. Cited by Franklin (1994), 94, n. 28.

38. Franklin (1994) has also seen a connection between Perino's *Crossing* and Rosso's *Moses,* 110–11.

39. The engraving can be compared with Bandinelli's pen and wash *modello* in the Louvre (inv. 99), reproduced in Chastel (1983), fig. 53. The numerous differences suggest that this was not Bandinelli's final version.

40. "Una stufa d'ignudi," Life of Antonio da Sangallo the Younger, B&B, 5:36; Eng. ed., 3:90.

41. His birth date is disputed; it is placed somewhere between 1492 and 1499.

42. The *modello* at Chatsworth (inv. 175, pen and wash, heightened with white over black chalk, squared on the left half, 232 × 415 mm), after long being regarded as Raphael's, was attributed to Penni for several decades, but has now been returned to Raphael by several leading authorities. See Fehl (1993), 70, n. 11, recording an oral communication of Oberhuber's, and *Giulio Romano,* photo on 84.

43. Joannides (1985), 18, attributes to Giulio, for example, the still-life elements in Raphael's *Portrait of Leo X* (Florence, Pitti).

44. Joannides asked the question (1985), 40.

45. Noted by Philipp Fehl (1993), 61, with a color detail illustration.

46. Lynne Lawner has brought together a large collection of paintings of courtesans, and although she may have extended the boundaries of the genre too far, it is a provocative study; see *Lives of the Courtesans: Portraits of the Renaissance* (New York: Rizzoli, 1987).

47. The surviving fragments and later copies are reproduced in Lynne Lawner, *I Modi: The Sixteen Pleasures. An Erotic Album of the Italian Renaissance* (London: Peter Owen, 1988). See also Talvacchia (1994).

48. John Shearman (1991), 295, in suggesting this as the reason for Giulio's decision to leave Rome, characterized it as "a career decision otherwise rather hard to understand."

49. Though Vasari mentions it, he describes it only as *Two Lovers;* B&B, 5:74; Eng. ed., 3:107.

50. The interpretation was proposed by Ferino Pagden (1991), 233.

51. The traditional and generally accepted dates of Polidoro (1499–1543) are based on Vasari. Ravelli (1978), 91–2, argues for a birth date around 1490, on the basis of an eighteenth-century life of Polidoro and a date of death c. 1536, after which there is no further documentation.

52. *Polidoro,* 22, citing Maria Grazia Ciardi Dupré and Giulietta Chelazzi Dini, "Polidoro Caldara da Caravaggio," in *I pittori bergamaschi dal XIII al XIX secolo. Il Cinquecento* (Bergamo: Poligrafiche Bolis, 1976), 2:257–75. Although Vasari says that Polidoro imitated Peruzzi's facades (B&B, 4:457; Eng. ed., 2:349), it is now recognized that their styles were different, as perhaps were their preferred materials. Marabottini, 1, 107, pointed out that if the pace was, as he calculated, about ten facades a year, only fresco would have allowed such rapid work.

53. Ravelli (1978) has assembled copies by site that enable us to reconstruct, in varying extent, the appearance of the originals and to document how widely these facades were copied; see his pt. 2.

54. Turin, Biblioteca Reale, inv. 17253, pen and wash, 390 × 260 mm.

55. Vasari remarked that Polidoro and Maturino had done some houses in Rome in colors as an experiment, but they did not turn out so well as those they did with grisaille, bronze, or earths; see the Life of Polidoro da Caravaggio and Maturino Fiorentino, B&B, 4:462–3; Eng. ed., 2:352.

56. See McTavish (1985a).

57. B&B, 4:458–9; Eng. ed., 2:350.

58. Among the subjects academicians are to draw, according to the 1596 rules, are the facades of Polidoro. Pevsner (1973), 61.

59. Letter from Summonte, cited in Marabottini, 1, 30 and 251, n. 23.

60. B&B, 4:457; Eng. ed., 2:350.

61. For example, *Storming the Town,* on the *Battle* wall. These reliefs have been attributed to Polidoro (e.g., by Marabottini, 1, 46–56), but it is more likely that a number of painters worked on them, perhaps including Polidoro, although he is not mentioned in the sixteenth-century sources as having worked there; see *Raffaello e i suoi,* 301.

62. Observed by Davidson (1963), no. 4, 20.

63. Perino and Polidoro appear to have worked closely together as early as the Vatican Loggie, and Polidoro was already developing the conventions of this style; see Dacos (1977); Parma Armani, 21, 23. The two painters worked on the Palazzo Baldassini, where Polidoro also painted the facade, probably in 1522, before Perino's departure for Florence, Parma Armani, 38–40, 254–7.

64. Smyth (1992) speaks of "the gathering of the Maniera" as early as the teens, and then as gaining focus in the twenties and thirties, 58–86. He rightly points to the importance of Baccio Bandinelli, fig. 52.

65. On Florentine palace facades, see Thiem (1964).

66. A prominent Roman example is the fresco cycle of the lives of Moses and Christ on the side walls of the Sistine Chapel by Perugino, Botticelli, Ghirlandaio, and others.

67. Turner (1966) reproduces a detail from one of the almost-destroyed lunettes, fig. 115; for colorplate, see Dacos (1977), pl. 19. See also Turner's article on Polidoro's murals, "Two Landscapes in Renaissance Rome," *Art Bulletin* 43 (1961), 275–87; and Gnann (1991).

68. Castiglione in the *Courtier* (Bk. I [8], Eng. tr., 21) cites Fra Mariano in a discussion of the pleasure of folly, "And if the vein of folly which we discover chances to be so abundant that it seems beyond repair, we will encourage it and, according to the doctrine of fra Mariano, we shall have saved a soul, which will be no small gain." On Fra Mariano, see Cynthia Stolhans, "Fra Mariano, Peruzzi and Polidoro da Caravaggio: A New Look at Religious Landscapes in Renaissance Rome," *Sixteenth Century Journal* 23 (1992), 506–25.

69. Musée Condé, Chantilly, inv. 95, pen and wash, 340 × 255 mm.

70. The altarpiece, if it was ever in fact executed, has been lost.

71. The drawing is discussed and the illusionism pointed out by Ravelli (1987), 28–30; and (1990), especially 302–3, but the connection is not made there to the subject and its meaning.

72. There is not consensus on whether Perino began the chapel before his departure for Florence, or only after his return.

73. This chapel was begun before the Sack but interrupted and not completed until Perino returned to Rome in the late 1530s.

74. The panel was damaged in the Tiber flood of 1530 and only portions of the upper zone have survived; see Shearman (1977).

75. Carroll (1987), 23.

76. From the Florentine perspective, a different picture of Clement's patronage emerges during these years, in which the pope was eager to keep Michelangelo at work on family projects at San Lorenzo. See Wallace (1994), 87 and passim.

77. Chastel (1983) invented the term "The Clementine Style," in an attempt to avoid the appellation Mannerism; see chap. 5, 149–78.

78. Riccomini, 6, found echoes of the Stanza della Segnatura in Correggio's Camera di San Paolo, indicating that he had visited Rome before 1518.

79. Shearman (1992), 247.

80. Popham suggested (1:93) that the *modello* for the *Martyrdom of Saints Peter and Paul* (British Museum, Popham, no. 190, pl. 135), later turned over to be engraved, was originally designed for the side walls of the Sala di Pontifici, which Pope Clement told Parmigianino he wanted him to paint, according to Vasari (B&B, 4:535; Eng. ed., 3:8). The ceiling had by then been completed by Giovanni da Udine and Perino del Vaga. The influence of Perino on Parmigianino's design, not previously noted, so far as I can tell, makes this a particularly interesting suggestion.

81. B&B, 4:536; Eng. ed., 3:9.

82. Windsor, Royal Library; Popham, no. 666, pl. 205.

83. S. J. Freedberg noted that in Parmigianino's figures, "The chief structural distortions from the High Renaissance type are in the narrowing of the torso and the diminution of the scale of the head" (1950), 11.

84. Vaccaro (1993).

85. On this altarpiece as an exemplar of *Imitation as Emulation,* see Shearman (1992), 239 and 242.

86. See Popham, 1:90.

87. No satisfactory explanation for the elongated canon other than the aesthetic one has yet been offered. Pontormo independently in Florence had also developed it. Some have credited its invention to Michelangelo, incorrectly in my view.

88. S. J. Freedberg (1950), 12.

89. Barolsky (1989), 14.

90. See Emison's examination of *grazia.*

91. *Grazia* for Alberti described a pleasing arrangement of colors, Emison, 432. Cf. Introduction, n. 22.

92. On grace in ancient writers and in the Renaissance, see Monk.

93. Emison, 432.

94. Monk drew the connection between Firenzuola and the French Academy, as did Cropper (1976).

95. Anthony Blunt, 90–1, analyzed Vasari's use of judgment in the preface for the *terza età*.

96. The recently attributed *Cleopatra* is undocumented, but as Franklin (1994), 148–55, and Fredericksen, 323–6, have argued, it fits most comfortably into this moment in the painter's career. I will develop Franklin's point that there is a strong similarity between the two paintings.

97. Nearly all scholars agree that this is the painting mentioned by Vasari (B&B, 4:481; Eng. ed., 2:358) as executed for the bishop of Sansepolcro, Leonardo Tornabuoni. S. J. Freedberg (1993), 201, said of it, "It may be the most immediate evidence we possess of religiously as well as morally cynical attitudes within élite circles of contemporary Rome." Franklin (1994), who has assembled and discussed the documentation, 138–42, disagrees.

98. Franklin's (1994) denial of eucharistic implications is unconvincing, 146, but Regina Stefaniak ("Replicating Mysteries of the Passion: Rosso's *Dead Christ with Angels,*" *Art Quarterly* 45 [1992]: 677–738) assumes far too great a familiarity with technical theological debate on the part of patron or painter.

99. Chastel (1983) makes reference to such a concept in relation to this picture, 166. Cropper (1976) alludes cautiously to the connection between aesthetic, religious, and sexual emotion in her discussion of Parmigianino's *Madonnas:* "they are the embodiments of that grace, charm, and desire whose virtue could excite a man's soul to love God," 393. David Freedberg (1989) treats the subject of arousal by image in chap. 12.

100. On Parmigianino's *Madonnas,* see Cropper (1976).

101. Franklin (1994) discussed the comparison and illustrated *Sleeping Ariadne* in his pl. 116.

102. Life of Andrea del Sarto, B&B, 4:394; Eng. ed., 2:323.

103. A waxed linen curtain is mentioned in a document discussed by Franklin (1994), 140.

104. Hirst (1981), 107.

105. The painting is lost, but it is recorded by Vasari, B&B, 5:93; Eng. ed., 3:115.

106. Raphael's painting was an ex-voto, offered by Julius II and hung in the church of Santa Maria del Popolo. It was not an altarpiece presumably, but its setting would account for its relatively large size in the genre of devotional image: 120 × 90 cm, as compared with an average 70 × 50 cm. Sebastiano's is almost the same size as Raphael's: 120 × 92.5 cm. Raphael's original was until recently thought lost, but scholarly opinion now generally accepts the painting at Chantilly, Musée Condé, as the authentic Raphael; Jones and Penny, 88, pl. 98.

107. Coxie, a fellow countryman of Enckevoirt and a painter resident in Rome, executed frescoes of Saint Barbara around 1531.

108. On the technique of that chapel, see Hall (1992), 137–42.

109. Hirst (1981), 126; *modello,* fig. 133. The subject was changed to the Nativity of the Virgin, see Chapter 4.

110. The *Pietà,* now in the Museo Civico, was painted for another church in Viterbo, San Francesco.

111. Recorded by Shearman (1967), 44, 112.

112. Chatsworth; Popham, vol. 2, no. 692, pl. 141. For a reconstruction of the Cesi Chapel in S. Maria della Pace for which Parmigianino designed his *Marriage of the Virgin,* see Gnann (1996).

113. See Landau and Parshall, 154, who argue against the generally accepted priority of Caraglio's engraved version in favor of Ugo's. Both prints are reproduced, figs. 163–4.

114. The contract for the Cesi Chapel in Santa Maria della Pace was signed 26 April 1524 and the last payment was 3 October; Carroll (1987), 21–2; Cellini, 95.

115. Carroll (1987), 74. It has also been proposed by Gilbert (1992) that Michelangelo's extraordinary and untypical drawing of a head called *Furia,* in the Uffizi, was Rosso's source and that he may have asked the master for a drawing before his departure for Rome, which he then used as the basis of his design for Caraglio.

116. Landau and Parshall, 159.

117. Carroll (1987), 38–9; cat. 19, 20, 27, 37.

118. Landau and Parshall, 298.

119. Illustrated by Shearman (1967), fig. 29. The whole series is illustrated in *Tra mito e allegoria,* cat. 58–77.

120. Letter of Sessa, cited in Julia Cartwright (Mrs. Ady), *Baldassare Castiglione, the Perfect Courtier: His Life and Letters, 1478–1529* (London: John Murray, 1908), 2:205.

121. Saxl discussed the Antichrist and the Cranach pamphlet, 264–5.

122. Chastel (1983), 72, fig. 40b.

123. Chastel (1983), 78, noted the antithesis, "The antagonism ran so deep that it declared itself in two utterly opposing modes of graphic discourse: on the one side, the tradition of monumental Mediterranean painting at the height of its powers; and on the other, the direct, popular, and quickly produced art of Northern printmaking, which for the first time in history became a major force in cultural and religious life."

124. Chastel (1983), 61–5.

CHAPTER THREE

1. Kurt Forster's "Metaphors of Rule" (1971) brilliantly analyzed the use of antique iconography by Duke Cosimo in Florence. This analysis can be extended to embrace the style *all'antica,* which was also borrowed and expanded to other courts.

2. On the emperor and his visits in the decades under study here, see Eisler, and Strong, pt 2, chap. 2, "Images of Empire."

3. Giulio had left his possessions in Rome, as if he intended to return, but in 1526 he was granted citizenship in Mantua, given a house, and created a nobleman, adviser at the court, and supervisor of all Gonzaga constructions, strong indications the marquis was satisfied with his performance, Hartt, 1, 73.

4. See Hall (1997), 22, 53, 114.

5. *Jupiter and Io* and *Jupiter and Ganymede* in Vienna; *Leda and the Swan* in Berlin; *Danaè and the Shower of Gold* in Rome, Borghese Gallery; for Federico's patronage, see Hope (1981).

6. Hartt, 1, 73 and 92.

7. Nicholas B. Penny, "Dead Dogs and Englishmen," *The Connoisseur* 192 (1976), 298, cites the letter quoted by Alessandro Luzio, "*Isabella d'Este e il Sacco di Roma,*" *Archivio Storico Lombardo,* ser. 4, vol. 10 (Milan: Cogliati, 1908), 37n. There is a drawing of a wonderfully pretentious dog monument preserved at the Cooper Hewitt Museum of Decorative Arts and Design, reproduced by Penny, fig. 2. It is also reproduced in *Giulio Romano* (1989), 363.

8. Life of Giulio Romano, B&B, 5:73; Eng. ed., 3:108.

9. The frescoing had begun and then the scaffolding removed for the emperor's second visit in November 1532. The execution, which exaggerates Giulio's already hyperbolic rendering in the drawings, was attributed to Rinaldo Mantovano by Vasari, B&B, 5:73; Eng. ed., 3:106.

10. John Onians, *Bearers of Meaning.* Princeton, Princeton University Press, 1988, 117–18; Barolsky (1978), 138.

11. Bk. II (45), Eng. tr., 145. Quoted by Verheyen, 48, who took this motto as the theme of his interpretation of the Palazzo Te.

12. Oberhuber (1989), 343, and Verheyen, 117, believe that the Sala di Psiche decoration should be dated 1527–8. We know that it was ready for the emperor's visit in April 1530.

13. Hartt's interpretation of these frescoes as also containing this allegorical level of meaning, 1, 136–8, was successfully refuted by Verheyen, 25–9.

14. Reported in the conservation studies, *l'Istituto Central del Restauro per Palazzo Te. Bollettino d'Arte Volume Speciale,* 2 vols. (Rome: Ministero per i beni culturali e ambientali, 1994), 75–84.

15. For discussion and color reproduction, see Hall (1992), 137–42.

16. As noted by Hartt, 1, 149.

17. Oberhuber (1989), 365, disputes Hartt's contention that the friezes are attributable to Primaticcio and that this iconography can be associated with Charles V because the drawing in the Uffizi with Charles's name (Hartt, 2, fig. 320) cannot certainly be connected to this room.

18. Talvacchia (1988), 235.

19. Vienna, Albertina, S. R. 400; Hartt, 2, fig. 388. Talvacchia (1988) discusses the sources and the program devised by a humanist attached to the Gonzaga court.

20. Pen and brown ink and watercolor heightened with white on gray-blue paper, 25.3 × 38.1 cm. London, British Museum, 1895-9-15-643. Talvacchia, disputing Hartt's identification, has found no specific text for this scene (in *Giulio Romano,* 1989), 408.

21. Ferino Pagden (1989), 92, related Giulio's use of chiaroscuro to the influence of Polidoro, with whom he had worked closely before coming to Mantua.

22. Jestaz and Bacou's closely reasoned argument *(Jules Romain)* has been generally accepted; see Grazzini in *Giulio Romano* (1989), 468; Cox-Rearick (1996), 379–83.

23. Oberhuber (1989), 163. All ten of Giulio's drawings for the *Triumphs,* nine in the Louvre and one at Chantilly, are reproduced in Hartt, 2, figs. 474–83.

24. Whether the commission originated with François or was diverted to him at some point between the inception of the drawings and the commencement of the weaving is still unknown.

25. See Chapter 6.

26. Michelangelo's transfer of the bronze statue from the Lateran to the Capitoline in 1538 is well documented; however, such a reinstallation had been under discussion for years, so Giulio must have been anticipating the fact with his plausible invention.

27. On Mantegna's series, see Andrew Martindale, *The Triumphs of Caesar by Andrea Mantegna in the Collection of Her Majesty the Queen at Hampton Court* (London: Harvey Miller, 1979).

28. Ferino Pagden (1989), 92, suggested that this drawing originated in Giulio's Roman period and was reused in the tapestry series.

29. The altarpiece is now in the Louvre and a replica is to be found in the chapel. Documentary evidence suggests a date for the commencement of the paintings no earlier than 1536, a few years later than Hartt had proposed; Giuseppe Pecorari, "Polissema Castiglione Boschetti e la cappella di San Longino nella basilica di Sant'Andrea in Mantova," in *Giulio Romano,* 442.

30. It has been generally held that the frescoes were executed by Rinaldo Mantovani, an attribution based on a document that has now been separated from this chapel. Oberhuber (1989), 140, attributed the *Crucifixion* to Giulio himself.

31. Oberhuber (1989), 145.

32. Ferino Pagden (1989), 88.

33. Benedetto Pagni da Pescia; Oberhuber (1989), 145.

34. Verheyen, 49.

35. Life of Giulio Romano, B&B, 5:78–9; Eng. ed., 3:110. The date of Vasari's visit to Mantua is given by Rubin (1995), 364.

36. Pinturicchio's contract for the Piccolomini Library in Siena, dated 1501, specified very precisely that he should make all the cartoons for the narratives with his own hand and execute all the heads on the wall; Vasari-Milanesi, 3:519–22. It is clear from documents and correspondence between artists and patrons later in the century that they knew and accepted the fact that the artist would not be much or at all involved in the actual painting.

37. Life of Giulio Romano, B&B, 5:60; Eng. ed., 3:100.

38. On the Verona and Parma commissions and Giulio's difficulties with the patrons of the Steccata, see Oberhuber (1989), 135–41.

39. Shearman (1992), 188–90, has pointed out that the illusionism of Giulio's Sala dei Giganti is a witty inversion of Correggio's illusionism in the dome of the Parma Cathedral.

40. See *Tra mito e allegoria,* 257–8.

41. The story is told in Lucian, *The Dream, or The Cock,* Loeb Classical Library, ed. E. Page et al. (Cambridge, Mass.: Harvard University Press, 1915), 2:177–9. The identification of this figure was made with respect to another, related

version of this print, dated 1539, by G. B. Ghisi: Carla Lord, "Tintoretto and the *Roman de la Rose*," *Journal of the Warburg and Courtauld Institutes* 33 (1970), 315–17.

42. Hartt, 1, 247–9, summarized the documents. Oberhuber (1989), 135, quoted Giulio's letter. Parmigianino's role in this commission will be discussed at n. 68, this chapter.

43. Parma Armani, 81, and n. 24 on 148. Baccio Bandinelli was commissioned in 1529 to make the portrait statue, but he never completed it and it remained in Carrara, where he had worked on it; Life of Bandinelli, B&B, 5:251; Eng. ed., 3:199.

44. Gorse, 23.

45. Davidson (1990) has reconstructed the cycle and its story from inventories and scattered evidence.

46. Reproduced in Parma Armani, for example, figs. 152–4.

47. Perino's drawing of the Rospigliosi sarcophagus is now in the Uffizi, reproduced by Parma Armani, fig. 95. The sarcophagus itself is in the Casino Rospigliosi (Casino of Aurora). At the end of the Quattrocento it was in "a church of San Lorenzo" (generally assumed to have been San Lorenzo fuori le Mura); it was walled into the Casino with other ancient reliefs in 1611–13; see Bober and Rubinstein, cat. 77, 112.

48. Davidson (1988) has reconstructed the lost series, traced its history and that of the cartoons, which have also disappeared, and interpreted the iconography of the room. I depend upon her in what follows.

49. Pietro Aretino, *Il primo libro delle lettere*, ed. Fausto Nicolini (Bari: Laterza, 1913), CXXX, 153–4; quoted by Parma Armani, 123.

50. The *Theogony*, 994.

51. Davidson (1988), 447.

52. As pointed out by William Eisler, 197, and repeated by Davidson (1988), 445.

53. Davidson (1988), 427.

54. B&B, 5:174; Eng. ed., 3:148. *Domenico Beccafumi e il suo tempo*, 158.

55. See *Domenico Beccafumi e il suo tempo*, 158, figs. 3–4. This exhibition catalogue contains many reproductions in color of Beccafumi's works and the latest scholarship.

56. Wolk (1985), who has also pointed out that the altarpiece is conservative in style and stands apart from the ornamental "stylish style" that has been used to describe Perino's entire oeuvre. (The term is Shearman's [1967].) She associates it with Perino's concern to adapt his style to the circumstances of the commission; see especially 45–8.

57. Wolk-Simon (1992) published the newly discovered drawing in Washington and described the project.

58. Davidson (1959), 319, remarked that although his figures and decorative motifs often seem imitated from the antique, the quotations have usually passed through some intermediary source in Raphael's work or in that of his studio. Wolk (1985) traced the source of most of the motifs of the *Adoration* to the Raphael circle in Rome.

59. Armenini, Bk. I, chap. 8, Eng. ed., 136.

60. Ibid.

61. Ibid, 138.

62. Parma Armani dates Perino's return to somewhere around

the end of 1537, when he received the Massimi commissions (see Chapter 4, 141); Perino's pupil and collaborator on the Massimi Chapel, Gugliemo della Porta, returned to Rome in 1537; see 177 and n. 1.

63. The altarpiece was commissioned by Elena Baiardi for her chapel in the church of Santa Maria dei Servi in Parma. It was installed on the patron's altar in 1542. For documentation on the sale to the Medici in Florence, see Vaccaro (1996).

64. This was Popham's count in 1971, 1:25; since then more have come to light.

65. Drawing in the Louvre no. 363, Popham (1971), pl. 345; see also 1:25.

66. We owe this insightful interpretation to Shearman (1992), 233–8.

67. A possible exception is the pen, ink, and wash study in a private collection, published by Philip Pouncey. From the photograph it is difficult to ascertain whether the Child's eyes are shut, but a clue may be his arm, changed in the painting, raised over his head in the classical position indicating sleep. "Popham's Parmigianino Corpus," *Master Drawings* 14 (1976), 172–6, pl. 43.

68. For a discussion of these female figures in the context of sixteenth-century dance, see Fermor, 138.

69. Suggested by Popham (1971), 1, 24.

70. The first contract was dated 10 May 1531. He collected about half of his total fees before it expired. The second contract was signed on 27 September 1535 and gave the painter two years to complete the work. Within a year after the expiration of the second contract he had still not executed the first half of the project. He was granted another extension of a year. Documents summarized by Freedberg (1950), 190–1.

71. Oberhuber (1989) reviewed sources on the Steccata commission from the perspective of Giulio Romano, 135 and 138.

72. Landau and Parshall, 265.

73. Reconstructed by Landau and Parshall, who reproduce all three stages, figs. 277–9.

74. Noted by Landau and Parshall, 269.

75. Gould (1994), 96.

76. Identified as Saint Benedict by Ekserdijian, 542, who also pointed out the dependence of Parmigianino's Saint Margaret here on Correggio's Mary Magdalen in a painting then in Bologna (now in the Prado, Madrid), the *Noli Me Tangere*, 545.

77. Hermann Voss, review of Lili Fröhlich Bum in *Deutsche Literaturzeitung* 43 (1922), 566; cited by Freedberg (1950), 143, n. 14.

78. Bober and Rubinstein, cat. no. 50. It was at the Villa d'Este in Tivoli in 1572, but its previous location in Rome is not known. It is recognized as the painter's source and reproduced by Gould (1994), 121–2, fig. 95.

79. B&B, 4:540–1; Eng. ed., 3:11.

80. Elizabeth Cropper's (1976) important interpretation of Parmigianino's *Madonna dal Collo Lungo* can be extended to encompass his other *Madonna* paintings of the period.

81. Life of Francesco Mazzuoli, B&B, 4:541; Eng. ed., 3:11.

82. See McTavish (1985b).

83. See Francis L. Richardson, *Andrea Schiavone,* Oxford Studies in the History of Art and Architecture (Oxford: Oxford University Press, 1980).

84. Reproduced in Gould (1994), 119, fig. 91.

85. For full details on this commission, see Franklin (1994), 161–6.

86. The identification of the subject as *Risen Christ in Glory with Virgin, Saints, and the People of Città di Castello* has been corrected on the basis of documents published by Franklin (1994), 185, 190.

87. Florence, Uffizi, black chalk, 36.8 × 27 cm.

88. Franklin (1994), 241–6, has presented a strong case for its authenticity, though in his caption to fig. 189 he labeled it "?copy." Carroll (1976), 1:184, called it a copy. The relationship to Rosso's Roman frescoes in the Cesi Chapel in Santa Maria della Pace is pointed out by all critics.

89. These influences were noted by Carroll (1976), 1:185, 187.

90. For a catalogue and full discussion of the king's collections, see Cox-Rearick (1996).

91. Leo X commissioned Raphael in 1518 to paint as diplomatic gifts to François not only the *Michael* but the *Holy Family* (called "of Francis I"), *Saint Margaret,* and the portrait of *Giovanna d'Aragona* (although the latter two were actually executed by Giulio Romano on Raphael's designs), all today in the Louvre. See Cox-Rearick (1996), 191–5, for the political background to the gifts.

92. The letters of the ambassador, Lazare de Baïf, are published in Vasari-Barocchi, *La vita di Michelangelo,* 3:1061–2. Cited by Franklin (1994), 263.

93. The king's letter and Michelangelo's reply are quoted by Cox-Rearick (1996), 295–6.

94. Life of Rosso Fiorentino, B&B, 4:486; Eng. ed., 2:361.

95. Elam (1993), and especially 63–9.

96. Adhémar, 312–13.

97. According to Cox-Rearick (1996), the marriage was widely regarded in Europe as "a travesty in which the king was humiliated by the emperor." She summarizes the extensive recent literature and supports the reading of the drawing as a satiric allegory, 267–73, and especially 271–2.

98. McAllister Johnson (1969), 14–15. Dumont discussed the experience of Rosso in stucco and the novelty of the Fontainebleau inventions, 50–7.

99. The end walls have both been remade. The painting by Rosso for an oval on the east wall of *Bacchus, Venus, Cupid and a Satyr* has been rediscovered in the Luxembourg Museum. As Béguin (1989), 838, stated, it is either a damaged original or a contemporary replica. See Cox-Rearick (1996), 46, 275, and fig. 301. In addition, the original cabinet and painting on the north wall has been lost, leaving only the *Danaè* of the mythological cycle still in situ.

100. Chastel (1972). See also the articles by Béguin, and McAllister-Johnson. Details of the iconography remain obscure and continue to be debated by scholars in the literature. For the purposes of this discussion I have focused on those parts that present the fewest difficulties. Although Chastel's article supplanted it, Dora and Erwin Panofsky's "Iconography of the Galerie François I^er," *Gazette des Beaux-Arts* ser. 6, 52 (1958), 112–90, continues to be a learned and useful source.

101. Carroll (1987), 290, has argued convincingly that the figure with sword and book does not resemble François and that it is the temple-palace that symbolizes the king here.

102. The interpretation of this scene (and the *Loss of Perpetual Youth*) require further explication. I am not persuaded by Carroll (1987), 231, that this fresco represents Minerva deprived of her armor, nor was Béguin (1989), although it was accepted by Cox-Rearick (1996), 384.

103. Jestaz (1973), 54.

104. Two modes of representation were identified by Zerner (1972a), especially 116–20.

105. See Zerner (1969), xiv, and Landau and Parshall, 308–9.

106. Carroll (1987), 228, reproduced on 229.

107. London, 35.1 × 50.8 cm; Béguin (1969), 105; Zerner in *L'Ecole de Fontainebleau,* exh. cat. (1972), cat. 319.

108. Life of Primaticcio, B&B, 6:144; Eng. ed., 4:193.

109. Haskell and Penny, 1–6, relate how Primaticcio came to make his molds. See also Cox-Rearick (1996), chap. 10.

110. Béguin (1986), 22. Oberhuber (1966), 172, recognized the influence of Fontainebleau in Perino del Vaga's frieze at the Massimo alle Colonne Palace (1537–9), his first commission after returning to Rome.

111. Fantuzzi's engravings of the Galerie, made in 1542–3, have been connected to Salviati's design for the Sala dell'Udienza in the Florentine Palazzo Vecchio, begun in 1543, Zerner (1969), Adelson (1980), 160–4. See Chapter 6.

112. Quoted by Cox-Rearick (1996), 264.

113. Identified by Dora and Erwin Panofsky, *Pandora's Box: The Changing Aspects of a Mythological Symbol* (London: Routledge and Kegan Paul, 1956), 63.

CHAPTER FOUR

1. Alfonso de Valdés, *Dialogo de las cosas ocurridas en Roma el ano de MDXXVII* (1529?), ed. Jose F. Montesinos (Madrid: Ediciones de la Lectura, 1928); Eng. trans. and ed. John E. Longhurst and Raymond MacCurdy (Albuquerque: University of New Mexico Press, 1952), as cited in Chastel (1983), 36–7.

2. Stinger, 322–3; Mitchell (1973), 137. According to George Hersey, the Sack was responsible for the deaths of 23,000 people: *High Renaisance Art in St. Peter's and the Vatican: An Interpretive Guide* (Chicago: University of Chicago Press, 1993), 27.

3. This interpretation is presented by Partner. His statement is, in my view, essentially correct, "Once the prejudice of the nineteenth century against Mannerist art is discarded, there is little reason for thinking the pontificate of Paul III culturally inferior to that of the Medici popes," 36–7.

4. His grandson and namesake, Cardinal Alessandro Farnese, oversaw the family's artistic commissions for Pope Paul. On the cardinal, see Clare Robertson's useful biography (1992).

5. Stinger, 326.

6. As characterized by Partner, 36, who rejects this view.

7. Cellini returned in April 1529, Giovanni da Udine was documented back in Rome by October 1528 (Dacos and Furlan, 137), and Peruzzi and Franco were in Rome by 1530.

8. Hirst (1981), 122–3.

9. B&B, 6:250–1; Eng. ed., 3:197. Chastel (1983), fig. 97, reproduces a drawing of Bandinelli's in the Louvre for the scheme. It was never executed, and Raffaello da Montelupo's (c. 1505–57) marble *Saint Michael,* of the same scale, was put up in 1544; this work in turn was replaced by the present bronze in 1753 and Raffaello's angel installed below in the Cortile del' Angelo.

10. Shearman has presented evidence in several public lectures that Pope Julius intended to have Michelangelo paint the *Fall of the Rebel Angels,* replacing the Quattrocento frescoes on the entrance wall and the *Last Judgment* on the altar wall.

11. The curious gesture of God, with both hands raised, seems to be addressed to something outside and to the left of the painting. Kathleen Weil-Garris Brandt, "Cosmological Patterns in Raphael's Chigi Chapel in S. Maria del Popolo," in *Raffaello a Roma. Il convegno del 1983* (Rome: Edizioni dell'Elefante, 1986), suggested the gesture is directed to the western Chigi tomb, the pyramid below. The Chigi tombs were still unfinished in Bernini's time, 145–6, 152–3.

12. Berlin and Paris; Hirst (1981), figs. 185–6. The Louvre *modello,* more than three feet high, is virtually a small cartoon, made by piecing sheets of paper together.

13. Hirst (1981), 143, identified the pose as that of the *Crouching Venus.*

14. See *Vasari on Technique,* chap. 10 (24), 89, "Oil Painting on Stone," 238–9.

15. Sebastiano never finished the painting, and it was still boarded up at the time of his death in 1547, some seventeen years after the contract was signed. Salviati was called in and completed the few remaining figures, as well as the eight scenes of the *Creation and Fall* in the drum and the four *tondi* in the pendentives, bringing it all finally to completion in 1554. Hirst (1981), 140–4. See Mortari, 123–4, for Salviati's contributions.

16. Life of Sebastiano Viniziano, B&B, 5:101–2; Eng. ed., 3:119. Confirmation is provided in a payment made for removing a wall preparation on 25 January 1536. The wall was ready for the painter to begin his work on 10 April, De Tolnay, *The Final Period,* vol. 5 (1960), of *Michelangelo,* 21.

17. For a reconstruction of the altar wall before Michelangelo's *Last Judgment,* see Wilde (1978), fig. 154.

18. See Riess.

19. Aquinas's formulation states the dogma: Christ's resurrection is the model and cause of our own resurrection. *Summa theologiae,* III qu54 ar2.

20. De Tolnay, vol. 5, pls. 127–30.

21. The self-portrait was not identified in print until 1925 by Francesco La Cava, *Il volto di Michelangelo scoperto nel Giudizio Finale. Un dramma psicologico in un ritratto simbolico* (Bologna: Zanichelli, 1925). Niccolò Beatrizet, the first to engrave the design, signed Michelangelo's name below the skin; noted by De Tolnay, 5:119, n. 62.

22. As De Tolnay repeated, 5:114, n. 44, earlier scholars had connected the calendar of feasts of the Sistine Chapel with the prominence of these two saints, but this interpretation has been discredited, see Barnes (1995), 68, n. 20. Saint Lawrence remains to be explained.

23. "There are also celestial bodies and there are terrestrial bodies. . . . What is sown is perishable, what is raised is imperishable. . . . It is sown a physical body, it is raised a spiritual body" 1 Cor. 15:40, 42, 44. Giovanni Andrea Gilio cites Augustine's belief concerning the age of the resurrected body, Barocchi, *Trattati* 2:66. The source is the *City of God,* bk. XXII, 15–17, where Augustine is interpreting Eph. 4:13. My thanks for locating this reference to Dr. Thomas Martin and Robert Kaschak, both of Villanova University.

24. Quoted from James M. Saslow, *The Poetry of Michelangelo: An Annotated Translation* (New Haven and London: Yale University Press, 1991), 70.

25. *Classic Art,* 198.

26. There is evidence, presented by Shrimplin-Evangelidis (1990), 634–41, that although Copernicus's book had not yet been published, its heliocentric theory was known in papal circles: Clement was briefed on it in 1533, 638. There is therefore no reason to exclude the hypothesis, discussed but dismissed by De Tolnay, 5:49 (mentioned by Shrimplin-Evangelidis 1990, 610, and explored in greater depth in 1994, 98), that Michelangelo used this exciting and novel idea as the basis of his cosmological image.

27. Stinger, 325–6.

28. This scene, as described in Ezek. 37:1–10, is usually represented in *Last Judgments,* but Michelangelo has given it more prominence than usual. The exception is Signorelli's fresco in Orvieto, where one entire wall is devoted to the Resurrection of the Dead.

29. The commentary of the contemporary theologian, Tommaso de Vio (Cardinal Cajetan), on Paul's letters to the Corinthians (*Epistolae Pauli et aliorum apostolorum ad graecam veritatem castigatae . . . ,* Paris, 1532) makes clear these distinctions between the spiritual bodies of the elect and the damned. All will be imperishable and freed from bodily needs, he says, but only the bodies of the elect will be glorified.

30. Bk. II, chap. 5, Eng. ed., 169. Vasari mentioned that Michelangelo had used such models to study light and foreshortening: B&B, 1:122; *Vasari On Technique,* 216.

31. Bk. I, chap. 8, Eng. ed., 130–40.

32. Armenini reported that the chapel was always occupied by pupils drawing the nudes, Bk. I, chap. 7, Eng. ed., 128; see also Bk. I, chap. 8, Eng. ed., 134. The engraving by Beatrizet, made a year or two after the fresco was finished, was copied by Niccolò della Casa and issued in 1543, 1545, and in a second edition in 1548. Four other engraved copies are known to have been made in the first two decades after its completion; Condivi-Wohl, n. 93.

33. Vasari was born in Arezzo, another city in Tuscany, so that he was not actually Florentine. He transferred himself there

34. He also painted Pope Adrian's datary, Enckevoirt, who gave him the commission to fresco his chapel in the Dutch church of Santa Maria dell'Anima. When Sebastiano procrastinated, the cardinal awarded it to Michiel Coxie. Peruzzi was favored with the commission to make Adrian's tomb for the same church.

35. Carel van Mander, *Het schilder-boek,* ed. Hanns Floerke (Munich: G. Müller, 1906), 1:268.

36. Saxl, "Lecture on Dürer and the Reformation," 271.

37. *Art before the Iconoclasm,* 1, 11.

38. His later works suggest that the painter in Rome who most influenced him was Polidoro da Caravaggio, whose appreciation of the romance of the ruins of ancient Rome probably mirrored his own, Dacos (1995), 29.

39. Posthumus was born in 1513, or the very end of 1512. His date of death is unknown. He was still alive in 1566 but was probably dead by 1588. Dacos (1995), 90, and n. 8, 120.

40. Gibson, chap. 1.

41. The painting was unknown and was published for the first time in 1985 after it had been acquired by the Prince of Liechtenstein. Rubinstein, 425.

42. Dacos (1985), 434.

43. Examples abound. An interesting one is the frontispiece of Serlio's Libro 3 ("Il terzo libro di Sebastiano Serlio bolognese, Nel qual si figurano, e discrivono le antiquità di Roma, e le altre che sono in Italia, e fuori d'Italia," Venice, 1540), on which is inscribed, "Roma quanta fuit ipsa ruina docet." The same inscription is penned at the top of one of the sheets in the Berlin sketchbook now ascribed to Posthumus: Bk. II, fol. 87v.

44. See also Chapter 2, n. 67.

45. Dated 1553–5; see Dacos (1995), 46; others can be seen at the Cancelleria, the Palazzo Ricci-Sacchetti, and Castel Sant'Angelo, Dacos (1995), 98.

46. There is the view attributed to Michelangelo that "Flemish painting consisted in old houses and green meadows, with some trees and bridges," in Francisco de Hollanda's *Four Dialogues,* as quoted in Boase, 199.

47. Dacos (1995), 46.

48. Hollanda wrote the *Dialogues* in 1548 in his native Portuguese after he had returned home, and they were not published until the nineteenth century; the first English translation appeared in 1928. Their authenticity, although much disputed in the past, has been accepted with reservations by recent scholars, importantly by David Summers (1981), 26–7.

49. Fols. 47 bis.v/48r, in his sketchbook *Desenhos das Antigualhas* (1538–41), now at the Escorial, Madrid.

50. Heemskerck's famous sketchbook was published early in the twentieth century by Huelsen and Egger.

51. Letters on the subject of the emperor's entry and preparations for it are dated 30 December 1535; 28 January 1536; 15 February 1536; François Rabelais, *Oeuvres completes,* ed. Pierre Jourda (Paris: Garnier, 1963), 2:533–59, cited in B. Mitchell (1978), 99. Roberto Lanciani, *The Golden Days of the Renaissance in Rome, from the Pontificate of Julius II to That of Paul III* (London: Constable, 1907), 111, did not think the report exaggerated.

52. Chastel (1983), 209; Jacks (1993), 205.

53. The Capitoline was in such a rustic state that this most obvious symbolic center had to be bypassed. Pope Paul was sufficiently embarrassed to undertake its renovation immediately and set Michelangelo to the task. Although, because of the shortage of funds, it was not completed until the following century, the Campidoglio as we see it today was designed and begun under these circumstances. See James S. Ackerman, *The Architecture of Michelangelo,* 2d ed. (Chicago: University of Chicago Press, 1986); Tilmann Buddensieg, "Zum Statuenprogramm im Kapitolsplan Pauls III," *Zeitschrift für Kunstgeschichte* 32 (1969), 177–228; Paolo Portoghesi, *Roma del Rinascimento,* 2 vols. (Milan: Electa, 1971); Strong, 83.

54. Chastel (1983), with bibliography, 209–15.

55. Dacos (1995), 75.

56. Including Dacos (1995), 74, and n. 20, 116. Although she points out that there is no longer any reason to assume that Heemskerck traveled to Mantua on his way home, 48, there is also no reason I can see to exclude him from participation in these preparations. Chastel (1983) reviewed the case, 284, n. 112.

57. The details concerning the altarpiece are still unclear. Daniele da Volterra received the commission in 1551, as part of "a major effort initiated in the early 1550s to complete the decoration of the Oratory, . . . and move on to the decoration of the church." Jean S. Weisz, "Daniele da Volterra and the Oratory of San Giovanni Decollato in Rome," *Burlington Magazine* 123 (1981), 355. Weisz conjectures that Daniele, a notoriously slow worker, was busy with other projects in this period and that the *fratelli* of San Giovanni Decollato became impatient while waiting for him to execute their altarpiece and therefore turned the commission over to Jacopino.

58. Edgerton, 84.

59. Weisz (1984), 27.

60. Hirst's suggestion (1966), 402, that it was a drawing for Perino's chapel in Pisa that he never executed and that he then passed on to a colleague has found wide acceptance; see S. J. Freedberg (1993), 442, n. 21; Parma Armani, 283.

61. On Jacopino's Madonna in Washington, see S. J. Freedberg (1985), especially 59–62.

62. The exception, of course, was Bandinelli's *Martyrdom of Saint Lawrence,* which was engraved but not executed (Fig. 46).

63. I am following S. J. Freedberg (1965) here and in the next paragraphs.

64. Life of Battista Franco, B&B, 5:463–4; Eng. ed., 4:19.

65. Iris Cheney (1982) confirmed the identification made by Keller, 71–2.

66. He departed in the spring, passed through Florence, Bologna, and possibly even Parma in June and July, and arrived in Venice in July. See I. Cheney (1963b), 337–8.

67. Mortari, 109, cat. 6.

68. B&B, 5:147; Eng. ed., 3:134.

69. The drawing in Budapest (no. 1838) is the discarded design. The drawing for the chapel as executed is in the Victoria and Albert Museum, London. See Parma Armani, 179; Gere (1960), especially 9–14. Vasari tells us that an altarpiece and vault decorations already existed, B&B, 5:148; Eng. ed., 3:134.

70. De Hollanda, Third Dialogue.

71. Perino had left the Chapel of the Crucifixion in San Marcello uncompleted at the time of the Sack and the commission was renewed after his return. In the first campaign the *Creation of Eve* and the *Evangelists Mark and John* were frescoed; the *Evangelists Matthew and Luke* were executed by Daniele in 1540–3 on Perino's design. Comparison between the two parts makes explicit the difference between the two artists; Parma Armani, 62–5, 258–62 for Perino, 65, 262 for Daniele.

72. According to Hirst (1967) there was a change in the chapel's iconography, as outlined in the contract of 1541. The early part of the chapel seems to have been executed according to this contract, but the lower sections, such as the altarpiece and walls, most likely date from c. 1545, when there could have been a second contract drawn up for the chapel's completion. See 500–1.

73. The stucco framework is almost entirely lost, but there are drawings after it that give us some idea of its appearance. For a photomontage of Daniele's altarpiece in its frame, see Senecal, fig. 74. Davidson (1967) has differentiated the personalities of Perino and Daniele and provided valuable insight into the artistic situation in the Rome of the forties in a series of articles.

74. Barolsky (1979), 82–3. He leaves open the possibility that the completion of the chapel may have dragged on after 1553.

75. Perhaps the earliest example is his Europa, balanced clumsily on the back of the bull: the *Rape of Europa,* Boston, Isabella Stewart Gardner Museum, 1559–62.

76. *L'Ecole de Fontainebleau,* 401. He worked with Primaticcio at the castle of Meudon, now destroyed, in 1552.

77. De Jong, especially 137–40.

78. Jacquio apparently returned to France after the Ricci commission, sometime around 1556, another victim of the hard times for artists during the reign of Paul IV. He is recorded as having worked as a sculptor on the tombs of François I and Henri II.

79. Both were reception rooms, but the Sala Regia was the hall of state, which gave it an added importance and formality; see the discussion that concludes this chapter.

80. Davidson (1976) has reconstructed the history of the Sala Regia from the documents and described it. She gives, 398, the following measurements: the room is 33.75 by 11.85 m; the height of the cornice is 13.12 m; although the total height had not been measured, she estimated it at 18 m. The Sala di Costantino was about the same width, but much shorter. See Quednau (1979), 23.

81. The significance of the iconography has been disputed. Harprath, 17–67, sought specific connections of each scene with events in Paul III's life, whereas Partridge (1980) found in it a statement of the utopian goals of Paul's papacy. Guerrini convincingly relates it to Plutarch's life of Alexander.

82. Noted by Rubin (1987), 85 and n. 19, who suggests that Salviati may have subcontracted the vault of the Cappella del Pallio. The heavy gilding was added in the restoration of Mazzuoli in 1725.

83. See Guerrini.

84. Raphael's design was engraved in Rome around 1540 after a lost drawing. Either the drawing or the engraving by Nicholas Béatrizet could have been Perino's source. Cox-Rearick (1996), reproduces the engraving, fig. 221.

85. The problem of the separation of hands here has been much discussed but not resolved. It is certain that Perino had a large workshop, but it appears that he made all the designs himself. Only one painter is mentioned in the documents, Marco Pino, who painted on the vault. Differences of hand can be discerned in the frescoes, and it is tempting to attribute, as has been done, the stiffer figures to Siciolante da Sermoneta and the more emphatic and flamboyant parts to Pellegrino Tibaldi. Nevertheless the coherence and consistency of the whole is unmarred. See Parma Armani, 209–26, 288–94.

86. The inscription below is translated: HE WHO ADMINISTERS ALL THINGS WITH JUST AND IMPARTIAL ORDER WILL FOUND THE GOLDEN AGE. The inscription above reads: HE SHALL SPREAD HIS EMPIRE PAST GARAMANT AND INDIA. Both refer to a passage in Virgil's *Aeneid,* "Augustus Caesar, son of a god, who shall again set up the Golden Age amid the fields where Saturn once reigned, and shall spread his empire past Garamant and India." Bk. VI, 794, as pointed out by Cox-Rearick (1984), 110.

87. We know so much about the iconography because Vasari described it in detail in his *Zibaldone.* Liana Cheney has translated the inscriptions and analyzed the iconography in a detailed study of Paolo Giovio's complex program, see L. Cheney.

88. Gilio in Barocchi, *Trattati* 2:15. Gilio's categories were pointed out by Dempsey (1982), 64.

89. As pointed out by Robertson (1992), 68, whose treatment of the room is followed here, 57–68.

90. Raphael had anticipated this combination of history and allegory in the borders of his tapestries. See Shearman (1972).

91. In his autobiography (B&B, 6:388; Eng. ed., 4:273–4) Vasari named six, but said there were many others. Significantly, most are otherwise unknown. One, Giovanni Battista Bagnacavallo, had been working with Primaticcio at Fontainebleau and would therefore have been a firsthand source of knowledge about the kind of ornaments *alla francese.* Like another traveling artist, Ponsio Jacquio, who came to Rome in 1553 after having worked with Primaticcio (see n. 78), Bagnacavallo would have been an important conduit of artistic influence. Carla Bernardino, "Note sul Bagncavallo junior," *Prospettiva* 18 (1979), 20–39.

92. Letter dated 18 December 1546, translation by Robertson (1992), 59.
93. B&B, 6:388; Eng. ed., 4:273.
94. Preface to the third part, B&B, 4:10; Eng. ed., 2:154.
95. Cited in L. Cheney, 145, n. 7, from a note in Vasari-Milanesi, 7: 680, n. 1.
96. Letter from Annibale Caro in Rome to Giorgio Vasari in Florence, 10 May 1548, translation by Gombrich (1976), 124.
97. B&B, 5:526; Eng. ed., 4:64–5.
98. B&B, 5:526; Eng. ed., 4:65.
99. See Rubin (1987) and Robertson's succinct summary (1992), 151–7.
100. See Rubin (1987), 89.
101. The John the Baptist is a later addition.
102. Rubin (1987), 85. Iris Cheney suggested that Jacopino del Conte is the hand we see in *Janus welcoming Saturn to Rome* and the other lunettes (1981), 246, n. 14. See also I. Cheney (1985), 307–8.
103. Rubin (1987), 92.
104. On the Horse-Tamers of Monte Cavallo, see Bober and Rubinstein, 159–61, no. 125.
105. S. J. Freedberg (1965), 194.
106. Bk. I, chap. 8, Eng. ed., 130.
107. Bk. I, chap. 4, Eng. ed., 109–13; see also Bk. I, chap. 7, Eng. ed., 130.
108. Noted by Nova (1992), 99. Bronzino, exceptionally, continued to make studies from life.
109. The print of the *Nativity of the Virgin* was engraved by the Master G. R. of Verona, based on Giulio's drawing, now in the Devonshire Collection, inv. 121. Both are reproduced in *Giulio Romano pinxit et delineavit*, no. 97.
110. See Bober and Rubinstein, no. 94, for a partial list. Phyllis Bober kindly identified the source of Salviati's invention for me. On the provenance of the versions known in the Renaissance and the association with Polykleitos, see Bober, "Polykles and Polykleitos in the Renaissance: The 'Letto di Policleto,'" in Warren G. Moon, ed., *Polykleitos, the Doryphoros and Tradition* (Madison: University of Wisconsin Press, 1995), 317–26.
111. This example was noted by Nova (1992), 91, who has discussed the phenomenon of reuse of drawings and its implications. The Uffizi drawing, no. 1077S, is in pen and brown ink, brown wash, heightened with white, on green paper, 410 × 265 mm. The poor condition makes it difficult to determine whether the sheet is original or a workshop copy, as Nova noted, n. 23. Rubin (1987), 91–2, also illustrated a number of examples of reused poses in the Cappella del Pallio.
112. Landau and Parshall, who quote Aretino's letter, 293–4, fig. 311. Salviati dedicated the print to the generosity of his patron, the Florentine Duke Cosimo, for whom he was then working. There is an oil painting by Salviati resembling the print in the Doria-Pamphili Gallery in Rome.
113. See *Vasari on Technique*, Introduction: Of Painting, chap. I (15), 74, "The Nature and Materials of Design or Drawing," 205. See also Benedetto Varchi's exegesis of a Michelangelo

poem in his lecture delivered in 1547 and published three years later, where the sculptor's creative process is described in similar terms, Mendelsohn, especially chap. 7. As Panofsky pointed out, 62, Vasari's *concetto* is the same thing as the "Idea" as it was used by other writers in the second half of the Cinquecento, like Armenini, Bk. II, chap. 11, Eng. ed., 203–4.
114. B&B, 4:6; Eng. ed., 2:152.
115. See Smyth's analysis of the conventions of the figure (1992), 39–49.
116. *Trattato dell'arte della pittura, scultura et architettura* (Milan: 1584), in Lomazzo, *Scritti sulle arti*.
117. Borghini, quoted in Panofsky, 74, n. 10.
118. Armenini, Bk. II, chap. 2, Eng. ed., 169.
119. *Vasari on Technique*, Introduction: Of Painting, chap. 3 (17), 79, "Foreshortenings," 216.
120. Nova (1992), 93, quoting Armenini, Bk. III, chap. 15, Eng. ed., 293.
121. Nova (1992), 95–9.
122. This is true of Vasari in the first half of his career. Once he installed himself in Duke Cosimo's service at the Palazzo Vecchio in the late 1550s he did develop a large workshop that included some artists who stayed with him for a number of years, although they did not fully subordinate themselves to the master and their individual styles are often identifiable.
123. Armenini, Bk. I, chap. 8, Eng. ed., 130–2.
124. Jan de Jong summarized the earlier literature on Ricci, 135–6.
125. Mortari places the completion between the second half of 1552 and the end of May 1554. See her discussion, 127–8, and also n. 117, 99. Dumont dates the frescoes to 1553–4; 133, and especially appendix I, 241–2.
126. Mortari's argument for a chronological reading is unconvincing, 125–6.
127. The interpretation is Nova's (1980), 33–8.
128. Murals in the House of Augustus on the Palatine are remarkably similar to these, even in the use of a mysterious and space-denying black background. Although these rooms were only recently excavated and unknown to the Cinquecento, there must have been other remnants of Roman painting known then which have since disappeared.
129. Hirst (1979) recognized and described these curiosities.
130. To avoid confusion, hereafter the room in the Palazzo Farnese will be referred to as the Sala dei Fasti Farnesiani, and that at Caprarola the Sala dei Fatti Farnesiani. Scholars alternate between both names for each of these rooms, and here I am following Gere's (1969) example, 110n.
131. Iris Cheney argued convincingly for this dating (1981), 253. Some scholars claim that they were not begun until after Salviati's return from France. Piecing together evidence, Cheney (1992) fixed Salviati's visit to France in 1556–7, extending even into early 1558.
132. I. Cheney (1981), 259. The usual identification of this scene as the Council of Trent was disputed effectively by Dempsey (1982), 63–4.
133. The miracle, in which the Host bled, was taken as a

demonstration of the doctrine of transubstantiation, which declares that the bread and wine are changed in substance into the body and blood of Christ when the priest consecrates them.

134. Jones and Penny explain the topical significance of the Stanze frescoes, 113–18, 150–1.

135. The same iconography recurred a few years later in the Villa Lante on the Janiculum, where Turini chose scenes of Numa Pompilius for his frescoes painted by Polidoro da Caravaggio. The references to Numa are understood in this context as standing for Leo, because Turini also had Medici arms and emblems displayed prominently in acknowledgment of his debt to his patron. Marabottini, 67. Jacks (1993), 179, makes the connection between the Capitoline ceremony and these frescoes, although he misdates the latter. Leo was alluded to only in this way, however, not by the inclusion of his portrait.

136. Varchi, *Lezzione della maggioranza delle arti,* for example, 44, "una artificiosa imitazione di natura," quoting Castiglione in *The Courtier,* as Paola Barocchi pointed out, *Trattati* 1:366, n. 1.

137. Varchi (1503–65) was a Florentine intellectual who was exiled as an anti-Medicean supporter of the Republic when Cosimo became Duke in 1537. He was pardoned five years later and returned to Florence to become Cosimo's principal instrument in reestablishing the Florentine hegemony in the arts. His *Due Lezzioni* were delivered to the newly established Florentine Academy in 1547. See Mendelsohn, chap. 1.

138. *Lezzione della maggioranza delle arti,* in Barocchi, *Trattati* 1:39.

139. Vasari's letter to Varchi on the *paragone* in Barocchi, *Trattati* 1:63; quoted by Mendelsohn, 126–7.

140. Hellmut Wohl, in *The Aesthetics of Italian Renaissance Art,* has traced the noble tradition of the ornate style in the Renaissance and shown that moments of style that were not ornate are the uncommon exception.

141. Bk. IV (67), Eng. ed., 352.

142. Panofsky, 62, whose interest in *Idea* was in the history of the philosophical concept, not in its relation to artistic practice, complained that Vasari's *concetto* was not the pure Platonic Idea but was corrupted by the intrusion of experience in the forming of it.

143. See Mendelsohn's study of Varchi's two lectures in the intellectual context of the 1540s.

144. S. J. Freedberg (1965), 188.

145. The defining analysis of Vasari's *Lives* is Alpers (1960), but see now also Rubin (1995), with bibliography.

146. On the *paragone,* see Mendelsohn, and Collareta.

147. A similar Florentine demonstration by Bronzino shows the front and back views of the dwarf Morgante (Florence, Uffizi storerooms); published and reproduced by James Holderbaum, "A Bronze by Giovanni Bologna and a Painting by Bronzino," *Burlington Magazine* 98 (1956), 441–2.

148. There were evidently a few remaining bits of stucco and gilding to be done, unfinished from the earlier campaign

that had been interrupted abruptly at the death of Paul III because the room had to be used to house the cardinals during the conclave to elect the successor. For a detailed chronology, see Partridge and Starn (1990), appendix II, 56–60.

149. The analysis is based on Partridge and Starn (1990), who identified the special character of halls of state and their decoration; see also Starn and Partridge (1992).

150. They each chose artists and subjects in keeping with their particular interests. Cardinal Alessandro Farnese chose the artist he had working for him at Caprarola, Taddeo Zuccaro, and a subject commemorating his papal uncle and namesake Paul III (the end wall). Cardinal da Mula was the ambassador of Venice, so he chose the assistant of Salviati who had gone to Venice, Giuseppe Porta, and the scene in which *Pope Alexander III reconciles with Emperor Frederick I Barbarossa in Venice in 1177,* favorable not only to the pope but to Venice.

151. See Pillsbury (1976). We will discuss Vasari's working method in Chapter 6.

152. Letter to Vincenzo Borghini, 13 January 1573, Frey, 2:754–5, quoted by Partridge and Starn (1990), 52, n. 83.

153. Frey, 2:790, quoted by Partridge and Starn (1990), 34 and 53, n. 91.

154. We will discuss Sixtus V's decorations in the last chapter.

CHAPTER FIVE

1. Louvre inv. 2198 was identified by Monbeig Goguel (1972), no. 201. Pen and brown ink, brown wash on black ground, 322 × 431 mm.

2. The decoration was described by Vasari as *intagli di fogliami,* "carved foliage." Quoted by Alessandro Zuccari in *Oltre Raffaello,* 85–6; B&B, Life of Michelangelo, B&B, 6:82; Eng. ed., 4:149; see also the Life of Simone Mosca, B&B, 5:343–4; Eng. ed., 3:260. Documentation of the process of work on the chapel was published by Alessandro Nova, "The Chronology of the De Monte Chapel in S. Pietro in Montorio in Rome," *Art Bulletin* 66 (1984), 150–4.

3. Nova (1981), 356.

4. As identified by Nova (1981), 366.

5. Joannides (1992) has identified and discussed this style in Michelangelo's late sculptures, drawings, and architecture.

6. This association was first suggested by Zeri (1957), 35, and supported by Hirst (1981), 136.

7. Letter from Sebastiano in Rome to Michelangelo in Florence, 24 February 1531, in Paola Barocchi and Renzo Ristori, eds., *Il carteggio di Michelangelo* (Florence: Sansoni, 1973), 3:299; as quoted by Chastel (1983), 174.

8. *Sebastiano del Piombo y España,* 87–93. The patron was Ierónimo Vich, the Spanish ambassador to the Holy See from 1507 to 1516, and to the court of Charles V from 1518; he returned definitively to Spain in 1521. Michael Hirst, in his review of the exhibition and catalogue (1995), 482, agrees that there is little doubt remaining that the *Christ in Limbo* was a wing to the Hermitage *Lamentation,* forming a triptych with another lost wing that is preserved only in

copies; both paintings by Sebastiano appear in documents concerning the Vich collection. Hirst, however, believes that the catalogue presses too hard for the date of 1516 and instead thinks that Sebastiano may have executed this canvas after finishing the *Raising of Lazarus,* commissioned by Giulio de' Medici, which kept him busy in 1517. Hirst thus retracts his previous date of 1532; see (1981), 129 and n. 32. He remains convinced of Michelangelo's role in the design.

9. The patron is not certain, but there is evidence that it was for Giovanni Grimani, who was later arraigned on charges of heresy because of his Lutheran leanings, Hirst (1981), 134–6. The starkness of the image tends to lead many to believe that the Budapest painting was the last executed in the series, and the last two dated versions (Prado and Hermitage) bear the year 1537. See also *Sebastiano del Piombo y España,* 103–4, where they give the date as c. 1535. The painting is on marble.

10. Hirst (1981), 135.

11. The frescoes are about six meters (nineteen feet) square. For the *Conversion of Paul,* begun in October 1541, 85 *giornate;* for the *Crucifixion of Peter,* probably begun in March 1546 and finished in 1550, 87 *giornate;* Baumgart and Biagetti, 48, 51, also reproduce diagrams, pls. 47, 50.

12. See Shearman (1972), reconstruction diagram, 25.

13. See Alfred Neumeyer's list, "Michelangelos Fresken in der Cappella Paolina des Vatikan," *Zeitschrift für bildende Kunst* 63 (1929–30), 181.

14. Steinberg, 17.

15. Steinberg traced the history of this criticism and found that until Dvorák and Neumeyer in the 1920s the two paintings were regarded as the decadence of Michelangelo's style. See Dvorák, "Der Spätstil Michelangelos," 2:127–43; and Neumeyer (as in n. 13), 173–82, and especially 178–80.

16. The issue of justification by faith alone raised by Luther was much discussed in evangelical circles of the Catholic Reform movement, with which Michelangelo and high officials in the church, like Cardinal Pole, were associated. There is extended discussion of Michelangelo's contacts with the Catholic Reform in Calì, especially chap. 4, 116–54. This was a widespread concern, not limited to Rome, by any means. Logan has documented, for example, a curious upsurge in Venice, at and before midcentury, of declarations of inability to merit salvation and total dependence on divine mercy, in last testaments, and he noted that it was a concern that was in the air.

17. Cited by Paola Urbani, "Controversie teologiche al tempo di Sisto V," in *Roma di Sisto V,* 494.

18. See Wallace (1989), whose photographs from the chapel entrance and from the altar demonstrate, as well as the camera can, the author's groundbreaking observations concerning the intended points of view and the effects of the natural light in the chapel.

19. Raphael's cartoon for the *Conversion of Paul* has not survived, but the composition can be studied in the tapestry in the Vatican Pinacoteca.

20. Steinberg, 23–5.

21. Wallace pointed this out and reproduced a reversed engraving by G. B. Cavalieri (fig. 15) where the problems of the composition are still more acute.

22. On Pulzone, see Zeri, and Calì, especially 191–2.

23. Although the tapestry was never executed, the cartoon was installed as a frieze in the Palazzo Spada, where it is to be seen today. The drawing is Uffizi no. 726E, pen, gray and brown wash on traces of black pencil, 337 × 453 mm. See Davidson (1966a), no. 49.

24. Jacopino's alleged flight into extreme mysticism after a meeting with Ignatius Loyola seems to me to be fictional. It is based almost entirely on the *Pietà,* now in the Galleria Nazionale (Palazzo Barberini) but usually associated in the literature with the Palazzo Massimi. The attribution by Zeri ("Salviati e Jacopino del Conte," *Proporzioni* 2 [1948], 182 and 183, n. 9) was based on his association of the *Pietà* with an altarpiece in Santa Maria del Popolo that has now been identified as another painting, leaving the so-called Jacopino *Pietà* without a provenance (Antonio Vannughi, "La 'Pietà' di Jacopino del Conte per S. Maria del Popolo: dall'identificazione del quadro al riesame dell'autore," *Storia del arte* 71 [1991], 59–93). I believe the *Pietà* reflects knowledge of Martin van Heemskerck's style after he returned home, possibly through his prints, and may be by a Flemish painter of the late 1540s. There is no other evidence for Jacopino as an eccentric mystic, nor can such a style be identified with Rome in the second half of the century.

25. Weisz (1991), 226.

26. Ibid., 229.

27. "Disputatio de cultu et adoratione imaginum," in *Enarrationes* (Rome, 1552), 130–40, quoted by Scavizzi (1992), 251.

28. Lee (1940/1967) was the first to show that the Counter-Reformation adapted Horace in support of new notions of appropriacy; in 1940, see 228–35 and especially 231–5; in 1967, see 34–41 and especially 37–41.

29. See Chapter 2, n. 47.

30. Roskill ed., 163–5.

31. The first chapel constructed was the Landi in 1545 (fifth on the left), followed by the Guidiccioni (third on the left). The Gonzaga Chapel is the fourth on the left.

32. Bross found documents to redate the chapel (see her appendix, 342–3) and place it in a more understandable historical context.

33. See Kummer, 41–50.

34. Bross, 342.

35. See Teresa Pugliatti, *Giulio Mazzoni e la decorazione a Roma nella cerchia di Daniele da Volterra* (Rome: Istituto Poligrafico e Zecca dello Stato, 1984).

36. Michiel Gast, born probably in Antwerp around 1515, worked in the circle of Martin van Heemskerck and stayed on in Rome after his departure. He appeared back in Antwerp in 1558. See *Fiamminghi a Roma 1508–1608. Artistes des Pays-Bas et de la principauté de Liège à Rome à la Renaissance* (Ghent: Snoek-Ducaju & Zoon, 1995), 195.

37. Agresti left town in the summer of 1557 for Narnia, Terni,

and maybe Forlì, not returning for four years. In 1561 he received the commission for an overdoor fresco in the Sala Regia; Bross, 342. Salviati probably left Rome in 1556; see I. Cheney (1992). Michiel Gast returned home sometime around 1556; he was documented as being in Rome until 1555, where from 1544 to 1555 he was a member of the Compagnia di San Luca; see Dacos (1995), 46. On Muziano, see Mack, 410, n. 2. It is not known where he went from Orvieto. Contrary to this trend, however, Lelio Orsi came to Rome in 1557.

38. Vasari's Life of Taddeo Zuccaro, hastily assembled in the two years after Taddeo's death and before the publication of the second edition, was used as the basis for Federico's drawings. Because Federico accepted Vasari's version as true, we can assume it is reliable.

39. B&B, 5:553–4; Eng. ed., 4:82.

40. Reproduced as no. 19 in Gere (1989).

41. B&B, 5:558; Eng. ed., 4:85.

42. The exact date of the contract is not known, but based on Vasari's chronology, it is usually believed to have been between 1556 and 1558; see Gere (1969), 71; Mundy, 91.

43. B&B, 5:569; Eng. ed., 4:93.

44. Quoted by Claudio Strinati in *Oltre Raffaello,* 120.

45. Views and discussion of all these vaults can be found in Kummer.

46. The drawing, in the Metropolitan Museum, is in pen and brown wash, heightened with white, on blue paper, 336 × 460 mm. The drawings of Taddeo have been more studied than his paintings. See Gere (1969), fig. 84, and Mundy, colorplate 16, both of whom reproduce a superb study for the *Beheading of Paul,* also in the Metropolitan Museum in New York.

47. Schutte, 276.

48. Barolsky (1979), 105.

49. A discussion and reproduction of color in this painting can be found in Hall (1992), 156–8, pl. 35.

50. See Vasari-Barocchi, *La vita di Michelangelo,* 3:1260, letter from Nino Sernini, 19 November 1541. The responses to the fresco have been gathered and discussed by De Maio, chap. 1 and now by Barnes (1998).

51. The letter appears in translation in Klein and Zerner, 122–4. They also print Aretino's letter of 1537 to Michelangelo making his suggestions for how the artist should should design the *Judgment,* 56–8.

52. De Maio mentions Aretino's ambition for the purple, 23.

53. Roskill ed., 163.

54. This point was again made by Molanus in his treatise, published in 1570 at Louvain, after the Tridentine Decrees came out, and translated by David Freedberg (1971), 241.

55. Roskill ed., 163.

56. My translation. See B&B, 6:90; as quoted in De Maio, 39, and n. 88 (59); Eng. ed., 4:157.

57. De Maio, 39.

58. Anthony Blunt reported that in 1936 rumors were current that Pius XI intended to continue the work of adding britches, 119, n. 1.

59. *Ultima apologia advesus rapsodias . . .* (Venice: 1532), fol. 17r.

60. See David Freedberg (1989), chap. 14: "Idolatry and Iconoclasm," and especially 385–6; *Art before the Iconoclasm,* 128; see also Pastor, 18:85–7.

61. The distinction is justified with the statement: Not because they were believed to contain any divinity, but because the honor paid them was referred to the prototype they represent. An accessible translated version of the Decrees on Art is in Klein and Zerner, 120–2.

62. Gilio in Barocchi, *Tratatti* 2:20, 46, 48.

63. Ibid., 40.

64. Evidently Gilio did not understand the iconography of the chapel, which has now been elucidated by Josephine Jungic.

65. Gilio in Barocchi, *Trattati* 2:71; Horace, *Ars poetica,* 396.

66. Gilio in Barocchi, *Trattati* 2:45.

67. The painting is now in the Accademia in Venice. See Klein and Zerner for the transcript of the trial, 129–32. For an interpretation of the document, see Fehl (1961), and especially the appendix, 348–54.

68. Gilio in Barocchi, *Trattati* 2:41.

69. Ibid., 42.

70. Ibid., 48.

71. Ibid., 46.

72. Ibid., 33, translation by Lee (1940), 234; or (1967), 40. This is the explicit indictment of the Maniera that is frequently cited.

73. Gilio in Barocchi, *Trattati* 2:3–4.

74. According to Paleotti, Michelangelo said, "this good man painted with his heart, so that he was able with his pencil to give outward expression to his inner devotion and piety," *Archiepiscopale Bononiense . . . , first part, 81b, quoted by Prodi, 2, 536, n. 37.*

75. *De Hollanda, Third Dialogue, 65.*

76. *Gilio in Barocchi,* Trattati 2:39.

77. Roskill ed., 167.

78. Drawing no. 18 from the Life of Taddeo Zuccaro series by Federico Zuccaro, sold at Sotheby's, 11 January 1990. Pen and brown wash, traces of red chalk underdrawing; the copy in Taddeo's hand is entirely in red chalk, the outlines of the figure in the *Last Judgment* are in black chalk, 419 × 177 mm.

79. *Michelangelo e la Sistina;* see 137–38 and 229–62, where a number of the copies are illustrated and discussed. Steinmann, 2:789–92, lists the seventeen prints after the *Last Judgment* before 1600.

80. Bernadine Barnes's (1998) Chapter 3 on the critical reception of the fresco breaks new ground in its study of the impact of the prints.

81. Gilio in Barocchi, *Trattati* 2:81.

82. Ibid., 38.

83. See Chapter 2, and Emison, 431–5.

84. *Libro della beltà e grazia,* in Barocchi, *Trattati* 1:83–91.

85. Ibid., 86.

86. Ibid., 87.

87. Blunt, 93.

88. Danti in Barocchi, *Tratttati* 1, chap. 7, "That grace is part of internal bodily beauty," 228–30.

89. Lomazzo in the *Libro de Sogni,* which Ciardi, ed., dates 1563, *Scritti,* 1:101.

90. Davidson (1966b), 57.

91. Reproduced in S. J. Freedberg (1993), fig. 216; Hall (1992), fig. 61.

92. Hunter, 24–6, and especially 25.

93. Dated 1565, reproduced and discussed in Hall (1992), 171–2. Hunter discusses Siciolante's works of the 1550s.

94. Zeri pointed out the emulation of Quattrocento style with reference to Santi di Tito and Federico Zuccaro, 54–5.

95. Mortari has a color reproduction of a detail of another fresco in this cycle, the *Presentation of the Virgin,* 87.

96. On Gilio's three genres of painting, see Chapter 4, n. 88.

97. In October or the beginning of November; see Ugo Procacci, "Una 'vita' inedita di Muziano," *Arte Veneta* 8 (1954), 242–64, and especially 245.

98. Gere (1966), 418, connected Muziano's fresco with a drawing by Taddeo in Hamburg; see fig. 49 on 419. The sharing of drawings in this period is less unusual than we tend to think. There are, of course, the well-known examples of Michelangelo supplying drawings to Sebastiano for his Christ of the *Flagellation* and the *Raising of Lazarus,* as Gere pointed out, 418. We recall Jacopino's use of Perino's sketch in the Oratory of San Giovanni Decollato, and the same painter apparently used a sketch by Daniele for his *Deposition* altarpiece in the Oratory. See Cox-Rearick (1989) for a Florentine example, in which Bandinelli supplied a drawing to Bronzino.

99. Strinati (1980), 16–7, has called attention to the importance of the Orvieto decorative ensemble and its influence, going so far as to refer to the Orvietan style, by which he means something akin to our Counter-Maniera. See Mack for documents and dates. Restoration of the paintings is presently under way and photographs should become available when it is completed.

100. His version in Santa Maria degli Angeli, commissioned in autumn 1584, is frequently reproduced, see, for example, S. J. Freedberg (1993), fig. 219. An inscription in the chapel records its establishment with a dedication to Saint Peter in 1584. Muziano's altarpiece was most likely commissioned at about this time; Mack, 410, n. 9.

101. *Instructiones fabricae et supellectilis ecclesiaticae* (Milan: 1577).

102. *Acta Ecclesiae Mediolanensis,* 37, cited by Evelyn Voelker, 239.

103. Boschloo (1974), in his extended analysis of Paleotti's writings, pointed out this difference between Gilio and Paleotti, 138–9. Prodi, 2:550, quotes a letter to Paleotti from his friend Ulisse Aldrovandini urging him to publish his treatise first in Latin. Prodi cites the fact that Paleotti ignored this advice as evidence that Paleotti wanted to address himself to the artists.

104. Paleotti in Barocchi, *Trattati* 2, Bk. I, chap. 21, 215.

105. Ibid., chap. 19, 211.

106. Ibid., chap. 3, 136.

107. Armenini, Bk III, chap. 2; Eng. ed., 218.

108. Ibid., chap. 5; Eng. ed., 232–4.

109. Schutte, 276.

110. The commission for the facade of the palace of Cardinal Tizio of Spoleto in Piazza Sant'Eustachio is mentioned by Vasari (B&B, 5:561; Eng. ed., 4:87). It has been recently restored, and the arms of Pius IV are still legible. Strinati noted the uniqueness of the sacred subject (1980), 15. Also unique is the fact that it was painted in color, rather than in monochrome.

111. See Monticone, 226, as cited in Robertson (1992), 160 and n. 79.

112. Robertson (1992), 162.

113. On the renovations in Florence sponsored by Duke Cosimo, see Hall (1979). All Mendicant churches must have had these *tramezzi,* as rood screens were called. In 1249 the Dominicans had made it obligatory to construct rood screens in their churches. See Giancarlo Pamerio and Gabriella Villetti, *Storia edilizia di S Maria sopra Minerva in Roma, 1275–1870,* Università degli studi di Roma "La Sapienza," Dipartimento di storia dell'architettura, restauro e conservazione dei beni architettonici, Studi e documenti, I (Rome: Viella, 1989).

114. Scavizzi (1992), 98–9.

115. The church to set the trend was the newly built Madonna ai Monti, 1580–2, built by Giacomo della Porta. Lewine, 65–70; Robertson (1992), 166.

116. Nicknamed Pomerancio, his birth is given as c. 1517/1524; it is likely to be closer to the latter. He died after 1597.

117. The patron who has been more thoroughly studied is happily also the most important, Alessandro Farnese; Claire Robertson's book (1992), which I am following in this section, is a rich fund of information on the period of his life, 1520–89.

118. Robertson (1992), 184–200. The fundamental work is Pio Pecciai, *Il Gesù di Roma* (Rome: Società Grafica Romana, 1952).

119. Reported by Pevsner (1925/1968), 22.

120. Letter to Bartolommeo Concini, 15 March 1567, Frey, 2:324–5.

121. Haskell and Penny, 14–15.

122. 13 March 1567, Frey, 2:318.

123. Partridge (1971), 470, n. 20, and 472. Robertson (1992), 111, n. 177, rejected the suggestion of Strinati (1974), 91–2, n. 13, that dissatisfaction with Federico's style was in part responsible for the cardinal's decision to dismiss him.

124. Noted by Robertson (1992), 97–8.

125. The expression he used was *getate a stampa,* in a marginal note to Vasari's *Lives,* published by Milanesi (7:102, n. 4), cited by Strinati (1974), 91.

126. Gere (1969) says that Federico was in Venice from October 1563 to 16 January 1566, with a brief return to Rome in the summer (probably July) of 1565, based on documents of payment in Rome and Venice; see 22–3, 108, 117, n. 1 on 118. Also see William R. Rearick, "Battista Franco and the Grimani Chapel," *Saggi e memorie di storia dell'arte* 2 (1958–9), for Federico, where he states that Zuccaro arrived for the first time in Venice in 1562, probably in the spring; 129–37, and especially 129.

127. Faldi, pl. 294–5.

128. For example, Lilio Gregorio Giraldi's *De deis gentium . . .*

(Basel, 1548); Natale Conti, *Mythologiae sive explicationis fabularum libri decem* (Venice, 1551); and Vincenzo Cartari's *Le imagini de i dei de gli antichi* (Venice, 1556). Seznec discussed the appearance of the mythological manuals in his chapter entitled "The Science of Mythology in the Sixteenth Century," Bk. II, chap. 1, 219–56, and especially 224–56.

129. The program for the Camera dell'Aurora, devised by Caro for Taddeo Zuccaro in 1562, was discussed by Robertson (1982), as well as the role of the manuals in the hands of the iconographic adviser.

130. Discussed in Robertson (1982), 170–1, and illustrated in Faldi, pls. 246–9.

131. Partridge (1995a) has published the program and his translation, and he has situated the program in the Protestant-Catholic debates on monasticism, penance, and good works.

132. Robertson (1992), 202. On the Mappamondo, see Partridge (1995b).

133. Noted by Robertson (1992), 202.

134. *Oltre Raffaello,* 228–34.

135. Paleotti in Barocchi, *Trattati* 2, Bk. II, chap. 10, 293, 291.

136. For illustrations, see *Il Palazzo Apostolico Vaticano,* ed. Carlo Pietrangeli (Florence: Nardini, 1992), 84–5.

137. Borromeo (1577), chap. 17, 44. Paraphrase based on the translation of Voelker, 231–2.

138. Dacos (1969), 131, citing Paleotti in Barocchi, *Trattati* 2, Bk. II, chap. 39, "Altre ragioni della origine delle grottesche, e perché abbiano preso questo nome," 433–9, and especially 435–9. Dacos identified Paleotti's source as Pirro Ligorio. Morel (1985), 170–6, and especially 174–5.

139. Wilkinson found an architectural treatise written for Prince Philip apparently just before the Escorial was built, laying out a program for a moral architecture based on a purified Alberti. See especially 46–7 and n. 50.

140. But completed in 1576; Wisch (1991), 237.

141. Wisch (1991) related the iconography to the contemporary ceremony of the procession, rather than to the play the confraternity had traditionally performed until it was suspended in 1539 when violence exploded after the performance; the audience at the Colosseum had stormed out and stoned actors and Jews, outraged at the savagery of the treatment of Christ. In response Pope Paul banned the play. *Sacre rappresentazioni* were increasingly condemned, until finally in 1574 Gregory XIII told the cardinals not to attend them. Gradually processions took their place, as was the case with the Gonfalone; see especially 238–43.

142. Although sometimes identified as *Christ before Caiaphas,* the presence of the soldiers with the fasces makes it clear that this is Christ's political trial, not his religious one. For a useful discussion of the role of Pilate in the Counter-Reformation, see Gibbons, chap. 4.

143. Gilio pointed out that the column should be accurately represented by painters, because they could go and see what it looked like at Santa Prassede; Gilio in Barocchi, *Trattati* 2:47. Mâle noted the new iconography of the short column, but not the connection to Gilio, see 262–7, and especially 263–4. Wisch (1991) identified Zuccaro's pioneering use of it; see 244–52.

144. Wisch (1990) convincingly identified it and its painter, 90 and 100, n. 72; it is also illustrated here in fig. 2–7.

145. Nebbia would enjoy a position of great prominence in Sixtus V's decorative campaigns; see the last chapter.

146. Robertson (1992), 203.

147. Wethey, 1:24, noted the quotations of antiquities. The Dresden version is his cat. no. 61 (fig. 4), dated c. 1565; the Farnese version (now in Parma) is his cat. no. 62 (fig. 5). Wethey believed that the obvious portrait at the left edge was a self-portrait and discarded the suggestion that it was the young Alessandro Farnese, future duke of Parma. If the young Alessandro were the patron, however, it would explain the transfer of the painting to the Parma wing of the Farnese family.

148. *I Farnese,* 248.

149. Either late in the decade (1578–9, Heideman), or immediately after the vault was finished in 1573 (Strinati in *Un antologia di restauri: 50 opere d'arte restaurate dal 1974 al 1981.* Exh. cat. Rome, Galleria Nazionale d'Arte Antica [Rome: De Luca, 1982], 123).

150. Mâle, 185.

151. Heideman, 453.

152. Heideman has found the key to interpreting the frescoes, see especially 453–7.

153. Heideman, 456–7.

154. Mâle, 76, 78–9, 54, 183–6, pointed out by Heideman, 456.

155. John Foxe's famous book, called *Acts and Monuments of These Latter and Perillous Days,* was published in London. A plate is reproduced in Buser, fig. 11, who gives further bibliography and an account of the Jesuit martyrdom cycles.

156. Recorded by Pastor, 20:597, n. 6, quoted by Buser, 428.

157. Nadal's book, *Evangelicae historiae imagines,* and the second part called *Adnotationes et meditationes,* were ready for publication in 1579, the year before his death, but did not appear until 1593–4, when they were published in Antwerp. The 153 engravings were mostly by the Wierix brothers on designs by "BP," although some are based on designs of Martin de Vos; Buser, 424–5.

158. See Massari's introduction to *Tra mito e allegoria,* especially xx.

159. The drawing by Rosso Fiorentino of the subject (Fig. 81), 1530, should be considered in this series as well.

160. David Freedberg (1989), figs. 172–4. It has been suggested that Agostino Carracci may have made the change; *Tra mito e allegoria,* 257.

CHAPTER SIX

1. Alessandro was a great-grandson of Lorenzo il Magnifico, but his grandfather was the hated Piero, who had been exiled in 1494. His father Lorenzo, the Duke of Urbino, portrayed in Michelangelo's statue in the New Sacristy at San Lorenzo, died young in 1519.

2. Cochrane, 10.

3. Two versions of the *Noli Me Tangere* hang side by side in the Casa Buonarroti in Florence. Costamagna accepts the version in a private collection in Milan as Pontormo's

original (cat. 69). European scholars tend to agree on accepting the version of the *Venus and Cupid* in the Accademia in Florence as the original among many versions (Costamagna, cat. 70), but American scholars reject it and regard the original as lost.

4. In Pontormo's diary of the years 1554 until his death at the beginning of January 1557, where there is little recorded besides what he ate, he noted frequently that he dined with Bronzino. His secluded way of life suggests this must have been on Bronzino's initiative. The diary has been translated into French by Jean-Claude Lebensteijn, with the collaboration of Alessandro Parronchi, *Jacopo da Pontormo* (Paris: Editions Aldine, 1992.)

5. I am following the dating originally suggested by Smyth (1955), which I find convincing.

6. Elizabeth Cropper, identifying this as the portrait of Francesco Guardi mentioned by Vasari, has discovered that the sitter was born in 1514 and was therefore too young to serve in the army but not too young to serve as a guard at the fortifications of the city against the besieging army of the emperor. *L'Officina della maniera*, 376, no. 140. In contrast, Keutner identified the portrait as being of Cosimo and dating to the early years of his rule (*Mitteilungen des Kunsthistorischen Institutes in Florenz*, 1955), a view further developed by Kurt Forster and Janet Cox-Rearick.

7. Documents published by Waldman show that Smyth's dating (1949), 202, on the basis of style was correct.

8. Smyth (1955), 191–6, established the link to the Bandinelli and the basis for accepting Vasari's implied dating of this piece in the early 1530s.

9. Observed by Smyth (1955), 202–10, whom I am following here.

10. Cosimo was descended from Cosimo *Pater patriae*'s brother Lorenzo, through Giovanni delle Bande Nere, a popular hero with the Florentine *popolo;* his mother, the greatly respected Maria Salviati, was, however, a granddaughter of Lorenzo il Magnifico, which enhanced Cosimo's qualifications considerably. The portrait of *Maria Salviati with her Son Cosimo* by Pontormo (Baltimore, Walters Art Gallery) shows Cosimo as the heir to both sides of the family through his mother and his dead father, whose medal Maria reverently holds. The date of this portrait has been much discussed, but the consensus of scholars now is that it was made retrospectively in 1537, when Cosimo succeeded. See Cox-Rearick (1984), n. 13, 237, for literature, and Langedijk (1981–7), vol. 2, who suggested that the portrait might be posthumous, that is, after Maria's death in 1543.

11. Cochrane, 54.

12. See Forster.

13. The statue of *Cosimo I as Augustus* was made by Vincenzo Danti, c. 1568–72, today in the Bargello; Forster, fig. 21. Earlier representations of Cosimo in antique armor, such as Bandinelli's statue and the depiction in the Sala di Leo X, show him as a generic Roman warrior.

14. Carlo Portello executed Salviati's design for the *Elevation of Cosimo to Duke,* and Bronzino made the scene of the

Dispute between Duke Alessandro and the Exiles before the Emperor in Naples, as Vasari related (Life of Aristotile da Sangallo, B&B 5:399–400; Eng. ed., 3:297–9). Forster, 92, shows a table of the paintings, which later formed the basis for decorations of the apartments in the Palazzo Vecchio.

15. Vasari did not paint it until the summer of 1540; Smyth (1992), 123, n. 110, citing Vasari's *Ricordanze.*

16. In the Casa Vasari, 1532, and in SS. Annunziata, 1536–7.

17. Härb makes a similar point, noting that following Vasari's first Roman visit he continued to use exclusively Tuscan models. Only after the second trip did he evidence knowledge of Roman sources.

18. All these changes are among the Maniera conventions analyzed by Smyth (1992), 39–49.

19. Identified and traced by Nova (1992); compare with the example of Salviati's reuse of drawings discussed in Chapter 4, 159. Härb points out that this figure is adapted from the Saint Paul in Raphael's *Ecstasy of Saint Cecilia* in Bologna, though the bare arm is Vasari's addition and is typical of the liberties he took with his sources.

20. The altarpiece, severely damaged in the flood of 1966, was removed to the restoration laboratory at the Fortezza del Basso.

21. The inscription was changed from the drawings to the painting. It reads, "Quos Evae culpa damnavit, Mariae gratia solvit."

22. Smyth (1992) discussed and reproduced the drawing (Florence, Uffizi, 1183E, fig. 65), together with an earlier version also in the Uffizi. A third, in the Louvre, more concerned with composition, makes the design more legible. Reproduced in Barocchi (1964), fig. 18.

23. Simon has done the best job of pulling together the literature and comes closest I believe to a correct interpretation, though mine differs in detail and in emphasis.

24. Ovid, *Metamorphoses,* X, 3–85, tells the story, but the tamed Cerberus is not part of it; this addition seems to be Bronzino's.

25. On the wedding celebration, see Minor and Mitchell.

26. *Ars poetica,* 391–400.

27. Langedijk (1976) brought the Bandinelli statue to attention and discussed the literary associations in Florence. She suggested, 48, that Cosimo had himself represented in Bronzino's portrait in Orpheus's role as the prince of peaceful intentions; Simon, 19, rejected this reading, finding the political message out of keeping with what he saw as an exclusively private image.

28. Simon noted the connection to the *Torso Belvedere,* fig. 19.

29. Neither of the ancient sources mentions Orpheus taming Cerberus, but Cerberus did accompany Orpheus in Bandinelli's statue; the reference would have been clear then, to the Florentines. Bronzino's dog was originally three-headed, but he painted over one head in the final version; see Tucker, fig. 27.

30. Ettlinger, 128, pointed out that Lorenzo, in particular, was connected to Hercules. Pollaiuolo's three large canvases of the *Labors of Hercules* had been hung in his *sala grande;* they

were removed in 1495 by the *Comune* to the Palazzo Vecchio.

31. See Tucker, and the outline drawing, fig. 25, of the first version.

32. Smyth (1955) suggested a trip to Rome at this time. Cox-Rearick (1993), 96, 137, concurs, seeing evidence of Bronzino's knowledge of recent Roman developments in style, especially Jacopino del Conte's *Preaching of the Baptist.*

33. All dates are from Cox-Rearick's recent and definitive study of the chapel (1993).

34. Noted by Cox-Rearick (1993), 301.

35. A door was cut into this wall in 1581–2 and the central part of Bronzino's fresco destroyed. His pupil, Alessandro Allori, painted the overdoor of the *Angels with Chalice, Host, and Globe,* probably where the window had been; Cox-Rearick (1993), 90.

36. See my earlier discussions of this, Bronzino's masterpiece: Hall (1979), 41–5; and (1992), 180–6, where the color is reproduced and discussed.

37. This connection was discovered by Cox-Rearick (1993), 305–6, fig. 180.

38. Cox-Rearick (1993), 314–18.

39. The *Last Judgment* was unveiled for a second time in 1994, after its cleaning and conservation; only when it could be seen afresh was the relationship to it of Bronzino's style and color apparent.

40. See my discussions of the history of the use of ultramarine, with examples and bibliography, in *Color and Meaning* (1992).

41. As pointed out by Cox-Rearick (1993), 143, whose publication preceded the unveiling of the cleaned *Last Judgment* in 1994.

42. This tension between flatness and postures requiring extension in three dimensions is another of the Maniera conventions catalogued by Smyth (1992), 41 and n. 57.

43. See Chapter 4, 140.

44. Life of Francesco Salviati, B&B, 5:522; Eng. ed., 4:62. See also Adelson (1980), 152–3. Cheney (1963a), 1:369, tells us that this image was exceedingly popular in the sixteenth century.

45. This impression is despite the fact that the frescoes have suffered considerable damage and losses.

46. Cheney (1963a), 1:163–4, pointed out that Machiavelli's comments on Livy's discussion of Camillus must have been well known in Cosimo's Florence (*Discourses on the first decade of T. Livius,* Bk. III, 23).

47. Cox-Rearick (1984) demonstrated the significance of the astrological symbolism in Cosimo's message. Elsewhere in the room are allegories of Virtue, Time, and Destiny, also referring to Cosimo. She analyzed the imagery of the Sala dell' Udienza in depth, 272–6.

48. This scene is depicted on the wall that adjoins the chapel. Reproduced in color in Mortari, 29.

49. Cox-Rearick (1993), 42–3.

50. Summers (1977a) discussed the importance of the *Discobolos* fragments in Renaissance Rome. The nude figure standing near the column can be identified as a Satyr with Panther.

It is similar to one in the Villa Albani, reproduced by Margarete Bieber, *The Sculpture of the Hellenistic Age* (New York: Columbia University Press, 1961), fig. 568. I am indebted to Jan Gadeyne for identifying this figure.

51. See Chapter 3, 111. Rubin (1987), 93, n. 50, and Adelson (1980), 161, 193–4.

52. Cox-Rearick (1993), 116, discussed aspects of Bronzino's style in the context of the *paragone* and quoted his letter in reply to Varchi. See also Chapter 4, 168.

53. Both artists were Flemish. Janni Rost (doc. 1536–died 1564) arrived in Florence from Ferrara, where he had been working for Ercole II d'Este, shortly before 11 September 1545. Nicholas Karcher (doc. 1539/1562), came from Mantua, where he had gone from Ferrara by 1539. See Adelson (1983), 907, 904, and n. 14.

54. On Cosimo's tapestry production, see Adelson (1985); on Bachiacca's tapestries, see especially 149–50, 160. See also Adelson (1983): Cosimo's decision to bring weavers to Florence was made quite suddenly, during the summer of 1545, and his motivation may very well have been political. One of the Ferrarese court's attributes of nobility was a ducal tapestry atelier; in fact, Ferrara had the oldest continuous tradition of tapestry weaving in Italy at the time. Cosimo's "abrupt establishment of the two former d'Este weavers, rather than seeking masters in Flanders, may have been a response to the new flare-up of the precedence dispute, calculated to rival – and peeve – Ercole," 915–18.

55. See Adelson's reconstructions (1985), figs. 40–4.

56. Adelson (1985), 158; cited by Davidson (1988), 428.

57. Adelson (1985), 173, n. 100.

58. In black chalk, with traces of squaring in black, 434 × 331 mm, excluding the strip added later at the top. Smyth (1971) convincingly suggested that the upper part of this drawing is preserved in the Uffizi, fig. 34.

59. Either in the Chapel of Eleonora or the Chapel of the Priors. See Cox-Rearick (1993), 82 and especially 32.

60. There has been much discussion and multiple interpretations offered in the recent literature, including the following:

Michael Levey, "Sacred and Profane Significance in Two Paintings by Bronzino," in *Studies in Renaissance and Baroque Art Presented to Anthony Blunt on His 60th birthday* (London and New York: Phaidon, 1967), 30–3.

William Keach, "Cupid Disarmed, or Venus Wounded? An Ovidian Source for Michelangelo and Bronzino," *Journal of the Warburg and Courtauld Institutes* 41 (1978): 327–31.

Graham Smith, "Jealousy, Pleasure and Pain in Agnolo Bronzino's 'Allegory of Venus and Cupid,'" *Pantheon* 39 (1981): 250–8.

Charles Hope, "Bronzino's Allegory in the National Gallery," *Journal of the Warburg and Courtauld Institutes* 45 (1982): 239–43.

Thomas Frangenberg, "Der Kampf um den Schleier: Zur Allegorie Agnolo Bronzinos in der National Gallery London," *Wallraf-Richartz-Jahrbuch* 46 (1985): 377–86.

J. F. Conway, "Syphilis and Bronzino's London Allegory,"

Journal of the Warburg and Courtauld Institutes 49 (1986): 250–5.

Iris Cheney, "Bronzino's London *Allegory*: Venus, Cupid, Virtue and Time," *Source* 6, no. 2 (1987): 12–18.

Lynette M. F. Bosch, "Bronzino's London *Allegory*: Love versus Time," *Source* 9, no. 2 (1990): 30–5.

Paul Barolsky and Andrew Ladis, "The 'Pleasurable Deceits' of Bronzino's So-called London *Allegory*," *Source* 10, no. 3 (1991): 32–6.

Robert W. Gaston, "Love's Sweet Poison – A New Reading of Bronzino's London *Allegory*," *I Tatti Studies* 4 (1991): 249–88.

Leatrice Mendelsohn, "L'Allegoria di Londra del Bronzino e la retorica di carnevale," in Monika Cämmerer, ed., *Kunst des Cinquecento in der Toskana,* 152–67.

Italienische Forschungen, ser. 3, vol. 17 (Munich: Bruckmann, 1992), Leatrice Mendelsohn, "Saturnian Allusions in Bronzino's London *Allegory*," in Massimo Ciavolella and Amilcare A. Iannucci, eds., *Saturn from Antiquity to the Renaissance,* University of Toronto Italian Studies, no. 8 (Ottawa: Dovehouse Editions, 1992), 101–50.

John F. Moffitt, "A Hidden Sphinx by Agnolo Bronzino, *'ex tabula Cebetis Thebani,'*" *Renaissance Quarterly* 46 (1993): 277–307.

Jaynie Anderson, "A 'Most Improper Picture': Transformation of Bronzino's Erotic Allegory," *Apollo* 139, no. 384 (1994): 19–28.

61. Cox-Rearick (1996), 229, argued convincingly that the gift would most likely have been sent between late 1544 and July 1545.

62. Panofsky's identification of the subject as an exposure of vice that was intended originally to be paired with the tapestry the *Vindication of Innocence* was the canonical interpretation of the allegory for a quarter century or more. In *Studies in Iconology: Humanist Themes in the Art of the Renaissance* (1939; reprint, New York: Harper and Row, 1972), 86–91.

63. Schlitt, chap. 5, discussed the rivalry between the two factions and the animus toward Salviati on the part of the faction centered around Tribolo.

64. This theme was first enunciated in Pontormo's portrait of the child Cosimo with his mother, see n. 10 in this chapter; Cox-Rearick (1984), 241.

65. For descriptions, identifications, and reproductions of all the Palazzo Vecchio decorations, see Allegri and Cecchi.

66. Kirwin, 114, n. 25. For the identification of the figures surrounding Cosimo, see 115–20.

67. Gombrich (1966), "The Early Medici as Patrons of Art," in *Norm and Form,* 35–67, and the Wittkowers (1964) made important early contributions to demythologizing Medici patronage.

68. Compare with the Vatican Sala Regia: 39 by 110 feet.

69. *Ragionamenti* (1588), in Vasari-Milanesi, 8:14–17, cited by Adelson (1980), 152.

70. The Consiglio Maggiore was instituted in 1494. At the inauguration of the Salone in 1495, 1,753 citizens were present, Allegri and Cecchi, 231–2.

71. Letter by Vasari to Duke Cosimo, 3 March 1563; Frey, 1:722.

72. On the Venetian ceiling, see Schulz.

73. Cited by Boase, 311 and 314.

74. For the wedding celebrations these walls were covered with temporary canvases. For description see Starn and Partridge.

75. Pillsbury (1976) reconstructed the working method in this manner from surviving drawings, some of which he reattributed.

76. The prototype Borghini had in mind for this imagery appears to be a fresco in the Sala dell' Udienza of the Palazzo dell'Arte dei Guidici e Notai painted in 1366; Van Veen (1998). An alternate reading by Starn and Partridge, 190, interpreted the inclusion of the shields as asserting Cosimo's control of the city and its guilds. Both meanings are, in fact, encompassed in the image.

77. It was edited after his death and published by his nephew, Giorgio Vasari the Younger, in 1588. The text was reprinted by Milanesi, 8:9–255. A translation was made by Jerry Lee Draper, "Vasari's Decoration in the Palazzo Vecchio: The *Ragionamenti* Translated with an Introduction and Notes" (Ph.D. diss., University of North Carolina at Chapel Hill, 1973).

78. The assault on overinterpretation was launched by Gombrich (1975) and taken up by Hope (1981, 1988) and Robertson (1982, 1992).

79. McGrath, especially 120–1. Much the same conclusions are drawn by Paola Tinagli Baxter, "Rileggendo i 'Ragionamenti,'" in the same volume, 83–93.

80. Williams (1998), 174.

81. Scorza, 279 and n. 54.

82. D'Addario, 78.

83. Hall (1979), 7, citing Antonio Panella, "L'introduzione a Firenze dell'Indice di Paolo IV," *Rivista storica degli archivi toscani* 1 (1929): 11–25.

84. Allori was back in Florence intermittently during this period and, according to Cox-Rearick (1992), 244, may have assisted Bronzino in finishing the choir in San Lorenzo in 1557, left incomplete by Pontormo at his death on 1 January of that year.

85. 17 March 1563, Frey, 1:737.

86. Wazbinski (1978), 50.

87. Frey, 3:215–16, cited by the Wittkowers, 46.

88. Dempsey (1980), 555. He discusses the transformation of the academy into a full replacement for the Compagnia di San Luca and the Arti di Speziali, especially 552–9; also Barzman.

89. Dated just after 1560 by Lecchini Giovannoni (1991), cat. 11, 218–19.

90. Wazbinski (1987b), 1, 197–213, analyzed the *Martyrdom* in these terms.

91. See Chapter 5, 191, and Gilio in Barocchi, ed., *Trattati,* 2:48, 46, 33.

92. Wazbinski (1987b), 1, 213. When Macchietti painted the *Martyrdom of Saint Lawrence* in Santa Maria Novella in 1573 he conspicuously avoided any reference to Bronzino and turned instead to Venice for inspiration; Hall (1979), 73. On the critical fortune of Michelangelo in seventeenth-century

artwriting, see Catherine M. Soussloff, "Imitatio Buonarroti," *Sixteenth Century Journal* 20 (1989): 581–602, with bibliography also on Cinquecento responses to his art and example.

93. The sculptors, too, participated, contributing the eight small bronzes for the corner niches.

94. Borghini's program is known through his correspondence with Vasari, published in Frey, vol. 2, especially 886–91. On the Studiolo, see Berti (1967), Vitzthum, and Schaefer. Bolzoni has connected Borghini's program to the memory theater of Giulio Camillo, on which see Frances A. Yates, *The Art of Memory* (London: Routledge and Kegan Paul, 1966), chap. 7, 129–59.

95. As pointed out by Hartt, *A History of Italian Renaissance Art,* 4th ed., ed. David G. Wilkins (Garden City, NY: Prentice Hall, 1994), fig. 706.

96. See Dempsey (1980), 565–6, for an excellent summary of how Renaissance academic thinking differed from the subsequent Idealist tradition.

97. Wazbinski (1987b), 1, 99–101, who pointed out that the theme of Michelangelo as a teacher and his works as "schools" for other artists was emphasized by Benedetto Varchi in his funeral oration.

98. Vasari's use of ekphrasis was first analyzed by Svetlana Alpers. Recent contributions include Carrier; and Land, with extensive bibliography.

99. Goldstein (1993), and especially 12–13. Barolsky (1998), making a similar point, likens Vasari to Boccaccio, a fellow teller of tales.

100. As pointed out by Rubin (1995), 403, who showed how Vasari used antique literary conventions in the construction of his *Lives.*

101. See Goldstein (1991), and especially 649–50.

102. In the second dedication, and in the preface to part 2. Alpers, 209, regarded these statements to be rhetorical attempts to praise the duke's patronage and Michelangelo's art, but pointed out that Panofsky and others had argued differently.

103. Zerner (1972b), 109. S. J. Freedberg (1965) characterized the Maniera generation in terms of a masked sense of inferiority.

104. The difference between Roman and Florentine chapels was pointed out by Iris Cheney in her review of Hall (1979), *Journal of the Society of Architectural Historians* 39 (1980): 245.

105. Published in Rollin van N. Hadley, ed., *Drawings. Isabella Stewart Gardner Museum* (Boston: Trustees of the Isabella Stewart Gardner Museum, 1968), no. 10, pl. 10: black chalk on white paper, 274 × 402 mm. The attribution was made by S. J. Freedberg, rejected by Smyth (1971), 43, as a workshop copy, but recently affirmed by Cox-Rearick (1992), 244.

106. Bober and Rubinstein, no. 109, now in Munich, Glyptothek. It can be seen in Martin van Heemskerck's sketch of the Maffei courtyard, where it is shown from a similar headfirst position; see Bober and Rubinstein, fig. on 476.

107. Roskill, ed., 149.

108. Pino, in Barocchi, ed., *Trattati,* 1:115.

109. S. J. Freedberg (1965), 189, observed that this is a device used repeatedly by these midcentury painters.

110. On the iconography of the Resurrection, see Hubert Schrade, *Ikonographie der christlichen Kunst: Die Sinngehalte und Gestaltungsformen: I, Die Auferstehung Christi* (Berlin, Leipzig: De Gruyter, 1932), especially chaps. 6 and 8.

111. Reproduced, for example, in De Tolnay, *The Medici Chapel* (1948), vol. 3 of *Michelangelo:* Windsor, fig. 145; Louvre, fig. 144.

112. Reproduced in Hall (1979), fig. 101.

113. Life of Pontormo, B&B, 5:331–2; Eng. ed., 3:253.

114. The frescoes were whitewashed in 1738 and finally destroyed completely in 1742; see Cox-Rearick (1964), 320 and n. 18.

115. Borghini, 78–9, 196.

116. See Berti (1993), for quotes from Bocchi (1591), Vasari, and Riccha (1757).

117. In the British Museum (BM 1974-4-6-36) as Bronzino; attribution to Pontormo by Cox-Rearick (1992), 246, which is certainly correct. For other surviving drawings, see Cox-Rearick (1964), 318–42.

118. For example, in the Life of Fra Angelico (Fra Giovanni da Fiesole), B&B, 3:273–4; Eng. ed., 1:341–2.

119. Borghini's letter to Vasari in Rome 19 October 1572, Frey, 2:706, cited by Wazbinski (1987a), 643, "Il *modus* semplice."

120. Borromeo, chap. 14, specified, "All the minor chapels should have the same length, height and width. They should, as far as possible, be similar in every part and mutually harmonious." Voelker, 177.

121. See Chapter 5, 201.

122. On this project and the style of Counter-Maniera in sacred art in Florence, see Hall (1979).

123. Borghini, 93–4.

124. Examples among several mentioned are Stradanus's *Crucifixion* in SS. Annunziata, Borghini, 116, and Naldini's *Deposition* in Santa Maria Novella, 103.

125. This is the criticism Borghini made of Jacopo Coppi's *Christ in Glory with Saints* in Santa Maria Novella, 99. See also the discussion of Naldini, *Ascension of Christ* in the Carmine, 115.

126. In the chapel of Girolamo Michelozzo, the son's portrait is discussed by one of the dialogue partners, whose altarpiece in the Carmine was painted by Santi di Tito; Borghini, 115. It was destroyed in the eighteenth-century fire in that church.

127. Borghini, 116.

128. See Chapter 5, 206.

129. Borghini, 77–8. Gilio is mentioned on 53 and 82.

130. Borghini, 61.

131. Borghini, 196.

132. All three of his altarpieces in Santa Maria Novella come off rather badly; Borghini, 199–200.

133. This criticism is of Vasari's *Christ on the Way to Calvary,* Borghini, 191.

134. Borghini, 177. Stradanus is criticized for cutting off figures at the waist in his *Ascension of Christ* in Santa Croce, 189.

135. Borghini, 178, 180.

136. Borghini, 181.

137. Borghini, 193.

138. Borghini, 196.

139. *Deposition,* Santa Croce; Borghini, 186.

140. Borghini, 200.

141. Borghini, 200.

142. Borghini, 194.

143. The cupola was executed 1420–36. See Howard Saalman, *Filippo Brunelleschi: The Cupola of Santa Maria del Fiore* (London: A. Zwemmer Ltd., 1980), 112–34, especially 112, 134.

144. On the history and execution of the commission, see Heikamp (1967) and now Acidini Luchinat (1995); the only discussion to appear so far in English is Acidini Luchinat (1998).

145. The letters were published by Cesare Guasti, *La cupola di Santa Maria del Fiore* (Florence: Barbèra, Bianchi & Co., 1857).

146. For detailed analysis of the iconography, see Verdon.

147. When Vasari was the artist in charge, work was begun before he could return from Rome, where he was finishing the frescoes in the Sala Regia by the Bolognese painter Lorenzo Sabatini, who had also preferred to work in *secco.* When Vasari discovered that Sabatini was working in *secco,* he put an end to that bad practice. Payments to Sabatini were concentrated between July and September 1572, and by 13 September he had already returned to Bologna. It is thought that Sabatini quit, or was sent away, because his work was deemed unsatisfactory; see Acidini Luchinat (1995), especially 75.

148. Heikamp (1967), 46.

149. Chapel of the Compagnia di San Luca, which was frescoed beginning in 1569 by Vasari, Santi di Tito, and Allori; see Summers (1969) and Wazbinski (1987b), vol. 1, pt. 1, chap. 3, 111–54.

150. Florence, Uffizi, no. 11072 F. See Lecchini Giovannoni (1991), cat. 59, 243: the drawing was traditionally attributed to Federico Zuccaro but had been reattributed by Pouncey and Cecchi to Allori. It is considered by Cristina Acidini Luchinat ("Federico Zuccari e la cultura fiorentina. Quattro singolari immagini nella cupola di Santa Maria del Fiore," *Paragone. Arte* 40, no. 467 [1989]: 28–56, esp. 54 and n. 52) as a possible project for the Duomo cupola, and would thus be dated c. 1574. However, Lecchini Giovannoni considers the Duomo connection improbable.

151. Acidini Luchinat (1995), 82.

152. Heikamp (1967), 44.

153. See his letter to Vasari regarding the *Resurrection* altarpiece for Santa Maria Novella, 28 January 1567, Frey, 2:291; quoted in Hall (1979), 111–12.

154. Borghini, 90.

155. See Chapter 5, 192.

156. I suggested a dependence of Santi on Federico Zuccaro in 1979, which has now been affirmed by other students of Santi: Hall, 104; Lecchini Giovannoni and Collareta (1985), no. 13 (fig. 14), confirmed the relationship, 34–5, and found Federico's influence as early as 1570–1; 13, 14. Spalding (1982), 332, did not concur.

157. The *Supper at Emmaus* is reproduced in Hall (1979), fig. 104, and Freedberg (1993), fig. 280 in color.

158. Borghini, 198, 106, quoted in Hall (1979), 104.

159. Spalding (1982), 69. Wazbinski (1987b) speaks of the classic quality of this art; 1, 188, 291.

160. See for example the *Annunciation* in the Accademia; Allori received payment in 1579, but the painting was more or less finished by 1578; Lecchini Giovannoni (1991), cat. 68, 246–7.

161. Pen and brown ink, brown wash, heightened with white, over black chalk, on blue paper, 366 × 474 mm. Heikamp (1968), 28, connected these drawings of Allori with tapestries and suggested that it was in this genre that Allori excelled. See also Lecchini Giovannoni (1991), who reproduced all four drawings.

162. Spalding (1987) explained the iconographical program.

163. The sixteenth-century debate over whether *colore* or *disegno* was superior grew out of the rivalry between Venice *(colore)* and Florence *(disegno).* The Florentine Vasari of course championed *disegno,* which he regarded as the intellectual component of painting. See Maurice Poirier, "Studies on the Concepts of *Disegno, Invenzione* and *Colore* in Sixteenth and Seventeenth Century Italian Art and Theory" (Ph.D diss., New York University, 1976); and Hall (1992), 2, for a summary.

164. The *Ecce Homo* was painted in Rome, c. 1604, and the *Deposition,* for Empoli, was executed in Florence in 1607.

CHAPTER SEVEN

1. McGinness (1982), 359, 361. The same author (1995), 178, noted that the rhetoric of blame had all but vanished from sermons in the 1570s.

2. On Pius IV's projects to renovate and even refound the city, see Marcello Fagioli Dell'Arco and Maria Luisa Madonna, "La Roma di Pio IV: la 'Civitas Pia,' la 'Salus Medica,' la 'Custodia Angelica,'" *Arte Illustrata* 5 (1972): 383–402; and "La Roma di Pio IV: Il sistema dei centri direzionali e la rifondazione della città," *Arte Illustrata* 6 (1973): 186–212.

3. On Protestant iconoclasm, see David Freedberg (1989).

4. Scavizzi (1989) pointed out that the Protestant attacks on images and specifically on the cross brought about a reaction in the Roman Catholic Church, which leaped to defend and promulgate veneration of the cross.

5. Michael Bury, "The Senarega Chapel in San Lorenzo, Genoa: New Documents about Barocci and Francavilla," *Mitteilungen des Kunsthistorischen Institutes in Florenz* 31 (1987): 327–56, especially 342. The author has transcribed the letter in appendix V.

6. The history of the obelisk and its transfer was given by Iversen, 18–46, based on the account of the architect himself, Domenico Fontana (modern edition, 1978).

7. Iversen, 38.

8. Michele Mercati, "Della nuova erettione del gli obelischi di Roma," in *De gli obelischi di Roma* (Rome, 1589), 347–8; Iversen, 50.

9. Gregory XIII had paid a visit to the villa in 1579 as soon as

it was ready. The pope repaid the hospitality by canceling the cardinal's pension as a "poor" cardinal, saying that he was "too rich." Borromeo wrote Cardinal Gambera in 1580 reproaching him for his extravagances. Cited by Coffin (1979), 340–1.

10. The projects mentioned here are only a sampling. For full documentation, see *Roma di Sisto V.*

11. Only Veronica is admitted from an extra-Gospel source; see Barroero (1991a), 141, for description, attributions, and reproductions.

12. On Sixtus's Franciscan mysticism and its role in the design of the Sistine Chapel in Santa Maria Maggiore, see Ostrow (1996), chap. 1.

13. Bevilacqua, 36. On Rocca, see Paola Munafò and Nicoletta Muratore, "Sisto V e Angelo Rocca," in *Roma di Sisto V,* 474–80. Antoniano probably made the final selection of subjects for the Vatican Library from those proposed by Federico Rinaldi: see Dalma Frascarelli, "Nota su Federico Ranaldi e Silvio Antoniano," in ibid, 469. On the program for the Lateran Palace, see Barroero (1991b).

14. The iconography of each of the rooms is summarized by Freiberg (1995b), 25–30.

15. On the various Constantine cycles at the end of the century in Rome, see Freiberg (1995a).

16. The best illustrations, all in color, are in Pietrangeli, 222–85.

17. Saunders analyzed these engravings in the context of iconoclasm.

18. *Le vite de' pittori scultori et architetti dal pontificato di Gregorio XIII. del 1572 in fino a' tempi di Papa Urbano Ottavo nel 1642* (Rome, 1642). Contributions to the separation of hands were made by Alessandro Zuccari (1992) and Bruno Haas, "Per una identificazione dei maestri dei cicli pittorici sistini," in *Roma di Sisto V,* 47–58.

19. Barroero (1991b), 217.

20. Zuccari (1992), 75–6.

21. Rudolph Wittkower aptly described the style advocated by Sixtus V as one that "tends toward dissolving Mannerist complexities without abandoning Mannerist formalism." See *Art and Architecture in Italy, 1600–1750,* Pelican History of Art, rev. ed. (Harmondsworth: Penguin, 1965).

22. Ostrow (1996), 80; see his n. 26 for bibliography.

23. Zucchi decorated the apse with a fresco of the *Descent of the Holy Spirit,* that is, *Pentecost,* commissioned under Pope Gregory XIII and dated 1583. He worked again in the church on the interior of the facade and the first chapel on the right, the Tolfa Chapel, beginning in 1588. Pillsbury (1974) published the documents. See also Valone, and *Roma di Sisto V,* 268–77.

24. For example, the Lateran basilica and the Lateran Baptistery, Santa Costanza, Santi Cosma e Damiano. See Ostrow (1990), 257.

25. Irving Lavin first pointed out that late Cinquecento marble revetment seemed intended to undermine the architectural system, in contrast to Bernini's innovative use of the same materials. See his *Bernini and the Unity of the Visual Arts,* 2 vols. (New York: Oxford University Press, 1980), 1:50–3, as cited by Ostrow (1990), 253.

26. The legacy of this kind of colored marble revetment to the Baroque was, of course, enormous. It was used already in the 1590s by Clement VIII for his chapel in Santa Maria sopra Minerva.

27. Shearman (1992).

28. Frederic C. Church, *The Italian Reformers* (1932; reprint, New York: Octagon, 1974), 219.

29. Paleotti in Barocchi, ed., *Trattati,* 2, Bk. I, chap. 19, 215.

30. For an up-to-date assessment of the early Jesuits, see O'Malley (1993b), especially chap. 7, "Religious and Theological Culture."

31. I am following Hibbard (1972) in this section; especially 35–41.

32. In a forthcoming book on the Gesù Nuovo in Naples, Maria Ann Conelli strengthens the evidence presented by Hibbard that the program was evolved by 1590 and that it was specifically Jesuit in its concerns.

33. Muziano's altarpiece has been transferred to the Jesuit College in Rome. It is illustrated in *Roma di Sisto V,* 172.

34. Hibbard (1972), 39.

35. The altarpiece was for the Chapel of the Passion, the second chapel on the right. The frescoes were executed by Guaspare Celio in the mid-1590s.

36. Zuccari (1995), 343–4.

37. On the document requiring symmetry in the design and materials of the chapels, see Daniele Ferrara, "Artisti e committenze alla Chiesa Nuova," in *La Regola e la fama,* 108–9.

38. Zuccari (1995), 349.

39. Michael Jaffé, *Rubens and Italy* (Oxford: Phaidon, 1977), 119, n. 27.

40. This was in May 1583, three years before the painting was completed: Barbieri, Barchiesi, and Ferrara, 56 and n. 242. Cited by Zuccari (1995), 343. Rubens's contract for the high altarpiece reflects a similar degree of control by the fathers. They required to see an example of his work; the design he proposed had to meet their requirements; and they reserved the right to refuse the finished painting and simply return it to him. Jaffé (as in note 39), 87.

41. Barbieri, Barchiesi, and Ferrara, 67.

42. Zuccari (1981a), who noted this motif running through the Chiesa Nuova altarpieces, has argued convincingly that the Mary in Caravaggio's *Entombment* (Pl. XXXII) with her arms outstretched is depicted in the ancient attitude of prayer, 97–105.

43. Baglione (1642) included a short life of Barocci. Bellori's biography, published in his *Vite* (1672), is our principal source for the career of Barocci.

44. On the Casino and its decoration, see Graham Smith (1977b), Walter Friedlaender (1912), and specifically on Barocci, Emiliani, 1, 15–25. The other principal painters were Santi di Tito and Federico Zuccaro. This commission provided the opportunity for the three of them to shape their reformed styles in tandem. The frescoes have suffered badly.

45. Zeri. Macioce, 72, pointed out that art "outside of time" – *senza tempo* was Zeri's phrase – transgressed the Council of

Trent's prescription that paintings should adhere strictly to sacred narrative and was therefore not a style that the Counter-Reformation would have championed. Sydney Freedberg's damning phrase, "the affectation of simplicity" (1993), 660, applies to the *arte sacra,* but not to Barocci.

46. Emiliani, 2:303–5, who reproduced detailed photographs and the few drawings for this sparsely documented painting.

47. Scavizzi (1989) identified a number of subjects dealing with the cross that received increased attention in the Counter-Reformation, among them the Brazen Serpent and the legend of the True Cross.

48. Mâle (1932), 65–72, discussed depictions of penitence, especially Peter's and Mary Magdalen's, although he did not mention Jerome. The special association of Sixtus V with Jerome, discussed by Ostrow (1996), 11–19, would have given added prominence to the saint in this period.

49. Letter from Grazioso Graziosi, the minister of the duke of Urbino, 1586, quoted by Emiliani, 2, 217–19.

50. Cigoli and Pagani went together to Arezzo, and then Cigoli persuaded Passignano to accompany him to Perugia, Dempsey (1987), 62. For the *Madonna del Popolo,* see Emiliani, 1, 128–49.

51. Emiliani, 2, 217–29, 346–59.

52. Emiliani, 2, 231, who also reproduced and discussed the preparatory drawings.

53. David Freedberg's term (1989), 237.

54. See Heimbürger, who made the case for Caravaggio's genre paintings as allegories on the model of Netherlandish prints.

55. The dates are only speculative. Gilbert (1995), 132–3, argues for a later date, 1595–6.

56. Explicated by Franca Trinchieri Camiz (1991), 217.

57. Hibbard (1983), 51.

58. See discussion in Chapter 5.

59. Jacob Hess, "Modelle e modelli del Caravaggio," *Commentari* 5 (1954), 272–3, associated her pose with the classical statue now in Florence in the Loggia dei Lanzi, but in Rome in Caravaggio's time. See Bober and Rubinstein, no. 166. This figure may or may not be precisely the source of the Madonna's crossed foot, but the motif is one that suggests an antique prototype.

60. Most recently, Gilbert (1995), 125.

61. Trinchieri Camiz (1992) has convincingly pushed the date forward on the basis of documents regarding the purchase, sale, and repurchase of the property by Del Monte.

62. Bellori (1671), 214, quoted by Mina Gregori in *The Age of Caravaggio,* 36.

63. W. Friedlaender (1955) reproduced an eighteenth-century engraving in which the tomb at the left is clearly legible, fig. 102, but it could have been an invention of the engraver rather than a reflection of something Caravaggio painted that has disappeared from sight. For the view that Christ is being lowered into the tomb in the area of the chapel altar, see Georgia Wright.

64. In this section I am following the model and using the insights of Janis Bell's analysis of Caravaggio's color and

light, demonstrated on the *Supper at Emmaus* in London (1995).

65. See Hall (1992) and the earlier essay specifically on modeling (1987).

66. See Bell (1995) for demonstration of this point.

67. Bellori's text is reprinted with a translation in Panofsky, 154–77, and especially 174.

68. For a bibliography of nineteenth-century views of the decline into *la maniera* described by Bellori, see Smyth (1992), n. 8. Smyth translated Bellori's comments, 22–3: "This vice, destroyer of painting, began to germinate in masters of honoured reputation and became rooted in the schools that then followed. Wherefore, it is incredible how much they degenerated, not only in comparison with Raphael, but with others who initiated *la maniera.* Florence, which prided itself on being the mother of painting, and the whole region of Tuscany, which was illustrious by reason of its painters, already were silent . . . and the others of the school of Rome, no longer raised their eyes to look at the abundance of examples, antique and modern, had forgotten every praiseworthy advantage [to be obtained from them]." It can be argued that Bellori is condemning not those "who initiated *la maniera,*" but those who allowed it to degenerate into *fantastica Idea* no longer based on nature.

69. Summers (1987), 285.

70. See Chapter 5, 194.

71. This is a hotly debated topic. For a review of the evidence since Nicholas Pevsner first examined it in *Academies of Art, Past and Present* (1940), see Goldstein (1988), chap. 3, whose conclusions are followed here.

72. Feigenbaum, 60–1.

73. Boschloo (1974), chap. 7, pointed out Paleotti's influence on the Bolognese artistic scene. For review of this issue and bibliography, see De Grazia Bohlin, 28.

74. His *Supper of Saint Gregory* is today in the Pinacoteca in Bologna.

75. Published by Fanti, who established that Annibale, not Agostino, was the author.

76. Cropper (1987) discussed the effect on the Carracci of Vasari's publication of the *Lives* and of the availability of reproductive engravings.

77. Denis Mahon, in a heartfelt effort to rehabilitate the Carracci's reputation, argued that Annibale was not a restorer of the Classic style of the High Renaissance but a reformer, 198. Rensselaer Lee's review of Mahon (*Art Bulletin* 33 [1951]: 204–12) reasserted the appraisal of the Carracci as eclectic. In 1971 Donald Posner published his two-volume monograph on Annibale Carracci. Taking a position similar to Mahon's, he gave only minimal consideration to Annibale's relationship to previous painting, for which he was attacked by Charles Dempsey in 1977. Dempsey distinguished Annibale's use of Correggio and Raphael from mere imitation; rather, he said, Annibale "imitated nature with their guidance," 55. Dempsey undertook to defend and define the Carracci academy.

78. How this kind of imitation continued in the seventeenth

century was made clear in the Domenichino exhibition, where Agostino Carracci's *Communion of Saint Jerome* (Bologna, Pinacoteca, c. 1591–2) and Domenichino's creative remaking of it (Vatican, Pinacoteca, dated 1614) were shown side by side. *Domenichino 1581–1641.* Exh. cat. (Milan: Electa, 1996), cat. nos. 20, 97.

79. Dempsey (1977, 1987) has discussed the influence of Barocci on Annibale.

80. Cited by Mahon, 257.

81. Dolce, Roskill ed., 156; cited by Robertson (1990), 28–9.

82. Posner, 1:44, pointed out the relationship to the *Sistine Madonna*.

83. Annibale's letters from Parma and Venice in 1580 published by Malvasia, though dismissed by some scholars as fabrications of the author, now appear to be genuine; De Grazia Bohlin, 36. If it took him six years to respond to his Venetian study trip, it would suggest that Annibale worked his way through his sources in a very systematic way.

84. Dempsey (1968), 371–2, pointed out among other examples that the *Polyphemus and Galatea* is an astonishingly literal "copy" of the painting described by Philostratus, and *Thetis carried to the Bridal Chamber of Peleus* (executed by Agostino) is based on a painting that Valerius Flaccus described as decorating the ship *Argo*.

85. See Chapter 5.

86. Zapperi has offered the interesting hypothesis that Cardinal Farnese, in his rivalry with Pope Celement VIII, had this kind of titillating display created precisely because the moralistic Clement's censorship could not reach him in his private palace. On Clement's censorship of images in churches, see Zuccari (1984), chap. 1.

87. Martin, 78.

88. For analysis and discussion of the frieze as a format, see Boschloo (1981).

89. Scott has recognized the relationship between the choice of statues and the subjects of the narratives.

90. Weston-Lewis, 301.

91. De Grazia Bohlin, no. 31.

92. De Grazia Bohlin, 31–3. It was Domenico Tibaldi (1541–83), the brother of Pellegrino Tibaldi, from whom Agostino learned Cort's technique when he studied with Tibaldi in 1578/1579–81.

93. Dated 1590–5 by De Grazia Bohlin, no. 190. *Tra mito e allegoria,* no. 131, published what appears to be a second state in which an attempt, of undetermined date, was made to "modify" the nudity.

94. Recorded by Malvasia, 1, 281. De Grazia Bohlin quoted the passage, 290.

95. Reproduced in De Grazia Bohlin, nos. 176, 177.

96. Freiberg (1995b), 37, cites Clement's sermon from archival documents.

97. See discussion in Dacos (1969), 121–35, and especially 122.

98. Battisti, "Classicism," in the *Encyclopedia of World Art* (New York: McGraw-Hill, 1959) and *L'antirinascimento: con un appendice di manoacritti inediti* (Milan: Feltrinelli, 1962).

99. See Chapter 5, n. 138.

100. Comanini, *Il figino* (Mantua, 1591), 187; on Zuccaro, see Summers (1987), 302.

101. He had begun work in the late 1550s. The first volume appeared in 1588 and the second in 1594, covering the period from the beginning of Christianity to the beginning of the fourth century. For recent studies concerning Baronio and art, see Romeo De Maio, et al. *Baronio e l'arte,* Atti di convegno internazionale di studi (Sora: 1985).

102. Krautheimer.

103. On the Altemps Chapel, see B. Torresi, "La capella Altemps in Santa Maria in Trastevere," *Quaderni dell'Istituto di Storia dell'Architettura dell'Università di Roma* (1975): 159–70; Helmut Friedel, "Die Cappella Altemps in S. Maria in Trastevere," *Römisches Jahrbuch für Kunstgeschichte* 17 (1978): 89–123; and *Roma di Sisto V,* 242–5.

104. Macioce analyzed the art of the last decade, and particularly of Cavaliere D'Arpino, and noted the continuing presence of Maniera conventions in the paintings executed for Sixtus V.

105. See the studies and photographs of the restoration completed in 1979: *Gli affreschi del Cavalier d'Arpino in Campidoglio. Analisi di un'opera attraverso il restauro,* exh. cat., Rome, Palazzo dei Conservatori (Rome: Multigrafica, 1980).

106. On acuity perspective, see Janis C. Bell. "Acuity: A Third Type of Perspective." *Raccolta vinciana* 27 (1997), 105–53.

Bibliography

As a general rule, the most recent work on a topic is listed and should be consulted for further bibliography.

ABBREVIATION: B&B: Vasari, *Le vite de' pi eccelenti pittori, scultori ed architettori nelle redazioni del 1550 e 1568.* Edited by Rosanna Bettarini and Paola Barocchi.

Acidini Luchinat, Cristina. "Traccia per la storia delle pitture murali e degli artisti." In Cristina Acidini Luchinat and Riccardo Dalla Negra, eds., *Cupola di Santa Maria del Fiore, Il cantiere di restauro 1980–1995,* 63–86. Rome: Istituto Poligrafico e Zecca dello Stato, 1995.

"Vasari's Last Paintings: The Cupola of Florence Cathedral." In Philip Jacks, ed., *Vasari's Florence: Artists and Literati at the Medicean Court. The Symposium. 16–19 April 1994,* 238–52. New York: Cambridge University Press, 1998.

Ackerman, James S. "The Belvedere as a Classical Villa." *Journal of the Warburg and Courtauld Institutes* 14 (1951): 70–91.

The Cortile del Belvedere. Studi e documenti per la storia del Palazzo Apostolico Vaticano, no. 3. Vatican City: Biblioteca Apostolica Vaticana, 1954.

Adelson, Candace. "Bacchiacca, Salviati, and the Decoration of the Sala dell'Udienza in Palazzo Vecchio." In *Le Arti del Principato Mediceo,* 141–200. Specimen, no. 6. Florence: Studio per Edizioni Scelte, 1980.

"Cosimo I and the Foundation of Tapestry Production in Florence." In Gian Carlo Garfagnini, ed., *Firenze e la Toscana dei Medici nell'Europa del Cinquecento. 3: Relazioni artistiche. Il linguaggio architettonico,* 899–924. Convegno internazionale di studi, Firenze, 1980. Biblioteca di storia toscana moderna e contemporanea, studi e documenti, no. 26. Florence: Olschki, 1983.

"The Decoration of Palazzo Vecchio in Tapestry: The 'Joseph' Cycle and Other Precedents for Vasari's Decorative Campaigns." In Gian Carlo Garfagnini, ed., *Giorgio Vasari: tra decorazione ambientale e storiografia artistica,* 145–77. Convegno di Studi, Arezzo, 1981. Florence: Olschki, 1985.

Adhémar, J. "Aretino: Artistic Adviser to Francis I." *Journal of the Warburg and Courtauld Institutes* 17 (1954): 311–18.

Gli affreschi di Paolo III a Castel Sant'Angelo: Progetto ed esecuzione, 1543–1548. Exh. cat. 2 vols. Rome: De Luca, 1981.

The Age of Caravaggio. Exh. cat. New York: Metropolitan Museum of Art, 1985.

The Age of Correggio and the Carracci: Emilian Painting of the Sixteenth and Seventeenth Centuries. Exh. cat. Washington, D.C., National Gallery of Art. New York: Cambridge University Press, 1986.

Agosti, Giovanni. "Precisioni su un 'Baccanale' perduto del Signorelli." *Prospettiva* 30 (1982): 70–7.

Allegri, Ettore, and Alessandro Cecchi. *Palazzo Vecchio e i Medici: Guida storica.* Florence: Studio per Edizioni Scelte, 1980.

Alpers, Svetlana Leontief. "*Ekphrasis* and Aesthetic Attitudes in Vasari's *Lives.*" *Journal of the Warburg and Courtauld Institutes* 23 (1960): 190–215.

Alt, Winston Drew. "Development in the Art of Annibale Carracci." 2 vols. Ph.D. diss., Harvard University, 1983.

Andrea del Sarto 1486–1530. Dipinti e disegni a Firenze. Exh. cat. Milan: D'Angeli-Haeusler, 1986.

Armenini, Giovanni Battista. *De' veri precetti della pittura* (1586). Translated and edited by Edward J. Olszewski. *On the True Precepts of the Art of Painting.* Renaissance Sources in Translation. New York: Burt Franklin & Company, 1977.

Art before the Iconoclasm. Northern Netherlandish Art 1525–1580. 2 vols. Gravenhage: Staatsuitgeverij, 1986.

L'Art de Fontainebleau. Actes du Colloque international sur l'art de Fontainebleau, Fontainebleau and Paris, 1972. Edited by André Chastel. Paris: Editions du Centre National de la Recherche Scientifique, 1975.

Askew, Pamela. "Perino del Vaga's Decorations for the Palazzo Doria, Genoa." *Burlington Magazine* 98 (1956): 46–53.

Baglione, Giovanni. *Le vite de' pittori, scultori et architetti: dal pontificato di Gregorio XIII del 1572 in fino a' tempi di Papa Urbano Ottavo nel 1642.* Eds., Jacob Hess and Herwerth Rottgen, *Studi e Testi.* Vols. 367–9. Citta del Vaticano: Biblioteca Apostolica Vaticana, 1995.

Bambach Cappel, Carmen. "A Substitute Cartoon for Raphael's *Disputa.*" *Master Drawings* 30 (1992): 9–30.

Barbieri, Costanza, Sofia Barchiesi, and Daniele Ferrara. *Santa Maria in Vallicella: Chiesa Nuova.* Rome: Palombi, 1995.

Barnes, Bernadine Ann. *Michelangelo's Last Judgment: The Renaissance Response.* Berkeley: University of California Press, 1998.

"Metaphorical Painting: Michelangelo, Dante, and the *Last Judgment.*" *Art Bulletin* 77 (1995): 65–81.

Barocchi, Paola. *Vasari pittore.* Florence: Barbera, 1964.

Barocchi, Paola, ed. *Trattati d'arte del Cinquecento fra manierismo e controriforma.* 3 vols. Bari: Laterza, 1960–2.

Barocchi, Paola, Adelaide Bianchini, Anna Forlani, and Mazzino Fossi. *Mostra di disegni dei fondatori dell'Accademia delle Arti del Disegno nel IV centenario della fondazione.* Exh. cat. Gabinetto Disegni e Stampe degli Uffizi, no. 15. Florence: Olschki, 1963.

Barolsky, Paul. *Infinite Jest: Wit and Humor in Italian Renaissance Art.* Columbia, Mo. and London: University of Missouri Press, 1978.

Daniele da Volterra. A catalogue raisonné (Ph.D. diss., Harvard University, 1969). New York: Garland, 1979.

"The Mysterious Meaning of Leonardo's *Saint John the Baptist.*" *Source* 8, no. 3 (1989): 11–15.

Michelangelo's Nose: A Myth and Its Maker. University Park: Pennsylvania State University Press, 1990.

Why Mona Lisa Smiles and Other Tales. University Park: Pennsylvania State University Press, 1991.

Giotto's Father and the Family of Vasari's Lives. University Park: Pennsylvania State University Press, 1992.

"The Trick of Art." In Philip Jacks, ed., *Vasari's Florence: Artists and Literati at the Medicean Court. The Symposium. 16–19 April 1994,* 23–29. New York: Cambridge University Press, 1998.

Barroero, Liliana. "La decorazione pittorica della Scala Santa." In Carlo Pietrangeli, ed., *Il Palazzo Apostolico Lateranense,* 139–89. Florence: Nardini, 1991a.

"Il Palazzo Lateranense: Il ciclo pittorico sistino." In Carlo Pietrangeli, ed., *Il Palazzo Apostolico Lateranense,* 217–86. Florence: Nardini, 1991b.

Barzman, Karen-Edis. "The Florentine Accademia del Disegno: Liberal Education and the Renaissance Artist." In Anton W. A. Boschloo et al., eds., *Academies of Art between Renaissance and Romanticism. Leids kunsthistorisch jaarboek* 5–6 (1986–7): 14–32.

Battisti, Eugenio. "Il concetto d'imitazione nel Cinquecento da Raffaello a Michelangelo." *Commentari* 7 (1956): 86–104.

Baumgart, Fritz, and Biagio Biagetti. *Gli affreschi di Michelangelo e di L. Sabbatini e F. Zuccari nella Cappella Paolina in Vaticano.* Monumenti vaticani di archeologia e d'arte, no. 3. Vatican City: Tipografia Poliglotta Vaticana, 1934.

Baxandall, Michael. *Giotto and the Orators: Humanist Observers of Painting in Italy and the Discovery of Pictorial Compositions, 1350–1450.* Oxford-Warburg studies. Oxford: Oxford University Press, 1971.

Béguin, Sylvie. Review of Henri Zerner, *Ecole de Fontainebleau, Gravures. Revue de l'art* 5 (1969): 103–7.

"Le programme mythologique." In *La Galerie François Ier au Chateau de Fontainebleau. Revue de l'art* 16–17 (1972): 165–72.

"Emilia and Fontainebleau: Aspects of a Dialogue." In *The Age of Correggio and the Carracci: Emilian Painting of the Sixteenth and Seventeenth Centuries,* 21–30. Exh. cat. Washington, D.C., National Gallery of Art. New York: Cambridge University Press, 1986.

"New Evidence for Rosso in France." *Burlington Magazine* 131 (1989): 828–38.

Bell, Janis C. "Light and Color in Caravaggio's *Supper at Emmaus.*" *Artibus et Historiae* 16, no. 31 (1995): 139–70.

Bellori, Giovanni Pietro. *Le Vite de' pittori, scultori e architetti moderni* (1672). Edited by Evelina Borea. Turin: Einaudi, 1976.

Bernardini, Maria Grazia. "*Giove, Nettuno e Plutone* di Caravaggio nel casino Ludovisi a Roma: Il cosmo in una stanza." *Art et Dossier* 6, no. 60 (1991): 18–21.

Berti, Luciano. *Il principe dello Studiolo. Francesco I dei Medici e la fine del rinascimento fiorentino.* Florence: Edizioni Edam, 1967.

Pontormo e il suo tempo. Florence: Banca Toscana, 1993.

Bevilacqua, Mario. "L'organizzazione dei cantieri pittorici sistini: note sul rapporto tra botteghe e committenza." In *Roma di Sisto V. Le arti e la cultura,* 35–47. Edited by Maria Luisa Madonna. Exh. cat. Rome: De Luca, 1993.

Blunt, Anthony. *Artistic Theory in Italy 1450–1660* (1940). Oxford: Oxford University Press, 1962.

Boase, T. S. R. *Giorgio Vasari: The Man and the Book.* A. W. Mellon Lectures in the Fine Arts, 1971. (National Gallery of Art, Washington, D.C.) Princeton: Princeton University Press, 1979.

Bober, Phyllis Pray. *Drawings after the Antique by Amico Aspertini. Sketchbooks in the British Museum.* Studies of the Warburg Institute, no. 21. London: Warburg Institute, 1957.

Bober, Phyllis Pray, and Ruth Rubinstein. *Renaissance Artists and Antique Sculpture: A Handbook of Sources.* London: Harvey Miller, 1986.

Bolzoni, Lina. "L'invenzione' dello Stanzino di Francesco I." In *Le Arti del Principato Mediceo,* 255–99. Specimen, no. 6. Florence: Studio per Edizioni Scelte, 1980.

Borghini, Raffaello. *Il Riposo.* Florence, 1584. Facsimile of 1584 edition, with bibliography and index, Mario Rosci, ed. Gli storici della letteratura italiana, no. 13. Milan: Edizioni Labor, 1967.

Borgo, Ludovico, and Ann H. Sievers. "The Medici Gardens at San Marco." *Mitteilungen des Kunsthistorischen Institutes in Florenz* 33 (1989): 237–56.

Borromeo, Carlo. *Instructiones fabricae et supellectilis ecclesiaticae.* Milan, 1577. In Barocchi, ed., *Tratatti,* 3:1–113. (See also Voelker.)

Borsook, Eve. "Technical Innovation and the Development of Raphael's Style in Rome." *Canadian Art Review* 12 (1985): 127–36.

Boschloo, A. W. A. *Annibale Carracci in Bologna. Visible Reality in Art after the Council of Trent.* 2 vols. Kunsthistorische Studiën van het Nederlands Historische Instituut te Rome, ser. 3, vol. 1. The Hague: Government Publishing Office, 1974.

"Il fregio dipinto nei palazzi Romani del Rinascimento: forma e funzione." *Mededlingen van het Nederlands Historisch Instituut te Rome* 43 (1981): 129–41.

Braham, Allan. "The Bed of Pierfrancesco Borgherini." *Burlington Magazine* 121 (1979): 754–65.

Brandt, Kathleen Weil-Garris. "Michelangelo's Early Projects for the Sistine Ceiling: Their Practical and Artistic Consequences." In Craig Hugh Smyth, ed., in collaboration with Ann Gilkerson, *Michelangelo's Drawings,* 57–88. *Studies in the History of Art,* no. 33. National Gallery of Art, Washington, D.C. Center for Advanced Study in the Visual Arts, Symposium Papers, no. 17. Hanover, N.H.: University Press of New England, 1992.

Brentano, Robert. *Rome before Avignon. A Social History of Thirteenth-Century Rome.* London: Longman, 1974.

Briganti, Giuliano, ed. *La pittura in Italia: Il Cinquecento.* Milan: Electa, 1987.

Bross, Louise S. "New documents for Livio Agresti's St. Stephen chapel in the church of S. Spirito in Sassia, Rome." *Burlington Magazine* 135 (1993): 338–43.

Brummer, Hans Henrik. *The Statue Court in the Vatican Belvedere.* Stockholm: Almqvist & Wiksell, 1970.

Bugge, Ragne. "Il dibattito intorno alle immagini sacre in Italia prima del decreto tridentino del 1563." In *Colloqui del Sodalizio,* 73–80. Sodalizio tra Studiosi dell'Arte, ser. 2, vol. 5. Rome: De Luca, 1975.

Buser, Thomas. "Jerome Nadal and Early Jesuit Art in Rome." *Art Bulletin* 58 (1976): 424–33.

Calì, Maria. *Da Michelangelo all'Escorial: Momenti del dibattito religioso nell'arte del Cinquecento.* Turin: Einaudi, 1980.

Calvesi, Maurizio. *La realtà del Caravaggio.* Turin: Einaudi, 1990.

Campbell, Malcolm. "Mannerism, Italian Style." In Sterling E. Murray and Ruth Irwin Weidner, eds., *Essays on Mannerism in Art and Music. Papers read at the West Chester State College Symposium on Interdisciplinary Studies, November 18, 1978,* 1–33. West Chester: West Chester State College, 1980.

Canons and Decrees of the Council of Trent. Original text and translation by H. J. Schroeder. Saint Louis, Mo.: Herder, 1941.

Carrier, David. "*Ekphrasis* and Interpretation: The Creation of Modern Art History." In *Principles of Art History Writing,* 101–19. University Park: Pennsylvania State University Press, 1991.

Carroll, Eugene A. *The Drawings of Rosso Fiorentino.* 2 vols. (Ph.D. diss., Harvard University, 1964). New York: Garland, 1976.

Rosso Fiorentino: Drawings, Prints, and Decorative Arts. Exh. cat. Washington, D.C.: National Gallery of Art, 1987.

Castiglione, Baldassare. *The Book of the Courtier.* Translated by Charles S. Singleton. Garden City, N.Y.: Anchor-Doubleday, 1959.

Cecchi, Alessandro. "Cigoli's 'Jael and Sisera' Rediscovered." *Burlington Magazine* 134 (1992): 82–91.

Cellini, Benvenuto. *The Autobiography of Benvenuto Cellini.* Edited and abridged by Charles Hope and Alessandro Nova, from the translation by John Addington Symonds. Oxford: Phaidon, 1983.

Cennini, Cennino. *The Craftsman's Handbook: "Il Libro dell'Arte."* Translated by D. V. Thompson. New Haven: Yale University Press, 1933.

Chappell, Miles L., and W. Chandler Kirwin. "A Petrine Triumph: The Decoration of the Navi Piccole in San Pietro under Clement VIII." *Storia dell'arte* 21 (1974): 119–70.

Chastel, André. "Le programme." In *La Galerie François I^er au Chateau de Fontainebleau. Revue de l'art* 16–17 (1972): 143–52.

"French Renaissance Art in a European Context." *Sixteenth Century Journal* 12, no. 4 (1981): 77–103.

The Sack of Rome, 1527. Translated by Beth Archer. Princeton: Princeton University Press, 1983.

Cheney, Iris. "Francesco Salviati (1510–1563)." 4 vols. Ph.D. diss., New York University, 1963a.

"Francesco Salviati's North Italian Journey." *Art Bulletin* 45 (1963b): 337–49.

"Les premières décorations: Daniele da Volterra, Salviati et les frères Zuccari." In *Le Palais Farnèse,* 1:243–67. 2 vols. Rome: Ecole française de Rome, 1981.

"A 'Turkish' Portrait by Jacopino del Conte." *Source* 1, no. 3 (1982): 17–20.

"The Parallel Lives of Vasari and Salviati." In Gian Carlo Garfagnini, ed., *Giorgio Vasari: tra decorazione ambientale e storiografia artistica,* 301–8. Convegno di Studi, Arezzo, 1981. Florence: Olschki, 1985.

"Comment: The Date of Francesco Salviati's French Journey." *Art Bulletin* 74 (1992): 157–8.

Cheney, Liana. "Giorgio Vasari's Sala dei Cento Giorni: A Farnese Celebration." In *Explorations in Renaissance Culture* 23 (1996): 121–50.

Chiarini, Marco, Serena Padovani, and Angelo Tartuferi, eds. *Lodovico Cigoli, 1559–1613: Tra Manierismo e Barocco. Dipinti.* Exh. cat. Fiesole: Amalthea, 1992.

Cochrane, Eric. *Florence in the Forgotten Centuries, 1527–1800. A History of Florence and the Florentines in the Age of the Grand Dukes.* Chicago: University of Chicago Press, 1973.

Coffin, David R. *The Villa in the Life of Renaissance Rome.* Princeton Monographs in Art and Archeology, no. 34. Princeton: Princeton University Press, 1979.

Gardens and Gardening in Papal Rome. Princeton: Princeton University Press, 1991.

Collareta, Marco. "Le 'arti sorelle': Teoria e pratica del 'paragone.'" In Giuliano Briganti, ed., *La pittura in Italia: Il Cinquecento,* 569–80. Milan: Electa, 1987.

Condivi, Ascanio. *The Life of Michelangelo.* Translated by Alice Sedgwick Wohl; edited by Hellmut Wohl. Oxford: Phaidon, 1976.

Corti, Laura. *Giorgio Vasari. Catalogo completo dei dipinti.* I gigli dell'arte, no. 3. Florence: Cantini, 1989.

Costamagna, Philippe. *Pontormo.* Milan: Electa, 1994.

Cox-Rearick, Janet. *The Drawings of Pontormo.* 2 vols. Cambridge, Mass.: Harvard University Press, 1964.

Dynasty and Destiny in Medici Art: Pontormo, Leo X and the Two Cosimos. Princeton: Princeton University Press, 1984.

"From Bandinelli to Bronzino. The Genesis of the *Lamentation* for the Chapel of Eleonora di Toledo." *Mitteilungen des Kunsthistorischen Institutes in Florenz* 33 (1989): 37–84.

"Pontormo, Bronzino, Allori and the Lost 'Deluge' at S. Lorenzo." *Burlington Magazine* 134 (1992): 239–48.

Bronzino's Chapel of Eleonora in the Palazzo Vecchio. California Studies in the History of Art, no. 29. Berkeley: University of California Press, 1993.

The Collection of Francis I: Royal Treasures. New York: Abrams, 1996.

Cropper, Elizabeth. "On Beautiful Women, Parmigianino, *Petrarchismo,* and the Vernacular Style." *Art Bulletin* 58 (1976): 374–94.

The Ideal of Painting: Pietro Testa's Düsseldorf Notebook. Exh. cat. Princeton: Princeton University Press, 1984.

"Tuscan History and Emilian Style." In *Emilian Painting of the 16th and 17th Centuries. A Symposium,* 49–62. National

Gallery of Art, Washington, D.C., Center for Advanced Study in the Visual Arts. Bologna: Nuova Alfa Editoriale, 1987.

Pontormo: Portrait of a Halberdier. Los Angeles: Getty Museum Studies on Art, 1997.

Dacos, Nicole. *La découverte de la Domus Aurea et la formation des grotesques à la Renaissance.* Studies of the Warburg Institute, no. 31. London: Warburg Institute, 1969.

Le Logge di Raffaello. Maestro e bottega di fronte all'antico. Rome: Istituto Poligrafico dello Stato, 1977.

"Hermannus Posthumus. Rome, Mantua, Landshut." *Burlington Magazine* 127 (1985): 433–8.

Roma quanta fuit: Tre pittori fiamminghi nella Domus Aurea. Translated by Maria Baiocchi. Rome: Donzelli, 1995.

Dacos, Nicole, and Caterina Furlan. *Giovanni da Udine, 1487–1561.* Udine: Casamassima, 1987.

D'Addario, Arnaldo. "Testimonianze archivistiche, cronistiche e bibliografiche." In *La comunità cristiana fiorentina e toscana nella dialettica religiosa del Cinquecento,* 23–194. Firenze e la Toscana dei Medici nell'Europa del Cinquecento. Florence: Becocci, 1980.

D'Amico, John F. *Renaissance Humanism in Papal Rome: Humanists and Churchmen on the Eve of the Reformation.* Johns Hopkins University Studies in Historical and Political Science, 101st ser., 1. Baltimore: Johns Hopkins University Press, 1983.

Danti, Vincenzo. *Il primo libro del trattato delle perfette proporzioni.* Florence, 1567. In Barocchi, ed., *Trattati,* 1:207–69.

Davidson, Bernice F. "Drawings by Perino del Vaga for the Palazzo Doria, Genoa." *Art Bulletin* 41 (1959): 315–26.

"Marcantonio's Martyrdom of S. Lorenzo." *Bulletin of the Rhode Island School of Design* 47 (March 1961): 1–6.

"Early Drawings by Perino del Vaga." *Master Drawings* 1, no. 3 (1963): 3–16; no. 4 (1963):, 19–26.

Perino del Vaga e la sua cerchia. Exh. cat. Gabinetto Disegni e Stampe degli Uffizi, no. 23. Florence: Olschki, 1966a.

"Some Early Works by Girolamo Siciolante da Sermoneta." *Art Bulletin* 48 (1966b): 55–64.

"Daniele da Volterra and the Orsini Chapel – II." *Burlington Magazine* 109 (1967): 553–61.

"The Decoration of the Sala Regia under Pope Paul III." *Art Bulletin* 58 (1976): 395–423.

Raphael's Bible: A Study of the Vatican Logge. CAA Monographs on the Fine Arts, no. 39. University Park: Pennsylvania State University Press, 1985.

"The *Furti di Giove* Tapestries Designed by Perino del Vaga for Andrea Doria." *Art Bulletin* 70 (1988): 424–50.

"The *Navigatione d'Enea* Tapestries Designed by Perino del Vaga for Andrea Doria." *Art Bulletin* 72 (1990): 35–50.

Davies, Martin. *The Earlier Italian Schools.* National Gallery Catalogues. London: National Gallery, 1951.

De Grazia Bohlin, Diane. *Prints and Related Drawings by the Carracci Family. A Catalogue Raisonné.* Washington, D.C.: National Gallery of Art, 1979.

De Hollanda, Francisco. *Four Dialogues on Painting* (1548). Translated by Aubrey F. G. Bell. Oxford: Oxford University Press, 1928.

De Jong, Jan L. "An Important Patron and an Unknown Artist: Giovanni Ricci, Ponsio Jacquio, and the Decoration of the Palazzo Ricci-Sacchetti in Rome." *Art Bulletin* 74 (1992): 135–56.

De Maio, Romeo. *Michelangelo e la controriforma.* Bari: Laterza, 1978.

De Strobel, Anna Maria, and Fabrizio Mancinelli. "La Sala Regia e la Sala Ducale." In Carlo Pietrangeli, ed., *Il Palazzo Apostolico Vaticano,* 73–9. Florence: Nardini, 1992.

De Tolnay, Charles. *Michelangelo.* 5 vols. Princeton: Princeton University Press, 1945–60.

Dejob, Charles. *De l'influence du Concile de Trente sur la littérature et les beaux-arts chez les peuples catholiques.* Paris: Thorin, 1884.

Dempsey, Charles. "'Et Nos Cedamus Amori': Observations on the Farnese Gallery." *Art Bulletin* 50 (1968): 363–74.

Annibale Carracci and the Beginnings of Baroque Style. Villa I Tatti Monographs, no. 3. Glückstadt: J. J. Augustin, 1977.

"Some Observations on the Education of Artists in Florence and Bologna during the Later Sixteenth Century." *Art Bulletin* 62 (1980): 552–69.

"Mythic Inventions in Counter-Reformation Painting." In P. A. Ramsey, ed., *Rome in the Renaissance: The City and the Myth,* 55–75. Papers of the Thirteenth Annual Conference of the Center for Medieval and Early Renaissance Studies. Medieval and Renaissance texts and studies, no. 18. Binghamton, N.Y.: Center for Medieval and Early Renaissance Studies, 1982.

"The Carracci *Postille* to Vasari's *Lives.*" *Art Bulletin* 68 (1986a): 72–6.

"The Carracci Reform of Painting." In *The Age of Correggio and the Carracci: Emilian Painting of the Sixteenth and Seventeenth Centuries,* 237–54. Exh. cat. Washington, D.C., National Gallery of Art: New York: Cambridge University Press, 1986b.

"Federico Barocci and the Discovery of Pastel." In Marcia B. Hall, ed., *Color and Technique in Renaissance Painting. Italy and the North,* 55–65. Locust Valley, N.Y.: J. J. Augustin, 1987.

"National Expression in Italian Sixteenth-Century Art: Problems of Past and Present." In Richard A. Etlin, ed., *Nationalism in the Visual Arts,* 15–24. Proceedings of the Symposium, 16–17 October 1987. Studies in the History of Art, no. 29. National Gallery of Art, Washington, D.C. Hanover, N.H.: University Press of New England, 1991.

Annibale Carracci: The Farnese Gallery, Rome. New York: Braziller, 1995.

Di Giampaolo, Mario. *Parmigianino. Catalogo completo dei dipinti.* I gigli dell'arte, no. 19. Pietro C. Marani, ed. Florence: Cantini, 1991.

Domenico Beccafumi e il suo tempo. Exh. cat. Milan: Electa, 1990.

Dumont, Catherine. *Francesco Salviati au Palais Sacchetti de Rome et la décoration murale italienne (1520–1560).* Bibliotheca Helvetica Romana 12. Rome: Institut suisse de Rome, 1973.

Dvořák, Max. *Geschichte der italienischen Kunst im Zeitalter der Renaissance.* 2 vols. Munich: Piper, 1927–8.

Ebert-Schifferer, Sybille. "Nuove acquisizioni sulla personalità artistica di Jacopo Ripanda." In Marzia Faietti and Konrad

Oberhuber, eds., *Bologna e l'umanesimo 1490–1510*, 237–45. Exh. cat. Bologna: Nuova Alfa Editoriale, 1988a.

——. "Ripandas kapitolinischer Freskenzyklus und die Selbstdarstellung der Konservatoren um 1500." *Römisches Jahrbuch für Kunstgeschichte* 23–4 (1988b): 75–218.

L'Ecole de Fontainebleau. Exh. cat. Paris: Musées Nationaux, 1972.

Edgerton, Samuel Y., Jr. "*Maniera* and the *Mannaia:* Decorum and Decapitation in the Sixteenth Century." In Franklin W. Robinson and Stephen G. Nichols, Jr., eds., *The Meaning of Mannerism,* 67–103. Hanover, N.H.: University Press of New England, 1972.

Eisler, William L. "The Impact of the Emperor Charles V upon the Visual Arts." Ph.D. diss., Pennsylvania State University, 1983.

Ekserdijian, David. "Parmigianino's 'Madonna of St Margaret.'" *Burlington Magazine* 125 (1983): 542–6.

Elam, Caroline. "Lorenzo de' Medici's Sculpture Garden." *Mitteilungen des Kunsthistorischen Institutes in Florenz* 36 (1992): 41–84.

——. "Art in the Service of Liberty: Battista della Palla, Art Agent for Francis I." *I Tatti Studies* 5 (1993): 33–109.

Elkins, James. *The Poetics of Perspective.* Ithaca: Cornell University Press, 1994.

Emiliani, Andrea. *Federico Barocci (Urbino 1535–1612).* 2 vols. Pesaro: Banca Popolare Pesarese, 1985.

Emison, Patricia. "*Grazia.*" *Renaissance Studies* 5 (1991): 427–60.

Ettlinger, Leopold D. "Hercules Florentinus." *Mitteilungen des Kunsthistorischen Institutes in Florenz* 16 (1972): 119–42.

Faietti, Marzia, and Konrad Oberhuber, eds. *Bologna e l'umanesimo 1490–1510.* Exh. cat. Bologna: Nuova Alfa Editoriale, 1988a.

Faietti, Marzia, and Konrad Oberhuber. "Jacopo Ripanda e il suo collaboratore (il maestro di Oxford) in alcuni cantieri romani del primo Cinquecento." *Ricerche di storia dell'arte 34* (1988b): 55–72.

Faldi, Italo. *Il Palazzo Farnese di Caprarola.* Turin: Edizioni Seat, 1981.

Fanti, Mario. "Le postille carracchesche alle 'Vite' del Vasari: il testo originale." *Il Carrobbio* 5 (1979): 148–64; "Ancora sulle postille carracchesche alle 'Vite' del Vasari: in buona parte sono di Annibale." *Il Carrobbio* 6 (1980): 135–41.

Farago, Claire. "Leonardo's *Battle of Anghiari:* A Study in the Exchange between Theory and Practice." *Art Bulletin* 76 (1994): 301–30.

Faranda, Franco. *Ludovico Cardi detto il Cigoli.* "I professori del disegno," no. 2. Alessandro Marabottini, ed. Rome: De Luca, 1986.

Farinella, Vincenzo. *Archeologia e pittura a Roma tra Quattrocento e Cinquecento: Il caso di Jacopo Ripanda.* Turin: Einaudi, 1992.

Fehl, Philipp P. "Veronese and the Inquisition. A Study of the Subject Matter of the So-called 'Feast in the House of Levi.'" *Gazette des Beaux-Arts,* ser. 6, 58 (1961): 325–54.

——. "Raphael as a Historian: Poetry and Historical Accuracy in the Sala di Costantino." *Artibus et Historiae* 14, no. 28 (1993): 9–76.

Feigenbaum, Gail. "Practice in the Carracci Academy." In Peter M. Lukehart, ed., *The Artist's Workshop,* 59–76. *Studies in the History of Art,* no. 38. National Gallery of Art, Washington, D.C. Center for Advanced Study in the Visual Arts, Symposium Papers, no. 22. Hanover, N.H.: University Press of New England, 1993.

Ferino Pagden, Sylvia. "Giulio Romano pittore e disegnatore a Roma." In *Giulio Romano,* 65–95. Exh. cat. Milan: Electa, 1989.

——. "I due amanti di Leningrado." In *Giulio Romano. Atti del Convegno Internazionale di Studi su "Giulio Romano e l'espansione europea del Rinascimento,"* 227–36. Mantua, 1989. Mantua: Accademia Nazionale Virgiliana, 1991.

Fermor, Sharon. "Movement and Gender in Sixteenth-Century Italian Painting." In Kathleen Adler and Marcia Pointon, eds., *The Body Imaged: The Human Form and Visual Culture since the Renaissance,* 129–45. Cambridge: Cambridge University Press, 1993.

Fontana, Domenico. *Della trasportatione dell'obelisco vaticano.* Edited by Adriano Carugo, with introduction by Paolo Portoghesi; reprint of 1590 edition. Milan: Il polifilo, 1978.

Forster, Kurt W. "Metaphors of Rule. Political Ideology and History in the Portraits of Cosimo I de' Medici." *Mitteilungen des Kunsthistorischen Institutes in Florenz* 15 (1971): 65–104.

Franklin, David. "A Document for Pontormo's S. Michele Visdomini Altar-piece." *Burlington Magazine* 132 (1990): 487–9.

——. "Rosso Fiorentino's *Betrothal of the Virgin:* Patronage and Interpretation." *Journal of the Warburg and Courtauld Institutes* 55 (1992): 180–99.

——. *Rosso in Italy: The Italian Career of Rosso Fiorentino.* London: Yale University Press, 1994.

Fredericksen, Burton B. "A New Painting by Rosso Fiorentino." In Mauro Natale, ed., *Scritti di storia dell'arte in onore di Federico Zeri,* 1:323–31. Milan: Electa, 1984.

Freedberg, David. "Johannes Molanus on Provocative Paintings." *Journal of the Warburg and Courtauld Institutes* 34 (1971): 229–45.

——. *The Power of Images: Studies in the History and Theory of Response.* Chicago: University of Chicago Press, 1989.

Freedberg, S. J. *Parmigianino: His Works in Painting.* Cambridge, Mass.: Harvard University Press, 1950.

——. *Painting of the High Renaissance in Rome and Florence.* 2 vols. Cambridge, Mass.: Harvard University Press, 1961.

——. "Observations on the Painting of the Maniera." *Art Bulletin* 47 (1965): 187–97.

——. "Rosso's Style in France in Its Italian context." In André Chastel, ed., *L'Art de Fontainebleau,* 13–16. Actes du Colloque international sur l'art de Fontainebleau, Fontainebleau and Paris, 1972. Paris: Editions du Centre National de la Recherche Scientifique, 1975.

——. *Circa 1600: A Revolution of Style in Italian Painting.* Cambridge, Mass.: Harvard University Press, 1983.

——. "Jacopino del Conte: An Early Masterpiece for the National Gallery of Art." *Studies in the History of Art* 18 (1985): 59–65.

——. *Painting in Italy 1500–1600* (1971). 3rd ed. New Haven: Yale University Press, 1993.

Freiberg, Jack. "Clement VIII, the Lateran and Christian Concord."

In Marilyn Aronberg Lavin, ed., *Il 60. Essays Honoring Irving Lavin on His Sixtieth Birthday,* 167–90. New York: Italica Press, 1990.

"In the Sign of the Cross: The Image of Constantine in the Art of Counter-Reformation Rome." In Marilyn Aronberg Lavin, ed., *Piero della Francesca and His Legacy,* 67–87. *Studies in the History of Art,* no. 48. National Gallery of Art, Washington, D.C. Center for Advanced Study in the Visual Arts, Symposium Papers, no. 28. Hanover, N.H.: University Press of New England, 1995a.

The Lateran in 1600: Christian Concord in Counter-Reformation Rome. New York: Cambridge University Press, 1995b.

Frey, Karl. *Der literarische Nachlass Giorgio Vasaris.* Munich: Müller, vol. 1, 1923; vol. 2, Herman-Walther Frey, ed. Munich: Müller, 1930; vol. 3, *Neue Briefe von Giorgio Vasari.* Herman-Walther Frey, ed. Berg: 1940.

Friedlaender, Walter. *Das Kasino Pius des Vierten.* Leipzig: Hiersemann, 1912.

"The Anticlassical Style." In *Mannerism and Anti-Mannerism in Italian Painting,* 3–43. New York: Columbia University Press, 1957. Translation of "Die Entstehung des antiklassischen Stiles in der italienischen Malerei um 1520" (1925).

Caravaggio Studies. Princeton: Princeton University Press, 1955.

Frommel, Christoph Luitpold. *Baldassare Peruzzi als Maler und Zeichner.* Vienna: A. Scroll, 1967–8.

Der Römische Palastbau der Hochrenaissance. 3 vols. Tübingen: Wasmuth, 1973.

"'Cappella Iulia': Die Grabkapelle Papst Julius' II in Neu-St. Peter." *Zeitschrift für Kunstgeschichte* 40 (1977): 26–62.

"'Disegno' und Ausführung: Ergänzungen zu Baldassarre Peruzzis figuralem Oeuvre." In Werner Busch, Reiner Hausherr, and Eduard Trier, eds., *Kunst als Bedeutungsträger. Gedenkschrift für Günter Bandmann,* 205–50. Berlin: Mann, 1978.

"Villa Lante e Giulio Romano, artista universale." In *Giulio Romano. Atti del Convegno Internazionale di Studi su "Giulio Romano e l'espansione europea del Rinascimento,"* 127–53. Mantua, 1989. Mantua: Accademia Nazionale Virgiliana, 1991.

Fumaroli, Marc. *L'Age de l'éloquence: Rhétorique et 'res literaria' de la Renaissance au seuil de l'époque classique.* Geneva: Librairie Droz, 1980.

Gere, John A. "Two Late Fresco Cycles by Perino del Vaga: The Massimi Chapel and the Sala Paolina." *Burlington Magazine* 102 (1960): 9–19.

"The Decoration of the Villa Giulia." *Burlington Magazine* 107 (1965): 199–206.

"Girolamo Muziano and Taddeo Zuccaro: A Note on an Early Work by Muziano." *Burlington Magazine* 108 (1966): 417–18.

Taddeo Zuccaro: His Development Studied in His Drawings. London: Faber, 1969.

The Life of Taddeo Zuccaro by Federico Zuccaro. New York: Sotheby's, 1989.

Gibbons, Mary Weitzel. *Giambologna. Narrator of the Catholic Reformation.* California Studies in the History of Art, no. 33. Berkeley: University of California Press, 1995.

Gibson, Walter S. *"Mirror of the Earth." The World Landscape in Sixteenth-Century Flemish Painting.* Princeton: Princeton University Press, 1989.

Gilbert, Creighton. *"Un viso quasiche di furia."* In Craig Hugh Smyth, ed., in collaboration with Ann Gilkerson, *Michelangelo's Drawings,* 213–25. *Studies in the History of Art,* no. 33. National Gallery of Art, Washington, D.C. Center for Advanced Study in the Visual Arts, Symposium Papers, no. 17. Hanover, N.H.: University Press of New England, 1992.

Caravaggio and His Two Cardinals. University Park: Pennsylvania State University Press, 1995.

Giles, Laura M. "A Major Composition Study by Pontormo." *The Art Institute of Chicago Museum Studies* 17 (1991): 22–46.

Gilio, Giovanni Andrea. *Dialogo nel quale si ragiona degli errori e degli abusi de' pittori circa l'istorie.* Camerino, 1564. In Barocchi, ed., *Trattati,* 2:3–115.

Giulio Romano. Exh. cat. Milan: Electa, 1989.

Giulio Romano pinxit et delineavit. Opere grafiche autografe di collaborazione e bottega. Catalogue by Stefania Massari. Ministero per i Beni Culturali e Ambientali, Istituto Nazionale Per la Grafica. Rome: Fratelli Palombi, 1993.

Gnann, Achim. "Polidoro da Caravaggio in S. Silvestro al Quirinale in Rom: Die Ausmalung der Kapelle Fra Mariano del Piombos." *Arte Lombarda* 98/99 (1991): 134–9.

"Parmigianino's Projekte für die Cesi-Kapelle in S. Maria della Pace in Rom." *Zeitschrift für Kunstgeschichte* 59 (1996): 360–80.

Goldstein, Carl. *Verbal Fact over Visual Fiction. A Study of the Carracci and the Criticism, Theory, and Practice of Art in Renaissance and Baroque Italy.* Cambridge: Cambridge University Press, 1988.

"Rhetoric and Art History in the Italian Renaissance and Baroque." *Art Bulletin* 73 (1991): 641–52.

"The Image of the Artist Reviewed." *Word & Image* 9 (1993): 9–18.

Golzio, Vincenzo. *Raffaello nei documenti, nelle testimonianze dei contemporanei e nella letteratura del suo secolo.* Vatican City: Pontificia Insigne Accademia Artistica dei Virtuosi al Pantheon, 1936.

Gombrich, E. H. "The Style *all'antica:* Imitation and Assimilation." In *Norm and Form,* 122–8. Studies in the Art of the Renaissance, no. 1. London: Phaidon, 1966.

Topos and Topicality in Renaissance Art. Annual lecture of the Society for Renaissance Studies. London: The Society for Renaissance Studies, 1975.

"The Leaven of Criticism in Renaissance Art: Texts and Episodes." In *The Heritage of Apelles,* 111–31. Studies in the Art of the Renaissance, no. 3. London: Phaidon, 1976.

Gorse, George L. "The Villa of Andrea Doria in Genoa: Architecture, Gardens, and Suburban Setting." *Journal of the Society of Architectural Historians* 44 (1985): 18–36.

Gould, Cecil. *The Paintings of Correggio.* London: Faber and Faber, 1976.

"Raphael versus Giulio Romano: The Swing Back." *Burlington Magazine* 124 (1982): 479–87.

Parmigianino. London: Abbeville, 1994.

Grendler, Paul F. "Man Is Almost a God: Fra Battista Carioni

between Renaissance and Catholic Reformation." In John W. O'Malley, Thomas M. Izbicki, and Gerald Christianson, eds., *Humanity and Divinity in Renaissance and Reformation: Essays in Honor of Charles Trinkaus,* 227–49. Studies in the History of Christian Thought, no. 51. Leiden: Brill, 1993.

Guerrini, Roberto. "Plutarco e la cultura figurativa nell'età di Paolo III: Castel Sant'Angelo, Sala Paolina." *Canadian Art Review* 12 (1985): 179–87.

Hale, J. R. *Artists and Warfare in the Renaissance.* London: Yale University Press, 1990.

Hall, Marcia B. "Michelangelo's *Last Judgment:* Resurrection of the Body and Predestination." *Art Bulletin* 58 (1976): 85–92.

Renovation and Counter-Reformation: Vasari and Duke Cosimo in Sta. Maria Novella and Sta. Croce, 1565–1577. Oxford-Warburg Studies. Oxford: Oxford University Press, 1979.

"From Modeling Techniques to Color Modes." In Marcia B. Hall, ed., *Color and Technique in Renaissance Painting. Italy and the North,* 1–29. Locust Valley, N.Y.: J. J. Augustin, 1987.

"Savonarola's Preaching and the Patronage of Art." In Timothy Verdon and John Henderson, eds., *Christianity and the Renaissance. Image and Religious Imagination in the Quattrocento,* 493–522. Syracuse, N.Y.: Syracuse University Press, 1990.

Color and Meaning: Practice and Theory in Renaissance Painting. New York: Cambridge University Press, 1992.

Hall, Marcia B., ed. *Raphael's School of Athens.* Masterpieces of Western Painting. New York: Cambridge University Press, 1997.

Härb, Florian. "Modes and Models in Vasari's Early Drawing Oeuvre." In Philip Jacks, ed., *Vasari's Florence: Artists and Literati at the Medicean Court. The Symposium. 16–19 April 1994,* 83–110. New York: Cambridge University Press, 1998.

Harprath, Richard. *Papst Paul III. als Alexander der Grosse. Das Freskenprogramm der Sala Paolina in der Engelsburg.* Beiträge zur Kunstgeschichte, no. 13. Berlin: De Gruyter, 1978.

Hartt, Frederick. *Giulio Romano.* 2 vols. New Haven: Yale University Press, 1958.

Haskell, Francis. *Patrons and Painters: A Study in the Relations between Italian Art and Society in the Age of the Baroque.* London: Knopf, 1963.

Haskell, Francis, and Nicholas Penny. *Taste and the Antique. The Lure of Classical Sculpture, 1500–1900.* London: Yale University Press, 1981.

Hayum, Andrée. *Giovanni Antonio Bazzi – "Il Sodoma"* (Ph.D. diss., Harvard University, 1968). New York: Garland, 1976.

Heideman, Johanna. "Saint Catherine of Siena's Life and Thought. A Fresco-Cycle by Giovanni De'Vecchi in the Rosary Chapel of Santa Maria sopra Minerva in Rome." *Arte cristiana* 77 (1989): 451–64.

Heikamp, Detlef. "Vicende di Federigo Zuccari." *Rivista d'arte* 32 (1957): 175–232.

Scritti d'arte di Federico Zuccari. Florence: Olschki, 1961.

"Federico Zuccari a Firenze 1575–1579. I: La cupola del Duomo. Il diario disegnato." *Paragone. Arte* 18, no. 205 (1967): 44–68.

"La manufacture de tapisserie des Médicis." *L'Oeil,* nos. 164–5 (August–September 1968): 22–31.

"Die Arazzeria Medicea im 16. Jahrhundert: Neue Studien." *Münchner Jahrbuch der bildenden Kunst,* ser. 3, 20 (1969): 33–74.

Heimbürger, Minna. "Interpretazioni delle pitture di genere del Caravaggio secondo il 'metodo neerlandese.'" *Paragone. Arte* 41, no. 489 (1990): 4–18.

Herz, Alexandra. "Cardinal Cesare Baronio's Restoration of SS. Nereo ed Achilleo and S. Cesareo de'Appia." *Art Bulletin* 70 (1988): 590–620.

Hibbard, Howard. "*Ut picturae sermones:* The First Painted Decorations of the Gesù." In Rudolf Wittkower and Irma B. Jaffe, eds., *Baroque Art: The Jesuit Contribution,* 29–49. New York: Fordham University Press, 1972.

Michelangelo: Painter, Sculptor, Architect (1975). London: Octopus, 1979.

Caravaggio. London: Thames and Hudson, 1983.

Hirst, Michael. "Perino del Vaga and His Circle." *Burlington Magazine* 108 (1966): 398–405.

"Daniele da Volterra and the Orsini Chapel – I: The Chronology and the Altar-piece." *Burlington Magazine* 109 (1967): 498–509.

"Salviati's Chinoiserie in Palazzo Sacchetti." *Burlington Magazine* 121 (1979): 791–2.

Sebastiano del Piombo. Oxford: Oxford University Press, 1981.

Exhibition review, "Sebastiano del Piombo and Spain," Madrid. *Burlington Magazine* 137 (1995): 481–2.

Holo, Selma. "A Note on the Afterlife of the *Crouching Aphrodite* in the Renaissance." *The J. Paul Getty Museum Journal* 6–7 (1978–9): 23–36.

Hope, Charles. "Artists, Patrons and Advisers in the Italian Renaissance." In Guy Fitch Lytle and Stephen Orgel, eds., *Patronage in the Renaissance,* 293–343. Folger Institute Essays. Princeton: Princeton University Press, 1981.

"Aspects of Criticism in Art and Literature in Sixteenth-Century Italy." *Word and Image* 4 (1988): 1–10.

Huelsen, Christian, and Hermann Egger. *Die römischen Skizzenbücher von Marten van Heemskerck, in Königlichen Kupferstickkabinett zu Berlin.* 2 vols. Berlin: J. Bard, 1913–16.

Hunter, John. "Transition and Uncertainty in the Middle Years of Girolamo Siciolante da Sermoneta." *Storia dell'arte* 59 (1987): 15–27.

I Farnese. Arte e Collezionismo. Edited by Lucia Fornari Schianchi and Nicola Spinosa. Exh. cat. Milan: Electa, 1995.

Il Cavalier D'Arpino. Exh. cat. Rome: De Luca, 1973.

Il Palazzo dei Conservatori e il Palazzo Nuovo in Campidoglio: Momenti di storia urbana di Roma. Pisa: Pacini, 1996.

Iversen, Erik. *The Obelisks of Rome.* Vol. 1 of *Obelisks in Exile.* Copenhagen: G.E.C. Gad, 1968.

Jacks, Philip. *The Antiquarian and the Myth of Antiquity: The Origins of Rome in Renaissance Thought.* New York: Cambridge University Press, 1993.

Jacks, Philip, ed., *Vasari's Florence: Artists and Literati at the Medicean Court. The Symposium. 16–19 April 1994.* New York: Cambridge University Press, 1998.

Jacobs, Fredrika H. "Vasari's Vision of the History of Painting: Frescoes in the Casa Vasari, Florence." *Art Bulletin* 66 (1984): 399–416.

Jestaz, Bertrand. "La tenture de la Galerie de Fontainebleau et sa restauration à Vienne à la fin du XVII^e siècle." *Revue de l'art* 22 (1973): 50–6.

Joannides, Paul. "The Early Easel Paintings of Giulio Romano." *Paragone. Arte* 36, no. 425 (1985): 17–46.

"'Primitivism' in the Late Drawings of Michelangelo: The Master's Construction of an Old-age Style." In Craig Hugh Smyth, ed., in collaboration with Ann Gilkerson, *Michelangelo's Drawings,* 245–62. *Studies in the History of Art,* no. 33. National Gallery of Art, Washington, D.C. Center for Advanced Study in the Visual Arts, Symposium Papers, no. 17. Hanover, N.H.: University Press of New England, 1992.

Jones, Roger, and Nicholas Penny. *Raphael.* New Haven and London: Yale University Press, 1983.

Jules Romain. L'Histoire de Scipion, tapisseries et dessins. Exh. cat. Paris: Musées Nationaux, 1978.

Jungic, Josephine. "Joachimist Prophesies in Sebastiano del Piombo's Borgherini Chapel and Raphael's *Transfiguration.*" In Marjorie Reeves, ed., *Prophetic Rome in the High Renaissance Period. Essays,* 321–44. Oxford-Warburg Studies. Oxford: Clarendon Press, 1992.

Keller, Rolf E. *Das Oratorium von San Giovanni Decollato: Eine Studie seiner Fresken.* Bibliotheca Helvetica Romana 15. Rome: Institut suisse de Rome, 1976.

Kemp, Martin. *Leonardo da Vinci: The Marvellous Works of Nature and Man.* London: Dent, 1981.

Kinkead, Duncan T. "An Iconographic Note on Raphael's *Galatea.*" *Journal of the Warburg and Courtauld Institutes* 33 (1970): 313–15.

Kirwin, W. Chandler. "Vasari's Tondo of 'Cosimo I with his Architects, Engineers and Sculptors' in the Palazzo Vecchio. Typology and Re-Identification of Portraits." *Mitteilungen des Kunsthistorischen Institutes in Florenz* 15 (1971): 105–22.

Klein, Robert, and Henri Zerner. *Italian Art, 1500–1600: Sources and Documents,* "The Counter-Reformation," 117–33. Sources and documents in the history of art series, H. W. Janson, ed. Englewood Cliffs, N.J.: Prentice-Hall, 1966.

Kliemann, Julian. *Gesta dipinte. La Grande decorazione nelle dimore italiane dal Quattrocento al Seicento.* Milan: Silvana, 1993.

Knab, Eckhart, Erwin Mitsch, and Konrad Oberhuber, with Sylvia Ferino-Pagden. *Raphael. Die Zeichnungen.* Stuttgart: Urachhaus, 1983.

Krautheimer, Richard. "A Christian Triumph of 1597." In Douglas Fraser, Howard Hibbard, and Milton Lewine, eds., *Essays in the History of Art Presented to Rudolf Wittkower,* 174–8. London: Phaidon, 1967.

Kummer, Stefan. *Anfänge und Ausbreitung der Stuckdekoration im römischen Kirchenraum (1500–1600).* Tübinger Studien zur Archäologie und Kunstgeschichte, no. 6. Ulrich Hausmann and Klaus Schwager, eds. Tübingen: Wasmuth, 1987.

Land, Norman E. "Titian's *Martyrdom of Saint Peter Martyr* and the 'Limitations' of Ekphrastic Art Criticism." *Art History* 13 (1990): 293–317.

Landau, David, and Peter Parshall. *The Renaissance Print 1470–1550.* New Haven: Yale University Press, 1994.

Langedijk, Karla. "Baccio Bandinelli's Orpheus: A Political

Message." *Mitteilungen des Kunsthistorischen Institutes in Florenz* 20 (1976): 33–52.

The Portraits of the Medici, 15th–18th Centuries. 3 vols. Florence: Studio per Edizioni Scelte, 1981–7.

Lecchini Giovannoni, Simona. *Mostra di disegni di Alessandro Allori (Firenze 1535–1607).* Exh. cat. Gabinetto Disegni e Stampe degli Uffizi, no. 33. Florence: Olschki, 1970.

Alessandro Allori. Turin: Umberto Allemandi, 1991.

Lecchini Giovannoni, Simona and Marco Collareta, eds. *Disegni di Santi di Tito (1536–1603).* Exh. cat. Gabinetto Disegni e Stampe degli Uffizi, no. 64. Florence: Olschki, 1985.

Lee, Rensselaer W. "*Ut pictura poesis:* The Humanistic Theory of Painting." *Art Bulletin* 22 (1940): 197–269. Reprint, New York: Norton, 1967.

Lewine, Milton Joseph. "The Roman Church Interior, 1527–1580." Ph.D. diss., Columbia University, 1960.

Lippincott, Kristen. "Two Astrological Ceilings Reconsidered: The *Sala di Galatea* in the Villa Farnesina and *Sala del Mappamondo* at Caprarola." *Journal of the Warburg and Courtauld Institutes* 53 (1990): 185–207.

Logan, O. M. T. "Grace and Justification: Some Italian Views of 16 and early 17c." *Journal of Ecclesiastical History* 20 (1969): 67–78.

Lomazzo, Giovanni Paolo. *Scritti sulle arti.* 2 vols. Edited by Roberto Paolo Ciardi. Raccolta Pisana di saggi e studi, nos. 33, 34. Florence: Marchi & Bertolli, 1973–5.

Macioce, Stefania. *Undique splendent: Aspetti della pittura sacra nella Roma di Clemente VIII Aldobrandini (1592–1605).* Rome: De Luca, 1990.

Mack, Rosamond E. "Girolamo Muziano and Cesare Nebbia at Orvieto." *Art Bulletin* 56 (1974): 410–13.

Mahon, Denis. *Studies in Seicento Art and Theory.* Studies of the Warburg Institute, no. 16. London: Warburg Institute, 1947.

Mâle, Emile. *L'art religieux après le Concile de Trente. Etude sur l'iconographie de la fin du XVIe siècle, du XVIIe, du XVIIIe siècle. Italie, France, Espagne, Flandres.* Paris: Colin, 1932.

Malvasia, Carlo Cesare. *Felsina pittrice. Vite de pittori bolognesi,* (1678). 3 vols. Bologna: A Forni, 1974–1980.

Manca, Joseph. "Michelangelo as Painter: A Historiographic Perspective." *Artibus et Historiae* 16, no. 31 (1995): 111–23.

Mandel, Corinne. "Golden Age and the Good Works of Sixtus V: Classical and Christian Typology in the Art of a Counter-Reformation Pope." *Storia dell'arte* 62 (1988): 29–52.

Marabottini, Alessandro. *Polidoro da Caravaggio.* 2 vols. Rome: Edizioni dell'Elefante, 1969.

Martin, John Rupert. *The Farnese Gallery.* Princeton Monographs in Art and Archaeology, no. 36. Princeton: Princeton University Press, 1965.

McAllister Johnson, William. "Les débuts de Primatice à Fontainebleau." *Revue de l'Art* 6 (1969): 8–18.

"Le programme monarchique." In *La Galerie François I^{er} au Chateau de Fontainebleau. Revue de l'art* 16–17 (1972): 153–64.

McGinness, Frederick J. "The Rhetoric of Praise and the New Rome of the Counter Reformation." In P. A. Ramsey, ed., *Rome in the Renaissance: The City and the Myth,* 355–70.

Papers of the Thirteenth Annual Conference of the Center for Medieval and Early Renaissance Studies. Medieval and Renaissance texts and studies, no. 18. Binghamton, N.Y.: Center for Medieval and Early Renaissance Studies, 1982.

Right Thinking and Sacred Oratory in Counter-Reformation Rome. Princeton: Princeton University Press, 1995.

McGrath, Elizabeth. "'Il senso nostro': The Medici Allegory Applied to Vasari's Mythological Frescoes in the Palazzo Vecchio." In Gian Carlo Garfagnini, ed., *Giorgio Vasari: tra decorazione ambientale e storiografia artistica,* 117–34. Convegno di Studi, Arezzo, 1981. Florence: Olschki, 1985.

McKillop, Susan Regan. *Franciabigio.* California Studies in the History of Art, no. 16. Berkeley: University of California Press, 1974.

McTavish, David. *Giuseppe Porta called Giuseppe Salviati* (Ph.D. diss., Courtauld Institute of Art, University of London). London: Garland, 1981.

"Roman Subject-Matter and Style in Venetian Façade Frescoes." *Canadian Art Review* 12 (1985a): 188–96.

"Vasari and Parmigianino." In Gian Carlo Garfagnini, ed., *Giorgio Vasari: tra decorazione ambientale e storiografia artistica,* 135–43. Convegno di Studi, Arezzo, 1981. Florence: Olschki, 1985b.

Mendelsohn, Leatrice. *Paragoni. Benedetto Varchi's* Due Lezzioni *and Cinquecento Art Theory.* Ann Arbor, Mich.: UMI Research Press, 1982.

Michelangelo e la Sistina: La tecnica, il restauro, il mito. Exh. cat. Rome: Fratelli Palombi, 1990.

Minor, Andrew C., and Bonner Mitchell. *A Renaissance Entertainment: Festivities for the Marriage of Cosimo I, Duke of Florence, in 1539.* Columbia: University of Missouri Press, 1968.

Mitchell, Bonner. *Rome in the High Renaissance: The Age of Leo X.* Norman: University of Oklahoma Press, 1973.

"The S.P.Q.R. in Two Roman Festivals of the Early and Mid-Cinquecento." *Sixteenth Century Journal* 9, no. 4 (1978): 95–102.

Monbeig Goguel, Catherine. *Vasari et son temps.* Vol. 1 of Roseline Bacou, ed., *Inventaire général des dessins italiens.* Paris: Editions des Musées nationaux, 1972.

"Francesco Salviati e il tema della resurrezione di Cristo." *Prospettiva* 13 (1978): 7–23.

Monbeig Goguel, Catherine, ed. *Francesco Salviati o la bella maniera.* Exh. cat. Milan: Electa, 1998.

Monk, Samuel H. "A Grace beyond the Reach of Art." *Journal of the History of Ideas* 5 (1944): 131–50.

Monticone, Alberto. "L'applicazione a Roma del Concilio di Trento: le visite del 1564–1566." *Rivista di storia della chiesa in Italia* 7 (1953): 225–50.

Morel, Philippe. "Il funzionamento simbolico e la critica delle grottesche nella seconda metà del Cinquecento." In Marcello Fagiolo, ed., *Roma e l'antico nell'arte e nella cultura del Cinquecento,* 149–78. Rome: Istituto della Enciclopedia Italiana, 1985.

"Le système décoratif de la Galerie Farnèse: observations sur les limites del la représentation." In *Les Carrache et les décors profanes,* 115–48. Actes du Colloque, Ecole française de Rome, 1986. Collection de l'Ecole Française de Rome, no. 106. Rome: Ecole française de Rome, 1988.

Morrogh, Andrew. "Vasari and Coloured Stones." In Gian Carlo Garfagnini, ed., *Giorgio Vasari: tra decorazione ambientale e storiografia artistica,* 309–20. Convegno di Studi, Arezzo, 1981. Florence: Olschki, 1985.

Mortari, Luisa. *Francesco Salviati.* Rome: Leonardo-De Luca, 1992.

Muller, Jeffrey M. "Rubens's Theory and Practice of the Imitation of Art." *Art Bulletin* 64 (1982): 229–47.

Mundy, James E. *Renaissance into Baroque: Italian Master Drawings by the Zuccari, 1550–1600.* Exh. cat. Milwaukee: Milwaukee Art Museum, 1989.

Nesselrath, Arnold. "Raphael's Archaeological Method." In *Raffaello a Roma. Il convegno del 1983,* 357–71. Rome: Edizioni dell'Elefante, 1986.

"Art-historical Findings during the Restoration of the Stanza dell'Incendio." *Master Drawings* 30 (1992): 31–60.

Newton, H. Travers, and John C. Spencer. "On the Location of Leonardo's *Battle of Anghiari.*" *Art Bulletin* 64 (1982): 45–52.

Nova, Alessandro. "Occasio pars virtutis. Considerazioni sugli affreschi di Francesco Salviati per il cardinale Ricci." *Paragone. Arte* 31, no. 365 (1980): 29–63, 94–6.

"Francesco Salviati and the 'Markgrafen' Chapel in S. Maria dell'Anima." *Mitteilungen des Kunsthistorischen Institutes in Florenz* 25 (1981): 355–72.

The Artistic Patronage of Pope Julius III (1550–1555). Profane Imagery and Buildings for the de Monte Family in Rome (Ph.D. diss., University of London, 1982). New York: Garland, 1988.

"Salviati, Vasari, and the Reuse of Drawings in Their Working Practice." *Master Drawings* 30 (1992): 83–108.

Oberhuber, Konrad. "Observations on Perino del Vaga as a Draughtsman." *Master Drawings* 4 (1966): 170–82.

"Raffaello e l'incisione." In *Raffaello in Vaticano,* 333–43. Exh. cat. Milan: Electa, 1984.

"Raphael's Drawings for the Loggia of Psyche in the Farnesina." In *Raffaello a Roma. Il convegno del 1983,* 189–207. Rome: Edizioni dell'Elefante, 1986.

"Marcantonio Raimondi: gli inizi a Bologna ed il primo periodo romano." In Marzia Faietti and Konrad Oberhuber, eds., *Bologna e L'umanesimo 1490–1510,* 51–88. Bologna: Nuova Alfa Editoriale, 1988.

"Giulio Romano pittore e disegnatore a Mantova." In *Giulio Romano,* 135–75. Exh. cat. Milan: Electa, 1989.

"Penni o Raffaello." In *Raffaello e i suoi: Disegni di Raffaello e della sua cerchia,* 21–6. Exh. cat. Rome: Carte Segreta, 1992.

Oberhuber, Konrad, and Lamberto Vitali. *Il cartone per la "Scuola d'Atene."* Fontes Ambrosiani, no. 47. Milan: Silvana Editoriale d'Arte, 1972.

L'Officina della maniera. Varietà e fierezza nell'arte fiorentina del Cinquecento fra le due repubbliche 1494–1530. Exh. cat. (Florence, 1996). Venice: Marsilio Editore, 1996.

O'Gorman, James F. "The Villa Lante in Rome: Some Drawings and Some Observations." *Burlington Magazine* 113 (1971): 133–8.

Oltre Raffaello: aspetti della cultura figurativa del cinquecento romano. Edited by Luciana Cassanelli and Sergio Rossi. Rome: Multigrafica, 1984.

O'Malley, John W. *Praise and Blame in Renaissance Rome: Rhetoric, Doctrine, and Reform in the Sacred Orators of the Papal Court, c. 1450–1521.* Durham, N.C.: Duke University Press, 1979.

"Renaissance Humanism and the Religious Culture of the First Jesuits." *Heythrop Journal* 31 (1990): 471–87. Reprinted in *Religious Culture in the Sixteenth Century: Preaching, Rhetoric, Spirituality, and Reform,* 471–87. Variorum Collected Studies Series, no. 404. Brookfield, Vt.: Variorum, 1993a.

The First Jesuits. Cambridge, Mass.: Harvard University Press, 1993b.

Ostrow, Steven F. "Marble Revetment in Late Sixteenth-Century Roman Chapels." In Marilyn Aronberg Lavin, ed., *Il 60. Essays Honoring Irving Lavin on His Sixtieth Birthday,* 253–76. New York: Italica Press, 1990.

Art and Spirituality in Counter-Reformation Rome: The Sistine and Pauline Chapels in S. Maria Maggiore. New York: Cambridge University Press, 1996.

Paleotti, Gabriele. *Discorso intorno alle imagini sacre e profane.* Bologna, 1582. In Barocchi, ed., *Trattati,* 2:117–503.

Panofsky, Erwin. *Idea. A Concept in Art Theory* (1924). Translated by Joseph J. S. Peake. New York: Icon-Harper and Row, 1968.

Parks, N. Randolph. "On the Meaning of Pinturicchio's *Sala dei Santi.*" *Art History* 2 (1979): 291–317.

Parma Armani, Elena. *Perin del Vaga. L'anello mancante.* Genoa: Sagep, 1986.

Partner, Peter. *Renaissance Rome, 1500–1559. A Portrait of a Society.* Berkeley: University of California Press, 1976.

Partridge, Loren W. "The Sala d'Ercole in the Villa Farnese at Caprarola, Part I." *Art Bulletin* 53 (1971): 467–86.

"The Sala d'Ercole in the Villa Farnese at Caprarola, Part II." *Art Bulletin* 54 (1972): 50–62.

"Divinity and Dynasty at Caprarola: Perfect History in the Room of Farnese Deeds." *Art Bulletin* 60 (1978): 494–530.

Review of *Papst Paul III. als Alexander der Grosse. Das Freskenprogramm der Sala Paolina in der Engelsburg,* by Richard Harprath. *Art Bulletin* 62 (1980): 661–3.

"Discourse of Asceticism in Bertoja's Room of Penitence in the Villa Farnese at Caprarola." In Joseph Connors, ed., *Memoirs of the American Academy in Rome,* 40 (1995a): 145–74.

"The Room of Maps at Caprarola." *Art Bulletin* 77 (1995b): 413–44.

Partridge, Loren W., and Randolph Starn. *A Renaissance Likeness: Art and Culture in Raphael's Julius II.* Berkeley: University of California Press, 1980.

"Triumphalism and the Sala Regia in the Vatican." In Barbara Wisch and Susan Scott Munshower, eds., *Triumphal Celebrations and the Rituals of Statecraft,* 22–81. Part 1 of *"All the World's a Stage . . ." Art and Pageantry in the Renaissance and Baroque.* Papers in Art History from the Pennsylvania State University, no. 6. University Park: Pennsylvania State University Press, 1990.

Pastor, Ludwig Freiherr von. *The History of the Popes. From the Close of the Middle Ages.* Vols. 6–23. Edited by Ralph Francis Kerr. Saint Louis, Mo.: Herder, 1898–1928.

Penny, Nicholas. "Raphael's *Madonna dei garofani* Rediscovered." *Burlington Magazine* 134 (1992): 67–81.

Pevsner, Nikolaus. "The Counter-Reformation and Mannerism" (1925). Translated and reprinted in *Studies in Art, Architecture and Design,* 11–33. Vol. 1 of *From Mannerism to Romanticism.* London: Thames and Hudson, 1968.

Academies of Art, Past and Present (1940). Reprint, with new preface by the author. New York: Da Capo Press, 1973.

Pietrangeli, Carlo, ed., *Il Palazzo Apostolico Lateranense.* Florence: Nardini, 1991.

Pigman, G. W. "Versions of Imitation in the Renaissance." *Renaissance Quarterly* 33 (1980): 1–32.

Pillsbury, Edmund P. "Jacopo Zucchi in S. Spirito in Sassia." *Burlington Magazine* 116 (1974): 434–44.

"The Sala Grande Drawings by Vasari and His Workshop: Some Documents and New Attributions." *Master Drawings* 14 (1976): 127–46.

Pillsbury, Edmund P., and Louise S. Richards. *The Graphic Art of Federico Barocci. Selected Drawings and Prints.* Exh. cat. New Haven: Yale University Art Museum, 1978.

Pinelli, Antonio. "Pittura e controriforma. 'Convenienza' e misticismo in Giovanni de' Vecchi. Note e schede." *Ricerche di storia dell'arte* 6 (1977): 49–85.

Pino, Paolo. *Dialogo di Pittura.* Vinegia, 1548. In Barocchi, ed., *Trattati,* 1:93–139.

Polidoro da Caravaggio fra Napoli e Messina. Edited by Pierluigi Leone de Castris. Exh. cat. Rome: De Luca, 1988.

Pope-Hennessy, John. *Raphael.* The Wrightsman Lectures. London: Phaidon, 1970.

Popham, A. E. *Catalogue of the Drawings of Parmigianino.* 3 vols. London: Yale University Press, 1971.

Popham, A.E., and Johannes Wilde. *The Italian Drawings of the XV and XVI Centuries in the Collection of His Majesty the King at Windsor Castle.* London: Phaidon, 1949.

Posner, Donald. *Annibale Carracci: A Study in the Reform of Italian Painting around 1590.* 2 vols. National Gallery of Art: Kress Foundation Studies in the History of European Art, no. 5. New York: Phaidon, 1971.

Pressouyre, Sylvia. "Le cadre architectural." In *La Galerie François I^{er} au Château de Fontainebleau. Revue de l'art* 16–17 (1972): 13–24.

Prodi, Paolo. *Il Cardinale Gabriele Paleotti (1522–1597).* 2 vols. Rome: Istituto Grafico Tiberino, 1959–67.

Quednau, Rolf. *Die Sala di Costantino im Vatikanischen Palast. Zur Dekoration der beiden Medici-Päpste Leo X. und Clemens VII.* Studien zur Kunstgeschichte, no. 13. Hildesheim: Olms, 1979.

"Aspects of Raphael's 'Ultima Maniera' in the Light of the Sala di Costantino." In *Raffaello a Roma. Il convegno del 1983,* 245–57. Rome: Edizioni dell'Elefante, 1986.

Quintavalle, Armando Ottaviano. *Il Parmigianino.* Milan: Istituto Editoriale Italiano, 1948.

Rabil, Albert, Jr., ed. *Renaissance Humanism: Foundations, Forms and Legacy.* 3 vols. Philadelphia: University of Pennsylvania, 1988.

Raffaello e i suoi: Disegni di Raffaello e della sua cerchia, 21–6. Exh. cat. Rome: Carte Segreta, 1992.

Raphael Invenit. Stampe da Raffaello nelle collezioni dell'Istituto Nazionale per la Grafica. Exh. cat. Essays by Grazia Bernini Pezzini, Stefania Massari, and Simonetta Prosperi Valenti Rodinò. Rome: Edizioni Quasar, 1985.

Ravelli, Lanfranco. *Polidoro Caldara da Caravaggio.* Bergamo: Edizioni "Monumenta Bergomensia," 1978.

———. *Polidoro a San Silvestro al Quirinale.* Bergamo: Edizioni dell'Ateneo di Scienze Lettere ed Arti, 1987.

———. "Gli affreschi di Polidoro in S. Silvestro al Quirinale." In Marcello Fagiolo and Maria Luisa Madonna, eds., *Raffaello e l'Europa,* 297–332. Rome: Istituto Poligrafico dello Stato, 1990.

La Regola e la fama: San Filippo Neri e l'arte. Exh. cat. Milan: Electa, 1995.

Riccòmini, Eugenio. "The Frescoes of Correggio and Parmigianino: From Beauty to Elegance." In *The Age of Correggio and the Carracci: Emilian Painting of the Sixteenth and Seventeenth Centuries,* 3–20. Exh. cat. Washington, D.C., National Gallery of Art. New York: Cambridge University Press, 1986.

Riess, Jonathan B. *The Renaissance Antichrist: Signorelli's Orvieto Frescoes.* Princeton: Princeton University Press, 1995.

Robertson, Clare. "Annibale Caro as Iconographer: Sources and Method." *Journal of the Warburg and Courtauld Institutes* 45 (1982): 160–81.

———. "*Ars vincit omnia:* The Farnese Gallery and Cinquecento Ideas about Art." *Mélanges de l'Ecole française de Rome. Italie et Méditerranée* 102, no. 1 (1990): 7–41.

———. "*Il Gran Cardinale*": *Alessandro Farnese, Patron of the Arts.* London: Yale University Press, 1992.

Roma 1300–1875. La città degli anni santi. Edited by Marcello Fagiolo and Maria Luisa Madonna. Exh. cat. Milan: Mondadori, 1985.

Roma di Sisto V. Le arti e la cultura. Edited by Maria Luisa Madonna. Exh. cat. Rome: De Luca, 1993.

Rosenauer, Arthur R. "Observations and Questions concerning Ghirlandaio's Work Process." *Canadian Art Review* 12 (1985): 149–53.

Roskill, Mark W., ed. *Dolce's "Aretino" and Venetian Art Theory of the Cinquecento.* Monographs on Archaeology and the Fine Arts, no. 15. New York: College Art Association, 1968.

Rousseau, Claudia. "The Pageant of the Muses at the Medici Wedding of 1539 and the Decoration of the Salone dei Cinquecento." In Barbara Wisch and Susan Scott Munshower, eds., *Theatrical Spectacle and Spectacular Theatre,* 416–57. Part 2 of *"All the World's a Stage . . ." Art and Pageantry in the Renaissance and Baroque.* Papers in Art History from the Pennsylvania State University, no. 6. University Park: Pennsylvania State University Press, 1990.

Rowland, Ingrid D. "Two Notes about Agostino Chigi." *Journal of the Warburg and Courtauld Institutes* 47 (1984): 192–9.

Rubin, Patricia. "The Private Chapel of Cardinal Alessandro Farnese in the Cancelleria, Rome." *Journal of the Warburg and Courtauld Institutes* 50 (1987): 82–112.

———. "Il contributo di Raffaello allo sviluppo della pala d'altare rinascimentale." *Arte cristiana* 78 (1990): 169–82.

———. "The Art of Colour in Florentine Painting of the Early Sixteenth Century: Rosso Fiorentino and Jacopo Pontormo." *Art History* 14 (1991): 175–91.

———. "Commission and Design in Central Italian Altarpieces c. 1450–1550." In Eve Borsook and Fiorella Superbi Gioffredi, eds., *Italian Altarpieces 1250–1550: Function and Design,* 201–29. Oxford: Oxford University Press, 1994.

———. *Giorgio Vasari. Art and History.* London: Yale University Press, 1995.

Rubinstein, Ruth Olitsky. "'Tempus edax rerum': A Newly Discovered Painting by Hermannus Posthumus." *Burlington Magazine* 127 (1985): 425–33.

Satolli, Alberto. "Quel bene detto duomo." *Bollettino dell'Istituto Storico Artistico Orvietano* 34 (1978): 73–140.

Saunders, Eleanor A. "A Commentary on Iconoclasm in Several Prints by Maarten van Heemskerck." *Simiolus* 10 (1978/1979): 59–83.

Saxl, Fritz. "Illustrated Pamphlets of the Reformation." In *Lectures,* 1:255–66. London: Warburg Institute, 1957.

Scavizzi, Giuseppe. "Storia ecclesiastica e arte nel secondo Cinquecento." *Storia dell'arte* 59 (1987): 29–46.

———. "The Cross: A 16th-Century Controversy." *Storia dell'arte* 65 (1989): 27–43.

———. *The Controversy on Images from Calvin to Baronius.* Toronto Studies in Religion, no. 14. New York: Peter Lang, 1992.

Schaefer, Scott J. "Europe and Beyond: On Some Paintings for Francesco's Studiolo." In Gian Carlo Garfagnini, ed., *Firenze e la Toscana dei Medici nell'Europa del Cinquecento.* 3: *Relazioni artistiche. Il linguaggio architettonico,* 925–38. Convegno internazionale di studi, Firenze, 1980. Biblioteca di storia toscana moderna e contemporanea, studi e documenti, no. 26. Florence: Olschki, 1983.

Schiavo, Armando. *Il palazzo della Cancelleria.* Rome: Staderini, 1963.

Schlitt, Melinda Wilcox. "Francesco Salviati and the Rhetoric of Style." Ph.D. diss., Johns Hopkins University, 1991.

Schröter, Elisabeth. "Der Vatikan als Hügel Apollons und der Musen. Kunst und Panegyrik von Nikolaus V. bis Julius II." *Römische Quartalschrift* 75 (1980): 208–40.

Schulz, Juergen. *Venetian Painted Ceilings of the Renaissance.* California Studies in the History of Art, no. 9. Berkeley: University of California Press, 1968.

Schutte, Anne Jacobson. "Periodization of Sixteenth-Century Italian Religious History: The Post-Cantimori Paradigm Shift." *Journal of Modern History* 61 (1989): 269–84.

Scorza, Rick. "Vasari's Painting of the Terzo Cerchio in the Palazzo Vecchio: A Reconstruction of Medieval Florence." In Philip Jacks, ed., *Vasari's Florence: Artists and Literati at the Medicean Court. The Symposium. 16–19 April 1994.* New York: Cambridge University Press, 1998, 182–205.

Scott, John Beldon. "The Meaning of Perseus and Andromeda in the Farnese Gallery and on the Rubens House." *Journal of the Warburg and Courtauld Institutes* 51 (1988): 250–60.

Sebastiano del Piombo y España. Edited by Manuela B. Mena Marqués. Exh. cat. Madrid: Prado, 1995.

Senecal, Robert. "A Note on Daniele da Volterra's Cappella Orsini in the Santissima Trinità dei Monti and Its Impact on Sixteenth Century Chapel Decoration." *Paragone. Arte* 41, no. 487 (1990): 88–96.

Settis, Salvatore, ed. *Memoria dell'antico nell'arte italiana.* 3 vols. Vol. 1, *L'uso dei classici.* Vol. 2, *I generi e i temi ritrovati.* Vol. 3, *Dalla tradizione all'archeologia.* Biblioteca di storia dell'arte. Turin: Einaudi, 1984–6.

Seymour, Charles. *Michelangelo's David: A Search for Identity.* Pittsburgh, Penn.: University of Pittsburgh Press, 1967.

Seznec, Jean. *The Survival of the Pagan Gods. The Mythological Tradition and Its Place in Renaissance Humanism and Art* (1940). Translated by Barbara F. Sessions. New York: Bollingen Foundation, 1953.

Shearman, John. "The Chigi Chapel in S. Maria in Popolo." *Journal of the Warburg and Courtauld Institutes* 21 (1961): 129–60.

Andrea del Sarto. 2 vols. Oxford: Oxford University Press, 1965.

Mannerism. Harmondsworth: Penguin, 1967.

Raphael's Cartoons in the Collection of Her Majesty the Queen and the Tapestries for the Sistine Chapel. London: Phaidon, 1972.

"An Episode in the History of Conservation: The Fragments of Perino's Altarpiece from S. Maria sopra Minerva." In Maria Grazia Ciardi Dupré Dal Poggetto and Paolo Dal Poggetto, eds., *Scritti di storia dell'arte in onore di Ugo Procacci,* 2:356–64. Milan: Electa, 1977.

The Early Italian Pictures in the Collection of Her Majesty the Queen. Cambridge: Cambridge University Press, 1983.

"Raffaello e la bottega." In *Raffaello in Vaticano,* 258–63. Exh. cat. Milan: Electa, 1984.

"The Chapel of Sixtus IV." In *The Sistine Chapel. The Art, the History, and the Restoration,* 22–91. New York: Crown-Harmony, 1986.

"Giulio Romano and Baldassare Castiglione." In *Giulio Romano. Atti del Convegno Internazionale di Studi su "Giulio Romano e l'espansione europea del Rinascimento,"* 293–301. Mantua, 1989. Mantua: Accademia Nazionale Virgiliana, 1991.

Only Connect . . . Art and the Spectator in the Italian Renaissance. A. W. Mellon Lectures in the Fine Arts, 1988. (National Gallery of Art, Washington, D.C.) Princeton: Princeton University Press, 1992.

"Castiglione's Portrait of Raphael." *Mitteilungen des Kunsthistorischen Institutes in Florenz* 38 (1994): 69–97.

Shearman, John, and Marcia B. Hall, eds. *The Princeton Raphael Symposium: Science in the Service of Art History.* Princeton: Princeton University Press, 1990.

Shoemaker, Innis H., and Elizabeth Broun. *The Engravings of Marcantonio Raimondi.* Lawrence, Kans.: Allen Press, 1981.

Shrimplin, Valerie. "Hell in Michelangelo's *Last Judgment.*" *Artibus et Historiae* 15, no. 30 (1994): 83–107.

Shrimplin-Evangelidis, Valerie. "Michelangelo and Nicodemism: The Florentine *Pietà.*" *Art Bulletin* 71 (1989): 58–66.

"Sun-Symbolism and Cosmology in Michelangelo's *Last Judgment.*" *Sixteenth Century Journal* 21 (1990): 607–44.

Simon, Robert B. "Bronzino's *Cosimo I de' Medici as Orpheus.*" *Bulletin, Philadelphia Museum of Art* 81, no. 348 (Fall 1985): 17–27.

Simoncelli, Paolo. *Evangelismo italiano del Cinquecento.* Rome: Istituto Storico Italiano, 1979.

Smith, Graham. "Bronzino and Dürer." *Burlington Magazine* 119 (1977a): 109–10.

The Casino of Pius IV. Princeton: Princeton University Press, 1977b.

Smyth, Craig Hugh. "The Earliest Works of Bronzino." *Art Bulletin* 31 (1949): 184–211.

Bronzino Studies. Ph.D. diss., Princeton University, 1955.

Bronzino as Draughtsman: An Introduction. With Notes on His Portraiture and Tapestries. Locust Valley, N.Y.: J. J. Augustin, 1971.

Mannerism and Maniera (1963). Second ed., with introduction by Elizabeth Cropper. Vienna: IRSA, 1992.

Spalding, Jack. *Santi di Tito* (Ph.D. diss., Princeton University, 1976). New York: Garland, 1982.

"Observations on Alessandro Allori's Historical Frescoes at Poggio a Caiano." *Storia dell'arte* 59 (1987): 11–14.

Standen, Edith A. "Some Sixteenth-Century Flemish Tapestries Related to Raphael's Workshop." *Metropolitan Museum Journal* 4 (1971): 109–21.

Starn, Randolph, and Loren W. Partridge. *Arts of Power: Three Halls of State in Italy, 1300–1600.* Berkeley: University of California Press, 1992.

Steinberg, Leo. *Michelangelo's Last Paintings. The Conversion of St. Paul and the Crucifixion of St. Peter in the Cappella Paolina, Vatican Palace.* London: Phaidon, 1975.

Steinmann, Ernst. *Die Sixtinische Kapelle.* 2 vols. Munich: Bruckmann, 1901–5.

Stenius, Göran. "Baldassare Turini e le sue case romane sulla base dei documenti." "The Prisoner Turned Pope. A Medicean Miracle in Raphael's Stanze." *Opuscula Instituti Romani Finlandiae* 1 (1981): 71–82; 83–102.

Stinger, Charles L. *The Renaissance in Rome.* Bloomington: Indiana University Press, 1985.

Strinati, Claudio. "Gli anni difficili di Federico Zuccari." *Storia dell'arte* 21 (1974): 85–117.

"Roma nell'anno 1600. Studio di pittura." *Ricerche di storia dell'arte* 10 (1980): 15–48.

"L'Oratorio del Gonfalone." In Anna Aletta, ed., *Conversazioni sotto la volta: La nuova volta della Cappella sistina e il Manierismo romano fino al 1550,* 77–85. Rome: Sinnos, COOP, 1992.

Strong, Roy. *Art and Power. Renaissance Festivals, 1450–1600.* Bury Saint Edmunds: Boydell Press, 1984.

Summers, David. "The Sculptural Program of the Cappella di San Luca in the Santissima Annunziata." *Mitteilungen des Kunsthistorischen Institutes in Florenz* 14 (1969): 67–90.

"Maniera and Movement: The *figura serpentinata.*" *Art Quarterly* 35 (1972): 269–301.

"Contrapposto: Style and Meaning in Renaissance Art." *Art Bulletin* 59 (1977a): 336–61.

"*Figure Come Fratelli:* A Transformation of Symmetry in Renaissance Painting." *Art Quarterly* ns 1 (1977b): 59–88.

Michelangelo and the Language of Art. Princeton: Princeton University Press, 1981.

The Judgement of Sense. Renaissance Naturalism and the Rise of Aesthetics. Ideas in Context. Cambridge: Cambridge University Press, 1987.

Talvacchia, Bette T. "Greek Heroes and Hellenism in Giulio Romano's Hall of Troy." *Journal of the Warburg and Courtauld Institutes* 51 (1988): 235–42.

"L'erotismo in Giulio Romano, fra decoro, decorazione, e scandalo." *La Nuova Città,* ser. 6, 5 (1994): 95–113.

Thiem, Christel, and Gunther Thiem. "Andrea di Cosimo Feltrini und die Groteskendekoration der Florentiner Hoch-renaissance." *Zeitschrift für Kunstgeschichte* 24 (1961): 1–39.

Thiem, Gunther, and Christel Thiem. *Toskanische Fassaden-Dekoration in Sgraffito und Fresko. 14. bis 17. Jahrhundert.* Munich: Bruckmann, 1964.

Tra mito e allegoria. Immagini a stampa nel '500 e '600. Catalogue by Stefania Massari and Simonetta Prosperi Valenti Rodinò. Rome: Istituto Nazionale per la Grafica, 1989.

Trinchieri Camiz, Franca. "Music and Painting in Cardinal del Monte's Household." *Metropolitan Museum Journal* 26 (1991): 213–26.

"Luogo molto vago et delitioso . . .": il casino del cardinale Del Monte ed un soffitto dipinto da Caravaggio." *Ricerche di storia dell'arte* 47 (1992): 81–8.

"Verso una nuova vita': L'iconografia della conversione e del battesimo nella pittura controriforma a Roma." In Fiorani, ed., *Ricerche per la storia religiosa di Roma,* 10, 1998 (forthcoming).

Tucker, Mark S. "Discoveries Made during the Treatment of Bronzino's *Cosimo I de' Medici as Orpheus.*" *Bulletin, Philadelphia Museum of Art* 81, no. 348 (Fall 1985): 28–32.

Turner, A. Richard. *The Vision of Landscape in Renaissance Italy.* Princeton: Princeton University Press, 1966.

Vaccaro, Mary. "Documents for Parmigianino's 'Vision of St Jerome.'" *Burlington Magazine* 135 (1993): 22–7; and the contract published in ibid. ("Parmigianino's contract for the Caccialupi Chapel in S. Salvatore in Lauro"), 27–9, by Sandro Corradini.

"Precisazioni sulla vendita della celebre 'Madonna dal Collo Lungo' del Parmigianino." *Aurea Parma* 80 (May–August 1996): 162–75.

Valone, Carolyn. "The Pentecost: Image and Experience in Late Sixteenth-Century Rome." *Sixteenth Century Journal* 24/4 (1993): 801–28.

Van Veen, Henk Th. "'Republicanism,' Not 'Triumphalism.' On the Political Message of Cosimo I's Sala Grande." *Mitteilungen des Kunsthistorischen Institutes in Florenz* 37 (1993): 475–80.

"Circles of Sovereignty: The Tondi of the Sala Grande in the Palazzo Vecchio and the Medici Crown." In Philip Jacks, ed., *Vasari's Florence: Artists and Literati at the Medicean Court. The Symposium. 16–19 April 1994,* 206–219. New York: Cambridge University Press, 1998.

Varchi, Benedetto. *Lezzione della maggioranza delle arti* (1547, published in Florence, 1550). In Barocchi, ed., *Trattati,* 1:3–58.

Libro della beltà e grazia (1543, published, 1590.) In Barocchi, ed., *Trattati,* 1:83–91.

Vasari, Giorgio. *La vita di Michelangelo nelle redazioni del 1550 e del 1568.* 5 vols. Edited by Paola Barocchi. Milan: Riccardo Riccardi, 1962.

Le vite de' pi eccelenti pittori, scultori ed architettori. 9 vols. Edited by Gaetano Milanesi. Florence: Sansoni, 1878–85. (The best version in English is *The Lives of the Painters, Sculptors and Architects.* 4 vols. Translated by A. B. Hinds. 1927. Revised edition edited with an introduction by William Gaunt. New York: Dutton, 1963.)

Le vite de' pi eccelenti pittori, scultori ed architettori nelle redazioni del 1550 e 1568. 6 vols. Edited by Rosanna Bettarini and Paola Barocchi. Florence: Sansoni; Studio per Edizioni Scelte, 1966–87.

Vasari on Technique. Translated by Luisa S. Maclehose. London: J. M. Dent, 1907.

Verdon, Timothy. "'Ecce homo': contesto e senso degli affreschi della Cupola." In *Il "Giudizio" ritrovato. Il restauro degli affreschi della Cupola di Santa Maria del Fiore,* 25–43. Supplement to no. 24, *TOSCANAoggi* (Florence), 25 June 1995.

Verheyen, Egon. *The Palazzo del Te in Mantua. Images of Love and Politics.* Baltimore: Johns Hopkins University Press, 1977.

Vinti, Francesca. *Giulio Romano: pittore e l'antico.* Pubblicazioni della Facoltà di lettere e filosofia dell'Università di Pavia: no. 77. Florence: Nuova Italia, 1995.

Vitzthum, Walter. *Lo Studiolo di Francesco I a Firenze.* I grandi decoratori, no. 9. Milan: Fabbri-Skira, 1969.

Voelker, Evelyn Carole. "Charles Borromeo's *Instructiones fabricae et supellectilis ecclesiaticae, 1577.* A Translation with Commentary and Analysis." Ph.D. diss., Syracuse University, 1977.

Volpe, Carlo. *L'opera completa di Sebastiano del Piombo.* Milan: Rizzoli, 1980.

Voss, Hermann. *Die Malerei der Spätrenaissance in Rom und Florenz.* 2 vols. Berlin: Grote, 1920.

Waldman, Louis Alexander. "Bronzino's Uffizi 'Pietà' and the Cambi Chapel in S. Trinita, Florence." *Burlington Magazine* 139 (1997): 94–102.

Wallace, William E. "Narrative and Religious Expression in Michelangelo's Pauline Chapel." *Artibus et Historiae* 10, no. 19 (1989): 107–21.

Michelangelo at San Lorenzo: The Genius as Entrepreneur. New York: Cambridge University Press, 1994.

Waterhouse, Ellis. *Italian Baroque Painting.* London: Phaidon, 1962.

Wazbinski, Zygmunt. "La prima mostra dell'Accademia del Disegno a Firenze." *Prospettiva* 14 (1978): 47–57.

"Giorgio Vasari e Vincenzo Borghini come maestri accademici: il caso di G. B. Naldini." In Gian Carlo Garfagnini, ed., *Giorgio Vasari: tra decorazione ambientale e storiografia artistica,* 285–99. Convegno di Studi, Arezzo, 1981. Florence: Olschki, 1985.

"Il *modus* semplice: un dibattito sull'*ars sacra* fiorentina intorno al 1600." In Micaela Sambucco Hamoud and Maria

Letizia Strocchi, eds., *Studi su Raffaello,* 1:625–48. Atti del Congresso Internazionale di Studi, Urbino-Florence, 1984. Urbino: QuattroVenti, 1987a.

L'Accademia Medicea del Disegno a Firenze nel Cinquecento. Idea e Istituzione. 2 vols. Studi, Accademia Toscana di Scienze e Lettere "La Colombaria," no. 84. Florence: Olschki, 1987b.

"Il cavaliere d'Arpino ed il mito accademico: Il problema dell'autoidentificazione con l'ideale." In Matthias Winner, ed., *Der Künstler über sein Werk,* 317–63. Internationales Symposium der Bibliotheca Hertziana, Rom, 1989. Weinheim: VCH, Acta Humaniora, 1992.

Weiss, Roberto. "The Medals of Julius II (1503–1513)." *Journal of the Warburg and Courtauld Institutes* 28 (1965): 163–82.

The Renaissance Rediscovery of Classical Antiquity. Oxford: Blackwell, 1969.

Weisz, Jean S. *Pittura e Misericordia: The Oratory of S. Giovanni Decollato in Rome* (Ph.D. diss., Harvard University, 1982). Ann Arbor, Mich.: UMI Research Press, 1984.

"*Caritas/Controriforma:* The Changing Role of a Confraternity's Ritual." In Konrad Eisenbichler, ed., *Crossing the Boundaries. Christian Piety and the Arts in Italian Medieval and Renaissance Confraternities,* 221–36. Early Drama, Art, and Music Monograph Series, no. 15. Medieval Institute Publications. Kalamazoo: Western Michigan University, 1991.

Weston-Lewis, Aidan. "Annibale Carracci and the Antique." *Master Drawings* 30 (1992): 287–313.

Wethey, Harold E. *El Greco and His School.* 2 vols. Princeton: Princeton University Press, 1962.

Wilde, Johannes. "The Hall of the Great Council in Florence." *Journal of the Warburg and Courtauld Institutes* 7 (1944): 65–81.

Michelangelo. Six Lectures. Edited by John Shearman and Michael Hirst. Oxford Studies in the History of Art and Architecture. Oxford: Oxford University Press, 1978.

Wilkinson, Catherine. "Planning a Style for the Escorial: An Architectural Treatise for Philip of Spain." *Journal of the Society of Architectural Historians* 44 (1985): 37–47.

Williams, Robert. "The Sala Grande in the Palazzo Vecchio and the Precedence Controversy between Florence and Ferrara." In Philip Jacks, ed., *Vasari's Florence: Artists and Literati at the Medicean Court. The Symposium. 16–19 April 1994,* 163–81. New York: Cambridge University Press, 1998.

Wisch, Barbara. "The Roman Church Triumphant: Pilgrimage, Penance and Processions. Celebrating the Holy Year of 1575." In Barbara Wisch and Susan Scott Munshower, eds., Part 1 of *Triumphal Celebrations and the Rituals of Statecraft,* 82–117. *"All the World's a Stage . . ." Art and Pageantry in the Renaissance and Baroque.* Papers in Art History from the Pennsylvania State University, no. 6. University Park: Pennsylvania State University Press, 1990.

"The Passion of Christ in the Art, Theater, and Penitential Rituals of the Roman Confraternity of the Gonfalone."

In Konrad Eisenbichler, ed., *Crossing the Boundaries. Christian Piety and the Arts in Italian Medieval and Renaissance Confraternities,* 237–62. Early Drama, Art, and Music Monograph Series, no. 15. Medieval Institute Publications. Kalamazoo: Western Michigan University, 1991.

Wittkower, Rudolf, and Margot Witthower. *The Divine Michelangelo. The Florentine Academy's Homage on His Death in 1564. A Facsimile Edition of "Esequie del Divino Michelagnolo Buonarroti." Florence, 1564.* London: Phaidon, 1964.

Wölfflin, Heinrich. *Classic Art* (1899). Translated by Linda and Peter Murray. London: Phaidon, 1952.

Wohl, Helmut. *The Aesthetics of Italian Renaissance Art.* New York: Cambridge University Press, 1999.

Wolk, Linda. "The *Pala Baciadonne* by Perino del Vaga." *Studies in the History of Art,* no. 18, 29–57. National Gallery of Art, Washington, D.C. Hanover, N.H.: University Press of New England, 1985.

Wolk-Simon, Linda. "The 'Pala Doria' and Andrea Doria's Mortuary Chapel: A Newly Discovered Project by Perino del Vaga." *Artibus et Historiae* 13, no. 26 (1992): 163–75.

Wright, Georgia. "Caravaggio's *Entombment* Considered *in Situ.*" *Art Bulletin* 60 (1978): 35–42.

Zandri, Giuliana. "Un probabile dipinto murale del Caravaggio per il Cardinale Del Monte." *Storia dell'arte* 3 (1969): 338–44.

Zapperi, Roberto. *Eros e Contrariforma. Preistoria della galleria Farnese.* Turin: Bollati Boringhieri, 1994.

Zeri, Federico. *Pittura e controriforma: l'arte senza tempo di Scipione da Gaeta.* Turin: Einaudi, 1957.

Zerner, Henri. *Ecole de Fontainebleau: Gravures.* Paris: Art et Métiers Graphique, 1969.

"Les estampes et le style de l'ornement." In *La Galerie François I^er au Château de Fontainebleau. Revue de l'art* 16–17 (1972a): 112–20.

"Observations on the Use of the Concept of Mannerism." In Franklin W. Robinson and Stephen G. Nichols, Jr., eds., *The Meaning of Mannerism,* 105–21. Hanover, N.H.: University Press of New England, 1972b.

Zuccari, Alessandro. "La politica culturale dell'Oratorio romano nella seconda metà del Cinquecento." *Storia dell'arte* 41 (1981a): 77–112.

"La politica culturale dell'Oratorio Romano nelle imprese artistiche promosse da Cesare Baronio." *Storia dell'arte* 42 (1981b): 171–93.

Arte e committenza nella Roma di Caravaggio. Turin: RAI, 1984.

I pittori di Sisto V. Rome: Fratelli Palombi, 1992.

"Cultura e predicazione nelle immagini dell'Oratorio." *Storia dell'arte* 85 (1995): 340–54.

Zuccaro, Federico. *Scritti d'arte di Federico Zuccaro.* Edited by Detlef Heikamp. Fonti per lo studio della Storia dell'Arte inedite o rare, no. 1. Florence: Olschki, 1961.

Photographic Credits

Index

337